0057769

THE CAMBRIDGE GUIDE TO THE ARTS IN BRITAIN

VOLUME 8 THE EDWARDIAN AGE AND THE INTER-WAR YEARS

The Cambridge Guide to the Arts in Britain

The Cambridge Guide to the Arts in Britain

edited by
BORIS FORD

VOLUME 8

THE EDWARDIAN AGE AND THE INTER-WAR YEARS

The right of the
University of Cambridge
to print and sell
all manner of books
was granted by
Henry VIII in 1534.
The University has printed
and published continuously
since 1584.

CAMBRIDGE UNIVERSITY PRESS

CAMBRIDGE

NEW YORK NEW ROCHELLE MELBOURNE SYDNEY

Published by the Press Syndicate of the University of Cambridge
The Pitt Building, Trumpington Street, Cambridge CB2 1RP
32 East 57th Street, New York, NY 10022, USA
10 Stamford Road, Oakleigh, Melbourne 3166, Australia

First published 1989

Printed in Great Britain by William Clowes, Beccles

British Library cataloguing in publication data

The Cambridge guide to the arts in Britain
 Vol 8 : The Edwardian age and the inter-war years.
 1. Arts – Great Britain
 I. Ford, Boris
 700'.941 NX543

Library of Congress cataloguing in publication data

The Cambridge guide to the arts in Britain.
 Includes bibliographies and indexes.
 Contents: – v. 2. The Middle Ages, 1100–1500
 – v. 8. The Edwardian Age and the inter-war years.
 1. Arts, British. I. Ford, Boris.
 NX543.C36 700'.941 87-11671
 ISBN 0 521 30975 1 (v. 2)

ISBN 0 521 30981 6

Contents

Contents

Notes on Contributors

John Beer is Professor of English Literature at Cambridge University and a Fellow of Peterhouse. His writings on modern authors include *The Achievement of E. M. Forster*; *E. M. Forster: a Human Exploration*; *Centenary Essays*, ed. with G. K. Das; and 'Lawrence's Counter-Romanticism' in *The Spirit of D. H. Lawrence*, ed. Salgado and Das.

Jacques Berthoud is Professor and head of the Department of English and Related Literature at the University of York. He has researched into literary modernism, and French and English literary relations. He is the author of *Conrad, the Major Phase*.

Richard Cork, formerly Editor of *Studio International*, is the art critic of *The Listener*. His books include *Vorticism and Abstract Art in the First Machine Age*, *Art Beyond the Gallery*, and *David Bomberg*. He co-selected the Royal Academy exhibition *British Art in the Twentieth Century* (1987).

Rupert Hildyard teaches literature for the Open University, and is working on the English short story from 1880 to 1930. He is engaged on research for the National Trust into the Lycett-Green family of York.

Michael Kennedy is staff music critic of *The Daily Telegraph* and was its Northern Editor 1960–86. He has written histories of the Hallé Orchestra and the Royal Manchester College of Music; biographies of Barbirolli and Boult; and studies of Elgar, Vaughan Williams, Britten, Walton, Mahler and Strauss. He is editor of the *Oxford Dictionary of Music*.

Wilfrid Mellers, who read English and Music at Cambridge, was Professor of Music at the University of York from its inception until his retirement in 1981. He has written books on (among others) Couperin, Bach, and Beethoven, on English music and poetry, and on Dylan. His compositions mostly involve words and/or the theatre.

Gillian Naylor is Senior tutor in Cultural History at the Royal College of Art. She has written two books on the Bauhaus, and a book on the Arts and Crafts movement.

Simon Pepper is Senior Lecturer at the Liverpool School of Architecture, where he teaches design and architectural history. His books include *Housing Improvement: Goals and Strategy* (with N. Adams), and *Firearms and Fortifications: Military Architecture and Siege Warfare in Sixteenth Century Siena*.

Neil Sinyard is a freelance writer and lecturer on film and literature, in particular Victorian fiction. His books include *Filming Literature: the Art of Screen Adaptation*, and studies of Billy Wilder, Richard Lester, Alfred Hitchcock and Woody Allen.

Sir John Summerson, CH, CBE, was Curator of Sir John Soane's Museum, London, 1945–84. He is the author of *John Nash*, *Georgian London*, *Heavenly Mansions*, *Architecture in Britain 1530–1830*, *Victorian Architecture*, and *The Classical Language of Architecture*.

Frank Whitehead was Reader in English and Education at the University of Sheffield from 1973 until his retirement in 1981. He is the author of *The Disappearing Dais*, and co-author of *Children and their Books*.

General Introduction

BORIS FORD

If English literature is, by common consent, pre-eminent in the world, the same would not often be claimed for Britain's arts as a whole. Indeed, the British people sometimes strike foreigners, and even themselves, as rather more philistine than artistic. And yet, viewed historically, Britain's achievements in the visual and applied arts and in architecture and music, as well as in drama and literature, must be at least the equal, as a whole, of any other country.

The Cambridge Guide to the Arts in Britain, to give it its full title, is not devoted, volume by volume, to the separate arts, but to all the arts in each successive age. Histories of the independent arts are legion. But being of their nature self-centred, they provide a very poor impression of the cultural richness and vitality of an age. Moreover, these separate histories obscure the ebb and flow of artistic creation from one age to the next.

When the arts in Britain are viewed collectively, it can be seen how often they reinforce each other, treating similar themes and speaking in a similar tone of voice. Also it is striking how one age may find its major cultural expression in music and drama, and the next in architecture or the applied arts: while in a later age there may be an almost total absence of important composers compared with a proliferation of major novelists. Or an age may provide scope for a great range of anonymous craftsmen. These contrasts in the degree to which the individual arts have flourished are nor fortuitous, but are bound up with the social aspirations and characteristics of the age, with its beliefs and preoccupations and manners, which may favour expression in one art rather than another.

The Cambridge Guide is planned to reveal these changes and the resulting character of the arts and the balance between them. Thus these volumes do not consist of a sequence of mini-surveys, packed with facts and dates. Rather, they are designed to help readers find their bearings in relation to the arts and culture of an age: identifying major landmarks and lines of strength, analysing changes of taste and fashion and critical assumptions. And these are necessarily related to the demands of patrons and the tastes of the various overlapping publics.

These volumes are addressed to readers of all kinds: to general readers as well as to specialists. But virtually every reader is bound to be a non-specialist in relation to many of the arts under discussion, and so the chapters on the individual arts do not presuppose specialist knowledge. On the other hand, these volumes are not elementary nor naive; they assume a measure of familiarity with the arts, and above all a wish to understand and appreciate the artistic achievements of successive ages in Britain.

The arts in the first half of the twentieth century in Britain, which are the subject of this eighth volume of *The Cambridge Guide*, were as rich and vigorous as in almost any previous age, when viewed collectively. For all the trauma and dislocations of the First World War and of the later economic depression, the Edwardian age and the inter-war years saw major creative achievements in virtually all the arts. And what is also notable is the degree to which the separate arts were linked to each other in the themes they treated and in their styles and technical preoccupations. In particular, artists felt themselves strongly drawn towards either traditionalism or modernism; or towards an attempt to reconcile the two, as in the case of Henry Moore, Vaughan Williams, Benjamin Britten, T. S. Eliot, D. H. Lawrence, to mention only some of the major artists of the age.

Each of the nine volumes in this series contains five kinds of material:

The Cultural and Social Setting

This major introductory survey provides a map of the cultural landscape, and an examination of the historical and social developments which affected the arts (both the 'high' and popular arts):

(a) The shape and pattern of society; its organisation, belief, ideals, scepticisms.

(b) How the concerns of society were embodied or reflected in the individual arts, and in the practical arts and crafts; the notion and 'function' of art at that time.

(c) The character and preoccupations of the separate arts, and of patrons and audiences. Why particular arts tended to flourish and others to decline in this age.

(d) The organisation and economic situation of the arts.

Studies in the Individual Arts

These studies of individual artists and themes do not aim to provide an all-inclusive survey of each art, but a guide to distinctive achievements and developments. Thus the amount of space devoted to the individual arts differs considerably from volume to volume, though it is interesting that literature is very strong in almost every volume.

In this section, one chapter focuses on the Garden City and one on a group of flats, as microcosms of the period.

Appendix

Bibliographies and brief biographies, for further reading and reference.

Illustrations

The volumes are generously illustrated, though it has been decided not to include pictures of individual artists.

Index

This is the key to making good use of each volume. Many chapters naturally refer to the same historical developments and works of art. These have not been cross-referenced in the texts, because material common to various chapters has been fully noted in the Index. So the Index is the place from which to explore and take full advantage of the interdisciplinary character of the volume: which is its distinctive strength.

Where the contributors to these volumes have been obliged to use specialist terms, they have for the most part explained these in the text. But they have also assumed that readers will use their dictionaries. The following are among the most useful dictionaries in relation to these volumes: *The Oxford Illustrated Dictionary*, *The Penguin Dictionary of Architecture*, *The Penguin Dictionary of Art & Artists*, and *The Penguin Dictionary of Music*.

In conclusion, I am greatly indebted to Professor Donald Mitchell and Dr Joseph Rykwert for their generous and detailed advice during the preliminary stages of this project: and to the staff of the Cambridge University Press, especially Sarah Stanton and Ann Stonehouse for their sympathetic collaboration and unfailing patience. The extract on p. 2 from P. J. Kavanagh (ed.), *The Collected Poems of Ivor Gurney* (1982) is reproduced by permission of Oxford University Press.

Part I
The Cultural and Social Setting

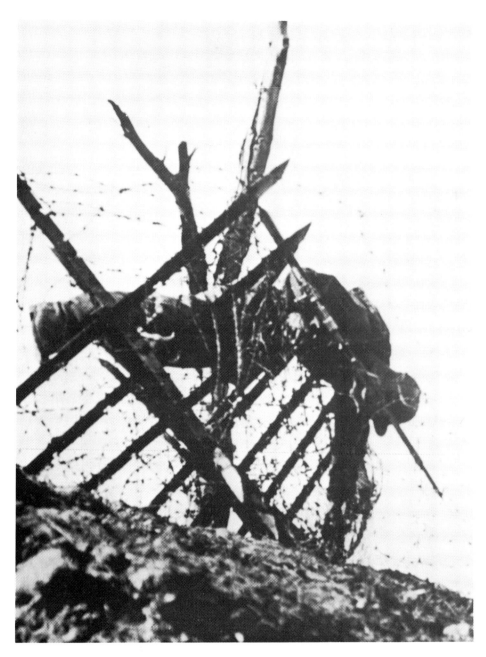

The noise and the dread alone
Was battle to us; men were enduring there such
And such things; in wire tangled, to shatters blown.
Courage kept, but ready to vanish at first touch.
Fear, but just held. Poets were luckier once
In the hot fray followed and some magnificence.
 Ivor Gurney: On Somme

1 The Cultural and Social Setting

WILFRID MELLERS AND RUPERT HILDYARD

The Edwardian years

Prologue

> I leant upon a coppice gate
> When Frost was spectre-gray,
> And Winter's dregs made desolate
> The weakening eye of day,
> The tangled bine-stems scored the sky
> Like strings of broken lyres,
> And all mankind that haunted nigh
> Had sought their household fires.
>
> The land's sharp features seemed to be
> The Century's corpse outleant,
> His crypt the cloudy canopy,
> The wind his death-lament.
> The ancient pulse of germ and birth
> Was shrunken hard and dry,
> And every spirit upon earth
> Seemed fervourless as I.
>
> At once a voice arose among
> The bleak twigs overhead
> In a full-throated evensong
> Of joy illimited;
> An aged thrush, frail, gaunt, and small,
> In blast-beruffled plume,
> Had chosen thus to fling his soul
> Upon the growing gloom.
>
> So little cause for carolings
> Of such ecstatic sound
> Was written on terrestrial things
> Afar or night around
> That I could think there trembled through
> His happy good-night air
> Some blessed Hope, whereof he knew
> And I was unaware.
>
> 31 December, 1900.
> (Thomas Hardy: 'The Darkling Thrush')

It is easy to see, in hindsight, ample historical justification for the foreboding with which the still small voice of the poet greeted the twentieth century. One might well adduce, for instance, the gathering difficulties of imperial Britain: the Boer War, the Irish Question, German and American competition; or the forces that were to transform the domestic life of the metropolitan country within a few years – the growing strength of the labour movement, the proliferation of urban influence throughout a yet rural land by way of the motor-car, and perhaps most far-reaching of all, the undermining of sexual identity prefigured both by the constitutional demands of the suffragettes and by the demographic shift to smaller families. If it were objected that this was hardly what the poet had in mind, one could still say that Hardy pegs his little nature poem, however deftly and lightly, to the cultural fact of the turn of the century, by way of the date and the reference to the 'Century's corpse'. Oblique and understated as it is, the poem associates Hardy's personal statement of agnosticism with disenchantment about secular progress.

As such 'The Darkling Thrush' was the last (the Queen died twenty-two days after the date of the poem) and least self-indulgent in a succession of Victorian poems expressing doubt and disillusion about the Victorian achievement – a succession which included Tennyson's notorious 'Locksley Hall Sixty Years After' (1887), which called forth a public response from the Prime Minister, Gladstone, no less; Yeats's 'Song of the Happy Shepherd' (1889), and Kipling's 'Recessional' (1897). Hopkins's magnificent sonnet 'God's Grandeur' sees the same situation in a religious context, asking why, though 'The world is charged with the grandeur of God' men no longer 'reck his rod', living as they must in a world 'seared with trade, bleared, smeared with toil', wherein 'the soil /is bare now, nor can foot feel, being shod'. Hopkins's sestet gave a positive answer to his question, but only in relation to his personal religious experience, which was far from being that of a 'representative' urban man.

What makes Hardy's poem the least self-indulgent of this series is his austere refusal, fortified no doubt by his novel-writing experience, to take an easy moralising line on this common loss of faith in the direction of modern Britain. And one peculiarity of the twentieth century in the history of the arts in Britain is the extent to which this scepticism about secular society came to be taken for granted amongst artists of all sorts during the period between the year to which Hardy looked forward with so little faith and that more generally ominous date about which another English poet, W. H. Auden, was to write – 1 September, 1939.

Politics and society 1901–14

Whatever Hardy's gloomy forebodings, during the first years of the twentieth century the imperial sun was at its zenith. Queen Victoria still reigned over the largest territorial empire ever seen on earth and by far the most populous of its time, her ministers and officers controlled the destiny of a quarter of the world's population, while her navy really did rule the seven seas, making empire inviolable and invasion impossible.

The economic basis of this imperial power was equally impressive. Britain had led the world in industrial development and was now its commercial master. In 1901 the British were still considerably the world's largest exporters of manufactured goods and by far the leading trading nation, accounting for some twenty-five per cent of world trade, which in any case was as likely as not carried in British ships and paid for in pounds sterling. As banker to the world, Britain controlled another so-called 'informal' empire through enormous overseas investments (in, for instance, China, the Middle East, North and South America, even the United States being a substantial debtor nation), and had for the first time unified the world in a stable financial system, based on gold-convertible sterling and run from the City of London.

Moreover the psychological impact on the British public was the greater in that this success had been achieved not by militarism, fanaticism or despotism, but by a society which prided itself on the commercial virtues of moral probity, individual effort and sobriety. The mind of the British public was quite incapable of imagining the havoc that had been wrought on slower agrarian societies or the jealousy that had been whipped up amongst its 'civilised' competitors. Free trade, industrialisation and the Royal Navy had not only provided the British people with unprecedented material power but had allowed them as well the luxury of moral superiority – no matter that others called it hypocrisy.

One theme of the next forty years of British history was the fall from such pride into the abject disgrace which, in 1939, W. H. Auden was to suggest 'stares from every human face'. In fact, beneath the superficial continuity and stability life in Britain and the global context in which it went on had already undergone a profound transformation. In geopolitical terms, by 1901 British power had become dangerously vulnerable. Within the Empire itself the first stirrings of indigenous nationalism were making themselves felt, both in native possessions like Egypt or India, and in the white dominions, most seriously South Africa. Externally there was increasing conflict with other colonialist powers – not only the traditional nineteenth-century enemies, Russia and France, but new imperial powers like America, Japan or, most unstable of all, Germany.

Economically, the British advantage of an early start in what we would now call development was beginning to turn into the disadvantage of being the most antiquated industrial nation. The British economy was based on the production of coal, iron, steel, textiles, and on ship-building – hardly the best foundation for the twentieth century – and even here German and American production was overtaking British. The situation was much worse in the new industries of the twentieth century, such as chemicals and machinery: in an age of great technological innovation (sometimes dubbed the second Industrial Revolution) producing, amongst much else, the motor-car and the power station, Britain could lay claim only to the invention of the steam turbine and the pneumatic tyre. Similarly the British, cushioned by their trading strength and blinkered by their faith in laissez-faire, fell behind in industrial organisation; firms remained small and privately owned, antiquated plant was not modernised, and the productivity of the British worker lagged

behind that of his international competitors. It was now that the apparently interminable preoccupation with national failure began, with analyses of industrial decline by economists like Alfred Marshall and J. A. Hobson, and hysterical press campaigns for 'national efficiency' and against goods 'made in Germany'.

Moreover the pace of technological change made military as much as economic power that much more vulnerable – one dreadnought battleship could make an overwhelming superiority of its predecessors obsolete overnight. In a tacit admission that the British Empire could no longer float in splendid political isolation from what Kipling called 'lesser breeds without the Law', Lord Salisbury's government contracted strategically expensive agreements with the United States (1901) and Japan (1902). The same logic later led Salisbury's successors to collude in the European system of armed alliances just as it was assuming its final fatal form. In the next ten years or so, while the pot of British society hubbled and bubbled with its own troubles, the European conjunction became increasingly malign, and Britain's association with this slide towards violence was no accident. The chickens had come home to roost: industrial and imperial expansion, out of which the British had derived such profit, had made the world a much more dangerous place. In the new century the British would be called to account for the power which they, like other Europeans, had amassed so easily in the past.

The boldest political response to this realisation of the vulnerability of British power was imperialism. Imperialism in this case denotes the programme adopted by those who believed British power could survive only if the Empire was transformed from a motley and heterogeneous collection of dominions, settlements and colonies, picked up at random and held together only by the Royal Navy, into a coherent and self-sufficient world-state capable of competing with the emergent super-powers, Germany, Russia and America, and more thrillingly, of containing the nebulous threat of the Yellow Peril (a worry that much exercised the Edwardians).

The leading advocate of imperialism was the maverick Radical politician, Joseph Chamberlain, who was given his head in what turned out to be the most spectacular imperial reverse of all, the Boer War (1899–1902), through which he had hoped to realise one imperial dream by anglicising South Africa forever. Although the War was eventually won, its real purpose was never carried out and when the decisive test of imperialism came up in the general election of 1906, and Chamberlain, on behalf of the Conservative–Unionist coalition, promoted protectionism ('tariff reform') as a step towards imperial federation, the electorate decisively rejected his schemes and instead swept the Liberals to power on the back of the Victorian sacred cow, free trade.

While the scales of international power were tipping against the British imperium, a profound transformation had swept through British society. When Victoria had come to the throne in 1837 the English people were still predominantly rural; even in 1850 only half the population was urban; by the time she died in 1901 the figure was seventy-seven per cent. Urbanisation and industrialisation had profound implications for society. It was, as much as anything else, the sheer complexity and urgency of organising these vast cities which called into being and legitimised 'collectivism' – what we would call

the growth of the public sector – in, for example, the provision of sanitation, gas supplies or trams for the towns. As one Liberal politician said, 'We are all socialists now', meaning that the middle classes realised they could no longer simply ignore the masses and leave every social problem to market forces.

At the same time industrialisation had at last enabled that old bogey of the bourgeois, the urban mob, to assume autonomous political shape. In 1900 the TUC gave its essential support to the establishment of a Labour Representation Committee, the forerunner of the Labour Party. The final spur to political self-expression had been the increasing effort of the employers to break the unions, culminating in the Taff Vale Decision (1901) which removed legal immunities enjoyed by the trade unions since the days of Disraeli and Gladstone. The middle classes were fearful of an independent Labour Movement – and with good reason. Not only were their interests now in conflict with the working class, whether over demands for social welfare or over labour rights that struck at business profitability, but severe poverty was endemic amongst as much as a third of the population, as the pioneering work of social investigators like Booth and Rowntree revealed at the time. As awareness of how society worked increased, the idea that poverty really was eradicable and a genuinely democratic society possible was spreading beyond a few visionaries into the common intellectual currency of the culture.

The middle-class itself had expanded greatly (to a quarter of the population on one reckoning), and to accommodate it suburbs had proliferated around the cities, helped by the development of modern transport systems – commuter trains, electric trams, bicycles, and, after about 1910, motor buses, cabs and cars. It was probably the increase in employment opportunities for middle-class women, in particular, as well as the trend towards smaller families, which enabled the campaign for votes for women to take off. Mrs Pankhurst founded the Women's Social and Political Union in 1903 and under her leadership the campaign escalated to a pitch of violence and extremism which only further entrenched male intransigence and bigotry. As with Home Rule for Ireland, it was only after world war had shaken society to its roots that the underlying resistance to social change could be overcome.

Urbanisation and industrialisation had also spelt the end for the rural order which supported the traditional political custodians of the nation: the landowners. The great House of Lords crisis (1909–11) was in the nature of a last stand for a class which became more irresponsible and extreme as it was pushed to the margins of power. But the immemorial way of life suggested by contemporary photographs of the countryside was drawing to its close: for both landowners and 'their' villagers, the Great War was to finish off the old order.

The middle-class Liberalism which had accomplished the ruin of the landed interest was, if anything, built on even more dangerous shifting sands. The Liberals were caught between the middle-class backing, the individualist ideology that had provided their traditional identity in the past, and the working-class vote and socialistic programme which they had to pursue to survive in the future. After they came to power in 1906 they introduced a

programme of social reform which would both help solve the problems produced by the nineteenth-century transformation of society and attach the working class firmly to Liberalism. Lloyd George's 1909 Budget established old age pensions by means of heavier taxation of the rich (health and employment insurance were to follow later), which in hindsight remains the Liberals' great achievement.

At the time, though, Asquith's government was embroiled in trouble, as the most reactionary elements in the Tory party, especially in the House of Lords, launched a wrecking campaign against successively the Budget (1909–10), the consequent curtailment of the Lords' powers (1910–11), and Home Rule for Ireland (1912–14). This culminated in the extraordinary spectacle of the Conservative–Unionist Opposition and the Anglo-Irish officered Army virtually threatening an elected government with mutiny and civil war if Ulster was included in the proposals for Home Rule. It was the Ulster crisis over which the politicians were bent when the ultimatums for a European war started to roll in, in July 1914. As if this were not enough, the government also had to face unprecedentedly violent campaigns from the suffragettes and militant strikers. An observer might be forgiven for thinking that the old British party political system was on the verge of collapse: certainly the crisis revealed the paralysis of established political thought.

The years between 1901 and 1914 were years of tremendous social turmoil as the pace of modernisation set in train during the Victorian age accelerated further. Beneath a social surface that remained glossily intact huge social movements strained and heaved: the old rural way of life sank and disappeared; the industrial working class assumed menacing political shape; Irish nationalism lunged like a knife at the jugular of Crown, Army, Land and Empire; the Empire itself creaked and teetered; and the suffragettes called into question the basic assumptions of a patriarchal society. To enumerate these problems sets off all the more strikingly how these same preoccupations dominated contemporary culture. For the Edwardian era was also a period of astonishing artistic exuberance, producing a last great efflorescence of traditional high culture, especially in music and literature, before the twentieth century descended. It can be no accident that Ireland, the New Woman, rural nostalgia, social criticism and imperial pretensions all figure so strongly in Edwardian culture – there can be few other periods when the arts mirror so faithfully the problems of the day. It is almost as if the artists were consciously straining to accommodate those forces which the failure of political imagination had left beyond the social pale. In what follows we shall look at the ways in which the pressures of Edwardian society impinged on the arts, and in particular at how the imperial outlook and the accommodation of the working class into society preoccupied artists of all sorts.

The imperial outlook

Great Power diplomacy and the problems of Empire may seem remote from aesthetic considerations, but in fact there is a fairly close, and clear, relationship. Writers in many different fields – scholarly, ideological,

imaginative, historical, children's books, travel and exploration – investigated the world which British power had laid at their feet. In doing so the author, be he Rudyard Kipling or J. G. Frazer, often not only produced justifications for British European colonial domination of 'uncivilised' natives and for British primacy among the European powers, but also projected domestic insecurities and identity crises on to the world stage. At the same time it was probably the vulnerability of the British Empire that made so many people for the first time acutely conscious of belonging to an imperial nation and, more generally, may have prompted the more thoughtful to question the very direction and purpose of British civilisation.

The basic cultural importance of the Empire was, of course, quite simply that it kept Great Britain afloat in considerable affluence – paying, as it were, for Henry James's butler and valet, Elgar's racing, and Sargent's commissions, not to mention creating the wealth that enabled fine houses to be built and furnished for the rich. More nebulously, the self-evident success of the British way of life in every corner of the globe, no less than her long and stable domestic progress and prosperity, must have given émigrés like Henry James and Joseph Conrad a sense that they were at the hub of the human story: that to be British was to occupy a commanding position over the destiny of mankind. Even so cosmopolitan a figure as James came to be condescending about the French and appalled by his fellow Americans, while for indigenous minor poets like Sir Henry Newbolt and W. E. Henley romanticised insularity was axiomatic.

This confidence informed not only literature but the more social of the other arts also – Edwardian-Imperial architecture, the music of Parry and Elgar, the operettas of Gilbert and Sullivan – if not perhaps the contemplative art of painting. Even there, however, the bravura of the American Sargent's portraits must stem from identification with a world-historical Anglo-Saxon ruling class, painted by Sargent, written up by James, intermarrying in the cases of Kipling, Chamberlain, Churchill, Marlborough and Vanderbilt. Indeed at this stage the modernity and vitality of America seemed not so much the nemesis of as the complement to the stability and traditions of the older Anglo-Saxon civilisation. It would have taken an extremely percipient observer to have recognised the cultural menace posed by the presence in London in 1910 of 'ragtime' music and a Mr Ezra Pound.

Yet the assurances of Sargent's portraits, of Elgar's pompous and circumstantial marches, of 'proconsular' public buildings, was belied by the very ease with which historical idioms were so eclectically invoked. The Edwardian revival of architectural styles, for instance, with its markedly mannerist emphasis – Baroque, Byzantine, Wren, 'proconsular' – is hardly equivalent to the ethical quality with which mid-Victorian Gothic and neo-classical are imbued. This eclectic appropriation of styles, sometimes dignified as 'revivalism', would seem to be rather a case of identity being sought for identity's sake.

An explicit recognition that such 'historicism' reflects a crisis of identity comes in Kipling, the one avowedly imperialist major writer of the day. From the simple expression in his early Indian stories (e.g. *Plain Tales from the Hills* (1888)) of the *esprit de corps* necessary to the colonial enterprise,

Kipling is led to elaborate a re-vision of the whole course of English history, pre-eminently in his children's stories, *Puck of Pook's Hill* (1906), while his marvellous books for younger children – *The Jungle Book*s (1894) and *Just So Stories* (1902) – were an attempt to take this story even further back down the evolutionary ladder. His supreme achievement *Kim* (1901) was simultaneously about the Imperial Dream and the adolescent innocence necessary to sustain it. It is not fortuitous that Kipling's remarkable late tales – such as 'Dayspring Mishandled', 'Wireless', 'The Wish House' or 'Mary Postgate' – became deeply disturbed and disturbing, at times morbidly sado-masochistic, the war had extinguished the conditions for such fabrications of identity. *Kim* itself would have been quite incredible after the 1919 Amritsar Massacre.

The greatest English composer of the era, Elgar, exactly complements Kipling. From one point of view Sir Edward revelled in the might and affluence of the world he so potently celebrated in 'Land of Hope and Glory'; had he not believed in that world he could not have created jingoistic music still potent enough to send shivers down even resentful spines. Elgar's 'serious' music – especially *The Dream of Gerontius* (1900) and the two magnificent symphonies of 1910 and 1912 – has a swagger and *nobilmente* panache that sprang from the composer's relish of what is usually held to be a materialistic society. The force of his genius lay in the fact that, in an England whose musical traditions were moribund, he had the confidence to acquire, virtually self-taught, a technique of astonishing virtuosity. This technique, profoundly English though Elgar was, was basically German – a fact not without its socio-political aspects; by means of it Elgar was able to rival Richard Strauss himself (whom Busoni had dubbed 'an industrialist even in his music') in expertise, and to assume the existence of a symphonic tradition which in this country had never happened.

Yet this dazzling facade is not what makes Elgar a great composer: for his mature work turns out to be a threnody on Edwardian opulence and imperial might. The top-hatted, morning-coated Sir Edward chatting to the rich and mighty at the races is a mask for the man of deep spiritual intuition, who conceived his sweeping themes while striding over the Malvern Hills; who along with Cardinal Newman probed the painful recesses of his 'Roman' faith in *The Dream of Gerontius*; who found in his *Falstaff* (1913) not a bloated old reprobate but a portrait of the decline and death of the ideal, total Englishman he would have liked to be, and in a sense was. The heroic Second Symphony is prefaced by Shelley's words, 'Rarely, rarely, comest thou, spirit of delight'; and ends with a dying fall. It was composed on the eve of the Great War, a war which destroyed Elgar's visionary England, and stifled his own creative fires, since although he lived until 1934, he produced no music of consequence after 1918. In old age he recognised with pain that his 'Land of Hope and Glory' had been savagely belied in the event. His was a vision of an England that 'never was' on land or sea, except in his heart's truth; and to that the new world was indifferent.

It is revealing to compare Elgar with his immediate contemporary Delius, for they are complementary opposites. Elgar, born in rural Worcestershire, began by celebrating Edwardian industrialism and Empire; Delius, born in

the northern manufacturing city of Bradford, the son of a wool-tycoon, abominated everything the industrial world stood for. Escaping to the solitudes of Scandinavian mountains, the Bohemian pleasures of Montmartre or the orange groves of Florida, he was – as a direct consequence of the industrialism he despised – rich and independent enough to pursue his Nietzschean ideal of 'courage and self-reliance'. His music sings a more cosmic farewell than Elgar's, hymning the twilight not merely of Britain but of 'Europe', and using to that end a ripe technique basically German, like Elgar's, though stemming not from Brahms and the central Teutonic tradition, but from that climacteric egotist of European culture, Wagner. Living in and for the self, Wagner's Tristan finds that he must surrender that self to nirvana. Delius does the same, only his nirvana is Nature, the impersonal forces of wind and sea which are antipodes to Bradford. In his *A Song of the High Hills* (1912) – scored for an immense orchestra such as was made possible only by nineteenth-century industrial technology – we may note a technical manifestation of this: for although impetus springs from the fluctuating tensions of Wagnerian chromatic harmony, the individual lines seem to seek – especially in the heart-rending, wordless choral episode – the pentatonic innocence of folk song. Delius, like Elgar, composed little during the War years, not in conscious disillusion, but in unconscious allegory as, crippled by the syphilitic paralysis that confined his once-Byronic presence to a wheel-chair, he 'recollected in tranquillity', in his garden at Grez-sur-Loire, where birds sang oblivious of industrial encroachment.

Delius's hymns to the death of God and of Europe may seem sublimely life-affirming when he, an even more independent egotist than Wagner, is inspired, but embarrassingly self-indulgent when he isn't. Again we may find a yardstick in the austere Hardy, whose 'Egdon Heath' is not dissimilar to Delius's 'High Hills', though its ecstasy is muted. Paradoxically, Hardy expected to 'live well' on his uncompromising art; and did so, even though his poetry attained its highest reaches in its most private manifestation – those retrospective love-lyrics to his dead first wife, which sing, no less than Delius, of love and loss, and which again were written, in 1912–13, on the eve of that First World War.

The great creators of the Edwardian years – Elgar, Delius, Hardy, Conrad, Housman, Kipling – all became valetudinarians after the War. There were other less sensitive souls who carried the imperial theme into the inter-war years. Their characteristic product was, like the best of Kipling, boys' adventure fiction, reaching back to the tradition established by Captain Marryat and Robert Louis Stevenson – though the latter's books were and remained in a class of their own. The most memorable names are G. A. Henty, Conan Doyle, Rider Haggard (*King Solomon's Mines*), Anthony Hope (*The Prisoner of Zenda*), Erskine Childers, John Buchan, A. E. Sapper (the Bulldog Drummond stories), and one might well include the Americans Jack London (*The Call of the Wild*) and Edgar Rice Burroughs (*Tarzan*). Some had very close connections with imperialism. Henty brought his historical adventures (e.g. *With Clive in India*) bang up to date in *With Roberts to Pretoria* (1902), Erskine Childers' thriller *The Riddle of the Sands* (1903) was a direct intervention in the politics of the Anglo-German arms race, while

Buchan had been one of the leading imperialists in Milner's 'Kindergarten' of brilliant young administrators in South Africa. Nearly all inculcated their juvenile readership with fantasies of white ruling-class male power, and show incidentally what an incurably puerile performance imperialist ideology was, with its heroic last stands and epic marches, Boy Scouts and *Boys Own Paper*, relief of Mafeking and race to the Pole.

Joseph Conrad, whose 'romantic adventure fiction' could comprehend not only the immorality of colonialism but also its disturbing implications for the Western self-image, was a different case, perhaps because, as an expatriate Pole aware of the suicidal hopelessness of Polish nationalism, he was sceptical of any ideology of national destiny. At any rate he alone proved capable, in works like *Lord Jim* (1900), *Heart of Darkness* (1902) or *Nostromo* (1904), of elevating the adventure story into serious art and using it to turn the investigatory apparatus of the novel on the imperial adventure itself.

As so often it was Hardy whose refusal to be interested in the lies of history enabled him, in his Boer War poem 'Drummer Hodge', to make the quietest yet most suggestive comment on the common man's experience of Empire (a comment later plagiarised and given a patriotic slant in Rupert Brooke's most famous poem). Although Young Hodge, 'fresh from his Wessex home', never knew 'the meaning of the broad Karoo' and had little idea as to what he was doing there, nonetheless:

> Some portion of that unknown plain
> Will Hodge for ever be;
> His homely Northern breast and brain
> Grow to some Southern tree,
> And strange-eyed constellations reign
> His stars eternally.

This is the simplest form of that prolonged meditation on cultural identity which was Conrad's subject, and which was the most profound legacy of Empire, a legacy inherited, in the changed post-war climate, by young writers like D. H. Lawrence, E. M. Forster, Somerset Maugham and George Orwell.

A similar message, again not decoded until after the War, was contained in other imperial plunder: travel writing, the beginnings of anthropology, and the taste for the exotic. Two writers at least discovered herein a wellspring for the creation of great art: C. M. Doughty, in *Arabia Deserta* (1888), evolved a quasi-archaistic prose to express what might be called an 'alternative vision' – formidable enough to amount to a criticism of then contemporary life; W. H. Hudson significantly fused nostalgia for the old rural England (in *A Shepherd's Life* and similar books) with nostalgia for a childhood which, in South America, had evoked realms of magic and romance (in *The Purple Land* 1885, *Green Mansions*, 1904, and his masterpiece, the directly autobiographical *Far Away and Long Ago* of 1918). At a less aesthetically nourishing level, similar impulses occur in the writings of D. G. Hogarth, W. S. Blunt and Gertrude Bell. In anthropology there was J. G. Frazer's seminal *Golden Bough* (1890–1915), Spencer's and Gillen's pioneering studies of the Australian aborigines, and, not so very far removed, Sir Arthur Evans's excavations of Minoan civilisation. Other exotica brought back to the global metropolis included Japanese painting, Arthur Waley's

translations of Chinese poetry and Constance Garnett's of the Russian novelists, Diaghilev's Russian Ballet, and even the book illustrations of Kay Nielsen, Edmund Dulac and Arthur Rackham.

All these – and we may well add the once obsessively popular *Hassan* of James Elroy Flecker – might be regarded as testament to the ability of Edwardian culture to absorb and assimilate the properties of other cultures. Only after the War would the taste for the exotic and interest in the strange cease to be one of the spoils of triumph and become instead a source of cultural disruption and a symptom of debilitated confidence. This alienation from England can be seen in the expatriation of nearly every leading English writer between the wars; in the explosion of 'escapist' travel writing; in the impact (mostly via Paris) of primitivism on European painting, sculpture and music. Although the African rhythms of jazz were to have only a minimal impact on British musicians for many years, there was already some evidence of this cross-cultural influence in Jacob Epstein's pre-war sculpture (which significantly was later to include a bust of W. H. Hudson's child of nature, Rima).

Of all the dimensions of the imperial experience only the question of Ireland offered much access to an authentic and neglected indigenous tradition, and encouraged more mature political attitudes: factors which were the making of at least two writers of world importance, James Joyce and W. B. Yeats, and perhaps too of the latter's brother Jack, who is not so far off being a major painter. It would be incredible if the permanent political crisis over Home Rule from 1880 to 1922 had nothing to do with the remarkable Irish literary flowering over the same period. At the very least the Irish Question must have encouraged in Irish writers as different as Oscar Wilde, George Moore, George Bernard Shaw, W. B. Yeats, J. M. Synge, and James Joyce (to cite only the major luminaries) a deep scepticism about the assumptions of British society and English literary tradition, and a stimulating confidence in their own prescriptive powers. Both qualities are notably in evidence in what they all shared – the wit which distinguishes them from their lugubriously earnest Saxon counterparts.

The stylishness of the Irish is a reminder of how imponderable formal influence is. There is an interesting parallel between Parnell and Wilde, both lionised and then scandalised by the establishment: perhaps it was Wilde's stylistic subversion that made him such a good scapegoat for a society afraid of change. In an atmosphere of imperial triumphalism the Edwardians piled excess on the elaboration of the Victorian age, whether in the magniloquent complexity of Henry James' prose or the decorative curlicues of Edwardian baroque and *art nouveau*. It was the ripeness and profusion of the old forms of art which made the Edwardians so susceptible to parody in such diverse forms as Wilde's drawing-room comedies, the gentle fun of Gilbert and Sulllivan, Max Beerbohm's elegant pastiche, Saki's vitriolic twist-in-the-tales and Ronald Firbank's camp satires. Even the very Bible of literary modernism, Joyce's *Ulysses* (1922), is something of an epic parody, or parodic epic; and certainly the spiritual home of P. G. Wodehouse and John Betjeman, who raised parody to unsuspected heights, was the Edwardian era.

It may then be that the great British success story, unbroken until 1914,

helped guarantee the allegiance of British artists to traditional forms at a time when artists from nations with a less comfortable relation to history were turning to consciously modern means of expression. The pretensions of empire encouraged a last luxuriant growth of traditional forms, but in so doing inflated them to bursting point; even before the Great War, the bombastic bubble of *Our Island Story* was ready for the puncturing prick of *1066 And All That*.

The condition of England

There was a close political connection between imperialism and the rise of the Labour Movement in that, in the minds of leaders and propagandists like Chamberlain and Kipling, one of the virtues of imperialism was that it fostered and required national unity and class collaboration, thus forestalling the threat of revolutionary socialism. Furthermore, imperialism was, like socialism, very much the product of a materialist Darwinian age – and, as the Little Englander G. K. Chesterton pointed out, Fabian socialists like George Bernard Shaw and the Webbs were often sympathetic to imperialist ideas. Indeed recruitment during the Boer War – or rather the non-recruitment of such a high proportion of working-class volunteers too under-nourished to be acceptable cannon-fodder – was one of the factors which thrust what we would nowadays call the 'inner city crisis' reluctantly to the fore-front of educated consciousness. Other factors were the various 'missions', 'colonies' and 'settlements' (the imperial analogy again) as well as Boys' Brigades, Scout movements, Temperance Unions, by which the middle class hoped to civilise the restless proletarian natives. As in party politics, it was not so much that the working class sought cultural expression, it was rather the over-weening pressure of the English middle class to remake everyone in its own mould which produced, in its various effects of resistance and submission, a distinctive working-class identity.

There were various efforts to comprehend the world of the industrial working class, such as Charles Booth's and Seebohm Rowntree's sociological surveys of urban living conditions among the poor; the 'working-class fiction' of Arthur Morrison, George Gissing, Rudyard Kipling, Robert Tressel and D. H. Lawrence; the unprecedented streetscapes of Sickert and the Camden Town Group; the social criticism of G. B. Shaw, H. G. Wells, Arnold Bennett and John Galsworthy. All of these were attempts to redress or mitigate the brutal facts of exploitation rather than signs of emancipation on the part of the proletariat itself. Their popularity, or perceived significance, like that of earlier introductions of the genteel audience to a plebeian vernacular by Dickens or Hardy, had as much to do with middle-class guilt and fear as with working-class self-assertion.

All the same, the attempt to accommodate the proletariat brought into existence by industrialisation and urbanisation is the surest sign of the continuing vitality of liberal culture, with its sense of the social responsibility of art and its untroubled confidence that art can represent reality with scientific objectivity. This can be seen most directly in the work and influence of the environmentally conscious designers and philanthropists who built

model housing, garden cities and suburbs, such as Port Sunlight, Welwyn Garden City and Hampstead Garden Suburb; as also in that of the philanthropic providers of culture (libraries, museums, galleries) like Andrew Carnegie, Passmore Edwards and Henry Tate, who further pushed to the fore the notion that art and culture were not merely the ornament of a privileged elite.

In literature, rather as their party political colleagues were trying to accommodate working-class political demands, so writers like Wells, Bennett, Galsworthy, Forster and Lawrence continued to write social novels, recognisably in the tradition of George Eliot, which were animated by the effort to include the working class in their representation of England. E. M. Forster's incorporation of a token proletarian, Leonard Bast, in the social diagram of *Howards End* (1910) is as good as example as any. There are few more striking differences between pre-war and post-war culture than the almost complete disappearance of social novels in this vein. Writers like Joyce, Woolf, Huxley, Waugh or Greene (not to mention Forster and Lawrence themselves) mutely abandoned the attempt to give a normative, unified diagnosis of contemporary social life in the important novels of the inter-war years – *Ulysses*, *To The Lighthouse* (1927), *Brave New World* (1932), *Vile Bodies* (1930), *Brighton Rock* (1938). If we want anything like the old tradition we have to look to minor novels like Winifred Holtby's *South Riding* (1936) or J. B. Priestley's more complacent if no less entertaining *The Good Companions* (1929).

For the actual manifestations of a working-class presence in the culture, rather than its translation into genteel forms, we must look elsewhere. It was in the late Victorian and Edwardian years that the forms of modern mass culture coalesced. This was not just a matter of the beginnings of the welfare state in old age pensions and national insurance. Fish and chips, tea drinking, working men's clubs, holidays in Blackpool, football and cricket, mass circulation newspapers like the new *Daily Mail*, retail chains like Liptons and Home & Colonial (another example of the interconnection between imperialism and the formation of the working-class identity), brass bands, music hall and latterly the cinema, all made their appearance during this period. Humble, not to say banal, as such phenomena may seem, a mass culture is also a universal, popular culture and as such they had their significance for the future.

But that future was still a long way off; meanwhile the Edwardians found the transition difficult. Much Edwardian art was an often feeble and insincere attempt to take account of and accommodate the vast changes brought about by the Victorian transformation of British society. There was also the much simpler alternative of attempting to evade the social dimension of art altogether. It is ironic, for instance, that at the very time when the material power of the landed gentry seemed to be finally on the wane, their symbolic function should achieve not just ascendancy but almost apotheosis. Not only did major artists like James, Hardy, Lawrence, Sargent, Elgar and Augustus John more or less toady to the aristocracy, but the gentry seemed to have cozened nearly all the native poets to their cause.

The Sitwells, aristocrats themselves, even claimed to be the central English

literary tradition. Most of their writing was done in the years immediately after the war; but they belong in the pre-war era since they made their artefacts out of elegiac retrospection of a vanished (Edwardian) world. Osbert told the world's, as well as his own, story in the mandarin prose of his monumental autobiography; at the same time he lampooned his survivors in his satirical squibs and verses – though not of course with the corrosive vitriol with which Wyndham Lewis, 'the Enemy', blistered Bloomsbury and especially the Sitwells in his uncomfortably savage *The Apes of God* (1930). Edith Sitwell created a bejewelled fantasy-world out of recollections of a painful childhood, before she less convincingly assumed the mantle of seer and prophetess in the dark years of the Second World War – which finally released her world from its protracted death-throes. Sacheverell, as it were from the eyrie of some lanky bower-bird, assembled his gallimaufry of strange lore and legend from the four corners of the earth, and span from it his mesmerising prose fantasies.

The Sitwells' fantasy worlds and childhood revocations, though often alluring, suggest that Tory–aristocratic values and attitudes no longer admissible at an adult level were not so much eliminated as displaced into sub-genres like children's literature, rural nostalgia, boys' adventures, romantic fiction, parody and the like, where they were reproduced and disseminated more insidiously. Boys' adventure fiction has already been referred to in connection with imperial influence, but there was a more attractive side to the cult of childhood. Beatrix Potter's stories (e.g., *Squirrel Nutkin* 1903), J. M. Barrie's *Peter Pan* (1904), and Kenneth Grahame's *Wind in the Willows* (1908) still delight modern children ninety years on, and it is their loss if John Masefield's long narrative poems about life at sea or about the (once aristocratic) old rural order, and his splendid adventure stories from *Capt. Margaret* (1908) to *Odtaa* (1925) are now forgotten. No less memorable is a fairy book for younger readers, *The Midnight Folk* (1927).

Contemporaneously from the cult of childhood came one writer, Walter de la Mare, whose verse for children, especially *Peacock Pie* (1912), uncovers mystery and terror as well as delight, so that it haunts those lucky enough to have been brought up on it through a lifetime. Not surprisingly, there is no sharp division between de la Mare's poetry for children and that for adults, while his short stories likewise invoke realms of the marvellous, manifest to many in childhood but to few in later years. The ornately stylised, almost *fin de siècle* prose which de la Mare favours contributed to the eerie effect. As with a child, art and magic, the natural and the supernatural, are in intimate communion.

De la Mare, like Masefield, writes of childhood and adolescence, but reanimates them in our adult experience. Lesser poets who became prodigiously popular were Rupert Brooke and A. E. Housman, though Brooke's fame may have been due more to his physical beauty and early death than to the intrinsic quality of his verse. Housman, wizened Latinist and crusty academic disputant, is a different case, who made pseudo-folk ballads set in a mythical Shropshire countryside, the last English Romantic 'masochistically practising heroics in the last ditch', as W. H. Auden put it. The potency of his in a sense wilfully synthetic verse is indisputable. *A*

Shropshire Lad (1896) brought home to the guts of thousands of English people not only the loss of the old rural England, but also the tie-up between that loss and the confrontation of human impermanence in a godless and faithless world. The 'beauty' of his best lyrics is as undeniable as their self-indulgence, compared with Hardy's lyrical confrontation of the same basic human predicament, at the same point in time. Housman's great contemporary popularity resides in the fact that most people understandably, even excusably, need a measure of self-indulgence. Insofar as his work had any social content, Housman, like so many other contemporary poets (Henley, Newbolt, Bridges, Hopkins, Masefield, Brooke, even early Yeats) seemed content to be the elegist of a vanishing rural world.

Housman's 'blue remembered hills' obviously stand for a more private sense of loss which the poet is not prepared to bare. In the same way, as British society, and in particular the ruling class, grew more solidly industrial and urban, there was an increasing idealisation of country life, and country-house life in particular (e.g. in the magazine *Country Life*). Individuals no longer built great houses – the old was more authentic. The series of country houses designed by Lutyens (see chapter 6 below, by Sir John Summerson) culminating in Castle Drago, built on the edge of Dartmoor in the style of a medieval castle, stands at the end of the long tradition of the English country house. Lutyens's collaboration with the garden designer Gertrude Jekyll, with its emphasis on integration with Nature and the cottagey influence, was more in the spirit of the coming century than Castle Drogo. Country writers like Richard Jefferies, W. H. Hudson, George Sturt and Edward Thomas belong to the same trend.

There was much that was public-spirited in this mood: the preservation of both the natural landscape and the historic heritage of Britain began to be seen as a matter of public responsibility rather than as an exclusively private concern. The garden cities and suburbs pioneered by philanthropic industrialists attempted to embody some of the ideas of Norman Shaw and William Morris – and redeem the promise that industrialisation and democratisation might imply not a diminution but an extension of good design. But it is symptomatic that while continental designers took from Morris the idea of a functional 'organic' application of art and design, made possible by and for industrial democracy, he inspired his compatriots to an escapist and ultimately elitist cottage craft movement.

Much of the Edwardian achievement must be called, without necessarily being pejorative, reactionary in form and content. But the extraordinary flourishing of the arts in the years 1901–14 – particularly compared to the febrile debility of the twenties and the polarised aridity of the thirties – was by no means entirely a matter of revelling in national success or harking back to the glories of tradition. As has already been suggested, much of the continuing vitality of English culture sprang from the effort to comprehend the forces which were modernising national life so irrevocably. If one had baldly to explain British culture of the whole period (1901–39) in terms of a single social development, it would have to be by reference to the transition from an essentially rural society to that of the modern city. Only slightly less significant was the realisation that imperialism had brought the whole world

into the European orbit, had created a world system. Alas for Edwardian culture, it was fated to be not so much left behind by these developments as flattened by them.

The First World War

The First World War and modern history

It is frequently suggested that the First World War had little effect on English culture since most of the post-war developments in the arts were already incubating before 1914. One can well argue to the contrary, that it is difficult to exaggerate the impact of the war, for it shattered the sustaining myth of a secular society, the belief that history (and in its Victorian incarnation, British history especially) is progressive and intelligible. The elderly Henry James put it as well as anyone:

The war is a thing that so gives away the whole long age during which we have supposed the world to be, with whatever abatement, gradually bettering, that to have to take it all now for what the treacherous years were all the while really making for and *meaning*, is too tragic for any words.

<div align="right">(Letters, Vol. II, 384)</div>

That James, notorious example of late Victorian verbosity that he became in his later years, should have singled out words as a principal casualty of the war is striking. For the war was itself a reassertion of the indecipherability of history, a reality so appalling that few of the many writers attracted to the subject do not at some point confess their own inadequacy; virtually everything written about it contradicts the simple-minded faith that history is amenable to rational analysis and positive interpretation.

Was the War a meaningless accident, concocted of diplomatic blunders and inflexible military timetables? Was it the inevitable result of imperialist rivalry? Was it a just and necessary struggle against German aggression, as with Hitler's War? Historians of all sorts – military, political, diplomatic, economic, social, academic, popular, Marxist, revisionist – give confused, contradictory and unconvincing answers, even if they regard these as fit questions at all. And when it comes to the central human fact of the war, the killing of millions of men, they can find little to say other than to pass a few sententious platitudes about the horror of the trenches and the folly of mankind.

On the other hand there are those who try to tell the truth about the war by concentrating on the actual experience – the writers of contemporary letters and diaries, of retrospective memoirs and fictions, the compilers of oral recollections of the war and commentators on its literary representation. Although these are all too apt to give simplistic, not to say glib, interpretations, the great value of these personal histories is that for almost the first time an attempt is made to communicate the individual human experience which 'official' public history has tended to neglect and thereby deny.

Furthermore these unofficial histories were only attempts, self-evidently and often self-confessedly partial, to communicate the incommunicable: mute testimony to the inadequacy of words in the face of death. A banal truism about the human condition, perhaps, but it took the First World War to establish this will-o'-the-wisp as an Historical Fact, a cultural commonplace of the twentieth century. And, unless these traces of so many devastated lives are simply ploughed under, it is just as difficult seventy years later to believe in any benign logic of historical development, to maintain the pleasant fiction by which we live, as it was for so many at the time.

Of course, compared to the famine and ruin, the collapse of institutions and civil strife, fascism and communism, and, in the arts, the avalanche of Modernism, which were the aftermath of war in Europe, the economic depression, political feebleness and cultural stagnation of Britain during the inter-war years may seem a mild enough visitation. Yet in a way the removal of the sanction of history was much more of a blow to a society which, more than any other European nation, had grown used to the comfortable idea of History as Divine Providence for British civilisation.

There were several ways in which the War's demonstration of the futility of history affected the contemporary artistic scene. In the first place there was the sheer interruption of artistic practice. The war was quite simply a four-year gap which separated the War generation and its successors from traditions which reached down to the Edwardian age. The nature and severity of this break varied from art to art, as will be seen in the chapters of Part II, 'Studies in the Individual Arts', below.

In the second place, it was the arts themselves, often enough, which opened up the gap between the individual's experience and the conventional liberal-humanist historical scheme of things: not only in the work of the poets, memoir writers and painters who directly addressed the war, but also in that of the great modernists whose achievement straddled the War and had, as we shall argue, so much to do with it.

In the third place, so much artistic endeavour in a secular society depends on the assumption of a nourishing connection between individual lives and social history: the obvious and relevant example being the nineteenth-century novel, which never recovered its stature after the War. On this reading, the art movements of the thirties – the involvement with left-wing politics and the growing influence of continental Modernism – would similarly suggest an attempt to renew the connection between individual experience and some sense of collective movement.

In the fourth and final place, the War, by piling up millions of dead and mutilated bodies in front of the fictions of idealism, nationalism and history, called into question the representativeness not merely of the political and military leadership of Europe, but also of the established values and cultural monuments of the Western tradition, and indeed the desirability of representing, in any sense, such a sick civilisation at all.

For all these reasons the First World War was a decisive event in the history of the arts in Britain, and it is at least as necessary to stress its traumatic influence on them as to emphasise, by contrast, the essential autonomy and continuity of their various traditions. Why then was the war

quite so shattering to the British imagination? First of all, it was unexpected, both generally – it ended a century of unparalleled peace and prosperity – and locally – the diaries, letters and memoirs of the time confirm a sense of tremendous shock which the aftermath only magnified. Not only had people forgotten what a real war was like, but war had in any case undergone a change. The enormous population increase, improved medical care and railway transport: just these nineteenth-century developments were enough to make slaughter possible on a hitherto unimaginable scale – in previous wars, for instance, far more soldiers had died of disease than of fighting.

More directly, the huge volume of firepower available from magazine rifles, machine guns, grenades, mortars and above all artillery made modern war a mass-destruction industry instead of an élite profession or craft. Entrenched with concrete and barbed wire, this firepower gave the defence an almost immovable strength, without however making it in any way immune to terrible losses of its own. For the attack, neither the old mobile arm of cavalry nor the new ones of tanks and aircraft were workable at this point in the state of the military art, and the lack of radio-communication (and the vulnerability of telephone networks) meant that generals had virtually no control over their enormous forces once a battle had started. Furthermore, if a breakthrough was achieved the defence could still be reinforced by railway, while the offensive could proceed only at the pace of the infantry-man and the mule. It was such logistics, rather than the stupidity of the generals – slow as they were to learn – which made the war of attrition both terrible and inevitable: an artillery war is by definition static, long drawn-out and enormously costly.

As might be expected in a war where the soldier's function was mostly reduced to filling the gaps between artillery (which apparently worked out at an average of five yards), casualties were terrifying, how terrifying can only be appreciated by turning to the memories, memoirs, letters and diaries of those who suffered. Statistics blunt apprehension, but for what it is worth about one in four of the 1914 age-group fifteen to twenty-four was killed – a proportion that would be far higher, of course, if restricted to those who were front-line troops. Such casualties hit particularly hard those whom the upper classes believed to be the brightest and best – the young officers.

But it was not just the sheer numbers killed: British casualties were actually lighter, both absolutely and proportionately, than those of Germany and France. The impingement of even such literally physical damage was mediated by culture, the most obvious social construct being the 'myth' of the lost generation. The most general explanation for the markedly traumatic impact of the War on British society is that it had been, of all Europe, the most cossetted and insulated by its history of success. More particularly, the very conditions that brought about attrition also maximised its public impact. Being static, long drawn-out, and near at hand, the trench experience was all the more available as an object of study. Officers in particular could and did commute between the Western Front and a home life which was hardly touched by the reality of the fighting. It is little wonder that pastoral nostalgia and bitter satire flourished together.

Moreover it was not just military technology which had developed over the

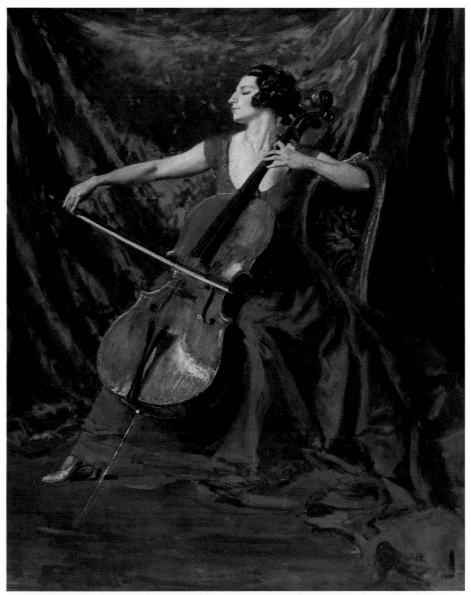

1. *Augustus John*, Madame Suggia *(1920–3)*. *(See p. 169)*

2. *Vanessa Bell*, Interior with Housemaid *(1939). (See p. 204)*

3. *David Bomberg,* In the Hold *(1913–14). (See p. 166)*

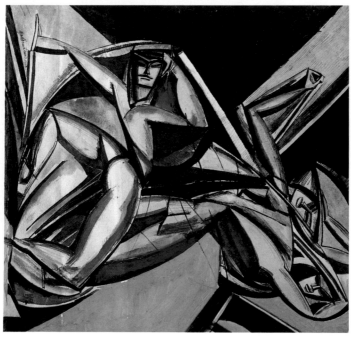

4. *Wyndham Lewis,* The Dancers *(1912). (See pp. 188–92)*

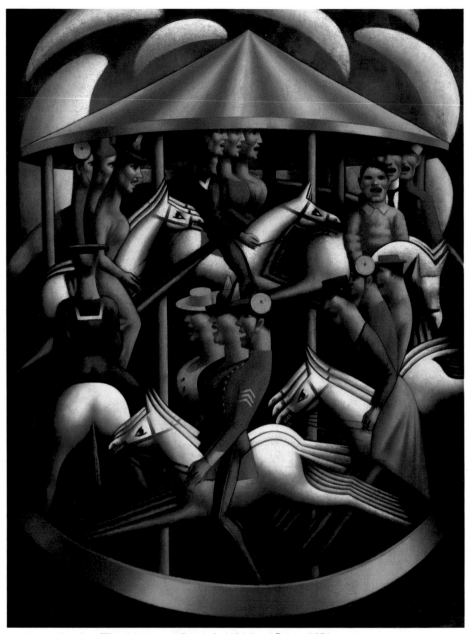

5. *Mark Gertler*, The Merry-go-Round *(1916)*. *(See p. 165)*

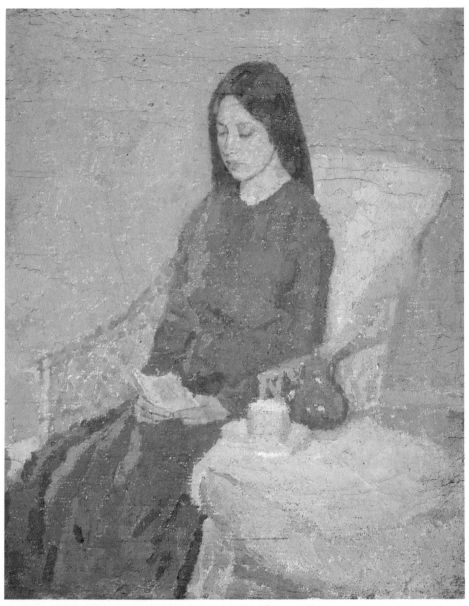

6. *Gwen John*, The Convalescent *(c.1915–25)*. *(See p. 169)*

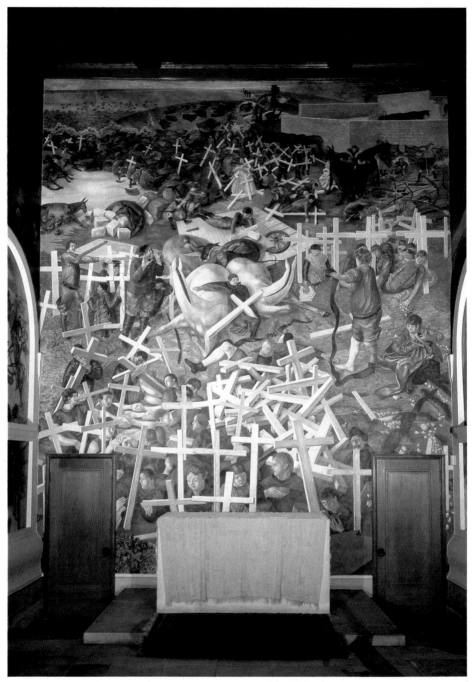

7. Stanley Spencer, Resurrection of the Soldiers *(1928–9). (See p. 168)*

8. *Duncan Grant: fabric; screen-printed cotton velvet (1936). (See p. 204)*

9. *Clarice Cliff: 'Crocus' pattern chinaware (1930s). (See p. 286)*

10. *Vanessa Bell: four-fold screen 'Bathers in a Landscape', for the Omega Workshops (1913). (See pp. 201–7)*

nineteenth century but also the machinery of thought and discourse. To take
but four names: without Marx, Ruskin, Freud and Marinetti the response to
the War would have been very different, and much more muted. A century of
civilised progress meant that the scrutiny turned on this European war was
very much more thorough than, say, the isolated ruminations of Southey or
Goya on the Napoleonic campaigns. As Paul Fussell has pointed out, for
example, the intersection in 1914–18 of universal education with the
continuing validity of an elite classical education meant that the reaction of
the British soldiery was not just literate but uniquely literary.

At the same time the domestic consequences of total war were, for millions
of erstwhile Edwardians, socially frightful. Whether or not the Liberal party
was already, before 1914, doomed to be overtaken by Labour, it is beyond
reasonable doubt that in fact the Great War sealed its fate. This watershed
for British political life condemned progressive politics to adversarial class
warfare and in practice ensured twenty years of Conservative hegemony
punctuated by two feeble minority Labour governments, lasting less than
three years between them.

In so far as the splitting of the Liberal Party was about policies rather than
the personalities of Asquith and Lloyd George, it concerned the necessity of
vigorous and extensive State intervention in national life for the efficient
prosecution of the war. This violation of the liberal ideal of individual
autonomy (freedom from conscription being especially considered the badge
of a free nation) further undermined the *laissez-faire* economy of the
Victorian era, already under siege from imperialist and socialist ideas. Not
that collectivism was unresisted, but the reaction to it only compounded the
economic damage of the war. Post-war Conservative policies harked back
nostalgically to a mythical 1914 of global hegemony, fiscal rectitude and
national consensus – a golden, or at least a gold-standard, age which looked,
ironically enough, distinctly Liberal.

The War also cost Britain a large slice of her world trade forever, and the
net outflow of capital meant that she could no longer act as banker to the
world. The direct effect was that the American crash of 1929 stopped the
painful recovery of Europe in the twenties dead in its tracks and helped
precipitate a second World War.

The British perception of the War might have been different if it had led
to a lasting settlement of Europe. Instead, the international anarchy of the
inter-war years was aggravated by British anxiety to avoid another war and
consequent lack of assertiveness. There was a beneficial side to this loss of
nerve in the British governing class – female suffrage slipped through in 1918
under cover of women's contribution to the war effort, decolonisation began
with the establishment of the Irish Free State and, despite the Depression,
poverty was never to be as harsh and unrelieved as in Edwardian times.
None the less the reassuring, consensual policies espoused by Baldwin and
Ramsay MacDonald turned out to have a high price in the international
arena.

These ramifications of the War have led us ahead of our story. To see how
guilt about the War could eventually lead to appeasement we must return to
the ways in which the Great War was engraved on the British imagination.

The First World War and the contemporary arts

Discounting memoirs, diaries and fictions, there were, one editor has said, 'thousands, possibly millions, of poems written in English during the First World War', of which those we refer to as 'the War poets' constitute only a tiny handful. Doubtless one reason why these particular writers – Brooke, Sassoon, Owen, Gurney, Rosenberg – have been recognised as representative is that they had access to the dominant literary elite, and spoke its language. Taking that for granted, it is still worth asking why they claimed attention.

The War experience, we have noted, took much of its significance from the contrast it offered to the pre-War norm. As Edmund Blunden retrospectively put it in 1939:

the emotional shock that so bewildering a change of prospect meant to those who enlisted for three years or the duration of the war awoke deeper utterance than men ordinarily need or permit themselves to attempt. At first, speaking broadly, poetry thus called into existence was concerned with the beauty of English life, made distinct by the act of separation, renunciation.

This applies to Rupert Brooke, C. H. Sorley, Julian Grenfell and, more profoundly, Edward Thomas and Blunden himself. But, as anyone who reads through an anthology of Great War poetry will be made aware, the trench experience increasingly breaks through Georgian poetic diction and patriotic themes, starting with the odd phrase in Sorley or Blunden, until it reaches the deliberately brutal description of horror in Siegfried Sassoon. A good example of the transition is Gurney's 'To his love', which starts as a pastoral elegy, with the traditional images of the lost comrade strolling and bathing in an Arcadian landscape of hills, rivers, sheep and flowers, but in the last verse confesses that the elegy's purpose is to smother horrific reality:

> Cover him, cover him soon!
> And with thick-set
> Masses of memoried flowers
> Hide that red wet
> Thing I must somehow forget.

Gurney, equally talented as composer as well as poet, used the tradition of English pastoral music in a similarly therapeutic manner, though this didn't prevent his being literally driven mad by his War experience, spending his last years in pitiful inarticulacy.

By the time we reach Sassoon's and Owen's direct confrontation of the War, the desire to hold off dread has been replaced by a need to transmit that experience back to the civilian public, even to din it into them in protest and revenge. And whatever the impressive and very different merits of Isaac Rosenberg, Herbert Read or David Jones as War poets, it is for and by *this* poetry that the War has been and is remembered. It is a commonplace of literary history that the War poets made an essential if subsidiary contribution to modern English poetry by clearing away the debris of Victorian verse – the stilted diction, clichéd imagery and artificial sentiment which had hung over in pre-War Georgian poetry. After Owen and Sassoon, War poetry of the 'Charge of the Light Brigade' type was not only

unreadable but unwritable. And it was not only the masculine military virtues ('all the arts of hurting') that went down; the whole moral universe of Victorianism had become a sham. 'It seems Tennyson was a great child. So should I have been, but for Beaumont Hamel', wrote Owen of his first experience under shellfire.

But the 'modernity' of Owen's and Sassoon's War poetry went deeper than this. Was English culture somehow psychologically ready, even masochistically yearning, for the horror show which Owen and Sassoon put on, being affected by the War in a way that German or American culture was not? If that seems a tasteless way to put it, it will at least be allowed that much of the attraction or power of their poetry lies in a thrill not entirely removed from that which keeps a vast industry of ostensibly sane books about war, militarism and violence grinding away today.

What distinguishes the War poets from this sort of thing is ultimately their inner Christian content, whether in Sassoon's voice of indignation or Owen's voice of compassion. Owen in particular came from a strongly evangelical background and had served as lay assistant to an Oxfordshire vicar before the War. This influence colours his verse's Biblical language, its imagery of Hell and the suffering Christ-figure, and, especially, the theme of sacrifice which so strikingly differentiates his horrific realism from that of Sassoon. Such a version of Christianity, centering on Christ-like compassion and Christ-like suffering, was deeply embedded in Victorian culture: it is, for instance a presiding spirit in Dickens. But such Protestant concern for the individual (as the image of Christ) is also in tension with the secularising and instrumentalising tendencies of modern society. Owen was the perfect voice and the First World War the perfect occasion to explode this tension.

Owen's Christianity gave him the ability to see a transcendental universal significance in one man's death or disability, and he sang it for all he was worth. But the simple political point was that Owen directed the horror, with all the pressure of Christian emotion, back at the society that had organised the War, juxtaposing the imagery of suffering with the clichés and stereotypes of civilian rhetoric. Owen and Sassoon helped to originate and articulate the conviction that something of such enormity had occurred as to suspend normal notions of responsibility to society.

In this they were reinforced by the spate of War memoirs and fictions that appeared, ten or more years after the Armistice, and from all points of view. Some came from the poets themselves, such as Sassoon's 'Sherston' series (1928–36), which sets his cataclysmic war experience in the context of his boyhood in England's agrarian and fox-hunting (upper-class if not aristocratic) past. Henry Williamson's long series of autobiographical books likewise trace semi-fictional relationships between the trench experience and nostalgia for the old rural England, embracing, in his masterly animal stories of which *Tarka the Otter* (1927) is the most justly celebrated, a return to the child's presumptive Eden. Gingerly flirtings with Fascism as riposte to the tawdriness of a mechanised society invite less of our sympathy, especially since they do not display the deep psychological acumen that distinguishes Ford Madox Ford's *The Good Soldier* (1915) and his explicit war-sequence *Parade's End* (1924–8).

A sensitive, more factual account of one man's transition from the old England into the trench horror is offered by Edmund Blunden in *Undertones of War* (1928) and by Robert Graves in *Goodbye to All That* (1929). A rank-listing soldier, C. E. Montague, naturally adopts, in his *Disenchantment* (1922), a more toughly professional stance. Non-combatants also made a contribution, for instance Vera Brittain in her best-selling *Testament of Youth* (1933), which relates the impact of the War to the growing pains of an intelligent and courageous young woman during a period of peculiar significance for women. Allies weighed in also, with e. e. cumming's American view of European war in *The Enormous Room* (1922), and with French Barbusse's *Under Fire*, translated in 1926. Even the enemy added to the spate, Remarque's *All Quiet on the Western Front* (1929) becoming as popular here as in Germany. All saw the war, in memory, as a negation not only of social and political authority, but also of the authority of tradition, culture and the past.

Since 1918 other events – totalitarianism, the Holocaust, the Bomb – have been adduced to much the same effect, but there can be little doubt that for the British imagination it was the Great War – the Somme, Passchendaele – that fatally damaged the legitimacy of secular authority. Of course, plausible as it may be to trace a significant line of thought in English intellectual life through the literature of the War, it would be much more difficult to substantiate the argument that it was the War writers who, by articulating a particular view of the War, set the political mood of a certain section of the educated class for the inter-war years, if not the century. Rather it should be said that they provide an indication of the War's importance in generating political thought in its widest sense. The War acted as a point of reference for non-revolutionary figures like Keynes, Macmillan, Leavis or J. B. Priestley as much as for the self-confessed enemies of established society, like Oswald Mosley, Wyndham Lewis, Bertrand Russell and D. H. Lawrence.

In one case the influence of the War poets was direct and avowed: that of Owen on probably the most important literary movement in Britain between the wars – the left-wing writers of the thirties, led by W. H. Auden. The diction, assonances and half-rhyme of Auden's first volume are palpably Owenesque, and generate comparable effects of dissidence and disaffection. Sassoon thought of himself as a socialist for some years after the War, while Owen's first published poem, 'Miners', matches his revulsion from the War to an almost Marxist view of society, seeing in the glow of a coal fire not an unproblematic consumption of nature, but the burning of the bones of soldiers and miners to keep society warm and safe:

> The years will stretch their hands, well-cheered
> By our lives' ember.

One might even say that after Owen's Christian compassion and Sassoon's cruder but unimpeachably sincere bitterness, even the most important poets – Yeats, Eliot, Pound – could not help looking slightly histrionic when they took themselves seriously as the poetic voice of humanity, and perhaps for that reason tended to entrench themselves all the deeper in difficulty or disdain. Their successors – notably Auden and in the later generation Larkin

– made a virtue of obliquity and self-depreciation; despite the potency of a few 'bardic' poets such as David Gascoyne, Kathleen Raine and, especially, Dylan Thomas, it has become rare for a British poet to speak in other than an assumed, often ironical, voice.

There were other ways in which the cataclysm actually fell in with literary preoccupations. Of the great modernist writers in English – Yeats, Pound, Eliot, Lawrence, Joyce – only the supernumerary Wyndham Lewis had any direct experience of the fighting, and Yeats and Joyce rather ostentatiously ignored it. (Yeats stated in 1915 that he would keep silent 'till bloody frivolity is over'.) There are of course local references in these writers to the War: Pound's famous *pro domo, pro patria* sequence in *Hugh Selwyn Mauberley* (1920); the demobilisation conversation in Eliot's *The Waste Land* (1922); Lawrence's story 'England, My England' (1922) and the Nightmare chapter in *Kangaroo* (1923); Joyce's marvellous doggerel satire 'Dooleysprudence' ('Poor Europe ambles / Like sheep to shambles'). More importantly all these authors found their distinctive, mature voices in works written during or in the immediate aftermath of the war: for instance, Yeats's *Michael Robartes and the Dancer* (1921), Pound's *Hugh Selwyn Mauberley*, Eliot's *The Waste Land*, Lawrence's *Women in Love* (1920), Joyce's *Ulysses* (1922). The question of how much works like these – the crowning achievement of what is certainly one of the great periods in English literature, and the very title deeds of international modernism – owe to the War is one of the most fascinating in literary history. Certainly all were under way before the War impinged on them, and although individually these works' secession from the past and closure of literary tradition might seem mostly coincidental, collectively it is difficult not to relate them to the War.

Yeats least fits the case; but the Easter Rising, the Troubles of 1919–23 and the end of the Protestant Ascendancy were perhaps his analogue of the Great War and, even with him, it is difficult to believe that the sense of the end of civilisation in poems like '1919' or 'The Second Coming' does not have as much to do with the European epic as with its provincial Irish parody. With the poetry of Pound and Eliot it is hardly necessary to press the point of historical breakdown while, in the more social context of the novel, the War confirmed both Joyce and Lawrence in their decided turns away from the educated reading public towards quite esoteric conceptions of their art. *Ulysses* rejects historical narrative and social context altogether: its turning points, in so far as it has any, are Stephen's statement that history is a nightmare; Bloom's that 'Force, hatred, history . . . That's not life for men and women . . .'; and the apocalyptic shattered glass and toppling masonry after Stephen raises his ashplant in the Nighttown brothel.

Lawrence's tragic transition from the openness and faith of *The Rainbow* (1915) to the bitter diatribes and perverse theology of *Women in Love* notoriously had everything to do with the War. Thereafter his work was an unflagging, vicious and futile war of attrition on the British reading public. Joyce and Lawrence can be said to have put an end to what F. R. Leavis was later to call the Great Tradition of the English novel. The novel survived, of course, but very much diminished and never with the same sense of explanatory authority – and here too it is difficult not to see the hand of the War.

Even if the common arrival at the conviction that history is a nightmare, and at forms and mythologies which strive to embody disintegration and fragmentation, can never be conclusively attributed to the war, it must be more than likely that the War diminished public resistance to innovation and disaffection, and encouraged the modernists themselves to carry their apocalyptic denunciation of society to extremes.

In looking at literature we have tried to delineate connections between the War and a distinctively 'modern' sensibility. Something analogous is manifest in the work of visual artists during the period. The war was a fatal blow to the possibility of any significant British participation in the modern art movement that swept Europe between 1900 and 1930. Avant-garde groups that seemed to be burgeoning in Britain between 1910 and 1914 were blasted apart. Some of their members – T. E. Hulme, Gaudier-Brzeska – were killed; others – Stanley Spencer, the Nash brothers – returned shell-shocked to make a powerful but hardly avant-garde art out of English nostalgia and mysticism. True, Henry Moore and perhaps Ben Nicholson later became 'international' modern artists, while relating their abstractions to the contours of English landscape. But the self-conscious linchpin of the modern movement, Wyndham Lewis, adopted the self-mutilating role of Enemy to all and sundry, alike in his paintings and his novels, stories and polemical writings.

In spite of the disruptive effects on, especially, Lewis's Vorticists – the only genuinely home-grown modern art group – the Western Front was a great moment for 'modern' art in Britain, the one time the idioms of Futurism, Expressionism and Cubism really carried conviction for both the avant-garde and a wider public. The remarkable collection of War art at the Imperial War Museum is certainly figurative rather than abstract, but English artists like C. W. R. Nevinson, Stanley Spencer, Paul Nash or Wyndham Lewis found in the War a world of fragmentation, mutilation, distortion and desecration for which the disintegrative, inhuman forms of modern art were entirely appropriate. And whatever the subsequent general retreat from modernity in British art, it may well be that it was as much the War which made 'modern art' acceptable and understandable to the arbiters of British taste, as the fear, *pace* Gombrich and others, of being wrong-footed over 'abstract' or 'modern' art in the way earlier critics had been in their dismissal of Impressionism.

It is interesting that during the War years and their immediate aftermath there were no stirrings of modernism in British music. After Elgar and Delius had reanimated our music from within conventions fundamentally European and specifically German, the task of English composers was to rediscover their national identity. For Holst and Vaughan Williams it was progressive to be regressive: to seek the traditional sources of British musical inspiration in (forgotten) folk song, in medieval organum and especially in Tudor polyphony. Vaughan Williams came from the small landed gentry but espoused the Christian communist cause of his hero John Bunyan, without being either a committed Christian or Marxist; he was once dubbed a 'Christian agnostic'. The musical task of his long lifetime was also social and philosophical, for in seeking to fashion, from the premises of English folk

song, organum and polyphony, an English symphony that compensated for our failure to achieve one during the burgeoning of the Industrial Revolution, he was also saying something about the nature and quality of English life.

Certainly we may say that although Vaughan Williams, and to a lesser degree Holst, may have spawned a great deal of ruminatively pastoral music from their minor successors, theirs was the central and necessary strand in British tradition. It is relevant to note that Vaughan Williams's Third Symphony, called the Pastoral, is an intensely indrawn, meditative work triggered off, on the composer's admission, not by a cosy English bucolic landscape but by the desolate battlefields of France: a post-war emptiness, physical and spiritual, which is given a more universal form in the weirdly disturbing finale to the Sixth Symphony in E minor: which postdates our period, yet palpably has its origins in the tritones and false relations of the Third Symphony of 1922. Clearly, the scars of that battlefield were not easily eradicated, if at all. Vaughan Williams's music may be poles apart from the European avant-garde with which it is contemporary. None the less it was, and still is, modern music, being, in Ezra Pound's phrase, 'news that STAYS news'.

Themes that had appeared overtly in the documentary and fictional writings of the late nineteenth and early twentieth century 'arts and crafts' writers like Jeffries and Sturt are, in the music of Holst and Vaughan Williams and the best of their successors, notably Rubbra and Howells, less patent but more creatively potent. So are they in the novels and poems of Hardy which, indeed, on occasion directly inspired the composers: consider Holst's *Egdon Heath* (1927) in relation to *The Return of the Native* (1878), or Vaughan Williams's (much later) Ninth Symphony (1958) in relation to *Tess of the D'Urbervilles* (1891). As in Hardy, conservation becomes rediscovery: a lifeline into the future the more necessary through the post-war world's inevitably intensified political and economic collectivism, its industrial and even architectural regimentation.

The inter-war years

Politics and society

At the end of 1918, Britain, though exhausted, was triumphant. Her enemies past – the German nation – and potential – Soviet Russia – lay in ruins, while alliances with Italy and France, Japan and America rendered her position, both on the continent and globally, apparently unassailable. The sorry tale of how this national security, won at such terrible cost, was thrown away has been rehearsed too often to need repeating here. Seeming triumph belied the magnitude of the problems that underlay it. The psychological impact of the war made it the more difficult for British politicians to cope with the fundamentally unimpaired, soon to be resurgent, and finally rampant power of a Germany now surrounded by weak and divided nations; with the vast over-extension of national strength, for little material return, required by the Empire; and with the worsening economic decline of Britain

in the context of chaos in international trade and class conflict at home. As a final blow, the victory of Allied democratic moralism over German militarism encouraged, via the League of Nations, delusions of international order and justice for which the other powers soon cynically abandoned responsibility. Britain was left with the thankless and dangerous role of a fat and flabby dowager playing policeman to a den of thieves.

If the only British role in international politics was a feeble and often hypocritical moralism, political vision was in even shorter supply at home. The dissipation of the conditions in which Liberalism had flourished left progressive politics in a state of ideological impotence. Two minority Labour Governments and the General Strike showed only too graphically that the Labour Movement had little idea what to do with power, even when presented with it on a plate. Outside the socialist camp the only progressive politician of any vigour, Lloyd George, was first imprisoned in his post-war alliance with the Conservatives, then deliberately and permanently frozen out of office precisely because the Conservative leader, Stanley Baldwin, mistrusted his 'dynamism'. In the circumstances it is hardly surprising that over the inter-war years the British electorate returned Conservative-dominated governments with majorities larger than the supposed 'landslides' of 1906, 1945 and 1983; there was little alternative.

As for right-wing energies, the coalitions of 1918–22, 1931–5, 1935–40 and the Conservative Government of 1924–9 pursued the politics neither of a robust capitalism nor of a collaborative national consensus, but of stagnation under a frightened, lazy and nostalgic elite. The ideas they entertained were mostly warmed-up left-overs of the Liberal debacle – suspicion of collectivism or State intervention, and a narrow-minded fiscal timidity diluted with a dash of social welfare. Notions of industrial regeneration, economic stimulation and the improvement of public services were either invisible, or seemed shameful, to those blinkered minds. Small wonder that writers, artists and intellectuals posed as enemies of society; the revolutionary rhetoric may not have been real but the sense of disinheritance was. Those who found this role too histrionic simply bathed in the escapism, privatisation and self-parody appropriate to a society whose public space enclosed mainly banality, insipidity and inertia.

The great 'achievement' of Stanley Baldwin, political colossus of the age, was to defeat the working class in the General Strike of 1926. The battle was fought over wage-reductions proposed for the work force in one of the old staple industries, coal-mining, the uncompetitiveness of which in the export market was itself largely the result of the over-valuation of sterling – a policy dictated by middle-class self-interest. To an extent the shame of the strike may be mitigated as only the most salient episode in the British preservation of parliamentary democracy as a bulwark against political violence, at a time when liberal constitutionalism was foundering all over Europe.

Similarly, historians nowadays often stress the positive achievements of the inter-war years: real economic growth, belated diversification into new industries, a tremendous expansion of housebuilding, the gradual improvement of social services. What these palliative arguments ignore is the extent to which the General Strike was a microcosm of the era. Baldwin may

have stemmed the tide of socialism that had been running strongly since the 1880s, but constitutional right and moral decency were mostly on the workers' side. Under cover of Baldwin's rhetoric of the national interest, it was the working class who paid the penalty for economic slump in persistent unemployment, cuts in wages and dole, and appalling living conditions throughout the twenties and thirties. If these conditions were not as terrible as those of pre-war days (as can be seen by comparing Rowntree's 1901 and 1935 surveys of poverty in York), unemployment was worse. The fundamental rottenness of inter-war Britain was that the political class lacked the will to implement what had already evolved as a logical consequence of nineteenth-century reform: the universal right to the possibility of a decent living standard. The working class was betrayed between the wars not just by Ramsay MacDonald and the trade union leaders, but also by the bourgeois politicians and intellectuals whose apathy allowed the working class to bear the brunt of economic depression.

This is the more unfortunate because, despite the neglect of the educated and cultured, much of the liveliest development in society and the arts between the wars lay in the burgeoning of a supposedly classless mass culture – the beginning of the Britain we live in today. Certainly the British economy was in decline from a position of overweening commercial preponderance. The War itself had brought unheard-of inflation, had damaged confidence in sterling and allowed trade rivals (especially America and Japan) to seize a substantial share of Britain's export market. Post-war dislocation, brought to a head by the Wall Street crash of 1929, led to the stagnation of world trade; whereas it had increased by twenty-five per cent per decade in the nineteenth century, it did so by only eight-and-a-half per cent in the twenties, and actually contracted in the thirties.

Even so, gross domestic product was still one and a half times greater in 1937 than in 1913: a performance better than that of Edwardian times or that of European competitors. New industries – cars, chemicals, electrical products, plastics, 'consumer durables' – prospered, helped by protectionism after 1931. In spite of the slump and unemployment, economic growth was spurred on by technological advances, and by demographic changes which had increased the producing working-class population while diminishing those who merely consumed – primarily children and the aged.

The corollary to this boom in the new industries and slump in the older ones was a substantial shift of labour from manual to white-collar, from manufacture and primary production to service and distribution, from craft skills to factory automation. The one lasting working-class gain from reconstruction after the War was the eight-hour day (or forty-eight hour week) while real income per head consistently rose, not only because of a steady increase in wages over prices, but also because of the reduction in the size of families. The 'disposable surplus' of income which many of the working class began to enjoy was the basis of the transition to a twentieth-century economy.

Against this, taxation tripled: a fact which affected the rich more than the poor. After the War, taxation, high land values and the high casualty rate in landed families all encouraged the break-up of estates – a quarter of England

is supposed to have changed hands between 1918 and 1921; by 1926 there had been a permanent shift of landholdings from landowners to owner-occupiers. The upper classes were hanging on rather than letting themselves spread, and to this retrenchment much of the nervousness and lack of confidence in the traditional arts may be ascribed. The inter-war years were not, for instance, a great age for the grand country house. You don't have to look further than the difference between a Sargent portrait and an Augustus John to observe the blurring, dilution and wavering of ruling class confidence in its identity.

It was neither the working nor the upper class which profited most from the inter-war years, but rather the middle class, who spent their increased financial resources on a private housing boom, aided by cheap mortgages, and on private education, cars and consumer goods. Dire poverty was restricted to a portion of the working class – above all the unemployed in the areas of declining industries – rather than being a universal rite of passage at certain stages (notably childhood, child-bearing, and old age) of the proletarian life-cycle. The general health of the population improved; by 1939 infant mortality was down to about its present rate, while illnesses like tuberculosis, pneumonia, diptheria and diabetes were under control. Among 'cultural influences' we might include the conquest of what is now euphemistically known as a 'social disease', syphilis, that scourge of nineteenth-century Bohemia. D. H. Lawrence attributed post-Renaissance repression of sexuality to the pox, so it may be that Molly Bloom and Lady Chatterley owe something to precognition of salvarsan.

More widespread knowledge of birth-control had something to do with it too. Fear of poverty discouraged the working class from having many children, while for the better-off large families made it more difficult to maintain their social status. Consequently women of all classes had more freedom – the poor to escape the confinement of perpetual pregnancy in a slum community, the middle class to read and write novels about the difficulty of the female lot. Smaller families changed attitudes to children also. Increased attention combined with the hangover of Victorian discipline to make all classes of the generation that grew up between the wars the most law-abiding in British social history. Moreover, greater affluence and leisure, allied to the lower incidence of children in the family dwelling, encouraged middle-class virtues of domesticity within the working class. They too aimed to cherish their privatisation in a warm and comfortable interior, as the religion of home-improvement began its evangelical sweep through a land as yet ignorant of the cryptic meaning of the letters DIY.

Even more significant than such interior transmutation was the change in the physical face of Britain between the wars. Despite the dark blot on the landscape made by the Industrial Revolution, slums, railways, dark satanic mills and all, it was the inter-war years that did most to make the mess in which we now live. Of course suburbs of bungalows and semi-detached villas, council housing, light industrial estates, arterial roads and bypasses – everything that J. B. Priestley and others abominated as the habitat of admass' – seem almost pastoral by now. And while nationalised health care, educational reform, full employment, the redistribution of wealth, and

eradication of poverty, the acceptance of trade unionism and planned town development all had to wait for the Second World War to be tackled if not achieved, the foundations for them were laid. House-building was the one substantial contribution of the inter-war years. True, the houses built were to be in part demolished by German bombs, and were in any case not remarkable for elegance (but see Simon Pepper on the Sunnyfields Estate in Chapter 9 below). Still, they were lighter and airier than their Edwardian counterparts, and more humane than the 'machines for living in' which Le Corbusier and his colleagues were busy preparing for us. One of the few constructive interventionist acts of Baldwin's administration was to initiate the electric National Grid; gas, piped water, baths, and central heating were all transforming the Englishman's castle, and were soon to be reinforced by washing machines, refrigerators and radio sets.

As for the spoliation of the English landscape (with all that implied for the English soul already racked by history), ribbon development, bungaloid growth and pylons provoked an outcry from conscious cultural reactionaries like Evelyn Waugh and John Betjeman, and from social designers such as Clough William Ellis. A Housing Act was ratified in 1935; town planning, garden cities, green belts, rural conservation, standards of interior design and layout, had all been in the air since the beginning of the century, but it took the Second World War, reinforced by Lord Reith, to reach a dubious solution in the shape of Planning.

Physical changes in people's environment naturally affected the ways in which they thought and felt; not all of the economic growth went into social utilities. There was some left over for cheap mass-produced clothes for the proletariat – barefoot children no longer picturesquely figured in English street scenes – and for fresher and more varied food – just in time for the link between poverty, diet and health to be 'scientifically' corroborated. These undoubted physical improvements may have been accompanied by advance in aesthetic standards of dress and cooking. Like many others, Rebecca West testifies to a real sense of cultural apartheid in the years before this clothing revolution:

In those days there were no attractive cheap ready-made clothes. If you were poor you had to wear clothes run up by sewing-women, and you looked terrible.

Such genuine material improvements in the lot of the masses were accompanied by the evolution of popular arts and entertainments designed to appeal directly to proletarian minds and senses – and of course to absorb those disposable shillings of the working-class weekly budget.

Mass culture

First among the demotic arts and entertainments comes the cinema; and the fact that the only essay on British cinema in this volume is on documentary film (see Chapter 7) speaks for itself: in all other departments the British film industry was something of a joke. This was not something the industry could readily have avoided, for it had had to close down 'for the duration' of the War, while Hollywood was building up an overwhelming preponderance, bolstered by the much larger home market it enjoyed. As a result the British

industry could not attract investment and remained cash-starved as well as artistically craven. The introduction of quotas for home-produced films led only to the industry's lowering its sights still further in order to produce the cheap and instantly forgettable 'quota-quickie'.

There were exceptions to the rule: notably Alfred Hitchcock, who first made thrillers in the silent era with *The Lodger* in 1926, produced the first British 'talkie', *Blackmail*, in 1929, and went on to make an eerily disturbing sequence of thrillers, *Thirty-Nine Steps*, *Sabotage*, *Secret Agent* and *The Lady Vanishes*. These entertainments all uncover a streak of the raw nerve evident in 'serious' modern art of the time – a fact which helps to explain their durability. Another exception, commercially if not artistically, was the Hungarian-born producer and director, Alexander Korda, whose *The Private Life of Henry VIII* brought the industry some prestige and considerable financial reward on the world market. But Korda was hardly a major creative talent, and Hitchcock, like Chaplin earlier, became part of a brain-drain to America. For the most part, film in Britain before the Second World War was primarily a matter of what was watched and consumed rather than produced.

It is a commonplace that Hollywood concocted fantasies to enliven the grey round in which most people lived, but beyond that the mutual influence of British society and American cinema is difficult to pin down. For instance, the division between high culture and society at large may have deepened as library, concert hall and picture gallery gave way to the movie palace (and dance hall) as places where people went to have their dreams massaged. The huge cinema attendances of the thirties even gave rise to an architectural genre in its own right – the 'Odeon-style' picture palace complete with Wurlitzer organ and Art Deco interior. But as far as the medium itself went, the economic handicaps of British cinema were compounded by the snootiness of British middle-class attitudes to the movies; even actors, with the exception of expatriates like Chaplin and Charles Laughton or music-hall stars like Gracie Fields and Jessie Matthews, sneered at film work. The twee drawing-room comedies, the flat-footed thrillers and the patronising use of variety stars like George Formby in 'regional comedy' all bespeak the extent to which British film makers were trapped in the mental horizon of another era.

Much the same triumph of American novelty and energy over British laziness and intellectual snobbery occurred in popular music, where technological innovations, notably the gramophone and radio, had again wrought a revolutionary metamorphosis. According to Ronald Pearsall, there were in the twenties more than 40,000 composers on the books of the Performing Rights Society, and by 1926 there were two million holders of wireless licences. The silent cinema was far from negligible in a musical context, providing as many as eighty per cent of musicians with relatively undemanding, and even enjoyable, employment. Although this vanished overnight with the coming of talkies, the gramophone came of age when, in 1926, electrical began to replace acoustic recording; previously pianola rolls recording famous pianists – Grainger plays Grieg, Busoni plays Liszt, Stravinsky plays Stravinsky – had produced serious opposition to, and some advantages over, primitive recordings.

The situation is similar in those aspects of music-production which overlap with theatre. The optimistic humour and togetherness on which music-hall had thrived died with the War; thereafter revue and musical comedy took over such ground as was left untenanted by the cinema. The popular music industry made its money not mainly from sheet music sales – as in the days of Ivor Novello when a cottage piano featured in every aspiring working-class home – but rather from record sales, performing rights and broadcasting. In song and on stage the native product was increasingly overwhelmed by American imports. Only the name of Noël Coward, with shows like *London Calling, On With the Dance, This Year of Grace, Bitter Sweet*, and songs like 'Mad Dogs and Englishmen' and 'Mad about the Boy', stood out – and still stands out – against the American tide. Talented US theatre composers like Jerome Kern, Irving Berlin, Cole Porter, Richard Rodgers, Harold Arlen, Vincent Youmans and Hoagy Carmichael – not to mention the great George Gershwin who obliterated barriers between entertainment and art – produced shows that became part of indigenous British culture. *No, No, Nanette, The Student Prince* and *Showboat*, 'Singin' in the Rain', 'Ole Man river', 'Tea for Two', and 'Summertime', seemed to be ours, and indeed still are. Even at this comparatively early stage of popular culture, it was the American ethos which prevailed in the 'dance culture' – *thés dansants*, dance bands, dance halls – which meant so much to the era.

All this Americanisation was, of course, a foreshadowing of the shape of things to come in social and political as well as cultural life. At a much deeper level it was manifest in the phenomenon of jazz, whose importance is suggested by an extravagant remark of Philip Larkin's:

. . . one could do without any twentieth century artist sooner than Louis Armstrong, for while the rest were pulling their medium to pieces Armstrong was giving jazz its first definitive voice, one that has changed the character of popular music down to the present day.

Although there is a trenchant irony in the takeover of Western culture by the music of its slaves, it has to be said of this period that by the time Negro jazz reached Britain it was thoroughly adulterated. A few real jazzmen – Armstrong himself, Jelly Roll Morton and his Red Hot Peppers, Duke Ellington – filtered through during the twenties and thirties, but most of the jazz bands to perform here were ersatz and anodyne British imitations – emasculated dance bands playing in venues like the Savoy Hotel and later, with the emergence of Swing and the Big Band, in commercial theatres. Real black jazz – of the 'dangerous' type now featured for minority audiences on Radio 3 – was banned from the airwaves, only Mickey Mousing vacuities like 'Yes, we have no Bananas' or 'Yes, Sir, that's my Baby' being sanctioned.

But if black jazz remained a music of the ghettoes, peripheral to the white world, it was a powerful undercurrent to the new *moeurs*. Gershwin wrote jazzy concert works which achieved, and still achieve, considerable popular success; here in Britain, Walton and Constant Lambert called on jazz rhythms and timbres, not in populist but in parodistic contexts, as in *Façade*, and even in the scherzo of a symphony and in a piano concerto. The appearance of a Louis Armstrong at London's Savoy Hotel momentarily imbued the superfices of the Cocktail Age with a darker reality, hinting that

the dance crazes of foxtrot, Charleston, Black Bottom – along with the
wearing of lipstick, mascara and rouge such as only the demimondaine or
worse had sported before 1914 – merited the paroxysms of moral outrage
with which the Establishment greeted them. The reality of Black Jazz points
to the powerfully positive aspects of this liberation – the beginning of the
'permissive' age we now live in. Yet it cannot be said that British popular
music, any more than British cinema, flourished on American stimulation.
Another world war and twenty years would have to pass before what first got
into the blood and under the skin in the twenties and thirties brought about a
regeneration of British popular music, with potent originality and creative
zest, in the pop songs of the Beatles and the Rolling Stones.

Anodyne, 'escapist', pseudo-jazz dance music featured in the early days of
the BBC; the bands of Jack Payne and later Henry Hall became 'household
words' in the homes of millions, whereas a Caroll Gibbons, at the Savoy
Hotel or elsewhere, had played mainly to those who dined or danced to the
music. Broadcasting, the new medium of and for the masses, was expected to
cater for all tastes. It brought music-hall-derived comedy and 'entertainment'
to the millions, diluting its impact while at the same time instigating
technological advances later to lead to enhanced sophistication in the
material. Increasingly, these innovations encouraged a polarising of public
taste. From one point of view broadcasting was a mass medium expected to
give mass civilisation what it wanted; yet at the same time state-sponsored
authority regarded broadcasting as an educational medium, offering the
public what it ought to have, and could take or leave. From 1923 it was a
'you can't win situation': the BBC was criticised at once for authoritarian
smugness and for a base pandering to the multitude.

Looking back, it seems to have held the balance fairly well. Between 1927
and 1930 various kinds of 'light' music had a preponderance, increasing from
29.45 to 35.84 per cent. The preponderance is not really surprising, since
'background music' was a natural and inevitable function of a merely audible
medium; and light music, though pap, was less insidious than today's
'muzak'. So-called 'dance music' was allotted a separate category, occupying
a mere 16.43 per cent, increasing by 1930 to 19.76 per cent; real (black) jazz,
still regarded as morally minatory, was not represented at all. But the
proportion of 'classical' music broadcast was quite high – 15.79 per cent
increasing to 20.01 per cent.

The availability of so much 'serious' music to thousands of people
previously unfamiliar with it was of inestimable value, and the work of
popularisers like Sir Walford Davies changed the musical face of Britain. At
the same time minority tastes were in this area by no means neglected. The
interminable Sunday morning series of Bach cantatas, considered suitable
fare for the Sabbath, was the butt of innumerable jokes; yet it was this
uncompromising 'exposure' that returned this great canon of then forgotten
music, if not to regular performance, at least to professional awareness – and
that long before 'authenticity' gave such awareness a sharper validity. A few
of us, moreover, are old enough to testify to the startling, profound and
durable effect made on their then youthful sensibilities by the BBC's
notorious Concerts of Contemporary Music, at which were presented not

merely the now accepted 'modern classics' of Bartók, Stravinsky, Schoenberg and Webern, but also the work of iconoclasts like Janáček and Varèse. Acceptance of such works was largely attributable, in Britain, to these uncompromising concerts. Struggle may also promote excitement. The battles Edward Clark fought at the BBC on behalf of modern and other unfamiliar music came near to killing him; but they sowed seeds in the more fruitful soil which Sir William Glock was to till so efficaciously after the Second World War.

The time allocated to drama in the BBC's early years was negligible, though from 1928 to 1930 it crept up from an infinitesimal 0.63 to a trifling 3.05 per cent. Moreover, its experimental aspects, as manifest in the radio plays of Tyrone Guthrie, though food for a few philistine guffaws, had a lasting effect on theatrical techniques generally, and are not without impact on audio-visual techniques today. 'Light entertainment' related to music-hall and cabaret was parsimoniously treated; its modest 5.26 per cent was even reduced, between 1928 and 1930, to 1.83 per cent. The spoken word, on the other hand, was more generously rewarded (about 15 per cent). In news bulletins, talks and discussions, the BBC found its most patent and potent educational outlet; many famous people, including G. B. Shaw, Wells, Bennett and Forster, served the BBC in advisory capacities in this field, while among the talking performers the names of Harold Nicolson, Ernest Newman, Stephen King-Hall, Raymond Gram Swing and John Hilton were a guarantee not only of cultural repute, but also of charismatic appeal to a wide audience. The BBC was undoubtedly the most powerful single factor in the dissemination of a potentially 'mass' culture. It still is, at a time when 'anti-educational' forces on the media are increasingly rampant.

High culture: modernism and insularity

If the essential dynamic of mass culture was its commercial appeal to the lowest common denominator of the greatest possible number of consumers, such commercialism at least had the corresponding virtue of making for accessible and democratic forms of art. However uniform and vulgar, it had none of the pretension to exclusivity and elitism of a decadent high culture, though it may well be that this promise, inherent in the arts of a mass culture, was to be redeemed, if at all, only in the boom conditions of the sixties. One thing that *was* shared by mass entertainment and the old arts during this period was the feverish quest for novelty. Obviously in the case of popular music and cinema the main reason for this was, again, commercial, but it would be wrong not to see in the consumers' demand for something eternally new, and the producers' readiness to supply it, a spiritual response as well.

Much of the highbrow insistence on being avant-garde and original was doubtless as commercially inspired as any novelty record from Tin Pan Alley. The histrionic tantrums of poets and musicians, the desperate succession of ephemeral art movements, the ever more outrageous lengths to which artists had to go to shock a thoroughly cowed and sheepish public, all

suggest nothing so much as a sulky child trying to get its mother's attention. Nonetheless the high arts at least had an alibi for their neurotic behaviour: the attempt to make it new was a response to a world made strange not just by the War and the break-up of the nineteenth-century European polity, but by a sea-change in Western Knowledge itself.

By 1900 Marx and Darwin were already undermining faith in the individual (educated, white, male) as the autonomous, conscious and effective subject necessary to a rationalist, objective theory of knowledge, making him the puppet of biology or history, and knowledge just part of the power-struggle of natural selection or class-conflict. Significantly, although it is Nietzsche who gets all the calumny, it is Marx and Darwin who are the decisive intellectual sources for twentieth-century totalitarianism, godfathers to Fascism and Communism alike. To this pair Freud made an unholy trinity, completing the devaluation of human discourse by making private life, too, merely the location for the clash of mechanistic and irrational forces. Of course none of the founding fathers would have wished their ideas to be framed in such a philistine way – but it was vulgar Marxism, vulgarised Darwin and Freud, which percolated into the cultural brew. At the same time the immensely important though historically almost invisible process of secularisation was steadily weakening the tradition which might otherwise have resisted this devaluation of the individual – the Christian Church.

Other philosophical and scientific thinkers had done much to shake belief in the Newtonian foundations of scientific knowledge. It mattered little that G. E. Moore and Bertrand Russell, Bergson and Wittgenstein, Einstein and Maxwell were only vaguely understood: what mattered was the obscure feeling that 'objective reality' no longer existed in quite the same way and could no longer be depended upon to underpin 'commonsense' attitudes to life. Spengler's immensely influential *The Decline of the West* gave a further twist to the screw, offering a readily embraced challenge to Western epistemology and a fashionable flirtation with apocalypse. The remarkable rash of aesthetic theory from writers such as T. E. Hulme, Ezra Pound, T. S. Eliot, Roger Fry, Clive Bell, Herbert Read, Nikolaus Pevsner, Wyndham Lewis, Christopher Caudwell, F. R. Leavis, I. A. Richards, and William Empson, also struck at the plain man's liberal-humanist conception of art by promoting a generally aggressive posture towards the ignorant philistines who resisted modernism in its various forms.

Not surprisingly, the most significant art created in Britain during these years of crisis was that which displayed a powerful, if deeply ambivalent, reaction to the complex cultural cross-currents of a Europe in transition. Alongside artists like Hardy, Holst and Vaughan Williams who, we saw, sought the survival or revival of liberal-humanist values by way of a reconstruction of the past, there were others who embraced modernism – sometimes too readily and too consciously – to effect what we might call a de-construction of the old world. British roots in Morris, Hardy, even James and Conrad, were torn out or misread. Significantly, the two leaders of modernism in literary Britain, Pound and Eliot, were both American Outsiders; and Pound – writing his elegies on a post-war 'botched civilization gone in the teeth' – remained a European rather than insular figure. In

Pound's *Hugh Selwyn Mauberley* and in the earlier of his *Cantos*, in Eliot's seminal *The Waste Land*, we encounter a dismembering of the symbiosis between a given artistic language and the social reality to which it was addressed: 'these fragments I have shored against my ruins'. The phenomenon, parallel to the visual Cubism of Picasso, was consciously international and historicist, although in England the movement was exclusively literary – apart from the peripheral work of Wyndham Lewis's Vorticists.

James Joyce – with Pound and Eliot the third major figure in English- (or Anglo-Irish-) speaking modernism – was another outsider who, at the age of twenty-two, left southern Ireland, let alone Britain, to become an international citizen of Paris and Trieste, forging *through* language the destiny of his (and our) race. Even W. B. Yeats, the fourth major figure, defiant in his stone (not ivory) tower, remarked 'I, too, have tried to be modern', though the basis of his stance was aggressively traditional. In his flirtings with occultism and Rosicrucian 'science' he created a complex of beliefs that amount to *A Vision* (1925): an 'alternative creed', if not faith, that irrationally ballasts the isolated ego, in a world wherein traditions, however esteemed, are willy-nilly foundering. 'Ireland' becomes at once a valid past and a mythical future.

Two other major writers, operating from within 'old' Britain, approached modernism through the force of their genius. D. H. Lawrence directly confronted the rural and industrial England which had moulded his Nottingham boyhood, interlacing autobiographical psychology with socio-logical issues, and transmuting both into mythical, ultimately apocalyptic, archetypes. He ended with an abjuration of England, seeking but never finding reborn worlds throughout Europe, Mexico, America and Australia. John Cowper Powys, staying at home except for money-making lecture tours of the United States, created from his Welsh ancestry a vision of the Arthurian 'mind of Britain', timeless and placeless in its dealing with elemental experience. His earliest and greatest novels – from *Ducdame* of 1925 to *A Glastonbury Romance* of 1930 – were in fact written in his forties and fifties; and it is interesting that in later work produced during a very long life he increasingly entered into realms we would now call science fiction. That creative energy dissipates the more he takes off from earth into space perhaps indicates how difficult was his initial undertaking; and the same may be said of the social chaos and religious hysteria that afflicts Lawrence's late work. J. C. Powys's brother Theodore Francis avoided such disruption by a deliberate limitation of range. In 1927 he wrote, in *Mr Weston's Good Wine*, one great, physically metaphysical novel, but in repeating the formula often retreated into a coyly ironical ruralism. At their greatest, D. H. Lawrence and J. C. Powys embraced political and religious issues because they were strictly speaking above and beyond them.

Not all (even) major artists managed this, as is demonstrated in Pound's Fascism and MacDiarmid's global Communism, not to mention the manifestations of authoritarianism in lesser figures like Wyndham Lewis, Henry Williamson and Roy Campbell. By the generation of Auden, Spender and Macneice in the thirties, Marxism had become intellectually respectable,

even obligatory, for it seemed to accord with a sane political and economic future. But either the turbulence of modernism – as promulgated by international figures like Joyce, Pound and Eliot, or more indigenously by Lawrence and Powys – or the re-creative conservatism fostered by the likes of Hardy, Holst and Vaughan Williams, called for exceptional imaginative stamina. If we accept that cultural conservatism's strength lay in its reanimation of the past, while modernism's strength lay precisely in its closure of tradition, we have to admit that the weakness of the one was its failure to embrace 'Europe', and of the other was its inability to embrace within its revolutions some kind of social engagement. Modernism and conservatism found it difficult to admit that they needed one another; in the face of this we may understand why many writers diverged from modernism into what we might call 'interiorisation'.

By far the finest, and most influential, was Virginia Woolf who, especially in *Mrs Dalloway* (1925) and *To the Lighthouse* (1927), created a generally valid world from the 'stream of consciousness' of her own memories and desires: a very English version of the *A la recherche du temps perdu* of Marcel Proust – who remarked that 'man is the creature that cannot come forth from himself, who knows others only in himself, and who, if he asserts the contrary, lies'. Minor figures like Dorothy Richardson and Katherine Mansfield are peripheral to Woolf – especially Mansfield's touching stories drawing on recollections of her childhood 'far away', in New Zealand. That Bloomsbury, where many of these writers and painters (but not musicians) lived, was a hermetic society consciously segregated from mercantile London bears on the nature of the art created in it. Not only the major writer Virginia Woolf ('well-born' into a famous literary family, but married to a left-winger), but also the historian-critic and ironic belletrist, Lytton Strachey, and the various members of the Garnett clan enjoyed financial as well as cultural privilege. It is pertinent to note that in the previous generation Constance Garnett (mother of David, writer of elegantly fabulous novellas) had translated the great Russian novelists, bringing to our consciousness their 'universal' psychological insights as well as their response to a pre-revolutionary world in decay – as was Bloomsbury's own, no less hermetic circle.

We may regard Robert Graves, a distinctively personalised lyric love-poet, and Ford Madox Ford, a psychologically-minded social novelist, as bridges between the private experience of Bloomsbury and the forging of a post-war conscience that could be communal as well as personal. Close to this category we may also cite an odd-woman-out like Ivy Compton-Burnett: for although her family novels are set in the Victorian and Edwardian eras, they deal, in stylised artifice and with sharp-witted malice and dolorous passion, with precisely those internecine feuds and subterranean tensions which, we have observed, led to Liberal disintegration. The pattern was set in the twenties with her early novels such as *Brothers and Sisters* (1929), and remained constant, and ever more relevant, until her death in 1969: for as Angus Wilson has remarked, 'in the age of the concentration camp no writer did more to illuminate the springs of human cruelty, bravery and suffering'.

Ivy Compton-Burnett was a woman, albeit one charged with 'masculine'

intellect and drive. During the years in which she worked, other women writers emerged who, if without her probingly imaginative genius, spoke both for the needs and rights of their sex and for beleaguered humankind in general. Rose Macaulay published in 1923 a novel which, under the title of *Told by an Idiot*, recounts the destinies of members of a family from the heyday of Victorianism, through phases she designates as *fin de siècle*, Edwardian and Georgian (sub-divided into Circus, Smash, Debris): ending in Macbeth-like disintegration in the year of the book's publication. At the opening of the novel the Victorian Mother, nicely named Mrs Garden, says 'in her crisp, even voice to her six children, "Well, my dears, I have something to tell you. Poor papa has lost his faith again."' With the help of both irony and compassion Rose Macaulay steers her creatures through catastrophe; and in later books similarly applies the balms of wit and psychological acumen to her own recurrent crises of faith.

Other women writers of Macaulay's generation veered either to religious, social and political commitment or to some kind of 'interiorisation'. The formidable Rebecca West wrote novels, but made a more decisive impact with unusually intelligent and informed journalism. Antonia White, on the other hand, found her main, perhaps only, theme in her own religious crisis, epitomised in *Frost in May* (1933); while Jean Rhys was a brilliant confessional novelist whose work, from *Leaving Mr Mackenzie* (1929) onwards, became a *cri de coeur* from hopefully emancipated women unable to accept sanctions, religious or social. Rosamund Lehmann, whose first novel has the pertinent title of *Dusty Answer* (1927), dealt with similar confessional themes in a classier, less painful, environment; she has made a come-back in old age with spiritualist 'answers' to the dust of the wicked world. Most distinguished, perhaps, in achieving an equilibrium between elegiac personal experience and the light or dark of world events, as the inter-war years merged into the second catastrophe, is the Anglo-Irish novelist and short story writer, Elizabeth Bowen.

Yet it may well be that the most durably 'relevant' of women's writing during these years is neither that which, like Rebecca West, is politically orientated nor that which, like Macaulay, White, Rhys and Lehmann, is self-committed even to the point of neurasthenia, but is rather that which appears to be independent of time and place, or at least is consciously separated from *our* time and place, as are the novels of Ivy Compton-Burnett. The fictional fables of Sylvia Townsend Warner – especially *Lolly Willows* (1926), *Mr Fortune's Maggot* (1927) and *The Tender Heart* (1929) – awake more echoes in the mind and ripples in the pool as time passes by. If we think of her 'conservationism' in relation to that of Holst and Vaughan Williams we may pertinently recall that she was not only a novelist and poet, but also a by no means insignificant scholar in the field of Tudor music. And if she is merely a tributary, this may in the long run matter more than a mainstream that, evading Eliot- or Lawrence-like confrontation, Woolfish interiorised dedication or Compton-Burnett-style clinical analysis, sought outlet in cynicism or frivol.

Evelyn Waugh's mordant satire is at once a criticism of and an escape from the world he inhabited – as are, for that matter, the convert-Catholicism and

nostalgia for an aristocratic heritage in his 'serious' novels. More likeable, though no more brilliant, is the scintillatingly silly Ronald Firbank, who published his dandyish, belatedly *fin de siècle* novelettes between 1915 and 1926; and the Sitwells in their satiric-fanciful vein. *Façade* (1922), in which Edith collaborated with the composer William Walton, has exhibited unexpected staying-power; the period-charm it evokes has become a whimsically periodless paradise, though Walton himself – who came from north country working-class stock and was youthfully patronised by the Derbyshire Sitwells – later revealed himself as no iconoclast, but a natural successor to Sir Edward Elgar, producing symphonies and concertos in which Elgar's *nobilmente* vein is recognisable, if soured.

The paradox is pointed as well as piquant, for Edwardian opulence and Sitwellian satire are opposite sides of the same coin. If Art and Life here coexist, in the eccentric figure of Lord Berners they are so interfused that one hardly knows which is which. His Firbankish novelettes (and still more his hilarious autobiographical *First Childhood*, 1934), his 'modern' music (in satirical inverted commas), his more conventional English landscape paintings afford modest delight, but less, perhaps, than the comic fairy-tale life he lived on his estates, and the innumerable anecdotes about his authority-debunking escapades. Such phenomena link up with the twenties' Cocktail Age, with the 'bright young things' of Michael Arlen's *The Green Hat* (1924), perhaps with the cult of homosexuality and 'affairs'. And if for Lord Berners Art and Life fused into Fun, this is only a *reductio ad absurdum* of many newly emergent, quite sophisticated yet demotic forms of entertainment.

For just as 'low', originally Black dance permeated British culture at fairly 'high' levels, so, inversely, elitist White dance turned into entertainment appealing to the (risen) middle-class public, at most age levels. In the wake of the grand Russian balletic Dream, an indigenous English ballet sprouted, under the aegis of balletomane Arnold Haskell, fostered by the imaginative and administrative genius of Marie Rambert, who had worked closely with Diaghilev. The Vic-Wells ballet evolved in harness with Lilian Baylis's nurturing of Opera in English; Rambert and a little later Ninette de Valois brought together native choreographers of high distinction, such as Frederick Ashton, and international dancers of the calibre of Anton Dolin, Alicia Markova and the magnetic Robert Helpman. They performed the major ballets of the nineteenth century, but also, and more importantly, commissioned ballet scores from relatively young British composers, as well as from Lord Berners himself, who embraced both 'charming' Victorian pastiche and Gertrude Stein.

The musical mentor was the young Constant Lambert, a conductor as cosmopolitan in cultural knowhow as he was technically efficient. While still a student in his teens he had composed a witty-whimsical ballet for Diaghilev, on the adolescent theme of *Romeo and Juliet* (1923). English in idiom, the music was peppered with Prokoviev-like spice; but of greater substance, and more appealing to the general public, was his *Rio Grande* (1929) for piano, chorus and orchestra, to another Sitwell text, this time Sacheverell's. Significantly, its jazzy seductions were particularly effective when it was transformed into a ballet for Lambert's company; still more considerable was

the triumph the Edith Sitwell-Walton *Façade* achieved when, choreographed by Ashton, it graduated, in 1931, from fashionable *succès d'estime et de scandale* into a middlebrow box-office winner.

English ballet was not, however, restricted to such hedonistic delights, for in the same year Vaughan Williams, the then doyen of British composers, untouched by twentyish frivolity, was commissioned to compose *Job*, a 'masque for dancing' rather than ballet proper, scored for full orchestra in the tradition of seventeenth-century English consort music. It was superbly choreographed by Ashton, inspired by the Job engravings of William Blake, an English poet–painter whose mystical–social approach was even closer to Vaughan Williams than was his beloved Bunyan. As danced by the pick of the Vic-Wells stars, it seemed a masterpiece in the early thirties; and still does so when revived – fairly frequently in the concert-hall, intermittently in the theatre. English ballet had come of age, though no later contribution to the genre – with the possible exception of Arthur Bliss's *Checkmate* (1937), a ballet of sturdy musical substance and dramatic force choreographed by Ninette de Valois – approaches its stature.

Job was an unexpected outcrop of the music-theatre of the thirties. In other areas hedonism usually proliferated not 'up', but 'down'. For instance, there is an obvious link between a 'privileged' satirist like Evelyn Waugh and a vastly popular comic novelist like P. G. Wodehouse who, himself coming from the upper class, offered fantasy-parody of his world, relishable by hundreds of thousands, perhaps millions, outside the charmed circle. Vicariously and momentarily, they could belong to it, while at the same time laughing it literally out of court. Wodehouse's international triumph is more difficult to understand, unless it be that outsiders enjoy peeking in at social *moeurs* as grotesque as ours.

There's a further link between Wodehouse and the Aldwych Theatre farces produced, over the same years, by Ben Travers. The cult of romantic fiction is another, no less obvious, escape-valve: as is the detective fiction of an Agatha Christie, since in her novels from *The Mysterious Affair at Styles* (1920) onwards, murder skulks in the shrubberies of genteel vicarages and in the drawing-rooms of grand country houses; an 'outsider' detective (a foreigner or spinsterish old lady) juggles with the destinies of people who are recognisable twenties types. The vast popularity of the genre may be due to the fact that the Great House, however threatened by all those (post-war) 'things that go bump in the night', survives. There must be something to such escapism when it can, as in the case of *The Mousetrap*, persist not merely in print, but in theatrical performance, over more than thirty years!

Various kinds of escapism, frivolous, hedonistic and nostalgic, are encapsulated in Chesterton-Belloc pub-rurality, which mells together Old England, autocratic Roman Catholicism, brilliant child-orientated nonsense verse, and ingenious detection; Chesterton's priestly sleuth Father Brown embodies them all. Even so, such delightful cheats were not the only possibility for intelligent and sensitive people who were of merely average ability. The old hegemony of Liberal England did not, after all, entirely break down. Indeed politically and socially the twenties and thirties were oddly the most conservative decades of the last hundred years; the crime rate,

for instance, fell so low that their posterity has, in comparison, been berated ever since. This does not invalidate the thesis that a breakdown of cultural confidence had occurred; it merely means that the absence of a coherent 'modern' consensus allowed conservative ideology and market forces to hold sway. Yet notwithstanding the decline in public acclaim and critical esteem of Galsworthy, or even of Bennett and Wells, and the Goodbye to All That uttered not only by romantics like Graves but also by genuine Liberals like Ford Madox Ford and E. M. Forster, there persisted beneath the luxuriant foliage of non- and anti-social art a sturdy sub-urb of socially responsible culture which would enter into its (now rather parochial) own after the Second World War.

In any case the liberally humane ideal of a socially responsible culture surfaced in the economics of a Keynes and the popular political philosophising of the later Bertrand Russell. This was the era in which sociology and anthropology, art history and social history, began to burgeon; Tawney and Trevelyan replaced Acton and Macauley. Stern moralists like Sir John Reith, involved in broadcasting to the multitude, or F. R. Leavis as critic and as tutor to generations of students, played their part, while Alan Bush – a fine English composer rigorously trained in Germany – was and still is a committed Marxist who hoped to use his music for social and ethical ameliorisation. Not only did he compose populist music for the Workers' Music Association; he also consciously modified (and anglicised) his 'difficult' art idiom to make it more communicable – though he has never threatened to graduate from the BBC's Radio 3 to Radio 1.

Most significant of all during these years, journalism became an important sphere of influence, encroaching on consciously literary artists such as Isherwood ('the Camera Eye'), and even on Auden himself. Christopher Caudwell, a Marxist theoretical writer, was a crony of Auden's circle, and an amphibious figure like George Orwell, part novelist, part political commentator, traced the stations of the Cross through which the thirties generation enacted their drama. His *Homage to Catalonia* (1937), perhaps his finest book, reveals how the Spanish Civil War became a quasi-mythological cause to which artists from wide areas of Europe and America rallied, almost always – apart from a freakishly Quixotic feudalist like Roy Campbell – in support of the Left. Orwell himself, Auden, Spender, Caudwell, Hemingway and Conlon Nancarrow were among the many who embarked on the Spanish pilgrimage: which in turn led towards the shocks of the Moscow Trials, Munich and the Nazi-Soviet Pact, to climax in 1939.

Left-wing partisanship rocked the establishment in more devious ways; this was the age of the high-born but communistically dedicated 'traitors'. On the whole, however, British artists of the thirties were soon disembarrassed, revealing themselves as humane liberals all along; Orwell, by the time of *Animal Farm*, had become anti-totalitarian-communist. Auden, fleeing to America, embraced Catholicism. Benjamin Britten, the English composer of the era most conspicuously endowed with genius, went with him. Then left-wing, though never a party member, he had collaborated with Auden in an anti-establishment oratorio, *Our Hunting Fathers*, for the politically respectable Norwich Festival, and also on the words-and-music for a famous documentary film, *Nightmail* (1936). But when Britten returned home (without

Auden), it was as a liberal Englishman who had no need of a Cause, political or religious. His music springs from English vocal tradition, while seeking once more a relationship between British insularity and the idea of 'Europe'. His perennial theme of the child-innocent and scapegoat is wondrously manifest in the two works that established his youthful reputation: the vocal *A Boy was Born*, composed in his late teens, and the instrumental *Variations on a theme* of his teacher Frank Bridge, composed for string orchestra in 1937. This piece starts from insular Britain, flows into a Mahlerian elegy on 'the death of Europe', dismisses Europe in a chain of brilliant parody-variations, and ends in a heart-felt, deeply moving lament for both Europe and England, then on the brink of the second of the cataclysms that may mark the beginning of the end of Western civilisation.

Significantly Michael Tippett – the other composer of genius belonging to Britten's generation – also produced as his first major work a concerto for (double) string orchestra that relates England's past (in folk song, Tudor polyphony and seventeenth-century consort music) to her and America's present (in the blues and jazz): ending with a song-dance of affirmation made, in 1939, on the eve of catastrophe. His next major work was to be an oratorio, directly concerned with 'current events', with the title of *A Child of our Time* (1941).

Britten's *A Boy was Born*, Tippett's *A Child of our Time*, presage, from within the fiery furnace, the possibility of a rebirth; which they at least brought to musical and theatrical consummation in decades that postdate this volume. It may be significant that the lyric art of music became so potent in these critical years; only the late poetry of Yeats (who died in 1939) and the late thirties sculpture of Henry Moore, and perhaps of Barbara Hepworth, speak thus decisively on behalf of the embattled human spirit. Later (mostly imported) abstract art and sculpture, and still more architecture, fits more neatly into the structure of corporate capitalism. Sometimes the architecture was termed Brutalism; and there is a sense in which the ethics of modernism may tend to be brutal, anti-humane, anti-liberal, anti-democratic. This is not to discount the formidable and necessary achievement of the leaders of the avant-garde, but is an admission that avant-gardism of its nature deepened the gulf between art and people, encouraging the fetishism of Art and the snobbery of an élite. In this context the anti-modernism of a supremely original genius like Britten may move us so much precisely because it nurtures the seeds of life, frailly emergent in that boy who is born; while the *conscious* anti-modernism of minor figures like Waugh or Larkin, or even Betjeman and Kingsley Amis, becomes credible and creditable, an essential strand in the warp and woof of the future.

Epilogue

After the Great War, what had previously been an unheeded avant-garde voiced, in forms both monumental and ephemeral, its ultimately cataclysmic disenchantment with the evolution of society; and society fell over itself to agree. Far from being vilified like *Jude the Obscure*, or ignored like the designs of Charles Rennie Mackintosh, *The Waste Land*, *Ulysses* and *Lady Chatterley's Lover* (1926–7) earned for their authors – despite ineffectual

official noises off – a prestige which has never been seriously challenged, and which in due course brought not inconsiderable pecuniary reward. This legitimation of the revolutionary intentions of modernism derived as much from its congruence with the culturally seismic impact of the War on British society as from the demands for autonomy from the requirements of the customer. In the long run the elevation of art to quasi-religious status, and its co-existence with the society it savagely criticised, was anything but a healthy sign in a national culture where it was axiomatic that morality and history walk hand in hand. In every art the emancipation of the avant-garde from social responsibility could imply trivialisation and banality; and banality does not necessarily mean harmlessness, as Hannah Arendt has pointed out. The more the artist tried to escape this fate, the more it closed in.

As so often the clever poetry of W. H. Auden has its finger on the pulse: in a culture where deference to art only confirms its impotence ('for poetry makes nothing happen'), nay-saying is as guilty, and philistine, as Wellsian optimistic millennialism. Like Hardy on 31 December, 1900, Auden is concerned on 'September 1, 1939', with the possibility of art's making for faith in life, even in a world indifferent to human morality. But whereas Hardy's intensely private poem is at most agnostic, locating vitality, if at all, in 'The Darkling Thrush', Auden's very public poem seeks in personal life the source of what he still diagnoses as a sickness:

> Out of the mirror they stare
> Imperialism's face
> And the international wrong.

And later,

> The error bred in the bone
> Of each woman and each man
> Craves what it cannot have
> Not universal love
> But to be loved alone.

This state may be susceptible to cure; in which case the function of art is clear:

> May I, composed like them
> Of Eros and of dust
> Beleagured by the same
> Negation and despair
> Show an affirming flame.

At exactly the same time as Tippett and Britten were making their immediately communicable musical affirmations in the Concerto for double string orchestra and the *Variations on a theme of Frank Bridge*, Auden wrote these words, and his great elegy 'In Memory of W. B. Yeats'. Speaking out of the retrospective guilt of the thirties, he asserts the artist's ultimate responsibility:

> In the deserts of the heart
> Let the healing fountains start,
> In the prison of his days
> Teach the free man how to praise.

Part II
Studies in the Individual Arts

6

BLAST

years **1837** to **1900**

Curse abysmal inexcusable middle-class
(also Aristocracy and Proletariat).

BLAST

pasty shadow cast by gigantic **Boehm**
(imagined at introduction of **BOURGEOIS VICTORIAN VISTAS).**

WRING THE NECK OF all sick inventions born in
that progressive white wake.

BLAST their weeping whiskers—hirsute
RHETORIC of EUNUCH and STYLIST—
SENTIMENTAL HYGIENICS
ROUSSEAUISMS (wild Nature cranks)
FRATERNIZING WITH MONKEYS
DIABOLICS—raptures and roses
of the erotic bookshelves
culminating in
PURGATORY OF
PUTNEY.

18

A page from Blast, 1 (1914), the periodical edited by Wyndham Lewis.

1 Literature and Drama

JACQUES BERTHOUD

Introduction

Any attempt to account for what is now generally thought to be one of the most brilliant periods of English literature must accord a central place to the artistic movement known as 'modernism'. By definition, of course, writing is always modern to its contemporaries; but much of the literature produced between 1900 and 1940 felt itself confronted by the conditions of modern life – by what shall be called 'modernity' in what follows – in a uniquely uncompromising way. Writers regarded the world inherited from the previous century as at once charged with special potential and bound by special constraints. It seemed to them unprecedently problematic both in what it offered for interpretation and in the means of interpretation it put at their disposal. That their resources turned out to be equal to this challenge is everywhere apparent in their achievement, and not least in the fact that even their bleakest visions – for example, that of the modern city in Conrad's *The Secret Agent* or Eliot's *The Waste Land* – are tense with the excitement of difficulty overcome.

A historian of the literature of the period cannot therefore evade the modernist phenomenon. Since however 'modernism' is not an abstract concept, but a historical one, the task of analysis cannot be straightforward. Most of the critics who have adopted the direct method of definition have either been too programmatic, and turned a living cultural development into a fixed critical system, or they have been much too general, and specified properties – 'concentration', 'intensity', 'experimentation' etc. – that could be equally well applied to any period of heightened creativity. Modernism cannot be studied as a self-sufficient movement. If we accept that it is in some sense a revolutionary project, it cannot be understood independently of the conservative or traditional practices against which it defines its innovations. It has to be treated as a term that takes its meaning less from what it is in itself than from how it is distinguished from some other term. 'Modernist' discourse is therefore logically related to what we can provisionally call 'representational' discourse.

But even this is too abstract. Modernism was not only a movement that invaded all the arts, but one that formed itself into an international style. This fact had a significant bearing on the literary culture centred on London. The great majority of the initiators of modernism in England were outsiders: a list would include such figures as Henry James, Joseph Conrad, Ezra Pound, T. S. Eliot, and even W. B. Yeats and James Joyce. The collision therefore between an imported modernism, and a local tradition of writing long protected by success and the fact of insularity, was pronounced. This shock further diversified the scene; yet, surprisingly, it did not fragment it. One of the characteristics of the period was the degree to which its writers communicated with one another – often in disagreement. Shaw's debates with Chesterton (c. 1910), James's quarrel with Wells (1915), Virginia Woolf's arguments with Bennett (1917–28), Lawrence's hostility to Galsworthy (1928), Eliot's repudiation of Lawrence (1934), and Yeats's dismissal of Owen (1936), are only the high points of a continuous interchange that is recoverable in the correspondence, memoirs and reviews of the day. Any attempt, therefore, to abstract a pure modernism from its engagement with a deeply naturalised tradition must end in false polemic and exaggerated antithesis.

In fact, as the period recedes into perspective, its disagreements begin to acquire the air of a family quarrel. This sense of community has little to do with the influence of a metropolitan establishment of publishers and reviewers, with whom in fact most of the writers themselves entertained at best ambiguous relations. It owes much more to a sense of solidarity provoked by the growth of mass culture under the market exploitation of general literacy. Serious writers, whatever their provenance, took one another seriously because they shared a distaste for the trivialisation of the art they professed. In this respect the London careers of two men in particular, the novelist Ford Madox Ford (1873–1939) and the poet Ezra Pound (1885–1972), are exemplary. Both have been regarded as literary entrepreneurs of phenomenal flair and versatility, but they should also be thought of as literary missionaries.

Ford collaborated with Conrad on three novels, published a book in defence of James, was in communication with Galsworthy and Wells, promoted Joyce, and was in touch with almost every significant figure of his time. In 1908 he launched *The English Review* in explicit defence of standards against the commercialism of publishers ready to package every pot-boiler as a masterpiece. During the two short years of his editorship his sense of the integrity of the craft of letters made a measurable contribution to the renewal of iterature. Not only did he advance the prospects of much of the best contemporary writing, but he discovered and published a number of unknowns, including Wyndham Lewis, Norman Douglas and D.H. Lawrence.

Ezra Pound, who regarded Ford's criticism of his own work as 'the most vital' he had ever received, performed similar services in the field of poetry. Reaching England from America in 1908, he quickly acquired a distaste for the sub-romantic slackness of contemporary versifying. In a succession of manifestos advocating clarity, directness, precision and concreteness he

attempted, in Eliot's celebrated phrase, to purify the dialect of the tribe. As Yeats's secretary from 1913 he helped him achieve a harder and more vigorous idiom. As Eliot's supporter from 1914, when he discovered him as a poet, he provided a constant stimulus, culminating in his editing *The Waste Land* in 1921. As Joyce's unswerving promoter, he was instrumental in publishing *The Portrait of the Artist as a Young Man* in 1914 and parts of *Ulysses* in 1917.

In their tireless efforts on behalf of new writing and their campaign against complacency and dilettantism, Ford and Pound were both instigators and representatives of the dynamic of modernism in England. They permit the perception of a two-fold polarity in the literary practice of the period: a horizontal one in the dialectic between modernism and traditionalism, and a vertical one in the opposition between high and vulgar writing. Both these distinctions have a defining role in the discussion that follows.

Henry James and Arnold Bennett

The modern movement in England originated at the turn of the century, and not, as it is sometimes believed, in the historical fracture of the First World War. Its early growth was fostered by the scepticism of the Edwardian decade; the war did no more than to complete the ruin of the ideologies of progress that had sustained Victorian self-confidence. Of the four main novelists of the reign, James and Conrad respectively recognised and anticipated the War as the inevitable outcome of long-established national and economic rivalries, whereas their literary antagonists, Bennett and Wells, responded to it in mainly practical and patriotic terms. What distinguished these two pairs of writers from each other, however, was less their personal prescience than their artistic orientation. The former's conception of fiction possessed an international dimension better accommodated to a tragic view of history than the traditional meliorism favoured by the latter. An account of the emergence of English modernism must therefore begin with a literary dispute.

As a class, Edwardian intellectuals were adapting themselves to the moral disruption engendered by nineteenth-century science. The previous generation had been traumatised by it, and had produced, in the rise of scepticism, a number of atheists; their successors tended to adopt the less combative stance of agnosticism. A restrictive orthodoxy was of course still in place, but it had lost its automatic authority, and progressive minds increasingly felt it to be – to the dismay of such earlier imperialists as Kipling who everywhere saw signs of national disintegration – anachronistic and absurd. In the space vacated, as it were, by the Victorian God, two new pieties began to flourish: 'art' and 'life'. As Richard Ellmann, the literary historian, has noted, these ideas acquired a whole cluster of reverential names. Art became a 'sacred struggle', an 'epiphany', a 'transfiguration' (James, Joyce, Yeats); life 'the god Pan', 'rebirth', 'truth' (Forster, Lawrence, Bennett). The interpretation of these master-concepts determines the major disputes of the period, of which the differences between Henry James

(1843–1916) and Arnold Bennett (1867–1931) offer a representative example.

James regarded the sort of novel favoured by Bennett as belonging to a tradition of 'fluid pudding' which he attributed to Tolstoy and Dostoevsky. 'Form alone *takes*, and holds and preserves, substance' he wrote to Walpole in 1912. By 'form' he did not mean an imposed shape, but an intrinsic principle of organisation: 'Don't let anyone persuade you . . . that strenuous selection and comparison are not the very essence of art.' For him mere 'substance' was without significance: 'There is nothing so deplorable as a work of art with a *leak* in its interest; and there is no such leak of interest as through commonness of form.' This sense of the pointlessness, even the vulgarity, of what exists outside of, or escapes from, 'economy and architecture' is not unlike Sartre's well-known record of the randomness and contingency of an animated Parisian street after an afternoon spent in a darkened cinema.

For James, a novel is an intentional structure, which by that token justifies the selection and disposition of every detail. In his last letter to Wells (1915) he went even further: without the focus of an individual organising sensibility, life would not achieve the status of life:

I live, live intensely and am fed by life, and my value, whatever it be, is in my very kind of expression of that. Art *makes* life, makes interest, makes importance.

In a collection of essays significantly entitled *The Sense of Life* published in 1928, Bennett, looking back on James's refined Edwardian novels, offered a counter-diagnosis:

My doubt is whether he had actually much to say in a creative sense, that needed saying. I think he knew a lot about the life of one sort of people . . . and very little indeed about life in general. I think that in the fastidiousness of his taste, he rather repudiated life.

The main charge is not that James processed his material out of existence, but that the original material itself was inadequate.

Bennett attributed James's inadequacy to his detachment – to his lack of a country, of a wife, of a mistress. A new set of criteria for 'life' and 'art' is brought into play here. For James, the distinction between the two terms is abolished in the artist's dedication to an art understood as the interpretation of life, or, more precisely, as the conversion of mere existence into meaningful life. For Bennett, the distinction is maintained, since experience precedes writing, both logically and causally. This is not to say that he has no conception of art. Of Chekhov he wrote: 'As you read him you fancy that he must always have been saying to himself: "Life is good enough for me. I won't alter it. I will set it down as it is."' In this view the artist's task is subjection to what is perceived, and not the acquisition of perspectives; his duty is to filter out filters, his art to renounce art. At the level of language, the consequence for him is the refusal of rhetoric: Chekhov's 'climaxes are never strained; nothing is over-idealized, sentimentalized, etherialized; no part of the truth is left out, no part exaggerated'. James repudiated the 'disconnection of method from matter'; Bennett denounced the distortion of matter by method.

This dispute was only an early stage in what was to become the central controversy in European literary modernism, reaching its climax with the famous debate between Lukács and Adorno after the Second World War. Some of its implications for literary practice can be suggested by a comparison of Bennett's *The Old Wives' Tale* (1908) with James's *The Ambassadors* (1903).

Prompted by Maupassant's *Une Vie*, Bennett's novel relates the birth, life and death of two middle-class sisters from the Staffordshire Potteries, Constance and Sophia Baines. The first spends her entire life in the parental house, where she marries, is widowed, and brings up a son. The second elopes to Paris with a commercial traveller who marries her but after four spendthrift years deserts her. She remains in France to make a success of running a boarding-house, but after a quarter of a century she returns home to die.

A novel that covers a period of forty-five years (roughly from 1860 to 1906) by focusing on two lives cannot but convey the impression that living is a form of dying. And indeed for Bennett, who in this follows his cynical French predecessor, 'what life is' (the phrase forms the title of the final part of the novel) would appear to be the nothingness that we become. Yet in fact *The Old Wives' Tale* creates an almost continuous effect of solidity and substance; its preoccupation with the remorselessness of change does not enforce the conclusion that all is vanity. A closer look at an episode will show how this can be.

After her husband's desertion, Sophia collapses and is nursed back to health by an ageing *demi-mondaine*, the sentimental and feckless Madame Foucault. Left alone one afternoon during her convalescence, Sophia explores the flat of her benefactress and inspects, with all the disapproval of her Midlands upbringing, the tawdry ostentation of her bedroom. Then:

She peeped behind the screen, and all the horrible welter of a *cabinet de toilette* met her gaze: a repulsive medley of foul waters, stained vessels and cloths, brushes, sponges, powders, and pastes. Clothes were hung up in disorder on rough nails; among them she recognized a dressing-gown of Madame Foucault's, and, behind affairs of later date, the dazzling scarlet cloak in which she had first seen Madame Foucault, dilapidated now. So this was Madame Foucault's room! This was the bower from which that elegance emerged, the filth from which had sprung the mature blossom!

As it is presented to Sophia, Madame Foucault's career is an abbreviated rake's progress. On arriving in Paris, Sophia had seen in a fashionable restaurant a resplendent courtesan who, despite an 'excessive ripeness', had seemed to her the very image of metropolitan confidence. More recently, that vision had resolved itself into Madame Foucault, now fallen into an alternately querulous and simpering obesity, but incapable of relinquishing the graces of seductiveness. But now the last veil has fallen and the final truth is laid bare.

One might be tempted to think that Bennett is presenting Madame Foucault's brutal collapse as an anticipatory emblem of Sophia's own inevitable decline. Certainly the novel exempts no one from subjection to the universal law of dissolution, or from the measure of compassion this entails:

not even the instruments of its heroine's disillusionment – Madame Foucault and especially Gerald Scales (Sophia's husband) who shares her self-destructive levity and mendacity. Yet in one essential respect Sophia is quite different from these two: she is a realist. Not only does she suffer disillusionment, which they, as self-deceiving romantics, cannot; but, having done so, she proves that she can take it. In the passage above, her scrutiny of the green-room of life is remarkably unflinching; and the reason is that her gaze holds all the toughness of her provincial upbringing. She respects the value of money; she can distinguish between words and deeds; she knows that survival depends on pride, determination, competence. In the midst of all the meretriciousness of the Second Empire, shortly to be blown away by the cannonades of Sedan, she represents the solid, tenacious and unimpressionable virtues of her Burslem inheritance.

She also represents a good deal of the author of the novel. Bennett was of course himself brought up in the Potteries, and spent long periods in France, where he wrote much of *The Old Wives' Tale*. Like Sophia's, his realism rests on provincial foundations. His special achievement as a novelist was the density with which he documented every aspect of his characters' physical and moral environment. But it has also to be recognised that his realism is not transferable. His major novels, from *Anna of the Five Towns* (1902) to *Clayhanger* (1910), absolutely depend on their setting in that part of England which he has so internalised that it gives him the stability of perception to permit him to speak confidently of 'reality'.

Bennett's realism is only superficially a matter of knowledge; its true basis is continuity of identity. Once this has been secured, whatever role Bennett may have sought to play (and during his life he was variously hedonist, socialist, reporter, connoisseur, businessman, and intellectual), he knows where he is. Even the calamities of existence, whether sudden like the siege of Paris or gradual like the grindstone of mortality, become, in the logical sense, accidental. It is to this sense of self that *The Old Wives' Tale* finally owes its manifest weightiness; and to it too its representational artistry, for if you know who you are, you know what you see.

A necessary condition for subjective stability, then, is membership of a community felt to change less quickly than its individual members. What threatens such communities, however, is less change itself (which can act as a stimulus, as it undoubtedly did in the case of Spain and Ireland in the first part of the century) than one of the things that change can bring – internationalism. The traditional realist cannot preserve security without retaining boundaries. Henry James, whose youth was divided between New York and various European capitals, and who settled in England at the age of thirty-three, necessarily practised his art without Bennett's pre-existing certainties. In his three Edwardian novels, *The Wings of the Dove* (1902), *The Ambassadors* (1903), and *The Golden Bowl* (1904), there are two rival criteria of social reality, one associated with America, the other with Europe.

The Ambassadors, which will serve as our second example, exhibits this duality more directly than the other two. It concerns a middle-aged American editor, Lambert Strether, who comes to Europe to rescue a promising young businessman, Chadwick Newsome, from the seductions of old-world

hedonism. A tension is immediately established within and around the protagonist between the values of Woolett, Massachusetts and Paris, France. The ruling spirit of the first is Chad's mother, a formidable New England widow, whose absence from the scenario of the novel only intensifies the pressure exerted on the characters by her 'principles', the nature of which are never in the slightest doubt. The presiding genius of the second is Chad's French patroness, Madame de Vionnet, an unhappily married Catholic aristocrat, whose exquisite presence forms a counter-influence all the more compelling for the doubts it seems to evoke. Her essential inscrutability – a distillation of the ambivalent seductiveness of Europe and Paris – is Strether's main preoccupation, for it turns on the question of the truth of her relations with Chad.

Unlike Sophia's discoveries in *The Old Wives' Tale*, the independence of which is guaranteed by Bennett's narrative omniscience, Strether's discoveries derive their significance entirely from the perspective of his particular quest. The events of the novel are almost wholly presented through the mediation of his consciousness; and the reader is left to interpret Strether's actions much in the way in which Strether is left to interpret Madame de Vionnet's. The parallel in Bennett's novel between heroine and author yields in James's to the parallel between hero and reader, but the issue in question remains the same: the relationship of art and life. To structure, as James does, a plainly aesthetic text in terms of its protagonist's perceptions – that is, to blur the distinction between the author and his character – is to invite the reader to regard these perceptions as a form of art. Moreover, the fascination that Madame de Vionnet exerts over Strether is that in everything she does she seems to hold out the promise of life-as-art. It is from this complex of perspectives that Strether's – and the novel's – findings acquire their point.

As American ambassador, Strether represents the renunciations of rectitude. But for that very reason, he brings to Europe a starved sensibility; and as Paris begins to work its enchantment on him, he starts to question the fittingness of his embassy. For Mrs Newsome, 'life' is something her son must be protected from. But Strether soon finds himself singing a different tune: 'Live all you can', he tells one of Chad's friends; 'it's a mistake not to'. Now this is plainly not a recommendation of epicurean licence; he does not seek to abolish Woolett, but to challenge it at a comparable level. He has glimpsed in Madame de Vionnet's apparent capacity to reconcile spontaneity and artifice that life might be raised to the status of art without ceasing to be life. She has turned Chad from a raw youth into a poised connoisseur – although there are signs that what she may have in fact created is a future advertising magnate; so Strether increasingly convinces himself that she may have the viable alternative. If Mrs Newsome's strength entails the sacrifice of experience to morality, her rival seems to offer the redemption of experience by art.

The climactic scene of the novel finds Strether taking a solitary day-trip into the French countryside in search of the original landscape of an exquisite painting he had failed to purchase many years before. He discovers it, and spends an afternoon of undisturbed happiness, ending the day waiting for his

supper in a river-side pavilion from which he can contemplate a scene that lacks only an appropriate human centre to bring it to perfection. And it duly appears.

> What he saw was exactly the right thing – a boat advancing round the bend and containing a man who held the paddles and a lady, at the stern, with a pink parasol. It was suddenly as if these figures, or something like them, had been wanted in the picture, had been wanted more or less all day, and had now drifted into sight, with the slow current, on purpose to fill up the measure.

They approach, and Strether recognises Madame de Vionnet and Chad at precisely the same time as they recognise him. The idyll is instantly shattered on both sides, and as the parties hesitate whether to acknowledge each other, the moment comes home to Strether as 'quite horrible'. They rejoin each other of course – but only on the pretence, connived at by both sides and maintained with increasing implausibility as the evening wears on, that the river trip has been an innocent one.

 The violence of Strether's reaction is not due to moral outrage in the tradition of Woolett. As the framing of his discovery indicates, the coherence of his dream of unity has been broken into by its opposite – actuality in its guise of random accident. His idealism cannot survive the naked fact of his friends' adulterous liaison – or, more precisely, it can only be preserved by a charade of innocence in which Madame de Vionnet's original grace of performance contracts into the subterfuge of keeping up appearances. Like Bennett's Sophia, he has been admitted back-stage, but the conclusions are his own. Art and life have split apart, and the alternative to Woolett has collapsed.

 It is not to be supposed, however, that error has given way to truth, or romantic illusion to pragmatic fact, for the disintegration of the European view does not legitimate the American view. In his predicament, Strether is unable to relinquish either the ethical (against Madame de Vionnet) or the aesthetic (against Mrs Newsome). Hence there can be unity neither in his consciousness nor in the world it inhabits. As his final poignant interview with Madame de Vionnet reveals to him, it is the plain, artless sincerity of sexual passion, and not the guile of artifice, that unfits her for the redemptive role he has imposed on her. As a participant in 'life's feast' she is condemned to an incompleteness that is not less than Mrs Newsome's, though it is its opposite. But so is Strether, who can only continue to regret the loss of his vision of wholeness by remaining what he has always been – a spectator.

 The case for James as a progenitor of modernism has to be made on the basis of his valorisation of art. If the modernist predicament consists of the failure to find unity in subject or object, then art remains the sole locus of coherence. *The Ambassadors* defiantly presents itself as an aesthetic object. The endlessly syntactic virtuosity of its style is more than exhibitionistic; it is celebratory of the powers of art. But even this defence is inadequate. As a modernist text, *The Ambassadors* is not merely in a relation of *contrast* with Bennett's traditionalist novel, for James's ambition tries and fails to achieve what Bennett can only manage by lowering his sights. For all the social etiolation of his final works, James's commitment to art was not a withdrawal

into solipsistic aestheticism, but a demand that art should recover and raise the fullness of experience. But since it is art itself, and not the natural perception of a Bennett, that alone permits an adequate diagnosis of modern dissociation, it cannot by definition overcome it. All that the Edwardian James could do, as *The Wings of the Dove* and especially *The Golden Bowl*, with their supremely ambiguous conclusions, testify, was to create artistic affirmations of the limits of art. In this view, James is a modernist because he has not lost touch with Bennett.

Joseph Conrad

Modernism cannot be adequately explained solely in terms of an evolution within the arts. Literary mutation is an expression of and a response to large-scale changes in the human world. Whether or not, therefore, Conrad is a greater novelist than James, he must feature more prominently as a modernist, for history enters his work on a much larger scale. During his life, Conrad was exiled not once but twice: first in Poland as a citizen of a country which had been deprived of an independent constitution since 1815; then in England as an inhabitant of a country whose language he heard for the first time at the age of twenty-three. Thus he was uniquely exposed to the great Eastern and Western wings of European history. Moreover, as a master mariner in the British Merchant Service he was for over fifteen years in the vanguard of the final phase of European expansionism, from Latin America to the East Indies, and from Australia to the Belgian Congo. The consequences of this extraordinary range of experience were recognised by James himself, who wrote to him in 1906: 'No one has *known* – for intellectual use – the things you know.' What Conrad knew – what he had seen at first hand – was the emergence of the modern world.

To have led an active life before writing about it – he published his first novel at the age of thirty-seven – dispensed Conrad from having to articulate his modernism in works of art about the nature of art. He had, of course, a conception of narrative, partly derived from Flaubert, which was akin to James's, and which identified the same opponents. In a letter to Bennett written in 1902, he argued the case for the fictional treatment of a perceived, as opposed to an objective, reality: 'You stop just short of being absolutely real because you are faithful to your dogmas of realism.' But his novels did not turn on the question of the nature of art. To be sure, they are deeply preoccupied with the problems of the self, but in the context of its survival rather than its fulfilment, and of solidarity rather than culture. Nor are they set in the centre of the civilised world, but at its edges – the Far East, South America, Central Africa – or if in Western capitals like London and Geneva, then in the international underworld of those cities.

The covert interplay between order and adventure (to use Rimbaud's famous distinction) that seems characteristic of modernism in England can be discovered in Conrad's case in his complex response to imperialism. In the first place there can be little doubt that the exiled wanderer found a refuge, and even a home, in the imperialist ethic of conduct. The ideal of service,

especially of service at sea, with its commitment to a professional code, offered the conditions for self-respect; and his capacity to rise to them seemed to him, both at the time and retrospectively, the recovery of a dislocated life. But the very uncertainty that made him so responsive to the integrative possibilities of service made him hypersensitive to the distintegrative implications of what he served. As a politically dispossessed Pole he could not but notice the commercial interests that launched the ships he commanded; as an exiled traveller he could not but recognise the challenge to his own culture of the alien societies he encountered. This meant that the security offered by the code of service could only be sustained close up; a wider perspective revealed it as limited, a still wider one as illusory.

The case of Kipling (1865–1936), whose identification with Anglo-India made him feel something of a foreigner in England, provides an instructive contrast. He begins from a position not unlike Conrad's – that service on the frontier is preferable to self-seeking at the centre. But with his unusual incapacity for self-knowledge, he is quite unable to see the degree to which this commitment acts as a safeguard against inner incoherence. Too assertive to go all the way in recognising the otherness of societies different from his own, he does not distinguish between service and ideology. To be sure, much of his early work – especially *Plain Tales from the Hills* (1888) and *Barrack Room Balads* (1890) – memorably celebrates the unsung trials and deeds of the obscure agents of empire; and his most famous novel, *Kim* (1901), records a remarkably direct response to the teeming demotic life of India. But in the last resort he cannot concede that 'the law', which is the ideal form of the *Pax Britannica* – whatever it might learn from the subject nations, and however superior it might be to the complacencies of the little Englander – could legitimately be challenged. Even his most independent declaration, the famous 'Recessional', which chastises the pride of empire at the height of the 1897 Jubilee, does so not for the sake of the colonised, but in the name of the divinity 'Beneath whose awful Hand we hold / Dominion over palm and pine'. Obeisance to a God disposed to endorse one's leadership of the world is not a sufficient proof of humility.

Kipling is a very difficult writer to assess, not because his political views are often unacceptable (next to the Pound of the *Cantos*, whose assumed extremism is notorious, he looks like a moderate), but because the power and authenticity of his best work seem out of synchronisation with his intellectual capacities. The contradictions he exhibits seem designed to disable rational criticism. The most influential public poet of the century, he protected his privacy to the point almost of paranoia; the most intransigeantly positive of moralists, he was haunted by anxieties and insecurities; the most instantly affecting of writers, his art was constructed on a repudiation of the artistic life. But on the question of the ethic of work at least, as exemplified for instance by *Captains Courageous* (1897), in which a spoilt boy is turned into a man by the discipline of a New England trawler, he has none of the irony of self-awareness so characteristic of Conrad's treatment of this theme.

Not even Conrad's most affirmative tale, *The Nigger of the 'Narcissus'* (1897), fails to interrogate the code of service, which survives the hazards of a return voyage from Bombay – the tests of storm and calm – only on the basis

of a strict demarcation of sea ethics from land practice. But it is the largely autobiographical *Heart of Darkness* that first properly exhibits his modernism. This famous narrative opens with an evocation of the glory of England's maritime exploits. But this Kiplingesque mood (it is to all intents and purposes a distillation of Kipling's 'Song of the English') is quickly punctured by a reminder that only a slight shift in historical focus is needed to disclose the primitive origin of civilisation. The author of this unorthodox view, Marlow, then develops it in an account of his experience as captain of a river boat on Leopold's river Congo. As a good sailor he is committed to standards of professional efficiency, and he is appalled to discover the level of demoralisation of the invading whites, motivated as they are only by the determination to ransack the country. However, unlike a good sailor – in whom, as he says himself, landfalls awaken no curiosity – he is deeply responsive to the elemental reality of Africa; and his awareness of that context turns the colonial activities of Belgian trade into what he calls 'a fantastic invasion'. It brings home to him the relativity of his own culture; not only are European concepts, such as 'waging a war' or 'dispensing justice', incomprehensible to the native inhabitants; but the very foreignness of the new environment renders such ideas unreal to those allegedly in possession of them. The invaders are, of course, content with this state of affairs, for it is in their interest to retain moral norms that impose no restraints on them and which at the same time illegitimise the resistance of their victims.

These whites, who are epitomised in the Manager of the Central Station, represent a first wave of practical exploiters. A second wave has followed, this time of alleged idealists charged with the task of civilising the blacks. The most gifted of these, a legendary up-river agent called Kurtz, offers Marlow a last hope of redeeming the idea of civilisation which justifies his presence in Africa. Hearing that Kurtz has collapsed, he eagerly takes a rescue party up river, only to discover that the celebrated agent, far from being an emissary of light, has offered no resistance to the temptations of power, and has turned trade exploitation into terrorism.

The indictment of civilisation now seems complete. The Manager is a cynic who regards Kurtz's crimes as mere incompetence. Kurtz is an idealist only for reasons of self-magnification. And as for Marlow, his ethic of service inverts itself into a method of self-survival. The conclusion seems inevitable: Europe is an idea without foundation. However, in the narrative's famous reversal – the conversion of Kurtz from an agent of perdition to a figure of salvation – this catastrophic insight turns out to be the one positive idea Marlow is able to take out of the Congo. Kurtz's ultimate judgement on his own life – the phrase 'the horror' which he whispers at the point of death – is not a nihilistic verdict, for it implies that he has been at last able to bring a moral idea into actual contact with his life. The significance of this breach of self-deception is shown by Marlow's treatment of Kurtz's 'intended' when he returns to Belgium. Finding that her sincere idealism is sustained by the thought of Kurtz's moral fidelity, he must decide whether to tell her the truth and destroy the basis of her faith, or to deceive her and turn her (and his) convictions into illusions. By choosing the latter, he commits himself to the

extreme paradox that the truth of conduct depends on a lie. But he has no alternative, for in the world which he has discovered, and which is also Conrad's own world, there is no essence, only effort, no self, only conduct.

In this conclusion, Conrad shows himself to be closer to James than to Kipling. Kipling knows what 'England' is, and if she reveals herself to be untrue to herself, he is able to denounce her in the conviction that he is right. James has no comparable assurance. If in his last fictions he is obliged to dissolve authorial certainty into the relatives of points of view it is because the relationship of the constituents of high culture – the aesthetic and the ethical – remains ambiguous. For example, at the end of *The Golden Bowl* we are left uncertain as to whether Maggie Verver's masterly decorum in compelling the adulterous pair, who have betrayed her father and herself, to behave as if nothing had happened is a moral triumph or a moral sham. More severely tested than James, Conrad concludes not in ambiguity but in contradiction. He knows that a lie is a lie, that moral laws are conventions, that the origin of civilisation is a darkness, that consciousness is an irrelevance on the face of nature. But the very capacity to make these discoveries is evidence that they matter.

Since original truth, for Conrad, is no longer a presence, but can only be affirmed negatively, he too is driven to abandon narrative techniques aiming at direct expression. In presenting Marlow as a narrator he warns us that Marlow's stories, unlike the ordinary seaman's yarns, do not envelop an extractable kernel of meaning but make visible around themselves, like a street-light bringing out a haze, a meaning which would otherwise remain unperceived. Thus *Heart of Darkness* renders opaque and perceptible the fact of cultural relativity, which would otherwise have remained invisible to the eye of the inmates of civilisation. But since this fact is of supreme moral significance (*Heart of Darkness* exhibits the consequences of a failure to understand it) Marlow cannot remain a mere locus of consciousness. He is also plainly presented as a man speaking to men, and by that very fact reaffirms the solidarity which his narrative had shown to be groundless. Thus he is much more than a literary convenience; he represents Conrad's central conception of art not as self-expression but as a measurable contribution to a common cause. Rebutting the Kiplingesque philistinism that sees artists as 'long haired things . . . who talk about the Aims of Art, and "theories" and "goals"', he declares: 'It never occurs to him that a book is a deed, that the writing of it is an enterprise as much as the conquest of a colony.'

In his own way, then, Conrad is as much a 'master of suspicion' as those twin godfathers of ideological modernism, Marx and Freud, for his experience of imperialism persuades him of the inexhaustibility of man's capacity for self-deception. But it would be a mistake to divorce this deconstructive impulse from its contrary – the need for an identity that can be trusted. In Conrad, unmasking reveals weakness; but this brings him no comfort, for the human world, such as it is, relies everywhere on men's capacity for action.

In *Lord Jim* (1900) he produced a devastating critique of the idea of the self as private property. The code of sea service has been erected on the presumption of unreliability. Its purpose is to secure efficiency under

conditions of danger, and this it does by promoting the sense of honour – that is, by encouraging the internalising of public standards. The novel's protagonist, the young officer Jim, has neglected the difficulties of service in favour of its rewards – notably the image of heroism which his chosen career may indirectly confer. He has left himself exposed, and when an emergency strikes, he finds himself helpless before the recoil of panic, and abandons a ship-load of passengers to their fate. By so doing, he has fallen from idea into fact, and discovered the truth that what a man is is what he does. But the very intensity of his sense of loss makes it impossible for him to accept that he is finished. His posthumous existence, as it were, actually brings him to life; and his ensuing career, which turns into a relentless struggle to demonstrate that he is more than the consequences of his action, and which Marlow – who is here as much listener as narrator – prevents us from dismissing as mere evasiveness, is one of the most powerful affirmations of identity in modern fiction.

Conrad's modernism is not therefore merely the recognition of a loss of centre. His scepticism is covertly dependent on what it questions; and for all its brooding comfortlessness, his work strikes a positive, even an heroic, note. His demonstration of the relativity of individuals to one another does not entail a downgrading of the subjective. The reason why his two greatest novels, *Nostromo* (1904) and *The Secret Agent* (1907), break up the logical sequence of chronology is quite as much that they retain a focus on the individual subject as that they lose faith in historical progression. The first of these novels chronicles the re-installation of Western capitalism in a Latin American republic. This takes place through a succession of linked individual actions, the consequences of which at once escape the control of their initiators. But this does not permit us to conclude that history must be seen as the domain of abstract forces; on the contrary, it is driven by human projects, either individual or combined, under given conditions – material, social, religious, geographical, meteorological, etc. – and whatever ironies may attend their failure, their vitality provides the momentum, as their earnestness the poignancy, of the collective process. For example, the oppression that the success of Charles Gould's silver mine inflicts on the land is given its depth by the moral audacity of his individual undertaking.

Conrad owed his political astuteness both to his own multiple backgrounds, which allow him to question affirmations of partisan reality, and to his own survival, which prevents him from nullifying the individual perspective. In *The Secret Agent*, which concerns the obliteration of a petty-bourgeois London family implicated in the machinations of foreign extremists, he presents metropolitan life as a labyrinth of cross-purposes. But this only serves to intensify his vision of subjective suffering, which he never permits to decline into a mere item in the play of social determinants, but offers as an expression of the (objectively indefensible) importance of human relationships. For Conrad, as we have seen, the self is not merely something that belongs to the individual; it is also something that belongs to society. A social role is therefore necessary for the achievement of personal identity: yet it is also insufficient, for it has to be a role in which the individual can believe. How problematic such a double condition can be is demonstrated in the last of his

Edwardian novels, *Under Western Eyes* (1911). The most searching of his studies in human isolation, this work describes the predicament of a young Russian, Razumov, who is forced to spy for the Czarist authorities whom he loathes, on revolutionary *émigrés* whom he despises, and who is thereby condemned to a social role entirely devoid of personal content. His sense of identity is thus erased – a condition which he finds utterly intolerable. Hence he is driven to resurrect it in the only way he can – by confessing what he is. But this in turn deprives him of any possibility of social function, for he is instantly rejected by both sides. This is indeed an extreme case; yet in his handling of it Conrad shows that he regards it as an exemplary one. He makes his principal narrator a liberal rationalist, an upholder of English or 'Western' decencies, who, in his conviction that the private and the public are easily reconcilable, finds the behaviour of the young Easterner strictly unintelligible. What this narrator fails to perceive, ironically enough, is that Razumov's irrationality and extremism are an expression of how necessary it is to be able to reconcile rationally the private and the public. *Under Western Eyes* demonstrates that the defeat of reason only makes sense to those who are capable of reason, and – more generally – that the force of a transgression, even in revolutionary art, is parasitic on the law it breaks.

The novel of the condition of England

The Edwardian novel in its innovative forms exhibited a tension between international – largely French – influences and a deeply rooted native tradition. In the decade that followed (hereafter called, as the last able to bear the name of its monarch, the Georgian decade) British participation in the European conflict of 1914–18 greatly intensified the pressure on native insularity. This had two effects on literary production. At the popular level it provoked a sudden access of jingoism and xenophobia. At the level of self-conscious writing in the 'English' style, it rendered the new emphasis on the idea of 'England' as a literary theme (a preoccupation as characteristic of the Georgians as the idea of 'life' had been of the Edwardians) increasingly problematic.

As a genre, the 'condition of England' novel was a creation of high Victorianism. Figures like Disraeli, Dickens, Kingsley, and George Eliot offered, in the name of a return to health, a fictional diagnosis in the realistic mode of the moral and social diseases caught by the body politic from rampant industrialism and commercialism. The development of this genre through the Georgian decade can be mapped in four representative texts: H. G. Wells's *Tono-Bungay* (1909), E. M. Forster's *Howard's End* (1910), D. H. Lawrence's *Women in Love* (written 1916–17, published 1920), and Ford Madox Ford's *Parade's End* (1924–8). Only the first and last were deliberately conceived within the terms of the genre, yet all four exhibit striking resemblances. All rely on the country house as a central symbol; all are at least initially cast in the socio-realist mode; all confront modernity as a historical crisis; all reject high art as a justification of life; and despite the

divergence of their professed politics (Wells was a socialist technocrat, Forster a liberal humanist, Lawrence an utopian vitalist, and Ford a *noblesse-oblige* conservative), all four are preoccupied with the question of the survival of the English national tradition.

H. G. Wells

By the time he was writing *Tono-Bungay*, Wells had produced a number of minatory scientific romances and realistic comedies of self-improvement. The new novel was a synthesis of both. Designed as a 'social panorama', it describes the rise and fall of a parvenu entrepreneur, Edward Ponderevo, who makes a flash fortune by marketing a patent medicine. Its narrative form is that of the autobiographical record – here of Edward's nephew George who from humble beginnings discovers, as he makes his way through opportunistic commercialism and transitory sexual liaisons, his true vocation as an engineer in the new military technology.

This structure gives Wells ample room in which to display his documentary genius. His terms of reference are the traditional hierarchy of Bladesover (the country house in which George has been brought up) and the headlong adventurism of the commodity market. Wells sees modern England as a random juxtaposition of obsolescence and profiteering, imaged in the urban architecture of the capital, an endlessly chaotic palimpsest of old and new. Bladesover represents, politically, the constitutional settlement of 1688: 'it was then that the broad lines of the English system set firmly'. But in its failure to adapt, it has been quite unable to control the economic acceleration of the previous hundred years, which now has the ungovernable morbidity of a 'cancerous growth'. Not even the private life is exempt from the effects of this disorder. The test case for George is his affair with Beatrice Normandy, an upper-class acquaintance from his Bladesover days, whom he meets again in adult life, and who shows him that love itself, 'like everything else in this immense process of social disorganisation in which we live, is . . . a fruitless thing broken away from its connections'.

What distinguishes Wells's anatomy of England from its Victorian models is its extremism, in which an anticipatory tremor of the earthquake to come can be sensed. His representation of England as a senseless apposition of surface frenzy and depth inanition suggests a terminal case, and thus inevitably leads his initially mimetic mode into symbolic regions. Edward Ponderevo's megalomania is plainly a figure of England's condition. For example, in an episode in which Wells draws on *Heart of Darkness*, Edward tries to shore up his collapsing fortune by abducting a cargo of 'quap' from West Africa. This sinister radioactive material, which destroys the ship that carries it, is an emblem of the principle of decay-as-growth that Wells identifies as England's malady. Nor does the case seem to him to be curable. In the novel's concluding scene, George takes a destroyer designed and constructed by himself on a test run down the Thames past the outstretched confusion of the city into the open sea. The intransigent beauty of this machine, the product of an impersonal effort that cuts clean through the clutter of private and political entanglements, constitutes a futurist manifesto

that accepts destruction, even of decaying England if need be, as the means to a new, purified, non-humanitarian reality.

E. M. Forster

Such a close can only be taken as a symptom of the ills to which it responds, for it is morally and politically vacuous. By contrast, *Howards End* seems to be, in its reticence, an altogether more responsible novel. Like Wells, Forster (1879–1970) sees the idea of England as being under challenge by a new entrepreneurial class. England is represented in a country house, the ownership of which provides the motive of the plot. But in *Howards End* the business class is accepted as a constructive element in the social fabric, and the symbolic building is a modest farm-house still in touch with the rural yeomanry. Furthermore, the novel's social range is confined to the middle classes – the Schlegel sisters, Margaret and Helen, the daughters of a civilised *émigré* from Bismarck's Germany, and the Wilcox family, public-school activists in the city or the colonial service who now run the country. The passionately idealistic Helen repudiates the Wilcoxes for their male complacency and materialism, while the Wilcox sons, Charles and Paul, find the Schlegels hysterical and affected. Forster too seems to develop a distintegrative opposition, here between the inner and the outer life, and seems to find analogous consequences in metropolitan rootlessness – the 'civilization of luggage'.

Howards End, however, is a novel of reconciliation. Its heroine, Margaret, recognises that the life she leads, with its emphasis on the sanctity of human relationships, is guaranteed by the wealth-generating classes. In the novel's over-famous slogan, she is able imaginatively to 'connect'; and so she marries the widowed head of the Wilcox family, Henry. But if this symbolic union is to survive, Henry too must make a connection for himself: that between the privileged and the deprived. Forster's earlier novels had consistently protested against the effects of the tunnel-vision known as respectability. This motif returns at the crisis of *Howards End* in the form of sexual transgressions: Helen's with the unemployed clerk, Leonard Bast, and Henry's with Bast's disreputable wife, Jacky. When confronted by Margaret for spurning her sister for the very lapse of which he has been guilty, Henry refuses to admit the correspondence. But this indirectly provokes the public disgrace of his son and his own emotional collapse. He ends by being committed to the protective care of his wife; and it is not the least irony of the novel that feminine imaginativeness proves more durable than masculine assertiveness.

To be sure, the idea of connectedness implies the idea of wholeness. Yet to what extent can a narrative focused on the sanctity of private relations be said to be about England? By providing the Schlegel sisters with German relatives and contacts, Forster is able to introduce a rival national perspective. Its main effect in the novel is to sharpen the perception of things English. German visitors provoke a variety of patriotic responses, from pride in England's imperial integrity to rapture over English landscapes. Margaret, who cares for culture at the point where it becomes morality, recoils from the

heroic abstraction of German thought into a new appreciation of the interdependence of values and particulars. For her the spirit, national or individual, needs a body and a home; and this is precisely what 'Howards End' – the house – provides, for it embodies the unaggressive continuities of English life. The masterful new men may own it legally, but its true possessor is the first Mrs Wilcox, whose reverence for the past enriches the present. Recognising before her death her spiritual kinship with Margaret, she has wished to leave the house to her; and because Margaret recognises its reconciling properties she must, and does, inherit it in the end.

Yet for all the apparent harmony of its close, *Howards End* does not escape the national anxieties of the run-up to the First World War. For no less than *Tono-Bungay* it offers a resolution that is in some measure sub-rational. If Margaret finally enters into her inheritance, it is not through any effort or even desire on her part, but through the agency of a sort of providential England working in accident and coincidence and preserved at 'Howards End' by a clairvoyant housekeeper. In a mimetic narrative – that is, one that offers itself as a normal depiction of life – recourse to such devices is a symptom of the difficulties under which even the most liberal conceptions of England are beginning to labour.

D. H. Lawrence

Judged by Bennett's standards of representation, neither Wells nor Forster are able to produce a seamless realism. The strains become apparent precisely at the point at which they try to close their novels; it is as if what they are dealing with – the 'matter of England' – is beginning to prove resistant to unifying procedures. But whatever irregularities traditional form exhibits in the pre-war period, they can scarcely be compared to the contortions it has to endure in a text like *Women in Love*, which was written in the darkest years of the War.

Yet no simple correlation of cause and effect can be established. D. H. Lawrence (1885–1930) had evolved his new method by May 1914, the date on which he completed the third draft of *The Rainbow* – a novel conceived as the first of a two-part work, the second finally turning into *Women in Love*. This new method was designed to radicalise received form. Just as *The Rainbow* subverted the family chronicle as practised, for example, by John Galsworthy, so *Women in Love* denaturalised the novel-of-England genre. Lawrence had read and admired both *Tono-Bungay* and *Howards End*, and his own version contains more than a trace of the paradigm. It has a pre-war setting; it foregrounds an industrialist family living in a country house in the Midlands; it entrusts the diagnostic point-of-view to the protagonist; it deploys even more brilliantly, if more intermittently, mimetic observation of a social cross-section, from a coal-mining village to a great liberal household, and from the provincial petty-bourgeoisie to metropolitan bohemia; and it even concludes by taking its action abroad, to the Austrian Alps. Yet so extreme is Lawrence's rewriting of the form that it is not easy to recognise the social novel in *Women in Love*.

Like his late Edwardian predecessors, Lawrence registered modernity as a

D. H. Lawrence's drawing of The Rainbow *(1915)*.

tightening of the tension between the private and the public; but unlike them he located the conflict in the unconscious. It would be tempting but mistaken to regard the author of *Sons and Lovers* (1913), with its Oedipal theme, as some sort of Freudian. For Lawrence, the self has a centre, which is the subjective life of the body, and a circumference, which is the outgoing life of the mind. The first establishes the self in the order of organic and animal nature; but it is of course dependent on the second, which can construct an artificial order or false consciousness repressive of nature – or, alternatively, can envisage a human world sustained and nourished by nature.

In such a view, sexual experience clearly has a determinant role; but it remains a source of potential difficulties, for it depends on an equipoise between the claims of the self or body, and of the circumference or mind: fear of the mind will produce claustrophobic fixation; fear of the body vertiginous over-activity. In short, self-fulfilment, for women as for men, requires both love and vocation, both the private and the public. Thus the difference between Lawrence's pre-war and wartime novels lies in the fact that while both dimensions ('night' and 'day', the 'vertical' and the 'horizontal', etc.) are available to *The Rainbow*, the latter dimension has ceased to be a possibility for *Women in Love*. *Women in Love* is a social novel in which social fulfilment has been abolished.

Lawrence's war novel is one in which the world preceding the war is understood in terms of the hindsight provided by the war. For Lawrence, 1914 was the subsidence of twenty centuries of civilisation into collective carnage, and he explored the moral and ideological implications of this view more uncompromisingly than any other writer of his time. He called into question the entire system of ideals on which Europe had been built up, and he showed up all participants in the conflict as equally complicit in the act of self-destruction. But since both sides manifestly believed themselves to be in the right, he was obliged to conduct the analysis represented by his novel in terms of unconscious motives, that is, of self-deception and neurosis. The governing principle of *Women in Love* is expressed in one of the many denunciations of humanity launched by its protagonist, Rupert Birkin:

And they say that love is the greatest thing; they persist in *saying* this, the foul liars, and just look at what they do! . . . they maintain a lie, and so they run amok at last.

Professed intentions are catastrophically contradicted by active intentions.

The malaise at the heart of the pre-war English establishment is shown in the fate of the family of the industrial magnates, father and son, who play a representative part in the novel. Thomas Crich, a second-generation mine owner, adopts a stance of sentimental paternalism towards the workers he continues to exploit. When this inconsistency finally produces a series of strikes, he gives up, and managerial control passes to his son Gerald who, obliged to replace the old ethic of benevolence with a new ethic of functional efficiency, ruthlessly rationalises the mines. Yet precisely as productivity improves, so does the family disintegrate. The mother is driven mad; the father sinks into a repulsive death; a sister is drowned, taking her rescuer with her; and Gerald himself, who as a boy had accidentally killed a younger brother, ends by committing suicide. Lawrence's treatment of England's

business class may not differ in kind from Forster's, but it most certainly does in degree.

There is a strange collaboration of energy with destructiveness in Gerald, the cause of which Lawrence finds in the area of sexual relations, where the balance of body and mind is most at risk. The narrative of the novel, which is consistently episodic, is organised around the erotic experiences of two couples: Birkin and Ursula Brangwen, a school-mistress, and Gerald and Ursula's sister Gudrun, an artist–teacher. Neither couple can escape the historical process of dissolution; the difference between them is that the first is aware of this process while the second is not. Gerald is given a full history (he has even fought in the Boer War and explored the Amazon) by which he seems determined; the only thing we know about Birkin is that he is an inspector of schools. He is less fixed in the system; his commitment to some idea of the organic life distances him yet further from what he calls the (social) 'life that belongs to death'. We encounter him as he is in the process of detaching himself from the aristocratic Hermione Roddice, whose pose of spiritual altruism veils an unbending will-to-power, and of failing to attach himself to the masculine Gerald, who has no convictions beyond serving the productive system.

When Birkin meets Ursula, he has completely repudiated traditional humanism, and sunk into a misanthropy that is at once negative and positive – a symptom of but also a reaction against the prevailing disintegration. She resists him, and their struggle towards relationship centres on whether or not the compromised vocabulary of value is recuperable. They are at last able to restore an acceptable meaning to the word 'love', in the inter-dependence of their feelings for each other; and they owe this to the acknowledgement of the impersonal order of nature, in which decay, 'the dark river of dissolution', is part of growth, 'the silver river of life'. But this remains a precarious achievement, for a couple is not yet a community, nor does this new 'love' extend to the idea of friendship.

The second pair, Gerald and Gudrun, have no such resources against the current of dissolution. Gudrun's advocacy of contemporary art, as her eventual alliance with the sculptor Loerke indicates, is a commitment to the abstract mental world. Gerald's submission to the industrial machine is even more drastic, for it contributes to the construction of the artificial social world. Nor does their repression of the elemental self cancel its claims; it only destabilises and perverts them. The subjective body, demoted to a condition of instrumentality, becomes the site of exasperated sensation, and pleasure is transformed into cruelty. The lovers are drawn into sado-masochistic intimacy – notably through two incidents in which Gerald viciously masters two terrified animals – and they cannot free themselves from an addictive spiral of gratification through punishment. They couple ever more frantically over a void, and when Gudrun finally turns against Gerald, the latent violence is released. Like Hermione, who closed her affair with Birkin by a murderous assault on him, Gerald in a convulsion of self-release tries to strangle his mistress, and when he is checked, lapses away to his destruction in the Alpine snows. Lawrence's image of the ultimate decadence of the West ends in a revelatory image of a vast abstract landscape in which life has no place.

Women in Love enacts the death-throes of England as a constituent part of the civilisation of Europe. In so doing it becomes the only novel rooted in the native tradition to achieve the full status of a modernist text. In its efforts to render the psycho-sexual fate of its representative characters, it buckles and distorts its mimetic surface in all manner of metaphorical, symbolic, ritualistic and mythological ways. Yet Lawrence, by choosing to write a novel of social analysis in which every institutional alternative – government, industry, labour, education, art – is ruled out as irremediably compromised, cannot do without the constraints of the received form, for the tensions and ruptures that his constant adherence to these constraints produce make it possible for him to transmit something of the magnitude of the war that shadowed his writing.

Ford Madox Ford

But even apocalypse becomes retrospective. The creation of large-scale literary works seems to require the psychological space provided by at least some belief in the future; but it is perhaps when a historical catastrophe has become the past that it qualifies for artistic treatment. Ford's tetralogy, *Parade's End*, which brings to fulfilment this novel-of-England sequence by placing the War in the centre of the picture, was written and published in the twenties. It differs from its predecessors in that the opposition it explores is not between equal characters or groupings of characters, but between one man and a corrupt system, and in that the corruption with which it is concerned is not an economic but an administrative one. Furthermore its protagonist is not a modern type – new technologist, emancipated woman, adversarial prophet, as in the previous three novels – but an anachronism. Christopher Tietjens is a feudal landowner from Yorkshire with the mind of a polymath and the temperament of a saint, and a Tory whose traditions hark back at least to eighteenth-century, or perhaps Burkeian, codes of honour. Yet there is nothing anachronistic about Ford's novel. He had a more extensive knowledge of English life than any of his predecessors, Wells included. An earlier masterpiece *The Good Soldier* (1915) had shown how deeply he could see beneath the surface of Edwardian decorum; and he knew personally a number of public figures, including C. F. Masterman, the cabinet minister portrayed as Waterhouse in *Parade's End*, and the author of the celebrated survey entitled *The Condition of England* (1909), which set the pace for the fictional genre. He was alone, too, in defining his project as 'the public record of a decade'.

The advantage of a ruling-class protagonist in civil and military office is that his affairs involve him directly in a social spectrum that includes members of parliament, Whitehall officials, military staff, affluent socialites, the intellectual elite and the landed gentry – not to speak of the lower ranks and orders. This means that the characters of the novel do not so much signify as *constitute* society. To be sure, Tietjens's story, which follows the transference of his allegiance from his wife Sylvia, a neurotically promiscuous and possessive fashionable beauty, to Valentine Wallop, an impoverished suffragette from an academic and artistic background, has a central thematic

relevance; but it remains wholly integrated in the representational complex of the work.

Ford's innovations, therefore, are achieved not against but with the grain of traditional realism. He has to do simultaneous justice both to historical scale and to subjective intimacy. To that end he adapts a method, originally evolved during his association with Conrad, which he calls 'impressionistic'. This requires the steady elaboration (or *'progression d'effet'*), in terms of individual perception and internal monologue, of a long scene constituting a historical moment. The first volume of the tetralogy, *Some Do Not . . .* (1924), is divided into two such scenes: an Edwardian weekend in Sussex in July 1916, where Tietjens, having agreed to keep Sylvia's adultery from public knowledge, meets Valentine; and a last day of leave in London in August 1916, when he decides against embarking on a sexual liaison with her. The second volume, *No More Parades* (1925), concerns three days behind the lines in early 1917, initially in a base depot where one of his men is killed, then in a Rouen hotel where Sylvia vindictively gets him transferred to the front. The third, *A Man Could Stand Up* (1926), begins and ends on armistice day in London when he and Valentine commit themselves to each other, but locates its central part in the trenches 'several months before' where Tietjens's company is withstanding one of the late German offensives. The final volume, *Last Post* (1928), set in the summer of 1920, discovers Tietjens turned furniture-restorer in the country with Valentine, who carries his child.

Ford's great achievement is the presentation of history and experience as a single process. To take one example only: in *No More Parades* one of Tietjens's men, nicknamed O Nine Morgan, is blown up in front of him. This is an instance of horrific violence, but it is much more than that. Morgan is killed because Tietjens, who identifies with his subaltern's anxiety about his own wife's conduct, has protectively denied him leave. The man's fate is involved in the officer's predicament, both suffering the double stress of presence in France and absence from home. Furthermore, Tietjens's exhausted response to this fatality is inextricably bound up with his obsessive worry, as relentless as the crash of the guns, over the incompetence of alcoholic officers, the break-down of communications and supplies, and the strategic confusion of the overall conduct of the war. His experience of the war directly connects his shock at Morgan's death to his suspicion of the rival machinations of England and France.

Such individual cross-sections of historical time achieve a notable density of inter-linked detail, and their accumulation creates a powerful sense of historical progression. Ford's vision of change is ultimately moral rather than political, for he believes that a community is held together by integrity of service rather than by structural reform; but his treatment of his protagonist reveals the seriousness of this view. Throughout the long narrative, Tietjens is subjected to the most unrestrained and unremitting persecution. A man of complete probity and competence, he is slandered, traduced, insulted, exploited and victimised without making the least attempt to defend himself. His is not a case of paranoia or masochism, for even during the worst of his war experiences he is able to retain contact with his English roots, keeping

hold of himself by writing a sonnet or imagining the peace of George Herbert's parsonage. Nor can his passivity be accounted for by the self-sufficiency of honour, for he suffers atrociously.

The explanation must be sought in his relationship with his wife, who is the most active of his tormentors. The more she owes to his kindness, the worse she behaves; the stronger her aggressiveness, the steadier his forbearance. Their marriage is a contest between her malice and his patience; and it is given so searching and sustained a treatment that it acquires representative status as the conflict between the old England and the new. Tietjens is the guardian of his country's moral tradition; and his obstinate, Quixotic affirmation of it against countrymen turning before his eyes into manipulators, opportunists and profiteers only serves to madden them. Thus his decision, timed to coincide with the ending of the war, to relinquish Sylvia in favour of Valentine, cannot be taken merely as opting for decency and trust. It is also a defeat, for it signals England's final separation from her chivalric past. Private happiness in a rural setting is of course a real form of individual survival. But when it requires the repudiation of 'Groby' – the Tietjens ancestral estate left in the hands of mercenary Americans – or even the selling of English antiques to foreign tourists, it marks the arrival of a lesser life. Ford's novel brings this particular phase of English fiction to a fitting close, for it contains an elegy on the passing of the conscience of England.

Georgian poetry

The best native poetry of the Georgian decade, which should not be identified too closely with the literary taste of Edward Marsh, the editor of the popular 'Georgian Anthologies', is, like the fiction of the period, caught in the interplay of traditionalism and modernism. In poetry the modernist challenge was first registered in the nineties, in the work of the members of the so-called Rhymers' Club (W. B. Yeats, Ernest Dowson, Lionel Johnson and Arthur Symons) who under the influence of the *symboliste* poets of France sought to restore meaning to the desacralised world of materialist science. If meaning could not be found in reality outside the self, it had to be projected into it. They developed an aesthetic of autonomous artifice that drove a wedge between art and nature; and they prized the musical suggestiveness of language for its power of evoking subjective impressions and occult insights. In contrast, the poets of the Edwardian decade (Rudyard Kipling, G. K. Chesterton, John Masefield) promoted the cult of a healthy manliness in narrative, humorous or patriotic verse, and looked back with contempt on the 'decadence' of their predecessors. There had been non-conformists, such as the exponents of the simple style, A. E. Housman, in his *Shropshire Lad* (1896), and Walter de la Mare in his *The Listeners* (1912). But it was the Georgian movement that presented them with the real challenge.

Its manifesto can be found in Edward Thomas's review of Robert Frost's collection, *North of Boston* (1914), which scrupulously celebrates rural life in New England. Thomas praises Frost for rejecting 'the exaggeration of

rhetoric' and the temptation of 'poetical words and forms', and for avoiding metrical 'pomp and sweetness' (Yeats) and 'discord and fuss' (Pound). Instead, he finds in him 'a calm eagerness of emotion' and 'the postures which the voice assumes in the most expressive intimate speech'. For all its unobtrusiveness, this review represents a revolutionary programme, for it renounces fashionable practice; but it also affirms a traditional task, for it proposes to renew the old Romantic reconciliation of the natural and the artificial.

One of the most characteristic aspects of English culture is that any celebration of an 'essential' England takes a pastoral form. Urbanisation is felt to be an excrescence and a disease. To the French poet, Paris is the queen of the republic; to the English poet, London becomes the great wen. In England, paradise is never artificial but always a garden, and an unregimented one at that. Any linguistic return, like Edward Thomas's, to the colloquial, the conversational and the vernacular, as against the magniloquent and the constructed, entails a return to a local environment. The dialectal wealth of one of Thomas's most ambitious poems, 'Lob', which he casts in unchiselled Chaucerian couplets, is quite inseparable from the history, landscapes, folklore and inhabitants of the South Country. So the first fruit of his vernacular poetics must be a distilled patriotism.

It now seems as if Edward Thomas (1878–1917), who wrote no poetry before the age of thirty-six, was awakened to his true vocation as much by the advent of war as the example of Frost. Certainly such idylls as 'Haymaking' and 'The Manor Farm' with their fusion of historical and mental landscape, evoke an image of England that is intensely poignant.

> Under the heavens that know not what years be
> The men, the beasts, the trees, the implements
> Uttered even what they will in times far hence –
> All of us gone out of the reach of change –
> Immortal in a picture of an old grange.

To him the war was not the chance of an escape from a damaged self, as for Rupert Brooke, but the release of a suppressed self. In 'This is no Case of Petty Right and Wrong', he defines his commitment to his country as a sort of gratitude of being – the reverse of public jingoism: 'as we love ourselves we hate her foe'. But this love, which includes death (as it did literally in his case), is fraught with incompletion. Thomas's countryside offers no refuge or recreation. In his evocation of scenes felt to be immemorial, the self is dispersed in time, and the very exactness of the perception defines a nature always out of reach. Poems like 'The Unknown Bird', 'Liberty', 'October' and 'Old Man' exquisitely enact in their searchingly hesitant phrases the sundering life of consciousness. And this is a condition he accepts for what it is: 'I am still half in love with pain, / With what is imperfect . . .' Such a stance is not inadequate to the experience of war. Thomas had no time to write of life in the trenches, but he saw how war breached the continuities of life at home. In one of his later poems, 'As the Team's Head Brass', a few words exchanged with the sole ploughman spared by conscription reveal not only the deprivation of the countryside but its enduring resilience. Thomas's conduct of the low-key narrative characteristically turns it into an instrument

able to trace natural recurrence in the circuit of the plough, the cycle of the seasons and the renewal of generations, and historical irreversibility in the emptiness produced by the distant catastrophe: '. . . Everything / Would have been different. For it would have been / A different world.' The sense of disrupted continuity is perfectly caught in the poem's concluding lines:

> . . . Then
> The lovers came out of the wood again:
> The horses started and for the last time
> I watched the clods crumble and topple over
> After the ploughshare and the stumbling team.

The most talented English poets of the decade, all of whom were killed on the battlefield, found that the experience of war did not destroy their pastoral inheritance, but transformed it. By the time Isaac Rosenberg (1890–1918) had enlisted, he was already in possession of a distinctive poetic method in which Georgianism had been sophisticated by Hebraic mythology and Slade School aesthetics. As a private he was not allowed the licence of protest available to such officers as Sassoon; but he is unlikely to have felt the prohibition, for his primary concern was exploration and definition. This he pursued through an entirely original use of the idea of nature. In 'Dead Man's Dump', for example, he confers a cosmic resonance on a heap of corpses, through the symbol of the 'Maniac Earth' that, like a Goya monster, swallows its own children; or he inverts a standard pastoral motif into the diction of death: '. . . when the swift iron burning bee / Drained the wild honey of their youth'. Or again, in 'Returning we Hear the Larks' the context of combat ('Death could drop from the dark / As easily as song . . .') turns a Georgian cliché into an expression of unbearable ecstasy. And in his most famous poem, a soldier's simple pastoral gesture – plucking from the edge of the trench above him a scarlet poppy to put behind his ear – becomes perhaps the subtlest statement in the literature of the First World War of the provisionality of individual safety.

> *Break of Day in the Trenches*
>
> The darkness crumbles away –
> It is the same old druid Time as ever.
> Only a live thing leaps my hand –
> A queer sardonic rat –
> As I pull the parapet's poppy
> To stick behind my ear.
> Droll rat, they would shoot you if they knew
> Your cosmopolitan sympathies
> (And God knows what antipathies).
> Now you have touched this English hand
> You will do the same to a German –
> Soon, no doubt, if it be your pleasure
> To cross the sleeping green between.
> It seems you inwardly grin as you pass
> Strong eyes, fine limbs, haughty athletes
> Less chanced than you for life,
> Bonds to the whims of murder,

Sprawled in the bowels of the earth,
The torn fields of France.
What do you see in our eyes
At the shrieking iron and flame
Hurled through still heavens?
What quaver – what heart aghast?
Poppies whose roots are in man's veins
Drop, and are ever dropping;
But mine in my ear is safe,
Just a little white with the dust.

Rosenberg is the most original of the trench poets. Wilfred Owen (1893–1918) was less qualified in his adherence to the Georgian tradition when he entered the war, and as a result the war changed his poetry more drastically. The moral outrage provoked by its realities found expression in a systematic inversion of the old heroic positives (whatever dying for one's country might be, it was not 'dulce et decorum'), and a redeployment of Keatsian sensuousness to describe mutilation and madness. Yet the celebration of physical delight in such pre-war verses as 'From my Diary, July 1914' is not merely negated by later poems like 'Greater Love'; the energies of romantic love are transformed into a kind of sacrificial eroticism. Owen's commitment to the young men under his command has a deeper source than moral conscience, though it is that too; it answers an emotional need and the promise of experience. In the ironically entitled 'Arms and the Boy', for example, which is certainly anti-epical, the real perversion of giving the boy 'cartridges with fine zinc teeth' is not the violation of a moral principle, but the fact that '*his* teeth seem for laughing round an apple'.

For Owen the war is finally unnatural because it simultaneously awakens and cancels a natural feeling in him. This is ultimately a feeling of intimate alliance and secret identification. In 'Miners', one of his best poems, the 'poor lads' who, like miners on the coal-face, toil unknown in the trenches and whose death will be forgotten by the future, moves him to a tenderness of grief that constitutes a lament for lost fellowship. And in his masterpiece, 'Futility', the pain of a soldier's death once again demands for its expression the language of nature ('Gently its touch awoke him once, / At home, whispering of fields unsown'), but now amplified to encompass both the event, and the poet's own response to it, as an arrest of the whole of creation:

Are limbs so dear-achieved, are sides
Full-nerved, — still warm, — too hard to stir?
Was it for this the clay grew tall?
— O what made fatuous sunbeams toil
To break earth's sleep at all?

The reduction of the Georgian tradition to the status of album-fodder is one of the less successful accomplishments of modern criticism. These poets show the tradition to possess a strength and adaptability capable of confronting the worst experience that the period under survey had to offer. Their extinction on the fields of France had incalculable consequences for the subsequent practice of English poetry.

Thomas Hardy and Ezra Pound

Thomas Hardy (1840–1928), a Victorian novelist who published the first of his twelve volumes of poetry in 1898, and Ezra Pound (1885–1972), an American student of Romance languages who led the London avant-garde from 1908 to 1920, would seem to have nothing in common but their longevity. Indeed, the dogged individualistic regionalism of the first and the iconoclastic polyglot cosmopolitanism of the second locates them at the opposite poles of the traditionalist–modernist antithesis. Yet the fact is that Pound held Hardy in a respect bordering on veneration. His retrospective verdict was, quite simply: 'No one has taught me anything about writing since Thomas Hardy died.' Of *Poems 1912–14*, the sequence written by Hardy after the death of his first wife, he wrote that they 'lift him to his apex . . . all good, and enough for a lifetime'; and early in 1921 he sent Hardy *Hugh Selwyn Mauberley*, his own sequence valedictory of his English life. It has been the argument of this survey that tradition and experiment are not in a relationship of contrariety. Just as the poetry of England revealed a capacity for development under the impact of the war, so the international modernists were drawn to centres of established culture. Hardy's comments on *Mauberley* drew the following response from Pound: 'I come from an American suburb . . . The suburb has no roots, no centre of life'. Hardy seemed to offer a necessary image of accommodated man.

Yet to judge by *Poems 1912–14*, which forms the central section of *Satires of Circumstance* (1914), Hardy is the poet of division and loss, not of unity of being. This is not only because the eighteen poems are elegies, but because they offer no consolation. They confront his wife's death as absolute extinction:

> Yet abides the fact, indeed, the same –
> You are past love, praise, indifference, blame.

The dead survive only in the memory of the living, and memory itself erodes and fails, as the poet himself knows:

> . . . my sand is sinking
> And I shall traverse old love's domain
> Never again.

Hardy's intellectual predicament was characteristic of late Victorianism. His acceptance of the positivism of the philosopher Auguste Comte had deprived him of his religious faith without depriving him of his religious needs. In one of his rare statements of artistic principle, he assigned to 'the interfusing effect of poetry' the role of mediating between 'religion' and 'complete rationality'. But this role has nothing to do with the immortalisation that poetry can confer. On the contrary, he uses every artistic resource to dispel the impression that art may be rearranging or interfering with the honesty of felt experience. Range of location, irregularity of diction and syntax, variety of stanza pattern, the mixing of falling and rising rhythms, and especially the elimination of the persona – all tend to an effect of unmediated confessional narrative.

This process of poetic camouflage, in which the maker or artificer

disappears into the living man confronting his experience, is integral to his
sense of life as a division between subjective and objective time. The
sequence enacts the irony of recovering love through death: the victory of
objective time resurrects the intensity of subjective time. The first poems of
the sequence are filled with the pain of opportunity lost. The wife dies with
the poet in a state of ignorance and insensibility:

> Never to bid good-bye,
> Or lip me the softest call,
> Or utter a wish for a word, while I
> Saw morning harden upon the wall
> Unmoved, unknowing
> That your great going
> Had place that moment, and altered all.

The unexpectedness of her death sharpens the contrast of his feelings before
and after. The sequence therefore describes the movement from time as
impersonal duration, a sort of death in life, to time as the poignancy of
memory, a sort of life in death. This takes the form of a journey from Dorset,
the site of his estrangement from her, to Cornwall, the setting of his original
discovery of her. The transition, psychological and geographical, is negotiated
by the use of a ghost-figure. A ghost is engendered by the association of place
and person – by the felt emptiness of a once familiar spot: in 'The Haunter'
it is presented as co-extensive with the mourner's desire. This means that the
vividness of the 'presence' is dependent on the actuality of the place that
lacks it. By visiting the landscape of her distant past, therefore, Hardy is
seeking his wife at a double remove.

In 'A Dream or No' the thought that her old landscape may have forgotten
her makes both unreal; but this momentary faltering is triumphantly
overcome in the next poem, 'After a Journey', which celebrates the
attainment of his two-fold destination: the 'ignorant' concreteness of the
setting, and the passionate ghostliness of its haunter:

> Hereto I come to view a voiceless ghost:
> Whither, O whither will its whim now draw me?
> Up the cliff, down, till I'm lonely, lost,
> And the unseen waters' ejaculations awe me.

The remaining poems continue to explore the paradoxes of memory –
nowhere more bleakly than in the poem that concludes the sequence, 'The
Phantom Horsewoman', in which the poet's dream-vision is suddenly
exposed to an external perspective, and shown to be the merely private
property of a 'toil-tried' old man.

Hardy may seek in *Poems 1912–14* a *trompe-l'oeil* effect, but that effect is
owed wholly to the results of a life-time of poetic practice. His patient
exploration of the interdependence of impersonal nature and existential loss
achieves in the end a commemorative intensity that has the weight of a
monument. And of course Hardy recognises this. The epigraph he affixes at
the head of the sequence – *veteris vestigia flammae*, 'the traces of an old flame'
– repeats Dido's spectral words to her underworld visitor Aeneas, and
challenges Virgil's majestic example. But it is noteworthy that the
acknowledgement is kept outside the frame.

Pound saw Hardy as the poet of the unified vision. Whether, however, it is personally less damaging to struggle out of one's social class, as Hardy did, than, like Pound, to emigrate from one's native land, is questionable; and it is arguable that Hardy's efforts to achieve unity in dissociation rested on a stubborn fidelity to self that cost him intellectual range and moral adventurousness. Yet this self-reliance also saved him from poetic fashionableness – he hated the 'jewelled line' of the nineties – and preserved his respect for verbal craftsmanship. And to this too Pound, who commended his language for 'shedding the encrustation', was acutely responsive.

The target of modernist attack was not tradition itself – with which modernism was in fact obsessed – but degenerate traditionality. Pound later claimed that the great lesson he learned from Ford was that 'poetry must be *as well written as prose*'. This presumes, of course, that poetry had ceased to be the province of serious writing. Pound therefore declared war on what he called 'literaryism' – that is, being content with drawing on a received store of intrinsically poetic words and conventions instead of seeking a direct linguistic encounter with the real. The two major stages in his campaign were his espousal of 'Imagism' in 1912 – the 'hard light, clear edges' of absolutely accurate presentation, first mooted by the avant-garde philosopher T. E. Hulme – and of 'Vorticism' in 1914 – the energising of the image into a 'radiant node . . . into which ideas are continually rushing' – or, in the words of Wyndham Lewis (1882–1957), the painter–editor of the revolutionary magazine *Blast* and subsequent author of savagely modernist novels, 'the heart of the whirlpool . . . where all energy is concentrated'. In short, for Pound the 'new poetic' upheld a dynamic concreteness in which the image concentrated and transmitted artistic fields of force; it formed the theoretical base of his most ambitious achievement, the *Cantos* (1917–70) which demonstrate the consistency of his artistic projects.

Pound's aesthetic in no way encouraged a realistic endorsement of the contemporary world, but sought to arrest its decline into materialist torpor, cliché and drabness. By attempting to revive the language of the great cultural moments of history in a raised and refreshed modern idiom, he tried to reconnect the present to the revitalising currents of the past. This put him in an ambivalent position vis-à-vis modern life, for he found himself both inside and outside it, being committed to reform a culture from the perspective of anterior cultures. Hardy's confessional stance was therefore not available to him. Accordingly he evolved one of the characteristic modernist alternatives – the persona, a device locating the poet half-way between autobiographer and dramatiser. Exploiting its possibilities, he produced the three great poetic suites of his English phase: *Cathay* (1915), in which he identified with the eighth-century Chinese poet Li Po, *Homage to Sextus Propertius* (1917), which he wrote in the guise of the Augustan elegiast, and *Hugh Selwyn Mauberley* (1920), in which, through the composite figure of a literary aesthete, he denounced the culture he had laboured to regenerate.

The *Mauberley* sequence is divided into two parts. The first consists of thirteen poems beginning with an epitaph on the poetic career of one E.P., following with satirical variations on English literary life, and concluding

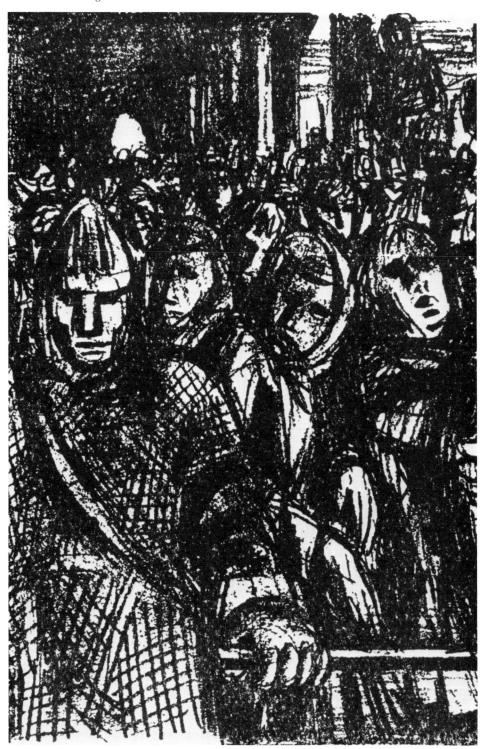

Peter Pendry's drawing of a scene from T. S. Eliot's play Murder in the Cathedral
(1935).

with an 'Envoi' modernising Waller's famous lyric, 'Go lovely rose'. The second is made up of five poems chronicling the career of Mauberley and concluding with a 'Medallion' on connoisseurship in porcelain iconography. The relationship of Pound to these two personae has proved problematic to criticism. E.P.'s story seems to echo Pound's biography in that he comes from 'a half-savage country', assumes the impossible task of 'resuscitating' poetry, erects Flaubert as a standard, and takes his bow in his early thirties. But 'Mauberley' also echoes Pound, if more faintly, in that he invokes the expatriate James, admires Flaubert and the classics, has to enter into negotiation with 'what the age demanded', and ends by being banished from 'the world of letters'. Any attempt to ignore this uneasy commerce between the real and the imagined produces an unsatisfactory result.

To treat *Mauberley* as autobiographical statement is obviously indefensible, despite the relevance of the satirical portraits of Part I to the London Pound knew. On the other hand, to harden the three figures, 'Pound', 'E.P.' and 'Mauberley', into dramatic units and seek to interconnect them, is to end up in the labyrinth. One must accept that the poem is structured in the logic of the persona, not of the biographical or the dramatic. Just as Pound the man has a shadowy part in the scene he castigates, so the fiction 'E.P.- Mauberley' is a shadowy presence within Pound himself. One of the major modernist achievements is the discovery that the self is simultaneously idea and fact, and that the self's actions are construable both in terms of sincerity and of performance.

If we turn from poet to poem we discover a similar ambivalence. *Mauberley*, like most modernist works, is supremely about art. The infamies as well as the aspirations of the age are understood in exclusively artistic terms; the great names of Greek, French and Italian constantly fracture the terse modern syntax. However, it also contains, in IV and V, a vision of the Great War as epic slaughter on a statistical scale unimaginable by the past, and moreover undertaken to save art that now seems scarcely worth preserving:

> There died a myriad,
> And of the best, among them,
> For an old bitch gone in the teeth,
> For a botched civilization,
>
> Charm, smiling at the good mouth,
> Quick eyes gone under earth's lid,
>
> For two gross of broken statues,
> For a few thousand books. (*v*)

An irreducible reality calls into question the value of art. Is it plausible to think that Pound failed to see that art, like the artist, is both imaginative construct and historical record? Such a recognition would only strengthen the reaffirmations that round off each of the two sections, the first resurrecting out of the real litter of English culture its ancient glory of song, the second coaxing out of the actual velleities of scholarship and stage-lighting a material image of unchanging Aphrodite – and both together defining the twin

properties of the poetic style they exemplify: musical rhythm and lapidary diction:

> Honey-red, closing the face-oval.
> A basket-work of braids which seem as if they were
> Spun in King Minos' hall
> From metal, or intractable amber;
>
> The face-oval beneath the glaze,
> Bright in its suave bounding-line, as,
> Beneath half-watt rays,
> The eyes turn to paz. ('Medallion')

James Joyce and Virginia Woolf

The novels of James Joyce (1882–1941) and Virginia Woolf (1882–1941) mark the high point of the modernist tide which, flowing ever more strongly through the first twenty years of the century, finally flooded the decade measured by the ending of the First World War and the beginning of the Great Depression. The war pushed into collapse a long-undermined cultural order; but the loss of one world seemed to clear space for another. The Russian Revolution of 1917 and the less dramatic German coup of 1918 released a brilliant experimental phase across all the arts; and even in those societies that seemed stable, traces of carnivalesque licence began to make themselves felt. Joyce had cut loose from oppressive and oppressed Ireland as early as 1904, and having at last found a publisher for his short stories *Dubliners* and his novel *Portrait of the Artist as a Young Man* in 1914, had been evolving *Ulysses* in Zurich, the capital of the European avant-garde during the war; but it was the twenties that received this masterpiece and turned its author into a connoisseur's celebrity. Virginia Woolf, too, had long reacted against the Victorian rationalism of her father, the critic Leslie Stephen; but again it was the twenties that released her most adventurous work – *Mrs Dalloway* (1925), *To the Lighthouse* (1927) and *The Waves* (1931).

High modernism must be distinguished from what could be called 'reactive modernism'. The latter is the transformation, in the effort of rendering modernity, of writing that retains the traditional task of interpreting reality. In the twenties, the condition-of-England novel broadened into that of the condition-of-Europe. It achieved its perspective on the old world by travelling to a new. Forster's *A Passage to India* (1924) relocates European values into a Hindu–Muslim context and examines them in terms of his characteristic standard of personal relationships. Two English visitors, Mrs Moore and Adela Quested, representing Western spirituality and conduct respectively, are either destroyed or transformed by their attempts to establish connection with the real India; while a third, Mr Fielding, a liberal educationist in the employment of the Raj, is finally rebuffed. What emerges is the impotence of Western reality where it really matters in its encounter with another reality. D. H. Lawrence's *Kangaroo* (1925), whose autobiographical protagonist, Richard Somers, suffers from the continuing

'nightmare' of the war, transfers to an Australian setting the totalitarian ethics Lawrence had detected in post-war Italy, and finally rejects them, less on account of their incoherence than their life-inadequacy when set against the unspoilt pre-historic beauty of the world of the antipodes. Reactive modernism feels 'the normal' to be under threat; its innovations come from its attempts to adjust traditional forms to new conditions. High modernism embraces change as a stimulus and an opportunity; it elaborates new forms less to preserve 'the normal' than to surpass it. This distinction, of course, defines outside limits: in practice, the writing of the period exhibits the whole range of the spectrum.

Joyce's *Ulysses*, for good or ill the most prestigious fictional text in any modern language, has the most banal of subjects – the chance meeting of two men at the end of a day's desultory business and recreation in Dublin. They are Leopold Bloom, a middle-aged advertisement canvasser worried about his wife's assignation with a flashy lover, and Stephen Dedalus, a young poet-teacher and intellectual disturbed by his religious intransigence at his mother's death-bed. A combination of high style and low matter is, of course, the formula of the mock-heroic. Yet in contrast with much modernist practice, *Ulysses* is relatively free of irony through inflation; and the reason is that it inserts itself in a tradition, memorably represented by Flaubert in *Madame Bovary* and already broached by Joyce in *Dubliners*, that finds greater consequence in the ordinary than in the extraordinary, and therefore no incongruity in the idea of an epic of common life. This means that *Ulysses* must start by being a realistic text. That it is also the classic of experimental modernism – *Finnegans Wake* (1939) as too much of an acquired taste, if it is ever that, to warrant the status – is no contradiction, for the realism peculiar to this novel is finally negated by the presentational virtuosity it generates. The tension between innovative and conservative impulses is now so completely installed within the text that the text ends up by unravelling its own realism.

Of the eighteen episodes of *Ulysses*, the first six and the last consistently, and many of the others intermittently, push the practice of mimetic realism to its ultimate limits. The novel colonises hitherto unclaimed areas of reality with the confidence and gusto of conquest. Far from being repelled by the products of modern life – the detritus of an urban beach, the seediness of an industrial suburb, the vulgarity of a popular pub – Joyce lavishes on them an attention endlessly sharpened by the nostalgia of exile. He delights in all the fragmentary codes of mass culture – the clichés, idioms, refrains, jokes, superstitions, sentimentalities out of which communal meanings are produced. He pries into the most censored reaches and the least salubrious recesses of individual thought, sensation and behaviour. So persistent is his drive for the real that he is gradually drawn to the frontier that separates fiction from fact, and it becomes increasingly difficult to tell the imaginary city-day apart from the actual Dublin of mid-June 1904.

Nor is this great tract of material merely surveyed and recorded. Everywhere it is set into activity, enacted, mimicked, ventriloquised, and always with an astonishing immediacy and resourcefulness. Everything is shown, nothing is explained. The best-known of Joyce's mimetic strategies is

the so-called stream-of-consciousness technique, which reflects, in the verbal medium, the living inconsequence of the mind's activity, as memory, stimulus, projection and perception jostle together. Joyce knew, presumably from personal experience, that internal monologue is accelerated by isolation, and it is in his two outsiders, the Jewish Bloom and the disaffected Stephen, that one discovers how dense and intimate this internal running-commentary can be. But there is nothing self-expressive about his handling of the technique. It is not that he abandons the narrative stance; it is only that he writes as if he himself possessed no knowledge outside the knowledge possessed by his characters – as if any reality outside the circle of their consciousness had been provisionally cancelled. He seems to relinquish all judgemental independence. Such asceticism is forced upon him by the very realism he practises, which requires the shedding of all a priori constraints. Sexual decorum, psychological reticence, aesthetic tastefulness, patriotic reverence, religious respect, moral discrimination, political commitment, intellectual certitude or doubt – in fact the entire spectrum of privileged or centred values which his characters so variously exhibit – have to be relinquished, except for a kind of pervasive tolerance that requires only the exclusion of its opposite, authoritarianism, for its unimpeded operation.

Such realism contains the principle of its own dissolution. The notion of novelist as nail-pareing divinity has radical consequences. With the disappearance of the authorial point-of-view – whatever its perspective – as the principle of selective structure, the idea of intellectual relevance evaporates. As a result, new generative mechanisms emerge. Since all reality is indifferently significant, a powerful, even incontinent, impulse to accumulate begins to take over, threatening to turn the novel into what Joyce himself recognised to be an encyclopaedia. Furthermore, since all reality is representational – that is, since the final function of language is enactment, so that a sentimental girl, for example, must be described in the language of the pulp romance she thinks in – the message turns into the medium and all style becomes parodic. Thus an equally powerful impulse to virtuosity declares itself, now threatening to turn the novel into a manual of rhetoric. To curb these two runaway tendencies, Joyce is forced to adopt external or formal restraints, themselves of course susceptible of endless elaboration. Hence narrative amorphousness is regulated by the Homeric paradigm, episodic fragmentation is latticed by analogical patterns, and the vertigo of inventiveness is quenched in the map of Dublin and the record of 16 June. All ideas – historical, ethical, philosophical or political – are converted into aesthetic functions, and the novel becomes, for all the penetration of its local perceptions, a work about itself.

The only affirmation that Joyce's totalising realism can make is a mythic one – and that only in the most inclusive sense of a perception of the whole of life as value. By the time the narrative reaches the long-awaited encounter between Bloom and Stephen, the post-realist extravaganza is in full command, and what we learn (in Joyce's own words) from the meeting is that the two men 'become heavenly bodies, wanderers like the stars at which they gaze'. It must said that even on the realist premises, they would have been too enclosed in their distinct subjectivities to have achieved significant

reciprocity. But what Joyce offers is not representation, but representativeness. Their conjunction, anticipated in the alliance of naturalism and symbolism of his early fiction, stands for the meeting of common humanity (Bloom) with artistic intensity (Stephen). Hence the novel concludes with a gigantic effort of synthesis. Molly Bloom's long insomniac reverie is a return of the favoured technique, but it now attempts to encompass the post-realistic adventures it has fathered. Joyce seeks to hear in her erotic musings the voice of the goddess of life. It may be that if realism drives sufficiently deep it will reach the archetype; but whether such a find would warrant, or indeed require, the epithet 'life-enhancing', as some of Joyce's apologists have claimed, remains in doubt. Whatever enhancement *Ulysses* affords should rather be sought in its Aristophanic celebrations of the underground areas of life, and in its astounding linguistic verve, where one may discover an effect long associated with the comic mode – celebratory or satirical release from the prison of literal-mindedness.

Joyce the man was born Irish, so that his European exile condemned him to an obstinately inexperiencing isolation. Joyce the artist was born cosmopolitan, so that his absenteeism from Ireland made possible the master-career of modernist letters. It was these conditions in their ultimate effect, rather than the environment of Paris in the twenties (when language had its brief play-time) that produced the solipsistic fiat of *Finnegans Wake* – less a novel than a decreation of the world into the Word of Joyce. What is to be gained from this particular performance is a question still under debate. But that something was lost can be deduced from Joyce's reported response to the news of Stalin's invasion of Finland – that it coincided exactly with the publication of the *Wake*. He had to pay something for allowing his original experience of Ireland to recede so far into the past, and with it his creative engagement with realism.

A self-regarding strain was detected early in Joyce's literary project. In 1918 Virginia Woolf, who had launched the Hogarth Press with her husband, read a manuscript draft of *Ulysses*; and although it proved too elaborate for publication, it exerted a marked influence on the first of her major novels, *Mrs Dalloway*, which charts the movements and thoughts of two characters through a London day, as one prepares to host an evening reception and the other drifts towards suicide. But her opinion of Joyce remained ambivalent, and she recorded in her diary that she thought *Ulysses* the work 'of a self-taught working-man' and, worse, an endorsement of 'the damned egotistical self'. In the light of her own snobbery and subjectivism, it would be very easy to turn both these remarks against her; yet they can be taken to indicate her essential distinctiveness. For unlike Joyce, who was the least snobbish of writers in that he took the whole of life for his province, she is committed to privileging special states of feeling; and unlike *Ulysses*, which defines with ruthless precision the activity of determinate minds, her best work presents these states as dissolving the boundaries of the self.

Virginia Woolf discovered her *métier* by reacting against the 'materialist' fiction of Bennett, Wells and Galsworthy. Her character Bernard, who partly represents the writer's perspective in *The Waves*, calls this the 'biographic style', the aim of which is to 'tack together torn bits of stuff' into the stencils

of character and plot, and to lay its conventions 'like Roman roads across the tumult of our lives'. However necessary this procedure may be to maintain social order, to Virginia Woolf it involves at best convenient, at worst alienating, fictions; for her claim is that we know both the self and the universe to be inscrutable realities, and that the space between them, which we inhabit as consciousness, cannot be resolved into coherence. When in *To the Lighthouse* Mrs Ramsay sinks away from her family and friends into the solitude of the self, she knows only a 'wedge-shaped core of darkness'; and when she looks across the bay at the distant reality of the lighthouse she can only recode its rays in terms of her own rhythm: 'the long steady stroke, the last of the three, which was her stroke'. Equally when Mr Ramsay, her philosopher husband, whose concern is not truth of feeling but the truth of intellect, goes to the lighthouse, he reverses her gaze and depersonalises the distant land, associated with her mode of being, into a 'vapour of something that had burnt itself out'. Neither, of course, represents the author's or the reader's final point of view: the lighthouse preserves its rigid and stony independence in the novel, as Mrs Ramsay retains her tangible and creative presence.

This double perspective, which asserts that nature within and outside us is equally inaccessible, returns to *The Waves* in a different guise. This novel simultaneously follows the lives of six subjectivities presented in formal monologues which are punctuated by set descriptions of the cycle of a day over a house and garden by the sea. It presents human life as a flux of consciousness locked in a relentless chronology quite independent of it. If however in such a world true order cannot be achieved, false order can be renounced. At privileged moments, her characters can meet to shed the masks and counters of everyday existence and release an unstructured simplicity of feeling. These individual currents are able to pulse in counterpoint with one another, and with the deeper rhythms of nature.

This means that Virginia Woolf's art is finally neither symbolic nor mimetic, for, as Bernard says, 'so the sincerity of the moment passed, so it became symbolical'. The human reality she seeks is at once temporal and transcendent. As such it uncovers affinities with the stillness-in-movement characteristic of formal poetry. Her conception of life can be called aesthetic, not in the sense the term acquired in the nineties, but in the stronger sense of reciprocal resemblance. Like Eliot of the *Four Quartets* but unlike the later Yeats, she reduces the distance between art and life. She was profoundly impressed by the 1910 Post-Impressionist exhibition in London, organised by the art-critic Roger Fry, whose biography she was eventually to write, and whose definition of the new movement as seeking 'not to imitate life, but to find an equivalent for life' she found revelatory. This is confirmed by her practice of including key artist-figures in her fiction – the raconteur Bernard whose closing monologue refocuses the entire action of *The Waves*; or the painter Lily Briscoe in the latter part of *To the Lighthouse*, whose painting, inspired by the memory of Mrs Ramsay's 'simplicity', is finished exactly as Mr Ramsay completes his expedition to the lighthouse – a project also planned long before under the influence of Mrs Ramsay's sympathetic initiative. Thus fulfilment in art and in life is unified in an originating moment of maternal grace.

The justification of human life in terms of special states of being analogous to artistic life is a position quite unlike Joycean comprehensiveness. But it would be a mistake to conclude that she is a merely lyrical writer who cannot be admitted to the company of the giants of high modernism. A more thorough comparison with Joyce brings out that she, unlike him, possessed an undiscouraged educative and moral energy. The variety of her literary and social criticism, her preoccupation with the fate of the English cultural tradition, her commitments to improving the status and identity of women, and the range of her contacts with her contemporaries are not signs of an innate solipsism. Nor are these activities in a merely contingent relationship with her fiction. Consider in this respect the implications of the fact that both *To the Lighthouse* and *The Waves* accord a central place to death. Neither novel finally allows us to separate out its private from its public implications. In *To the Lighthouse* the central death, that of Mrs Ramsay, is part of a process that includes the carnage of the Great War and the destructiveness of time. In *The Waves*, the death of Percival, the crucially 'absent' seventh character whose identity is entirely a function of its impact on the responses of the other six, becomes the chief event in their lives, conferring on them the experience of continuity and community.

Moreover, her treatment of this theme shows how far her work, in its positive or creative failure to effect artistic closure, belongs to the high tide of modernism. For in her major novels death inspires both fear *and* resistance, conditions both fugitiveness *and* intensity, determines both social vacuity *and* social interdependence. *To the Lighthouse* is haunted by dissolution and loss, but it is also marked by continuity and achievement. What is notable about this opposition is not that its terms need each other, as they do (it is only because her life has ceased that Mrs Ramsay is at last able to inspire the fulfilment of the projects of those who survive her), but that ultimately they can only co-exist – that is, that they can only be noted. Lily Briscoe's famous final brush-stroke, which completes her picture, can refer indifferently to Mrs Ramsay (loss) or to the lighthouse itself (attainment): the question simply cannot be decided. The disjunction dramatised in *The Waves* is even more brutal. How can the two discourses of the novel be reconciled? Subjective monologue is obviously dependent on objective description: we are conscious because we are part of the cycle of nature. Yet nothing is able to give meaning to both at once. Few moments in modern writing are more bleakly exhilarating than the closing sentences of *The Waves*. Bernard, quickened by the memory of Percival, hurls defiance at death: 'And in me too the wave rises. It swells; it arches its back. I am aware once more of a new desire. . . .' and what is nature's response? '*The waves broke on the shore.*' In its evocation of a repetition that is implacable opposition, no ending could be more inconclusively final.

Virginia Woolf is not the only native representative of high modernism. A case could be made for Dorothy Richardson (1873–1957), whose sequence of novels, *Pilgrimage* (1915–67) remorselessly exploits the stream-of-consciousness technique in an attempt to create what Virginia Woolf herself called 'the psychological sentence of the feminine gender'. An even stronger case could be made for David Jones (1895–1974), whose *In Parenthesis* (1937)

is a mixed-mode epic seeking, with concussive eloquence, to make intelligible the experience of modern war. But she is the only writer of English origin whose range and seriousness make her work measurable against the achievements of Joyce, Eliot and Yeats.

W. B. Yeats and T. S. Eliot

The poetry of the twenties is dominated by two masterful figures, W. B. Yeats (1885–1939) and T. S. Eliot (1888–1965), whose work reached its full stature in that decade. Their main collections, Yeats's *The Tower* (1928) and *The Winding Stair* (1933), which are companion volumes, and Eliot's *The Waste Land* (1922) and *Ash Wednesday* (1930), which mark a strong contrast, would appear to show that they have nothing in common, and that there is no basis for a comparison between them.

Yet their careers add up to what is virtually a typology of the modernist's biography. Both were culturally self-divided – Yeats between Irish Nationalism and Irish Protestantism, Eliot between the New World and the Old. Both were therefore impelled to discover and absorb anterior cultural traditions – Yeats the Ireland of folk-tale and heroic myth, and later of the eighteenth-century ascendancy, Eliot seventeenth-century English drama and poetry, and later the Anglicanism of Lancelot Andrewes, Nicholas Ferrar and George Herbert. Both were profoundly influenced by Arthur Symons's mediation of the stylistic revolution of late nineteenth-century France – in the case of Yeats the iconographic *symbolisme* of Mallarmé, in that of Eliot the discursive *decadence* of Laforgue. Both submitted themselves to the tutorship of Ezra Pound, the promoter of concrete imagery and exemplary culture.

In the poetry as in the fiction of the twenties the nature of high modernism can be further defined by reference once again to D. H. Lawrence, whose *Birds, Beasts and Flowers* (1923) show him to be the main representative of reactive modernism in the decade. Lawrence was indifferent to, and indeed contemptuous of, the French-dominated nineties, and his contact with Italian Futurism was ephemeral. Instead he read Hardy, welcomed the first Georgian anthology as an awakening from the 'dream of demolition' of foreign intellectuals like Flaubert, Mann and Ibsen, and above all discovered in Whitman a predecessor in what he called 'the poetry of the immediate present'. This he defined as an attempt to secure permanency in the present's 'wind-like transit', not in the 'finality' of formal perfection produced by the closure of retrospective or prospective experience. He achieves modernism only by confrontation – by exposing civilised self-consciousness to the elemental naivety of animal and even organic life. His poems cannot therefore begin in generalisation, but in an effort of specific attention on the here and now that destabilises the consolidations of culture.

They record his subjective encounter with snakes, tortoises, fish, mountain lions, figs, anemones, etc., in a form of free verse that is exquisitely responsive to the fluctuations of perception and feeling. These attempts to imagine non-human life are not mystical but sympathetic; and they defy the before and after of history not by reaching for some dimension of eternity,

but with the immediacy of autobiographical time. The effect is not confessional but exemplary; it breaches, as it were, the edges of the human, not to promote an unintelligible vitalism, but to secure a space for continued contact with the natural. But this is a traditional function: if Lawrence's poetry is modernist, it is because of his quasi-apocalyptic sense of what he is up against.

By contrast, the extent of the investment of Yeats and Eliot in the idea of 'art' becomes fully apparent. For them, as for Joyce and Virginia Woolf, modernism is less a reaction against modern life regarded as external to their art than a process within art corresponding to the transformations of modernity. They are always aware that their practice takes place within literature regarded as a cultural institution. They are obsessed with its traditions and they assume kinship with its past creators, from Homer and Dante to Flaubert and Baudelaire. And their efforts to sustain this great line, which produces their modernism, represents the final flare of a dying culture.

Far from severing itself from the past, high modernism tries to retain a dialogue, or at least a dispute, with it. Yeats called himself the last romantic, but his work was born out of his quarrel with romanticism. The danger of neo-romanticism, as it meets new conditions of life, is solipsism. Yeats launched his career into the Celtic Twilight, seeking refuge from Victorian materialism in its mystical islands of repose; and he seemed to find this impulse confirmed in the solitary perfectionism of esoteric verse. But from the beginning this dream bred its opposite, for he knew that the folk-lore that nourished it belonged not to him but to the country people of Ireland, and that supernaturalism required the assumption of the objectivity of image and symbol. This counter-impulse towards the communal and the external was strengthened by the influence of Maud Gonne's patriotism from 1889 and of Lady Gregory's patronage from 1896; but its source was inherent in his art, which from the first associated the self-creating energies of romanticism with the recreation of a national culture. This identification was made possible by the condition of Ireland, whose national identity was, by virtue of its subjection to England, necessarily ideal, and whose culture was, in contrast to England's, still largely pre-industrial, at least outside Dublin and Belfast. Yeats's modernism was therefore generated by a double tension: the first between the romantic self and the national community, the second between ancient Irish tradition and contemporary English cosmopolitanism.

The poetry of *The Tower* and *The Winding Stair* is characterised by a triumphant sense of difficulty overcome.

> An aged man is but a paltry thing,
> A tattered coat upon a stick, unless
> Soul clap its hands and sing, and louder sing
> For every tatter in its moral dress,
> Nor is there singing school but studying
> Monuments of its own magnificence;
> And therefore I have sailed the seas and come
> The holy city of Byzantium. ('Sailing to Byzantium')

Its affirmations draw their power from the fact that they have fully confronted and been fully stretched by what they oppose. Attempts to find

modernist imagery in Yeats's style which, though it becomes increasingly idiomatic and concrete, never deigns, like Eliot's, to mention oil-slicks, gasworks and taxis, remain unconvincing. On the contrary, he retains the dignity of traditional verse forms and the control of grammatical logic. But the demands he makes on stanza and syntax are unprecedented, for they are required to order massively disruptive material; and the resultant achievement is never quite free of a sense of narrow escape. Unlike Milton, Yeats can no longer presume on the mind's superiority over the passions, or unlike Wordsworth on the reciprocity of thought and feeling. Indeed, Yeats no longer believes in the possibility of articulating truth and achieving identity. Lawrence still seeks to preserve the natural self, the basis of unified experience, from the alienation of self-consciousness. For Yeats such a unity has been irremediably split, and he can only affirm it negatively, by doing full justice to each of the divided elements.

In 'A Dialogue of Self and Soul' or 'Vacillation', for example, all he can do is to acknowledge that part of himself craves for the clarifications of eternity (the 'soul' whose destination is death), and that part cannot relinquish the entanglements of life (the 'self' or 'heart' whose habitat is time). Only in the constructions of art, so memorably celebrated in the 'Byzantium' poems, can the two elements find connection, for art encompasses both dimensions. It achieves its 'eternity' through the agency of nature or supernature (the living poet), and its 'eternity' consists in proclaiming 'what is past, or passing, or to come' (the living audience). However, such connectedness is not reconciliation, but interaction. For Yeats, 'man can embody truth, he cannot know it': the embodiment takes the form of enactment; and enactment is art:

> I mock Plotinus' thought
> And cry in Plato's teeth,
> Death and life were not
> Till man made up the whole,
> Made lock, stock and barrel
> Out of his bitter soul,
> Aye, sun and moon and star, all . . . ('The Tower', iii)

If the term 'dialectical' is applicable to Yeats, it is because he cannot apprehend a given reality without imagining its opposite – that is, what it is not. For example, the great poems of old age, such as 'The Tower' or 'Among School Children', gain their power from the fact that the knowledge of old age is the discovery of lost youth, and that the attainment of intellectual mastery exacts the forfeiture of beauty and passion.

> Bodily decrepitude is wisdom; young
> We loved each other and were ignorant.

Or again, the equally memorable poems recording the collapse of civilisation, 'Meditation in Time of Civil War' and 'Nineteen Hundred and Nineteen', and the elegies on Lady Gregory's 'Coole Park', gain their authority from the recognition that the destruction of the past is also the creation of the future.

> Odour of blood when Christ was slain
> Made all Platonic tolerance vain
> And vain all Doric discipline.

But Yeats's dialectic is quite un-Hegelian or unprogressive, for it locates the synthesis, on the basis of which the new oppositions are presumed to develop, *in art*, that is to say, outside the process. Yeats represents its logic in the figures of the 'mask' (or 'anti-self') and of the 'gyre'. The first (a biographical and experiential principle) affirms that the natural self, by definition incomplete, achieves a complementary unity by imagining its own opposite in role or style. The second (an historical and processive principle) asserts that the dwindling of one epoch feeds the expansion of the next, or that 'we die each other's life and live each other's death'. Taken together, these two principles define a conception of reality as total drama – the individual actor retaining contact with the play not by understanding it, which is impossible, but by playing his role as well as possible, that is, by finding the self in the anti-self.

Yeats defended this dialectic (notoriously set out in *A Vision*, 1925 and 1937) not on the grounds of its truth, but of its utility: it helped him, he said, 'to hold in a single thought reality and justice' – or, in the debased currency he despised, fact and value. In short, it enabled him to preserve the authenticity of the romantic subject without denying the reality of the world that declared it to be obsolete. That he was therewith able to produce some of the most eloquent, passionate and powerful poems in the language must be regarded as a vindication of his system. Yet if this is so, the poems remain indebted to a structure for which the criterion of truth has become problematic. It is here, in the depth rather than on the surface of the work, that the characteristic fractures of modernism are to be found.

Yeats's modernism is the reverse of Eliot's. Yeats's grows out of an attempt to preserve a tradition, Eliot's out of a need to find one. Eliot's point of entry into the modern movement was 'decadence', not symbolism – and specifically the decadence of Laforgue, to whom he claimed to 'owe more than to any one poet in any language'. Laforgue's poetry was discursive, not iconic, but it took the form of arrested discourse. This specialist of the baffled 'complaint' sought to communicate in the very act of undermining the conventions which make communication possible. The major pieces of Eliot's 1917 collection, *Prufrock and Other Observations*, recreate the Laforgueian 'psychological tone poem', with its cross-rhythms, abrupt transitions and verbal skirmishings, sustained in a characteristic note of lyrical irony:

> In the room the women come and go
> Talking of Michelangelo.
>
> And indeed there will be time
> To wonder, 'Do I dare?' and, 'Do I dare?'
> Time and turn back and descend the stair,
> With a bald spot in the middle of my hair –
> They will say: 'How his hair is growing thin!'
> My morning coat, and my collar mounting firmly to the chin,
> My necktie rich and modest, but asserted by a simple pin. ('The Love Song . . .')

Like his master, Eliot evokes, from within the perspective of subjectivity, the mentality of a new type, that of the sensitively refined urban outsider – yet without promoting solipsism. The cityscapes and interiors which this figure despises and desires are not projections or symbols, but real localities. With

all their vulgarity and triviality they exist in the public realm, and as such they provide the social space which the private self needs for confirmation and response.

Thus it is a mistake to regard these poems as exposés of a condition demanding psychological diagnosis or moral censorship, for they exhibit a representative predicament: the transformation of the inhabitants of the modern world into strangers. What is impressive about this poetry is that it refuses to connive with such a state by lapsing into indifference or mere privacy, but continues to stake its claim to a place on what appears to be an impossible public terrain.

It is commonly assumed that Eliot's career was marked by two major breaks, the first caused by his association with Pound from 1914 and his conversion to the modernist aesthetic of impersonality and the 'objective correlative', worked out in the *Poems* of 1920 and *The Waste Land* of 1922; the second by his formal conversion to Anglo-Catholicism in 1927, involving a new emphasis on authority and ritual, and finding expression in the *Ariel Poems* and *Ash Wednesday* of 1930. While there is no denying this pattern, too great an insistence on it fails to do justice to the essential continuity of his development. The doctrine of impersonality rests on a clear distinction between 'the man who suffers' and 'the mind that creates' – that is, between the psychological and the logical, or the cause and the object of an emotion. But as such it merely builds on his earlier presentation of urban alienation as a meaning to be understood rather than a symptom to be diagnosed. Whether or not *The Waste Land* was created out of the raw material produced by Eliot's alleged nervous breakdown, the electricity generated by the resourcefulness and brilliance of his use of montage belongs to the poems, not the biography:

> O city, city, I can sometimes hear
> Beside a public bar in Lower Thames Street,
> The pleasant whining of a mandoline
> And a clatter and a chatter from within
> Where fishmen lounge at noon: where the walls
> Of Magnus Martyr hold
> Inexplicable splendour of Ionian white and gold.　　(iii 'The Fire Sermon')

And the poem is much more than a confession of private defeat or a manifestation of public disgust. The intensity with which it assembles and juxtaposes the broken scenario of civilisation implies, as the shadowy narrative line of the poem indicates, a quest – the pointed scrutiny of an eye searching for a fullness of meaning it can only discover in traces or relics. *The Waste Land* therefore enacts a sort of drama of dislocation, in which the subject, as it were straining away from itself, interrogates the very environment which has made it what it is.

From this point of view, the conversion that so appalled his modernist friends need no longer be seen as a reversion into a self-created world. Instead, it becomes an entry into possession of a portion of the real world in which a surviving tradition is still practised. But this possession is not freehold, for the mark of the serious convert is the need for a real transformation of the self, not for a mere refuge from anxiety or a discipline

for incoherence. This implies a commitment to process rather than product; the new self must exist within the context of the old, otherwise it will be taken for granted.

Eliot's position gains definition by juxtaposition with Yeats's. Shortly after his conversion, Eliot declared, perhaps with some defensiveness: 'My own beliefs are held with a scepticism which I can never even hope to be rid of.' Yeats's version of the paradox offers a remarkable contrast in tone: 'We must not make a false faith by hiding from our thoughts the causes of doubt, for faith is the highest achievement of the human intellect, the only gift man can make to God.' What for Eliot is a predicament is for Yeats a challenge. The one regards the reservations of the mind as a necessary impediment to faith, the other as the final test of faith.

Yeats thinks of God as the supreme Other – the outside real, whose ultimate irruption into the self will declare its obliteration – 'At stroke of midnight God shall win' – but Who, for that reason, provides the self with its greatest opportunity and definition. Eliot has no such confidence and envisages no such defeat; he does not seek self-creation but self-transcendence. His use of the vegetation myth, for example, which on the seasonal analogy holds that the birth of the new requires the death of the old, is quite different from Yeats's. He does not turn it into a figure for the operation of objective history; he is not the man to look on and laugh in tragic joy. He is located within the process; the new he seeks by shedding the old is his own, not history's. Even in the pre-conversion *The Waste Land*, the structuring paradigm of anthropological ritual exists to define a personal venture.

In the later poetry, this search has not disappeared; the only difference is that the goal is now in focus. The lucent stillness of *Ash Wednesday*, for instance, far from being a complacent pastiche of Dante in his pre-Raphaelite guise as some have claimed, is upheld and sustained by an extreme, quasi-surrealistic, effort of renunciation. And this pattern is amplified and enriched in the great, if uneven, cycle of the *Four Quartets* (1935–42). The quest acquires a metaphysical intimacy; its location is a spot of time, its goal intimations of the infinite and the eternal. A visionary moment in a neglected Gloucestershire garden, an afternoon in a sleepy Somerset village, a memory of the New England sea-coast, mid-winter at an Anglican shrine in Huntingdonshire: these do not provide experiences of acquisition, but of the agency of renewal and loss; they do not package transcendance, but define the conditions of its possibility:

> Footfalls echo in the memory
> Down the passage which we did not take
> Towards the door we never opened
> Into the rose-garden. My words echo
> Thus in your mind. (*Burnt Norton*)

Indeed, the *Four Quartets* strikingly refuse the conventional diction of piety. If they earn a high place in the achievements of the age, it is because their language and thought remain that of a man who respects the survival of the unconverted self, and who is thus still committed to the high-risk tensions of the modernist style.

W. H. Auden and the thirties

The thirties provided so distinctive a setting for the resurgence of an updated English tradition, particularly in the poetry of the so-called Auden generation, that it is easy to overlook the fact that the last great monuments of high modernism – Joyce's *Finnegans Wake*, Virginia Woolf's *The Years* and *Between the Acts* (1941), Eliot's religious poetry and Yeats's *A Full Moon in March* (1935) and *Last Poems* (1936–9) – cast a large shadow across the decade. Nor were these works – with the possible exception of Joyce's, which has a Parisian context – unresponsive to the new climate. The increasing politicisation of English life found a reflection in a higher level of political consciousness. Virginia Woolf's promotion of feminism as a counter to collective male aggression became more marked; Eliot's public defence of classical order against irrationalist creeds became more explicit; Yeats's affirmation of heroic art against the falling apart of things became more uncompromising. Yet despite this reorientation, the modernism of the thirties owed its momentum less to the new climate than to the surge of former decades, and it seemed less to engage with than to glide over a temporal landscape that grew ever more alien as it approached the Second World War.

That the culture of the thirties no longer sustained modernism is not only an English fact. It was a submerged part of a wider phenomenon – the comprehensive European attack on experimental art from 1929 onwards. In Germany, Hitler's rise licensed the destruction of the cultural apparatus of the Weimar Republic, which had supported Expressionism on a large scale; in the Soviet Union, Stalin's accession to power obliterated the innovative consequences of the Revolution, which had been protected by Lunacharsky, Lenin's enlightened commissar for the arts. A similar backlash was shortly to be experienced in Spain, and even in Italy – despite the support of Fascism by important elements of the avant-garde. The installation of various forms of totalitarianism in these countries and their appropriation of the energies of art to promote ideological conformism and nationalist aggrandisement were not without consequences for the fate of modernism in the western democracies. Two of its essential premises were radically undermined: faith in the supremacy of art, and a-political concern with modernity as a global phenomenon. It is no accident that almost without exception writers in the modernist tradition, in contrast to those in the English tradition, were either reactionary or conservative.

After the First World War international power had begun to pass from British hands, and as Europe rearmed, the relative vulnerability of the country became perceptible to its writers to a degree never experienced by their predecessors before 1914. The exemplary career of the period was that of its finest poet – W. H. Auden (1907–73), and he was specially attuned to the relative decline and parochialisation of England. In his 'A Summer Night 1933', for example, the moon, seen from an English garden, 'climbs the European sky' and opens out a space beyond the intimate and the insular that shows them to be illusory:

> To gravity attentive, she
> Can notice nothing here, though we
> Whom hunger does not move,

From gardens where we feel secure
Look up and with a sigh endure
 The tyrannies of love:

And, gentle, do not care to know,
Where Poland draws her eastern bow,
 What violence is done
Nor ask what doubtful act allows
Our freedom in this English house,
 Our picnics in the sun.

Similarly, in 'Dover 1937', the aeroplanes fly 'in the new European air', and this 'makes England of minor importance'. His contemporaries also returned to the English theme. However dismayed they may have been by collective deterioration, they did not, or did not yet, adopt the extreme measure of expatriation – as was the case with Robert Graves (1894–1986) who, under the influence of the vernacular craftsmanship of Roman verse and the elliptical modernism of Laura Riding, turned himself from a war-damaged Georgian into a wryly passionate poet of remarkable individuality. Auden's associates, Day Lewis and Stephen Spender, and in their different ways the novelists George Orwell (1903–50) and Graham Greene (b. 1904) continued to attend to the English theme.

But their England was no longer that of the Georgians: the natural had yielded to the social, and the immemorial landscapes were now obscured by the industrial city, with its dereliction and unemployment. Despite the persistence of the forms of imperialism, England was no longer felt to be calling the questions; she was herself called into question, externally, on one side by the economic power of America, on the other by the growth of the European military state, and internally by the effects of the economic slump. For a while, writers entertained hopes of international socialism, but this mood was extinguished in the Spanish Civil War (1936–9), which left them either dead or betrayed. Orwell's memorable autobiographical documentary, *Homage to Catalonia* (1938) with its discovery of Communist opportunism, and Auden's celebrated poem 'Spain', which locates the 'struggle' not in the revolutionary effort, where one would expect it, but in the moment of personal choice, demonstrate the ineradicably liberal character of native radicalism.

That Auden did not produce, as many poets of equal merit have done, a single outstanding masterpiece has less to do with the limitations of his talent than with his conception of poetry. In contrast with the modernists, he did not think of art as constituting an alternative world, or of the artist as the keeper of a special vocation. What distinguishes the poet is his craft, which is linguistic; but in this he is no different from the engineer or the physician who are also defined by their respective crafts. His 'Musée des Beaux Arts', which recalls Breughel's treatment of the fall of Icarus as only one event in the ordinary business of life, distances itself from the dramatic centralisations of high-Renaissance or high-modernist art. His style adopts a lower profile: lyric intensity diffused into unobtrusive precision of statement; conversational candour tightened by a quietly virtuoso technique. Time forgives all poets, Yeats included, because of their love of language; but this love can take many forms. Auden's is for language as the vehicle of scrupulous reflection,

leavened by an undercurrent of hedonism and verbal play.

If there were such a thing as an English intelligentsia, Auden would belong to it. He exhibits all the symptoms of the poet as intellectual: mistrust of authority, contempt for mystification, mental curiosity, wariness of tragic modes, faith in the emancipatory function of the understanding. Nowhere is he further from the modernist ethos than in this. The modernists experience modernity as personal crisis; Auden is at home in modern life, and the worst it can do to him does not weaken his essential command of his values. His attitude to Marx and Freud as exemplified in his elegy on the latter is entirely progressive in that he accepts the insights without the discipleship. His attitude to England is neither nostalgic nor symbolic: the landscape of 'The Malverns', for example, records the responses of a mind open to geological, social and economic reality; its thunder 'mutters . . . over the Cotswolds', not as Eliot's 'over Himavant', and it proclaims the need to correct the effect of historical folly rather than the approach of spiritual renewal. His attention to the *conditions* rather than the significance of the modern – it is not unimportant that his major sonnet sequence, 'In Time of War', was the fruit of a commission to report on the Sino-Japanese conflict in 1938 – reflects the rise of the status of the documentary, a form which occupied a place in the thirties analogous to that of anthropology in the earlier decades.

It would be an error, however, to suppose that the Auden group reacted against their predecessors. Theirs was the more subtle response of assimilation. In absorbing the modernist sense of the new, particularly T. S. Eliot's, they made it familiar – that is, they deprived it of its novelty. Auden declared his debt to Thomas Hardy and Edward Thomas and acknowledged the pre-modernist craftsmanship of the Victorian poet G. M. Hopkins (1844–89) whose work surfaces in 1918. He and his group upheld the native tradition by diverting and domesticating the modernist current. The renewed strength of that tradition in the thirties can be measured by comparing the London reception of the Post-Impressionist exhibition in 1910, which was recognised by those who mattered as a cultural landmark, and the response accorded to the Surrealist exhibition of 1936.

Surrealism – the last great wave of the international movement – broke over London with scarcely a splash. It had arrived too late and in the wrong place. Its impact on literary Spain before Franco – for instance on Federico García Lorca – shows up the feebleness of the work of those English poets – David Gascoyne (b. 1916) or Herbert Read (1893–1968) – who tried to imitate it. Surrealism requires a culture given to the gestural – to Catholic ritual and public rhetoric; the intimacy and particularism of English life are fatal to it. English absurdism is not visionary or political, but logical and linguistic. Auden's nonsense verse has its roots in Victorian language-games. Not even Dylan Thomas (1914–53), whose early poetry seemed, in the exultance of his 'sullen art', to challenge the predominant style of the decade, can be assimilated to surrealism. His dissolution of syntax, his metaphorical fusions, his rhythmic impetus all aim, like the bardic recitation of his Celtic past, at an intoxicating unity of effect quite different from the transgressive and distorting violence that characterises the Parisian movement.

Drama

A summary history of English literature in the British Isles between 1900 and 1940 can only attempt to do justice to its main principles of coherence. This account has had to focus on a culture centred on the capital, where all the transactions of publication, distribution and reception take place. All other aspects of what is a complex and variegated scene – particularly nationalist movements in Ireland and to a lesser extent in Scotland and Wales, have had to yield to the main theme. But the fact remains that no serious writing produced anywhere during the period was able to remain unaffected by the tensions between innovation and tradition which have been traced through this record.

Since the French Revolution the literature of Europe has essentially been an achievement of the middle classes. In its final phase, the English version of which has been described here, it represents a reaction within these classes to the world they have created. French pre-modernist literature of the second half of the nineteenth century was characterised, as in the work of Flaubert and Rimbaud, by its hostility to the idea of the bourgeoisie, on which it nevertheless remained wholly dependent for its force and substance. This is tantamount to saying that modernism is the product of a contradiction in consciousness.

Nowhere has the middle class been stronger and more homogeneous than in England. This means that the English modern movement was at once specially vigorous, since the contradiction was well established, and specially vulnerable, since conservative structures were solidly in place. The effects of this insecurity are particularly visible in the fate of innovative drama. French literature, which privileged fiction and poetry, had virtually ignored the theatre; the great majority of the English modernists, James, Conrad, Lawrence, Joyce, Yeats and Eliot – not to speak of Hardy and Auden – were drawn to it. Drama, however, is more tightly integrated into the life of society than other art forms. Unlike the publication of a novel or poem, the production of a play relies for its success on instant public approval.

During the first half of the century the metropolitan stage was governed by the expectations of what was probably the most supine public in Europe. From H. A. Jones (1851–1929) and Arthur Pinero (1855–1934) at the start of the Edwardian decade to Noël Coward (1899–1973) and Terence Rattigan (1911–77) at the close of the thirties, the formula on offer was the so-called 'well made play' of upper-middle-class sexual intrigue.

The only serious playwright who proved equal to these conditions was George Bernard Shaw (1856–1950). He turned them to his advantage by adopting a conventional form to show up conventional ideas. The well-known exchange in *You Never Can Tell* (1896) neatly epitomises the virtues of this approach:

> There is only one place in England where your opinions would still pass as advanced.
> The Church perhaps?
> No: the theatre.

In the irreducible Shavian paradox, a theatre that mocks its own conventionality ceases to be conventional. The real subject of Shaw's best plays, which he mostly produced during the Edwardian decade, is not his own doctrine (Fabian socialism mixed up with a sort of evolutionary vitalism), but what that doctrine enables him to do – to unmask conventional ideas. His work is deconstructive rather than affirmative, but always in a spirit of comic irreverence. It is to this disinterested delight in loosening the grip of the received idea that he owes his greatest gift – the capacity to cut or strike without leaving a wound or bruise. In a play like *Man and Superman* (1903), which startlingly reverses the usual claim that the female sex is weaker than the male, or *Major Barbara* (1905), that a Salvation Army officer is morally superior to an armaments' manufacturer, he creates an atmosphere in which virtuous literal-mindedness cannot survive.

Perhaps the most telling of these plays is *Pygmalion* (1912), based on the Greek legend of the sculptor who falls in love with the female figure he has made. We may be inclined to read this work, in which an expert in spoken dialect, Henry Higgins – a composite of the Oxford linguistician Henry Sweet and the fictional Sherlock Holmes – transforms for a wager a cockney flower-girl, Eliza Doolittle, into a passable duchess, as finally making the point that people cannot be treated as social experiments – if only because when the experiment works they will begin to act on their own behalf, independently of the wishes of the social engineer. This is plainly correct, but as it stands it does little justice to Shaw's manipulation of conventional expectations. He begins by demonstrating that the differentials of the English class system – particularly accent and speech – are trivial products of social conditioning. Having got his audience, however, to assent to this over-optimistic proposition, he tempts them into the further expectation that all obstructions to a romance between master and pupil are now removed. But the play, faithful to its title, takes the form of an arrested love-affair. The audience is not allowed to relinquish a comfortable assumption (that a good accent is a mark of innate breeding) for another more comfortable one (that class distinctions do not matter). In the play, Eliza does not simply leave the working class; she joins the leisured class; and having done so, she is obliged to find the best way of remaining in it – which is not marriage with Higgins.

For all his gaiety, Shaw's destabilising of received ideas is always in the interests of intellectual independence. Yet even he ceased to command attention when he gave up flirting with his public. Perhaps his most original play, *Heartbreak House* (1916–17), which presents a disturbingly ambiguous image of England at the outbreak of the First World War, failed disastrously when it was produced in London in 1921. Nor did the leading European playwrights fare any better: Ibsen could scarcely survive on the Edwardian stage, and Chekhov was still unacceptable in 1924.

The complacency of main-stream production served to marginalise innovative writing for the stage. Only the Irish dramatic movement escaped this blight, and that was because in the Dublin Abbey Theatre, sponsored by the English patroness, Miss A. E. Horniman, and directed by Lady Gregory, the moving spirit of the Irish Literary Renaissance, such playwrights as W. B. Yeats, J. M. Synge (1871–1909) and later Sean O'Casey (1880–1964)

were able to command an alternative audience. The national struggle, for all its artistic narrowness, was able to create social conditions under which literature and theatre could negotiate an approach. But such a drawing together proved much more difficult in an English context. Some writers scarcely wrote with the theatre in mind: Hardy's *Dynasts* (1904–8), an epic cycle on the Napoleonic Wars, was at best designed for one-off compromise performances; and one can hardly believe that Shaw's endlessly tedious *Back to Methuselah* (1921), despite its New York production, was not destined for the study. Others, like Lawrence, wrote in a kind of vacuum: his remarkable collier play, *The Widowing of Mrs Holroyd* (1914) had to wait until 1970 before it received its first professional showing.

In the thirties, however, a serious attempt was made to find a foothold for poetic drama that was not merely literary. Attempts to commandeer the tradition of popular entertainment led to such experiments as Eliot's syncopated fragments, *Sweeney Agonistes* (1935), on the brutality of contemporary mores, and the Auden–Isherwood collaborations suggested by Brecht's use of music-hall (1936–9). These were given short-lived performances by the 'Group Theatre', a private dramatic society created in Westminster for the purpose. But the best that can be said for such gestures is that they anticipated, in the problem they addressed, the wholly different mobilisation of the contemporary accomplished in the early sixties after the collapse of the establishment tradition.

However, attempts to adapt existing ritual forms achieved much more impressive results. Such plays as Eliot's *Murder in the Cathedral* (1935) and *The Family Reunion* (1939), and Yeats's later drama, *Four Plays for Dancers* (1921), inspired through Pound's mediation by the Japanese Noh, together with the haunting and haunted pieces that followed them, such as *The Words upon the Window-Pane* (acted 1930) and *Purgatory* (acted 1938), all represent a very considerable achievement.

Murder in the Cathedral, which enacts the last phase of Thomas à Becket's martyrdom, was designed for performance in Canterbury Cathedral, where, of course, the original event occurred; and it was subsequently transferred to London, where it ran for several months. It has been described as the only poetic play to achieve popular success since the closure of the theatres by the Commonwealth. Be that as it may, it boldly adapts the Anglican liturgy, and it exploits introits, a chorus-choir, and sermon by the protagonist in order to turn the audience into a congregation, and to honour, in a highly traditional practice, a sacred place by re-enacting the cause of its original sanctification. Its theme is equally theological: the examination of the nature of the act of martyrdom, publicly as a differentiating collision between the sacred and the secular, subjectively as a reconciliation of the tension between ambition and humility or 'action' and 'suffering'. This plainly simplifies dramatic conflict almost to the point at which it ceases to be drama; but Eliot brilliantly recovers his play for performance by constructing a kind of palimpsest which superimposes Greek tragedy, medieval morality and modern satire into a single text.

Yeats's final plays are also concerned with the supernatural, but without the benefit of an accepted institutional structure – unless the occult seance

Design by Gordon Craig for mask of the Blind Man, in Yeats's On Baile's Strand
(1911).

can be so regarded. He is therefore obliged to invoke other conventions –
notably the sense of a heroic and ceremonial past as perceived from a debased
present. In his *The Words upon the Window-Pane*, a banal clairvoyante, Mrs
Henderson, attracts to a seedy Dublin boarding house a random collection of
spiritualists. But the house was once inhabited by Vanessa, the rival of
Jonathan Swift's Stella, and has thus been the site of great suffering. In one
of the memorable shocks of the modern theatre, there suddenly breaks
through the medium's commonplace routine the terrifying eloquence of
Swift's despair and rage. The thrill of the supernatural is stunningly
provoked, but it operates ultimately in terms of cultural incongruity – the
sudden irruption of a majestic past into modern suburbia. In this view, the

real 'medium' of a tragic suffering allegedly incompatible with contemporary triviality – indeed, what raises tragic suffering to its full stature – is that very triviality. Seldom has virtue been better made out of necessity.

Yeats's penultimate play, *Purgatory*, achieves with an astonishing directness of concentration what its precedessor accomplished by means of a lateral method. It owes its success partly to its verse – a free mixture of four- and five-stress lines, which carry an eloquent starkness and purged colloquilism, and partly to its exploitation of the device of the play-within-the-play. Once against a ceremonious past, the rooted life of a great house, is contrasted with a disintegrated present, the feckless life of two pedlars, father and son. But this time attention is focused on the mechanism of decline. The house, located upstage, is now ruined; but it is visible to the disreputable pair as they are visible to the auditorium; and it is lit up for the ghostly purgatorial re-enactment of a former disaster – the sexual obsession of its aristocratic inheritor for a drunken virile groom whom she fatally marries, and thus destroys her noble legacy. The old man watching this scene is the product of that union; his mother has died giving birth to him, and at the age of sixteen – the present age of his son – he has killed his father in a fit of murderous loathing for having defiled the family honour and squandered the family fortune. And as he witnesses yet again a repetition of the act that generated him, the pattern of consequences in the distant prospect begin to reproduce themselves in the foreground scene: his ruffianly son tries to steal his money; in the struggle the coins are wantonly scattered; the youth threatens the father. To break the continuing cycle of violence that dooms his mother to her treadmill of remorse, the old man abruptly knifes his son to death. But in fact that very gesture completes the transfer of obsessive repetition from the inner to the outer stage, that is, from the dead to the living. He is now a murderer twice over. He has extended, not broken, the chain of consequences; and as the curtain falls he hears with horror the ghostly approach of galloping hoofs informing him that the purgatorial round is about to start again.

That this fearful play is concerned with historical collapse as a form of guilt, with the destruction of the past regarded as a crime, there can be little doubt. In fact, in a narrative that multiplies deeds of blood, this act of destruction is the only one that counts as a legal transgression:

> . . . to kill a house
> Where great men grew up, married, died,
> I here declare a capital offence

As with original sin, degeneration from the order of plenitude begins with a sexual coupling, product and cause of irrational violence. But it is ultimately structured in terms of the psychological experience of obsessional remorse, and it aims at nothing less that the subjectivising of the historical process. By projecting this experience onto the supernatural plane, where ghosts haunt – that is, cannot relinquish – the place of their earthly suffering, going over and over some irreversible action of their past lives, Yeats suggests that history actually *suffers* the decline it enacts – indeed that the suffering is precisely what drives the process forward.

If this is the case, then, *Purgatory* becomes the most startling version of the subject–object dichotomy that defines Yeats's modernism. Yeats's plays deserve to be performed more frequently than they are; but the fact is that they have never appealed to a wide audience. The social conditions that constrained the stage of the period condemned him to find his voice in coterie drama.

In general, the various attempts during the forty years under survey in England and even in Ireland to achieve a living collaboration between modernism and the theatre must continue to tell a story of defeat. As far as the English are concerned, this is all the more remarkable for the depth of their commitment to the art of acting, which has made and continues to make them the most subtly, though not the most ostentatiously, histrionic people in Europe.

Conclusion

This survey began by suggesting that the writing of the period could be interpreted in terms of two axes drawn along the modern–traditional and the serious–popular distinctions. These two sets of distinctions are brought into play by the emergence of modernism, for modernism is marked by a commitment to high art as opposed to entertainment art, and by the promotion of innovation and experiment as against traditional practice. The pursuit of a project marked by intellectual rigour, linguistic concentration and formal adventurousness distinguishes it sharply from the literature of continuity and consolidation, and from the predictable gratification of fashionable drama or the standard formulas of mass fiction. Serious writing in the English tradition produced a rather different kind of criticism, for it aimed less at destabilising existing structures than at enhancing or correcting them. But, with the exception of Joyce, every modernist was also a major critic, though usually in occasional forms like the essay and the review. This naturally favoured the growth of literary magazines. The earlier initiatives – such as Ford's *English Review* and Pound's *Egoist*, already referred to – were followed by a proliferation of serials, the most notable of which were perhaps Eliot's *Criterion* (1922–39) and John Middleton Murry's *Adelphi* (1923–55). The critical scene thus produced was heterogeneous, but the central drift, as befits the modernist orientation, was prescriptive and revisionist.

Out of this practice, the early thirties saw the start of a remarkable attempt to reorder the two polarities by reducing the tensions between them – specifically by closing the first distinction (modernism–traditionalism) and opening out the second (serious–popular). F. R. Leavis's *Scrutiny* (1932–53), published from Cambridge, sought to combine the intellectual standards of high art with the moral standards of English dissent. Leavis's own early publication, *New Bearings in English Poetry* (1932) and *Revaluation* (1936) offered respectively a defence of modernist poetry centred on Eliot and Hopkins, and a map of the tradition of English poetry drawing on the vitality of living speech. At the same time, in collaboration with his wife, Q. D. Leavis, he elaborated a critique of English culture in terms of pre-

industrial 'organic' values which set popular urban writing at an irredeemable distance. He found support for this overall position in a line of nineteenth- and early twentieth-century novels (Jane Austen, George Eliot, Henry James, Joseph Conrad) firmly distinguished from French 'aesthetic' fiction (Flaubert) and English 'entertainment' narrative (Thackeray, and initially Dickens who was later accorded major status by the Leavis's). On such assumptions, the profile of twentieth-century production had to be drawn very strongly: D. H. Lawrence, at once English and modernist, became the perfect candidate for Leavisian honours, while a cerebral amoralist like Joyce, whoring after foreign gods, turned into the natural antagonist.

Leavis felt himself to be radically at odds with the literary tendencies of the thirties, a period during which the idea of art began to lose the supremacy it had enjoyed for nearly forty years. Yet in his programme of cultural consolidation, his faith in the educative power of literature, his commitment to criticism as experience, and his aversion to what can retrospectively be called the University English Department mentality, he was clearly a product of the decade that closed one of the most brilliant episodes in English letters.

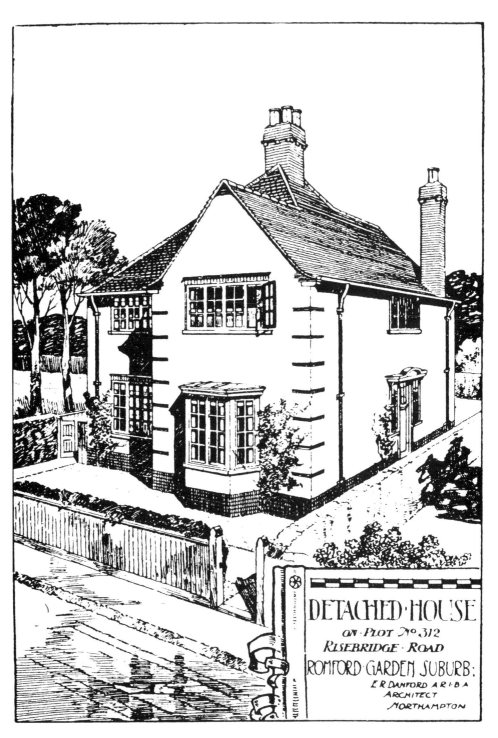

DETACHED·HOUSE
ON·PLOT №312
RISEBRIDGE·ROAD
ROMFORD·GARDEN·SUBURB:
E·R·DANFORD·A·R·I·B·A
ARCHITECT
NORTHAMPTON

Romford Garden Suburb: Class I house in Gidea Park, from the Exhibition Catalogue.
Architect: E. R. Danford. Builder: G. F. Sharman.

2 The Garden City

SIMON PEPPER

Introduction

In 1898 Ebenezer Howard – a self-educated and previously unknown shorthand clerk for Gurneys, the Parliamentary recorders – published his visionary pamphlet, *Tomorrow: A Peaceful Path to Real Reform*. It was to be republished under the better known title *Garden Cities of Tomorrow* in 1902, and quickly translated into French, German, Italian and Russian as Garden City Associations sprang up across Europe to promote his ideas on the development of self-contained, low-density settlements which would combine the best features of town and country. By 1903 a pioneer company had been formed to build the first English garden city at Letchworth, in Hertfordshire. Three years later, a second front was opened at Hampstead Garden Suburb, providing Londoners with their most accessible example of the new approach to planning. By the eve of the First World War there was scarcely a major British city without its own leafy development of picturesque cottages with gardens, perhaps with communal tennis courts or club, but always claiming allegiance to 'garden city principles'.

Most of these claims would have been resisted by the purists of the English Garden City and Town Planning Association. For Howard's vision of the ideal garden city projected a view of a total environment and a new urban society which was more radical than any surburb, however attractive. Restricted in size to 6,000 acres, the Garden City proper was to occupy 1,000 acres, the rest of the land being given over to the industry and agriculture needed to sustain a largely self-sufficient and self-governing community. Its population was to be limited to 32,000 inhabitants, representing a complete cross-section of society. Land was to be owned, developed and controlled on a co-operative basis, with home ownership under the leasehold system, but with the profits of land betterment ploughed back into the community chest. Howard thus saw the garden city in social, economic and political terms – a 'social city' as he termed it. Each component had its precedent in a tradition of utopian literature that extended back from William Morris's *News from Nowhere*, to the Renaissance, and beyond. From this tradition was assembled what Howard himself called a 'unique combination of proposals'.

His idea was promoted by a unique combination of politicians, social reformers, and enlightened industrialists as well as temperance campaigners and assorted do-gooders whose participation opened the door to much gentle ribbing. Thus Osbert Lancaster:

... rows of quaint and whimsy cottages ... appeared in the northern suburbs of London in clusters, which their builders considered themselves justified (by the presence of two sunflowers and a box hedge) in calling garden cities ... From surroundings such as these did the New Woman emerge to bicycle off to an interesting meeting of the Fabian Society.

The libel travelled well enough for Sinclair Lewis to saddle the heroine of *Main Street* with the ambition of transforming Gopher Prairie, Minnesota, by means of 'village green, and darling cottages, and a quaint Main Street!' As Carol Kennicott (New Woman of the Middle West) put it, 'Why should they have all the garden suburbs on Long Island?'

In fact cranks were far outnumbered by those who appreciated that Howard's proposals contained within them the potential for real advances in planning and housing provision. After a century of uncontrolled urban growth, bye-laws had been passed by most local authorities which laid down minimum standards for houses, roads and drains which – while banishing the horrors of back-to-backs, courts, and cellar dwellings that had shocked the

The Three Magnets diagram, from Ebenezer Howard, Garden Cities of Tomorrow *(1902)*.

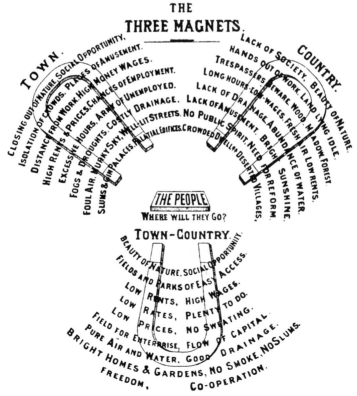

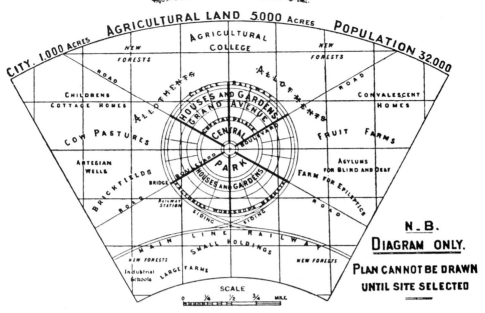

Diagram of the Garden City in its Agricultural Belt; no Garden City like this was built.

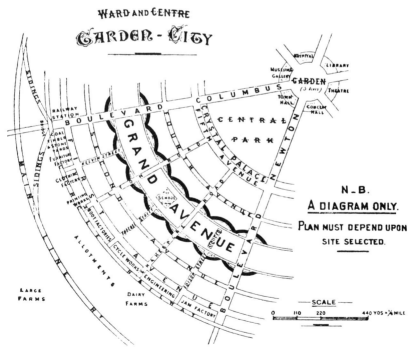

Diagram of a segment of the Garden City showing a residential ward, focused on the school: civic buildings surrounded by the central park and glazed arcade; and the peripheral industrial zone.

mid-Victorian sanitary reformers – imposed a residential streetscape of appalling monotony. On the expanding urban frontiers narrow-fronted terraced houses faced each other across bare streets, and looked out from overshadowed rear windows into tiny yards and narrow back alleys. For the wealthy few, the new railway network offered an escape to the small country houses that so impressed foreign visitors. The garden city, or the less ambitious garden suburb, promised space, trees and small cottages with gardens to a far wider section of the community. And it did so at a time when the link between slums and the poor health of the nation had been highlighted by the numbers of would-be recruits for the South African War who had been rejected as unfit for active service.

It was this connection with housing reform that attracted the backing of men such as John Burns, MP, President of the Local Government Board (the ministry then responsible for housing, planning and health, as well as local government), and Lord Northcliffe, proprietor of the *Daily Mail* and a leading publicist of domestic improvements through his 'Ideal Home' Exhibitions. Industrialists had for many years recognised the value of good housing in securing a stable, healthy and disciplined workforce and it was this that ensured the support of William Lever in Merseyside, George Cadbury in Birmingham and Seebohm Rowntree in York – all of whom were engaged in providing what amounted to industrial garden villages for their employees. Sound principles of estate development appealed to the commercial instincts of landlords. Self help, of course, appealed to Liberals and Conservatives. The social idealism (even the proletarian origins of the founder) would prove attractive to left wing national and city governments seeking appropriate models for mass housing following the First World War. The garden city idea could be nearly all things to all men.

The Garden City movement

Letchworth

To the pragmatic British the best advertisement for Howard's ideas was the fact of Letchworth, the existence of a demonstration scheme, built by privately raised funds on 1,300 of the 3,826 acres acquired by the joint stock company in 1903. Building began in 1904 on the competition-winning plan devised by Raymond Unwin and Barry Parker (architects for Rowntree's New Earswick garden village). Many other designers also contributed to the irregular, vernacular, Arts and Crafts architecture which was the hallmark of Letchworth and the dominant style of most subsequent garden suburbs. Letchworth's layout, however, shows respect for the formal order of the City Beautiful movement, which had dominated American planning since the Chicago World Fair of 1893. In place of the tight bye-law street grid, Unwin and Parker had the tree-lined main roads radiate from the centre, intersecting with circumferential avenues to form huge housing blocks with room for generous front and back gardens and a wide variety of semi-detached houses and short terraces. There was space for larger buildings too, including new

Family housing, 35–37 Baldock Road, Letchworth (1905); among the earliest houses built in Letchworth Garden City. Architect: H. Clapham Lander.

Meadow Way, Letchworth: housing for businesswomen, with communal facilities, built by the Howard Cottage Society Ltd (1916).

departures in residential architecture such as the collegiate block of flats for single businesswomen, with shared dining and common-room facilities, designed by Courtney Crickmer. Factories were located to the east (so that the prevailing wind would carry away their smoke) and served by sidings from the main railway line which ran through part of the garden city.

Because of chronic under-capitalisation, progress at Letchworth was painfully slow. Indeed, many of the civic buildings planned for the centre

were never built, and by 1914 the 'city' supported a population of only 9,000. It was the growth of wartime industry on the northern approaches to London, and the post-war subsidised housing estates, that rescued the pioneer enterprise at Letchworth and in 1920 created the opportunity for a second garden city foundation at nearby Welwyn. Only after a second world war would the dreams of Ebenezer Howard be properly fulfilled in the New Town programme and Green Belt legislation, both conceived on a scale that promised to control – perhaps to reverse – the expansion of existing cities (see Chapter 4, 'The New Towns', in volume 9 of this series). Until then garden city ideals were represented in this country by Letchworth and Welwyn, and by dozens of more modest suburban developments.

Hampstead Garden Suburb

Hampstead Garden Suburb was founded in 1906 by Henrietta Barnett on a site overlooking the Hampstead Heath Extension, which she herself had campaigned to preserve. Mrs Barnett was also interested in improving society. She aimed both to provide new homes for the East End slum dwellers her husband had been helping at Toynbee Hall for the previous twenty years, and to reverse what she regarded as the socially damaging trend towards the physical separation of the classes. Hampstead Garden Suburb was intended to be a socially mixed and harmonious community of some 8,000 people on the 240 acres which Mrs Barnett's trust had purchased from Eton College. The more expensive properties would be sold outright or (more commonly) rented for upwards of £100 a year. There were also to be cottages renting for as little as six shillings a week, whose occupants could enjoy 'a sense of home life and an interest in nature' and still afford the journey to work in central London, assisted by twopenny fares on the newly opened tube extension to Golders Green.

It has to be said that very few ex-slum dwellers found themselves living in Hampstead Suburb until, with Letchworth and Welwyn, the project benefited from the state-subsidised council housing drive which followed the First World War. Until then low-rental accommodation was provided by what were known as public utility societies; development companies which undertook to limit dividends to five per cent, and were permitted to borrow half (later two-thirds) of their capital from the Public Works Loan Board. The rest of the capital would be raised by selling loan stock and by requiring tenants to purchase £50 worth of shares in the company (which was about what an unskilled worker earned in a year). Much the biggest and most successful of these companies was the Co-partnership Tenants Limited, an association of local affiliates, which by 1910 had raised over £100,000 in investment capital and was able to offer planning expertise, bulk purchased building materials, and a scheme whereby its tenants could obtain their £50 shares by instalments (the dividend on the first acquisitions being paid in shares). Even the cheap housing at Hampstead was open only to those already in a position to help themselves.

Hampstead emerged as much the most architecturally distinguished of the southern developments. While Barry Parker remained to supervise

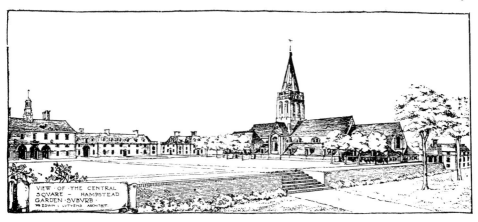

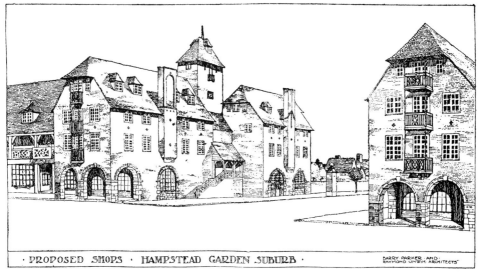

Hampstead Garden Suburb: (top) Edwin Lutyens's St Jude's Church and central square; (bottom) Arthur Penty's shops and flats at the Fortune Green entrance to the garden suburb. From Raymond Unwin, Town Planning in Practice *(1909).*

development in Letchworth, Raymond Unwin moved to London to co-ordinate the planning of the new project and to exercise much tighter architectural control over the many designers. Shops were built on the western boundary of the suburb along Temple Fortune road, where A. J. Penty designed distinctly Germanic brick and timbered blocks, with arcades screening the shopfronts, raking staircases, clock towers, and as many as three tiers of dormer windows in the steeply pitched roofs. Baillie Scott's design for Waterlow Court (another block of flats for single women) continued the central European idiom, while the earliest small family houses retained the Old English vernacular of Letchworth with all of its labour-intensive and expensive complexity. But the hill top central area of the suburb is its masterpiece.

Here from 1910 Edwin Lutyens laid out, not a village green, but a formal

The Garden City Method of Development.

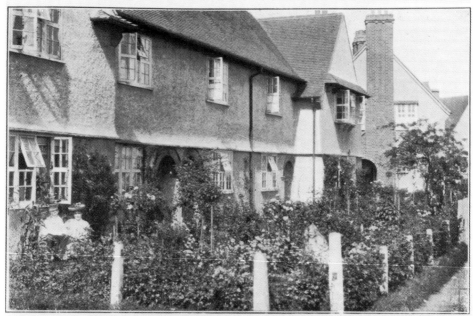

FRONT GARDENS TO HOUSES UNDER TOWN PLANNING.

The By-Law Method of Development.

ORDINARY SUBURBAN VILLAS, SHOWING AMOUNT OF SPACE FOR FRONT GARDEN.

Hampstead Garden Suburb and Speculative Development Compared, from Raymond Unwin's pamphlet Nothing Gained by Overcrowding *(1912). The upper photograph is of Hampstead Way, built in 1907.*

close, framed by ranges of the much simplified neo-Georgian terraced houses that were already seen by the more sophisticated housing architects (headed by Raymond Unwin himself) to offer the best and cheapest model for collective housing. On the east side of the close were placed the institute and the schools, while in the centre rose Lutyens's two churches, the Free church with its dome, the Anglican with its steeple. Seen from across the Hampstead Heath extension, dome and steeple rise over a marvellously picturesque ensemble that is bounded on this side by a vestigial city wall (the towers of which form summer houses and garden sheds for the properties behind). Most of it had been built in ten years, but it looked as if it had grown up over centuries.

The quickest way to develop a garden suburb was to hold a combined housing exhibition and competition; which involved building the entries and judging the results after completion (a very different proposition from the paper schemes of today). Following the exhibition the properties would be sold. Cheap housing exhibitions in 1905 and 1907 had helped Letchworth get started, and in 1911 the public was invited to visit no less than 140 show houses laid out in the grounds of Gidea Hall, in Romford, Essex.

Romford Garden Suburb (Gidea Park)

The Romford Garden Suburb, or Gidea Park as it is known today, was the inspiration of Sir Herbert Raphael, MP, who had planned the exhibition as the first stage of a development scheme for 450 acres of recently acquired

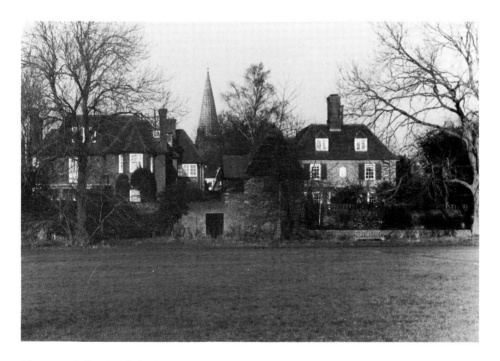

Hampstead Garden Suburb: the city wall and St Jude's spire from the Heath extension.

land. Prizes were offered for the best detached houses in the £500 and £375 cost brackets, which removed any lingering doubts about the philanthropy of his motives. These were middle-class homes. Many of them were good of their kind, but the overall effect of so many different designs struck one critic as 'if not exactly "higgledy-piggledy", . . . at any rate, abnormally picturesque'. Raphael's promotional tactics were unusual too. John Burns MP, the minister, opened the show and served as President of the Exhibition Committee, with a Vice-Presidential cast of dozens, including the Archbishops of Canterbury and Westminster, Lord Curzon, General Baden-Powell, Sir Hiram Maxim, H. G. Wells and the Poet Laureate. Special trains carried visitors from Liverpool Street to the newly-opened Squirrels Heath station, 200 yards from the site. Admission was free and for one shilling (profits to Kings College Hospital) househunters obtained the 150 page guide book containing plans and perspectives of the 'Hundred Best Houses' together with homilies from many of the Vice-Presidents on the theme: 'What is wrong with your house and how it is to be bettered.' Some of the advice was very sensible. The exhibition was successful enough to be repeated on another part of the estate during the 1930s, when some daringly modern concrete houses again found buyers. At Gidea Park, property developers and the evangelical wing of the Garden City Movement marched hand in hand.

Romford Garden Suburb: Class II house in Gidea Park, from the Exhibition Catalogue. *Architect: Harry E. Rider. Builder: W. J. Fryer & Co.*

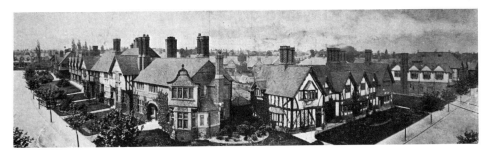

Port Sunlight: houses in Park Road and Bridge Street. William Lever occupied the large brick house on the corner. The Collegium (far right) was destroyed in World War II.

Port Sunlight

A different brand of self-interest motivated the patrons of the industrial garden villages. Port Sunlight had been started in 1888 by William Lever (later Lord Leverhulme) as a company village for the soap factory he was then establishing just outside Birkenhead, on Merseyside. Rowntree at New Earswick, and Cadbury at Bournville did much the same for their chocolate makers; although the later decision to turn the ownership and management of Bournville over to an independent village trust put a more charitable gloss on that enterprise.

By the turn of the century, Port Sunlight had developed sufficiently to become the immediate northern showplace for the nascent Garden City Movement. During the working week Lever himself occupied one of the houses in the original nucleus which included a post office and general store, branch library and institute, and was arranged informally around a sunken park, known as the Dell, just outside the factory entrance. The informality was a virtue born of necessity, however, for the site of Port Sunlight was broken up by a finger-like pattern of tidal creeks which could be filled for landscaping but remained quite unsuitable for building. The housing constructed during the early 1890s was decent working-class terraced stock, mostly with three bedrooms and a single combined living-room-and-kitchen, with baths provided under the scullery worktop. A few four-bedroom houses with separate parlours and bathrooms were provided for foremen and senior clerical staff. They were embellished with elaborate chimney stacks and decorative brickwork, all much improved by the open layout and village amenities. The principal architect was William Owen, of Warrington, who was joined in practice by his sons, Segar and Geoffrey. Later phases, however, employed a variety of architects influenced by current fashions in Arts and Crafts vernacular, Elizabethan, Queen Anne and even touches of countrified neo-Georgian. 'A singularly vivid impression of rusticity was created', noted a contemporary author, 'nothing seems to have been neglected which may produce in the town-dweller the illusion that he has indeed gone back to the land.'

It was an unusually well-serviced version of the rustic idyll. By 1916 Port

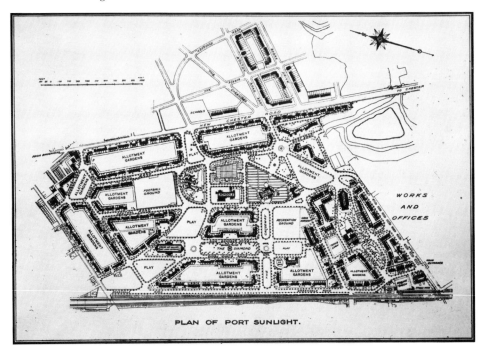

PLAN OF PORT SUNLIGHT.

Plan of Port Sunlight, nearing completion in the 1920s. Note dense early development close to the factory (right) contrasting with open spaces and allotments of the more formal later phases.

Port Sunlight: half-timbered housing block making a 'place' at the junction of two streets.

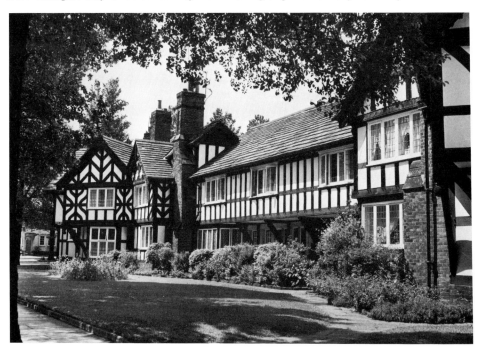

Sunlight's residential area covered 140 acres, and its residents shared a church, Lyceum, two schools, cottage hospital, gymnasium, open-air swimming pool, fire station and the 'Collegium' Hall capable of seating 3,000. After a vote on licensing, the Bridge public house had been opened, with rooms where non-alcoholic drinks and food would be served (a compromise devised to meet the objections of the dry lobby, which included Lever himself). At the centre was the Diamond, a landscaped space laid out in 1910 on formal City Beautiful lines following a competition (won by Ernest Prestwich, a third-year student) at the nearby Liverpool School of Architecture, where Lever had endowed a new chair in Civic Design. The completion in 1922 of the classical Lady Lever Art Gallery and the splendid War Memorial effectively ended the development of a garden village with social and cultural facilities that would have been the envy of much bigger towns.

*Liverpool Garden Suburb, Wavertree (bottom) and the dense bye-law development that might have been used on the same site (top). (*The Builder, *5 July, 1912).*

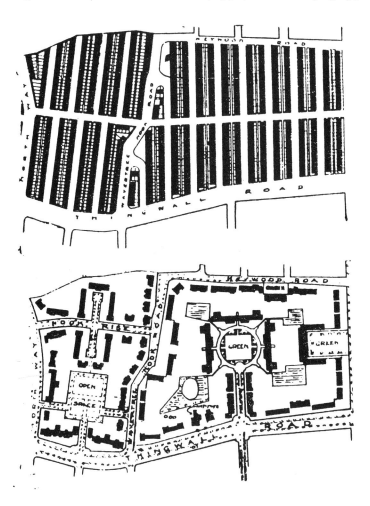

Liverpool Garden Suburb

On the other side of the Mersey, the Liverpool Garden Suburb was more representative of the kind of scheme to be found on the fringes of so many great Edwardian cities.

In 1910 the Liverpool Garden Suburb Tenants Limited, an affiliate of the Co-partnership Tenants, obtained an option on a 999 year lease of 185 acres owned by the Marquis of Salisbury. The site was served by the stations of two railway companies, and was divided by Queen's Drive, the dual-carriageway 'boulevard' and tramway route which the City Engineer was constructing through Liverpool's suburbs. Ideally located for housing development, the completed estate would contain some 1,900 houses with an estimated total value of £500,000 – making it much the biggest of the Co-Partnership's enterprises. The society's under-secretary was despatched to Liverpool to take charge of this operation and two other projects in Manchester and Chester. Applications were invited for 5,000 £10 shares, and for four per cent loan stock to the sum of £100,000. Plans for the entire estate were to be the subject of yet another student competition at the University, but before this could be arranged Raymond Unwin was engaged to plan the layout for the first phase of some seventy dwellings at the junction of Thingwall and Wavertree Nook Roads.

April 1911 saw the launching of the provisional Tenants' Council at a meeting attended by thirty of the residents. A spokesman from the society explained that 'living in a co-partnership suburb did not mean being isolated tenants, but that the whole of the social and recreative life of the estate would be managed by the tenants themselves'. A committee of four men and four women was deputed to draft a constitution for the Tenants' Council, which would be their formal link with the Board of Directors. The rest of the meeting then proceeded to discuss the design of their flag! The constitution set down rules for a Council of ten elected by all residents aged over twenty-one. Committees were also formed to run the tennis, chess and bowling clubs, the children's playground, ladies' group, open-air village parliament, and social institute. It was to be a brave new collective suburban life style, with a magazine – *Co-Partnership* – to chronicle its dramatic offerings, gardening competitions, maypole dancing and politics. The first Council election was held on 8 June, 1911, with all ten candidates returned. unopposed, 'to the regret of those ardent spirits who delight in a keen fight'.

By 1912 the design of the project had been taken over by G. L. Sutcliffe – another of the society's consultant architects – and 126 houses completed on the parcel to the west of Queen's Drive. The optimistic plans for 1,900 houses evaporated during the First World War, but the first two phases survive as a classic Arts and Crafts garden suburb.

The key feature of Unwin's planning ever since Letchworth had been the use of large blocks, giving an extensive roadside perimeter along which well-lit wide-fronted cottages could be set out at a density of no more than twelve houses to the acre. Extra plots were gained by placing buildings around three sides of 'greens'. There was also space to step back individual houses or entire blocks of terraces, giving longer front gardens, and making a much

more interesting view along the staggered block – the complex 'street picture' that was so important to Arts and Crafts architects. The land in the centre of the block was then exploited by cul-de-sacs, or even complete 'greens' of houses reached by lower grade access roads, known as carriage streets. The technique is explained at length in Unwin's *Town Planning in Practice* (1909), but the Liverpool plan was singled out for illustration by Stanley Adshead (first Professor of Civic Design at the University), who contrasted it with the tightly packed rows of bye-law terraces that would otherwise have covered the same site at forty-one houses per acre.

Unwin's low-density planning was justified on economic as well as aesthetic grounds in a widely distributed pamphlet entitled *Nothing Gained by Overcrowding!* (1912). The argument turned on the costs of land and the costs of its development by means of roads, drains and other expensive services. In central areas, high land costs dictated high density; but on relatively cheap suburban sites, better 'value' was obtained from slightly more expensive but very much nicer low-density solutions. In the suburbs, he argued, thirty-four houses to the acre would give a house plot of 83 square yards for a ground rent of eightpence a week: while a density of only fifteen to the acre would treble the plot size (to 261 square yards) but only increase the ground rent to a shilling because of the much reduced site development costs. Of the superior environmental quality of the garden suburbs, he had no doubt. Nor it seems, did the next generation of speculative house-builders and their customers. For the low-density cottages with gardens pioneered by Unwin and his confreres in the Garden City Movement became the model for both private enterprise and council estates in the great house-building drives of the inter-war years.

An early wind-up gramophone.

3 Music

MICHAEL KENNEDY

Introduction

From whatever cause, the art of music blossomed anew in Britain as the
nineteenth century drew to its end. Not only was this the case where
composition was concerned: performance, teaching and scholarship also
attained new and higher standards. By the time Queen Victoria died in
January 1901, Britain had, in Edward Elgar, a composer who was attracting
the attention of the most distinguished international conductors and
executants. But to imagine that Elgar preceded some of his contemporaries in
doing so is to distort the perspective of history. True, he can plainly now be
seen to stand head and shoulders above the rest, but the operas of Stanford
and Ethel Smyth were performed in Germany more frequently than in
Britain at this date; and there is the special case of Delius, a Yorkshireman
who settled first in America and then in France, and won a high reputation
in Germany in the early years of the twentieth century before he had any
kind of following in his native country.

If we accept that the nineteenth century really ended in 1914, with the
outbreak of the First World War, then the musical period 1901–45 supports
this interpretation of events. Although some major figures bestride the
Edwardian and post-war years, hardly any of them continued to write the
same kind of music; one may perceive an almost total emotional fracture in
some cases, notably in the work of Elgar and Frank Bridge. No distinct single
pattern can be traced for the development of British composers of this period.
It is a sign of health that there are many diverse patterns. If some found their
salvation in folk-song, others found it in a rejection of such a nationalistic
stance and looked abroad, as their predecessors had done in Tudor and
Jacobean times, absorbing and selecting influences to suit their own needs
and personalities.

Where any pattern can be said to exist, it is in a parallel with literature.
Britain produced its 'Georgian' composers as counterparts of the 'Georgian'
poets. The 'pastoral school' of English composers, personified by Ralph
Vaughan Williams, has a unifying thread in its devotion to setting the poems

of A. E. Housman and, rather less extensively, those of Thomas Hardy. The nostalgia for a vanishing rural Britain, its traditions as well as its landscape, which these and other poets expressed, was echoed by composers, for many of whom folk-song became the musical symbol of their nostalgia. Urbanisation, it was believed, was killing off such simplicities; the next generation was not interested in learning folk-songs, and many of the agricultural tasks which they were designed to accompany and lighten were in any case becoming mechanised. This proved to be a faulty prognosis because the tunes also migrated to the towns and to industry, but it scarcely mattered, since a rich harvest of traditional songs was gathered, in many regional variants, at this particular moment in their continuing meta- morphoses on the lips of successive generations.

One is cautious about ascribing the richness of British music in the period 1901–14 to any special dispensation granted to the United Kingdom from Mount Olympus, since there have been few more prolifically creative periods in the European arts generally. Britain merely had its slice of a particularly spicy cake. No composer, except for the inhabitant of a hermetically sealed ivory tower, could be deaf or impervious to the copious influences on offer. To replace the influences, powerful enough in all conscience and then still being imperfectly absorbed, of Wagner, Brahms, Verdi, Dvořák and Tchaikovsky, the first decade of the twentieth century offered the operatic realism of Puccini and Mascagni, the tone-poems and early expressionist operas (*Salome* and *Elektra*) of Richard Strauss, the symphonies of Mahler, the *Nocturnes*, *La Mer* and *Pelléas et Mélisande* of Debussy, the *Miroirs* of Ravel, the first symphonies of Sibelius, the piano concertos of Rachmaninov, Stravinsky's ballets for Diaghilev, culminating in the shock-horror of *The Rite of Spring*, and for those with ears especially finely tuned to the future, there were the *Five Orchestral Pieces*, the *Three Piano Pieces*, op. 11 and *Pierrot Lunaire* of Schoenberg and the early works of Berg and Webern. Only in Hungary, in the music and researches of Bartók and Kodály, was there anything comparable with the English folk-song revival. In literature and painting, too, the formative figures of the twentieth century were already at work. In some cases they linked hands with music, either in providing texts (like Hofmannsthal) or by association with Diaghilev's Russian Ballet, where the music of Stravinsky, Falla, Ravel and Debussy was danced against backcloths painted by Picasso, Bakst, Benois and Utrillo.

Just how deeply music has ever entered into the British consciousness is a matter for long and ultimately fruitless speculation. 'The British don't like music, they just like the noise it makes', said the cynically witty Sir Thomas Beecham with more than a grain of truth. What remains inescapably true is that the British are extremely chary of their own music, and although throughout the twentieth century there has always been a passionate minority championing the cause of British music, a minority it remains. Elgar and Britten were both convinced that the British were essentially philistine where music was concerned, even though they were both fortunate enough to enjoy lucrative popular success. Taking the widest view, it would be true to state that the musical voice of England in the Edwardian age was not Elgar but the composers of the music-hall songs which were whistled in the streets and sung in the pubs.

If it was a hard row for the composer to hoe in 1901, it was even more difficult for the executive musician. Apart from a few singers, scarcely any British musician enjoyed an international reputation. The pianists, violinists and cellists who played in the Queen's Hall and the Royal Albert Hall were foreigners, as were the vast majority of conductors. Except for Sir Henry Wood, there was no front-rank conductor of British birth when the twentieth century opened. Wood's Promenade Concerts, founded in 1895, educated and elevated public taste by gradual degrees. Both at these concerts and at those he gave with the Queen's Hall Orchestra, Wood introduced dozens of new works by British and other composers. Until the advent of the BBC he was the biggest single formative influence on public taste in orchestral music. Some composers were good conductors of works other than their own, notably Frederic Cowen, but when Sir Charles Hallé had died in 1895, the triumvirate of businessmen who took over his orchestral concerts in Manchester used Cowen merely as a stop-gap while they looked abroad, to Vienna, for his successor. Although it took four years of negotiations to lure Hans Richter from the Vienna Opera to the Free Trade Hall, he came (he was, in any case, no stranger to Britain, having given regular series of concerts in London and the provinces since his first visit with Wagner in 1877). When he retired, in 1911, even though Thomas Beecham and Landon Ronald had joined Wood as outstanding native conductors, the Hallé committee still went to the continent for its next conductor, Michael Balling. At Covent Garden, Percy Pitt was the only bearer of an English name to occupy the conductor's chair until, in 1910, Beecham arrived, his wealthy father having agreed to finance ventures which included the first London performances of Strauss's *Salome*, *Elektra* and *Der Rosenkavalier*.

With the outbreak of the First World War in 1914, anti-Teutonic sentiment flourished and the age of the foreign maestro was over. Beecham was indefatigable in his work for Manchester, Liverpool, Birmingham and other provincial cities, and his sway over London orchestras was paramount. When private financial considerations compelled him in 1920 to withdraw from the musical scene for four years, he was able to recommend Hamilton Harty to the Hallé. Between 1918 and 1925 four younger men emerged, Adrian Boult, Eugene Goossens, Malcolm Sargent and John Barbirolli, who were to dominate the British conducting scene for the next half-century.

Alongside the conductors came the executants, the violinists Albert Sammons and Arthur Catterall, the pianists Solomon, Harold Samuels, Myra Hess and Clifford Curzon, the violist Lionel Tertis, the oboist Leon Goossens, the bassoonist Archie Camden, the clarinettists Charles Draper, Frederick Thurston and Reginald Kell, and the horn-players of the Brain family. At last the seeds of improved teaching at the music colleges were beginning to germinate. The Royal College of Music had a number of illustrious pupils in spite of teaching methods and conservative attitudes that would be universally deplored today, and the Royal Academy of Music gradually shook off its Victorian notoriety when, as Cyril Ehrlich has written, teaching procedures were described as 'chaotically unco-ordinated and incompetent'.

Since 1893 Manchester had been a centre of musical education, with the foundation by Hallé of the Royal Manchester College of Music. On his

death in 1895, the Russian violinist Adolph Brodsky became principal until 1929 and was remarkably successful in attracting musicians of the quality of Wilhelm Backhaus and Egon Petri to its teaching staff. Birmingham's School of Music flourished under Granville Bantock after 1900, and London's two other music colleges, Trinity and the Guildhall School, attracted a wide range of students, the latter being under the direction of Landon Ronald from 1910 to 1938. Nevertheless, an amateur approach to music persisted in the work of many of these establishments. Teachers' prejudices were too often the guiding-spirit and an inquiring mind was discouraged. Thus, students at the Royal Academy of Music in about 1912 had to rehearse Ravel's string quartet in the lavatories because such music could not be allowed in the practice-rooms. At the RCM in the 1930s, Benjamin Britten's request for a score of Schoenberg's *Pierrot Lunaire* to be acquired by the college library was contemptuously rejected and earned him a reputation as a dangerous radical.

Throughout most of the period under review here, national or municipal subsidisation of music and musical events was a rare, almost unheard-of, occurrence. The colleges were not the recipients of massive grants-in-aid. Although Bournemouth in 1897 took over the band Dan Godfrey had founded in 1893 and became its employer, no other British city spent ratepayers' money on music until in 1920 Birmingham contributed £1,250 to a newly-formed orchestra, the City of Birmingham Orchestra, doubling this sum five years later after Boult had been appointed conductor. Here the enlightened attitude of Neville Chamberlain was a beneficent influence. Manchester contributed a sum for schoolchildren's concerts by the Hallé in the 1930s but did not subsidise the orchestra's main concert series until 1944, when Barbirolli had been appointed conductor and was crusading for its proper recognition as a major municipal asset.

From the vantage point of today, when London has at least four symphony orchestras of international standing, the orchestral scene in the capital at the turn of the century seems unbelievable. Only the Queen's Hall Orchestra, conducted by Henry Wood, had any kind of homogeneity. The opera orchestra at Covent Garden and any other orchestras drew on a pool of players and were, therefore, ad hoc. Probably some of these players were from the Queen's Hall Orchestra, for this was the period of the pernicious 'deputy system', when a player who might have played at the rehearsals for a concert could, in the evening, send a deputy while he accepted a more lucrative engagement elsewhere. He paid his deputy, therefore, and still made a profit. The effect of this custom on orchestral standards can easily be imagined; Wood fought against it for years and eventually, in 1903, insisted that his Queen's Hall players should have a clause in their contract forbidding them to send deputies. The result was that a large number broke away and, in 1904, formed a new self-governing orchestra, the London Symphony. Outside London, where the attractions of a choice of engagements were fewer, orchestras were spared the deputy system. Thus, the Hallé maintained a steady personnel who regularly rehearsed and played together.

The 1920s represented the nadir of orchestral standards in London. Harty

Sir Henry Wood conducting a Promenade Concert at The Royal Albert Hall (1942).

in Manchester from 1920 to 1933 and Boult in Birmingham from 1924 to 1930 set standards appreciably higher than those of London orchestras. Visits to the capital by Harty's Hallé and later by Furtwängler's Berlin Philharmonic and Tosconini's New York Philharmonic led to the urgent realisation that London must have a new orchestra capable of rivalling the best in Europe. To the chagrin of almost every concert-giving organisation in the land, the new orchestra was provided by the British Broadcasting Corporation in 1930. Invasion of the public domain by the BBC was deeply resented – it was strongly felt that the BBC Symphony Orchestra should stay in the studio and not compete in the open market-place. During the planning-stage of the new orchestra – 119 strong – there was a possibility

that the conductor might have been Beecham, but the BBC became as wary of him as he of it, and the post went, after the first season, to Boult. Not to be outdone, Beecham found private patronage to enable him to create the London Philharmonic Orchestra in 1932. This, too, rapidly established itself in the forefront. Thus, within two years, a transformation had occurred.

Broadcasting, as is obvious today, provided the biggest opportunity for the musical education of the public. An individual or a family could hear symphony concerts and operas in their own home for the cost of a licence of a receiving-set. Yet the fear of the public concert organisations was that their livelihood would disappear: why, they argued, should anyone venture out on a winter's night to attend a concert when they could stay by the fire and hear one? As we now know, broadcasting stimulated an interest in music so that more people attended live concerts. It also led to enlargement of the repertoire. A new, rare, or difficult work could be broadcast, which no orchestra wholly dependent on the box-office would have dared to include in a programme.

The BBC, with Percy Pitt as its first director of music, was active in promoting music in the eight years between its foundation in 1922 and the formation of its Symphony Orchestra in 1930. The first act of Mozart's *Die Zauberflöte* was relayed from Covent Garden in January 1923; concerts from London, Birmingham and Manchester were regularly broadcast from the same year. The BBC's own 'augmented wireless orchestra' gave a series of public concerts in the Central Hall, Westminster, in 1924 (Elgar conducted one of them). A year or two later it promoted a series of 'national concerts' including such novelties (at that date) as Schoenberg's *Verklärte Nacht* and Honegger's *King David*. The cause of contemporary music was strongly pressed by Edward Clark, who at first was in charge of the BBC's station in his birthplace of Newcastle-upon-Tyne, but in 1924 moved to London to assist Pitt. It was through his contacts with the European avant-garde that such leading figures as Schoenberg, Webern, Ansermet and Hermann Scherchen could be persuaded to conduct for the BBC. Richard Strauss also conducted his own works for British broadcasting. In 1927 the BBC assumed responsibility for the Promenade Concerts – not without severe misgivings on the part of Sir Henry Wood – when Chappell and Co, lessees of Queen's Hall, could no longer provide financial assistance.

It was not only through the relaying of music that the BBC, under its Director-General Sir John Reith, undertook to educate listeners; it soon initiated talks on the subject and in doing so discovered the first 'natural' broadcaster connected with the arts. He was Sir Walford Davies, then professor of music at the University of Wales and later organist of St George's Chapel, Windsor. His long-running series *The Foundations of Music* began in 1927 and earned him the gratitude of thousands for whom his easy, un-pompous style of dress opened vistas to which they were previously blind. Victor Hely Hutchinson and Alec Robertson were others in a similar mould (the tradition is continued to this day by Antony Hopkins).

Running rather ahead of the public taste of the day was the Sunday evening series of J. S. Bach's cantatas which began in 1928. The BBC had formed its own 'wireless chorus' four years earlier. Boult succeeded Pitt as

Head of Music in 1929 and it was with the formation of the BBC Symphony Orchestra that the most ambitious plans were fulfilled. Its high standard of performance attracted to its studio (and its public concerts) the cream of the world's conductors – Strauss, Bruno Walter, Felix Weingartner and eventually Arturo Toscanini. Smaller regional symphony orchestras were established, first the BBC Northern in Manchester in 1934, then the BBC Scottish (Glasgow) and BBC Welsh (Cardiff) in 1935. These were augmentations of existing smaller studio ensembles.

After that first Mozart relay, the BBC frequently broadcast opera from Covent Garden, though not without considerable difficulties relating to finance, the refusal of certain singers to be broadcast, and the machinations of Beecham. Nevertheless, listeners heard Wagner's *Siegfried*, Mozart's *Le Nozze di Figaro* and Strauss's *Der Rosenkavalier*. An opera from Glyndebourne was first broadcast in 1935, the Sussex opera house's second season, and Sadler's Wells and the Old Vic were also the venues for broadcasts. The first opera produced in a BBC studio was Gounod's *Roméo et Juliette* in October 1923. Others followed – among them the same composer's *Faust*, Massenet's *Manon*, Vaughan Williams's *Hugh the Drover* and Smetana's *The Bartered Bride*. When television broadcasts began in 1936, opera was an obvious candidate for transmission and in the three years until the service was suspended because of the outbreak of war in 1939, nearly thirty operas were produced, including Busoni's *Arlecchino* and Puccini's *Gianni Schicchi*. The second act of Wagner's *Tristan und Isolde* was televised in 1938.

Yet broadcasting was not the first important 'mechanical' aid to music of the century. The invention of the gramophone record, enabling a performance to be preserved and a work to be studied, had still not been fully exploited by the time the BBC Symphony Orchestra was founded. The tenor Enrico Caruso began to make records in 1902 and was the first serious musician to realise both the artistic and commercial capabilities of the invention. Others followed him. The first composer to recognise the importance of the gramophone for education as well as for preservation was Elgar. He encouraged it from the start, and in 1914 first went into the recording studio to conduct one of his own short pieces. In the remaining twenty years of his life he conducted several of his major works for the gramophone and he agreed that his Third Symphony, alas never to be completed, should be recorded *before* its first public performance. Although both Stravinsky and Strauss made recordings of their own works, credit for being the first to appreciate the gramophone's place in music belongs indisputably to Elgar.

Another contributory factor in the twentieth-century revival was the emergence of a more scholarly and specialist group of critics working for daily newspapers as well as for periodicals. Shaw's brilliant, caustic and inimitable writing on music in the 1880s and 90s paved the way for the 'new school' of critics like Ernest Newman (first in Manchester, then in Birmingham and London), Arthur Johnstone (in the *Manchester Guardian*), J. A. Fuller Maitland and H. C. Colles (in *The Times*), Samuel Langford (who succeeded Newman in Manchester), A. J. Sheldon (in Birmingham),

Herbert Thompson (in Leeds), and later Neville Cardus (in Manchester).

If the emergence of Elgar after 1901 dominated English music, we do him an injustice if we regard him as a figure in isolation, set apart from his contemporaries. He was the greatest of his period, but he was not an Everest set among foothills. 'The English can only recognise one of their own composers at a time', Sir Hubert Parry (1848–1918) ruefully remarked on one occasion. 'First it was Sullivan, now it's Elgar.' Because their reputations were established long before Elgar's, as discussed in Volume 7, we tend to forget that Parry and Stanford were his contemporaries, Parry nine years older and Stanford five. Both continued to turn out a large number of compositions after 1900, and Stanford was also much in demand as a conductor (he directed the Leeds Festival for some years). The 'modern cacophony' as represented by Strauss was anathema to him. Although his five *Songs of the Fleet* of 1910, for baritone, chorus and orchestra, are of striking inventiveness and vigour, his music tends to suffer from the emotional inhibitedness and dread of vulgarity that made him suspicious of some of Elgar's work.

Parry, on the other hand, while he may have lacked Elgar's genius, notably his melodic gifts, was a composer of considerably higher stature than has been granted him in the years since his death. In his last years, from 1901 to 1918, he wrote some of his finest music, much of which is only now being re-discovered. He virtually abandoned the biblical texts of his earlier career for a series of humanistic works of which *A Vision of Life* (1907) aroused Elgar's enthusiasm. Another, a 'symphonia sacra', was *The Soul's Ransom* (1906), extraordinary in its visionary range, and his setting of *An Ode on the Nativity* (1912) has a flexible grace in the vocal writing and a serene tenderness in the orchestra that make it one of his highest achievements, comparable with the Fifth Symphony of the same year and the *Songs of Farewell* of 1916. Some of the seventy-four solo-songs of his *English Lyrics* (1881–1918) seem to hint in their bleakness at some deep personal unhappiness, another Elgarian trait. Like Elgar, too, he could capture the nation's mood and speak for it in music. His choral song 'Jerusalem' (1916), written two years before he died, has achieved a popularity comparable with 'Land of Hope and Glory' – it is significant that Elgar provided an orchestration for it in 1922, though Parry's own orchestration is superior – and the anthem 'I was Glad', written for Edward's VII's coronation in 1902 and used at each subsequent coronation, can be mentioned in the same breath as Handel as a masterpiece of its genre.

In a lecture on 'the future of English music', delivered in 1905, Elgar expressed his faith in the 'English school' of composition while confessing that he did not know what it was. He felt that 'something is moving' and cited the earnestness and sincerity of 'the younger men'. Over the next twenty-eight years he would hear many of the 'younger men', whose reputations rose and fell in a manner that at least proved that there was now jostling for place in the queue behind him. There would merely be tedium, in a chapter of this nature, in making a series of brief value-judgements on the vast number of British composers who entered the field in the first half of the twentieth century. It is a healthy sign that today's listeners are being encouraged, thanks to eloquent and persistent enthusiasts, to explore the

music of some of the less prominent among them. For Elgar, the 'younger men' of 1905 would have included William Hurlstone and Coleridge-Taylor, both to die young with promise only partially fulfilled, and Joseph Holbrooke and Rutland Boughton, whose inclinations lay with opera, an area which then offered scant encouragement to any native composer. Some critics of the day rated the music of Granville Bantock as high, or even higher, than Elgar's and Elgar himself said he learned some new harmonic tricks from the 'experiments' of Cyril Scott.

The music of Bax, Ireland and Bridge gained a foothold before 1914. The first two, avowed romantics, never fully came to terms with the post-war world, even though they composed the bulk of their music in those years. Bridge, his pacifist principles strengthened by the war, changed direction and went ahead of his time, so that he is highly regarded today while his two contemporaries are 'out of fashion'. We cannot know how George Butterworth, Denis Browne and Ivor Gurney would have developed, for they were war casualties, the last-named surviving in an asylum, but their songs have become a staple part of the English repertoire. Gerald Finzi continued to produce his exquisitely wrought art into the 1950s; he summed up a whole era of British music in 1955 in his aromatically nostalgic Cello Concerto. A lustier strain, owing something to the renewal of interest not only in folk-song but in Elizabethan and Jacobean composers, found robust expression in the music of Warlock and Moeran; a cosmopolitan European sophistication guided the pen of Lord Berners, while its American equivalent, with the accents of Negro jazz, was part of the inspiration of Constant Lambert. Bliss and Howells, Rubbra and Lennox Berkeley, Havergal Brian and J. H. Foulds, Alan Bush – all have their champions and their claim to extended commentary. Rubbra, who was to write eleven symphonies before his death in 1986, completed the first four by 1941. Of these, the Third caused Vaughan Williams to write that it had made him 'fall in love with music all over again'.

Nevertheless, six composers dominated the years until the end of the Second World War and it is to their music that fuller attention will now be given.

Elgar, laureate and poet

The year 1901 was a watershed in the career of Edward Elgar (1857–1934), for it was then that he firmly established himself as the nation's unofficial musical laureate. This process had begun in 1897, the year of Queen Victoria's diamond jubilee, with the *Imperial March*. It continued when, depressed by the performance in October 1900 of his *The Dream of Gerontius*, he returned to Malvern and began to write one of his most exuberant and colourful works, the concert-overture *Cockaigne (In London Town)* (1901), a musical portrait of London in jubilee year, with bands marching through the streets, lovers strolling in Regent's Park, and an evocation of the city's history as symbolised by Guildhall: '. . . looking at the memorials of the city's great past . . . I seemed to hear far away in the dim roof a theme, an

echo of some noble melody'. He described it to his friend A. J. Jaeger, who
worked for Elgar's publisher, Novello's, as 'cheerful and Londony, stout and
steaky', and remarked to the conductor Hans Richter that 'it is intended to be
honest, healthy, humorous and strong, but not vulgar', adjectives that sum up
admirably the beefsteak qualities of this brilliant and lovable work.

The panache of its orchestration, particularly the writing for the brass,
belongs to the Elgarian vein of the *finale* of the *Enigma Variations* of 1899.
With the *Variations* and *The Dream of Gerontius*, Elgar – as shown in
Volume 7 – won the admiration of European musicians and lit the fuse for
the real revival of British music to begin. With the first two of his *Pomp and
Circumstance* marches (1901), he fired the enthusiasm of a wider British
public. They were performed first in Liverpool and three days later in
London. Like Tchaikovsky's third movement in the *Pathétique* Symphony,
they treat the march symphonically besides recapturing something of the
spirit of Schubert's *Marches Militaires*. The D major March (No. 1) had to
be played three times at its first London performance on 22 October (the
Boer War was at its height). 'The people simply rose and yelled', said Henry
Wood, who had conducted. The melody of the trio section, a broad,
essentially melancholy theme, is instantly memorable and it is said that
Edward VII sent a message to Elgar suggesting that the tune would benefit
from the addition of words. Elgar took the hint and embodied it into the
Coronation Ode (1902) he composed for the King. Thus was born *Land of
Hope and Glory*, which quickly became, and has remained, a second national
anthem. Whether he liked it or not, Elgar now had to accept that his tune
had acquired political and nationalistic overtones and that it would associate
his name thereafter in some minds with imperialism and jingoism. It is an
unjust association, for there is a hollow note in the tune and much of Elgar's
music, in the *Ode* particularly, is closer in spirit to Kipling's *Recessional*:

> Far-called, our navies melt away;
> On dune and headland sinks the fire:
> Lo, all our pomp of yesterday
> Is one with Nineveh and Tyre!

The greatness of the tune of *Land of Hope and Glory* and the reason for its
immense popularity lie, I believe, in the sense of nostalgia that it embodies, a
nostalgia more potent than anything A. C. Benson's words can evoke. The
nostalgia Elgar expresses is not nostalgia for a particular period or social
ethos, but for the lost innocence of childhood or for an earthly paradise
beyond our grasp but not beyond our imagining – a nostalgia that never goes
out of fashion. Elgar wanted to escape from his present as much as we do
from ours, and he did so (through his music) into the wand of youth and to
the days of Caractacus on the Malvern Hills, to the chivalry of Froissart and
to Shakespeare's Falstaff. Also to Newman's Gerontius, 'no end of a worldly
man, and now brought to book', as his soul begins its journey toward the
unknown region.

This nostalgic Elgar found ideal expression in 1901 in the incidental music
he wrote for the play *Grania and Diarmid* by W. B. Yeats and George
Moore. This contains a funeral march which Elgar himself described as 'big
and weird', perhaps because its elegiac nobility is tinged by the Celtic

mysticism of the play. 'Elgar must have seen the primeval forest as he wrote', Moore said, 'and the tribe moving among the falling leaves'. Yeats's description was: 'wonderful in its heroic melancholy', a well-nigh perfect summing up of Elgar's music as a whole.

After the triumph of the Marches, the year ended for Elgar with a performance of *Gerontius* in Düsseldorf. This vindicated his belief in his biggest work to date, and it was followed by another performance in the city the following May at the Lower Rhine Festival, with most of Europe's leading musicians present, headed by Richard Strauss who hailed Elgar in a speech the next day as 'the first English progressivist'. When news of this speech reached England it caused resentment in some academic quarters, where Elgar the non-university musician was regarded as something of an outsider and Strauss, in any case, was regarded as the godfather of hideous modern cacophony. But in other quarters it led to a new interest in *Gerontius* and to a realisation that in Elgar, Britain had a composer whose music was taken seriously on the continent.

In his anguish and fury over the treatment *Gerontius* had received in Birmingham in 1900, Elgar declared that his heart was 'now shut against every religious feeling and every soft gentle impulse *for ever*'. But of course it wasn't; and in October 1903 Birmingham was again the scene of a first performance, of the oratorio *The Apostles*, intended to be the first part of a trilogy. Just as *Cockaigne* followed *Gerontius*, so another picturesque and vivid orchestral work followed *The Apostles*. Spending part of the winter of 1903–4 in Italy at Alassio, Elgar captured its passionate warmth and historical grandeur in *In the South*, a tone-poem of Straussian proportions even though designated, like *Cockaigne*, a 'concert-overture'. Of all Elgar's works it is perhaps the most romantically orchestrated, truly 'full of the warm South' and uninhibited in its melodic breadth and prodigality. Its first performance was in London in March 1904 during a three-day festival of Elgar's music given at the Royal Opera House, Covent Garden, each concert being attended by a member of the Royal family. No British composer had hitherto been fêted and honoured in this way, and his knighthood a few weeks later was the inevitable climax.

At the same time he moved from Malvern to a rather grander house in Hereford where he wrote the *Introduction and Allegro for Strings* (1905), one of his finest and most compact works, and worked against time to complete a second oratorio, *The Kingdom*, for the 1906 Birmingham Festival. He was on the verge of a 'nervous' or psychological breakdown while composing what was to be his last oratorio. He no longer went regularly to Mass and his more despondent letters refer to his 'disgust' with the world and his conviction that his music had no value and that the British public's philistinism made his work a waste of time. Foolishly, for a man of his nature – he resembled a thoroughbred racehorse in the sensitivity of his responses – he accepted the specially created chair of music at Birmingham University, suffered agonies from the controversy which followed his strong and pertinent but unpopular criticism (in a series of lectures) of English musical life, and extricated himself from the post as soon as he decently could.

The Apostles and *The Kingdom* have suffered from comparison with the

popular *The Dream of Gerontius*. They are oratorios, modelled on the Bach
Passions, whereas the earlier work is in a category of its own, neither cantata
nor oratorio. In recent years, perhaps as a result of Boult's fine recordings,
the two oratorios have been performed more often and are appreciated in
their own right. They are more diffuse than the intensely dramatic and
concentrated *Gerontius*, but they contain resplendent and striking music. The
opulent and expressive use of the orchestra, in addition to superb choral
writing, is among Elgar's highest achievements and led sympathetic critics
such as Ernest Newman to implore him to abandon the outdated genre of
Victorian biblical oratorio in order to concentrate on purely orchestral works.

The pressures upon Elgar of his public fame undoubtedly took a severe
toll. As a youth he had resented his lack of recognition when he knew within
himself that he was a genius condemned, as he believed, to a provincial
obscurity; now he longed to return to the quiet and peace of those youthful
days. The melancholy that can always be discerned in his music turned, after
1901, into a dark and neurasthenic strain. The sweetness was tainted with
sourness. Yet only a few of his contemporaries, such as Bax, were percipient
enough to hear the unhappiness in Elgar's music: for the majority Elgar was
synonymous with confidence, optimism and faith. Why, he didn't look like a
musician, more like a general.

Nor was the majority entirely wrong. One can go too far in isolating the
dark side of Elgar, just as one can go too far in depicting Mahler as a
neurotic obsessed with a death-wish. Both were complex men and artists, and
there is no 'one' Elgar or 'one' Mahler, but a kaleidoscopic Elgar or Mahler
expressing themselves through a virtuosic range of feeling. Thus, although
one can hear the heroic Elgarian melancholy in his First Symphony (A flat
major, op. 55) of 1907–8, his description of the work as having 'no
programme beyond a wide experience of human life, with a great charity
(love) and a *massive* hope in the future' is accurate. The long march-theme
which opens the Symphony and serves as its motto-theme is certainly
confident and aspiring. This is the 'great beautiful tune' which Elgar's wife
heard him playing in 1907 three weeks after his fiftieth birthday. Like
Brahms he had been a long time tackling a symphony, although in the late
1890s he toyed with the idea of one based on the life of General Gordon. But
work on the two oratorios ruled out a large-scale orchestral composition.
After completion of *The Kingdom* he wrote a fourth *Pomp and Circumstance*
march (1907) and then amused himself by re-scoring and re-working
incidental music he had composed as a boy for a play, *The Wand of Youth*,
which he and his brothers and sisters had written and performed. This
return to a vanished world kindled his imagination and he began to sketch
the symphony. It had always been promised to Richter, who conducted the
first performance in Manchester in December 1908. No symphony by an
English composer had ever had such an enthusiastic reception. The applause
was such after the third (slow) movement, that Richter encouraged Elgar to
go on to the platform. The enthusiasm after the *finale* was equally
uninhibited, and the orchestra stood and cheered Elgar. The critical praise
was rapturous. In just over a year the work had 100 performances, in cities as
far apart as Vienna, Sydney and St Petersburg.

In its span of just over fifty minutes, the Symphony encompasses the full range of familiar Elgar moods. The themes of the first movement are heard in conflict and in harmony with each other, but they all stem from some element of the motto march-theme, which thereby gives the music both structural and emotional unity. The world of *The Wand of Youth* is evoked in the second movement; when he was composing it, Lady Elgar called it 'a lovely river piece. You could hear the wind in the rushes by the water'. Her language is not fanciful merely: Elgar said of himself: 'I am still the dreamy child who used to be found in the reeds by Severn side trying to fix the sounds and longing for something very great', and when he rehearsed this movement he told the orchestra: 'Play it like something you hear down by the river.' Its theme derives from the march played backwards. Later, slowed down, it becomes the principal tune of the sublime slow movement, an idyll in D major which Vaughan Williams described as having 'that peculiar kind of beauty which gives us, his fellow-countrymen, a sense of something familiar, the intimate and personal beauty of our own fields and lanes'. In the *finale*, the 'massive hope for the future' is enshrined in the grandiose return of the march-tune, but it has no easy processional triumph, for an accompaniment of irregular crashes tries to disrupt its progress.

The audience at the first performance, and at the first London performance a few days later, recognised the mastery of the music and that here was an English composer who could score for the orchestra with a brilliance, beauty and virtuosity that rivalled Strauss. Yet there were dissenters, among them Beecham, who annoyed Elgar by cutting the work (by over ten minutes) when he conducted it. He also described it as 'neo-Gothic, the equivalent of the towers of St Pancras station'.

The opulent style of the symphony carried over into Elgar's next major composition, a concerto (1910) written for Fritz Kreisler, the Austrian violinist who was ranked with Ysaÿe as the greatest of his day. Here again the grand scale of the music masks a special intimacy in the content which makes the concerto elusively difficult to interpret. The soloist must be an orator, but must also be a lover, whispering secrets into the listener's ear. During these years, Elgar enjoyed a deep friendship – let us call it no more – with Mrs Alice Stuart-Wortley, daughter of the painter Millais. She was the inspiration of this work – 'our concerto', he repeatedly called it – and some of its themes he called 'Windflower' themes, 'Windflower' being his private name for her. The concerto enjoyed almost as big a public success as the symphony. Its profusion of melody, combined with the dramatic contest between soloist and orchestra, hold the attention throughout nearly fifty minutes. The slow movement, when Elgar retreats into the solitude of the cloister to muse passionately over 'what might have been', is an extraordinary example of rarified scoring – violin and muted brass, for example. It is surpassed by the hypnotic appeal of the long accompanied cadenza in the *finale* when the soloist, in Elgar's words, 'sadly thinks over' themes heard earlier. The demands of the virtuoso and of the poetic interpreter are alike satisfied.

Six months after the triumphant first performance of the Violin Concerto in Queen's Hall in November 1910, Elgar's Second Symphony (E flat, op. 63,

1903–11) was introduced in the same hall, but was received with markedly less enthusiasm (Elgar complained 'they sat there like stuffed pigs'). King George V's Coronation was less than a month away and perhaps a symphony that included a funeral march, an outburst of almost hysterical violence and a tranquil, resigned ending, was not the kind of music the audience had expected to hear. Even more than the concerto, this symphony is autobiographical, partly connected with Mrs Stuart-Wortley (to whom he gave all the sketches). Some of it was sketched as early as 1903 and perhaps was a remnant of the 'Gordon Symphony' idea. The elegiac slow movement is not a funeral ode for Edward VII, even though the symphony is dedicated to his memory, but was inspired by the sudden and early death in 1903 of the Liverpool businessman and musician Alfred Rodewald, one of Elgar's closest and most generous friends. One of the themes of the *finale* is a portrait of Hans Richter. Some of the music was written in Venice. Another place-name inscribed on the score is Tintagel, in remembrance of a visit Elgar paid to Alice Stuart-Wortley while she was on holiday there. He wrote to her of 'weaving strange and wonderful memories' into the music and he gave it a poetic motto from Shelley: 'Rarely, rarely, comest thou, Spirit of Delight'. The music is headstrong with passion, it is reflective, angry, sinister, ennobling and, in the end, consolatory. 'The passionate pilgrimage of a soul' was Elgar's own description, and as usual it is the best. The Second Symphony is a mosaic of constantly repeated short themes, as if Elgar was showing us different refractions of light. It belongs to the psychological world of Mahler's Ninth and Tenth Symphonies, its exact contemporaries, and expresses similar terrors, uncertainties and doubts, yet for long it was regarded as the musical expression of a self-satisfied aspect of the Edwardian era. It is undoubtedly Edwardian, but the Edward concerned is Elgar.

Another work which was begun in 1903 but not completed until 1912 was the setting of Arthur O'Shaughnessy's ode *The Music Makers*. This poem, for all that it is not highly regarded, is nevertheless stubbornly evocative and appealed strongly to the romantic dreamer in Elgar who identified himself with such a line as 'we dwell in our dreaming and singing a little apart'. Just how powerfully the text affected him is shown by his use in his setting of numerous apposite quotations from his own works. He wrote of the 'suffering' which the artist experienced even in the ecstasy of creating and, referring to the Concerto, the Second Symphony and *The Music Makers*, he told Mrs Stuart-Wortley: 'I have written out my soul . . . in these works I have *shewn* myself'.

He was by 1912 living in Hampstead in a large and impressive house, entertaining and being entertained by the leaders of musical and intellectual society, but although he was inhabiting their world, he was not really of it; he was still morose, still disgusted by the philistinism of the public and of publishers as reflected in the financial returns for his work, still quick to suspect slights and to take offence, for all that the shopkeeper's son was now Sir Edward Elgar, OM. *The Music Makers* was another journey into the past, and so was *Falstaff* (1913). This symphonic-study, on the scale of Strauss's *Don Quixote*, is regarded by many as Elgar's best orchestral work. Characteristically it is a romantic vision of Falstaff, its outstanding passages

being the fat knight's dreams of his youth, his rejection by the King, and his death. Not surprisingly, there is a good deal of Sir Edward in Elgar's Sir John and, in the two interludes, further dreams of days beyond recall.

England embarked on the First World War in a blithe mood of crusading zeal. Elgar never shared that mood, though he tried to capture it momentarily in the popularly acclaimed recitation with orchestra, *Carillon* (1914) in which he hymned the heroism of 'brave little Belgium'. At the first Promenade Concert of the war, on 15 August 1914, the audience's enthusiasm was aroused only by *Land of Hope and Glory*; a new Elgar work, *Sospiri* for strings, harps and organ, a brooding, introspective piece curiously prophetic of the national mood a few years later, passed almost unnoticed. He avidly seized in 1915 the opportunity to write a big score of incidental music for a children's fairy-play, *The Starlight Express*. Here was escape for him from a reality almost too dreadful to contemplate. Yet that reality eventually drew from him a moving and compassionate choral work, *The Spirit of England* (1915–17) to poems by Laurence Binyon, music in which the banner of St George is not flaunted bravely aloft but is replaced by a mourning pennant.

In 1917 the Elgars found a secluded Sussex cottage where he could work in the rural peace which was a necessity for his creative instinct. There he wrote three chamber works (violin sonata, string quartet and piano quintet, 1918–19) and the Cello Concerto (1918–19). Although there is an autumnal haze over this music – Lady Elgar's description was 'wood magic' – there is also creative energy and zest. If the Cello Concerto is restrained in mood and style and ends with a cry of despair, it is also 'a real large work and I think *good* and alive', as Elgar told one of its dedicatees. Yet the public was not ready for a restrained Elgar, or had already grown tired of him, for neither the chamber works nor the concerto established themselves for several years.

The death of his wife in 1920 crystallised for Elgar the difference between the world before 1914 and after 1918. He felt out of sympathy and out of key with almost every aspect of post-war Britain. Royalties from sales of his works were pitifully small and his publishers did not attempt to disguise from him that they would prefer a part-song from him to a symphony. No longer was there a tight circle of admiring friends around him. Most of the continental musicians who had admired and performed his music were either dead or had retired and their successors either did not know it or, as a result of the war, did not want to know it. From 1920 to 1930 he produced only orchestrations of other men's works (Handel and Bach) and published part-songs, occasional music and theatre music which was probably concocted from material written years earlier. We know that sketches from as far back as 1879 went in 1930 towards the making of the *Severn Suite* for brass band and a year later towards the charming *Nursery Suite*. In 1932 he rallied enough to contemplate an opera based on a Ben Jonson play but what survives of the music was a re-working of old sketches. Then a BBC commission for a third symphony excited him, but this too drew on old ideas. The widower Elgar returned to Worcestershire rather as Shakespeare had returned from London to the sights and sounds of his earliest recollections.

Elgar died on 23 February, 1934. The obituaries acknowledged him as the greatest English composer since Purcell, but his music was already

undergoing a period of relative neglect which was not to be reversed until after the centenary of his birth in 1957, when there was renewed interest in romantic music coincident with the intense concentration on the symphonies and songs of Mahler. Today his music is more highly regarded, more often played and more deeply loved by his fellow-countrymen than it has ever been, and foreign musicians have discovered it as their predecessors of the pre-1914 age had done. Never have so many international virtuosi played and recorded the concertos. His achievement was to forge a strongly personal idiom from the influence of Wagner and Brahms, Liszt, Massenet, Delibes and Saint-Saëns. Yet this idiom is regarded as quintessentially English. One can analyse and describe the means by which his style was formed but this does not explain the intense appeal his music makes to those who are 'on his wavelength'. What is so affecting, so enduring, is the palpable impression of his humanity, his vulnerability, his use of crotchets and quavers as a private language which only he and his attuned listeners really understand. 'A man's attitude to life' was his explanation of the Cello Concerto. What was that attitude? Again, he gave the best answer: 'I have put it all in my music – and much more that has never happened'.

Delius, the past-master

The place of Frederick Delius (1862–1934) in the English musical revival is ambivalent, to say the least. 'Did you say English music?' he once asked his amanuensis Eric Fenby. 'Well, I've never heard any.' He was right. To define 'Englishness' in music has defeated most writers. Many a listener would say that Delius's music, especially such an enchanting piece as *On Hearing the First Cuckoo in Spring* (1911–13) or *Summer Night on the River* (1912), calls to mind the English rural landscape. Yet the first was based on a Norwegian folk-song and the second was inspired by the river near his French home at Grez-sur-Loing. *In a Summer Garden* (1908, rev. 1913) is about Grez, too. But if we move ahead to 1945 to Britten, a composer whose nationalistic Englishness would have been scornfully denied by his admirers then, though they might be less emphatic today, we know that it is the North Sea as seen from Suffolk that is pictured musically in the Dawn Music of the opera *Peter Grimes*.

Elgar was described by Jaeger as 'thinker and dreamer'. Delius he would have described as 'dreamer', but we err if we overlook the profound thought behind what sounds so fluent and seamless. Indeed, most deductions about Delius have been shown to be in error one way or another. If the music sounds soft-centred, the man was strong as steel; if the music sounds luxuriant, the man was ascetic; if the portraits show the face of a suffering saint, the reality was very different, immoderate, anti-religious, caustic. His music is not best interpreted by conductors whose temperament matches it. His finest interpreter was Thomas Beecham, who likewise looked at life with an ironic gaze and an eyebrow raised and kept a restraining hand on any tendency to sentimentality.

It might appear as if Elgar and Delius were poles apart. Yet their

similarities are as striking as their differences. Both were attempting in their music, by very different means, to re-enter and recapture an idyll. Elgar's was the idyll of the king, Delius's of Sir Lancelot (or Tristan). Both came from provincial backgrounds, Delius's better-off than Elgar's. Neither had an academic training in any real sense, for Delius's brief stay at Leipzig Conservatory was a waste of time. Both had to find their own style through long and arduous struggle and experiment. Both were violinists, but whereas Elgar grew up in a musical environment, with a musician for a father, Delius's father was a rich German-born wool merchant who loved music and was on the committee which organised Hallé's concerts in Bradford but regarded music as a highly unsuitable profession for his son. Whereas Elgar was always part of the musical community, Delius was on the outside looking in. While Elgar was playing the organ in church, teaching the violin to schoolgirls and settling to married life with a general's daughter, Delius was 'banished' by his father to manage an orange-grove in Florida. (If the plan was to divorce Delius from music, it failed miserably, for the nearby town of Jacksonville had a thriving cultural life.) Delius, too, taught the violin to girl pupils, but with a good deal more pleasure during – and after – the lessons than Elgar experienced.

Eventually Delius senior relented and allowed Frederick to go to Leipzig. It was too late. The young man had already visited Norway and become a friend of Grieg and then settled in Paris amid the artistic community, living with an artist, Jelka Rosen, who some years later became his wife. He became an individual composer by hearing his music away from English life and social patterns. No choral-festival, organ-stool background for him. Imagine a Coronation March by Delius!

In the first decade of the twentieth century Delius thought Elgar's music 'long and dull'. Elgar's attitude to Delius was (according to Delius) 'slightly censorious as if he considered it not quite proper'. The years mellowed these harsh judgments. When Elgar, at seventy-six, flew to France in 1933 to see the infirm Delius, they talked animatedly. Delius ribbed Elgar about his 'long-winded oratorios' – 'the penalty of my English environment', Elgar replied – and confessed enjoyment of the *Introduction and Allegro* and *Falstaff* ('the outcome of a rich nature'). They continued to correspond during the last months of Elgar's life. Elgar made a significant and touching reference to Delius's choral work *A Mass of Life* (1940–5), to a text from Nietzsche:

It has been a matter of no small amusement to me that, as my name is somewhat unfortunately indissolubly connected with 'sacred' music, some of your friends and mine have tried to make me believe that I am ill disposed to the trend and sympathy of your great work. Nothing could be farther from the real state of the case. I admire your work intensely and salute the genius displayed in it.

Delius told their mutual friend, the critic Ernest Newman, that Elgar's visit had been

quite an event in my life. It was the first time that the real Elgar was revealed to me and that I could talk intimately with him and that I had the opportunity of appreciating his fine intellect and intelligent nature. How I now regret that we were not brought together earlier.

It is a happy coincidence that Elgar and Delius should have written their first orchestral masterpieces in the same year, 1899, the *Enigma Variations* and *Paris: the Song of a Great City*. But the major differences between them on their path to maturity was in vocal music. Whereas Elgar trod the conventional English road of the secular cantata – *The Black Knight*, *King Olaf*, *Caractacus* – Delius wrote operas. By the time Elgar had completed the *Coronation Ode* in 1902, Delius had written five operas and his only choral work remotely comparable with Elgar's was *Appalachia* (1901–3), a set of variations on an old Negro slave song. His fourth opera, composed in 1900–1, was *A Village Romeo and Juliet*, the only one of his six operas to hold the stage, even if intermittently, since its first performance. It is a seminal Delius work, combining the twin major musical influences on him, Grieg and Wagner, strange bedfellows indeed. It is also central to his European conception of a composer's ethos and links him to Schoenberg in Germany and Debussy in France, both of whom in the same year completed works with a relationship to Wagner's *Tristan und Isolde*.

Yet all three composers had exposed themselves also to powerful influences from the other arts. In *Pelléas et Mélisande* (1901–2) Debussy reflected the symbolism of Maeterlinck, which had inspired Schoenberg to compose a tone-poem on the same subject. Schoenberg's huge choral work, *Gurrelieder* (1900–11), was to a text by the Norwegian J. P. Jacobsen, whose poems had been set by Delius. Jacobsen was widely read in turn-of-the-century Germany where he was equated with the 'poetic realists' whose work appealed so strongly to Delius. One of their number was the Swiss writer Gottfried Keller, and it was on one of his short stories that Delius based *A Village Romeo and Juliet*. A further ingredient of Delius's aesthetic was the painting of his Norwegian friend Edvard Munch – expressionist rather than impressionist, but in turn related to Munch's admiration for Jacobsen and Nietzsche, enthusiasms he shared with Delius. A perceptive and witty critic, Donald Mitchell, has described Delius as the only 'German impressionist', a remark that takes into account the debt musical impressionism owes to Wagner from his prelude to *Das Rheingold*, the fire music of *Die Walküre*, the forest music of *Siegfried* and the magic garden in *Parsifal*.

Whatever its dramatic defects, *A Village Romeo and Juliet* offers musical delights of a rare quality. The Swiss scenery is brought before our eyes by the orchestra and by Delius's love of mountains – woodwind and distant horns work the spell. There is considerable variety: a chorus of vagabonds; a dream wedding; a village fair; the sinister Dark Fiddler and his strange companions; the river bargemen with their haunting song, 'Travellers we a-passing-by'. But Delius's concentration is on the two lovers, Sali and Vreli, children of feuding farmers, symbols of the death-wish, who count the world well lost for love and walk, to music of exquisite and tender poignancy, to the deserted inn, the 'Paradise Garden', whence they drift to their death on the river by scuttling a hay barge. Their *Liebestod* may derive from Wagner's, but there is no surging sea of passion in this music, instead a fragile loveliness, an ache. This ache, an acute sense of the transience of life and love, can be felt in later Delius works, most notably in the Whitman setting *Sea-Drift* (1903–4), where the sea-bird searches for its lost mate who will never return – 'O Past!

O happy life.' But the model for all Delius's cries for the days that are no more is the final scene of *A Village Romeo and Juliet*, the first of his golden journeys to Samarkand. Its plangent harmonies echo down the twentieth century in the unlikeliest places, in Constant Lambert's *The Rio Grande* (1927), in Gershwin's *The man I love* and *Porgy and Bess* (1934–5), in Duke Ellington's *Mood Indigo*. Its nearest contemporary parallel is Chausson's opera *Le Roi Arthus* (1887–8).

But *Village Romeo* is not Delius's masterpiece. That term must be reserved for his choral *Eine Messe des Lebens* (*A Mass of Life*). This is no religious Mass – perish the thought where Delius is concerned – but eleven soliloquies selected from Nietzsche's prose-poem *Also sprach Zarathustra* (1883–5). Mahler and Strauss had preceded him to this source, the former setting a verse from it as the fourth movement of his Third Symphony (1895–6) and Strauss basing a tone-poem on it which is merely another opportunity for some thinly-disguised musical autobiography. Of the three composers, Delius was nearest to Nietzsche in outlook. He had an iron spirit, a detestation of philistinism and bourgeois standards. He rejoiced in a hedonistic existence involving the pleasures of the flesh and the senses. In 1898 he set 'Zarathustra's Midnight Song' for baritone, male chorus and orchestra and this was to be the kernel of *A Mass of Life*, which was written in 1904–5. Part II of the work was performed in Munich in 1908 and Beecham conducted the first complete performance in London in June 1909.

It is Delius's largest non-operatic work. It employs a very large orchestra – including triple woodwind with bass oboe, cor anglais, bass clarinet and double bassoon, six horns, four trumpets and three trombones – which is used with consummate mastery, colour and, more often than not, restraint. Those who regard Delius solely as a chromatic purveyor of nostalgia need to revise their views where sections of this work are concerned. True, there is much poetic reverie in it, but this is the music of Delius's vigorous manhood, the Delius who lived in the Paris of the nineties, friend of Gauguin, Strindberg and Munch, living life to the full and then striding off to the mountains of Scandinavia to walk and climb. ('What a wonderful feeling being up so high, tramping twelve or fourteen hours a day in this invigorating air – how I enjoyed it!' he wrote to Jelka in 1896). In *A Mass of Life* the exultation and physical strength of the young Delius find expression.

This exultation bursts forth in the first bars, the *Invocation of the Will* – 'preserve me for one great final destiny, that I may stand prepared and ripe in the full noontide, like glowing ore in the furnace'. The music engulfs us like huge ocean-breakers; it is music like the start of Bruckner's *Te Deum* or Mahler's Eighth Symphony, which it anticipated by two or three years. Mahler's 'Veni creator Spiritus' might equally be saying 'Preserve me for one great triumph!' Mahler comes to mind, too, in the *Song of Laughter*, with its castanets and heavy brass. When the soprano enters in the *Song of Life*, it is as if Salome, still being composed in Berlin, were among us. Strauss is an influence throughout the work, the exulting horns recalling the climax of *Don Juan* (1889), a passage Delius admired and enjoyed. One of the first great emotional peaks of the Mass comes in the *Night-Song* at the end of Part I when, after a choral and orchestral nocturne, the solo baritone likens his soul

to the song of a lover. The treatment of the strings in this movement and the combination of diatonic and chromatic constitutents in the harmonic texture are Delius at his most eloquently characteristic. So is the orchestral prelude which opens Part II, *On the Mountains*. This is the world of Alpine symphonies, of songs of the high hills and of Mahler's cowbells echoing across the valleys. Delius shows himself here to be the equal of any of the romantic masters in the creation of a mood-picture. The stillness of the music is ruptured by a choral paean to man's noontide.

In the subsequent section, *Song of the Lyre*, Delius evokes the *fin de siècle* world of Ernest Dowson (whose poetry he set), Baudelaire and Aubrey Beardsley, and he is here the Delius who is constantly in search of the time that has passed. The orchestral introduction to the *Dance-Song* (a Viennese waltz in Strauss's tone-poem, of course) is among Delius's most potent compositions as well as most beautiful. Henceforward, to the end of the work, the score is suffused by the last warming rays of the sunset of musical romanticism which glow also in the closing pages of Elgar's Second Symphony and of Mahler's Ninth and Tenth, their reflections shining for another forty years in the music of Strauss. The wordless chorus of women's voices is as seductive as the tone-painting of evening in the forest where Zarathustra, like Parsifal, finds flower maidens dancing together. In the work's last movement, Zarathustra sings the 'Midnight Song' – 'O Mensch! gib acht' – and soloist and chorus join in a peroration in praise of joy and eternity, endless, everlasting day – 'tiefe Ewigkeit'. This was written three or four years before Mahler's *Das Lied von der Erde*, which ends with repetitions of the word 'Ewig'; and Delius also lets the music die away, reminding us as always that regret is a part of joy.

Seventy years ahead of his political time, Delius was the first fully-fledged English member of the European community; beside him Elgar was merely a co-opted delegate and Britten a visiting fellow. You might as well call Strauss's *Deutsche Motett* an English choral work as *A Mass of Life*. There is no sound like it in English choral music (even when it is sung in English), for Delius owes nothing to the tradition of religious contrapuntal music which influenced Purcell, Elgar, Vaughan Williams, Walton and Britten, however differently they individually reacted to it. Where did Delius learn his choral style? Wagner is hardly the answer. Mahler's *Resurrection Symphony*, perhaps? Debussy's *La demoiselle élue*? The most convincing answer is that he evolved it himself, for its principal feature is that it is essentially an extension of the orchestral texture, a further piece of poetic instrumentation. Superb as Elgar's choral writing is, I do not think it ever surpasses Delius in *A Mass of Life*.

Delius often dispenses with words – it was certainly not their meaning or rhythm that governed his inspiration, but their possibilities as sound. If *A Mass of Life* relies for its effect today on Delius's illumination of Nietzsche's text, it would be a dead duck, for not many of us can find much sustenance in this flatulence. But Delius, by his magical if limited command of harmonies, his innate sense of poetry in sound, can compel our belief in the rapture which he so obviously felt while composing. Let there be no mistake, it is a tremendous work and it was not created by doodling. Delius's

emotional range may be limited, but within the confines of his powers he was a master, and a master of the technique he needed to realise his expressive limitations.

A Mass of Life explodes the theory, propagated even by Beecham, that Delius was a kind of amateur in these matters. Especially remarkable is the almost seamless development of the music. A work like this cannot be 'analysed' in terms of leitmotiv (of which there are hardly any) or germ-cells of phrases, of thematic transformations and inversions. The art of Delius is the art of harmonies, of modulations, of the growth of the poetic phrase from the text, the art of orchestral illustration, of a moment of rapture ensnared and then reluctantly let slip. We don't go to Delius for structure or symphonic logic, we go to him for dreams, for stimulation of the senses. But the structure is there, just the same; beneath the stucco and the climbing shrubs of orchestration which obscure the building material from view, the building is there all right, resting on steady foundations, firm and braced.

So much space has been allocated to *A Mass of Life* because it contains the whole of Delius where other works show only one aspect. In the years immediately after completing it, he composed *Brigg Fair* (1907), the best-known of his larger orchestral works in which he rhapsodises on a folk-song collected by his friend Percy Grainger (1882–1961), the *Songs of Sunset* (1906–8) and the *Song of the High Hills* (1911), in which the chorus and soloists are wordless and their voices, merging and coalescing with the instruments, seem to come to us from among the Norwegian summits. The music is passionless, remote, yet paradoxically it is instinct with passion, the passion for life and nature. Those who believe that Delius merely repeated a successful formula in work after work should compare *Song of the High Hills* with the tone-poem *In a Summer Garden*. The *Summer Garden* is constructed from short motifs proliferating and evolving, capricious changes of speed, as if a light wind suddenly disturbed the flower-beds, and the merest hint of formal devices such as recapitulation and coda; the *Song of the High Hills* is simpler in outline (ternary form), its orchestration less impressionistic, its harmony broader.

During the First World War, Delius left France for England and unpredictably abandoned choral works and tone-poems. Instead he essayed the traditional forms, sonatas, string quartet and three concertos (for violin, cello, and violin and cello). These have been harshly judged, even sympathetic critics, such as Neville Cardus, believing that he was shackled by the classical conventions and wasted material on forms that did not come naturally to him. A more favourable view would be that, notably in the Violin Concerto (1916), the Cello Concerto (1921) and the Cello Sonata (1916), he bent concerto and sonata forms to his own uses with astounding success. In a long and famous essay on the Violin Concerto, the late Deryck Cooke proves with a formidable analytical armoury that its structure obeys all the rules observed by classical composers, but in doing so he tends to miss the point of the music, namely that Delius writes a concerto which is all his own and like no other, a sustained lyrical outpouring in which monotony is held at bay by his amazing development of tone-colour. That Delius achieved this by a technical mastery the equal of any of his outwardly more intellectual

colleagues is satisfying to know, but who, listening to the music unfolding in such an original manner, could doubt it? The poetic vision is consistently realised, and it scarcely matters how that is done. The result is pure music, which matters most.

Before the grip of his illness, involving gradual paralysis and blindness but no mental deterioration, tightened so that he could not put the notes on paper, Delius composed a *Requiem* (1914–16) for those who perished in the war and followed it with his last big score for the theatre, the incidental music to Flecker's play *Hassan* (1920–3). Again we hear the whole Delius, not only the enchanter of the well-known *Serenade* but a Delius capable of expressing barbarity, harshness and cruelty in his music with a savagery of instrumentation many would believe alien to the composer of *In a Summer Garden*. And it ends on a note of almost religious exaltation as the caravan takes 'the golden road to Samarkand'. That might have been Delius's last word had it not been for the intervention a few years later by a young Yorkshire organist Eric Fenby who offered himself as amanuensis to the composer and went to live at Grez. By a daunting mixture of patience and courage, unforgettably described in his book *Delius As I Knew Him*, Fenby enabled Delius to complete several more works, sometimes using material composed many years earlier, the finest of which are the *Songs of Farewell* (1930), the orchestral *Song of Summer* (1930) and a third Violin Sonata (1930).

Vaughan Williams and Holst, the liberators

To the gifted song-composer C. W. Orr (1893–1976), Delius once wrote: 'Always stick to your likings – there are profound reasons for them.' It was advice such as might also have been given by Vaughan Williams (1872–1958). In 1907, at a time when Vaughan Williams was dissatisfied with his own music, he took his then incomplete choral setting of Walt Whitman, *A Sea Symphony* (1903–9), to Delius and played it to him. One might have thought this was because he knew Delius had recently completed a Whitman setting, *Sea-Drift* (not performed in England until 1908), but the request for a meeting followed his enjoyment of Delius's Piano Concerto (1906–7). If ever a composer searched in public to 'find his own soul', it was Vaughan Williams. The descendant of Darwins and Wedgwoods, modestly well off but blessed by a radical determination to succeed on his own merits, he achieved the unusual distinction in the 1880s of being allowed to hire the hall of his public school, Charterhouse, for a concert of his own compositions. He also unconventionally spent two years at the Royal College of Music before going to Trinity College, Cambridge, and returned to the College for another year. He was taught by Parry and Stanford and at Cambridge by Charles Wood (1866–1926). None of them, possibly excepting Parry, would have forecast a brilliant future for this earnest, ungainly pupil who had to grind hard where his fellows were often quick and agile. At the college he formed a lifelong friendship with Gustav Holst (1874–1934), his antithesis in many respects, but both were quietly determined to succeed as 'English composers' by eradicating any Teutonic accent from their music.

Vaughan Williams was twenty-eight before he composed his first success, the song *Linden Lea* (1901), composed before he had collected a single folk-song yet often mistaken for a folk-song, although its ancestry is Schumannesque. He was initiated into folk-song by Lucy Broadwood, but his interest in it was kindled by an article by Cecil Sharp which moved him to believe that increasing urbanisation could mean the disappearance of songs which had been transmitted orally from one generation of countrymen to the next. He went into the fields, the workhouses and the pubs as a musical archaeologist. His delight in his discoveries led to three orchestral *Norfolk Rhapsodies* (1906; only one survives), although his first surviving orchestral work, *In the Fen Country* (1904), distils the spirit of folk-song without direct quotation. Folk-song plays but the briefest part in *A Sea Symphony*. A major and admitted influence here was Elgar's *The Dream of Gerontius*, but Parry and Stanford are among its musical godfathers, and there is a suggestion of Delius in the second-movement nocturne, 'On the beach at night alone'.

Just after his meeting with Delius, Vaughan Williams, already aged thirty-five, became even more firmly convinced that he needed the kind of ruthless teaching which had been denied him by Parry's 'beefsteak optimism' and Stanford's dismissive rudeness. He found it – the most ironic paradox in the career of this quintessentially English composer – in Paris with Maurice Ravel, his junior by three years. For three months Vaughan Williams studied scores given to him by Ravel to aid his search for 'clarity'. After his return to England he began to compose with the freedom, assurance and individuality that never deserted him. 'The only pupil who doesn't compose my music', Ravel said of him, but the Ravel influence may easily be detected not only in the Housman song-cycle *On Wenlock Edge* (1909) but many years later in the Fifth Symphony (1938–43). In the *Fantasia on a Theme by Thomas Tallis* in 1910 Vaughan Williams composed his first unflawed masterpiece, a synthesis of all that had gone into his making: Frenchified harmony, folk-song, the Tudor composers and Tallis's tune itself, which he had discovered in 1904–6 while editing the music for the new *English Hymnal*. Suddenly he was prolific, composing incidental music, a string quintet (1912), his first opera (*Hugh the Drover*) (1910–14), the *Five Mystical Songs* (1911) and *A London Symphony* (1911–13).

The symphony owes nothing to German influences, as Elgar's *Cockaigne* of 1901 did, but in it we hear Debussy's *La Mer*, Stravinsky's *Petrushka*, the folk-songs of Herefordshire, the music-hall songs of the Old Kent Road. Yet there is a broader significance which the symphony shares with *Cockaigne*: the composers show themselves to be true contemporaries of Tchaikovsky, Mahler and Strauss by bringing into their music the contours and rhythms of the popular music of the day. In Elgar's overture a military band marches through the score; in Vaughan Williams's symphony not only is there a march, but a London street-cry, the sound of an accordion-player, and a healthy, forthright melody which comes as a direct echo of the music-hall. In spite of other picturesque touches, such as the Westminster chimes and the jingle of a hansom-cab, Vaughan Williams insisted that the work should really be called 'Symphony by a Londoner' and was not intended to be descriptive. And there lurks behind these graphic touches a visionary work with tragic undertones. An underlying dissonance and the sombre tone of the

march in the *finale* suggest that this is no tone-painting of the capital in its Edwardian splendour, but a more realistic view of the city as a symbol of human social contrasts, of wealth and poverty, grandeur and squalor, conviviality and loneliness. This symphony, though it might have surprised Vaughan Williams to know it, is Mahlerian in its achievement of 'embracing everything', just as Elgar's Second Symphony is Mahlerian in its autobiographical neuroses. It is also more comprehensively Edwardian than Elgar's, where the Victorian values which guided his life are enshrined.

A London Symphony reflects the aims defined by Vaughan Williams in an article he wrote for the Royal College of Music Magazine in 1912 called 'Who wants the English composer?' Was it not possible, he asked, that the English composer had something to say to his own countrymen that no-one of any other age and any other country could say?

Have we not all about us forms of musical expression which we can purify and raise to the level of great art? For instance, the lilt of the chorus at a music-hall joining in a popular song, the children dancing to a barrel-organ, the rousing fervour of a Salvation Army hymn, St Paul's and a great choir singing in one of its festivals, the Welshmen striking up one of their own hymns whenever they win a goal at the international football match, the cries of the street pedlars, the factory girls singing their sentimental songs. Have all these nothing to say to us? Have we not in England occasions crying out for music? . . . We must cultivate a sense of musical citizenship; why should not the musician be the servant of the State and build national monuments like the painter, the writer or the architect? . . . The composer must not shut himself up and think about art, he must live with his fellows and make his art an expression of the whole life of the community.

Vaughan Williams's doctrine seemed almost to adumbrate the Soviet attitude to a composer's role, but no one was more jealous of an artist's personal freedom, more resistant to external pressure, more truly liberal and free-thinking. He was not advocating state-controlled composition but music which reflected national traits. Parallel with the *London Symphony* he composed the opera *Hugh the Drover*, designedly a ballad opera, set at the time of the Napoleonic wars, with real folk-songs alongside arias in a folk-song style, a boxing-match, a village fair and some of the most lyrical and passionate love music by a British composer. He had no expectation when he wrote it that it would ever reach the stage and, together with some other works, he put it aside when, at the age of forty-two, he joined the army in August 1914 and served throughout the First World War, spending much of it in France.

When he returned to musical life in 1919, it was to a new world, a world which so distressed Elgar that he fell virtually silent. Vaughan Williams, too, had his misgivings, stemming from the death of some of the younger composers whom he had befriended, Butterworth, F. B. Ellis and Denis Browne among them. 'I sometimes dread coming back to normal life with so many gaps', he wrote to Holst. 'I sometimes think now that it is wrong to have made friends with people so much younger than oneself – because soon there will be only the middle-aged left.' But he overcame these scruples and joined the staff of the Royal College of Music, where he made contact with a new group of rising composers. His first major new work was *A Pastoral*

Symphony (1916–21), one of his most original compositions and one of his most misunderstood and misinterpreted.

The title, of course, challenges Beethoven, but there are no bird-songs, no happy feelings on going into the countryside, no storm. To the superficial ear it is an uneventful work with three slow movements and a scherzo, brooding, quiet, hinting at but never quoting folk-song. 'Like a cow looking over a gate', was Philip Heseltine's amusing judgement, but he also said it was a masterpiece. To some it is merely a musical picture of an English landscape, the Cotswolds perhaps, but the fact is that the first sketches were made in France in 1916 when the composer was impressed by a Corot-like sunset. Yet even this is a part of the smokescreen Vaughan Williams regularly created around the deeper meaning of his works, as if he were trying to put the listener off the scent and so retain the real key to their secrets for himself. There is always more to Vaughan Williams than first meets the ear or than one reads in his programme-notes.

In the case of *A Pastoral Symphony*, the music is a landscape, but it is a landscape with figures, the corpses of those who were killed and maimed in France. There is no whine of shells, no rattle of machine-guns. But in this war requiem there is the bugler sounding an ethereal Last Post and the wordless voice of a woman singing a lament. There are harmonic clashes so discordant that they betray the suppressed anger of the symphony's creator, but they are so quiet that they merge into the flow of the music. Its melodies are not developed or varied but evolve one from another, seamless and endless. Once only, in the orchestral passage which follows the soprano's introduction to the *finale*, is there a fortissimo outburst where perhaps it is merely fanciful to detect a fleeting resemblance to the climax of Butterworth's *A Shropshire Lad* Rhapsody. 'The light we sought is shining still . . .'

Throughout the 1920s Vaughan Williams was at his most versatile, composing in a wide variety of genres, from the unaccompanied Mass in G minor (1920–1), which emulates the *Tallis Fantasia* in re-creating Tudor music in a modern image, to the ballet *Job* (1927–30), which will be discussed more fully below. His style was less opulent than it had been up to 1914, his scoring sparer, his harmony barer. He flirted with neo-classicism in a violin concerto, but returned to the colouristic influence of Ravel in *Flos Campi* (1925), a suite for viola, small orchestra and small wordless chorus. This was inspired by the *Song of Solomon*, in its sensuous rather than its spiritual connotation, and it is an effective answer to the charge that Vaughan Williams had no 'technique' with which to convey a wide and subtle variety of tone-colour. Its potent mixture of pastoral, eroticism and orientalism baffled Holst who admitted he 'couldn't get hold of it a bit'.

Job is the epicentre of Vaughan Williams's music. It sums up all that had preceded it and anticipates much of what was to follow. To compose it he laid aside three operas which, amazing as it may seem, he was composing almost simultaneously – four if one counts intermittent labour on *The Pilgrim's Progress*, which was not completed until 1951. In 1924 he had begun a Falstaff opera based on *The Merry Wives of Windsor*, which was eventually to become *Sir John in Love* (first performed 1929); in 1925 he began to set, practically line for line, J. M. Synge's gloomy one-act play about the

misfortunes of Irish fisherfolk, *Riders to the Sea* (first performed 1937); and in 1927 he began a comic opera – almost what would now be called a musical – to be called *The Poisoned Kiss* (first performed 1936), in which echoes of jazz and the dance-hall mingle with echoes of folk-song. But when in 1927 Geoffrey Keynes, the Blake scholar, suggested commemorating the centenary of the artist–poet's death by a ballet based on the *Illustrations of the Book of Job*, Vaughan Williams was immediately enthusiastic. Diaghilev, to whom the project was mentioned, rejected it as 'too English'. While a stage presentation hung fire, therefore, Vaughan Williams's enthusiasm burned on, and he completed the score to his own scenario. It was first performed as a concert-suite, for large orchestra, at the 1930 Norwich Festival. A staging, with reduced score arranged by Constant Lambert, followed in July 1931, with choreography by Ninette de Valois. Vaughan Williams described it as a 'masque for dancing' and was insistent that it must not be danced in the Russian Ballet style.

Blake's illustrations combine eloquence and simplicity, words that aptly describe the music, too. Magnificent as *Job* is on the stage, it is equally dramatic and vivid in the concert-hall, where it might almost be described as a symphonic-poem. The serene opening scene, showing Job enjoying an untroubled family life, with country dances threading in and out of the placid music, and the majestic saraband to which Heaven and the throne of God are first revealed to us, are subverted by the furtive menace of two descending octaves for strings and bassoons which advertise the presence of Satan. When he begins to dance, to an accompaniment including a xylophone, muted brass, and a mocking version of the *Gloria*, the music's harshness and stridency would have come as a surprise except to those who knew Vaughan Williams's 1925 oratorio *Sancta Civitas*, where dissonance and violence are first unleashed. Other examples of orchestral *coups de théâtre* are the chord on horns and trumpets over a cymbal roll which rises like a whirlwind to overwhelm the sons and daughters-in-law of Job, and the use of the E flat saxophone, whining and ingratiating, to represent the three hypocrites with whom Blake displaced the biblical Comforters. The long solo violin which represents Elihu's Dance of Youth and Beauty and the final diatonic triumph of Heaven and Hell are in Vaughan Williams's most lyrical and ennobling vein, never more effective than in this context.

Satan's Dance may perhaps have been one of the sparks which set off composition in 1931 of a new symphony, his first for a decade. This was No. 4 in F minor, completed in 1934 and first performed in 1935, by which date the likelihood of another European war was increasing. This is Vaughan Williams's harshest, noisiest and most uncompromising symphony. It stunned the English critics at its first performance. Forgetting the hints thrown out to them in *Job*, the Piano Concerto (1926–33) and *Sancta Civitas* (1923–5), they expected the Vaughan Williams of the rolling landscape. It was as if a saint had suddenly sworn at them, and they interpreted the work as a sermon in sound on the international situation. Although the music can be heard as a prophecy of wrath to come, Vaughan Williams denied any such intention. Another smokescreen? Or was the denial a smokescreen in itself? If there is any 'programme', it is more likely to be personal than topical: a self-portrait,

it has been suggested. He regarded it as an experiment to show that a 'modern' symphony could be written to a classical formula. The model was Beethoven's Fifth Symphony, as can be heard from the use of short motifs on which the whole structure is founded and by the bridge-passage between *scherzo* and *finale*. Compared with some other excursions to the wilder shores of dissonance, the F minor Symphony is no doubt essentially conservative, but its conciseness, power and integrity make it an exhilarating and rewarding musical experience.

It is interesting in retrospect to note that, at its first appearance, not everybody viewed the symphony as grim and violent, the critic of *The Times* writing of the 'humour' of the *scherzo* and the 'daring and gaiety' of the *finale*. Eric Blom wrote that the Symphony made Vaughan Williams 'one of the most venturesome composers in Europe', though how much of the music of Europe's venturesome composers was well known in Britain at this date may be doubted, and in view of Blom's savage dismissal (in the 3rd edition of Grove's *Dictionary of Music and Musicians*) of the music of Stravinsky, this compliment was perhaps worthless. Cardus thought that a continental listener would wonder why Vaughan Williams

having discarded the idioms and general emotional tones of pre-war English music, has stopped short of a post-war freedom of rhythm and a post-war harshness of dissonance . . . The technique, as I have suggested, is old-fashioned, looked at from standards unashamedly modern.

Here Cardus was aligning himself with those who believed that inter-war English music was parochial and behind the times. Vaughan Williams was not likely to be unduly troubled by his failure to keep up with the atonalists, but he was not so far distant from Hindemith and Bartók. Cardus forecast that the Symphony would not be listened to twenty years after its first performance. He was resoundingly wrong, for the stature of the work has steadily increased and it has gone into the repertoire of several foreign conductors. Whether it was ahead of or behind the times has ceased to matter. As for the composer, his comment on it has passed into history: 'I don't know whether I like it, but it's what I meant.'

Whether or not it was prophesied in the Fourth Symphony, war came in 1939. Its principal musical effect on Vaughan Williams, as he neared the age of seventy, was to take him into the film studio. As his 'war work', he offered to write music for propaganda films and found that he enjoyed the discipline imposed on him. He also enjoyed the larger orchestral resources available to him, with the consequence that his scores called for augmented percussion sections and for a richer array of exotic instruments. But since 1938 he had been at work on a fifth symphony, using and re-shaping material from his projected opera based on *The Pilgrim's Progress*, which he had been sporadically composing for the best part of twenty years. Deciding that the opera would never be finished, he took some of its themes for the Symphony, which he dedicated to a composer he deeply admired, Sibelius. No greater contrast to the Fourth could have been imagined than the new work, which was first performed in 1943. Where the F minor had been rough and acerbic, the D major was tranquil and benevolent. Its predominantly ecclesiastical

mood, its links with Bunyan and the Heavenly City and its Epilogue, which sounds like a polyphony of alleluias chanted like a *Nunc Dimittis*, led to speculation that this was Vaughan Williams's farewell, a benediction and a laying-on of hands. Nothing could have been further from the truth. In 1944, using themes discarded from a film score, he began to compose a sixth symphony which was to prove as controversial as the F minor and was to cause a further revaluation of this erratic pilgrim's progress when it was performed in 1948. Altogether he composed four more symphonies before he died in 1958, as well as several large choral works, a quantity of smaller pieces and the Bunyan opera itself (its failure at Covent Garden was a hurtful blow).

Vaughan Williams's style is easy enough to imitate and he had a number of imitators, none of them of much substance. They could imitate his modality but what they could not imitate were his courage, strength and vision. His insistence that a composer should be national before he could be international has led to his being accused of musical chauvinism, but he was too big as man and artist for that. He believed, with Parry, that 'style is ultimately national', and his concern was that a composer should be true to himself, which usually meant to his own background and traditions, if he was to achieve spontaneity.

These were the views he shared with Gustav Holst (1874–1934). Their names are invariably coupled although the differences in their music outnumber and outweigh the similarities. Both attributed at least a measure of their 'liberation' to folk-song, alhough Holst, unlike his friend, was never a practical collector (he could not spare the time, because of his necessity to earn a living as a teacher). The fundamental difference between them was that Vaughan Williams was a visionary, Holst a mystic. They both set Whitman, but Holst fairly early in his career also began to set texts from the *Rig Veda*, teaching himself enough Sanskrit to be able, with the aid of a crib, to make his own translations. Orientalism was all the rage during the Edwardian years, but for Holst it was not a means to an exotic end but the attraction of a philosophy that met most of his own spiritual requirements. The *Rig Veda* hymns (1907–8) contain some of his most beautiful and spontaneous music and are still too little known. In 1908 he took an Indian theme for his short chamber opera, *Savitri*, a work astonishing not only for its intensity and clarity and the purity of its melodic line, but for its anticipation by over fifty years of the atmosphere of Britten's church parables.

Whereas Vaughan Williams had some resounding successes before 1914, including two Leeds Festival choral works (*Toward the Unknown Region* in 1905 and *A Sea Symphony* in 1910), nothing like this came Holst's way. His Whitman setting, *The Mystic Trumpeter* (1904), melodious in the best tradition of English music of the period, was savaged by the critics for having ventured too far along 'forbidden paths'. Publishers rejected his works, and his fierce self-criticism caused him to withhold or withdraw such fine works as the *Invocation* for cello and orchestra (1911), which was not heard until fifty years after his death.

Success in the fullest sense did not come until the end of the First World

War and the early performances of the ambitious orchestral suite *The Planets*, which had been composed in 1914–16. In some respects it is an uncharacteristic work. Its use of a Straussian orchestra is rare in Holst and, more than most of his music, it betrays the influences working on him at the time, from Elgar to Stravinsky and Debussy and even perhaps the Schoenberg of the *Five Orchestral Pieces* which he had heard in London in 1912. Yet what an achievement it is – nothing in his previous output had suggested such mastery of a symphony orchestra and never in English music had an orchestra pounded and ground away with such mechanical ferocity as at the start of *Mars*. In providing seven miniature tone-poems, skilfully varied, melodious and glittering with orchestral colours and excitement, such as the organ *glissandi* in *Uranus*, Holst to his intense surprise found himself famous overnight – and was not sure he liked it. He had a puritanical conviction that success could, probably would, corrupt an artist's work. 'A man should pray not to be a success', he told his pupils.

He must have been even more surprised by the success of his next work, *The Hymn of Jesus*, a short setting for chorus and orchestra of words from the apocryphal Acts of St John. Completed in 1917 and performed in 1920, its whole-tone chords, strings of rising triads, and use of plainsong might have resulted in a piece of self-conscious archaism; instead they convey a burning luminosity which still, all these years on, surprises, shocks and stimulates audiences. So often one sees Holst described as austere, but there is nothing austere in *The Hymn of Jesus*, its orchestral part a-quiver with rhythmic interest at such passages as 'Divine grace is dancing', where Holst's joyous approach to religion recalls Haydn's.

Holst's prayers were answered, for his success did not last. In the fourteen years of life which were all that remained to him, he had no more triumphs. One of his noblest works, the *Ode to Death* (Whitman) (1919), written in memory of friends killed in the war, was performed at Leeds in 1922 and in London and then was forgotten. The full score was not published until the 1970s, when a recording was issued. It was neglect of such a score as this that perhaps impelled Vaughan Williams to declare in a speech in 1936 that 'the average Englishman hates English music'. The two composers who had put themselves 'into training' as young men to achieve a break with foreign tradition now found themselves overtaken by the next generation, the path for whom they had cleared. For it cannot be said that Vaughan Williams's works in the 1920s were received with the enthusiasm that had greeted his *Sea Symphony* in 1910. But a sufficiently large minority appreciated his work, whereas Holst did not have even that support. His *Choral Symphony* to poems by Keats was introduced in Leeds in 1925 and even Vaughan Williams could profess only 'cold admiration'. A total lack of understanding met his orchestral impression of Hardy's *Egdon Heath* (1927). Even today this masterly score is still described as 'cold' and 'arid', though its evocation of a wild, changing landscape as described in the opening words of *The Return of the Native* is among the most heartening achievements in British orchestral music, an opinion which can be checked only against a recording and the occasional broadcast performance, for none of our major orchestras seems yet to have heard of the work. To the majority today Holst means *The*

Planets and not much else. The stigma that he was more interested in solving technical problems than in creating music – as if the two processes were mutually exclusive – is still bedevilling his reputation. Of all the major English composers of the twentieth century, he is the most under-rated, the most enigmatic.

Walton, the 'white hope'

If Parry had lived into the 1920s, which English composer would he then have regarded as the public's single obsession? Elgar was the dominant name, but his music became increasingly out of favour. The new age was out of key with it. After the muted reception given to the chamber music and the Cello Concerto in 1919, there were no new major works to stimulate renewed interest. In 1924 he became Master of the King's Musick, as if he had not been that for a quarter of a century already. He left London for semi-squirearchical retirement in Worcestershire. His major works were still regularly performed but often to half-filled halls even if he was the conductor. Only at the Three Choirs Festivals was he undisputed sovereign – and in the recording studio. The major national celebration that might have been expected on the occasion of his seventieth birthday in 1927 did not happen. Neither Vaughan Williams nor Holst took his place as focal figure for public interest. As we have seen, both composed important and excellent works in the 1920s but full appreciation of them was delayed for several years, in most cases until after 1945. After *The Planets*, the biggest personal success by a member of the middle generation was enjoyed by Rutland Boughton's opera *The Immortal Hour* which, against the trend of fashion, ran for 216 performances in London in 1922.

There was not at this period working in London a conductor whose zeal for the cause of British music was his prime motivation (and, as already stated, it was a thin time for orchestras). Wood, of course, championed many unpopular causes at the Proms and elsewhere, from the newest British works to first English performance of Janáček and Mahler (Eighth Symphony) and Landon Ronald remained faithful to Elgar. But Boult was working in Birmingham, where the pre-war Elgar and Vaughan Williams works were played; Harty was in Manchester; Sargent and Barbirolli were making their names mainly in opera; Goossens was in the United States.

But in any case the cry in the 1920s was for novelty, for 'modernity' at any price. The headlines where English musical life was concerned were reserved for the younger men who seemed to be breaking away from the pre-war traditions and following the new gods, headed by Stravinsky and *Les Six* from Paris. Thus, if Paris had its Erik Satie, London had its Lord Berners. The witty and outrageous works of Milhaud and Poulenc were balanced by Arthur Bliss's *Rout* (1920) (in which the soprano sang a string of syllables and was effectively an extra instrument in the small ensemble) and his string quartet entitled *Conversations* (1920). Today these delightful works present no problems; then, they were notorious even though a few discerning critics noticed that Bliss's techniques were not as avant-garde as all that. However,

neither Bliss nor Berners, neither Warlock nor Lambert was destined to be the 'white hope' of English music of this decade. This dubious and dangerous privilege was reserved for a composer who, by delightful irony, caught the attention of Parry. Shortly before the great man died, he went to Oxford in 1916 to examine candidates for degrees. He stayed with the Dean of Christ Church, the music-loving Thomas Strong, and he glanced through the manuscript compositions of one of the college's choral scholars, a boy of fourteen. 'There's a lot in this chap, you must keep your eye on him', he remarked to Strong. The chap's name was William Walton (1902–83). An even more delicious irony is that Walton was not one of the intellectual dilettantes who crowded the Chelsea concert-halls for performances of works by Stravinsky, Bliss, Berners – and eventually Walton – but a boy from Oldham in Lancashire, lower middle-class, reserved, and fundamentally conservative in his musical tastes and tendencies.

Walton was the son of an organist, choirmaster and singing teacher who had been one of the first students at the Royal Manchester College of Music. When William was ten his parents applied for him to have a voice trial for a choral scholarship at Christ Church, Oxford. On the day of the interview he and his mother missed the first train because his father had drunk the money for the fares and it had to be borrowed from the local grocer. On arrival at Oxford they found the examination was over, but Mrs Walton pleaded for her son to be heard. He was accepted. His first term at Oxford, he recalled, was 'odious' because of gibes about his Lancashire accent, which he shed as quickly as he could. He remained in the choir school for six years. When in 1914 straitened circumstances at home threatened to curtail his stay, Dr Strong paid the balance of the fees not met by the scholarship. Walton was by then composing and it was Strong who again intervened with financial help to enable him to join Christ Church as an undergraduate to continue his studies under Hugh Allen. Walton's university career was short. He was resident for only eight terms, failing the examination known as Responsions (but passing the second part of his B.Mus. in June 1920). But it did not matter. He was lucky, as so often in the early part of his career. Luck this time came in the shape of Sacheverell Sitwell.

The Sitwells – the brothers Osbert and Sacheverell and their sister Edith – were the children of Sir George Sitwell. They were writers and poets, and their early efforts shocked the bourgeoisie of which they were a considerable ornament. They were clever, smart, up-to-the-minute and relentless in their pursuit of exciting and preferably progressive new talent. They knew 'everybody' and they went to everything. Sacheverell was the youngest and was twenty-one in 1918 when he encountered Walton and decided, on the strength of the piano quartet, that the youth was a genius. Osbert was called in to corroborate this judgement, and the family virtually adopted Walton as an extra brother, hijacking him to join their enthusiasms, first of which at this juncture was the music of the Dutch-born composer Bernard van Dieren (1887–1936). Before he knew it, Walton was helping to organise a van Dieren concert at which some of his own songs might also be performed. He was being invited to Garsington by Lady Ottoline Morrell, taken to the première of the new Diaghilev ballet *Parade* (music by Satie) and was preparing to

meet Stravinsky. In the spring of 1920 they took him to Italy, with which he
fell immediately and lastingly in love, and in London he was given a room in
their Chelsea house. Moreover, they persuaded Dr Strong, Siegfried Sassoon
and Lord Berners to join them in guaranteeing him an annual income so that
he need not work but could concentrate on composition. Any idea that he
should go to the Royal College of Music for a formal musical education was
scotched by the Sitwells, to whom the idea of any 'establishment' training for
their young genius was abhorrent. They gave him instead a much wider
cultural education by taking him to concerts, recitals, plays and exhibitions in
abundance.

The effect on a weaker character than Walton of this violent and sudden
change in his life-style might have been calamitous. But he was remarkably
level-headed, and his sturdy Lancashire no-nonsense background must have
counted somewhere. He was also solely and utterly dedicated to music, and
he was a hard worker. A fellow-undergraduate, the poet Roy Campbell,
noted this characteristic as early as 1919. All that Walton required from his
relationship with the Sitwells was the constant availability of a piano.
Without one, Osbert recorded, he was 'in despair'. The first musical fruit of
Walton's new status was the 'entertainment' *Façade*, composed during 1921
and first performed at private houses in London early in 1922. *Façade*
comprised a series of poems by Edith Sitwell recited in a kind of speech-song
with accompanying music for a small chamber ensemble. The poems were
written as experiments in verbal rhythms and sonorities and although they
appear at first to be nonsense, running through them are allusions, metaphors
and personalities which give them a continuous zany sense. Some of them are
deeply moving in their melancholy.

The *Façade* heard in 1922 differed markedly from the version so well
known today. Only six of the eighteen numbers then performed survived into
the 'definitive' version, which was not published until 1951. For the first
public performance, in June 1923, several new numbers were added. This
performance caused a scandal, whipped up by the popular press, which
ensured that Walton's name, in addition to the Sitwells', was now 'news'.
Ernest Newman wrote that 'as a musical joker' Walton was 'a jewel of the
first water'. When *Façade* was next performed in London, in April 1926, it
was a fashionable success. The instrumentation had been considerably
revised. According to Constant Lambert, the original version was notable for
'complicated arabesques and the melodic interest was slight – the second
version, however, is one good tune after another and each number is a gem of
stylisation or parody'. Walton seems to have 'tinkered', as Elgar would have
said, with *Façade* throughout his life, reviving and revising some discarded
items for a *Façade 2* as late as 1979. Clearly it was of special significance to
him, and understandably so. *Façade*, for all its wit and frivolity, is a serious
work. There are poetry and romance behind the hornpipes and tangos, the
foxtrots and waltzes, the mock-Rossini and the music-hall parodies. It
contains the essence of Walton in its blending of lyricism and flippancy. It
has remained unique.

Two months after the 1923 *Façade*, Walton's early string quartet was
selected for performance in Salzburg at the first festival of the International

Society for Contemporary Music. It impressed Berg, who took Walton and Berners to meet Schoenberg. Berg evidently regarded Walton as the leader of British atonalists, a title the Englishman had produced no reason for claiming. But the Sitwells must have been well pleased with their *protégé*; his reputation could not have been more sensationally scandalous. Walton's next important work, the overture *Portsmouth Point* (1925), was also for an ISCM festival. Inspired by Rowlandson's print of the same name, it crystallised twin influences on Walton – the Stravinsky of *The Soldier's Tale* and the Elizabethanisms revived by Warlock in his roistering mood. Character-istically, Walton did not wholly surrender to either influence. The music has a sardonic edge which keeps it fresh. Walton had his tongue in his cheek, knowing that for all its spicy rhythms and spiky orchestration, his overture was firmly rooted in traditional procedures.

Yet in spite of all temptations to belong to other nations, to become a Satie clone, Walton remained an Englishman. Listening to *Façade* and *Portsmouth Point*, it would have been an astute musician who would have identified Walton as being in the line of succession from Elgar – and such a thought would have mortified Osbert Sitwell, whose dislike of Elgar's music and all that it represented was intense. Yet in 1929, in the Viola Concerto, Walton wrote a work firmly within the orbit of the English romantic tradition. Elgar hated it, which at least proves that he did not regard it as imitation. Nor is it. But its Elgarian features are obvious – the slow ruminative first movement in the style of Elgar's Cello Concerto followed by a mercurial *scherzo*, and the most weight concentrated into the *finale*, which ends in elegiac pathos as the first movement is recalled. Tremolando strings accompany the soloist's first-movement cadenza, recalling a similar device in Elgar's Violin Concerto. The choice of viola was brave, but the instrument's husky tone and capacity for melancholy exactly suit the music Walton wrote for it. All Walton's technical fingerprints are in the score, outstandingly the syncopated rhythmic patterns and the added-note diatonic harmony.

His next work was a short but action-packed oratorio on the subject of Belshazzar's Feast, originally commissioned for broadcasting but eventually offered to the Leeds Festival of 1931. The text was compiled by Osbert Sitwell. This celebration of Old Testament barbarity, with extra brass sections adding to the clangour of the score, was a triumphant success at its first performance and was acclaimed as the most important English choral work since *Gerontius*. It was regarded as shatteringly modern, but Walton had again cleverly pulled the wool over his listeners' ears. *Belshazzar* mixes nineteenth-century chromaticism with diatonic devices Handel would have recognised. Immense rhythmical vitality generates the excitement; the large forces are reserved for use when most effective; unaccompanied choral passages and recitative by the baritone soloist contribute to the dramatic contrasts. The orchestral descriptions of gold, silver, iron, wood, stone and brass are magnificently scored – a field day for the percussion. It is here that Walton first introduced one of those splendid march tunes which served him for the coronations of two sovereigns and the flight of the Spitfire fighter aircraft.

The year after *Belshazzar's Feast*, Hamilton Harty asked Walton to write a

symphony for the Hallé. He accepted, telling Siegfried Sassoon that he would try to 'knock Bax off the map'. Two movements were written quickly. The third (slow) movement took longer and the work, against Walton's better judgement, was performed without its *finale* in December 1934. Harty had by then left the Hallé and become conductor of the London Symphony Orchestra, which was probably why he was so anxious for the kudos of this first performance. Unfortunately the impression was given that Walton 'couldn't think' of a *finale*, even though much of that great movement was already written, and when the completed work was played the *finale* was harshly criticised. An emotional crisis in Walton's life had caused the delay, as is fairly obvious from the passionate and stormy course of the symphony. Like Vaughan Williams's Fourth, Walton's symphony was regarded as a harbinger of war, but he dismissed this interpretation as 'all nonsense'. It is a symphony as uninhibitedly emotional as are Elgar's. The grandeur of its writing for brass and woodwind and the use of pedal-points and ostinati are gestures in the direction of Sibelius, whose influence on English music of this date threatened to be overpowering (witness Moeran's Symphony in G minor). The work was ecstatically received and has retained a strong grip on British audiences' affections, its sheer vitality and full-bloodedness overcoming the impression of noisy over-scoring that can be given by an inadequate performance.

By the mid-1930s, Walton, at the age of thirty-three, was in the forefront of English composers. Invited to compose a march – *Crown Imperial* – for King George VI's Coronation in 1937, he showed that Elgar's mantle was by no means too big for him, and his friend Lambert, by now the author of a provocative and perceptive survey of contemporary music, *Music Ho!*, dubbed him 'the late Sir William'. In 1938 he was commissioned to write a violin concerto for the New York World Fair where it was to be played by Jascha Heifetz. It was not ready in time and the first performance was given in Cleveland in December 1939. Heifetz received a concerto – in B minor, like Elgar's – which catered fully for his supreme virtuosity in music of impassioned eloquence, sensuous and brilliant colours and a warmth which perhaps derived from its having been written in Italy. Its structure repeats that of the Viola Concerto, but there is more of rapture, less of wistfulness in it and it has entered the repertoire of the world's leading virtuosi.

Interviewed in America in 1939, Walton uttered some prophetic words:

Today's white hope is tomorrow's black sheep . . . I seriously advise all composers to die at the age of 37. I know! I've gone through the first halcyon periods, and am just about ripe for my critical damnation.

After completing the concerto he had told a friend he was 'going to learn composition' by composing chamber music. Some psychological 'block' seems to have operated in Walton's creative spells. While writing *Belshazzar's Feast* and the Symphony he had reached an impasse where a problem had delayed him for months. He was exceptionally self-critical and often needed the spur of rivalry – with Lambert's *Rio Grande* in the case of *Belshazzar's Feast*, Bax and the proposed Elgar Third Symphony in the case of the Symphony, Howells for the piano quartet. A block of another kind descended on him in

1939 with the outbreak of war. He completed his best short orchestral work, the overture *Scapino* (1940), for Chicago and arranged some Bach for a ballet; otherwise he wrote mainly film and radio music, some of it for propaganda films such as *Next of Kin* or the life of R. J. Mitchell, the Spitfire designer, in *The First of the Few*. In 1944 he composed music for *Henry V*, the first of three Shakespeare films on which he collaborated with Laurence Olivier. The chamber music, which includes a lyrical string quartet, was delayed until 1947. By then the stage was held by a new 'white hope', Benjamin Britten (1913–76).

Walton's post-war music belongs to a later chapter, and this is not the place to attempt an examination of the reasons why it has never rivalled the popularity of his pre-1939 works. But the public's change of front was epitomised by a British publisher's remark made in Walton's presence at a 1948 reception in Buenos Aires: 'Of course, Walton isn't our most important composer – Britten is!'

Britten, on the road to Grimes

Britten at that date was thirty-five and his name had been prominent for fifteen years, since 1933. His route to prominence took a direction totally different from any of his predecessors. From the age of thirteen he had regular composition lessons from an established composer, Frank Bridge. Britten's time at the Royal College of Music was virtually a waste and taught him nothing except resentment of the academic musical establishment, in which he had in any case been well tutored by Bridge, another 'outsider'. After leaving college his practical composing experience came in film studios, with small ensembles working on a tiny budget, for radio and in the small left-wing theatre clubs which were a feature of London life in the 1930s.

Britten had begun composing at the age of five. Some of the music he wrote when he was ten was used for his *A Simple Symphony* (1933–4) and shows an innate gift for melody. Britten was to remain a composer of tunes – he regarded melody as a primary ingredient of music. Bridge was a severe teacher, instilling into his pupil a mastery of and respect for technique and 'to think and feel through the instruments'. He was also a 'one-man Sitwell' to Britten, taking him to London concerts and teaching him to admire Stravinsky when all around were wringing their hands. Bridge also communicated to Britten his pacifism and hatred of any form of cruelty. Both were thin-skinned; Britten's sensitivity to criticism developed almost to a paranoiac level.

Britten's music was first performed in London in 1932. Two of his works were broadcast during 1933, one of them (with Leon Goossens as oboist) the *Phantasy Quartet* which was chosen for the 1934 ISCM festival. In 1935 he was asked to compose music for short documentary films being made for the GPO film unit by the directors John Grierson and Paul Rotha. These films were educative and were also propaganda. Many of those concerned in them were of left-wing or at least anti-establishment persuasions, although their content today seems very mild and would alarm no one. No finer training for

a future opera composer could have been devised, for Britten had to improvise, compose to an exact duration of time and sometimes invent new sounds, such as the famous combination of sandpaper and wind-machine for a railway engine. While working for the film unit, Britten met the poet W. H. Auden who provided texts for two of the films. Early in 1936 they decided to collaborate on a song-cycle 'on animals'. This took shape as *Our Hunting Fathers*, for soprano (or tenor) and orchestra, first played at the Norwich Festival in September 1936. Auden selected three poems and himself wrote a prologue and epilogue. The work was both a private and public statement – 'private faces in public places'.

Our Hunting Fathers remains, after half-a-century, one of the most radical and alarming of Britten's works. It has a bitter savagery that arose not only from the sympathy with hunted animals implicit in the text, but reflected Britten's concern over the international situation (the Italo-Abyssinian war) and the situation in Germany. The work begins quietly enough, but with 'Rats Away!' an unprecedented sound entered British music, first with the scurrying and shrill ascending scales spreading through the orchestra like a plague of rats, then with the soprano soloist's version of the orchestral scales, a bizarre incantation rising to a shriek. Whether most of that first audience realised that the rats were the Fascists on the loose in the world may be doubted. Did they also miss the point in the third song, where towards the end the hounds' names 'German' and 'Jew' are deliberately juxtaposed? This song, 'Hawking', is a dance of death, a dance just beginning in Europe. The episode for orchestra alone in this movement shows a virtuosity that unsettled the London orchestral players, who had to be reprimanded at rehearsal and asked to give the young composer a chance. They had not encountered the works by Mahler, Bartók and Shostakovich which influenced this astounding passage; its ferocity was beyond them. A London performance followed, but this great work then disappeared for nearly twenty-five years and has only recently been appreciated as an extraordinary achievement. In it, Britten came of age.

His capacity for working fast and for turning out a good professional job earned Britten a reputation for 'facility' and superficiality. It was unfair and ill-informed criticism. Composing cost him agonising effort – he wrote and re-wrote 'Rats Away!' several times before he was satisfied – and his feelings were always deeply engaged. But perhaps his feat in composing in just over five weeks his *Variations on a theme of Frank Bridge* (1937), for the Boyd Neel String Orchestra to play at Salzburg, encouraged these misconceptions. Neel at any rate knew he had received a masterpiece, as time has proved, a work in which Britten's capacity for sharp and telling vignettes, for appropriate parodies and for 'thinking and feeling through the instruments' was displayed in all its most appealing guises. It was just after completing this work that Britten had lunch with Walton, whom he described in his diary as 'the head-prefect of English music, whereas I'm the promising new boy'.

The new boy was busy breaking more new ground for an English musician. He set French poetry in his song-cycle with orchestra, *Les Illuminations* (1938–9), Italian poetry in *Seven Sonnets of Michelangelo* (1940). He wrote cabaret songs for an Auden play (1939) and incidental music for

Priestley (1939). When he and his companion, the tenor Peter Pears, joined Auden in America in 1939, Britten demonstrated his uncanny knack of assuming an extra musical 'skin' and atmosphere by composing, in *Paul Bunyan* (1940), an American operetta which anticipated a musical like *Oklahoma!* and captured the idiom in a way no native composer had yet managed. If the work has its flaws, principally in Auden's libretto, it is still witty, exhilarating and touching, with a breadth of vision that anticipates his later stage works. Britten suppressed *Paul Bunyan* in 1941, but in 1974 was persuaded to revise it and to release it for performance. Thank goodness he did; its inventiveness explains how, only three years later, he could produce such a masterly 'first opera' as *Peter Grimes*.

Paul Bunyan also emphasises that Britten's strength lay in his ability to take the conventional devices of music and give them new life and colour. He was no revolutionary. He adhered to a key-system and to classical forms, treating them all in his own way. The two major orchestral works he produced in America, the Violin Concerto (1939) and the *Sinfonia da Requiem* (1940), reinforce these aspects of his development. The concerto, a threnody for the victims of the Spanish Civil War, is exactly contemporary with Walton's and until recently has lagged behind it in public esteem. Yet it has similar lyrical qualities and is scarcely less virtuosic in its demands. Its moving *finale* is a passacaglia, the first of several uses of this form by Britten as a means of expression for some of his most impressive and deeply-felt music.

The concerto also showed that Britten could think in long paragraphs. There is a self-generating force here, a symphonic logic, the thematic material all derived from a single 'cell'. The manic fury of the orchestration of *Our Hunting Fathers* gives way to a more disciplined scoring, but still with such Berliozian imaginative strokes as a tuba solo accompanied by staccato ostinati for piccolos. A monothematic, or 'cellular', method is used, too, in the *Sinfonia da Requiem*. This is even more concentrated than the concerto, lasting barely twenty minutes, encompassing a savage orchestral *Dies Irae* which splinters into fragments of theme, one of which becomes the consolatory subject of the finale. Where this music again differs from any being written by a British composer of this date is in its creative indebtedness to the examples of Berg, Mahler and Stravinsky.

Britten returned to England in 1942. He signalled his return with a masterly setting of English poets, the *Serenade* for tenor, horn and strings (1943). Here he showed two aspects of his genius: the Purcellian vivacity and clarity of his word-setting and the stimulus he derived from writing for specific artists, in this case the tenor Pears and the horn-player Dennis Brain. But the success of this work – it was speedily recorded – paled beside that of the major opera, *Peter Grimes*, on which Britten worked from 1943 to 1945 and which was chosen for the re-opening of Sadler's Wells Theatre on 7 June 1945 in spite of hostility to it within the company.

Peter Grimes is based on an episode in Crabbe's poem *The Borough* and tells of the hounding to death by the inhabitants of an East Anglian coastal village of a fisherman suspected of murdering his apprentices. Its appeal to Britten was multiple. The borough was Aldeburgh in his native Suffolk,

where he now lived. Its seascape and storms found their way unforgettably into the score. Its variety of characters offered the chances for a series of sketches at which Britten had shown himself adept in *Paul Bunyan* and, instrumentally, in the *Variations on a Theme of Frank Bridge*. Its central figure was an individual in opposition to the crowd, as Britten was as a conscientious objector (and, although this was not in 1945 a subject for comment, as a homosexual). Thus Grimes was idealised in the opera, whereas he was a villain in the poem. Britten seized the opportunities to create an opera which seemed to be new in its treatment but in reality was based on a series of well-tried devices – choruses, a storm, an off-stage church service, a dance and a mad scene. Only in Gershwin's *Porgy and Bess*, which hardly anyone then knew, had a community been so closely depicted on stage. The borough came alive for that first-night audience, not merely Grimes, but the pub's landlady, the village drug addict, the vicar, the fishermen. Like Berg in *Wozzeck*, Britten uses orchestral interludes to bind the action and to give the work symphonic unity and cohesion. The whole is a magnificent piece of theatre, moving, gripping, cathartic. The public instantly recognised its power and authenticity. Here at last was an English opera. Just as Elgar's First Symphony was England's first symphony, even though it had had many predecessors, so this was England's first opera notwithstanding all which had gone before, some of them excellent in their limited way.

And notwithstanding that Michael Tippett in 1944 had composed his oratorio *A Child of Our Time*, that much could still be expected of Walton, that Vaughan Williams had over a decade of creative activity left in him, that Bax, Ireland, Howells, Rubbra, Moeran and all the rest were alive and working, *Peter Grimes* ensured that the next twenty years in English music would belong to Britten. At a juncture in his career equivalent to Elgar's in 1901, Britten inherited a potentially more musical Britain than had ever existed. The war had stimulated interest in all the arts. Thousands who had never entered a concert-hall had now heard concerts and recitals in aircraft hangars and munitions factories. The organisation which had co-ordinated these activities, The Council for the Encouragement of Music and the Arts, was re-constituted when war ended as the Arts Council of Great Britain, the first Government-aided official body with powers to finance and assist artistic activities. Some of the existing orchestras were put on a firmer basis, new ones were formed. Broadcasting was on the eve of the inauguration of the Third Programme. It was a world of opportunity of which the pioneers, only half a century earlier, could not have dreamed.

Jacob Epstein, Conrad Bust *(1924)*.

4 The Visual Arts

RICHARD CORK

Innovation, retrenchment and renewal

During the final years of Queen Victoria's reign, there was a widespread feeling of complacent and insular satisfaction about Britain's achievements in the visual arts. The Royal Academy, not yet shaken by the avant-garde uprisings which would soon vigorously challenge its authority, continued to behave as if the Impressionist revolution had never existed. Leading Academicians like Sir Lawrence Alma-Tadema (1836–1912) commanded vast prices for works which avoided any direct encounter with modern life, preferring instead to provide skilful evocations of classical civilisation. The influence these painters exerted was formidable, not least through purchases made with money from the munificent Chantrey Bequest which shaped the representation of contemporary British art in the Tate Gallery. Criticism of the Academy's power was beginning to mount, but Roger Fry (1866–1934) was not yet ready to put the question he eventually posed in his damning review of Alma-Tadema's Memorial exhibition in 1913, asking how long it would take 'to disinfect the Order of Merit of Tadema's scented soap'.

Soon after Queen Victoria's death, however, London began to be invaded by exhibitions offering evidence of an outlook far more challenging than anything so far favoured by established artists of the day. In 1905 Durand-Ruel started the year with an Impressionist survey at the Grafton Galleries, containing over 300 paintings by artists who included Degas, Renoir and Manet. It excited considerable controversy, and the National Gallery scornfully rejected the offer of a fine Degas painting around this time. But an emergent generation of British artists was already taking a different view of continental developments. An older painter, Walter Sickert (1860–1942), encouraged them to explore the new possibilities opened up by radical French painting. He had been close to Degas during the 1880s, and upheld his mentor's belief in the importance of depicting contemporary society without regard for conventional notions about 'appropriate' subject-matter. Although no more of a thoroughgoing Impressionist than Degas himself, Sickert was prepared to experiment with colour, composition and themes

which shocked many of his friends. The *Camden Town Murder* series, inspired by the sensational killing of a prostitute, caused some artists to sever their relationship with him. They could not stomach the 'sordid' nature of such a subject, but Sickert was unrepentant. He believed that 'the more our art is serious, the more it will tend to avoid the drawing-room and stick to the kitchen. The plastic arts are gross arts, dealing joyously with gross material facts'.

To our eyes, there is nothing 'sordid' about Sickert's art during these years. Rather does he discover a sensuous intensity in his paintings of dark

Walter Sickert, The Camden Town Affair *(1909)*.

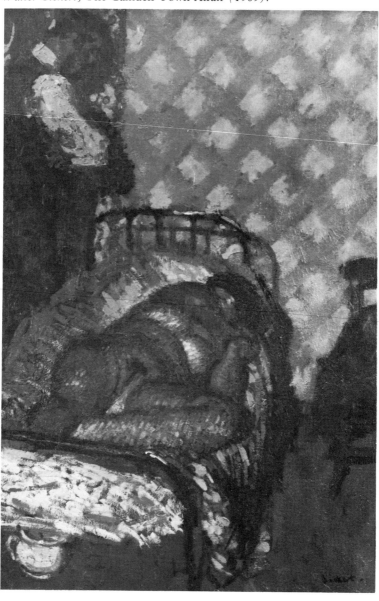

interiors at Mornington Crescent, where women either semi-naked or nude recline on beds and stare through veiled windows towards the source of the light. If feelings of repression and yearning can be found in these small canvases, they also convey Sickert's conviction that the lives of 'ordinary' people deserved to be depicted by serious British artists. Hence his determination to focus on the poorest levels of society in music-hall paintings which managed, at one and the same time, to provide a faithful record of the audience crowded in the cheapest seats and the fantasy world engendered by the stage lighting, the performers and the encrusted ornament in the auditorium.

Other painters, considerably younger than Sickert, shared his concerns. Spencer Gore (1878–1914) was particularly enchanted by the exotic spectacle to be found on the music-hall stage itself, but he was equally drawn to the streamlined modernity of the railway station and housing at Letchworth where his friend Harold Gilman lived for a while. Gilman (1876–1919), a socialist who was likewise committed to the depiction of the workaday aspects of society, scrutinised the world with a disciplined blend of incisiveness and audacity. While rooting himself in penetrating observation of his landlady's lodgings, an eating house or Leeds Market, he invested these mundane scenes with high-keyed colour and stern structural rigour. Charles Ginner

Spencer Gore, Letchworth Station *(1912).*

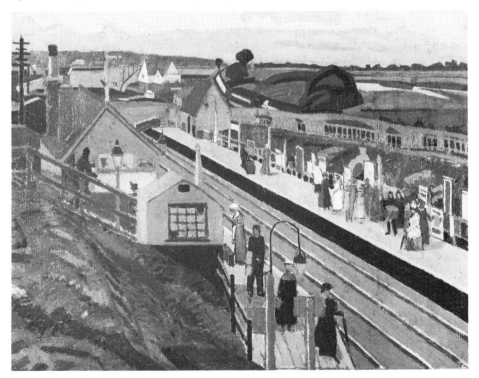

(1878–1952), in paintings like *Piccadilly Circus*, concentrated on the modern city and gave its hard pavements, increasingly motorised traffic and looming architecture a toughness verging on the austere. But beneath his severity lay a passion for Van Gogh, and he shared with both Gore and Gilman a lively interest in all the Post-Impressionist painters.

By the time they joined Sickert and other young artists to form the Camden Town Group under Gore's presidency in 1911, London had finally become aware of Post-Impressionism's existence. Roger Fry, a prominent critic whose own recent paintings displayed a growing debt to his new hero Cézanne, mounted at the Grafton Galleries in November 1910 an exhibition which forced every artist in Britain to acknowledge that a profound change had taken place in French art. 'Manet and the Post-Impressionists' was a huge survey, focusing on the triumvirate of Cézanne, Van Gogh and Gauguin but also including examples of Fauvist painting and pre-Cubist work by Picasso. Many visitors were horrified by the show, and it created a furore so prolonged and well-publicised that Post-Impressionism entered the national consciousness at last.

Young painters who had yet to establish themselves were profoundly impressed, however, and Fry soon gave them another chance to become acquainted with the forces he had unleashed in the metropolis. In October 1912, at the same Galleries, his 'Second Post-Impressionist Exhibition' opened, with English and Russian artists supplementing the representation of French painters. Although Vanessa Bell (1879–1961) and Duncan Grant (1885–1978) were the two British contributors most closely in sympathy with Fry's critical standpoint, Clive Bell's introduction to the English Section of the show spoke for the other participants as well – men like Frederick Etchells (1886–1973) and Wyndham Lewis (1882–1957), who would later sever their connections with the Bloomsbury coterie. 'The battle is won', Clive Bell wrote triumphantly:

We all agree, now, that any form in which an artist can express himself is legitimate . . . We have ceased to asked, 'What does this picture represent?' and ask instead, 'What does it make us feel?' We expect a work of art to have more in common with a piece of music than with a coloured photograph.

For a moment, at least, the new generation of avant-garde British artists seemed united by a common determination to find an emancipated alternative to what Bell described as 'traditional forms'. The solidarity, if it ever really existed, proved short-lived. But a memorable coming-together of diverse painters and sculptors did occur in the summer of 1912, when Madame Strindberg unveiled London's first artists' cabaret, the Cave of the Golden Calf. This exuberant night-club, situated in a basement off Regent Street and dedicated to profane delight, broadcast the new spirit in art with uninhibited *élan*. Spencer Gore, in overall charge of the ambitious decorative scheme, executed huge wall-paintings of brazen jungle scenes. So did Charles Ginner, and the two Camden Town friends were joined by Wyndham Lewis who painted a vast canvas called *Kermesse* for the staircase. Although Lewis produced at least one other wall-painting in the Cave, as well as a drop-curtain for the cabaret stage, *Kermesse* was his most significant contribution. The first large-scale British painting convincingly to demonstrate an

awareness of Cubism, Futurism and even Expressionism, it catapulted the young Lewis to the very forefront of his generation.

The sculpture in the Cave was equally remarkable. Jacob Epstein (1880–1959) carried out brilliantly painted plaster reliefs on the columns supporting the low ceiling, while Eric Gill (1882–1940) made gilded images of the calf itself both for the entrance and a pedestal in the central room. The two men were united in their desire to revolutionise British sculpture. Inspired by Indian and African cultures rather than the traditional classical or Renaissance sources, they adopted a radically simplified approach which stressed the importance of primal themes: birth, virility, motherhood and erotic ecstasy. All these subjects had appeared in Epstein's earlier sequence of statues for the British Medical Association in The Strand, and soon afterwards he collaborated with Gill on a visionary scheme for a temple in Sussex, 'a sort of twentieth-century Stonehenge'. The project was never realised, but surviving fragments suggest that the two allies intended it as a monument to the principle of 'carving direct'. Close manual engagement with the sculptor's material, letting the stone or marble play a crucial role in determining the shape of the final image, became their *modus operandi*.

Epstein's massive *Tomb of Oscar Wilde*, installed in Père Lachaise Cemetery, Paris, in 1912, exemplifies this belief. The cubic bulk of the original block of Hoptonwood stone was retained in the sculpture, and the flying figure of the 'demon-angel' seemingly grows out of the block to which he is attached. Gill was equally attentive to the innate identity of his stone in early carvings like *Ecstasy*, even if he never supported Epstein's enthusiasm for the extreme distortion to be found in African and Oceanic art.

Friendships formed in Paris with Brancusi and Modigliani confirmed Epstein's involvement with 'primitive' figures, which affected the outstanding carvings he produced after his return to England in 1913. Working in rural seclusion on the South coast, he made three flenite carvings, two marble Venus figures and some groups of copulating doves. All, in their distinct ways, owed a profound debt to 'primitive' sculpture, but Epstein was also able to infuse them with a very personal apprehension of fertility and sexual magnetism.

At the same time, he developed the idea of a totemic male figure who would embody not only phallic power but the thrusting dynamism of the machine age. Epstein was encouraged to pursue mechanistic metaphors by his new friendship with T. E. Hulme, a philosopher and critic who was convinced that

the new 'tendency towards abstraction' will culminate, not so much in the simple geometrical forms found in archaic art, but in the more complicated ones associated in our minds with the idea of machinery.

The example set by the Italian Futurists, insisting on the importance of conveying the speed and energy of the machine world, must also have played a part in the evolution of this extraordinary sculpture. Epstein, however, decided to go further than Futurism. With astonishing audacity, he purchased a second-hand American rock drill mounted on a tripod, and modelled a white plaster figure who straddled the machine. The combination of man-made driller and ready-made implement was a revolutionary one,

paralleled at that time only by Marcel Duchamp who announced that an ordinary *Bicycle Wheel* was a work of art. Epstein considered the possibility of setting his *Rock Drill* in motion, but then discarded the plan. He was, after all, sufficiently removed from Futurism to dislike the representation of motion in art, and his stark drawings for *Rock Drill* are more closely allied with the vision defined in Wyndham Lewis's contemporaneous work.

Epstein was too sturdily independent a personality ever to become a member of the movement whose arrival was announced in July 1914 by *Blast*, a witty and belligerent magazine edited by the tireless Lewis. But Epstein did contribute two drawings to *Blast*, and there is no doubt that *Rock Drill* can be closely related to many of the Vorticists' concerns. For Lewis, and the other young artists who signed the Vorticist manifesto in *Blast*, were convinced that British culture should place the dynamic transformation of twentieth-century life at the very centre of their work. The Vorticists damned the entire Victorian era, not because they shared Futurism's desire to destroy the past, but because they wanted British art to confront the dramatically changing character of modern existence. Proud of their country's prowess as an industrial nation, they believed that it should now produce a vigorous and indeed explosive movement to interpret the spirit of their own era.

The energetic and multi-talented Lewis was the principal driving force behind the Great English Vortex, writing many of its theoretical texts as well as painting and drawing some of its most forceful images. But he gathered round him a number of equally robust individuals. Ezra Pound, who had earlier attempted to revolutionise English poetry through the Imagist movement, gave Vorticism its name and became its most indefatigable source of critical support. He was especially close to the young French sculptor Henri Gaudier-Brzeska (1891–1915), who had settled in London a couple of years earlier. Although he could be bewilderingly eclectic, moving from classicism to primitivism with virtuoso assurance, Gaudier did formally identify himself with the Vorticists. He signed their manifesto in *Blast*, wrote a defiant credo for the same magazine, and introduced to carvings like *Redstone Dancer* (1914) an interest in geometrical rigidity which became fused with his innate response to organic vitality. *Bird Swallowing Fish* (1914) reveals the strength of Gaudier's ability to turn these complex concerns into convincing sculptural form. The action of the bird's predatory impulse is brilliantly defined, and Gaudier also succeeds in transforming both the combatants' bodies into eerily mechanistic components.

The painters associated with Vorticism were strikingly youthful, too. Both Edward Wadsworth (1889–1949) and William Roberts (1895–1980) had recently left the Slade, but they made impressive contributions to the Vorticists' harsh, clean-cut and often dazzlingly coloured vision of the modern world. Wadsworth was exhilarated by the new visual possibilities opened up by air travel and photography taken from aeroplanes. Its imagery helped him to define a new way of looking at Britain's great northern industrial centres, some of which Wadsworth had known since his Yorkshire childhood. Roberts, by contrast, was a Londoner, and based most of his Vorticist work on life in the metropolis: street games, boatmen and dancing were among the subjects he tackled, in large canvases which have since been tragically lost.

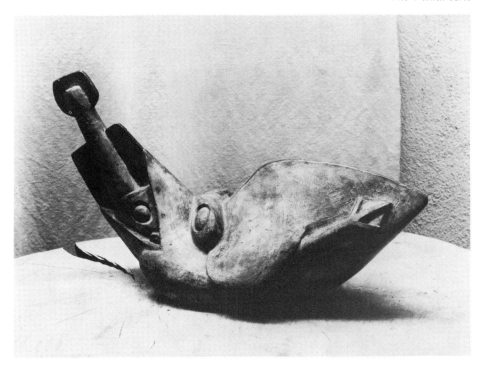

Henri Gaudier-Brzeska, Bird Swallowing Fish *(plaster; 1914)*.

Many of the major paintings shown in the Vorticist Exhibition, held in June 1915 at the Doré Galleries, have likewise failed to survive. But enough still remains to prove that Vorticism was a vital and inventive attempt to confront the rapidly changing character of twentieth-century existence. The advent of the First World War gave the movement very little time to establish itself, and the second issue of *Blast* (July 1915) proved to be the last. Before they left for active service in France, though, the Vorticists defined for themselves an art with a fiercely independent identity. The debt to the Italian Futurists, who had first exhibited in London in March 1912, was considerable: Marinetti's exclamatory insistence on interpreting the speed and dynamism of machine-age life awoke many English artists to its importance. Vorticism, however, rejected the blurred multiplicity of Futurist art and its rhapsodic attitude towards the modern world. The British, as *Blast* pointed out, had been an industrial society long before the Italians, and the Vorticists adopted a less romantic and excitable attitude towards their chosen subject-matter. Within their tightly defined contours they enclosed a prophetic awareness of the capacity for destruction which mechanised armaments would fully unleash during the Great War.

Although enlistment halted the careers of many young artists caught up in the conflict, and terminated Gaudier's life when he died in the trenches, it also produced some impressive war paintings. Christopher Nevinson (1889–1946) had previously been Marinetti's most faithful British disciple, but first-hand experience of slaughter forced him to reject the Futurist's enthusiasm for the violence of battle. Invalided home, he started painting a

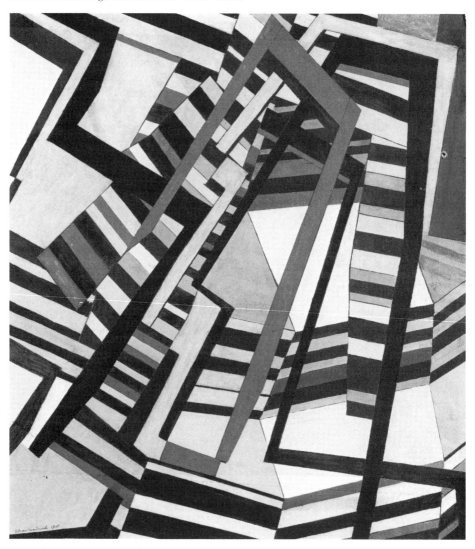

Edward Wadsworth, Enclosure, 1915 *(gouache)*.

remarkably uncompromising series of images which stressed the futility and despair engendered by war – anti-heroic images courageously at odds with the jingoism of the patriotic propaganda produced by the government's enlistment drive. *Returning to the Trenches* is among the most memorable of these canvases, with its marching soldiers caught up in a dehumanised process over which they have no control.

Nevinson's anger, which abated once he became an Official War Artist, was taken up in the later years of the battle by Paul Nash (1889–1946). Before the war, Nash had been a visionary landscapist in the tradition of Samuel Palmer and the Pre-Raphaelites, defining his rapt response to the English countryside on a small scale with ink, pencil and watercolour. Confrontation with the appalling desolation of the trenches transformed him into an enraged witness,

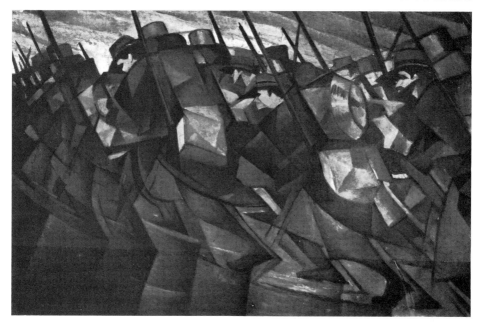

Christopher Nevinson, Returning to the Trenches *(1914)*.

determined to convey the 'bitter truth' of war to the public at home. Although *We Are Making a New World* is among the first oil paintings Nash ever produced, it manages to mount a stark and unforgettable assault on the futile waste of a conflict which threatened, at the time, to exact an endless toll on human lives.

Nash and Nevinson were not alone in the eloquence of their response to the war. Mark Gertler (1891–1939), who had previously concentrated on scenes of Jewish life inspired by his own East End childhood, produced in *The Merry-Go-Round* a hellish vision of humanity trapped on a fun-fair ride which reduces everyone to the level of manic, yelling automata (colour pl. 3). And several of the Vorticists executed as official commissions large-scale war paintings which confirmed their earlier promise. Lewis's *A Battery Shelled* and Roberts's *The First German Gas Attack at Ypres*, commissioned by the British and Canadian governments respectively, achieve the difficult feat of reconciling their earlier avant-garde concerns with the more documentary demands of memorial image-making. Both artists were aided in their tasks by a genuine desire to retreat from near-abstraction, and forge a figurative art which retained the formal tautness they had developed during their Vorticist period.

It was, all the same, a difficult time for painters who had pushed their work to the greatest extreme in the pre-war period. David Bomberg (1890–1957), a young artist from the same East End Jewish background as Gertler, found the transition especially agonising. The paintings he produced around 1913–14 were among the most impressive and adventurous of the period, drawing on an intelligent understanding of Cubism, Futurism and Vorticism while asserting an independent alternative of his own. Fascinated

by the energy of 'a great city, its motion, its machinery', Bomberg transformed the spectacle of men working on a ship in dockland, or bodies exercising at a Whitechapel Steam Baths, into spare, jagged and exuberant images. *In the Hold* and *The Mud Bath* are among the most enduring canvases in early twentieth-century British art, and Bomberg's pared-down vision of life in the 'steel city' made his 1914 one-man show an outstanding event (colour pl. 4).

Bomberg's gruelling experience of war profoundly altered his perception, however. Realising that the machine world had a terrible capacity for destruction, he recoiled from his earlier work and set about searching for a more representational language. The first version of *Sappers at Work*, commissioned by the Canadian government in 1918, was a brave attempt to reconcile his previous style with a greater awareness of figurative priorities. But it was rejected by the Canadian committee, and Bomberg ended up compromising himself with a more detailed and almost 'photographic' version of the painting which excluded too much of his true imaginative fire.

The immediate post-war years proved an uneasy period for many British artists. When Lewis organised an exhibition containing many former Vorticists in 1920, the non-committal label 'Group X' was chosen for an event which proposed 'no theory or dogma that would be liable to limit the development of any member'. In common with many initiatives on the continent, there was a widespread desire to 'return to order' and revalue the classical tradition. As a result, abstraction played little part in 1920s art, and most of the artists who thrived during this period of retrenchment concentrated on the human figure. In sculpture, both Epstein and Gill developed into formidable carvers on an architectural scale. Although he spent an increasing amount of time modelling dramatically characterised portrait busts, Epstein carried over his pre-war involvement with 'primitive' art into monumental carvings like *Rima* in Hyde Park and *Night* and *Day* for the Underground Railways headquarters at Westminster, all of which aroused the kind of heated opprobrium Epstein had by now come to expect with every new public sculpture. Gill also worked on the Underground project, albeit in a less prominent position, and the experience he gained there helped him to respond with conspicuous poise and confidence when the BBC invited him to embellish the facade of Broadcasting House.

While the former Vorticist Lawrence Atkinson (1873–1931) pursued a lonely direction carving near-abstract images throughout the decade, the greatest acclaim for a sculptor was enjoyed by Frank Dobson (1888–1963). He commenced his career by executing squat, angular figures in the tradition of pre-war Epstein, but during the 1920s he evolved a more rounded and serene style of his own. Whether in the gleaming brass head of *Sir Osbert Sitwell Bt.*, or the more rounded classical fulfilment of *Cornucopia*, Dobson asserted a sensuous serenity which was also celebrated in paintings of the period. Matthew Smith (1879–1959) became its most voluptuous exponent, combining his earlier enthusiasm for intense Fauvist colour with a frankly ardent response to the female nude. His models, often clasping roses near their ample breasts, recline and tumble in ecstatic tangles of flesh, cushions and rich drapery.

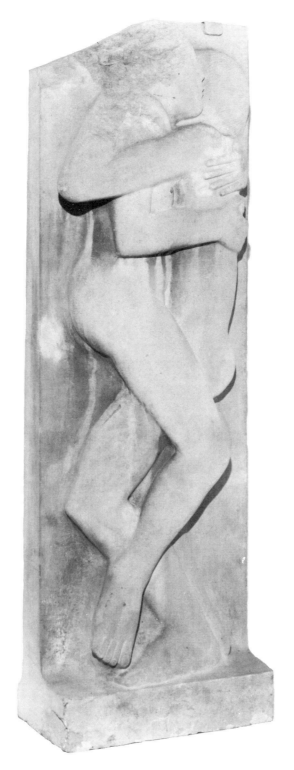

Eric Gill, Ecstasy *(1911)*.

Such a full-blooded celebration of womanly sexuality is rare in British art. The erotic is more often laced with anxiety or guilt, and in the work of Stanley Spencer (1891–1959) it is accompanied by an intense visionary strain as well. He defined his identity soon after leaving the Slade in 1912, with pictures which brought his admiration for artists as disparate as Gauguin and Giotto into a wholly personal synthesis. But it was during the 1920s that his reputation flowered, nowhere more spectacularly than in the vast *Resurrection* which formed the centrepiece of his 1927 one-man show at the Goupil Gallery. Although Spencer continually rooted his art in the Berkshire village of Cookham, where he lived for much of his life, he set no limits on the miraculous events which occurred there. Time and again in his paintings, a concrete and meticulously realised depiction of everyday reality becomes the setting for an epiphany. Christ's entry into Jerusalem is seen as a moment which transforms the village street into a wild and mysterious place, where children run headlong down pale blue pavements and fear rather than joy is the prevailing emotion.

The full complexity of Spencer's attitude towards sexuality is revealed in his *Self-Portrait with Patricia Preece*, where the artist appears oddly detached from the sagging, inert nude lying on the bed beside him. Far more affirmative was the majestic sequence of paintings he carried out for the Sandham Memorial Chapel at Burghclere. Completed in 1932, for a building Spencer played a prominent part in designing, these heartfelt images redeem the horror of the First World War by stressing the brotherhood of army life and the culminating hope of resurrection. The Burghclere chapel marks a high point in British painting between the wars, and if William Roberts had found a similar patron he might also have been able to achieve a similar grandeur on an architectural scale. For Roberts's work is consistently monumental, and his involvement with workaday scenes ensures that the paintings he executed during the 1920s and 1930s amount to a vivid and compelling interpretation of city life. At the dance club, in the cinema and at the Hippodrome, the severe angularity of his early Vorticist style gradually gives way to a warmer and more rounded vision of humanity (colour pl. 7).

Other artists who had once been allied with the Vorticist movement also returned to more representational ways of seeing. Lewis, the former extremist, now became an impressively steely portrait painter. He transformed the ubiquitous features of Edith Sitwell into a memorable amalgam of deity and mannequin. British painting has, however, been marked throughout its history by a passionate preoccupation with landscape, and during the 1920s several outstanding artists concentrated on developing a close relationship with nature. Bomberg's new-found involvement with landscape painting, confirmed during a four-year sojourn in Palestine, is free of overt introspection. He found relief from earlier bouts of depression by studying the pristine architecture of Jerusalem, and the sensuous pink rock-face at Petra, with a devoted care that sometimes bordered on the topographical.

The notable stillness of Bomberg's painting in the Holy Land, eradicating people in favour of a keen-eyed scrutiny of buildings and the terrain they inhabit, reaches eerie proportions in the later work of Edward Wadsworth.

Turning away from the industrial world in order to pursue his love of maritime themes, he began to discover in harbour settings a strangely disquieting mood. Nautical instruments are juxtaposed with seashells in cool, impeccably ordered still-life groups which exude calm and mysterious expectancy alike. The quietude becomes uncanny and, in the end, perturbing, as if Wadsworth sensed that the tranquillity which had descended on these coastal settings could at any moment be replaced by a nightmarish alternative.

Not all British painters of the period shared this obsession. Mark Gertler echoed Frank Dobson's move away from stark angularity towards a more Mediterranean sense of ripeness and serenity, revealing a clear interest in the neo-classical monumentality explored on the continent by Picasso and other former members of the Parisian avant-garde. Well-rounded and sometimes awesomely aloof, the imposing female nude became a familiar figure in British painting between the wars. Gertler gave her a Renoir-like lusciousness in some of his canvases, festooned with plump fruit, burgeoning hothouse blooms and gaudily patterned fabrics. In these crowded and almost airless compositions there is a *horror vacui* that discloses the nervous strain beneath Gertler's apparent hedonism. Like many artists who had survived the Great War, he never fully succeeded in finding his equilibrium again. Even Paul Nash, who had exorcised the horror of the trenches in his great paintings of 1918–19, continued to signify his disquiet. The gaunt atmosphere of war still informs his images of the seashore at Dymchurch, where bleak ramparts seem to brace themselves against possible onslaught by the knife-edge waves.

A similar unease can be found in the lonely, attenuated figures who people the work of Gwen John (1876–1939). Her only London exhibition was held in 1926, when visitors at last began to realise that her art seemed more impressive than the increasingly erratic paintings produced by her celebrated brother Augustus (1878–1961). The contrast between them could hardly be more extreme. He was ebullient, gregarious and profligate, recklessly squandering his precocious talent as he grew older. She was reclusive and quietly determined, concentrating with singleminded stubbornness on an ever more refined vision. Augustus became a victim of his own notoriety and facility as an artist. Gwen remained virtually unknown outside a small circle of devoted friends and patrons, producing her work intermittently and with difficulty. He became best-known for portraits of distinguished sitters and exotic Romany themes (colour pl. 1). She focused almost exclusively on images of anonymous women, inhabiting austere surroundings which echo the severe simplicity of their poses (colour pl. 6).

While Augustus dreamed of vast decorative paintings filled with exuberant gatherings, Gwen restricted herself to canvases of modest dimensions containing single figures alone. The youthful fame he once enjoyed has since been replaced by critical indifference and disparagement. But the obscurity she cultivated during her lifetime is rapidly giving way to widespread admiration. Gwen, in fact, now looks like a far more satisfying and distinctive artist than her brother ever managed to become. Isolated her sitters may be, but they are fortified by an inner strength which enables them to cope with their loneliness. Most of her seated women are strikingly erect in bearing, as

if buttressed by their own spiritual resilience. The rooms they inhabit look bare, but Gwen herself regarded a small and sparsely furnished interior as ideal accommodation. Here, she implied in her paintings, women can attain the restoration of selfhood. Soothed by silence, and shored up by the realisation that independence can sustain them, Gwen's most stoical sitters have discovered how to survive with grace, dignity and imperturbable poise.

With the advent of the 1930s, artists like Nash realised that their desire to marry pellucid clarity with the strangeness of a dream had much in common with the Surrealist movement. Without committing themselves to any formal affiliation with the Parisian Surrealists, both Nash and Wadsworth acknowledged that André Breton and his allies had defined an arresting new territory for modern artists to explore. Having experimented with abstraction and Surrealism alike, Nash finally decided in 1933 that the British avant-garde would benefit from the solidarity of a new movement. Accordingly, he announced in June through a letter to *The Times* the birth of Unit One, a group dedicated to 'the expression of a truly contemporary spirit'. Its aims were vaguely defined, and the artists who became its members ranged from Wadsworth and Nash himself to the altogether more abstract Ben Nicholson (1894–1982). But it embraced two of the most impressive young sculptors in Britain – Barbara Hepworth (1903–75) and Henry Moore (1898–1986). It also won the loyalty of modernist architects like Wells Coates, a founder member of MARS (Modern Architectural Research Group) and designer of some flats in Lawn Road, Hampstead, which are among the most distinguished modernist buildings of their time (see p. 242). So although Unit One lasted for less than two years, after holding a lively and controversial exhibition which travelled the country, it indicated that formidable new forces in British art were once eager to contribute to the ferment of experimental developments on an international level.

In terms of Surrealism, Unit One boasted in Edward Burra (1905–76) an artist whose work amounted to a great deal more than a faithful adaptation of continental models. Burra was undoubtedly stimulated by the Surrealist art he encountered in Paris, and his interest in the irrational power of dream imagery allies him with the French movement. From the outset, however, his work possessed a quite personal predilection for the raffishness of low life in Mediterranean ports, where young sailors conscious of their sexual allure roam streets pulsating with crowds whose hectic energy is worthy of Hogarth himself. Burra indulged in an irrepressible love of social satire, subverting the bourgeois propriety of his home town at Rye by painting delirious fantasies of barebreasted waitresses invading the local teashop. Concentrating on watercolour, but investing it with a formal complexity and richness of meaning more normally found in the most elaborate oil paintings, this quirky and uninhibited individualist created his own imaginative world. It was capacious enough to range from a brittle and orchidaceous celebration of Hollywood movie queens like Mae West, to a savage and fearful denunciation of the diabolic forces at work during the Spanish Civil War.

Nothing could be further removed from the restless vision of Burra, by turns disturbing, sarcastic and unashamedly 'camp', than the steady certitude of Henry Moore. The son of a Wakefield mining engineer, Moore displayed

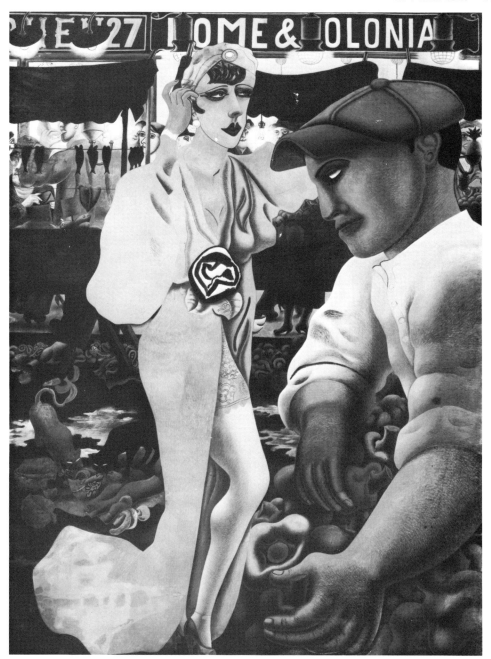

Edward Burra, Saturday Market *(gouache; 1932).*

an intuitive feeling for the strength and looming authority of the Yorkshire rockface from an early stage in his development. His vision of the reclining female figure, who dominates most of his sculpture, is permeated with a profound apprehension of the structure and tactile solidity of the land she

inhabits. Like Epstein, whose early carvings influenced the young Moore at a crucial stage in his career, he was determined to explore the most primal aspects of the human condition. He also shared Epstein's passionate interest in cultures far outside the Hellenic and Renaissance traditions, learning in particular from ancient Mexican carvings how best to charge his reclining figures with the maximum amount of awesome repose.

The emphasis on 'carving direct', which Epstein and Gill had pioneered before the Great War, was likewise of great importance to Moore. He honoured the intrinsic identity of the stone while he carved, allowing it to affect the character of the final image. 'Truth to materials' became for a while a much-quoted dictum, and Moore's work of this period invariably conveys an intense awareness of the stone or wood block which initially confronted him in the studio. Respecting the monumental mass of the substances he carved with such assurance helped Moore to invest his figures with an impressive and unrhetorical grandeur. At a formative stage he had come across copies of the Vorticists' magazine *Blast*, and Gaudier's 'Vortex' essay especially impressed the young man. 'Sculptural energy is the mountain', Gaudier had written, before adding that 'sculptural feeling is the appreciation of masses in relation'. Moore shared this titanic yet firmly disciplined view of the carver's role, and his finest work possesses a craggy majesty entirely compatible with Gaudier's stirring mountain metaphor.

But Moore did not confine himself to the pre-war generation in his search for artists he could admire. Acutely aware of continental developments as well, he learned from Arp and Picasso while searching for ways of investing his figures with the swollen erotic fruitfulness of biomorphic form. Moore was willing to be associated with a variety of avant-garde groups as the 1930s proceeded, showing in an 'Abstract and Concrete' exhibition of 1936 which brought together artists from several European countries, and in the very same year contributing to the great 'International Surrealist Exhibition' which shocked London with its unsettling exploration of subconscious desires. Although he was in sympathy with the Platonic idealism of the abstractionists, and the altogether more anarchic nightmares uncovered by Surrealism, Moore reserved the right to stake out a singular path for himself by remaining faithful to a lifelong obsession with the earthbound recumbent figure.

Barbara Hepworth, the other outstanding sculptor of the period, shared Moore's involvement with the female body. But she did not become as fascinated by the reclining nude, and her carvings assert a gentler order of feeling than Moore's robust, sometimes disturbing vision encompasses. They are, nevertheless, united by their Yorkshire upbringing, which gave Hepworth the same abiding respect for the land. She liked to imagine her standing figures erected in remote stretches of the countryside, and the elemental form assumed by so many of Hepworth's carvings reveals her veneration of the great prehistoric standing stones still to be found in the British landscape.

Although early in her career she studied traditional techniques of marble carving, while living at the British School in Rome, Hepworth soon displayed a pioneering enthusiasm for abstract experimentation. After visiting

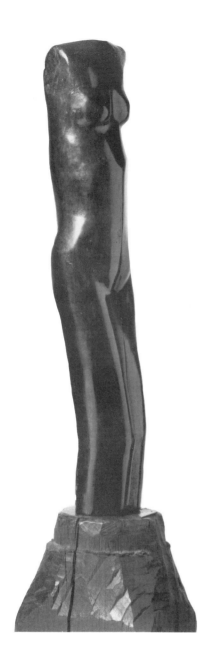

Barbara Hepworth, Torso *(1932)*.

the studios of Picasso, Brancusi, Arp and Mondrian in the early 1930s, she
showed scant hesitation in joining the group Abstraction–Creation in 1933.
Always more attracted to the purity of simple geometric forms than Moore,
she began carving primary shapes which no longer bore any overt relation to
figurative themes. Nevertheless, Hepworth's public identification with the
abstractionist cause does not mean that she abandoned her most profound
sources of inspiration. On the contrary: she stressed in the Unit One
publication of 1934 that 'in the contemplation of Nature we are perpetually
renewed, our sense of mystery and our imagination is kept alive and, rightly

understood, it gives us the power to project into a plastic medium some universal or abstract vision of beauty'.

Ben Nicholson, who was married to Hepworth at this time, fully endorsed her belief in the universality of abstract form. Having taken a long time to find himself as an artist, he was fired in his determination to become a serious painter by an encounter with the work of Picasso and Braque in Paris. When this Damascan moment occurred, in 1921, he was not yet ready to absorb its full implications in his own work. But after a period of landscape and still-life painting in a consciously 'naive' style, aspiring to the freshness of vision he found in the untutored pictures of the Cornish fisherman Alfred Wallis, Nicholson reached an impressive maturity in the 1930s. He accompanied Hepworth on those seminal visits to the Paris studios of Picasso, Arp and Mondrian, and their inspiration proved decisive. Around this period his painting takes on a new authority. Whether in the cubist complexity of *Au Chat Botté*, where the still life images merge with the shop-window lettering to an almost hallucinatory degree, or the minimal austerity of his all-white reliefs, Nicholson balances strength and refinement with exquisite calculation.

Draughtsmanship of the most assured and incisive kind plays a vital part in his finest work. Even in paintings which reveal his feeling for bleached colours in all their subtle variations, line is often allowed to enjoy a life of its own. It curves, ripples and meanders among the painted forms, often scratched into the picture-surface with the end of a brush. Nicholson's fascination with linear movement issues from the same sensibility which was enthralled by the finesse and rhythmic exuberance to be found in the games of tennis he enjoyed so much.

When Mondrian settled in the same road as Nicholson in 1938, joining earlier artists from abroad like Gabo and Moholy-Nagy, London looked for a while as if it might blossom into a cosmopolitan centre for contemporary art. The publication of *Circle*, jointly edited by Gabo, Nicholson and the architect Leslie Martin, summed up the spirit of optimism which led them to suppose that Constructivism in painting, sculpture, architecture and design could renovate 'the whole of our culture'. But the advent of the Second World War shattered that utopian hope. Mondrian left England for ever, while Nicholson went down to St Ives with Hepworth and their three children. Although the artistic colony they formed there with Gabo was remarkable, its full flowering only took place after the privation of war came to an end.

Not that the 1930s had been a comfortable time for British artists. As the Depression intensified, more and more young painters became involved with left-wing politics in their search for a role less dependent on the vagaries of a capitalist art market. In 1937 William Coldstream (1908–87) explained how he had become

convinced that art ought to be directed to a wider public; whereas all ideas which I had learned to regard as artistically revolutionary ran in the opposite direction. It seemed to me important that the broken communication between the artist and the public should be built up again and that this probably implied a movement towards realism.

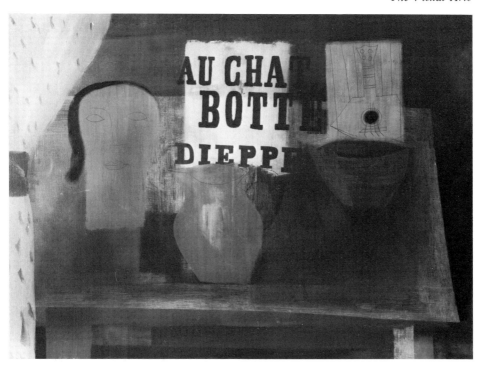

Ben Nicholson, Au Chat Botté *(1932)*.

Ben Nicholson, White Relief *(1935)*.

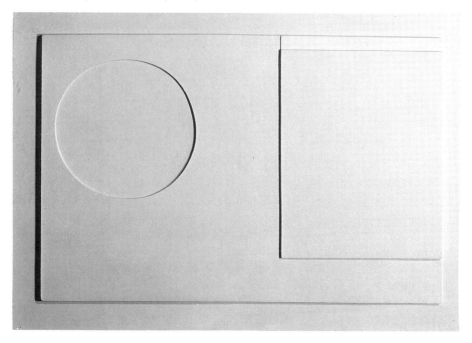

The sincerity of this conviction led Coldstream to work for a while with John Grierson's legendary documentary film unit, collaborating with his friend W. H. Auden on a pioneering study of mining life called *Coal Face*. Coldstream's interest in film-making proved short-lived, but it did confirm his belief in the accessibility of art. He went on to work with the anthropologist Tom Harrison and the painter Graham Bell (1910–43) on a project for Mass Observation – an enterprising and imaginative venture which attempted to study working-class life and culture with a new objectivity and analytical insight. Both Bell and Coldstream painted the smoke-laden cityscape of Bolton with a reticent sensitivity that characterised the School of artists they had helped to originate in 1937. Victor Pasmore (b. 1908) and Claude Rogers (1907–79) were the initial founders of the Euston Road School, but Coldstream and Bell soon became prominent members who contributed significantly to its achievements. As its title suggests, the School shared the earlier Camden Town Group's partiality for ordinary life with a bias towards the urban scene.

Sickert was the senior British painter venerated by all the Euston Road School's artists, but they had no desire to ape the remarkable late phase that the old man had by now embarked on. Sickert's work of the 1930s, which has only recently been given the attention it deserves, was based on the overt use of photographs. Either culled from newspapers and film stills, or taken according to specifications from the painter himself, these unorthodox images gave Sickert the springboard he needed. Nothing was too 'vulgar' or

Victor Pasmore, The Quiet River: The Thames at Chiswick *(1943–4)*.

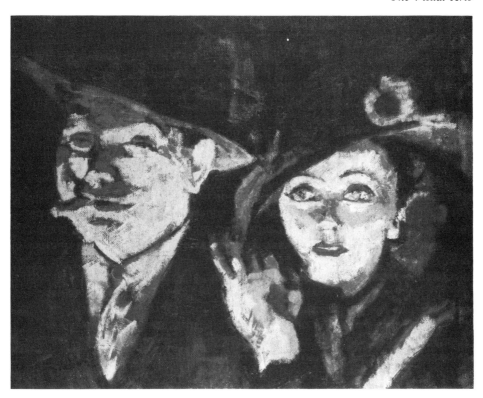

Walter Sickert, Jack and Jill *(1936). (This painting shows Edward G. Robinson and Joan Blondell in the film* Bullets and Ballots*).*

mundane for his attention, and he ranged from the high-kicking Plaza Tiller Girls to Edward G. Robinson in an omnivorous enthusiasm for virtually every aspect of inter-war society.

The Euston Road School's members admired Sickert's open-minded willingness to paint mining life or a shop window in the high street, and they showed a distinct preference for commonplace subjects like a self-service café, St Pancras Station and a flower-stall on the street. But the resolutely reserved and measured approach they favoured was far removed from the deliberate roughness of Sickert's late handling. Lawrence Gowing (b. 1918), who attended the School of Drawing and Painting in Euston Road, wrote of his *Mare Street, Hackney* that 'I privately thought of the subdued but respectful manner in which I painted as in some way identifying with people deprived of the fruits of their labour'.

A far more openly political identification with the poor and unemployed of the Depression era came to the fore with the Artists International Association. Although originally a small Marxist group, dedicated to using art as a means of aiding working-class struggle, it developed into a broader force capable of attracting many artists who did not place proletarian liberation at the centre of their work. United by their abhorrence of Hitler and Mussolini, an impressive range of painters and sculptors contributed to the AIA's 1935 exhibition 'Artists Against Fascism & War'. In essence,

though, realism of a decidedly polemical kind remained the AIA's fundamental purpose, laced with the satirical venom of James Boswell (1906–71) and James Fitton (1899–1982), who contributed barbed Grosz-like illustrations about the evils of both capitalism and Fascism to the pages of the *Left Review*.

The sense of solidarity fostered by events like 'Artists Against Fascism & War', no less than the AIA's persistent emphasis on the social role of art and the need to widen its audience, bore fruit when the Second World War broke out. For the War Artists' Advisory Committee, swiftly established under the chairmanship of Kenneth Clark, was able to bestow surprisingly extensive patronage on a great number of British artists. If the Committee failed to encourage painters as outstanding as Bomberg, and sometimes lavished its plentiful funds on disappointing practitioners, Clark did succeed in nurturing some excellent work as well. Stanley Spencer, whose *Travoys Arriving with Wounded at a Dressing Station at Smol, Macedonia* had been one of the outright masterpieces of First World War art, was now invited to visit shipbuilders on Clydeside. The outcome was a superb sequence of paintings celebrating the intent and communal activity of men and women engrossed in the energetic business of assembling vessels for the war-effort. Another veteran of the Great War's art scheme, Paul Nash, concentrated on the theme of crashed German aircraft and produced, in *Totes Meer*, an elegiac master-piece that displays nothing but compassion for the pilots who lost their lives in the moonlit cemetery of shattered Luftwaffe fighters.

Clark was, however, alive to the merits of younger artists as well. Henry Moore, whose reputation had not previously spread far beyond the limited avant-garde circles where his sculpture was appreciated, now found himself reaching a broader public through war work. His sustained series of shelter drawings, inspired by the rows of sleeping civilians taking refuge on underground platforms during the Blitz, are clearly related to his earlier reclining figure carvings. But the visitors avidly attending the war artists' exhibitions as they toured the country immediately understood his shelter studies. People who might previously have mocked Moore's sculpture responded to the powerful blend of melancholy and resilience in his underground drawings. At once weary and stoical, the quiet spirit of endurance to be found in these sleeping forms helps to explain why Londoners so bravely survived the destruction of the metropolis and the perpetual threat to their own lives.

Clark also managed to preside over the wartime emergence of young artists associated with the neo-Romantic movement. John Piper (b. 1903) was its most popular adherent, having turned away from the abstract experiment-ation of his earlier painting in order to call for a return 'to the tree in the field'. So far as Piper was concerned, the tree was less important than the buildings to be found in the British countryside. As author of the Shell Guide to Oxfordshire, he became an authority on architecture, and his finest paintings invariably focus on the forms of a church, a castle or a country house. Under Clark's patronage, his feeling for the drama and nostalgia of picturesque ruins gained a tragic dimension. Piper's virtuoso line, bravura handling of watercolour and vivacious scratching techniques charge his

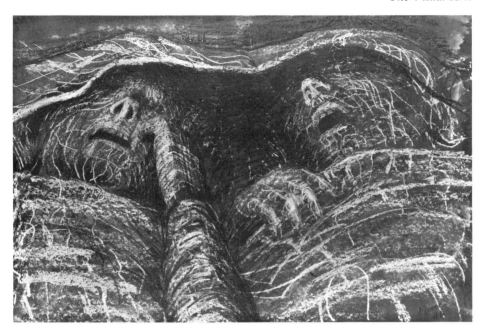

Henry Moore, Two Sleepers *(chalk and watercolour; 1941).*

pictures of bomb-damaged cities with genuine poignancy.

The other most impressive neo-Romantic, Graham Sutherland (1903–80), likewise made a successful transition from landscape painter to war artist. During the 1930s his early devotion to visionary idylls in the Samuel Palmer vein gave way to a darker mood. Discarding etching in favour of watercolours and oils, he found in the narrow lanes and waterways of Pembrokeshire a vision that stressed the menacing, claustrophobic and even violent aspects of the natural world. The Welsh countryside is seen as a disturbing terrain, haunted by thunderous intimations of the apocalypse sensed by so many other artists as the unrest in Europe reached its height. Sutherland therefore found himself well-equipped to transfer this awareness to his official war pictures, which survey the sad dereliction of bombed East End houses, define the grotesquely distorted remains of burnt-out factories, and discover in the corridors of tin-mines the grim resignation of men who spend their lives labouring in subterranean gloom.

The sense of foreboding and strain in such images is rarely to be found in the work of other war artists, who were largely shielded from first-hand experience of combat and had to content themselves with depicting the home front or the uneasy expectancy of soldiers waiting for battle to begin. After the war came to an end, however, the anxieties felt by Sutherland and some of his contemporaries were fully released, and this eruption contributed to the uncompromising bleakness displayed in the work of many artists who took on the task of interpreting the troubled condition of the post-war world.

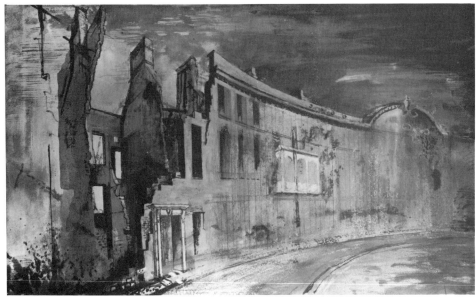

John Piper, Somerset Place, Bath *(watercolour drawing; 1942)*.

Graham Sutherland, Devastation 1941: An East End Street *(1941)*.

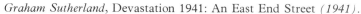

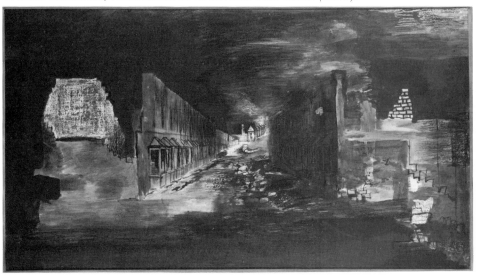

Epstein and Moore

Jacob Epstein's vantage-point as an outsider, a New York Jew who forsook his home to settle in London at an early stage in his career, helped him to develop a radically independent alternative to the prevailing British sculpture of his time. He soon came to view the sculptural conventions of early twentieth-century Britain with the impatience of an invader, a man who did not feel in the least bound to respect the tradition upheld by his predecessors.

After completing his early statues for Charles Holden's British Medical Association façade in The Strand, where Rodin and contemporary Viennese sculpture vied with Michelangelo, Donatello and Greek art as dominant influences in his work, he quickly grew dissatisfied with Hellenic, Renaissance and modern European sources of inspiration. Even in the BMA figures he displayed a restless determination to portray naked humanity without shame, and to deal in an uninhibited way with virility, procreation, maternity and sensual delight. He shared a love of Walt Whitman's poetry with Holden, and the two men believed in the importance of sculpture's ability to explore such themes in the teeth of the most ferocious opposition.

The public furore which greeted Epstein's BMA statues in the summer of 1908, and led to their virtual destruction almost thirty years later, was the first of many similar uproars provoked by the unveiling of his carvings. But he was never deflected by the opprobrium his sculpture attracted. Unabashed, the young Epstein continued to celebrate sexuality of the most overt kind in carvings like the massive 1910 *Maternity*, where his admiration for Indian art appears in the sinuous rhythms and openly erotic appeal of the pregnant woman's bountiful body. At the same time *Maternity* displays, in its deliberately 'unfinished' state, a desire to stress the primal identity of the stone from which it is fashioned. The principle of direct carving, tackling the block with vigorous manual urgency and honouring its original identity, is exemplified here on a monumental scale. Epstein's refusal to complete the work is surely bound up with his desire to remind the spectator that the image has been 'freed' from the stone, and that the character of his material exerted a profound influence over the form assumed by the emergent figure.

Epstein set no arbitrary limits on the range of cultures which could feed his imagination with new expressive possibilities. His omnivorous and open-minded readiness to absorb fresh sculptural experiences found an abundance of inspiration in the great collections housed at the British Museum. The Assyrian debt so evident in the winged figure on his *Tomb of Oscar Wilde*, installed at Père Lachaise cemetery in 1912, soon gave way to more primitive and extreme alternatives. Contact with Modigliani and Brancusi in Paris, where he stayed after installing the Wilde tomb, helped to convince him that African and Oceanic carvings possessed the formal and expressive power he admired most. After returning to England, Epstein spent most of 1913 making images that sought the primal grandeur of so-called 'primitive' art.

The most self-consciously archaic sculpture he produced during this intense period were the flenite figures: pregnant women bowing over their swollen stomachs with a mixture of fulfilment and defensiveness, as if fearful that their manifest joy in maternity might at any moment be threatened by aggressive forces. T. E. Hulme, who saw in these figures 'a new means of expression', admired Epstein's determination to purge his sculpture of the 'sloppy dregs of the Renaissance' and explore a more 'tragic' order of feeling. But the predominant urge behind Epstein's work was celebratory rather than apprehensive. The copulating doves who appear in three carvings around this time exude serenity, and their coolly simplified masses reappear at the base of two radically simplified Venus statues which extol the virtues of fertility and dignity alike.

Although Epstein was too independent to become an official member of the Vorticist movement, he admired the 'sculptural' qualities of Lewis's draughtsmanship and agreed to reproduce two of his own drawings in the first issue of *Blast*. They testified to his obsessive emphasis on birth, most dramatically in a disturbing brush study where a baby seems to have just emerged from the body of a screaming mother. It is a harsh image, but not in the end as troubling as the eventual outcome of Epstein's prolonged involvement with his great *Rock Drill* project.

In 1915, when the first version of this sculpture was placed on view, it must have appeared to be an awesome reflection of the sculptor's enthusiasm for the machine age. The man-made figure, mounted on a real drill supported by the strong pyramidal structure of its tripod, possessed an outsize authority. Although the driller's body had been transformed into a sequence of harsh mechanical components, Epstein did not as yet regard it as a tragic metamorphosis. Admiring the prowess of the pneumatic implement enough to incorporate its raw presence in his sculpture, he invested both man and machine with formidable virile strength. Only in the more organically modelled form of an embryo, lodged so unexpectedly within the driller's rib-cage, did he raise disconcerting questions about humanity's future in an age dominated more and more by technological inventiveness.

By the time Epstein displayed the second version a year later, however, all this triumphant poise had disappeared. *Torso in Metal from the 'Rock Drill,* as he now retitled it, is an elegiac image. Shorn not only of his machine but of legs and hands as well, the driller seems powerless. His mask-like head juts forward now at a plaintive angle, as he seeks to anticipate the prospect of danger. But his body has become so crippled and abject that he is no longer capable of defending himself, let alone dominating the world as he once did on his mighty machine. He is as forlorn and pathetic as the severely wounded soldiers who were returning from the Front in horrifying numbers, testifying through their broken bodies to the nightmarish carnage in the trenches.

Epstein abhorred war, and his detestation surely contributed to the dramatic transformation of his *Rock Drill* after 1915. Once he realised what machines were capable of destroying, in the first industrialised war humanity had ever fought, his whole attitude to mechanisation altered. When the drill was taken away from his sculpture, his infatuation with machine-age achievements vanished, too. After suffering a severe nervous breakdown towards the end of the war, he continued work on a radically different image which heralded the direction his work would take in the post-war world.

He called this attenuated bronze figure *Risen Christ*, as if to signify his hope that human existence would itself experience a resurrection after the trauma and waste of conflict. But no facile optimism can be found in this reticent and sombre figure, who emerges from death with resigned stillness rather than joy. Epstein's modelling displays a new interest in figurative elaboration which contrasts with the stripped-down austerity of his pre-war work, and in the 1920s he established himself as a virtuoso portraitist in busts that make vigorous expressive use of the clay he manipulated with such freedom. With sitters ranging from Joseph Conrad to Rabindranath Tagore, he soon became widely celebrated as a portrait modeller in the post-war period.

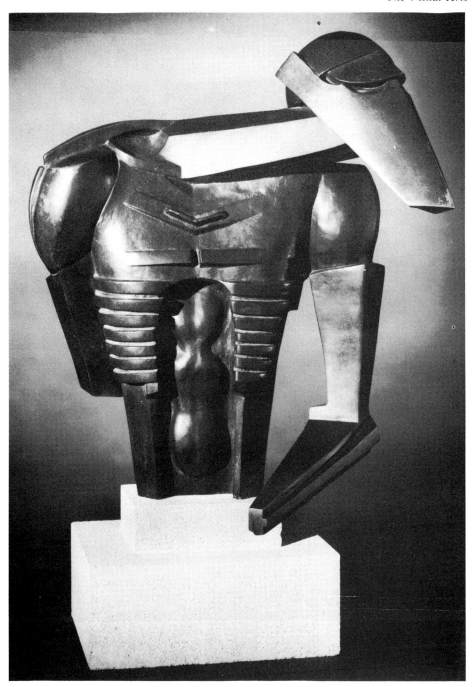

Jacob Epstein, Torso in Metal from the 'Rock Drill' *(1913–16)*.

His most impressive work, however, can be found in carving. After a long pause he resumed his love of cutting into monolithic slabs of stone in the mid-1920s, when commissioned to execute a memorial to W. H. Hudson in Hyde Park. The outcome, an ecstatic celebration of the wood-nymph Rima's

accord with the natural world, was reviled after its unveiling. But Epstein, by now all too familiar with such hostility, refused to be deflected. In *Night* and *Day*, two immense carvings executed for the new Underground Electric Railway headquarters towards the end of the decade, he produced his finest architectural sculpture. The commitment to an outspoken figurative art is still as strong as ever, and in *Night* Epstein reveals an involvement with Michelangelo's *Pietà*. But alongside this renewed interest in the Renaissance tradition, he remains faithful to non-European sources of inspiration as well. They give *Night* and *Day* a richness of associations which complements the severity of the style Epstein employed in his desire to fuse the carvings with the bareness of the buildings they embellish.

During the 1930s Epstein continued, without any encouragement from patrons, to make carvings of magisterial quality. *Elemental*, among the most outstanding, proves that his interest in primal themes remained as powerful as it had been when he made the flenite figures, and the carving's deliberate lack of finish helps to emphasise his continuing respect for the innate identity of the stone. In later statues as colossal as *Behold the Man* and *Adam*, Epstein reasserted his fidelity to the cubic mass of the material which confronted him in the studio before carving commenced. And *Jacob and the Angel*, an outright masterpiece completed in 1941, dramatises his physical and spiritual struggle to wrest the image he required from the vast block of veined alabaster. Although regarded for many years as a near-pornographic freak, worthy only to be exhibited in a peep-show display at Blackpool, this tumultuous work demonstrates that the later Epstein had relinquished none of his fire and ambition as a carver on the grand scale.

By the time he executed *Jacob and the Angel*, however, Epstein had lost his once-dominant position as the most audacious sculptor of the period. That mantle now passed to Henry Moore, who had good reason to feel grateful to Epstein at a formative period in his career. The son of a working-class mining family from Yorkshire, Moore was almost as much of an 'outsider' as Epstein himself. In his student days, Moore lost little time in realising the importance of the work made by the older man before the Great War. The pages of *Blast*, which Moore studied with admiration, alerted him to the drawings of maternity and birth themes which Epstein had reproduced there. They excited Moore as much as Gaudier's work, and helped to confirm his obsession with motherhood and the fruitful female form in his own sculpture. Moore shared the pre-war generation's belief in direct carving and remaining true to the intrinsic identity of his working materials. He also saw every reason to follow Epstein's lead in looking beyond the classical and Renaissance tradition for precedents that would help him revitalise sculpture in his own day.

Epstein proved useful to Moore in a practical sense, too:

He bought works of mine before ever I had an exhibition, and he showed an excitement in my work . . . on one occasion he jumped into a taxi with a piece of sculpture of mine he had just bought from me, even though I did not regard it as completely finished, because it was his and therefore he wanted it then and there.

Such enthusiasm was of immeasurable help to Moore at this early stage in his career, when he encountered plenty of hostile reactions to the uncompromising work he was producing. Epstein also contributed an appreciative foreword to the catalogue of Moore's second one-man show in London, and was instrumental in securing for the younger man an important commission on the Underground Electric Railways building in 1928. Although Moore was assigned a position on the façade far less favourable

Jacob Epstein, Jacob and the Angel *(1940–1)*.

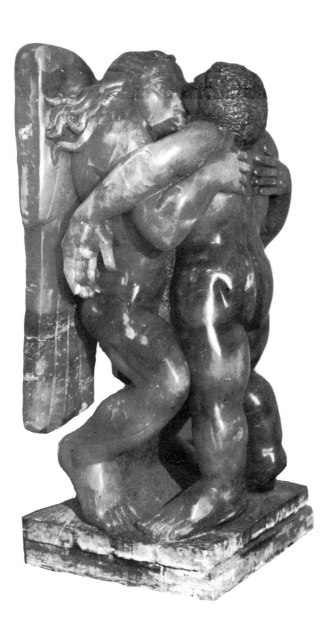

than Epstein enjoyed, he succeeded in carving the finest of the flying figures which a number of young sculptors contributed to the same building. Working for the very first time on a truly monumental scale, Moore gave his *West Wind* a large-limbed energy and gravitas which helped him to charge his subsequent recumbent women with compelling, unforced grandeur.

In the great Leeds *Reclining Figure* of 1929, Moore's debt to ancient Mexican carvings like the Toltec-Maya *Chacmool* statue becomes resoundingly clear. But it is in no sense slavishly dependent on this awesome source. Moore gives his Brown Hornton stone woman an epic resonance that derives fundamentally from a quite personal apprehension of the union between a female body and the earth she inhabits. It is a consoling vision, which seeks to heal the rift between humanity and nature which the machine age had done so much to widen. Moore's carvings insist, with a primordial sense of assurance, that the rift can still be countered. Moreover, he brings about a synthesis of womanly and landscape forms so complete that we cannot precisely tell where one ends and the other begins. The entire expanse of *Reclining Figure*, lying with such an air of physical fulfilment on her rough-hewn base, is equated with the dip and swell of the English countryside. Breasts become metaphors for hills, the waist slopes away into a gentle valley, and the thighs rise up like momentous affirmations of a mountain's rugged authority.

Moore developed rapidly in the 1930s, and soon took his place among the most outstanding sculptors of his generation on an international level. Always

Henry Moore, Reclining Figure *(1929)*.

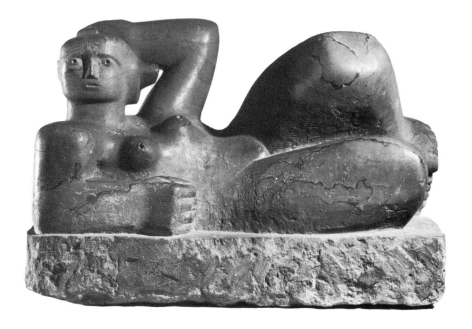

aware of new developments in Paris, even as he looked back at the achievements of the past, he learned a great deal from the emergent Surrealists. Like Francis Bacon, who at a later stage would benefit in his painting from Picasso's most Surrealist phase, Moore found he had much in common with the strangely swollen and distorted images Picasso produced around 1928. They confirmed his own belief that biomorphic forms offered rich possibilities to the artist involved with erotic and fertile themes. Picasso, of course, also explored a strain of macabre violence at this period, which ensured that Bacon would be attracted to his example. Sinister elements can sometimes be discerned in Moore's work as well, especially when he became concerned about escalating political unrest on the continent as the 1930s proceeded. But Moore's art is, in the end, profoundly affirmative. His reclining figures have a reassuring air of solidity and permanence, as if they would imperiously resist any attempt to disrupt or undermine their deep-seated accord with a natural order.

A felicitous commission in 1936 from the architect Serge Chermayeff helped Moore to consolidate his preoccupation with the landscape. Although he was by now out of sympathy with architects who tried to place sculpture in frankly subordinate positions on their buildings, Moore welcomed Chermayeff's invitation to carve a figure for the grounds of a house he had designed for himself in the Sussex countryside. Linked with Chermayeff's building by means of a garden screen, and yet able to establish an independent identity as well, the *Recumbent Figure* Moore produced is one of the most satisfying works he executed in the inter-war period. By this time he had begun carving regularly in the open air, having taken a cottage near Canterbury with a large garden for the purpose. The experience gained there fortified his earlier resolve to bring about a fusion of figure and landscape, thereby laying the foundations for his post-war success in siting his sculpture with such finality on a wide range of outdoor areas.

The Chermayeff project shows how sensitively attuned he had grown to the character of the surrounding countryside. Rather than simply conceiving the *Recumbent Figure* in his studio, and then imposing it on the location he was offered, Moore took his cue from the lie of the Sussex land. Recalling later that Chermayeff's house 'was a long, low-lying building and there was an open view of the long sinuous lines of the Downs', he described how

I became aware of the necessity of giving outdoor sculpture a far-seeing gaze. My figure looked out across a great sweep of the Downs, and her gaze gathered in the horizon . . . I think it introduced a humanising element; it became a mediator between modern house and ageless land.

Chermayeff and Moore also came together in a publication called *Circle*, which attempted to bring about a union between painters, sculptors, architects and writers sympathetic to the Constructivist ideal. Naum Gabo, the moving force behind *Circle*, held out the hope that after the 'disintegration' of the Great War 'we are now entering on the period of reconstruction'. Moore was happy to align himself with the spirit of optimism which gave the publication its essential impetus. But he never allowed himself to become too closely affiliated with any of the avant-garde

movements which provided the 1930s with so much of its vitality. In one context exhibiting with the Surrealists, and then displaying his work alongside artists more strongly committed to abstraction, he took what he wanted from each tendency and reserved the right to remain faithful to quite individual obsessions.

Although his sculpture varied considerably in both style and intention during this momentous decade, then, Moore held fast to an underlying preoccupation with the human figure. However ostensibly abstract his sculpture may at times have appeared, and however willing he was to inject it on occasion with outright Surrealist menace, Moore remained at heart a man engrossed by a consuming passion for the female nude as a vehicle for all his feelings about our relationship with the earth. Walks in the country and by the seashore provided this singleminded man with a perpetually renewable fund of ideas. The pebbles, rocks, branches, bones and shells he brought back with him to the studio were treated as a vital seedbed, from which a plethora of works grew. The organic pulse running through Moore's sculpture is immensely vigorous, and it infuses enduring life into his images of human existence.

Their defiant insistence on survival and repose became even more movingly explicit during the Second World War. Moore's disturbing *The Helmet*, executed in 1940, is a powerful metaphor for the armoured defensiveness which the British were forced to construct for themselves when the threat of Nazi invasion was at its height. Later on, though, Moore defined a mood of less explicit unease in his superb Underground shelter drawings. Working now for the War Artists' scheme, he saw the sleeping figures on London Underground platforms as embodiments of a nation under siege. Enclosed by claustrophobic tunnels, and unable to stir beyond their confines for fear of destruction in the Blitz, these gaunt yet stoical slumberers are resigned to enduring the perpetual onslaught in the hope of emerging the other side of war. In this respect, they reflect Moore's own determination to outlast Hitler's aggression and win through to a positive end. When the war eventually terminated, he had already been given a one-man show in New York which led to the gaining of enormous success during the post-war years. While Epstein had to content himself with a largely national reputation in his old age, Moore became familiar to a world audience and gave the British sculptors who came after him the highest possible achievement to measure themselves against.

Lewis and Bomberg

Towards the end of 1913 Wyndham Lewis's friendship with Ezra Pound, whose critical interest in the visual arts was now acute, prompted them to think about founding a revolutionary movement of their own. Having been associated in the public's eyes with the Italian Futurists, whose leader Marinetti had become notorious through his exclamatory performances in London, Lewis was now eager to establish himself with an independent identity. Pound, for his part, had grown dissatisfied with Imagism, the experimental movement in poetry he had helped to found two years before.

He christened the new alliance as Vorticism, and explained its meaning by announcing that the Great English Vortex was 'a radiant node or cluster . . . from which, and through which, and into which, ideas are constantly rushing'. Lewis preferred to emphasise the centrality of the Vorticists' endeavour, telling a friend to think

at once of a whirlpool . . . At the heart of the whirlpool is a great silent place where all the energy is concentrated. And there, at the point of concentration, is the Vorticist.

It was surely no accident that so many of the people associated with Vorticism came from outside England. Lewis was born on a yacht moored near Amherst in Nova Scotia; both Pound and Epstein had come over from America; and Gaudier was a Frenchman. They shared a restless dissatisfaction with established British art. The predominant tone of the Vorticists' magazine is aggressive and oppositional. *Blast*, which first appeared in July 1914, announced the arrival of Vorticism with strident and exhilarating forcefulness. Although indebted to the precedent established by the Futurists' magazine *Lacerba*, and to Apollinaire's manifesto *Futurist Anti-Tradition*, its typographical inventiveness has a very individual bulldog attack.

Lewis's abilities as a writer came to the fore, not only in the initial manifestos with their blend of bombast, humour and real passion but also in the rest of the magazine. His essays established him as an incisive and acerbic critic of contemporary art. He attacked everything from the Royal Academy to Marinetti, impelled by the fierce hope that England might be able to produce a truly radical art movement. He wanted the nation's artists to recognise the harsh, disturbing and yet dynamic reality of twentieth-century life – the fact that their existence was being transformed by industrialisation and 'the forms of machinery, factories, new and vaster buildings, bridges and works'. Lewis drew a clear distinction between the Vorticists' attitude to the machine age and the Futurists' rhapsodic stance. He rejected Marinetti's ultra-romantic celebration of speed and mechanical prowess. The British, claimed Lewis, 'are the inventors of this bareness and hardness, and should be the great enemies of Romance'. He hoped Vorticism would adopt a cooler and more detached viewpoint, far removed from the blurred motion and melodramatic fervour of Futurism. In this respect, Lewis situated himself nearer to the monumental austerity of Cubism, and he honoured Cézanne as the 'genius' who had initiated the move towards a 'superbly severe' new art. (See also colour pl. 5.)

But Cubism itself was too 'morose' for Lewis, too concerned with an enclosed studio-bound world of posed models and still-life compositions. He wanted to arrive at a unique synthesis of Futurist vitality and Cubist grandeur, involving himself with the modern urban clangour of the machine age and yet dealing with it in a stringent manner. His own Vorticist pictures may be volcanic in their implications, but their restless and often vertiginous forms are all contained within clearly defined contours. Lewis always opted for lucidity, and his drawings and watercolours of the archetypal twentieth-century city are controlled by a whiplash emphasis on line. Although he had

not yet visited New York, it seems to have shaped his image of the modern metropolis. One of his Vorticist watercolours is entitled *New York*, and in 1913 Alvin Langdon Coburn exhibited some photographs of the city in an influential London exhibition. Coburn subsequently became interested in Vorticism, collaborating with Pound on some abstract experiments called Vortographs which attempted to parallel Vorticism in photographic terms.

The publication of *Blast* confirmed the arrival of a rumbustious new force in British art. It included written contributions and illustrations by many of the liveliest new painters and sculptors in London, with Lewis the most prominent voice of all. But the sudden intervention of a world war disrupted the movement's activities all too quickly. Although the Vorticists were able to organise a Vorticist Exhibition in 1915, and publish a second issue of *Blast* the same year, they were granted very little time to develop their work. An astonishing amount was achieved in the hectic period between the publication of *Blast*'s first issue and 1916, when most of the artists went off to fight in France. But the tragedy of war inevitably affected them, and the second issue of *Blast* was a grim, monochromatic affair which included an obituary informing its readers of Gaudier's tragic death in the trenches.

Lewis himself enlisted in the Garrison Artillery, training first as a Gunner and then as a Bombardier. Although he survived his experiences at the Western Front as a subaltern in a siege battery, the war had a profound impact on the course of his art. Commissioned by the Canadian War Memorials Fund to paint an enormous canvas of *A Canadian Gun Pit*, he adopted a more representational style. And in 1918, when the Imperial War Museum invited him to paint another huge composition called *A Battery Shelled*, he produced an impressive and desolate image which juxtaposed his new figurative idiom with a more angular and mechanistic reminder of his Vorticist days. Many years later, in a letter to James Thrall Soby, he described the Vorticist period as

a little narrow segment of time, on the far side of World War I. That first war, you have to regard, as far as I am concerned, as a black solid mass, cutting off all that went before it.

The commissions for war paintings led Lewis to carry out an extended series of drawings and watercolours on the same theme. War is seen from the siege battery point of view, as a matter of waiting for attacks to begin in a bleak terrain where, from time to time, energetic attempts are made to pull the guns into position. Since the starkness of the scenes he depicted still related to the character of his earlier work, the change to a more representational approach did not appear momentous. But after the war sequence came to an end, Lewis felt the need to embark on a period of drawing from life. Both he and the other former Vorticists realised that their whole attitude towards the machine age had been changed by the war. Mechanisation was responsible for the destruction of human lives on an appalling scale, and it produced a feeling of revulsion. The Vorticist language did not seem an adequate means of conveying their altered awareness. Apart from Lawrence Atkinson, who alone pursued an uncompromising abstractionist vision, all the former Vorticists returned in their different ways

to a more representational approach. But Lewis did not regard this new development as a repudiation of his pre-war stance. In 1920 he firmly announced that 'the experiments undertaken all over Europe during the last ten years should be utilised directly and developed'. Even his drawings from the posed model retained the wiry discipline and taut structural concentration so evident in his earlier Vorticist work.

As the new decade developed, Lewis's fascination with portraiture grew. In 1914 *Blast* had published a reproduction of his *Portrait of an Englishwoman*, a stern watercolour which interpreted the lady's features as a sequence of uncompromisingly Vorticist blocks and bars. It appeared to launch an attack on the whole notion of conventional portraiture, but in 1919 Lewis inaugurated a new approach with a huge and frankly figurative portrait of Pound. He used himself as a sitter, too, executing an aloof *Portrait of the Artist as the Painter Raphael* which paid overt homage to the Renaissance and classical tradition. Iris Barry, who lived with Lewis at the time, was transformed into a mesmerising and strangely metallic presence called *Praxitella* – probably a reference to the Greek sculptor Praxiteles. Lewis produced his most memorable portrait of the 1920s when he painted Edith Sitwell as a haughty figure, half marionette and half deity, engrossed in enigmatic thought behind her hooded eyelids.

In view of the extraordinary intensity Lewis was able to invest in these images, it seems regrettable that he did not produce more during the 1920s. After temporarily setting aside the Sitwell canvas in 1923, he painted no further portraits for the rest of the decade. Indeed, he virtually abandoned working in oils altogether until the 1930s, concentrating instead on drawings and watercolours which offer a tantalising prospect of the paintings he might have executed. For the first half of the 1920s he devoted much of his energy to researching and writing a projected 'megalo-mastodonic masterwork' called *The Man of the World*. It was never published in that form, but Lewis subsequently divided the material into several books, including *Time and Western Man* and *The Apes of God*. This substantial literary achievement prevented him from devoting a great deal of time to visual art, and the lapse in his production of oil paintings made Lewis feel frustrated on occasions. In 1926 he refused an invitation from his old friend T. S. Eliot to write an article for *The Criterion*, explaining that 'it may be that as I have not been able for some time to have a studio and practise my delightful calling that, since I am prevented from doing it, I do not care to write about it'.

Financial considerations also played their part in the sad diminution of Lewis's output as a painter. His ambitions to execute large-scale mural decorations foundered through lack of patronage, and he had to content himself with executing a series of drawings in a precise, intense, delicately coloured vein. Since very few of them were ever sold, Lewis resigned himself to perpetual isolation in a country which refused to encourage him. No wonder he came to the conclusion at the end of the 1920s that 'the few dozen artists' making genuinely imaginative work 'have become like Aztecs or Atlantans, representatives of a submerged civilisation'. They kept the spirit of 'ambitious experimentalism' alive, modifying and extending the achievement of the pre-war 'tornado of Cubism, Futurism, Expressionism, Vorticism'

without betraying its fundamental aspiration. Lewis's work of the 1920s proves that he was justified in counting himself among them.

In the last three decades of his life, writing claimed so much of Lewis's energy that painting took an increasingly subordinate position in his work. But as the 1920s drew to a close, David Bomberg finally defined the direction which gave his art an increasing richness as he grew older. After returning from Palestine, where he had lived since 1923, Bomberg felt dissatisfied with the prevailing character of his work. The sojourn in Jerusalem, interrupted by occasional expeditions to Petra, Jericho and the pioneer settlements founded by Zionist communities, had fortified in him a resolve to concentrate on discovering a new relationship with the natural world. Like so many other artists who had belonged to the avant-garde generation of 1914, he felt an overwhelming desire after the war to turn away from the machine age and find consolation in a communion with the land.

Before the war commenced, however, Bomberg had been among the most uncompromising exponents of an art that confronted mechanisation on its own harsh terms. In the catalogue of his July 1914 one-man show, which proclaimed the emergence of a major new British painter, he declared that 'I look upon *Nature*, while I live in a *steel city*'. Although he based his art on observable reality, even when his style was at its most extreme, the young Bomberg ensured that the figures and urban settings in his work were shaped by the form-language of the machine world. As the son of a Polish immigrant who settled in the Whitechapel area, he had grown up acutely aware of the metropolis at the zenith of its power. His major pre-war canvases all took as their starting-point scenes Bomberg knew well in the East End, and he used them to make forceful meditations on the dramatic transforming dynamism of urban life at the beginning of a new century.

Like Chagall, he was able to reconcile the innate expressive vitality of his Jewish temperament with the implications of Cubism and Futurism. Bomberg admired the French movement for paring its vocabulary down to an austere scaffolding of forms, and he warmed to the Italian movement's insistence that the world of ever-accelerating speed and industrial strength should be placed at the very centre of contemporary art. In this respect, he had much in common with the Vorticists, but he always resisted Lewis's attempts to enrol him in the English movement. Bomberg refused to let his work be reproduced in *Blast*, and his name is conspicuous by its absence from the list of signatories at the end of the Vorticist manifesto. He was his own man, retaining a stubborn sense of independence which stayed with him throughout his life. And Bomberg's precocious early masterpieces demonstrate that his confidence was well-founded.

In the Hold, inspired by the unloading of a ship in London's dockland, is dominated by the heroic forms of two labouring men. Their harsh, clear-cut limbs chime with the equally stark structure of the ship which frames their movements, and a preliminary drawing reveals a strong figurative intention permeating the entire composition. By imposing a sixty-four-square grid on this design, however, Bomberg shattered the solidity and legibility of the scene. The fierce action of the squares, and the splintered triangles they contain, threatens to turn the entire painting into a prism-like abstraction.

But the more this prodigious canvas is examined, the more we appreciate that Bomberg has arrived at a carefully orchestrated balance between the schematic impact of the grid and the figurative scene beneath.

As well as allowing the rival claims of representation and geometric abstraction to wage war all over this combative picture, Bomberg uses the grid as an expressive device to convey his vision of the mechanistic energy in modern life. A similar motive lay behind his other great pre-war painting, *The Mud Bath*, which originated this time in Bomberg's experience of Schevzik's Vapour Baths in Brick Lane. Curative massages were offered at the Baths, a favourite rendezvous for the Jewish community, and clients would emerge from a visit feeling purged and revitalised. The figures who jerk, leap and fling their limbs across the surface of *The Mud Bath* are equally purified. Bomberg carves them into tense, stripped-down amalgams of white and blue, so that their angular bodies jut against the blaring red rectangle of water. Half human and half machine, they are reminiscent of the plaster figure who once bestrode the first version of Epstein's *Rock Drill*, and their construction was bound to appeal to T. E. Hulme. Bomberg was gratified to receive a long and enthusiastic review of his 1914 one-man show from Hulme, who believed with extraordinary prescience that Bomberg 'will develop remarkably, and he is probably by this kind of work acquiring an intimate knowledge of form, which he will utilise in a different way later'.

After his auspicious debut, the onset of war gave Bomberg very little time to develop this compelling vision. His gruelling experiences in the trenches, where conditions became so terrible that they drove him to administer a self-inflicted wound, left a permanent mark on his outlook. On his return from

David Bomberg, The Mud Bath *(1914)*.

the conflict, Bomberg found he could no longer deal with machine-age life in such a forceful spirit. Having once identified it with the dynamism of construction, he now saw it as the agent of destruction. Far too many soldiers had been slaughtered at the Front, including friends like Gaudier, Hulme and Bomberg's boyhood companion Isaac Rosenberg. The exhausted painter began to regard mechanisation as a sinister development, which threatened to dehumanise and alienate. He eventually began to realise that the only salvation was to be found in recovering a relationship with the natural world.

Just as he turned away from the angular severity and ruthless simplification of his pre-war style, so he exchanged his youthful obsession with the human figure for an equally singleminded interest in landscape. Disillusioned with a country which seemed to offer him little patronage or critical support, he decided in 1923 to leave Britain and settle for a while in Palestine. Although unsympathetic towards Zionism, he did attempt to paint scenes of life in the rural settlements. But they satisfied neither his Zionist patrons nor Bomberg himself, who was far happier studying the rooftops of Jerusalem or the surrounding countryside with an almost Pre-Raphaelite zeal.

After he held a one-man show of his Palestine paintings at the Leicester Galleries in 1928, Bomberg felt dissatisfied with the tight, near-topographical approach he had adopted during his stay there. Some of the Palestine works can be counted among the weakest he ever produced, but others show how much intensity he was now prepared to give his scrutiny of landscape. He learned how to paint from nature in that period, and the experience stood him in good stead as he tried to break free from painstaking detail in his subsequent work. Always happier painting in Mediterranean countries than in Britain, he achieved a breakthrough during a trip to Toledo in 1929. Bomberg's brushwork grew broader and more expressive as he allowed himself to project his own passionate emotions into the scenes he studied. The smaller Toledo pictures are often astonishingly free, and Bomberg realised that he should explore the possibilities they opened up in his subsequent work.

It was a courageous and lonely path to pursue. His new work attracted scant support back in England, where it offended the traditionalists and failed to excite interest among avant-garde groups now fascinated by Surrealism and abstraction. But Bomberg was undeterred, and after a disillusioning Russian expedition in 1933 he decided to return to Spain. Initially at Cuenca, and then at the southern town of Ronda perched on its massive plateau of rock, he discovered renewed inspiration. The spectacular grandeur of Ronda, where the rock is split by a dramatic ravine, brought out the most turbulent of Bomberg's responses. He stressed its fortress-like solidity and at the same time conveyed its vertiginous instability in images which seem almost to heave and buckle with the tension of the conflicting forces they contain.

If the gathering unrest of Civil War had not forced Bomberg to flee to England in 1936, he might well have stayed in Spain for the rest of his life. Back in London, the indifference he had already encountered grew to galling proportions, and his mood darkened in a sequence of gaunt, introspective self-portraits. Frequent bouts of depression meant that he sometimes became unable to paint for extended periods, and only in 1942 did he regain his

impetus with a commission from the War Artists' Advisory Committee. Its members reluctantly gave him a modest invitation to make one painting of an underground bomb store near Burton-on-Trent. The paintings he carried out in this disused mine are animated by a wild, tragic awareness of the destructive forces stacked in the eerie subterranean stronghold. The whole experience awakened memories of the First World War in Bomberg's mind, and he invested his outstanding sequence of Bomb Store paintings with an elegiac understanding of war's eruptive horror.

The War Artists' Advisory Committee refused to give him further patronage, however. Despite Bomberg's pleas, he was unable to receive the funding which would have allowed him to paint a huge 'Memorial Panel' based on his Bomb Store studies. The loss is ours, and the prophetic quality of the images he painted there was confirmed when the Burton-on-Trent store blew up in 1944, causing widespread devastation and loss of life in the biggest explosion ever recorded in Britain. Bomberg did not hear about this uncanny event, contenting himself with a series of views of blitzed London which show how deeply he felt about the grievous damage sustained by the city he regarded as his home. But the silhouette of St Paul's Cathedral rides over many of these scorched images as a symbol of endurance, and in the post-war period Bomberg would himself survive to enjoy a late flowering as a painter of landscapes so exuberant that they give little indication of the neglect he continued to suffer.

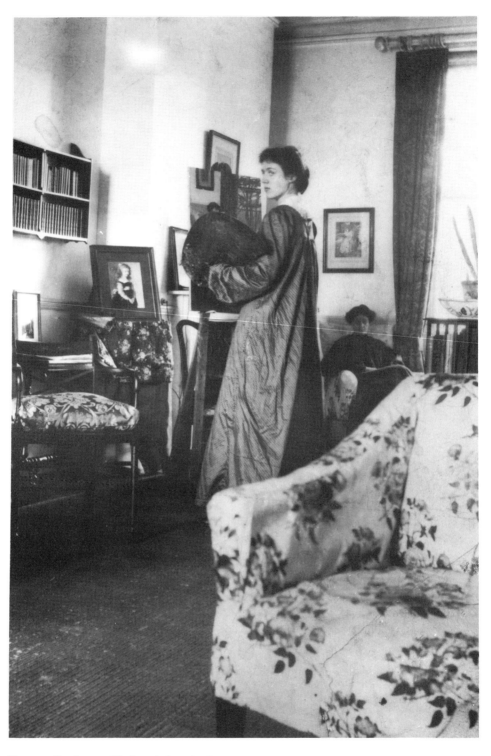

Vanessa Stephen at Chelwood Gate in Sussex, working on her portrait of Lady Robert Cecil (1906).

5 The 'Civilisation' of Bloomsbury

JOHN BEER

Introduction

To those whose names were associated with it, and to those who grew up in its midst, the firm identification of 'Bloomsbury' as a set of people characterised by strongly-held doctrines was irritating and even mystifying. Quentin Bell, who as the son of Vanessa and Clive Bell was as close to the centre of that group as it was possible to be, protested that it was not a clique with a common purpose and beliefs but a group of friends who found it profitable to meet each other at intervals. From this point of view the group was not a society for the promotion of élitism or for mutual advancement, still less for relentless warfare against other artists. Those who asserted that it was were challenged by him to produce their evidence.

Some qualities now associated with Bloomsbury were apparent outside the circle from an early stage, nevertheless; towards the end of the First World War, when few of the works that were to make its members famous had been published, Virginia Woolf wrote in her diary:

> . . . the dominion that 'Bloomsbury' exercises over the sane & the insane alike seems to be sufficient to turn the brains of the most robust. Happily, I'm 'Bloomsbury' myself, & thus immune; but I'm not altogether ignorant of what they mean. & its a hypnotism very difficult to shake off, because there's some foundation for it. Oddly, though, Maynard seems to be the chief fount of the magic spirit.

Since at that time London society was still compact, the circle to which she was referring was no doubt limited, but that circle had already recognised something new.

Some of the continuing attraction of Bloomsbury has been associated with specific issues. The growth of feminist movements has focused attention on Virginia Woolf (1882–1941): as author, in *Three Guineas* (1938), of a forceful polemic, as supposed victim of a male-dominated society and as advocate of the androgynous mind. The success of Lytton Strachey (1880–1932) and Maynard Keynes (1883–1946), the brilliant biographer and the most influential English economic theorist of the century, has fostered an interest

in their associates. The discovery, finally, that long before freedom of sexual behaviour and sexual choice were common in British society, a group of people existed who took such freedom for granted and practised it despite the danger of public disapproval and scandal, has helped stimulate further interest, prompting in turn a flood of biographical volumes.

Bloomsbury and the Cambridge Apostles

The association of the group with Bloomsbury was due to the fact that after the death of Sir Leslie Stephen in 1904, his four children decided to set up house in that quarter of London at 46 Gordon Square, which became the natural meeting-place for their friends; despite various moves that area was the one to which they continued to return. In addition to being beautiful young women, Vanessa and Virginia Stephen were notable for minds and personalities which exercised an unusual magneticism on those who came to know them. Bloomsbury also took a distinctive colouring from the various friends of their brother Thoby, who, while never himself a member, had come to know several of the Cambridge Apostles, the discussion society in which selected undergraduates of unusual intellectual promise met in secret to discuss a variety of issues.

During the first decade of the century the character of the Apostles changed markedly. Having been at the turn of the century a group of young men with metaphysical and idealistic interests, it became more lighthearted and satirical. This was in tune with the greater candour of the age and the growing discontent with their Victorian predecessors. By 1905 the dominant members were Lytton Strachey and John Maynard Keynes, both of whom were notable not only for their cleverness but for a determination to look at the world dispassionately, avoiding the hypocrisies and emotionally-dominated opinions that were rife about them. Their position was to prove particularly valuable during the First World War, with its slogans and hysteria on both sides: Keynes worked in the Treasury, playing a part in formulating financial policies during the War that was second to none; Strachey began his career as a writer, making his reputation early in 1918 with *Eminent Victorians*.

The publication of the latter book was timely, since it caught a moment when thoughtful people were increasingly disillusioned with the older statesmen and others whose policies had brought Europe into four years of senseless slaughter. So timely was it, indeed, that as the term 'debunking' came into fashion it was commonly associated with Strachey himself. The new approach had not by any means originated with him, however. In the decades before the war there had appeared Froude's *Thomas Carlyle* (1882), Samuel Butler's *The Way of all Flesh* (1903) and Philip Gosse's *Father and Son* (1907), all of which in one way or another subverted the reputations of highly respected figures. The tradition whereby the death of a great man or woman was followed by the publication of a *Life and Letters* (commonly in two volumes) which was expected to set the subject in a favourable light had already been under attack.

Viewed against these works, in fact, the biographical studies in Strachey's book seem somewhat mild. Strachey's chief weapon was an irony like that of Gibbon; in his preface he deplored the lack of an English biographical tradition to match the achievements of French writers such as Fontenelle and Condorcet. Biography, 'the most delicate and humane of all the branches of the art of writing', had for too long been regarded as journeyman work.

It is this side of his endeavour which aligns him most closely with the larger spirit of Bloomsbury. Clive Bell's art criticism made much of the concept of 'significant form' in art; Strachey's work showed such a concept at work in a specific literary genre. From the mass of details in the standard sources for a biography he would choose those which seemed to bring out the true significance of the person and his or her career. As a result of that choice a pattern would emerge which need not be dwelt upon by the author, but which could be further explored by the reader.

Most Bloomsbury figures aimed at a similarly dispassionate view. The experiences of Leonard Woolf (1880–1969) in the British colonial service dovetailed with the critiques of those who saw a debasement of values at work in English culture. Maynard Keynes, similarly, urged a coolheaded and dispassionate attitude to Germany after the War, when feelings were still running high. His book *The Economic Consequences of the Peace*, written over a few months in late 1919 after the signing of the Versailles Treaty, was a forceful *exposé* of the behaviour of the participants in which he not only demonstrated step by step how the pressure of vindictive feelings had caused the terms on which Germany had surrendered to be ignored in the drawing-up of the final settlement, but argued forcefully that in the signatories' best interests they should have given more thought to the likely consequences of an attempt to cripple the economy of a great European power.

This combination of humane contention with hardheaded reasoning, along with Strachey's attempt to link an open-minded view of the world with a scepticism and irony akin to that of the eighteenth century, helped to foster the image of Bloomsbury that was being established in the public mind. The fact that both cultivated homosexual relationships – Keynes for a time, Strachey throughout his life – gave a further colouring to that image, though the prominence of such behaviour among the Cambridge Apostles had been short-lived, giving way in subsequent years to a less important and subordinate cult.

By 1910, in fact, the Cambridge circle on which Bloomsbury drew had been revolting against that first phase, entering a brief period of efflorescence as a community of the new country-loving, idealistic kind that was common in England at that time. Frances Cornford and Gwen Raverat, Ka Cox and Rupert Brooke, among others, had made up the 'Neo-Pagans', a group who enjoyed canoeing, walking, camping and platonic heterosexual relationships. In Nottinghamshire, meanwhile, a group of young people (mostly student-teachers) that formed around D. H. Lawrence (1885–1930) at this time also called themselves the 'Pagans'. Both groups were associated with the contemporary cult of nature in literature and the desire for a new freedom in social relationships between the sexes: aspirations which were shortly to be swept away in their innocent form by the grim violence of the First World

War, but which for the moment were equally appealing in Bloomsbury and in midland England.

New attitudes to art: Post-Impressionism

The sense of liberation that showed itself in all these activities was also evident in new attitudes to art such as those of Roger Fry (1886–1934), an older member of the Apostles whose passion for absorbing and disseminating new ideas had been fed by living in Paris and discovering the work of artists such as Cézanne, Gauguin, Matisse and Van Gogh at a time when English artists had hardly absorbed the impact of the Impressionists from the previous century. Fry (who in fact coined the term 'Post-Impressionism') believed their work to mark a radical departure, occupied with the inner truths of structure, where the Impressionists had concerned themselves with surface effects of light. In 1910 he introduced some of the chief works of the

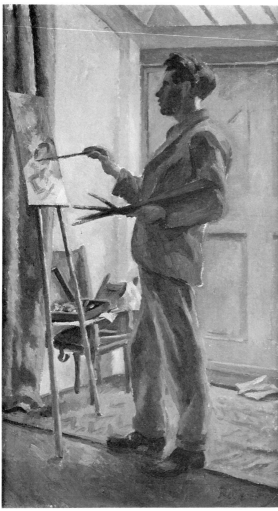

Roger Fry, Duncan Grant at Work *(1925–6)*.

new movement to London by arranging an exhibition, the impact of which was to be recalled later in one of Vanessa Bell's 'Memoirs':

It is impossible I think that any other single exhibition can ever have had so much effect as did that on the rising generation . . . here was a sudden pointing to a possible path, a sudden liberation and encouragement to feel for oneself which were absolutely overwhelming. Perhaps no one but a painter can understand it and perhaps no one but a painter of a certain age. But it was as if one might say things one had always felt instead of trying to say things that other people told one to feel. Freedom was given one to be oneself and that to the young is the most exciting thing that can happen. Even the elderly caught the spirit. Sometimes one or two old painters who had plodded patiently all their lives painting as they understood they should paint, threw their petticoats, should one say, over the windmill and became comparatively honest and sensitive. Of course many did foolish things . . . but that does not matter. The important thing, how important one cannot know, is that one or two perhaps who might, like the old brigade, have said their say by the age of 35, may, owing to that influx of new life and all that followed, find as did Rembrandt, Titian and Cézanne new things to say, fresh feelings to express as long as they lived. Such surely should be the fate of the artist. But in England at least he needed rescue in the early years of this century.

At the time, excitement among the young was marked by controversy in the English art world generally, where it seemed that the world was turned upside down and a long tradition of figure work subverted. The representational qualities of traditional art had been dominated by belief in the need for discipline. There had already been protests from artists of the old school, such as G. F. Watts, against recent movements, but nothing so

Omega Workshops: post-impressionist room displaying designs featured at the Ideal Home Exhibition, 1913.

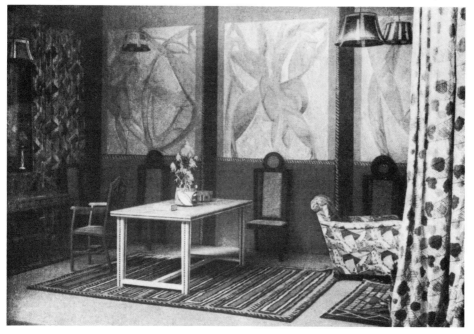

revolutionary as was now being exhibited had been foreseen. Fry, in turn, was acerbic concerning the lack of intellectuality or strenuous commitment among English artists by comparison with the French, but this concern was not echoed by the majority of those who visited the exhibition. Leonard Woolf, who acted as secretary for the second exhibition two years later, described the attitudes that were still evident: nine out of ten of the people who came in, he recalled, after a single look at the pictures (by Cézanne, Matisse, Picasso, Bonnard and so on) would either roar with laughter or become enraged,

> And every now and then some well groomed, red faced gentleman, oozing the undercut of the best beef and the most succulent of chops, carrying his top hat and grey suede gloves, would come up to my table and abuse the pictures and me with the greatest rudeness.

The response to the exhibitions was by no means overwhelmingly unfavourable, however. On the contrary, D. S. MacColl, returning to London three months after seeing the first exhibition, was dismayed to find 'the new religion established, the old gods being bundled without ceremony into the lumber-room'. Among the Bloomsbury artists, meanwhile, experimentation with abstract styles was encouraged. Vanessa Bell (1879–1961), who had already learned about vertical emphasis from Sickert, began using flat, abutting and overlapping planes. Such experiments did not in the event last long, however; partly no doubt because the First World War turned attention elsewhere, but also for lack of a full intellectual basis. The personalities of individuals played a correspondingly strong part. Vanessa, for example, enjoyed putting the immediate events of her family life on to canvas – experimentally but still very recognisably and without too many concessions to abstraction (colour pl. 2). Her greatest gift was an ability to combine a sense of vibrating life with a strong sense of design. Some of her most memorable designs were those executed for the covers of her sister's novels and essays, where artlessness is matched by underlying calculation.

Her physical presence was a further important factor. According to Marjorie Strachey she emanated 'a sense of repose and understanding', another friend declared that when she came into a room all the forms in it seemed to change into a new harmony. Nor did her individual style and solitary vision preclude lightness of touch.

The Omega Workshops

While the effects of the two Post-Impressionist exhibitions were to be felt for many years afterwards, Fry's chief achievement in the following years lay in the setting up of the Omega Workshops (1913), which enabled him and others to experiment with a wide range of objects and textures. These inevitably invite comparison with William Morris's enterprise in the previous century, aimed at reviving craftsmanship within a larger commercial setting. Fry, however, was less concerned with large political or social doctrines: if an object could be made more readily by a machine than by a craftsman without loss of quality he would encourage its use. His concern was also to open

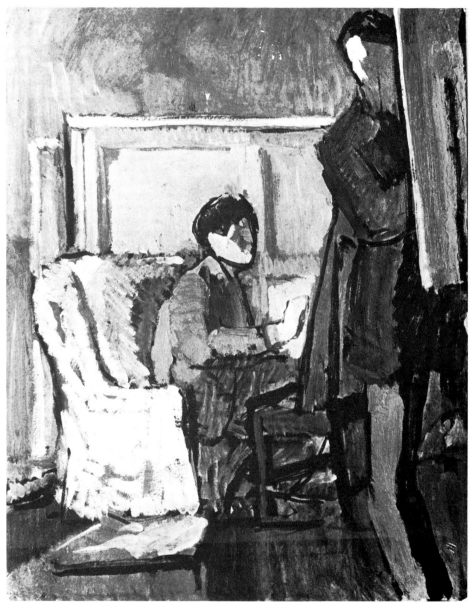

Vanessa Bell, The Studio: *Duncan Grant and Henri Doucet painting at Asheham (1912).*

opportunities for young artists who had no work and to offer scope for the talents of established friends such as Duncan Grant (1885–1978) and Vanessa Bell. The use of geometric forms and shapes of all kinds led on to experiment with abstract forms in relationship; at the same time the immediate impression made on the *Times* reviewer was of colour and gaiety: 'They are not pharisaically or aggressively artistic, but in doing what they like themselves they have managed to forget all the bad art they do not like.' Experiments were made in the design both of individual furnishings and of

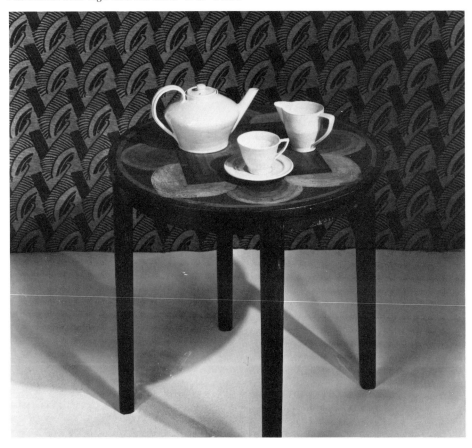

Omega Workshops: pottery tea set (designed by Roger Fry); 'Cracow' cloth (by Vanessa Bell); and table (1912–18).

Duncan Grant, Fan; *painted with dyes on silk (1913).*

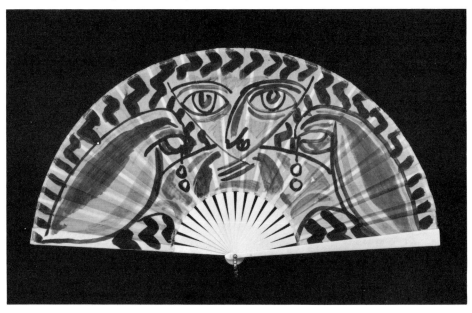

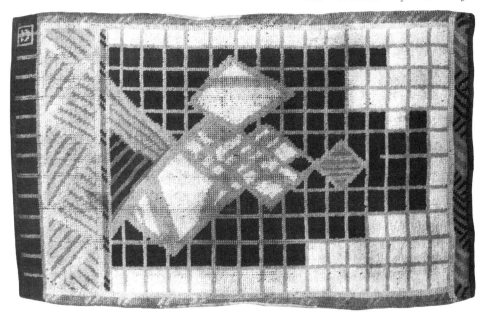

Frederick Etchells's hand-knotted woollen rug for the Omega Workshops (1913).

An Omega nursery, including curtain fabric and cane-backed chairs by Roger Fry, chest of drawers probably by Vanessa Bell and rug by Frederick Etchells (1913).

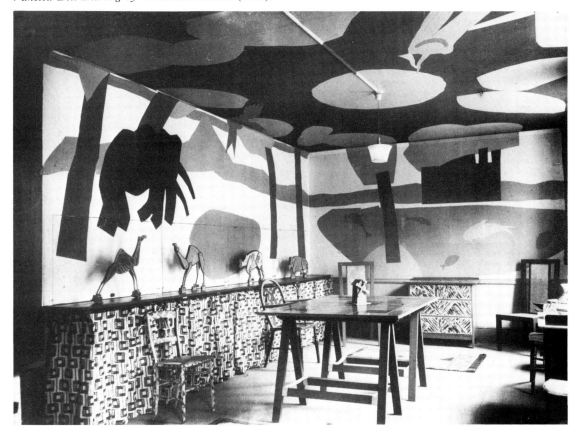

Vanessa Bell: jacket designs, for The Hogarth Press.

whole ensembles such as a nursery or a lounge, along with bold surface decorations in bright colours which some critics found lugubrious (colour pl. 8, 10). Although Fry himself was active in every sphere, his best contributions were in the field of pottery: Clive Bell thought some of his pots better than his paintings.

The Omega Workshops survived, rather surprisingly, throughout the war years; by 1919, however, the project was beginning to run out of steam and came to an end. Fry had tried to make the products available to a wider public by keeping down their prices but they had continued to be bought mainly by rich customers, while commercial manufacturers had begun to produce pale imitations while charging more. After the closure his energies were directed into the exhibitions arranged by the London Group, where the work of his Bloomsbury friends could be seen alongside that of new and rising artists. The impact of the Workshops had nevertheless been such that design in England was not to be the same again (see p. 260).

New attitudes to literature: Virginia Woolf

Fry's intellectual activities were not confined to the visual arts. In the latter field he thought the English view to be corrupted by a certain kind of literariness ('they like the associations of things, not things in themselves'); he also believed that the conception of good literature itself called for change: in writers such as Shelley and even Shakespeare he could trace the vice 'of distorting reality, of importing impure associations, of contaminating the stream with adjectives and metaphors'. The kind of Post-Impressionist movement in literature which seemed to be called for by such strictures was emerging meanwhile in the writings of his friend Virginia Woolf, who in her most experimental novels takes apart ordinary perceptions of reality, resetting them in a new structure. In *The Waves* (1931) this is achieved partly by her invention of a stream of discourse for each of her speakers which is neither speech nor unconscious flow of thought but an amalgam of both, the interplay offering new insights into the significance of existence.

Awareness of the latter aim helps to establish further the distinction between Virginia Woolf and Roger Fry on the one hand and writers such as Strachey and Keynes on the other. Such metaphysical concerns had been more typical of the older generation of the Apostles: older friends of Fry's such as McTaggart and Lowes Dickinson had believed that true reality was revealed only occasionally, and then in privileged states of mind. So far as commonplace life was concerned, said Fry, 'It is sometimes delightful to realise that such things are all shams and that at any moment the surface may dissolve and the reality appear, whatever that reality may be . . .' Virginia Woolf's 'moments of being' are of the same order.

The cultivation of such attitudes had been encouraged by the experience of living in a world dominated by the theories of Darwin: the prospect of a dreary round of competitive struggle in a world of scepticism prompted attention to those states of mind which did not fit the Darwinian view, and to the desirability of being sceptical about scepticism itself. In the wake of Darwin's theories it had become difficult to develop an aesthetic attitude which did not have naturalism at its centre; Fry solved the problem for himself by maintaining that the human mind worked in two different ways when confronted with the world, thus creating a double life, the actual and the imaginative:

Between these two lives there is this great distinction, that in the actual life the processes of natural selection have brought it about that the instinctive reaction, such, for instance, as flight for danger, shall be the important part of the whole process, and it is towards this that the man bends his whole conscious endeavour. But in the imaginative life no such action is necessary, and, therefore, the whole consciousness may be focussed upon the perceptive and the emotional aspects of the experience.

Fry's was a dominating presence in some parts of the English art world during his later years: his lectures were always delivered to packed audiences. Their popularity was due not only to his manifest energy and commitment, but to underlying concerns which opened out an imaginative dimension in everything he had to say about art. Virginia Woolf evidently found that his

views helped her make sense of her own condition, in which an inexorable hardheadedness like that of her father subsisted alongside the inescapable play of her imagination. For Darwin's integrity she would always have the deepest respect, while his demonstration of the marvellous varieties of the world must have made its impact on the author of *The Voyage Out* (1915), in which the heroine is travelling, as Darwin had done, to South America.

Although the world of Darwin contained delight, however, it had no *necessary* imaginative dimension. Fry's world did, and Virginia Woolf's fictional world was correspondingly illuminated. While her characters live in the world of physical actuality, her rendering stresses continually the play of their consciousness, its power to dance off at this tangent or that – calling up a line of poetry or a lost memory at the most unexpected moment, for example. This contributes to the sense that a further life surrounds the ordinary life of every day, subsisting in the fuller work of the mind, conscious and unconscious, which in turn endows it with a continuity that it would not otherwise possess. As she put it in a famous passage,

Life is not a series of gig lamps symmetrically arranged; life is a luminous halo, a semi-transparent envelope surrounding us from the beginning of consciousness to the end. Is it not the task of the novelist to convey this varying, this unknown and uncircumscribed spirit, whatever aberration or complexity it may display, with as little mixture of the alien and external as possible?

Virginia Woolf was equally insistent that there was no restricted world of the novelist, no 'proper stuff of fiction': the novelist must be at once alive to every detail of the physical world and intent on conveying the quality of the 'luminous halo' with which human consciousness endowed it.

In novels such as *Mrs Dalloway* (1925), *To the Lighthouse* (1927) and *The Waves*, her cultivation of the imaginative life was governed by an impulse towards unification of vision. As she grew older, however, she became more and more preoccupied by her own condition as an artist, caught between that impulse and an equally strong need to recognise the solid resistancies of the human world. In *Between the Acts* (1941), her last novel, the chief event, the staging of a historical drama in a historic and pastoral setting, dramatises that stress.

Her letters and diaries, meanwhile, allowed her imagination lighter play: where her novels are dominated by an elegiac tone, her everyday relationships were characterised by wit, light fantasy and a love of gossip. T. S. Eliot saw her as the last representative of a literary tradition in which the artist could write without consciousness of debts to be paid to society; William Plomer commented on her habit of quizzing her friends by offering them fantastic versions of their lives which they were invited to comment on, often prompting the projection of unexpected confidences on their part into the space thus created.

Her admirers also sensed genius. Clive Bell (1881–1964), her brother-in-law, claimed that he had known only two people from whom that quality emanated unmistakably, the other being Picasso:

Virginia and Picasso belonged to another order of beings; they were of a species distinct from the common; their mental processes were different from ours; they arrived at conclusions by ways to us unknown.

She was certainly possessed of extraordinary literary powers, which could come out as fully in a private letter to a chance friend as in a critical essay.

The writer of the time who resembled her most closely, E. M. Forster (1879–1970), had many close contacts with the Bloomsbury group. He too had belonged to the Apostles during that period when the spirit of McTaggart and Fry, and their insistence on the need to keep open the dimension of an imaginative or spiritual life, was still in the ascendant. His allegiance to this view emerges most openly in the novel dedicated by him to the Apostles, *The Longest Journey* (1907), but is also implicit in his investigation of 'spiritual' inheritance in *Howards End* (1910) and his openmindedness towards Indian religion in *A Passage to India* (1924).

Forster's presence in Bloomsbury was always tangential, his status remaining, in spite of regular contacts with people such as the Woolfs, that of visitor rather than intimate. Between him and Virginia Woolf the relationship was always a little barbed: he criticised her work for its failure to produce memorable characters ('Life on the page she could give; . . . Life eternal she could seldom give') while she in turn mocked him for an apparent belief that novelists 'must first and foremost hold themselves at the service of the tea-pot and the pug-dog'. Yet each respected and even feared the judgements of the other, recognising common preoccupations behind their differences of viewpoint.

Some of them (whether they realised it or not) belonged with the vision of the Apostles at the end of the previous century. However much Virginia Woolf admired the directness and wit of Strachey or the cleverness of Keynes, the period she looked back to was the time when she had found the problems posed by the contrast between her parents resolved in the circle round her brother at Trinity. Behind the animated family life of the Stephenses had existed the more austere code of Sir Leslie himself, the strict regard for truth that had caused him to resign his tutorship at Cambridge and the strong vein of positivism which gave him links back to the eighteenth century. Her mother, by contrast, had been notable for an outgoing sympathy with others that expressed itself both in a host of charitable works and in a whimsical gaiety. Among her brother's friends at Trinity she found a seriousness coupled with lightness of touch that reconciled these qualities. Her father had pointed a way for her in his love of libraries – our nearest hope, he intimated, of re-entering paradise – but it was in Cambridge, among young people enthusiastically reading the Elizabethans or Greek poetry, discussing issues of morality and metaphysics, that she had found that primary imaginative world for herself as writer which was to be further adumbrated in the writings of Roger Fry.

The inhabitants of Bloomsbury cannot be dismissed as having been out of touch with the real world. Most were hard-working people who devoted themselves to their chosen crafts. Virginia Woolf and her husband, for instance, were not idle members of a leisured class: in addition to writing careers which many would have considered enough in themselves (Leonard being particularly active in the politics of his time also) they managed and worked at one of the most successful small publishing houses of the time, the Hogarth Press. Lytton Strachey was an industrious scholar, as his archives

show, while Keynes was an exemplary figure not only for the hard work that brought about his early death but for the intellectual powers which helped to increase efficiency in many public spheres. At a straightforward material level, indeed, the chief legacy of Bloomsbury lay in his artistic enterprises, including the creation of the Arts Council in 1945.

D. H. Lawrence's antipathy towards Keynes and his friends when he met them at Cambridge in 1915 ('It is this horror of little swarming selves I can't stand') has sometimes been cited in support of a contention that he was opposed to Bloomsbury generally; and Keynes's conclusion in 'My Early Beliefs' that there might have been 'just a grain of truth when Lawrence said in 1914 that we were "done for"', has been read as supporting that view. The publication of the relevant documents in full, however, has shown that Lawrence's distaste was for the kind of homosexual activities that he became aware of, and that other parts of his visit to Cambridge, where Russell was more to the fore, were agreeable. He had an enjoyable conversation with G. H. Hardy, another Apostle, for example. Keynes's admission of the 'grain of truth' is connected with this: earlier in the essay he recounts that among the Apostles during these years there had been some falling away from the purity of the doctrines derived from G. E. Moore. 'No one, probably, who has asked himself the question, has ever doubted that personal affection and the appreciation of what is beautiful in Art or Nature, are good in themselves', Moore had asserted, and it was to this ideal that the Apostles had addressed themselves; towards 1914, according to Keynes, such concentration had become 'thoroughly mixed up with the, once rejected, pleasure'.

It was this particular moment, with its 'short sharp superficial "intrigues"' that Lawrence was encountering and disliking. Yet his own desire to sidestep moral preoccupations ('With "should" and "ought" I have nothing to do') and his membership of a group resembling the Neo-Pagans would have made other aspects of Bloomsbury congenial to him. Virginia Woolf, though unable to appreciate his work, thought it a defect in herself that she could not, while Forster wrote a strongly-worded protest when hostile obituaries appeared after his death. As early as 1915 some Bloomsbury writers had rallied to the defence of *The Rainbow* when it was prosecuted for obscenity.

The chief point of positive contact between Lawrence's thinking and the Bloomsbury ethos lay in his belief that the future of civilisation would lie with those who recognised that human life was both precious in itself and greater than any simple account of it might suggest. Roy Harrod recalls how Keynes, at a dinner given for him by the Royal Economic Society in 1945, proposed a toast to economists, 'who are the trustees not of civilization, but of the possibility of civilization'. This distinction was one which his friends in Bloomsbury would have applauded; if they had tried to define what that civilisation actually was, however, they would probably have found themselves thrown back on a definition less concrete than is normally found, concerning the serious cultivation of subtle perceptions. They might, for example, have quoted Virginia Woolf's reference to 'that indescribable inequality, stir, and final expressiveness which belong to life and life alone'. If they had lived to read it, they would no doubt have approved P. N. Furbank's attempt to describe what made E. M. Forster special:

He lived the imaginative life, and, whether in company or in solitude was attending to imaginative impressions . . . He felt as if, on occasion, he could see through to 'life': could hear its wing-beat, could grasp it not just as generality but as a palpable presence.

Writers and artists who believed that such preoccupations lay at the heart of 'civilisation' were not likely to find their ideas endorsed by many of their contemporaries. Since that time, however, it has become more possible to see what they were about: they had grasped that the fragmentation of culture which was already taking place about them would make 'civilisation' in the old sense increasingly difficult to sustain, committing the artist to processes of analysis and remaking that would raise questions concerning the very nature of human sensibility. Lawrence would have understood that, even if from across a gulf.

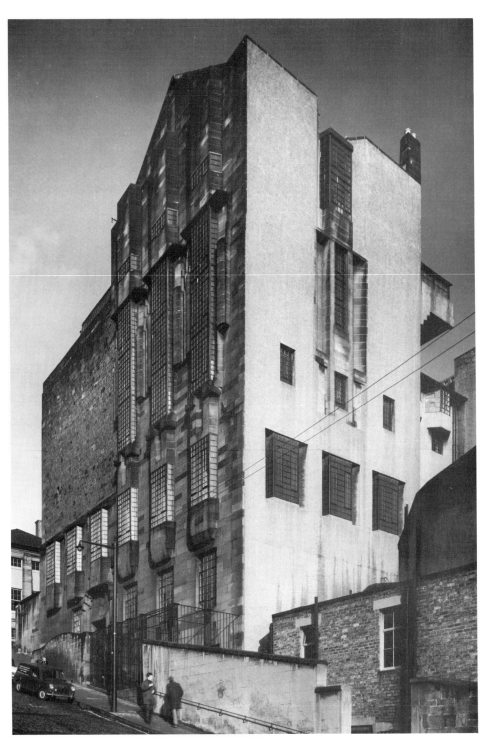

Glasgow School of Art, Library Wing (1905–9). C. R. Mackintosh.

6 Architecture

JOHN SUMMERSON

Introduction

At the turn of the century everything in architecture flourished. Enormous country houses, with servants' quarters as extensive as the house itself and far more complicated, were still being built. A huge cathedral was just finishing at Westminster; another, no less majestic, was in contemplation at Liverpool. Expensive churches, courts of law, a considerable part of Whitehall, museums of the grandest kind, schools and polytechnics, hospitals of capital size and quality, town halls, office blocks, branch banks – all were moving with vigour and continued to do so for seven or eight years. It was the late Victorian momentum spilling over into the new reign, which it continued to do till 1908, a year which seems to mark the highest point, after which the energy, damped by an economic setback, seemed to have spent itself. The competition for London's County Hall (1907) fell rather flat and people began to say that such things were done better in France.

What sort of architecture prevailed in these fortunate years? There were in 1901 two powerful influences – Richard Norman Shaw (1831–1912) and Philip Webb (1831–1915). Both were seventy, Shaw still active, Webb gone into contemplative retirement, but their influence stretched far into the new century and nearly every question of style up to 1914 has to be referred to one or both of them. Shaw had been the most powerful and wide ranging. He had promoted, if not invented, the so-called 'Queen Anne' style in the seventies, had proceeded to revive Georgian in the eighties and, by the time of his death in 1912, had got well into Baroque with the Piccadilly Hotel.

Philip Webb, a socialist saint, the very opposite of Shaw in so many ways, fostered, in his reclusive fashion, his own philosophy of anti-style, producing a modest number of town and country houses made up of 'vernacular' ideas partly gathered from observation and partly nurtured in his own imagination. It was less his style (which was no style) than his philosophy of life and art which set some of the young moving in new directions. C. F. A. Voysey, W. R. Lethaby and, a little later, Charles Holden, for instance, learnt from Webb the discipline of innocent simplicity and craftsmanly detail. But Webb

also helped to unlock the vistas of free-style invention explored by Beresford Pite, C. H. Townsend and C. R. Mackintosh.

As we look at the period now, what seems to stand out in the first decade is the return to monumental classicism. To this we usually fix the label 'Edwardian Baroque', though some of it is pre-Edwardian and not all of it is Baroque. Shaw had led the way in this but E. W. Mountford and the offices of John Belcher and Lanchester and Rickards made the most striking contributions. The Gothic revival still held its own, with Bodley the veteran master and his pupils continuing the tradition even up to 1939. There were many cross currents. One was the Arts and Crafts movement, inflecting both the Classic and Gothic strains: another the re-discovered Byzantine, introduced by Bentley in his Westminster Cathedral and, at a more radical level, by Lethaby and Pite. There was a feeling for Michelangelo's architecture. There was the *Beaux Arts* manner from Paris. By 1914, architecture in Britain had passed through one of the most complex and interesting crises in its history.

Four years of war then reduced building activity of every kind, other than housing for munition workers, almost to zero. In November 1918 the dawn of a new era was widely proclaimed though what was in fact hoped for was the resumption of the 'normality' of pre-1914. Reconstruction, restoration and recovery were the watchwords of the day and in fact pre-war conditions did to some extent revive. By 1920, commercial and industrial schemes halted by the war were again in motion, and the building industry had its hands full with the housing programme launched by Lloyd George's government to provide, at short notice, homes for demobilised and disgruntled heroes. With this architects had little to do. It was administered by local authorities and their surveyors, advised by the town planner (an emerging professional type) rather than the architect.

One pre-war source of employment which never revived was the building of great country houses. There was no longer the surplus wealth for such adventures, nor perhaps the self-confidence; and the once inexhaustible reservoir of 'domestic service' was being drained off into industry with its offers of shorter hours and better pay. The building and maintenance of a large country house was becoming an anachronism. The more modest low-ceiling type of house with basically Tudor elements, as invented by C. F. A. Voysey, and the type with open plan and cosy ingle-nooks evolved by Baillie Scott, continued to flourish; and the neo-Georgian took a new turn with the arrival of Clough Williams-Ellis and Oliver Hill, young men who had seen active service in the war and turned to architecture with a relish for novelty and new eyes for the past. Their Georgian, less solemn than Shaw's or Blomfield's, has something of the spirit of Claude Lovat Fraser's sets for the *Beggar's Opera*, running from 1920 at an obscure theatre in Hammersmith, to the delight of all London. Williams-Ellis (1883–1978) was a robust, larger-than-life personality who, not content with building other people's houses built a model town for himself – Portmeirion in north Wales, which he developed from 1926 as something between a folly and a profitable investment. His enjoyment of architecture was infectious and the book he wrote with his wife, Amabel, in 1924, *The Pleasures of Architecture*, broke

some of the frozen ground which separated the profession from the general public, whose indifference to the subject had long been a cause of complaint. He followed this with the influential *England and the Octopus* (1928), a caustic and deeply-felt assault on bad planning, 'ribbon development', and spoliation of the countryside.

If we look for sublimity of style and feeling in the twenties, we find it in what, in the circumstances, was a predictable form – the war memorial. Punctually on the signing of the armistice, the creation of memorials seized the nation's imagination. Designs issued, often uninvited, from every conceivable source. Every town and city, every village, every parish set itself to an act of commemoration: a shrine, a hall of memory, an obelisk, a pyramid, a cross, a winged victory; the possibilities were endless, down to a simple tablet bearing the names of the fallen on a church wall. Rich institutions with specially emotive rolls of honour, like public schools and universities, were able to attract wealth to the extent of building on a considerable scale, adding useful as well as symbolic structures to their building stock. Lutyens, Herbert Baker and Giles Gilbert Scott did some of their best work in this category. The Imperial War Graves Commission, set up in 1917, planned the burial places of more than a million dead and produced the most impressive memorials of the century.

Apart from memorials, the twenties cannot be said to have been specially fruitful or inventive. A new type, however, was the cinematograph theatre which now graduated from the ramshackle 'electric theatre' of pre-war years to architectural performances of such quality as Robert Atkinson's Regent Cinema, Brighton, as well as others of a more exotic kind. The motor-car's maturity resulted in a disfiguring rash of petrol stations in the countryside, as well as an occasional grand show-room like Curtis-Green's classical Wolseley building at No. 160 Piccadilly (now a bank). Regent Street was rebuilt; Kingsway was completed. Devonshire House, Grosvenor House and Chesterfield House were demolished to give place to hotels and flats. In 1924, the British Empire Exhibition at Wembley, architecturally unremarkable in itself, marked the beginning of a period of renewed optimism which, notwithstanding the general strike of 1926, lasted for five years. Then in 1929 came the cataclysmic event of the decade: the world depression.

In the matter of style, the great discovery of the English twenties was the romantic modernity of Scandinavia. Ragnar Ostberg's heroic masterpiece, the Stadhus at Stockholm, was inaugurated in 1923 and the Swedish capital at once became a place of pilgrimage. Unflattering variations of Ostberg's wonderful tower sprang into graphic life on British drawing boards and were, alas! sometimes built. Competition designs for municipal buildings never seemed complete without a flicker of the Ostbergian silhouette or failing that, something like the play-boy classicism of Ivar Tengbom's Stockholm Concert Hall. Norwich Town Hall, designed by C. H. James and S. Rowland Pierce, in 1937 had a bit of both and is, perhaps the most interesting product of the Anglo-Swedish phase. A fashionable phase is all it was but it lasted well into the thirties. A Dutch phase enjoyed almost simultaneous success, drawing inspiration from W. M. Dudok's schools and town hall at Hilversum. These and other no less superficial foreign influences were all in play by 1929, the

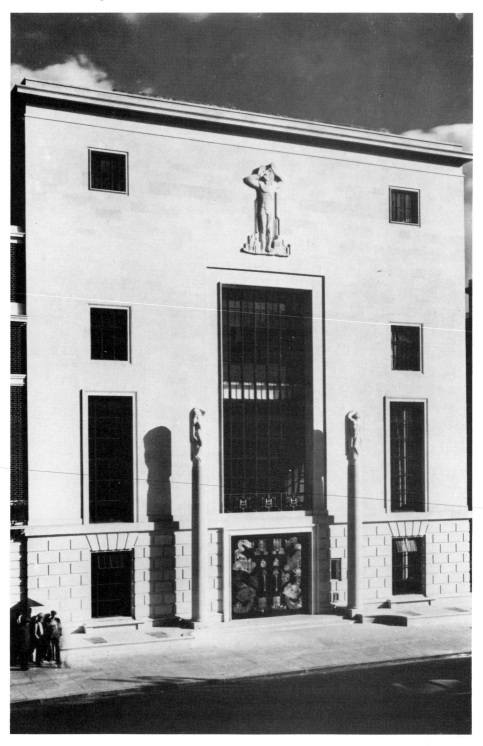

RIBA Building, Portland Place, London (1934). Grey Wornum.

year when the practice of architecture met the cataclysmic event of the decade: the world depression.

The 'slump', as it was generally called at the time, administered a rude shock. Hundreds of architects were thrown out of work and the future of the profession was overcast. Now, for the first time, the myth of 'normality' was deflated and a total re-orientation became inevitable. In the course of the twenties the internal structure of the profession had been changing. Articled pupilage had almost entirely surrendered to academic training in schools of architecture approved by the Royal Institute of British Architects (RIBA). The battle for Registration reached a crisis and the first Registration Act was passed in 1931. This enabled the architect qualified by examination to call himself a 'chartered architect'; the final closing of the profession, with the protection of the word 'architect', came with the Act of 1938.

The effect of Registration was, of course, long-term; it could hardly be perceived until a generation had passed. The effect of the drift from apprenticeship to academic training was more immediate, especially in the circumstances of the twenties. The war had created a very real 'generation gap'. The RIBA's roll of honour alone accounts for over 400 young architects and the survivors often missed their vital years of training. The younger men, meaning those born around 1900, felt little loyalty to their predecessors, whom they were inclined to dismiss as Victorian muddle-heads, out of touch with the twentieth century. Those trained in the schools had wider horizons and a strong inclination to discover architectural truth in their own way. They wanted to be 'modern', a word which, from meaning simply 'contemporary' had, by 1920, acquired a rudimentary stylistic meaning: a square-cut silhouette, dramatically severe vertical lines and the exclusion of conventional ornament. The various '*art nouveau*' and 'Free Style' movements of the earlier part of the century were repudiated.

Meanwhile, influences from Sweden, Holland, France and Germany were drifting through the pages of the architectural journals. All this reached a crucial point around 1931, when the 'modern' became 'modernism'. 'Modernism' was not so much a style as a philosophy, largely derived from readings of Le Corbusier's *Vers une Architecture* (1923). The effect of that philosophy will be observed later but we must note here the way in which the new ideas seemed to engage with the social problems of the day, with their dry, statistical urgency, rather than with the less articulate but more genial programmes of traditional practice. Slum clearance and urban renewal in the form of mass housing loomed on the horizon, challenging the architect to a new role in society, not without political implications. The role once accepted, a world of new aesthetic, even romantic possibilities opened up. Over the great sprawling, slum-ridden cities of Britain hovered a vision of Le Corbusier's *Ville Radieuse*.

From 1932 there was a general and rapid recovery, initiated by an upsurge in the building industry itself. From that date two parallel outlooks prevailed in architecture. There was the 'traditional' outlook which signified a general tolerance of historic styles: Gothic, or some diluted version of it, for churches; Classical, more or less Americanised, for city buildings; and Tudor or Georgian for domestic work. In sharp relief was the exclusive doctrine of

the modernists, founded on a 'functionalist' principle which, while excluding all reference to historic styles, admitted a new 'poetry' of emotive relationships in the play of geometrical form against programmatic calculation. A fervid minority of young architects adhered to the new movement and in 1933 the MARS (Modern Architectural Research) Group was founded. Between 1933 and the outbreak of the Second World War in 1939, the Modern movement attempted to infiltrate the Traditional and not, as we shall see, wholly without success.

 The 1930s were a decade of transition and acutely conscious of the fact. 'We live in an age of Transition' was a phrase rarely absent from presidential addresses and after-dinner speeches. Transitional feeling pervades some of the best buildings of the time – for example, Grey Wornum's new home for the RIBA in Portland Place, traditional in many of its details, with a decidedly Swedish accent but also a new spacial energy in the plan. With hindsight we may well ask, transition from what to what? In this essay it is only the first part of the question which we need to answer and I have already mapped out some of the ground. It remains to look more closely at some of the personalities and episodes in the period.

'Edwardian Baroque'

If I had to choose one architect and only one as representative of the years 1901–14 it would have to be Aston Webb (1849–1930; no relation to Philip Webb). He is the paragon, the all-round success. In 1901 he had in hand the Victoria and Albert Museum; the Royal Naval College, Dartmouth; the Imperial College of Science, South Kensington; Christ's Hospital, Horsham; and Birmingham University; added to these, a few years later, were the Admiralty Arch, the Victoria Memorial and the refronting of Buckingham Palace. As leader of the profession he was Norman Shaw's successor, but no two men could have been less alike. Shaw shied away from public office and had no appetite for honours (he declined a baronetcy); Aston Webb was a first-rate committee man and a conspicuous success as president of the RIBA in 1902–4 and of the Royal Academy from 1919 to is death. He was knighted in 1904. But as a designer he lacked Shaw's genial magic. Nearly everything Shaw did was admired and imitated; Webb was admired rather than imitated. He was certainly clever; his plans are ingenious and efficient and in stylistic manipulation there was nothing he could not do.

 Trained in a classical office he followed the fashion for Francis I and won the Birmingham Assize Courts competition (1886) with a sparkling exercise in that style. French Renaissance, with its persistent Gothic strain, colours all his earlier works; but like a skilled organist he could improvise, moving from French to English (Tudor or Wren), Italian or Spanish Renaissance or indeed to quite stiff and starchy academic (the Buckingham Palace façade). Improvisation has its risks and sometimes Aston Webb floated into unmanageable combinaions of style: as for instance, at the Victoria and Albert Museum where, in the main front, he gives us a Renaissance version of a Romanesque portal (a deliberate echo of Waterhouse at the Natural

History Museum), a superstructure modelled on the Certosa at Pavia and a crowning feature paraphrasing the steeples at Newcastle and St Giles's, Edinburgh. This is uninspired improvisation on a daunting scale. But the staircases in the same building, in their arched cages of carved masonry are imaginative and show Aston Webb's invention at its best. They are Mannerist in style and adumbrate the final stage of his development which was Baroque.

'Baroque' was a word not much used at the time and its application to Edwardian buildings is modern usage. In retrospect it may fairly be applied to webb's new façade for Buckingham Palace (1913), The Victoria Memorial (1913) and the Admiralty Arch (1911). But we are accustomed to apply the term to other Edwardian buildings which it fits rather less well, and this needs sorting out.

Of the various types of so-called 'Edwardian Baroque' the most familiar is that represented by the Old Bailey (the Central Criminal Courts) in London, designed by E. W. Mountford (1855–1908). Mountford, a champion competition winner, was a good hand at Renaissance improvisation but for the Old Bailey he moved forward from Renaissance to the classicism of Wren and English Palladianism as being appropriate to a site in the City of London, dominated as it still was by Sir Christopher Wren's domes and steeples. The Old Bailey may be described as English Palladian on a somewhat inflated scale with a dome taken from Wren's at Greenwich but dished up with some extra curves and a statue of Justice. Some ornament from the Arts and Crafts vocabulary enriches the entrance front and there is a quantity of allegorical sculpture of a kind which British sculptors had learnt in the studios of Paris. The totality is impressive in a superficial and somewhat amateurish way. Strictly speaking it is not Baroque at all. Mountford would have called it 'Later English Renaissance' and we may accept the definition.

The style of the Old Bailey, or something very like it, is to be found all over England and in Belfast the huge and lavish City Hall by Brumwell Thomas (1868–1948) shows it at its most extravagant with five domes all borrowed from the dome and west tower of St Paul's. It became the style adopted for competition entries. Banks and insurance companies favoured it. With all its faults and stylistic muddle-headedness it seems to have satisfied the Edwardian mind as a noble representation of British tradition, security and wealth.

A more sophisticated kind of 'Edwardian Baroque' issued from the office of John Belcher (1841–1913). He was already sixty in 1901 but employed congenial assistants who shared his interest in Baroque design. One of these was A. Beresford Pite (1861–1934) who designed in 1890, under Belcher's name, the Chartered Accountants Hall in the City of London, a daring mixture of English and Italian classicism, with emphasis on Italian Baroque ornament and an effective use, in an Arts and Crafts spirit, of relief sculpture by Thorneycroft and Harry Bates. In the following year, Belcher competed for the Victoria and Albert Museum. He lost to Aston Webb but his design, in which, no doubt, Pite had a major share, was Baroque (in the modern sense) and made a great impression. Pite left the Belcher office in 1897 but

was replaced by a Scotsman, J. J. Joass (1868–1952), another Baroque
enthusiast. Joass's style is at once recognisable by its vertical thrust and
tensely packed ornament. Among his successes in London were the Royal
Insurance offices at No. 161 Piccadilly and premises for Mappin and Webb at
No. 156–8 Oxford Street (both now in other occupation) where the city
street-front problem is solved by reducing the design to thin vertical strips
modelled in a brittle style derived from Michelangelo's Laurentian library at
Florence and beautifully executed in Pentelic marble. The triumph of Belcher
and Joass, however, came with the Ashton Memorial at Lancaster, a hill-top
temple with five domes which, by skilful modelling, are made to coalesce
into a single dramatic gesture. There is something of Wren, something of
Michelangelo as well as a great deal of Joass in this extraordinary per-
formance, one of the most dazzling of the period.

Yet another version of 'Edwardian Baroque' is the work of E. A. Rickards
(1872–1920), a draughtsman of rare brilliance who was taken into partnership
by H. V. Lanchester (1863–1953) and, with him, won the Cardiff City Hall
and Law Courts competition of 1898. But Rickards's architecture is basically
not so much 'Baroque' as Louis XV. He was an accomplished planner, which
cannot be said for many Edwardians; his plans have Parisian elegance and
create fine interior spaces. What is truly Baroque about Rickards is his
ornament. He knew how to compose it, how to distribute it and how to
combine it with figure sculpture; and his style of ornament is that of German
and Viennese palaces. A beautiful small work by him is the town hall at
Deptford, where the alien Baroque goes, surprisingly but happily, with a
loose English vernacular type. His last building, designed with Lanchester,
was the Central Methodist Hall at Westminster. This was not a subject to
inspire Rickards and the ornament, though still brilliant, has become
mechanical and evokes too readily the busy pencil and the click of the set-
square.

An architect who comes rather doubtfully into the 'Edwardian Baroque'
category is Sir John James Burnet (1857–1938). 'Doubtfully' because his
principal work was the Edward VII gallery at the British Museum, which is,
on the face of it, as far from Baroque as one can get. But there is more to be
said, especially as this was perhaps *the* outstanding classical building of the
pre-war years.

Burnet was the son of a successful Glasgow architect, to whom he was
articled. He then proceeded to Paris and the atelier of Jean-Louis Pascal.
Returning to Glasgow he built a series of very personal and curiously varied
buildings (some decidedly Baroque) and by 1903 had the reputation of being
the most accomplished architect north of the Tweed. No doubt it was in that
role that the RIBA named him in a list of appropriate candidates for the
building of the new northern extension of the Museum. The Trustees wisely
chose the North British outsider and work started in 1904.

The composition was a stroke of genius. Clearly, in a continuation of Sir
Robert Smirke's Greek Rivival building of 1923–47 respect had to be paid to
the continuous neo-classical colonnade of the south front. Merely to copy it
in the north block would have been a confession of failure: to ignore it,
equally so. What Burnet did was to take nineteen bays of the (slightly

remodelled) Ionic colonnade and fling them across the new front as an attached order, overlapping a massive pylon at either end. The effect is that of a Grecian screen displayed across an essentially modern building – a gesture which is characteristically Baroque in its dramatic impact, while still paying respect to Smirke's neo-classical scholarship. The working out in detail is as masterly as the composition. It shows Burnet's indebtedness to Pascal and a technical competence in the handling far beyond what most English practitioners of the new classicism had yet achieved. Opened by George V in 1914, it brought the 'Edwardian Baroque' story to a triumphant close.

C. R. Mackintosh and Charles Holden

Outside the group of architects associated with 'Edwardian Baroque' in its various metamorphoses it is possible to identify certain individuals, born in the sixties or seventies, who deliberately avoided the Baroque trend and attempted to work in the light of Ruskinian philosophy as transmitted by Philip Webb. I choose here two names, one a Scotsman practising in Glasgow, the other an Englishman practising in London: Charles Rennie Mackintosh and Charles Holden.

Born in Glasgow in 1868, Mackintosh was twenty-seven when he designed the building on which his fame chiefly depends – the Glasgow School of Art. The son of a police superintendent, he had been articled to a Glasgow architect and won various student awards, including one which took him to Italy. He was obviously a bright and dedicated designer but there was nothing yet to show of what he would be capable. He joined the firm of Honeyman and Keppie and having designed several of their buildings with credit, the competition design for the School of Art (not a very profitable enterprise even in the event of success) was put into his young hands. With the commission secured, the details were left entirely to him.

At this date (1895), the School was in a flourishing state under the inspiring direction of its principal, Francis Newbery. Mackintosh was no stranger to what was going on there, a fact which has an important bearing on the design. He had attended evening classes and become friendly with Newbery, who introduced him to some young artists whose outlook seemed to match his own. They were producing decorative schemes, posters, furniture and other things which brought together some of the many current fashions in the world of art but stood well outside the Arts and Crafts movement. There was something of pre-Raphaelitism, something of the Japanese, something of Beardsley and Whistler and something of the mystical Dutchman, Jan van Toorup. Among these young Glasgow artists were Herbert MacNair, intending to be an architect, and two sisters, Margaret and Frances Macdonald. Mackintosh joined them. They exhibited in Glasgow and elsewhere. They became known as 'the Four'. MacNair married Frances and Mackintosh married Margaret.

So in making his designs for the new building Mackintosh was combining two roles: first, that of professional architect, and secondly that of a graphic

artist, one of 'the Four'. In the first role he could tackle the problem of
the restricted site, the no less restricted finances and the problems of
construction. In the second he could bring the new-found vision of his group
to illuminate the whole enterprise and this is what makes the performance so
remarkable. It would be difficult to find in British architecture so striking an
example of a fusion of vision between artist and architect. But that is not all.
Mackintosh's designs showed a feeling for the English and Scottish
architecture of the sixteenth century; the building has its roots in the Tudor
and Baronial.

The first part of the school, including the main entrance hall and staircase
and most of the great range of northward-facing studio windows, was
finished in 1899. Finance then ran short and six years elapsed before the
library extension went up in 1905–9. In the six-year interval there was a
change of mood as well as a change of function. In the library wing we leave
the rational severity of the mullion-and-transom studio windows for a mode
of lighting appropriate to the library. This takes the form of continuous oriel
windows, streaming up in a set of three, contrasting dramatically with an un-
windowed area of squared rubble, with a flattened gable at the top and a
heavily moulded doorway at the base. One is reminded simultaneously of the
massive, textured stonework and crisp heraldry of a Scottish castle and the
grey, plain areas, with sudden, tense concentrations of detail in a Beardsley
drawing – the two terminal points in Mackintosh's range of sources. The
library itself is a room without precedent: a combination of timber columns
and timber beams with a coffered timber ceiling and a gallery along two sides
which does not reach the columns but rests on timbers which do; an arrange-
ment which is entirely logical but is so contrived as to give a mysterious
spacial effect, enhanced by the delicacy and economy of the ornament.

After the School of Art, the opportunities which came Mackintosh's way
were sadly few. There were the tea-rooms for Mrs Catharine Cranston, a
lady who combined intolerance of alcoholic beverages with a genius for
catering enterprise. These are mostly interior installations, done with a light
touch and the same invention, the same subtle tensions which are found in
the Art School. There are several country houses where Mackintosh effects a
marvellous fusion of the picturesque and the formal. He designed a Gothic
church in Glasgow and entered a Gothic design for the Liverpool
competition of 1903, but these show his limitations; they are mannered
interpretations of the Gothic without the depth of feeling which Scott was
soon to bring to the style in his work at Liverpool.

With the 1914 war, Mackintosh's career virtually ended. He had retired
from the firm of Honeyman and Keppie and went to live first in Sussex, then
in the south of France, where he took to painting water-colours, remarkable
for a volumetric vigour which at once recalls his architecture. Illness forced
his return to London where he died in 1928.

Mackintosh's active career lasted little more than ten years and made no
impression either on Scottish or English architecture. His Glasgow firm said
good-bye to 'that sort of thing' and followed a conventional classical routine.
He was, however, noticed on the continent and in 1924 Charles Marriott, art
critic on *The Times*, made the far-reaching statement that 'the whole

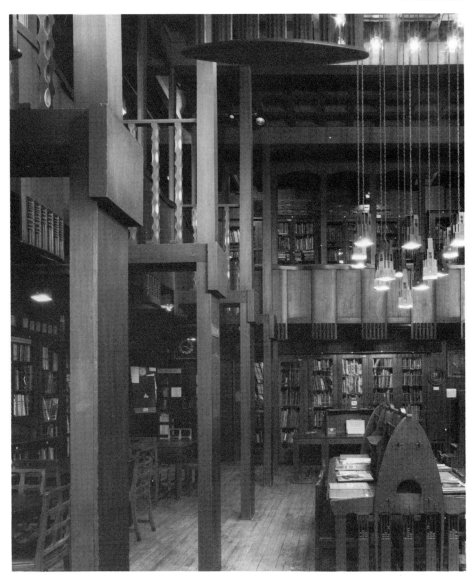

Glasgow School of Art Library (1905–9). C. R. Mackintosh.

modernist movement on the continent derives from Mackintosh': an overstatement as we see things now but one which in 1924 containted more than a grain of truth.

In England there were few architects who could reasonably be compared with Mackintosh for sheer artistic invention. But there is one outstanding case – the young Charles Holden. The 'young' Holden because his creative period ended with his youth; his later work, after the First World War, though thoughtful and sincere, is singularly lacking in vision.

Holden was born in Bolton, Lancashire, in 1875 and was thus younger than Mackintosh by seven years. He came from a hard northern background. His father's bankruptcy and his mother's death when he was eight deprived him of education other than what a village school could supply. Brought up by an elder sister he found various humble employments and eventually, his father having become solvent again, was articled to a Manchester architect. Thence he proceeded to London and was for a year with C. R. Ashbee (1863–1942), the leading personality in the Arts and Crafts movement. But by this time he had got to know the writings of Walt Whitman and Edward Carpenter and having nourished his philosophy of life and architecture from those sources, he came to feel that that philosophy did not go along with the aestheticism of Arts and Crafts. In 1899 he joined the office of H. Percy Adams, who was developing a tough-minded hospital practice and in 1907 became a partner.

Holden was a man of great modesty and simplicity, qualities reflected in his work. It was natural that Philip Webb's ideas should appeal to him, though he confessed also to an early admiration for the ornamentalism of Henry Wilson. His first executed work, shared with Adams, was the Belgrave Hospital at Kennington, begun in 1901. Adams made the plan, a logical and harmonious design with which Holden had full sympathy. He brought it up into steep, almost styleless elevations in which gabled surfaces slide behind and between slim towers, all in plain red brick but with drama and poetry in it which owes something to Ashbee but more to Philip Webb.

The economy and spareness of the hospital are closer in spirit to the Glasgow Art School than any contemporary English work. It was followed by the no less remarkable Edward VII sanatorium near Midhurst. In 1902 Holden entered, on his own account, for the Bristol Central Library

Bristol Central Library (1905). Charles Holden.

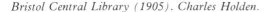

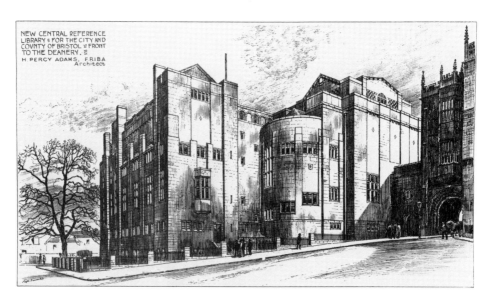

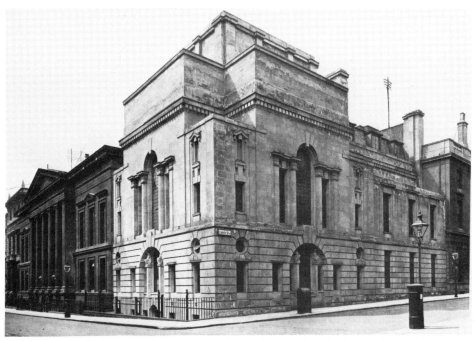

Law Society Building extension, Chancery Lane, London (1902–4). Charles Holden.

competition, dispatching the designs within a couple of weeks. He carried off the award, the Adams office then undertaking the commission. The exterior is generally Tudor to make it go with the adjoining Abbey gateway, but the side and rear elevations are freely modelled, rather in the spirit of the Belgrave Hospital. Here the Tudor dissolves into pure abstraction. Perspectives published in 1906 were evidently noticed by C. R. Mackintosh in Glasgow, just then preparing designs for his Art School extension, and in the conversion of Tudor to a 'free style' idiom Holden becomes the preceptor of the older Glasgow master.

In the same year as the Bristol competition Holden had his attention diverted from Tudor to Classical. Just as the Bristol context had dictated an approach through Tudor, so the addition of a library wing to the Law Society's Greek revival building (1828–32) in Chancery Lane, commissioned in 1903, dictated a Classical approach. But of what sort? Holden avoided all current revivals – Wren, Queen Anne, Palladian, Baroque, and found an idiom of his own, based (as he confessed) on the work of the sculptor–architect Alfred Stevens. This explains the somewhat Michelangelesque character of the Law Society extension (it is worth remembering, too, that Philip Webb was fascinated by Michelangelo) but not the sense of cubic composition which is Holden's own. The extension is on a cruciform plan with the spaces between the arms filled in nearly to cornice level and the central area of the cross rising as a low cubic tower. The 'cubism' comes into Holden's detail and it was from Holden, no doubt, that Mackintosh took it and used it in the niches of his Art School oriels.

Holden followed Philip Webb in the belief that architecture should go hand in hand with the crafts and with painting and sculpture. In his British Medical Association Building (now Zimbabwe House) in the Strand (1907–8) designed in the spirit of the Law Society extension, he invited Jacob Epstein to participate by carving nude full-length figures, snugly placed in rectangular recesses at second-floor level. The effect was striking but the nudity was found offensive to sensitive citizens passing along the Strand. Although mutilated when it was alleged that parts of them were falling off into the street, the figures survive.

Holden's patronage of modern sculpture is conspicuous again, nearly thirty years later, in the first of his post-war buildings – the London Transport headquarters at Broadway, Westminster (1927–9). But the building itself is disappointing. The plan is ingenious and original but rises into frigid cliffs of Portland stone on which the figures by Epstein and the reliefs by Moore, Gill and others seem arbitrary attachments. Much more interesting are the suburban stations which Holden designed for the London Underground; with their geometrical shapes and classical proportions they are eloquent of their social purpose and agreeable to use.

Holden's last work, the University of London buildings in Bloomsbury, started in 1932 with a promising plan, subsequently abandoned. The completed part consists mainly of the Senate House and Library, the latter rising into a towering book-stack. The building is bare of ornament and seems to symbolise only the bleakest aspect of University life: books, books and more books. The interiors are severe without being grand and in the whole there is a lack of any of the qualities which we noticed in the architect's earlier work.

This loss of vision in Holden's late work is difficult to understand. He perhaps went some way to explaining it when he said of himself, in 1936, that all his life he had a passion for elimination. In the Edwardian climate this meant a challenge to prevailing stylistic trends which brought out Holden's creative puritanism. In the very different climate of the thirties, when elimination had become the order of the day, it was otherwise. There was nothing from which to subtract. It might also be true to say that in Holden's late buildings we see, more clearly than in any other architect's work, the trauma of the First World War.

Edwin Landseer Lutyens

Lutyens's background was a rare one for an architect; he was born into the English gentry. His father was an army officer who, having reached the rank of captain, resigned his commission to become a painter of horses. In this he was none too successful and Edwin, the eleventh child in a family of fourteen, had little in the way of formal education. His health, moreover, was affected by an attack of rheumatic fever, a setback which prevented him from playing games and, as he said himself, induced him 'to use my eyes instead of my feet'. He taught himself to draw and at fifteen it was evident that he would be an architect. He spent a year in the office of Sir Ernest George

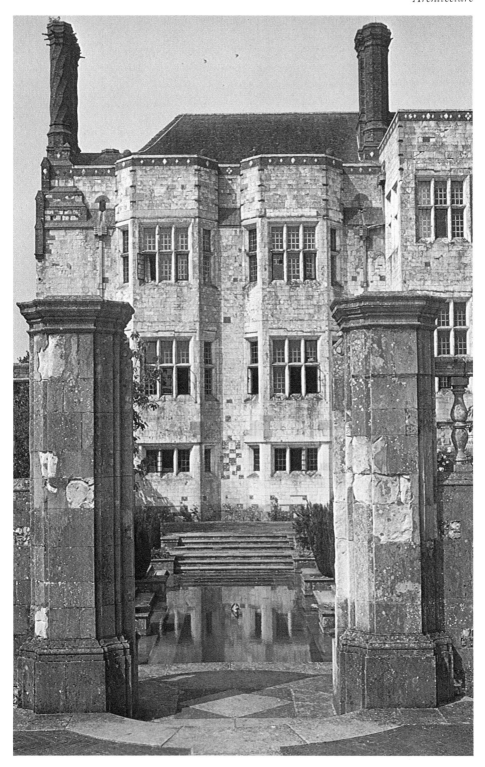

Marsh Court, Stockbridge, Hampshire (1902–4). Edwin Landseer Lutyens.

(1839–1922) and was launched into practice by commissions from family friends. In 1897 he married the daughter of the Viceroy of India and became the favoured architect of the proud and wealthy, especially the wealthy, for if Lutyens undertook to build a house he would build it in his own way and no other. As a personality he was extraordinarily attractive, wholly lacking in pomp, a maker of puns and alive with fun. Architecture, for him, was a game, but one to be played, in the last resort, with intense seriousness.

Between 1897 and 1914 he built the series of country houses which, with the help of *Country Life* and its founder Edward Hudson, made him famous and by the latter date he was the only British architect whose name was familiar to a large public.

The great Lutyens houses are these: Tigbourne Court, Witley, Surrey (1899); Deanery Garden, Sonning, Berkshire (1899–1902); Grey Walls, Gullane, Scotland (1900); Marsh Court, Stockbridge, Hampshire (1901–4); Little Thakeham, Sussex (1902); Nashdom, Taplow, Buckinghamshire (1905); Heathcote, Ilkley, Yorkshire (1906); Great Maytham, Rolvedea, Kent (1909); Castle Drogo, Devon (1910); and the Salutation, Sandwich, Kent (1911). The clients included a stock-jobber, several industrialists, and an heiress married to a Russian prince. The styles of the several houses cannot easily be categorised. Tudor is a common basis for four of them but of these some have interiors of Stuart or Georgian style. Two are early Georgian, one (Heathcote) Italian Classical, based on Sanmichele, and one (Drogo) is in a castle style of Lutyens's own devising.

Many houses of the period by other architects are as mixed in style: those for instance of Ernest Newton (1856–1922) and Guy Dawber (1861–1935). They are original and accomplished performances. But Lutyens's houses stand apart from these and the reasons are easily stated. I have used the word 'improvisation' in an earlier chapter to describe a way of designing characteristic of the late Victorian and early Edwardian years. Improvisation came strongly into country-house design but the word will not do for Lutyens. Notwithstanding his free plans and his changes of style not only from house to house but often within the walls of one house, the lasting impression is of a decisively conceived work of art. Two things are exceptional about Lutyens: invention and control. His invention was fabulous – an irrepressible fountain of ideas, sometimes profound, sometimes bordering on the childish and it was perhaps this very prodigality of ideas which forced the need for severe counter-measures. Control in the first instance is a matter of obsessive care in detail: the exact conciliation of plane to plane, of eaves to wall, the return or mastering of cornices. But control in Lutyens becomes a more intellectual issue and he was eventually to erect for himself a system of ratios, an invisible 'armature of planes' within which invention could run without running riot. It is the sense of absolute control in a Lutyens house which survives the shock of pleasure in its inventions, engraving its wit and humour on the memory. The same discipline unites the houses with their gardens which Lutyens planned on the same principles and often with the collaboration of his friend Gertrude Jekyll.

Through the country-house series runs a strong thread of appreciation of the classical language and this is exposed conspicuously in Heathcote, Ilkley

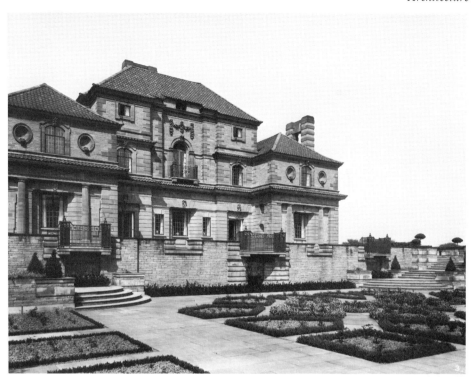

Heathcote, Ilkley, Yorkshire (1906). Edwin Landseer Lutyens.

(1906). Here, a rich Yorkshire industrialist had given Lutyens a free hand, resulting in the creation of an exterior based on Sanmichele's city gateways at Verona – a study of the Doric order in solid masonry, with extensive terracing and steps, playfully rusticated. The adoption of the classical as a linguistic discipline seems to date from this time and Lutyens longed for an opportunity to use it in a big way and to play what he liked to call 'the high game' on the scale which Wren or Vanbrugh had enjoyed. In 1907 he was invited to compete for the new London County Hall. He put his heart into it and submitted a beautiful design, much indebted to Wren, but it did not win, and his disappointment was bitter. Then at last in 1912 came the invitation to lay out the new capital of Delhi, followed almost immediately by an appointment to design the Viceroy's house. Now, aged forty-three, when his genius had come to full maturity, he had at his feet the greatest architectural opportunity the world had to offer. The work was started and continued on a reduced scale throughout the 1914–18 war.

In 1918, Lutyens, by now acknowledged to be the foremost living British architect, was summoned by Lloyd George to discuss the provision of a 'catafalque' in Whitehall as a focus for the victory celebration. 'Not a catafalque but a cenotaph', said Lutyens; Lloyd George agreed and the word stuck. Lutyens produced his design the same day and the temporary structure was ready by the end of the month. Lutyens then set himself to redesign the monument with mathematical precision. The permanent structure was

complete by the anniversary of armistice day, 11 November, 1920, and has been reverenced ever since as an incomparable embodiment of its symbolic purpose.

Lutyens designed many memorials to the Great War (over fifty between 1919 and 1925), not only in British towns and cities but on the battlefields of the continent, culminating in the mammoth complex of arches constituting the memorial to the Missing at Thiepval – a design which led to his last great design, the Roman Catholic Cathedral at Liverpool, of which only a part of the crypt was completed before 1939. In 1945 the project was abandoned.

In 1920, Lutyens's practice took a new turn. In that year he was commissioned by the Anglo-Persian Oil Company to design their head office in Moorgate, in the City of London, a five-storey block with one straight and one curved façade linked by a short straight run in the connecting street. Britannic House, as the building was called (until its recent re-naming as Lutyens House) emerged in Lutyens's imagination as a conjunction of two Italian palaces, one hovering over the other, the lower palace solid, with sharp incised openings, the upper one grandly open with a Corinthian order in high relief, on the model of Sanmichele's Bevilacqua Palace at Verona. The result of this exotic disposition is a building which displays not only

Britannic House (renamed Lutyens House), Moorgate, City of London (1920). Edwin Landseer Lutyens.

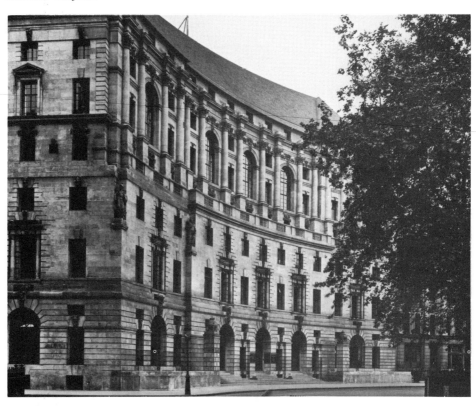

Lutyens's inventiveness but his magical sense of surface and the quality
which he called 'colour' (as one uses the word in literary or musical contexts).
The finely judge recessions and projections, the contrasts of naked wall and
brittle enrichment in shadow and the whole pattern of void and solid are
something beyond the reach of the ordinary architect and make Britannic
House a very special building.

Then, in 1921, the Midland Bank invited Lutyens to design a branch bank
at 196A Piccadilly, a site next to the churchyard of Wren's St James's. The
result was a cubic block with a pyramidal slate roof and enlivened by a
picturesque dialogue in brick and stone in the spirit of Wren. This led to
commissions for three other Midland Banks, including the new headquarters
building in Poultry and Princes Street (1924–39). This is again in the spirit
of Sanmichele – Doric on the ground floor, above the Doric a mezzanine and
then three storeys of rusticated masonry with windows set in grooves arched
at the top; a massive prison-like composition appropriate, perhaps, to the
sense of security expected of a great banking house.

In 1929 the Viceroy's house at New Delhi was completed and the new
capital was inaugurated in 1931. The Viceroy's house displays Lutyens as a
great classical architect: the plan, the disposition of masses and the
proportional equilibrium of void and solid all converge to confirm this
verdict. It also displays a marvellous intuitive ability to suit the architecture
to the cultural, as well as the physical climate of the sub-continent. The
allusions to ancient Indian monuments are no mere 'historic references'; they
fuse with the western classical tradition. The principal order has a specially
composed 'Delhi' capital and the entablature is a Lutyens equivalent of the
traditional Mogul *chujja*. The dome which, in other hands, might have been
yet one more Edwardian variant of Wren's Greenwich, takes on the profile of
the Great Stupa at Sanchi. The building is as acceptable to the India of
today as it was to the British raj in the brief remaining years of the Empire.

Lutyens's death in 1944 was felt to mark the close of an epoch in British
architecture – the epoch dominated first by Norman Shaw and then by
Lutyens; the last epoch of the great country house as the seed-bed of British
architectural genius, as well as the last in which British imperialism would be
celebrated in the arts.

Churches: Liverpool Cathedral and its architect

By 1900 the Gothic Revival had all but blown itself out. All the great Goths
had gone: Scott in 1878, Street in 1881, Pearson in 1897 and Butterfield in
1900. They had been followed by a less passionate generation of church-
builders, of whom George Frederick Bodley (1827–1911) was the leader. He
had been a pupil of Scott and his early works were 'early French' following
Street. Around 1870, however, he gave up being 'early' and 'French' and
took up with the native tradition of 'Dec.' and 'Perp.', introducing what
Lethaby liked to call the 'soft' phase of the Revival, as opposed to the 'hard'
fifties and sixties. Bodley's last work was the delicately perfect Holy Trinity,
Kensington Gore (1902). His pupils continued the Bodley style right up to

1914 and, indeed, beyond into the twenties and thirties. Examples are J. N. Comper's St Cyprian, Clarence Gate (1903) and Walter Tapper's church of the Ascension, Old Quebec Street (1913).

A new initiative came in the nineties with the building of the Roman Catholic cathedral at Westminster, where Cardinal Vaughan dictated an 'early Christian' style to mark the cathedral's separateness from the Gothic minster. His architect, John Francis Bentley (1839–1902), brilliantly translated his Gothic skills into an eclectic manner with a strong Byzantine colouring and the cathedral was completed in 1902. That was the year in which W. R. Lethaby (1857–1931) built the village church at Brockhampton, Herefordshire, a 'primitivist' exercise in the simplest imaginable Gothic terms, with unmoulded transverse arches springing nearly from the ground and carrying a thatched concrete roof. This radical gesture was soon followed by other members of the Arts and Crafts group – by Randall Wells at Kempley and by E. S. Prior at Roker (1906–7). Elsewhere there were reversions to the Renaissance and Classicism. At Hampstead Garden Suburb, Lutyens built St Jude's-on-the-Hill, barrel-vaulted inside but externally like a great tiled barn with a tower consisting of open arches supporting a conical spire – an essay in solid geometry. In Kingsway, London's new street, two churches were built, both classical. The Catholic church, St Anselm and St

Anglican Cathedral, Liverpool, from E.N.E. (1904–76). Giles Gilbert Scott.

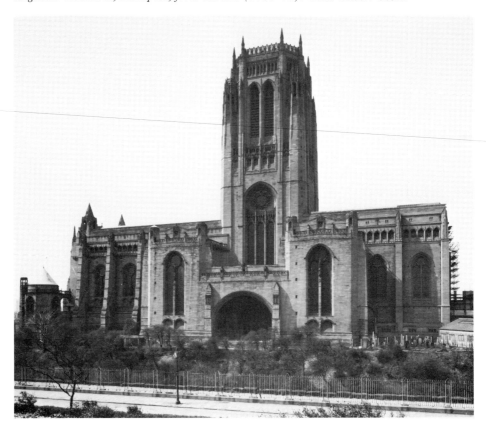

Cecilia (1909), by F A. Walters, is a sensitive version of François I, the Anglican church, Holy Trinity (1910), nearly opposite, by Belcher and Joass with a Baroque façade inspired by Santa Maria della Pace, Rome, but with a domed interior and – in the design but not built – a steeple on themes by Wren and Gibbs.

But the greatest ecclesiastical monument of the period was Giles Gilbert Scott's Anglican cathedral at Liverpool. A competition had been held in 1885 but proved abortive and it was only in 1901 that the dominating site on St James's Mount was secured and a new competition announced. The announcement specified that the style of the new cathedral should be Gothic but this roused a gale of opposition. A petition from architects and laymen was organised with the result that the stylistic restriction was removed. Bodley and Norman Shaw were appointed assessors to ensure fair play but in the event all five short-listed designs were Gothic, and the award went to Giles Gilbert Scott, grandson of Bodley's master and son of a brilliant architect father (another George Gilbert) whom he never knew.

The assessors' award was unacceptable to the building committee. They had required a large central area for mass congregations, which Scott failed to provide. They were, moreover, horrified to learn that the winner was only twenty-two and had built nothing. This last objection was removed when Scott accepted the offer of partnership with Bodley; the first was eliminated by the architect after a long struggle. The work started in 1904 and the Lady Chapel, the first limb of the new building, is perhaps more Bodley than Scott.

Scott's competition drawings showed a complex, somewhat over-articulated cathedral with two transeptal towers. He revised this in 1904 but was not very happy about it, and there was friction with Bodley. Bodley died in 1907; Scott then took a deep breath and decided, in his own words, 'to start all over again'. He could not literally do this because the choir of the Cathedral was already in progress, but in 1910 everything west of the choir was changed. In effect, the whole conception of the design was transfigured. Instead of the lateral towers there was to be one huge tower rising over an ample central space. West of this there was just room on the site for a three-bay nave, duplicating the three-bay choir. Scott was now building on a symmetrical bi-axial plan almost as classical as that of Liverpool's St George's Hall.

Scott's urge for change and the character which his new design assumed are easy to understand if we consider what was going on in the minds of some of his contemporaries. For them, the Gothic Revival was long out-dated, its place filled by various forms of classical or quasi-Byzantine or by 'free-style' adventures. The most daring of the under-forties were attempting the rhetoric of the Baroque; E. A. Rickards (Lanchester and Rickards) had even submitted a Baroque extravaganza in the London County Hall competition (1907). It was unplaced, but a glance at that design may provide a clue to what happened at Liverpool in 1910. Scott was committed by family tradition and apprenticeship to Gothic but he now had the itch to give his cathedral the newly re-discovered glamour of the Baroque. Rickards's dramatic three-stage tower, rising between massive wings with a screen across

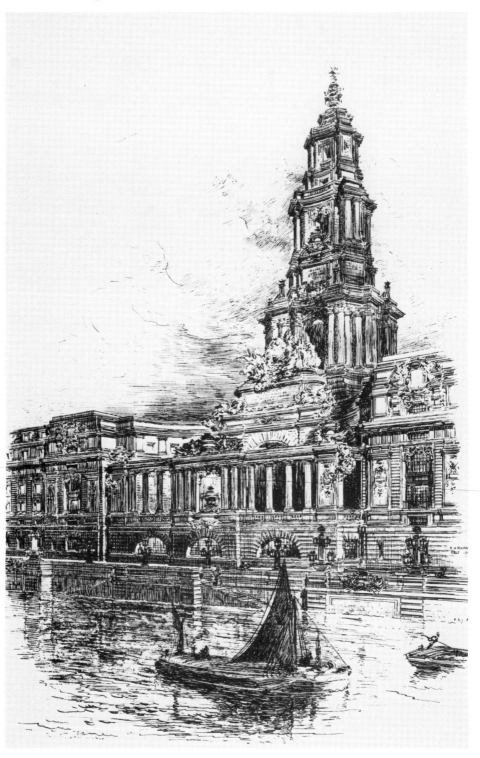

Competition design for London County Hall (1907). E. A. Rickards.

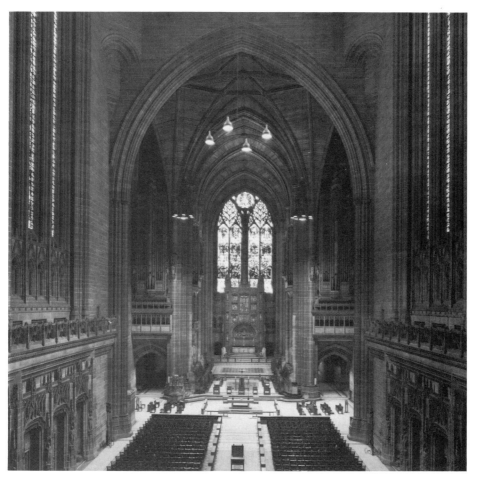

Anglican Cathedral, Liverpool (1904–76). Giles Gilbert Scott.

the opening was a composition which might be interpreted as well in Gothic as in Classic; and several other architects were playing Baroque in this free, exciting way (Brumwell Thomas, for instance, in his Stockport Town Hall, 1908). Young Scott was drawn to these new flights of invention, and there are drawings by him of Baroque fantasies in the spirit of Piranesi, dating from this period. He could not turn from Gothic to Baroque but he could turn his Gothic into something breathing the spirit of Baroque while at the same time satisfying the requirement of a great central space.

Scott had a long and happy career in architecture but he never again did anything as brilliantly original as this sudden diversion of late Victorian Gothic into an equivalent of Edwardian Baroque. As the building proceeded, the architect grew comfortably middle-aged and lost the passion of 1910. The tower grew higher and slimmer, more fastidious in detail and more restrained in silhouette. The nave, built after 1945, was, in the main, a replica of the choir. Scott died in 1960 leaving the west end to be detailed by his old pupil, Roger Pinckney. The cathedral was at last finished in 1976.

Clare College New Building, Cambridge (1923–34). Giles Gilbert Scott.

Still only fifty in 1930, Scott built much of consequence before the Second World War. With his Liverpool Cathedral reputation he was, inevitably, called to design many churches. Mostly in a Gothic or Italian Romanesque idiom, each has some striking novelty of plan or section. Thus at Broadstairs (Our Lady of the Sea, 1930) the apsidal chancel is twice the height of the nave; at High Wycombe (St Francis, Terriers, 1930) the 'clerestory' has no windows, the nave being lit only from the aisles; at Luton (St Andrew's, 1932) the aisles have no windows and the nave is lit from massed lancets in the clerestory. In the memorial chapel at Charterhouse (1926) all the light comes from hugely tall, widely separated lancets (a recollection of Albi).

University buildings also came his way. In the new building for Clare College, Cambridge, (1923–34) Scott introduced his personal version of the Georgian tradition: dainty and refined, with a slight American accent. The library (1931–4) at the same university is again somewhat American, with a

central tower, tile-roofed, serving as a book stack. This was followed by the new Bodleian (1936–40) at Oxford in a quasi-modern style which nobody has ever much liked. Scott's most curious contribution to the thirties was his attempt in 1933 to soften the rude impact of the mammoth power station at Battersea by an elaborate modelling of its external brickwork and by giving the four chimneys a profile of quasi-classical refinement.

Scott's classical works did little to enhance a reputation made solely in the manipulation of Gothic. His inventive flair, like Charles Holden's, was a casualty of the First World War, and if his late churches have some charming surprises, his classical manner lacks the rationality and coherence which are classicism's *sine qua non*. It is as the creator of Liverpool Cathedral, the last great Gothic building in Europe, if not in the world – a cathedral uniquely planned for its own time but whose vaults swing upward with all the confidence and might of Seville or Gerona, that he is entitled to posterity's regard.

The sense of the modern and the 'Modern Movement'

It remains to chronicle the rise of the 'Modern Movement' in Britain and to consider what it achieved before 1939. To begin with, we must remind ourselves that what may be called a 'sense of the modern' had been felt continuously since early in the century. It was a *fin de siècle* phenomenon and is discernible in Charles Holden's early work; his assembly of cubic forms in the Law Society's building (1902–4) is a significant forecast, prompting perhaps the cubistic detailing of Mackintosh's oriel windows in the Glasgow Art School (1905–9). J. J. Joass's Baroque has a strong rectilinear feeling and the massive square-cut and 'battered' pylons of Burnet's British Museum (1908) were felt to have a 'modern' character as distinct from the neo-classical colonnade which overlaps them.

There followed a vogue for square-cut American verticalism, deriving from Louis Sullivan, first exhibited in T. S. Tait's Kodak building (1911) in Kingsway, and later, after the War, in the same architect's ferociously emphatic Adelaide House, London Bridge (1922). This was seen, for a few years, as the quintessence of the 'modern' and was imitated here and there, but with the thirties came the impact of new ideas from the continent. 'Verticalism' went out and 'horizontalism' came in. An early instance in London was Hay's Wharf just across the Thames from Adelaide House, designed by H. S. Goodhart-Rendel (1887–1959) in 1931. Here was something different – a rational statement about form and function: the horizontal floor-levels emphasised but the verticals of the frame structure also clearly articulated. On the river front the board-room and director's office were set in a rectangular, sculptured frame to establish their hierarchic identity. This was a rationalism of the Viollet-le-Duc model and Rendel, asked to describe the 'style' of the building, replied 'early French Gothic'. Hay's Wharf was not much liked at the time, but in retrospect it is one of the few intellectually respectable buildings of the period.

In 1930–2 continental movements began to be reflected in the whims and

Adelaide House, London Bridge (1922). T. S. Tait (Sir John Burnet and Partners).

fancies of British practice: for example, in Joseph Emberton's new hall at Olympia, hinting at German Expressionism; or, more nearly up-to-the-minute, Frederick Etchells's reconstruction in Corbusian style of Crawford's (the advertising agency) in High Holborn. In the domestic field the first 'modernist' shock was administered in 'High and Over', the house which the New Zealander, Amyas Connell, designed for a professor of classical archaeology at Amersham, Buckinghamshire, in 1930. Its flat roof, all-glass staircase and horizontal windows alarmed the bourgeoisie of 'Metroland' and aroused a resistance to modernism which made the selection of sites for future houses in the new style a sensitive matter. ('Metroland' was an expression invented by the Metropolitan Railway Company in the early twenties to describe the countryside, mainly in Buckinghamshire, being opened up to the middle-claass commuter by the extension of the Company's lines.)

 Individual rebuffs and general discontent with the complacency and insularity of British architecture brought together a group of younger architects intent on further research into the nature of modernism and how

*Hay's Wharf, London
Bridge (1931).
H. S. Goodhart-Rendel.*

to promote it. Armed with the principles enunciated in Le Corbusier's *Vers
une Architecture* and those taught by Gropius in the Bauhaus, they
constituted the intellectual élite which formed, in 1933, the Modern
Architectural Research Group (MARS). Proposed in the first instance by the
writer, P. Morton Shand, promoted by the Swiss architectural historian,
Siegfried Giedion, it was affiliated to the Congrès Internationaux de
l'Architecture Moderne (CIAM), of which Giedion was secretary. The research
which MARS proposed to undertake was to cover a very wide area of
technology and design, including town planning. This soon proved to be
beyond the capacity of busy architects just emerging from the depression and
with little time for theoretical speculation. MARS did, however, fly the modern
flag with some effect and created a focus for periodic discussions among
members of the group. Its exhibition at the New Burlington Gallery in 1938,
applying the Vitruvian criteria of 'firmness, commodity and delight' to
modern problems and modern means of solving them, was a public gesture of
considerable effect. Le Corbusier was a guest at the opening.

The first chairman of MARS was Wells Coates who immediately secured
the participation of Edwin Maxwell Fry. The honorary secretary from the
start was Godfrey Samuel, architect son of the statesman, Viscount Samuel.
The editor of the *Architectural Review*, H. de Cronin Hastings, was closely

associated with the group and published the works of its members in up-to-date style. A membership of about sixty was in due course recruited, but MARS was nothing if not exclusive. Architects with an established reputation for mild versions of modernity, like Oliver Hill and Grey Wornum were considered not to be doctrinally sound and even Howard Robertson, who had done more than anybody to bring the work of continental moderns to the notice of architects in Britain, was not invited to join the Group. A select number of engineers and writers was admitted, including Sir Owen Williams, the engineer for the Empire Exhibition of 1924 and the Boots factory in Nottingham; and among writers, J. M. Richards; a future Poet Laureate, John Betjeman; and the present writer. A point worth noting is that some of the most active in the early membership were young architects from Australia, New Zealand and Canada, ambitious to make a reputation in the new enlightenment which seemed about to dawn in the old world.

Maxwell Fry and Wells Coates were the acknowledged leaders of the movement and as they came to the leadership by very different routes – one from within the architectural profession, the other from outside it, it may help to illustrate the situation if we compare their careers up to 1933.

Maxwell Fry was born in Cheshire in 1899 and by the age of fifteen had decided to be an architect. He graduated at Liverpool University School, worked for a short period in the New York office of Carrere and Hastings, returned to England and took a job in London with a firm of town planners and architects working in a 'traditional' style. He later became a partner in the firm. In the deepening recession of 1929–30 Fry took to writing, mostly for the *Architects' Journal*, and this excited his interest in continental modernism especially in the relation between the philosophy of the modern movement and the then pressing problem in Britain of low-cost housing. Meeting Elizabeth Denby, a specialist in housing theory and practice, he was commissioned with her to design a block of low-cost flats, Sassoon House, Peckham. This was a more or less philanthropic development (an investment yielding two per cent) of an experimental kind, built in 1934. It was followed by another housing project where Fry again worked with Denby – Kensal House, for the Gas-light and Coke Company, comprising besides flats, a club, a school and a circular playground formed within the foundation of a demolished gas-holder. Like Sassoon House it was an attempt to bring architectural design and construction into the closest possible relation to a socially conceived programme, putting aside all considerations of style, but producing an acceptable visual pattern. In this it succeeded and the scheme was completed in 1936.

Wells Coates's entry into architecture was of a more oblique kind. Born in Tokyo in 1895, the son of an academic theologian, his early education had familiarised him with Japanese life and culture. He served in the last phase of the First World War, then obtained a PhD in engineering at a Canadian university. He had no intention of becoming an engineer, still less an architect, but the disciplines of technology fascinated him. So did other things, including journalism. He came to England in 1922 and joined the *Daily Express* as a sub-editor. Disenchanted with Fleet Street he returned to Canada in 1926 but was in London in 1928, when a chance meeting with a

Kensal House, Kensington, London (1935). E. Maxwell Fry and Elizabeth Denby.

man who was marketing dyed and printed silks directed his attention to the design of shops, and a series of 'Cresta' shops, followed by a 'Cresta' factory at Welwyn, mark Coates's entry into architecture. In 1929 his interest in the possible uses of plywood in shopfitting brought him into contact with the firm of Venesta, where he met Jack Pritchard, and from this meeting emerged, eventually, the model block of flats in Lawn Road, Hampstead which may fairly be considered the first British building to reflect, both in the client's intentions and the architect's interpretation, the philosophy of the modern movement. The Isokon flats were completed in 1934, a year or two before Fry's Kensal House.

As with Maxwell Fry's two housing projects, the relevance of the scheme turned on the application of modern building technology to a specific social need. These flats, however, were not designed for working-class people nor for the affluent, but for young professional men and women with an income of about £500 a year who would normally be living in 'digs' or 'bed-sitters'. The flats were equipped with built-in furniture, designed in meticulous detail by Coates, of a type which would reduce the problem of furnishing to a minimum.

As a real-life manifesto of the modern movement, the Isokon flats were a sensational success; and there is perhaps no other English building which so neatly interprets the ideals of CIAM and MARS. It is not quite architecture and not quite engineering but the work manifestly of an engineer-architect, a technologist with a flair for the 'elegant solution' in any direction which

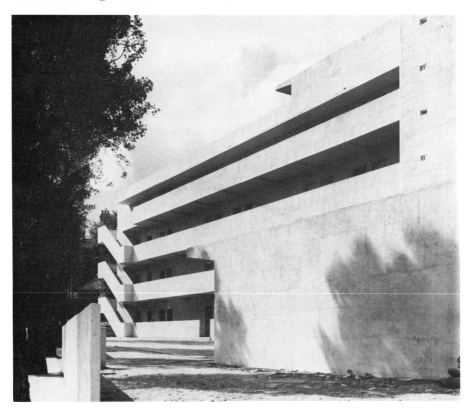

Isokon Flats, Lawn Road, Hampstead, London (1934). Wells Coates.

attracted him. Coates could design a wireless set (he won the competition for the best-selling 'Ekco' set in 1932) and he could, and did design a catamaran. A building was just another problem along the way. If there are limitations to this heroically technological approach they become apparent if we compare Coates's work with Fry's. Fry's Kensal House is a humane and cheerful building. About Isokon flats there is not a flicker of a smile.

These two buildings are central to the British movement in its first phase. In 1934, Fry entered into partnership with Walter Gropius whom events in Germany had compelled to leave the Bauhaus. With Gropius he designed Impington Village College, Cambridgeshire, a social experiment launched by the progressive and imaginative education officer, Henry Morris. Of Fry's personal work, Sun House, Frognal Way, Hampstead, with its harmonious proportions and attractive play of terraces and canopies, is a well-known example.

Country houses in the modern manner for people of some wealth were important, even if they had not the cachet of socialistic betterment. Amyas Connell, the New Zealander, has already been mentioned as the architect who shocked Amersham with his 'High and Over'. It was, to be sure, a somewhat immature performance and the later houses he designed in partnership with Basil Ward are more in line with MARS group orthodoxy;

they are strongly influenced either by Le Corbusier or the Dutch Cubist school, or both.

The Russian-born but English-educated Serge Chermayeff, who entered architecture by way of furniture and interior design for Waring and Gillow, built his own simple and perfectionist house at Bentley, Surrey, and the Gilbey warehouse at Camden Town, but his major work was shared with Erich Mendelsohn who, like Gropius, sought the hospitality of Britain with the rise of Nazism. The design for the Bexhill Pavilion, which won the open competition of 1933, with T. S. Tait as assessor, is broadly and simply conceived, recalling the instant ideograms of Mendelsohn's earlier work.

Among the other MARS members practising before 1939, by far the most important was the group called 'Tecton', led by the Soviet Russian émigré, Berthold Lubetkin. Born in 1901, Lubetkin moved from Russia to Paris in 1922. There he completed his training and built an apartment block with Jean Ginsberg. In 1930 he moved to London, met Godfrey Samuel and was introduced by him to young architects who had recently graduated at the Architectural Association School. Lubetkin was a magnetic personality with a rare combination of intellectual ability and creative imagination, irresistibly attractive to his younger contemporaries. Through Solly (later Lord) Zuckerman he was commissioned by the London Zoo to build a house for two young gorillas. This was followed by the famous Penguin Pool, 1935, an oval water-holding enclosure in which two interlacing spirals provide the penguins with opportunities to exercise themselves in view of the public. The pool, moreover, was a witty demonstration of the shape-making capacities of reinforced concrete.

Tecton's next commission was for a six-storey block of luxury flats on an estate at Highgate. It was the first such building in London to be designed on strictly modern principles and with the freedom of plan facilitated by reinforced concrete construction. Thus the upper part of the building rests on *pilotis* (thin cylindrical piers or piles), round which the public rooms on the ground floor are freely planned. This block, 'High Point I', was followed by a second block on the same estate, 'High Point II', in 1938. In this Lubetkin moved from the diagrammatic character of the first block to something more deliberately formal, and with more than a hint of neo-classicism, even introducing copies of the Erectheion caryatids to support the canopied entrance. A sense of classical formality also characterises Tecton's last work before the war, the Finsbury Health Centre of 1938. It is combined here, however, with much originality in the use of new materials in unfamiliar patterns (see p. 245).

Notwithstanding these achievements, the modern movement had made very little headway in Britain by 1939 and there were no more than perhaps a dozen buildings which might be expected to interest a sophisticated foreign critic. Nor was there much in the way of critical writing. The best of it was in the *Architectural Review* which 'went modern' in lay-out, typography and content in 1929. Etchells had translated *Vers une Architecture* in 1927 and *Urbanisme* in 1929. Books on the modern house, by F. R. S. Yorke and Raymond McGrath, came out in 1934 but there was nothing in the nature of a printed manifesto of the new architectural outlook in Britain till the

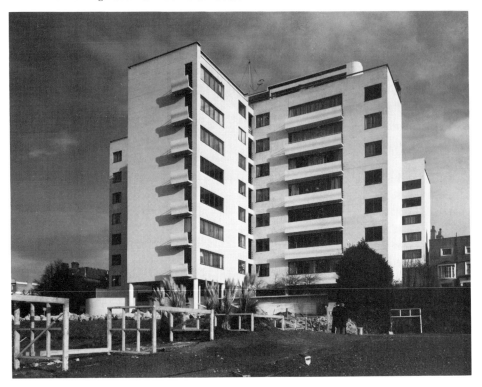

Highpoint, Highgate, London (1938). Berthold Lubetkin and Tecton.

publication of *Circle* in 1937. This was a miscellany of essays on painting, sculpture and architecture edited by J. L. (later Sir Leslie) Martin, the architect; Ben Nicholson, the painter; and Naum Gabo, the Constructivist sculptor, and included Le Corbusier, Gropius, Fry and Mendelsohn among the architect contributors. The theme of *Circle* was the theme of the decade: transition. 'A new cultural unity', declared the editorial, 'is slowly emerging out of the fundamental changes which are taking place in our present-day civilization'; and Martin, in an essay called 'The State of Transition', saw the position like this:

The aesthetic corresponding to the machine technique is no longer a matter for speculation. The new aesthetic exists in the motor-car and the aeroplane, in the steel bridge and the line of electric pylons. Its values . . . are the product of artistic selection.

Painters and sculptors, he maintained, were evolving a related vocabulary which would be another step in the transitional phase towards cultural unity or what Moholoy-Nagy, in a later book, called 'the New Vision'.

To students enetering the architectural schools in 1937–9 the feeling for the 'New Vision' was intense. It inspired a new sense of realism as well as a sharply critical attitude towards architectural education, an attitude which the students themselves articulated and pressed with some vigour. The gathering war-clouds and the events leading to September 1939 failed to subdue the

great tide of optimism and the conviction that a goal was in sight beyond which lay a wonderful future for the human race. The war years were a period of suspended crisis in the great transition. How the crisis resolved itself and what became of the New Vision are subjects outside the limits of this volume.

Finsbury Health Centre (1938). Tecton.

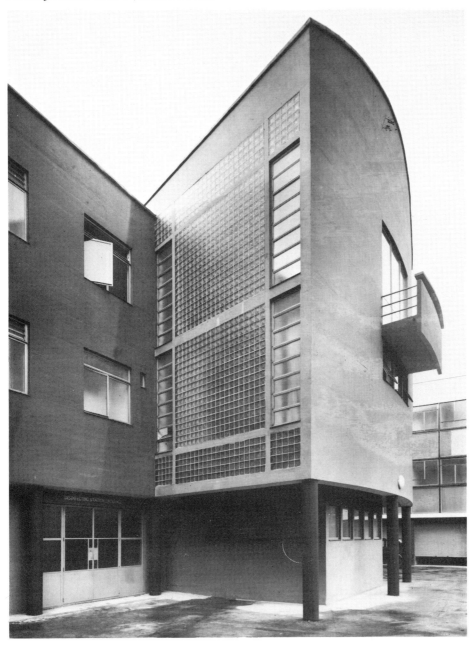

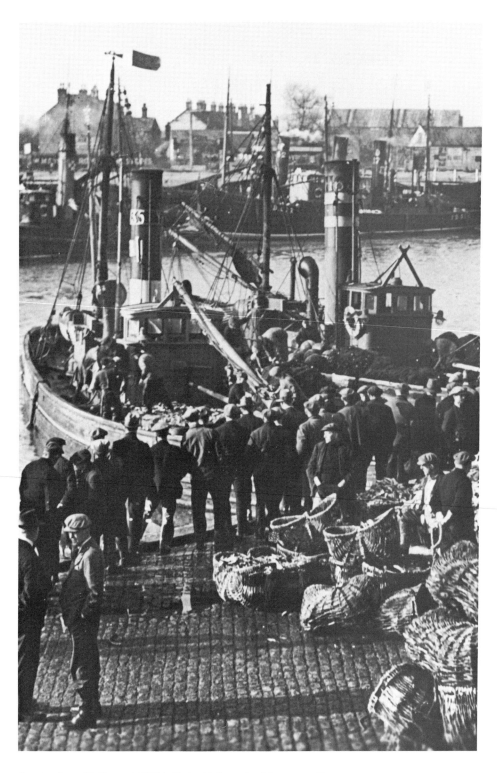

A scene from Drifters *(1929), John Grierson's debut as a director.*

7 Grierson and the Documentary Film

NEIL SINYARD

Introduction

Reviewing Robert Flaherty's film about the daily life of a Polynesian youth *Moana* in 1926, John Grierson remarked that it had 'documentary value'. He cannot have suspected that the word 'documentary' was to be as closely associated with his name throughout his career as 'suspense' was with Alfred Hitchcock. Grierson later came to see it as a clumsy term for what he had in mind but could not think of anything better. He had coined it from the word *documentaire*, which the French used to describe travelogues, but over the years Grierson was to propound and develop a conception of documentary that went far beyond mere travelogue.

Grierson's contribution to British documentary film has been described by critics and fellow film-makers in terms that make him sound like a cross between F. R. Leavis and Serge Diaghilev. Like Leavis in the field of literary criticism, Grierson was no theorist, but he was a profound moral force. He believed that the duty of film was to contribute to democracy through the promotion of international understanding and that its particular exploitable strength was its capacity to dramatise what he called 'the living scene and the living theme in the living present', in preference to escapist, acted stories artificially re-created in a studio. Like Diaghilev, Grierson was more creative administrator than creative artist, but with an extraordinary gift for infusing his disciples with his own documentary demon and for bringing out the best in his team of collaborators.

Grierson was born in Deanston in Scotland in 1898. His philosophical studies at Glasgow University were interrupted by the First World War, when he served on a Royal Navy minesweeper. The first strong indication of his future interest and involvement in films came when he accepted a Rockefeller Research Fellowship in 1924 and spent three years in America studying the effects of mass communications on public opinion. Returning to London in 1927, he secured an appointment as films officer to a government department, the Empire Marketing Board. Encouraged by their head of public relations,

Stephen Tallents, he set up his own film unit, recruiting such young directors as Basil Wright, Edgar Anstey and Harry Watt who were to become important figures in the documentary movement of the thirties. During this time, Grierson also directed his first and most famous film, *Drifters* (1929), a fifty-minute documentary about a trawler on a North Sea herring catch. Nowadays the film looks overlong and dated, but at the time it had considerable interest in its depiction of the working man, and Grierson later described it as a declaration of faith in the beauty of common life.

Drifters was first shown in a Film Society programme which included the first screening of Sergei Eisenstein's hitherto banned film, *Battleship Potemkin* (1925), which Grierson had first seen in America; indeed he had prepared the English titles for the film. The Soviet cinema of the 1920s had made a big impact on Grierson, as had Flaherty's *Nanook of the North* (1922). He had reservations about the revolutionary utopianism of Eisenstein and Pudovkin, and similar doubts about the nostalgic romanticism of Flaherty. (Something of the conflicting attitudes of Grierson and Flaherty to documentary is felt in the 1933 film they made together, *Industrial Britain*, which Grierson intended as a tribute to the working man and Flaherty saw more as an enquiry into the possibility of individual craftsmanship in an industrial age.) But from these three directors he saw the possibilities of film as a means of dignifying the common man, serving the national interest, and involving international audiences in ostensibly limited or esoteric themes. He was also enormously impressed by the technical skill of these film-makers in getting their message across.

The artistry of the craftsman is celebrated in this shot from Industrial Britain *(1933), made by John Grierson and Robert Flaherty for the* Empire Marketing Board.

When the Empire Marketing Board was dissolved in 1933, Stephen Tallents (now Sir Stephen) was appointed public relations officer of the General Post Office and one of his first acts was to bring Grierson and his whole film unit with him. Between 1934 and Grierson's departure in 1937, the GPO film unit was to make some of the most famous and highly regarded documentaries in the history of the cinema, including Alberto Cavalcanti's *Coal Face* (1935) and Harry Watt's *Night Mail* (1936).

During this time Grierson made clear the aim of his films in his writings. He believed in films that stressed theme and purpose more than art, and education more than entertainment. Art might sometimes be achieved in the process, but only probably because the purpose was educationally honourable and the technique energised by the scope of the theme. Documentary, he thought, was basically 'the creative treatment of actuality', and its uniqueness lay in its capacity to bring ordinary people and the spontaneity of ordinary life within the range of the film camera. Documentary could be a critique of political propaganda, revealing the reality behind the promises, but Grierson believed also in documentary as propaganda itself, extolling a vision of national identity and social cohesion.

Grierson made no bones about his desire to use cinema as a pulpit and as a vehicle for public education. In his own film criticism, this meant rejecting the majority of mainstream cinema. Looking at the erotic stylisation of Josef von Sternberg's studio-bound *Shanghai Express* (1932), Grierson could only compare it unfavourably with Sternberg's more realist earlier films and lament, in the famous aphorism: 'When a director dies, he becomes a photographer.' He stood at the opposite pole to Alexander Korda's enormously popular Imperialist fantasies, like *Sanders of the River* (1935) and *Elephant Boy* (1937); and Alfred Hitchcock's scintillating British thrillers like *The Man Who Knew Too Much* (1934) and *The Thirty-Nine Steps* (1935) were dismissed by him as 'the cinema of effects'.

Clearly, in a sense, Grierson was very much a figure of his time, an intellectual who wished to contribute to a national self-enquiry during an age of anxiety. Like many artists in the 1930s (and one should remember that W. H. Auden contributed the verses for *Night Mail* and Benjamin Britten the music) he was dismayed by the way the world was going and wished to champion a common humanity and enlarge the sympathies between nations in the face of the rising tide of Fascism. Like the writers involved with Mass Observation, he was fascinated by the minutiae of everyday life and wished to record them accurately and compassionately. (Humphrey Jennings' 1939 film for the GPO, *Spare Time*, was one of the documentary movement's key contributions to Mass Observation.) Like George Orwell in the 1930s (and there is much in common between *Coal Face* and *The Road to Wigan Pier*), Grierson saw himself as a combination of socialist and sociologist, without actually committing himself to a party line. But how effectively and coherently did the films fulfil Grierson's intentions?

One of the things that is most striking about the films now is their variety. They range from the rich exoticism of Basil Wright's *Song of Ceylon* (1934)

to the grim greyness of John Taylor's film about urban pollution *Smoke Menace* (1937). They include the experimentation of Len Lye's *Colour Box* (1935), which is ostensibly about new postal charges but is really a formal experiment with the technique of painting directly onto film negative; the poetry of Harry Watt's *Night Mail* (1936), which is superficially about the journey of the mail train from London to Glasgow but is actually an exquisite miniature on the theme of human communication; and the grittiness of Edgar Anstey's and Arthur Elton's *Housing Problems* (1935), in which the film experimented with the use of direct sound recording on location to enhance the impact of its exposure of appalling living conditions in parts of South London.

Film historians and even film-makers themselves have disagreed since over the nature and achievements of the 1930s documentary film movement. Some felt that the very variety of the films and Grierson's encouragement of offbeat talents like Flaherty, Lye, Norman McLaren and Richard Massingham are a lasting tribute to the flexibility of his standards. He was not too wedded to the concept of social realism to eliminate formal eccentricity and the kind of aesthetic experimentation with sound that particularly characterised the work of Alberto Cavalcanti in films like the 1934 *Pett and Pott* (which aimed to encourage people to use the telephone) and *Coal Face*. Others see this as a dilution of Grierson's social and propagandist polemics. For all his commitment to realism and public education, is he not, through his reliance on government and industrial sponsorship, limited in what he can say and show? How truthful are these films as a picture of the time? Where is Grierson's documentary on unemployment, for example?

It is true that many of the films date badly. Because of the commentaries and tone of voice, they never escape the impression of being middle-class perceptions of working-class life: sympathetic certainly, but also detached, inauthentic and with a hint of condescension. The film-maker Joris Ivens, who made the famous documentary on the Spanish Civil War, *The Spanish Earth* (1937) with narration by Ernest Hemingway, alluded to that criticism when he characterised the English documentary film movement as 'exotic dirt'. It is a similar criticism to the one that Richard Hoggart has made about Orwell's genteel slumming in *The Road to Wigan Pier*. Britain's foremost film fantasist, Michael Powell, contemptuously dismissed the documentary movement of this time as 'films by out-of-work poets'. John Mortimer thought the films were much less hard-hitting about their society than much of the Hollywood cinema which Grierson purported to despise (for example the fatalistic dramas of Fritz Lang, the moral comedies of Frank Capra, the gangster movies of Warner Brothers, and hard-hitting social protest films such as the 1932 classic, *I was a Fugitive from a Chain Gang*).

One must also wonder about the contemporary impact of the documentary film movement on the general public. Clearly this was limited, since distribution of the films was so limited. Grierson claimed that one of the successes of the movement was to widen film distribution into schools, libraries and film societies. This was undoubtedly true and indubitably valuable. Yet there is a certain irony connected with that achievement. Starting out as a form dedicated to public education and mass democracy, the

The slums of South London as revealed in Edgar Anstey's Housing Problems *(1935), one of the most socially concerned and grimly realistic of Grierson's documentaries.*

A shot from Alberto Cavalcanti's Pett and Pott *(1934), which gives a hint of Cavalcanti's more satirical and surreal attitude to documentary.*

documentary film became marginalised almost as the definitive example of British art film, which was only to be screened and savoured in draughty halls by the dedicated enthusiast.

In the end, Grierson's view of documentary was probably too simplistic. He miscalculated and even overrated the effect of cinema in an era when, with the spread of radio and television, mass communications were becoming much more diverse. In seeming to believe that an accurate cinematic portrait of the life of a nation was actually achievable, he lay himself open to the charge that he was implicitly endorsing the plainly fallacious view that the camera never lies. In seeming to assume that an honest, sympathetic portrait of life in one country would foster comradeship in another and contribute to international understanding, Grierson seemed at best optimistic and at worst naive. In Grierson's terms, documentary was an anti-romantic form that aimed to stress the interdependency of life, not the independence of the individual. Ironically, one of the results of that was that, although directors like Basil Wright, Harry Watt and Paul Rotha made fine films within Grierson's co-operative enterprise, few of them found success in the more cut-throat commercial cinema. The most successful was Cavalcanti, who had always thought documentary a silly term anyway. 'Films are the same, fictional or otherwise,' Cavalcanti thought, 'and all of them ought to go into cinemas'. His skill was to be brilliantly demonstrated in films such as *Went the Day Well?* (1942) and *Dead of Night* (1945).

Yet for all of the contradictions in the theory and aims of the documentary movement, one must not underestimate its contribution to British film culture nor decry Grierson's zeal and beneficial influence. It certainly gained increasing international prestige for the British cinema, and was a great influence on British films during the war period, which profited enormously from the documentary's pioneering balance between realism and propaganda. Perhaps most of all, it had a prodigious influence on critical attitudes to British film. Art in the British cinema has commonly been equated by the critics since with documentary verisimilitude and realism has invariably been held in higher regard than imagination.

In this regard, Grierson's influence has often been seen as limiting, whereas the truth is that this is a limited perception of what Grierson was actually advocating. For Grierson himself, documentary was a complex attempt to poeticise and politicise the working man, to democratise and decentralise public information, and, not least, to northernise the British cinema. (Traditionally British cinema had – and has – always seemed physically and temperamentally to operate mainly in the region of the Home Counties – when it did not, it was perceived as anomalous and strange.) Such an ambitious programme was probably doomed to failure, but his pioneering efforts were to be an example and inspiration for many future film-makers, including those associated with the 'New Wave' British cinema in the early 1960s (Lindsay Anderson, Tony Richardson, Karel Reisz, John Schlesinger). The Grierson legacy lives on most particularly in two of the finest examples of post-war British cinema – the Bill Douglas trilogy and Ken Loach's *Kes* (1969).

In his final article written before his death in 1972, Grierson reflected on

The London to Scotland train on its nightly run in Grierson's documentary, Night Mail *(1936). Although the direction is credited to Harry Watt and Basil Wright, Watt claims in his memoirs,* Don't Look at the Camera *(1974),'I directed every foot of the picture'.*

the achievements and failures of his documentary ideal. He recalled that documentary was a response to a growing social awareness in the 1930s to developments in technology, problems in international relationships, failures in social policy – themes that were not the province of the entertainment film. Although perhaps underestimating the compromises this involved in content, Grierson congratulated himself for finding financial support outside the film business in terms of sponsorship from Government and industry; and also he congratulated himself for finding an audience outside the cinemas. He acknowledged that television had now supplanted the documentary film in the provision of public enlightenment in one form or another, but he queried whether television documentary had ever matched the cinematic qualities of films like *The Song of Ceylon, Coal Face* or *Night Mail*. In Grierson's eyes, documentary was never just good journalism, and it might be that the cinematic virtues of his films have stood the test of time better than their social insights.

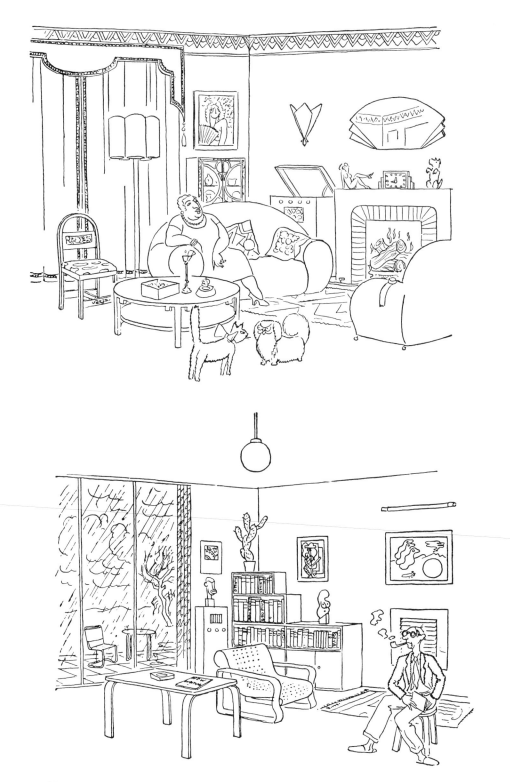

Top: 'Modernistic'; Bottom: 'Functional'; from Osbert Lancaster, Homes Sweet Homes *(1936).*

8 Design and Industry

GILLIAN NAYLOR

The legacy of the crafts

During the latter part of the nineteenth century, Britain's architects, designers and craftsmen had enjoyed an unprecedented prestige, in the United States as well as in Europe. It was, however, a prestige founded on ambiguities. Britain's economic strength was based on the ingenuity and invention of its industrial entrepreneurs, and sustained by expanding industrial production and world trade, the Empire supplying raw materials as well as captive markets. The majority of British architects and designers (as well as their clients), however, turned their backs on what they considered was ill-gotten wealth, sharing William Morris's conviction that 'art cannot have real life and growth under the present system of commercialism and profit mongering'. They created an aesthetic that was based on nostalgia, and they revived or invented vernacular and pre-industrial traditions of craftsmanship which had a wide appeal. These British achievements were acclaimed, in part because they represented a triumph of individualism and the celebration of vanishing skills and values, and in part because they demonstrated a commitment to social and humanitarian ideals. For British theory, it seemed, was as persuasive as British practice: the campaigns were conducted under the banner of a Utopian socialism, which condemned capitalism, factory production and Imperialism – those very forces which had created the wealth that sustained this latter-day renaissance of British craftsmanship.

By the turn of the century, however, the facade was cracking; Britain's status as a leading industrial nation was being challenged by the United States and by Germany, and at the same time the survivors and inheritors of the Arts and Crafts generation were questioning the validity, as well as the economics of their activities. C. R. Ashbee, for example, who had founded his Guild of Handicraft in London's East End in 1888, and who, following the spirit of Ruskinian teaching, had fled the town to re-establish the enterprise in the Cotswolds in 1902, had to admit failure and disband his 'little group of men' six years later. He blamed a recession, unfair

competition from amateurs and imitators, and the distance from London customers and commissions; subsequently, however, in his unpublished memoirs, he was to acknowledge the fundamental dilemma of Arts and Crafts idealism:

We have made of a great social movement, a narrow and tiresome little aristocracy working with great skill for the very rich.

At the same time, Thorstein Veblen, the pioneer American sociologist of conspicuous consumption and analyst of 'the physiognomy of goods', was also commenting on the cult of craftsmanship in his *Theory of the Leisure Class* (1899). 'Machine-made goods of daily use', he argued, were cheaper, more efficient and 'more perfect' than similar 'hand-wrought' goods. 'They are a more perfect product – show a more perfect adaptation of means to end'. Because they were cheap and 'perfect', however, they lacked prestige and status:

Hence it comes about that the visible imperfections of the hand-wrought goods, being honorific, are accounted marks of superiority in point of beauty, or serviceability, or both. Hence has arisen that exaltation of the defective, of which John Ruskin and William Morris were such eager spokesmen in their time; and on this ground their propaganda of crudity and wasted effort has been taken up and carried forward since their time. And hence also the propaganda for a return to handicraft and household industry.

(1953, p. 115)

For Veblen, then, the medium of the hand-made failed to convey the message of social reform implicit in the British celebration of craft traditions. Few other commentators were as radical (or as witty) as Veblen in their interpretation of this British phenomenon. Hermann Muthesius, however, who arrived in England in 1896 as an emissary of the Prussian Board of Trade, also had some shrewd observations to make in his book *Das Englische Haus* (published 1904–5 in Berlin in three volumes; English translation and adaptation 1976). Not that Muthesius set out to criticise: his brief was to report on 'the recent revival of the applied arts' in Britain:

The end of the nineteenth century saw the remarkable spectacle of a new departure in the tectonic arts that originated in England and spread across the whole field of our European culture. England . . . was pointing the way which the world was following.

Muthesius believed that the point of reference for this revival was the English house, especially the 'country' houses recently built (within commuting distance from large towns) for the affluent and cultured upper middle classes. Here one could celebrate the delights of English hospitality, and the English week-end: informality, relaxation, and tea and toast in timeless houses that seemed to fit their owners like a glove.

Nevertheless Muthesius did not allow the conviviality of his field studies to cloud his critical judgement, and he was perplexed by English furniture. He believed that while the owners of these houses could no longer countenance Victorian over-stuffed opulence, neither could they cope with what he described as 'the modern art' (or *art nouveau*). They therefore looked for inspiration to 'the only room in the house to which the artistic strivings of

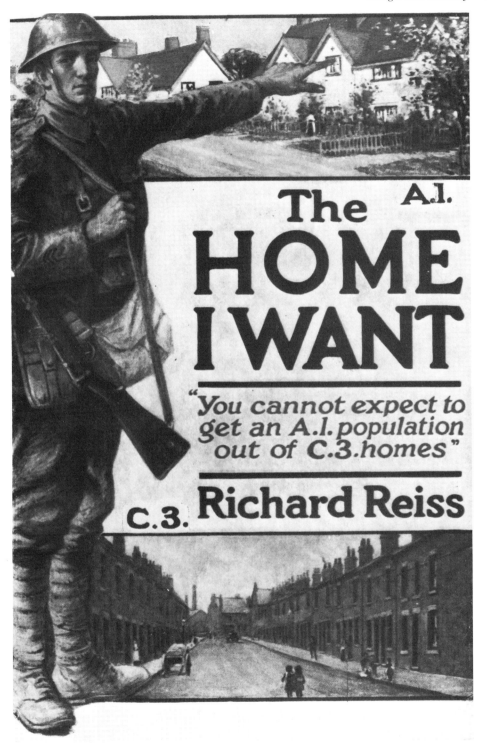

Front cover of the pamphlet Homes for Heroes *(1919).*

the time had not penetrated' – the kitchen. So their chairs were like kitchen chairs, their cupboards like kitchen cupboards – with one vital difference – they were very expensive.

To call [this furniture] modern would be an anachronism: it is reactionary. They have got so caught up in this ideal of handicraftsmanship that they have no ears for anything else . . . One searches for modern art, that is for pieces which will suit perfectly on modern conditions, and one finds rough jointed kitchen cupboards for which one is supposed to pay as many pounds as they would be worth in Thalers.

Muthesius's definition of modernity is interesting in that it is related to Continental rather than British conceptions of 'style'. The demand for a 'style' to match or mirror the spirit of the age was to be one of the major preoccupations of the European protagonists of modernism in the inter-war period. In England, however, although debates of this nature had taken place (especially among theorists associated with the Schools of Design in the 1850s), they lost credibility following the onslaughts of Ruskin and Morris, who, of course, associated 'modern conditions' with the dehumanisation implicit in factory life and factory conditions. Economic reality, nevertheless, had to be faced – a reality that Muthesius was well aware of – he was, after all, a trouble shooter for the Prussian Board of Trade. 'The curse which lies upon their products is one of economic impossibility' he wrote in *Das Englische Haus*. Like the majority of British designers and theorists whose work he was recording, Muthesius believed that design and architecture should be agents of social change. But like the Continental protagonists of the Modern Movement, he also believed that mass-production was a reality that could not be ignored, and that the techniques inherent in factory production should be acknowledged as determinants for form.

Although Muthesius's book had to wait some seventy years for an English translation, several British designers and theorists at the turn of the century were beginning to share his conviction that the craft ideal was no longer valid, either as the sole determinant for style and form, or as an expression of the 'spirit of the age'. W. R. Lethaby (1857–1931), who had worked in Norman Shaw's architectural office, and who was appointed first Principal of London's Central School of Arts and Crafts (in 1896), summed up current thinking in a lecture he gave to the Royal Institute of British Architects in 1910:

However desirable it may be to continue in the old ways or to revert to past types, it is, I feel, on reviewing the attempts, impossible. We have passed into a scientific age, and the old practical arts, produced instinctively, belong to an entirely different era.

As far as Lethaby was concerned, however, the rejection of 'the old ways' did not imply the rejection of the need for a coherent design philosophy, and in the same lecture he called for a 'method of design' that would be appropriate to modern needs and modern techniques:

The method of design, to a modern mind, can only be understood in the scientific or engineer's sense, as a definite analysis of possibilities – not as a vague poetic dealing with poetic matters, with derivative ideas of what looks domestic, or looks farm-like, or looks ecclesiastical – the dealing with a multitude of flavours . . .

For Lethaby, therefore, Arts and Crafts associationism had worn thin, and a new symbolism was needed to express the realities as well as the aspirations of the twentieth century.

Relating such concepts to practice, however, was beset with difficulties, on ideological as well as practical levels. In the first place, this essentially functionalist theory implied a total rejection of Arts and Crafts values, denying craft's role as a redemptive force in society as well as the individuality inherent in concepts of craftsmanship. Again, Lethaby's call for 'scientific method' in the approach to design problems was alien to traditional interpretations of the design process. Taken to their logical conclusion, Lethaby's (and Muthesius's) ideals could also imply a less creative role for the designer – form now being determined by materials and technique and the potentials of machinery. This shift of emphasis from the workshop to the factory also meant that previous patterns of patronage were no longer valid – designers and craftsmen would no longer be working for individual clients or for wealthy and selective patrons, but collaborating with industry to produce goods for a largely anonymous market. The emphasis in design reform, therefore, shifted from the individual to the commercial producer, from art and craft to design and industry.

This re-orientation in design reform polemics was acknowledged by the formation of the Design and Industries Association in London in 1915, its model being the *Deutscher Werkbund*, an association of artists, manufacturers, designers and tradesmen which had been founded – largely at Muthesius's instigation – in Munich in 1907 to promote the 'best in art, industry, craftsmanship and trade'. But whereas the German enterprise had a strong tradition of industrial rationalisation and co-ordination to draw on, its English equivalent set out, in the early years at least, to relate the craft ethic and aesthetic to industrial production. For Lethaby, who gave his support to the new association, this made all too simple sense. As he maintained in a speech to launch the association, the manufacturer must often puzzle over what will sell,

and indeed it must be a maddening problem; but let him rather recast the question into 'What is good, what is the best that can be done at a given price?' and the question of design will at once be simplified, if not solved.

There is, of course, a gulf between the ideal of what is good and the reality of what will sell, and 'the question of design' was neither solved nor simplified in the inter-war period. Politics as well as economics could no longer be ignored, and design reform lobbies tended to polarise into two main factions: government sponsored or approved campaigns to improve standards for economic as well as ideological reasons, and the avant-garde (architects and painters) whose aim was to promote more radical ideologies.

The concept of a cultural avant-garde in design and architecture is, of course, essentially a twentieth-century phenomenon. For although many of the Arts and Crafts designers were radical in their politics, their approach to design was essentially conservative. They were campaigning for the re-establishment of a tradition in design which they believed had been shattered by industrialisation and mechanisation, and their work was a comment on the nature of work.

To many radical design reformers in the twentieth century, however, art (or more specifically abstract art) replaced craft as the ideal determinant for form, and the abstract artist was considered the pioneer of the 'new vision' that this shift of emphasis implied. These ideas were essentially Continental in origin, and they were formulated by campaigners for 'modernism' in France, Holland, Germany and Russia in the years immediately following the First World War, when what remained of the old order was challenged by social and political revolutions as well as by economic distress. England was slow to respond to these ideologies and the radicalism they implied, although Roger Fry's Omega Workshops might be described as unorthodox precursors of these Continental campaigns for an intellectual and aesthetic modernism. Roger Fry, sickened by the death throes of the Arts and Crafts movement, and 'the hideous muddle-headed sentimentality of the English – wanting to mix an elevated moral feeling with everything', set up the Omega Workshops in 1913. Bloomsbury group artists were involved, including Duncan Grant and Vanessa Bell – their work was anonymous – and the aim was to promote 'a new movement in decorative art'. The Workshops closed, due to the War and lack of funds in 1919, although the painters continued to involve themselves in projects for industry, especially ceramics and carpets.

The Omega experiment, however idiosyncratic and eccentric it may have seemed to the design establishment in Britain, is nevertheless significant because of its celebration of art at the expense of craft. The Omega designers never considered themselves makers in the Arts and Crafts sense: they transformed everyday objects by painting on them, or by the literal reproduction of their paintings as textiles, screens, etc. Craftsmanship and concern for the nature of materials and concepts of 'fitness' were certainly not their primary concern; the group, according to Fry, was attempting to introduce 'the spirit of fun into furniture and fabrics'. At the same time, however, Fry saw Omega as celebrating the unity of art and design, a unity which he believed had been destroyed by what he described as the 'photographic vision of the nineteenth century', which had inhibited the appreciation of pure form.

The modernist aesthetic was also concerned with form: unlike Fry, however, the continental pioneers of modernism rejected the past, and campaigned for a cultural transformation that was to be demonstrated by the universalising tendancies of both art and industry. Such claims for art, however, were alien to British theory, at least in the years leading up to the First World War, and it was during this period that 'design', in British polemics, began to carry the social and moral connotations once associated with 'craft', associations that were now related to industrial production.

British industry, therefore, was now charged with the demonstration of the humanistic values once associated with craftsmanship, and manufacturers as well as consumers were exhorted to appreciate the values (economic as well as ethical) of 'good design'. But although now focused on industry, the design reformers' crusades were still based on the Ruskinian assumption that it was the manufacturer's duty 'to form the market, as much as to supply it'. (The quotation comes from Ruskin's address to manufacturers in Bradford in 1859, which was published in his seminal *The Two Paths* and reprinted by

the Design and Industries Association in 1917.) The inter-war period, therefore, was characterised by campaigns to improve standards of design in industry, to educate public taste and to institutionalise 'good design' in Britain. Predictably enough, however, it was the small-scale producers rather than the large manufacturing enterprises who rallied to the cause. Founders, or early members of the DIA, for example, included Ambrose Heal, the designer/retailer (under his direction the shop in the Tottenham Court Road was dedicated to the sale of 'reasonable' furniture), Harry Peach, who had founded Dryad to sell moderately priced cane furniture, and Harold Stabler, who although trained as a silversmith was a partner in Carter, Stabler and Adams (better known as Poole Pottery).

Rather than aiming for 'modernism', however, these enterprises tended to demonstrate the continuation of the craft tradition in the work they produced; paradoxically, this was particularly true of newly founded or newly structured firms like Heals and Dryad, and the furniture workshops established by the Russells in Broadway in the Cotswolds. The story of the Russells' approach to furniture design and production is frequently used as a 'case study' to demonstrate what Nikolaus Pevsner described as the 'patient progress' towards rational design. The workshops were first established to conserve and renovate antique furniture for the Lygon Arms, a coaching inn in Broadway bought at the turn of the century by the Russell brothers' father in the well-founded anticipation of an increased tourist trade, particularly from America. After the First World War when Gordon (later Sir Gordon) Russell (1892–1980) returned from the front, he began designing and making rather than restoring furniture, and his brother, R. D. Russell, went to train

Benjamin Fletcher: cane restaurant suite, made by Dryad, Leicester; proprietor Harry Peach (from c.1912).

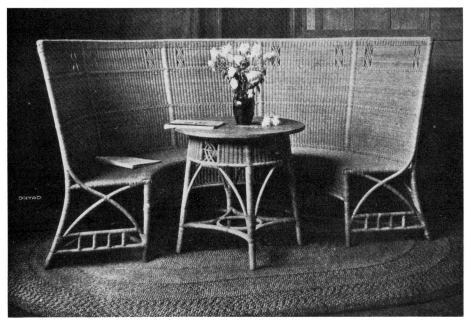

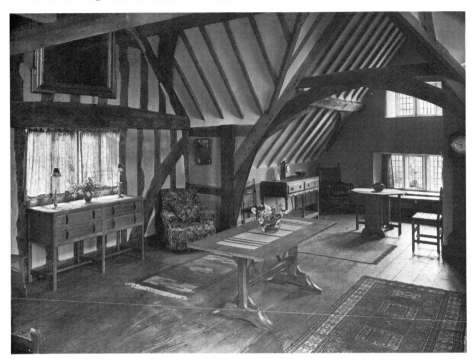

Gordon Russell furniture, at the Gordon Russell Workshops, Broadway, Worcestershire (1920s).

as an architect at the Architectural Association in London. Throughout the twenties the brothers worked with local craftsmen to produce 'one-off' designs in the Broadway Workshops. Gradually, however, machine techniques were introduced, and the use of machines to produce components for furniture was accelerated after Gordon Russell was asked to design a range of low-cost radio cabinets for Murphy Radios in 1930. This collaboration, according to Nikolaus Pevsner (1920–83),

resulted in great benefits to both sides, to Murphy's because they got the best wooden radio cabinets then existing in any country in the world, to Gordon Russell's because they learned what real engineering precision meant and how the most intelligent use could be made of machinery.

Activities of this sort were supported not only by Pevsner, who was to become one of the most influential commentators on British design and architecture in the inter-war period, but also by a small coterie of writers and theorists including John Gloag (editor of *The Cabinet Maker*, and a prolific writer), Anthony Bertram and Noel Carrington. To these crusaders, the Russells' achievements, both in radio and furniture design, provided an object lesson in how to relate the humanistic values of craft to quantity production, and it was perhaps inevitable that when the 'Utility' scheme was launched in 1942, Gordon Russell would be asked to supervise the production of 'Utility' furniture, and again, when the Council of Industrial Design (the culmination of all these inter-war efforts) was set up by the Board of Trade in 1944, that he would be appointed its first director.

Most 'progress' in design in the inter-war years, therefore, was mainly achieved by individuals who had the personality and the power to control and direct the enterprises associated with them: Frank Pick's work for London Transport, for example, the Anderson family's for the Orient Line, Jack Beddington's campaigns for Shell Advertising, and Raymond McGrath's work for the BBC. These new forms of patronage provided a foothold for the newly emerging design profession. Shell and London Transport legitimised the activities of the 'commercial artist'; the Orient Line attempted to revitalise the role of the interior designer, and the BBC supported these activities, not only in broadcasts, but in the design and furnishing of its new headquarters in Langham Place.

In spite of these well-intentioned efforts, however, many British manufacturers in the inter-war period remained impervious to the design reformers' crusades, which, it was felt, never faced up to the practical problems facing industry. W. F. Crittall, for example, an 'enlightened' manufacturer producing metal framed windows, summarised these preoccupations in letters to *The Cabinet Maker* in 1932:

To the manufacturer design goes much deeper than form or colour. It embraces such things as probable demand; what the public will pay; the cost of production; competitors' prices and designs; selection and cost of materials; machining methods; operation costs; transport, etc.

(2 Jan., 1932)

There can be no doubt that if art is to enter into a genuine alliance with industry, and not merely take up an attitude of tolerant and pitying superiority with regard to its members, there must be a far more genuine understanding of industry's requirements than exists at the moment.

(20 Jan., 1932)

The dilemmas of design in the twenties

Crittall's comments to the *Cabinet Maker* sum up the dilemmas facing British industry throughout the twenties. For while the design reform lobbies continued to insist on the relevance of Arts and Crafts values to industrial production, industry in Britain, especially the consumer goods industries, were faced with unprecedented problems and challenges. In the early twenties, these were related to post-war reconstruction programmes: the building and furnishing of homes fit for heroes at prices the heroes could afford – demands that did not diminish with the economic crises of the late twenties, since the recession created new patterns of production and consumption which industry had to acknowledge in order to survive. Throughout the inter-war period, therefore, economic realities were challenging the assumptions, as well as the values, of the crusaders for 'good design'.

During and immediately after the war, Britain, like most European countries, was involved in plans for social as well as economic 'reconstruction'. (Reconstruction, according to a British War Cabinet report of 1917, was 'not so much a question of rebuilding society as it was before

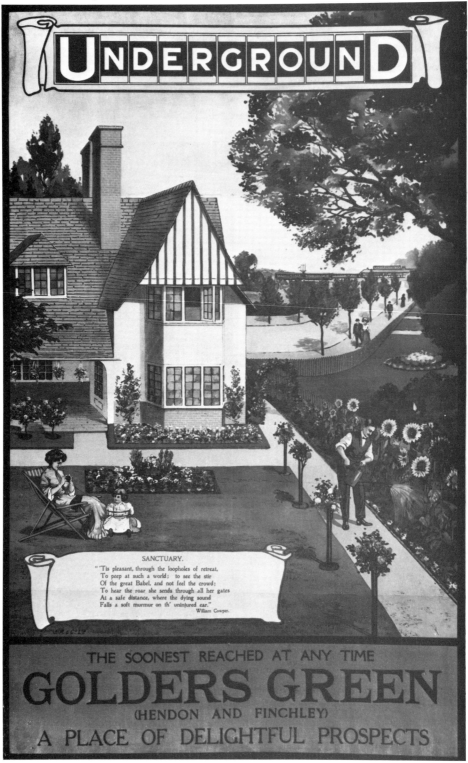

London Transport poster (1908).

the war, but of moulding a better world out of the social and economic conditions that have come into being during the war'). The priorities, of course, were health and housing – related problems that required urgent solutions. Between the wars, over a million new houses were built by local authorities, and when mortgage interest rates fell in the 1930s, there was also a boom in private house building. So as well as the subsidised 'homes for heroes', home ownership, which was rare before the war, also increased rapidly in the inter-war period, both developments involving new demands for furniture, furnishing and household equipment.

To the design reform lobbies, therefore, the possibility of 'moulding a better world' at last seemed achievable. The problem now lay in persuading the new householders, as well as the manufacturers supplying them, of the moral, as well as the economic value of 'good design'. For the public, it seemed, preferred the trivial to the timeless, and industry was all too ready to meet these spurious needs. As A. Clutton Brock wrote in a DIA pamphlet in 1916,

If only they [the public] could be persuaded that plain things are the most beautiful, they would see for themselves that they are far more beautiful than most of the ornamented things, from fire irons up to grand hotels with which their taste has been depraved.

Four years later, Lethaby (describing housing as 'the necessary preliminary "plant" and "capital" for our national life') was complaining about 'extravagant expenditure on the worthless; the lowering of our demands to a penny picture post-card level; overcrowding with trivialities and worse'.

The solution of the problem, or so it seemed, lay in education, in schools as well as in art colleges, in industry as well as in the home, so that designers, manufacturers and consumers would share a collective ideal of 'taste'. As early as 1914 (the year before the Design and Industries Association was founded), the Board of Trade and the Board of Education collaborated to establish a British Institute of Industrial Art, with aims similar to those of the DIA, and a brief to promote these ideals through exhibitions. Its inauguration was postponed because of the war, and it was finally launched, with a small Treasury grant, in 1920, under the chairmanship of Sir Hubert Llewellyn Smith. The Institute opened a gallery in Knightsbridge, London, for exhibitions of 'industrial art and handicraft', and although the grant was withdrawn in 1921 for economic reasons, the BIIA continued to exhibit in London and the provinces until the early thirties. Exhibitions included 'Modern Crafts and Manufactures' (1920), 'Present Day Industrial Art' (1922), 'Industrial Art of Today' (1923), and 'Industrial Art for the Slender Purse' (1929). The activities of the BIIA were also strengthened in 1921 by the Federation of British Industries' formation of an Industrial Art Committee – a committee composed of manufacturers and industrialists – to advice on design policy as well as design education. In 1924 a Register and Employment Bureau for designers was also set up, in order to establish practical links between designers and industry.

During the 1920s, however, the emphasis, especially in the BIIA exhibitions, was on craft, and craft-based activities, so much so, that to some

observers they presented a sense of unreality or *déjà-vu*. Reviewing 'Industrial Art of Today' (which was sponsored by the DIA as well as the BIIA), a commentator for the *Cabinet Maker* wrote:

Neither the good taste, nor the skill of the British craftsman has ever been in doubt, and an exhibition which merely points out how excellent hand-made things may be, while full of interest, does not go to the root of the matter.

'The root of the matter', of course, lay in cost, as well as the changing nature of British industry and the British market. The *Cabinet Maker*'s reaction to the 'Industrial Art for the Slender Purse' is again worth noting:

They should realise that the number of those who really want to furnish very plainly and live the simple life suggested by simple surroundings is very limited indeed. From a trade point of view they are of small importance compared with the immense majority whose conceptions of furnishing are pictorial rather than plain, and whose aspirations are in the direction of the picture palace rather than the craftsman's cottage.

This was in 1929, the year of the Wall Street Crash, which confirmed the instability of Britain's industrial base. Industries such as coal, textiles, steel and ship-building were in decline, unemployment reached three million in 1932, and the once thriving industrial regions in Scotland, Wales, Lancashire, West Yorkshire and the North East were designated 'depressed areas'. The bleak decline of these former 'staple' industries, however, was to a certain extent counter-balanced by the growth of new ones – the automobile industry, for example, the electrical and chemical industries, and by the rapid expansion of the building industry. An average of 345,000 new houses were built annually from 1933 to 1937; towns like Leicester and Coventry expanded, and 'ribbon development' extended the London suburbs into the Home Counties, with associated improvements in transport and in trade. As far as the domestic market was concerned, therefore, the 'ideal home' was now located in the new suburbs, 'Merrie England' only surviving in the speculative builders' Mock tudor – 'bypass variegated', as Osbert Lancaster was to describe it, in advertising, which tended to stress the rural rather than the urban delights of life in the new suburbs, and in British promotions of British design.

Design and domesticity

Possibilities for a new life style, however, were genuine in this period. The introduction and expansion of hire purchase schemes meant more buying power; the travel, entertainment and associated industries and services enjoyed unprecedented expansion, and traditional concepts of domesticity were transformed by revolutions in methods of cooking, cleaning and heating, the housewife now relying on appliances, rather than servants (or elbow grease) for household help.

This radical transformation, of course, was achieved through the introduction of electricity into the home. In 1918 only six per cent of British houses were wired for electricity, but its use became more widespread (and

less expensive) in the late twenties and early thirties with the establishment of the National Grid, which stimulated a demand for associated new products – cookers, washing machines, irons, toasters, vacuum cleaners, etc. The design of some of these appliances was based on American precedent (the Hoover factory on the Great West Road, built between 1932 and 1938, symbolising the triumph as well as the expansion of the new technology). Again, it was American *theory* that transformed the housewife into home manager, the kitchen becoming the laboratory for the demonstration of the new 'domestic science'. (Mrs Christine Frederick's *Scientific Management in the Home*, which related time and motion studies used for factory and office work to household tasks, was published in the USA in 1915, and was available in England in 1922.) Work of this kind implied a new domestic order, and challenged traditional concepts of 'Good Housekeeping', the 'scientific' approach to household tasks offering the housewife managerial status as well as control.

In the twenties and early thirties, however, it was difficult to relate these ideals to reality, since the equipment for these new 'laboratories' – cookers, washing machines, boilers, etc., remained cumbersome, grotesque and awkward, in no way aspiring to the concepts of efficiency and modernity that industry and advertising, as well as ideology, was attempting to promote. It was some time before improvements in metal technology and manufacturing techniques enabled manufacturers to produce more efficient, less eccentric and above all less expensive products. MOreover, since the design of these products was related to engineering, rather than craft techniques, it is hardly surprising that few designers were involved in their appearance or 'styling' in the twenties, or that this type of equipment is scarcely mentioned in the literature of design reform until the mid-thirties. Nikolaus Pevsner's seminal

The original Hoover Vacuum Cleaner, Model O (1907).

Hoover Junior 370 (1934).

Thor Electric Washing Machine (1924). *Ferranti Panel Fire (1929–30).*

An Enquiry into Industrial Art in England, published in 1937, does not mention gas or electric cookers – although illustrations of one solid fuel cooker and a solid fuel stove are included, and it was not until the mid-thirties that cookers were exhibited in British displays of 'industrial art'.

Attitudes to the furnishing and furbishing of the remainder of the house were more ambiguous, for it was here, where in theory the collaboration between designer and industry could have most impact, that the lamentable passion for the seemingly tasteless and trivial continued to triumph. The alternatives demonstrated by the would-be 'taste-makers', on the other hand, were too restrained and at the same time too expensive to have any great appeal to the growing market for consumer goods. In 1925, for example, when the French organised their prestigious exhibition of decorative arts – the criteria for selection being modernity and modernism – the British Department of Overseas Trade presented an Arts and Crafts inspired exhibit, designed by the architects Easton and Robertson, with heraldic decorations by Henry Wilson. Exhibits included work by Gordon Russell, Heal & Son and Edward Barnsley. In terms of quality and craftsmanship, their work could not be faulted, but it lacked the panache and the unashamed luxury and elitism of the majority of the French exhibits, which according to a book on interior decoration published in London in 1926, demonstrated

the ingenuity of the designer and the wealth of the purchaser . . . There were rooms for dancing, but none for reading, rooms for cocktails but none for breakfast, rooms for undressing, but none for sleeping.

To the French on the other hand, the British pavilion was a source of amazement and amusement:

'Why the motley-coloured plaster, the glass steeple with the galleon perched on it like a weathercock?' a French critic asked. 'Is this all old Albion can bring us? A fantasy created in an opium den by a retired Colonel?' I put these questions to the Secretary-General of the British Section. 'As our pavilion', he replied, 'is sited on the banks of

the Seine we have given it the stylised form of a boat to emphasise our naval power and our decorative additions have been inspired by our traditions of heraldry. Our architects have complied with the regulations of the exhibition with something new and original.' Such a disarming reply obliges one to tolerate the British pavilion as one does a highly coloured Christmas card.

(Martin Battersby, *The Decorative Twenties*, 1969, p. 149)

Needless to say the 'Christmas card' image continued to surface in British presentations in trade fairs and exhibitions throughout the twenties and the thirties, as well as in the nostalgic furnishing of 'Dunroamin' – 'Jacobean' furniture and fabrics, for example, panelled rooms, with the ubiquitous Tudor galleon carved on wardrobes, stamped in brass and copper, and emblazoned in coloured glass for the front door.

The designer as decorator

At the same time, however, the 'modernity' of French decorative design in the twenties offered a persuasive alternative to British nostalgia. For the French never totally abandoned their beaux arts (or academic) traditions in design and architecture. Ideals of the vernacular played no part in their essentially urban and urbane conceptions of craftsmanship, and in spite of the revolutions of the eighteenth and nineteenth centuries, the traditions of 'Royal' patronage were sustained in furniture, ceramics and textile design. The innovations of the twenties evolved rather than deviated from these traditions to meet the demands of a rich and élitist market: the beau monde who entertained, travelled, patronised the theatre (and the cinema) and above all the new luxury shops or boutiques selling fashion and all the accessories of fashion – from perfume to interior decor.

The British, of course, could never totally emulate the French in these delightful demonstrations of conspicuous consumption: they had neither the market nor the craftsmen. But in spite of the preference for period styles at all levels of society, there was some demand, among the rich and the fashionable, for a more appropriate decor to match their lifestyles. The new (and often very lucrative) profession of 'interior decoration' was established in England in the twenties, initiated by society hostesses (Lady Sybil Colefax, for example, and Syrie Maugham, 1879–1955) whose 'flair' for decoration was demonstrated in their own homes, and who set up business in order to professionalise their talents. The style and expertise of Syrie Maugham (the wife of Somerset Maugham) became apparent in the early twenties when she furnished the Villa Eliza, their house in fashionable Le Touquet, with such élan and sophistication that she was inundated with requests for advice. She opened her decorator's shop in Baker Street in 1922, moving upmarket to Grosvenor Square two years later. Her tour de force, however, was her house in Chelsea, which she furnished throughout in shades of white.

The skill of these 'hostess' decorators lay in their ability to create an appropriate ambience for their friends and clients. They were innovators in their use of colour and texture, in the dramatic placing of a vase or a painting, and in subtleties of lighting, but they rarely commissioned or

Syrie Maugham: all-white drawing room with mirror screen (1933).

designed anything radically new. If an appropriate piece was lacking in a suite of furniture (usually eighteenth-century), a design might be made to complement the range, just as fabrics could be commissioned in appropriate materials and colourways.

Nevertheless, this work for private clients did enable some young designers to become established. Marion Dorn (1899–1964), for example, who came to England in the early twenties, and who was to specialise in fabric and carpet design, received one of her first major commissions from Syrie Maugham when she was asked to design and make the living room carpet for the Chelsea house. Dorothy Todd, writing for the *Architectural Review* in October 1932, and describing Marion Dorn as an 'architect of floors', saw

this masterpiece being made: 'She has had about 500 shades specially dyed; for instance I noted some six different tones of white and cream, three blacks and literally dozens of beiges, browns and greys.' Subsequent Dorn clients were to include Arnold Bennett, Diana Wynyard and Kenneth (later Sir Kenneth) Clark. Her most prestigious commission (for a client, rather than for industry) came in 1932 when she was asked to produce carpets for Claridges, parts of which were being redesigned by Oswald P. Milne.

Claridges was one of the many hotels that were built, rebuilt or updated in the early thirties to meet the demands of an increasingly cosmopolitan clientele. The Savoy, Claridges' sister hotel (both belonged to the d'Oyly Carte family) was renovated at the same time, no doubt to compete with the rival attractions of the ultra-modern Strand Palace which had opened across the street in 1930. The Cumberland Hotel off Oxford Street was refurbished in 1933, and the magnificent new Midland Hotel in Morecambe was also opened that year. At the same time the great ocean liners – those 'floating marvels of luxury and speed' were rivalling the new hotels in comfort and dazzling decor, their construction bringing work to the shipyards, and their furnishing involving teams of designers as well as lucrative and prestigious orders for the contractors and the furnishing industries. The Cunard Line's *Queen Mary*, partly government financed, crossed the Atlantic for the first time in 1936, and Sir Colin Anderson's S.S. *Orion* made its maiden voyage to Australia in 1935.

Oliver P. Bernard: foyer of the Strand Palace Hotel, London (1930).

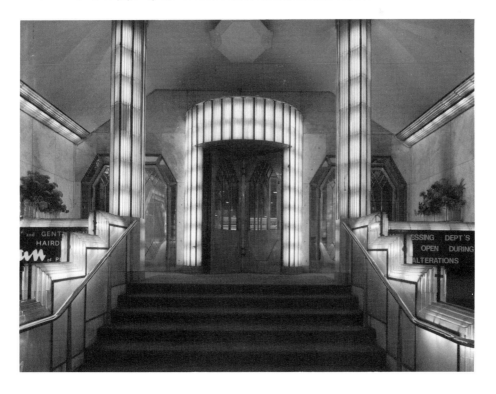

The designers and architects involved in the hotel commissions did not attempt to recreate the glories of Tudorbethan times. The majority used new materials and techniques to fashion opulent environments for their transient clients – *décors de luxe* that were part Parisian, part Hollywood in inspiration. Moreover commissions such as these professionalised the role of the interior designer as a co-ordinator of excellence – responsible for every detail from murals to tea cups and door knobs. It is hardly surprising, therefore, that Oliver Bernard (1881–1939), who designed interiors for the Cumberland, Strand Palace and Regent Palace Hotels, as well as Lyons Corner Houses and Snack Bars, was a stage-set designer in America and England (designing *inter alia* sets for Drury Lane) before he began to work as an interior designer. He brought this eclecticism and his ability to create fantasies to these new commissions. The foyer of the Strand Palace Hotel, for example, was a filmset creation in marble, steel and glass, with a sweeping staircase fit for 'stars'. Shoppers and office workers were also given star treatment in the Lyons Cornerhouses. Bernard's former secretary, Eileen Parker, described him as 'an arch innovator – seeing new possibilities in traditional materials as well as in new ones'.

He could be very amusing, utterly impossible – kind and a bully. He could, and did, strike terror into the hearts of the contractors, reducing some of them to tears, but he would suddenly forget it all and become impish and human. Yet out of all this came superb drawings, unique ideas crystallised and foundations were laid for work which had never hitherto been attempted, including the stunning entrance in glass, steel and lights of the Strand Palace Hotel and the wonderful marble murals in the Coventry Street Cornerhouse featuring fabulous landscapes of forest and waterfall fashioned largely from the natural marking of the marble specially selected on site by OPB in the Italian quarries.

(Eileen Parker, 'Working for Oliver Bernard in the early days of Pel Ltd.)

Oliver Hill (1887–1968), Bernard's contemporary, was equally eclectic. Unlike Bernard he was trained as an architect (with William Flockhart and at the Architectural Association in London), but like so many aspiring young architects in the Depression, he first established his reputation as an interior decorator (working on Syrie Maugham's house in Le Touquet) and then as an architect to the rich and fashionable. For them he designed houses in a variety of styles – 'modern', Georgian, craft revival, or what Osbert Lancaster called 'pseudish' – he was able, as one commentator has written 'to put a stamp of luxury on all his buildings, but with a sensitivity carrying them clear of the merely flashy or tawdry'.

In the thirties he completed several major commissions, including the Midland Hotel at Morecambe, with work by Eric Gill, Eric Ravilous, Marion Dorn and Duncan Grant. Hill designed every detail, including the grand piano and the plugs for the washroom (which *Country Life* proclaimed 'adorable'), although his insistence that coloured towels should be provided in the bathrooms shocked his conventional clients: 'I am not satisfied that the clientele we are likely to get at Morecambe will appreciate too much of this kind of idea', wrote a spokesman for the London Midland and Scottish Railway Hotel Services. 'We must not be too influenced by what is done in what I may call the more artistic circles of London. Do not let us get too

"precious".' To which Hill replied by return: 'As far as I am concerned, there is no chance of the hotel and its furnishings being "precious" . . . we have a unique opportunity of providing something worthy, without being in the least metreticious or precious.'

Hill also became a quasi-official designer of British exhibitions in the thirties, designing the Dorland Hall exhibition of British Industrial Art in 1933, the Contemporary Industrial Art in the Home exhibition in 1934, and the British Pavilion for the Paris International Exhibition of 1937. But in spite of (or perhaps because of) this work for the fashionable as well as the Board of Trade, Hill was not invited to join the Modern Architecture Research Group (MARS) when it was instigated in 1933, Wells Coates, one of the founder members, maintaining that 'certain people . . . popularly and notoriously known as "modern" architects . . . do not qualify in our sense'.

Patrons as pioneers

The grand hotels and the Cornerhouses, no doubt because their 'glamour' could be associated with elitism or frivolity, could scarcely serve as models for twentieth-century design reform. There were several patrons in the inter-war period, however, who demonstrated policies and standards that were acceptable to the reformers, and one of the first of these was Frank Pick of London Transport.

Frank Pick (1878–1941) had joined London Transport in 1906; he was appointed Traffic Development Officer for London Underground in 1909, and then Commercial Manager in 1912. As Commercial Manager, Pick was given a free hand to formulate his own promotional policies. He began by commissioning posters to advertise the services and the delights of London Transport, and by rationalising the lettering (station signs, direction signs, etc.) associated with the organisation. During the War, he asked Edward Johnston, a disciple of William Morris then teaching calligraphy and lettering at the Central School of Arts and Crafts, to design him a type-face for use throughout London Transport. Johnston was reluctant, at first, to undertake the commission (true to his Arts and Crafts principles he believed that the design of type-faces was the responsibility of the punch-cutter), but once persuaded he worked painstakingly to produce the now familiar letter-forms. These were first introduced in 1916, together with the circle symbol for the station names. After the War, Pick assumed control of the design and architectural policy throughout London Transport; he commissioned the architect Charles Holden to design the new stations as well as LT's headquarters, and he also invited avant-garde artists to design posters. Paul Nash, for example, produced posters for the Underground, and the most successful and consistent designs were the work of Edward McKnight Kauffer, a young American painter who came to London in 1914 (after working in Munich and Paris) and established himself as a pioneer graphic designer with his bold, mainly abstract designs.

London Transport, therefore, set a precedent in demonstrating how one organisation could achieve a 'corporate identity', unifying all its activities

from design and architecture to communication; it needed the strength and determination of one man, however, to set all this in motion.

Colin (later Sir Colin) Anderson of the Orient Line was another such committed and determined patron of 'modern' design when he joined the family shipping firm in 1930. This was when plans for a new liner, the *Orion*, were being discussed, and Sir Colin was determined from the outset that the new ship should not be yet another 'floating hotel'. (His father had, in fact, been associated with the DIA since its inception, so that Sir Colin's convictions obviously had some support.) Sir Colin commissioned Brian O'Rorke (1901–74), then a virtually unknown young architect from New Zealand, to co-ordinate the interiors of the ship, and both had to start from scratch to define and establish their ideal of the 'ship-shape'. Sir Colin was later to write:

There was no Council of Industrial Design at that date, and therefore no Design Centre. It would be hard to exaggerate the difficulties we met in the prevailing proud and successful industries, that not a single object in their entire output was acceptable for a modern ship interior. How could we even explain to them what we meant by such an interior? We found ourselves having to discover designers capable of producing new designs for a wide range of products from carpets to cutlery who understood what it was we were after. And this was not at all easy, for there were no such people as industrial designers; there were a few artist designers if one knew where to find them.

(*Architectural Review*, 1967, Vol. 141, p. 451)

The designers involved in the *Orion* were subsequently to become familiar names: Keith Murray (also from New Zealand, who was to work as both designer and architect for Wedgwood) designed the china and glass; Marion Dorn and McKnight Kauffer (now partners) were sub-contracted to produce carpets and curtains; McKnight Kauffer also designed an engraved glass mural for the dining room, as well as a range of printed material (including luggage labels). Gordon Russell was also involved, although Brian O'Rorke designed most of the furniture.

Perhaps the most surprising of these pioneer patrons of 'modern' design, however, was that bastion of British culture and tradition, the BBC. Broadcasting House, the new headquarters in Langham Place, was built between 1928 and 1932, and Raymond McGrath (1903–77) an Australian-born architect, was put in charge of the BBC Studio Design Committee in 1929. He commissioned Serge Chermayeff (born in the Caucasus) and Wells Coates (from Canada) to work with him. Chermayeff (b. 1900) was responsible for the orchestral and talks studios, Wells Coates (1895–1958) designed the special effects, news and gramophone studios, while McGrath worked on the dance music and chamber music studios. Edward Maufe, a traditionalist, was given the delicate task of designing the religious talks studio.

The designers, of course, had to comply with acoustic standards laid down by the sound engineers, and at the same time they had to create a relaxing but not too informal environment for the performers, most of whom were required to broadcast in full evening dress. It is significant, however, that the designers involved in this commission were virtually unknown in Britain at

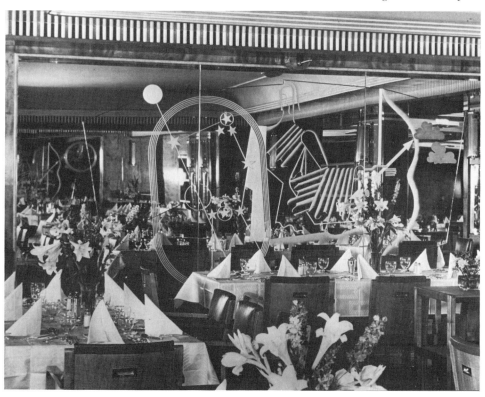

Edward McKnight Kauffer: engraved glass mural for dining room on the Orient Line's
SS Orion, *(1935)*.

that time, and their appointment demonstrates the changing nature of the
design profession and design patronage in Britain in the thirties. Chermayeff,
for example, had come to this country at the age of ten, and was educated at
Harrow, and at the Beaux-Arts Academy in Paris. He first established his
reputation as a designer/decorator in the French tradition when he was put
in charge of Waring & Gillow's modern art department in 1928, and
organised an exhibition of 'Modern Art in French and English Furniture' for
the department store ('By far the best thing yet done in this country',
according to the DIA Journal). Raymond McGrath was trained at the Sydney
School of Architecture, and was a research student at Cambridge. His first
commission was the Art Deco-inspired redesign of Finella, a Victorian house
owned by the English don Mansfield Forbes; Forbes's formation of a (short-
lived) Twentieth Century Society enabled McGrath to meet the influential
staff of the *Architectural Review*, as well as Chermayeff and Wells Coates.
Wells Coates (Canadian) had an engineering degree, and came to London to
write a doctoral thesis on 'The gases of the diesel engine'. After war service
he joined a firm of architects, calling himself an 'architect-engineer'.

The BBC commission at the end of the twenties marked the coming of age
of modernism in this country, for this was a project that relied on 'design' in
the fullest sense of the word, rather than 'decoration' for its successful

achievement. The work there was 'as affirmative in form and intention as the spoken word', according to *The Listener*, and the designers involved then went on to confirm their reputation for avant-garde as well as socially responsible work.

Wells Coates: Studio 6D (Effects), BBC Broadcasting House, Langham Place (1932).

Definitions of modernism

Several factors, however, contributed to definitions and demonstrations of modernism in this country. In the first place there was a growing awareness of Continental theory. Le Corbusier's *Towards a New Architecture* was available in English in 1927; in this text Corbusier defines the house as a 'machine for living in', proclaims the avant-garde artist, architect and engineer as 'form-givers', and relegates industrial design to the evolutionary processes of technological determinism. (Any concept of 'applied' or 'decorative' art was anathema to him.)

A more first-hand experience of Continental (and especially German) theory was reinforced when the refugees from Nazi Germany began to arrive in this country. Walter Gropius (1883–1969) and Marcel Breuer (1902–81) from the Bauhaus came to England in 1934, and their colleague Laszlo Moholy-Nagy (1895–1946) followed them a year later. (Gropius's seminal book *The New Architecture and the Bauhaus* was published by Faber in 1935.) The architect Erich Mendelsohn emigrated in 1933, and formed a partnership with Serge Chermayeff; Bernard Lubetkin settled in England in 1930 after working in Moscow, Berlin and Paris. (Sir John Summerson describes his own encounters with several of these émigrés in chapter 6 above.)

It was the experience of the Stockholm exhibition of design and architecture in 1930, however, that was to prove of more lasting significance to British designers, for 'Swedish Grace', as it was called, seemed to offer a more humanistic alternative to the frivolity of Art Deco on the one hand, and to the icy rationalism of Continental Modern Movement theory and practice on the other. Swedish design, it seemed, reflected all the virtues of Swedish democracy – it was popular rather than populist, and Swedish manufacturers, in collaboration with artists, designers and craftsmen, drew on natural resources to set new standards in furniture, ceramics and glass:

Sweden, with her instinct for using materials well and her serious sense of social values, has set an example to all Europe of the way modern architecture can solve such problems as the housing of industrial workers and the mass production of elegant household furniture.

(J. M. Richards, *An Introduction to Modern Architecture*, 1940, pp. 78–9)

Also during the thirties there was a significant expansion of literature devoted to the problems of design, and the magazines and pamphlets published by organisations such as the DIA were reinforced by a growing number of books on the subject. One of the leading authorities in this field was, of course, Nikolaus Pevsner, the German scholar and art historian who had arrived in Britain in 1935. Before he left Germany, Pevsner's academic research had been related to studies of Baroque and Mannerism. At the same time, however, he had also studied and approved of German attempts to improve design standards – the Werkbund's ideological and practical achievements, for example, the positive response of some sections of German industry to Werkbund ideals, and the efforts in German design schools, especially the now legendary Bauhaus, to train designers to work for all

sections of industry. When he left Germany, however, the idealism which had inspired these developments was suspect – 'modernism' according to Third Reich propaganda being too closely associated with socialism, collectivism and left-wing agitation to be tolerated.

These experiences, it goes without saying, had a profound effect on Pevsner's conception of the social implications of design. As far as he was concerned Morris and the Arts and Crafts generation had already established England as pioneering an ideal of social commitment in design, and the first book that Pevsner published in this country, *Pioneers of the Modern Movement from William Morris to Walter Gropius* (1936), set out to trace the 'progress' of these social concerns from the idealism of William Morris to the achievements of Walter Gropius as an architect, idealist and teacher. For in spite of his admiration for Morris, Pevsner could not reconcile what he felt was a dislocation between his theory and his practice. 'Morris the artist may in the end not have been able to reach beyond the limits of his century', he wrote, 'Morris the man the thinker did.' Morris's failure, according to Pevsner, lay in his inability to acknowledge the 'spirit of the age'; for in Pevsner's philosophy 'the ruthless scrapping of tradition' was essential if 'a style fitting our century was to be achieved'. Any form of associationism in design, therefore, was immoral – to be valid, to achieve moral credibility, design had to be anonymous, a-historical, anti-historical:

The warmth and directness with which the ages of craft and a more personal relation between architect and client endowed the buildings of the past may have gone for good. The architect, to represent this century of ours, must be colder, cold to keep in command of mechanised production, cold to design for the satisfaction of anonymous clients.

(*Pioneers of Modern Design* (revised edition, 1960, p. 214)

Pevsner also related this architectural credo to the products of industry, and his *Enquiry into Industrial Art in England* (1937) was a violent attack against what Pevsner considered was immorality in design:

The pleasure which most people take in an entertainment so vicarious as the cinema, as well as the pleasure in vulgar and boastful design, is largely accounted for by the universal and irresistible longing for escape. Looked at from this point of view, the question of design is a social question, it is an integral part of *the* social question of our time. To fight against the shoddy design of those goods by which most of our fellow men are surrounded becomes a moral duty.

(p. 11)

Pevsner, therefore, campaigned against the sham and the fake, and all who perpetrated them. The economics of design were given scant consideration in his survey, because he, true to Ruskinian (as well as DIA) principles, believed that it was the duty of the manufacturer to form rather than to follow the market.

Pevsner, of course, was not alone in his seeming lack of concern for economic reality, since the majority of design reformers in the inter-war years were convinced that good design meant good business; and there were also many others who shared his conviction that designers and architects in Germany in the Weimar period had begun to demonstrate a model approach

to the problem of designing for industry. Herbert Read's seminal book *Art and Industry*, for example, which was first published in 1934, probably reached a wider audience than Pevsner's *Pioneers* and *Enquiry*. The basis for Read's aesthetic was founded in Continental theory, reinforced by his contact with the émigrés (especially Gropius and his colleagues from the Bauhaus). 'I have no other desire in this book', he wrote, 'than to support the ideals expressed by Dr. Gropius.' In a chapter headed 'The solution proposed' Read quotes extensively from a paper given by Gropius to the Design and Industries Association in May 1934, in which the Bauhaus interpretation of the fusion of art and industry was described, the 'artists' in the German school being, according to Gropius:

a picked body of men of all round culture who were thoroughly experienced in the practical and mechanical, as well as the theoretical, scientific and formal aspects of design.

Throughout the book, however, Read concentrates on the role of the abstract artist as 'form giver', since abstraction in art was related to the structure rather than the appearance of natural form:

For nature herself is abstract, essentially mathematical, and our human needs simply acquire the condition of greatest freedom when they conform to that discipline 'whose golden surveying reed marks out and measures every circuit of the New Jerusalem' [Milton].

The illustrations to Read's book (perhaps more than the text) demonstrate his ideal of form – Chinese vases from the Sung dynasty, Wedgwood's 'Queensware' (designed in the eighteenth century), and eighteenth-century English silverware are juxtaposed to metal work from the Bauhaus, cutlery used in Lyons restaurants and furniture made by Gordon Russell Ltd. So that while the Bauhaus, for example, would never admit to any 'tradition' in design, Herbert Read selects pure (in other words unornamented forms) from the past to demonstrate standards of excellence for the present. (The predominance of ceramics in the book is perhaps explained by the fact that Herbert Read had worked for ten years in the Victoria and Albert Museum, mainly in the ceramics department.)

In the index to the first edition of the book Read lists thirty-three manufacturers and twenty-five designers; only thirteen of the manufacturers and eight of the designers are British (two of the eight were not British-born, since the list includes Naum Slutzky from the Bauhaus, and Wells Coates). Moreover in the illustrations, German work predominates, so that according to Read's canon the British, after a century of grappling with the problems of designing for industry, were still failing to establish a viable design profession.

Architect/designers and continental influences

In spite of the pessimism of authorities like Read and Pevsner, England was beginning to establish a design profession in the thirties. Some of the designers, as we have seen, were trained as architects, some were fine artists,

some would consider themselves craftsmen, and others had art and design school training. Because of this varied background, however, members of the new profession approached the problems of designing for industry in different ways.

The architect/designers, especially those associated with the BBC commission, were perhaps the most radical, a close knit circle of clients supporting their activities. Wells Coates, for example, had designed shops and shop-fittings for Tom Heron's Cresta Silks Ltd before the BBC commission. Tom Heron (the father of the painter Patrick Heron) was attempting, through the Cresta chain of dress shops, to improve the quality of the merchandise he sold, as well as the environment for selling. Paul Nash (1889–1946) the painter, designed fabrics for him; McKnight Kauffer (1890–1954) designed printed material and shop fronts, while Wells Coates was put in charge of the overall design of the shops. Coates used plywood for the shop-fittings, a material that was being marketed in this country by Jack Pritchard an indefatigable entrepreneur and patron of avant-garde architecture and design. Pritchard had joined the Vanesta Plywood Company in 1925; he, like Wells Coates, had seen and admired the work of Le Corbusier (he commissioned Le Corbusier to design the Vanesta Stand at the Building Trades Exhibition in 1930). Also in 1930 he and his wife Molly, together with Wells Coates and Chermayeff, went on an architectural tour of Germany, visiting the Bauhaus in Dessau, and the Stuttgart 'Weissenhof Siedlung', a colony of houses in the International Style sponsored by the Werkbund.

The result of this remarkable pilgrimage was the establishment by Pritchard of a firm which he called Isokon (Isometric Unit Construction) in order, as he put it later, 'to provide a focus for the new ideas and techniques largely inspired by the Bauhaus'. Isokon was intended to be a practical as well as a proselytising organisation, and its ideals inevitably outstripped its achievements, due to an entrenched suspicion of Continental modernism in this country. Isokon is remembered today for the ranges of furniture using plywood that were introduced in the thirties, and for the Lawn Road flats in Belsize Park, designed by Wells Coates and completed in 1934. Sir John Summerson discusses the architectural significance of the Lawn Road flats in chapter 6 above – they were, as he points out, 'a real life manifesto of the Modern Movement', and as such were intended to demonstrate the fusion between architecture and design – heating, lighting, sanitation, as well as furniture and furnishings, being, as Wells Coates put it, 'integral with it, a part of its construction, and therefore of its form'. 'Modern design', according to Coates' must begin with the interior plan (including the furniture and equipment) as generator, and make explicit externally the processes, functions and qualities included in the whole scene.'

There are echoes of Le Corbusier in Wells Coates's evocation of the plan as generator of form; the inspiration for these flats, however, and for other Isokon schemes that were never built, was the concept of the 'minimal dwelling' as demonstrated by several German local authorities before 1933. The German housing programme, based on the standardisation of building components as well as household equipment, was a short-lived response to

Serge Chermayeff: cocktail cabinet (1928–30).

economic conditions in Germany in the inter-war years. The sparseness that these ideas evoked, however, met with little sympathy in England, and the Lawn Road flats, conceived by and for an intellectual élite, remain one of the few practical demonstrations of German modernist theory in this country in the inter-war years.

Some of the furniture produced by Isokon to complement this ideology, however, was eventually to have an impact on the 'trade' – particularly Isokon 'unit' furniture – co-ordinated ranges of cupboards, book-cases and storage units designed for use in a restricted space. The practicality of this kind of furniture prompted several firms as well as designers to experiment with it. Chermayeff, for example, produced a range of 'Plan' furniture in 1934, based on designs by Franz Schuster of Vienna; Wells Coates designed a range (including fitted cupboards and shelf units) for the Bristol firm of P. E. Gane in 1936; and the Russells had begun to replace the traditional free-standing 'sideboard' with various types of cupboards and shelf units in the early thirties. Paradoxically, however, later Isokon furniture – chairs, tables, trolleys, etc. – using bent plywood (a technique pioneered by the Finnish architect Alvar Aalto in 1932) were not commercially successful, and it was the German inspired use of tubular steel for furniture, rather than the Scandinavian alternative, that swept the British contract market in the thirties.

Domesticating new materials

Initiatives to 'domesticate' materials such as tubular steel and plastics in this country came from the manufacturer as much as from the designer, since during the Depression certain sections of industry were striving to extend and diversify their markets. The two firms most closely involved with the development and production of tubular steel furniture in Britain, for example, were Cox & Co and Accles and Pollock (Cox manufacturing automobile components, using tubular steel for car seats, while Accles and Pollock, a branch of Tube Investments, produced seamless steel tubing). Their 'models', however, came from Germany, where Marcel Breuer of the Bauhaus had pioneered the use of the material for furniture which was manufactured by a Berlin firm (Standard Möbel) and by Thonet (more generally associated with bentwood furniture). Thonet opened a showroom in London in 1929 to promote their tubular steel designs, and Cox introduced their furniture shortly after this. In 1931 Accles and Pollock set up a subsidiary – Practical Equipment Ltd (Pel) – to design and market furniture that was to be used in grand hotels and village halls throughout the thirties.

Serge Chermayeff: 'Plan' chair, with tubular steel frame by Pel (1933).

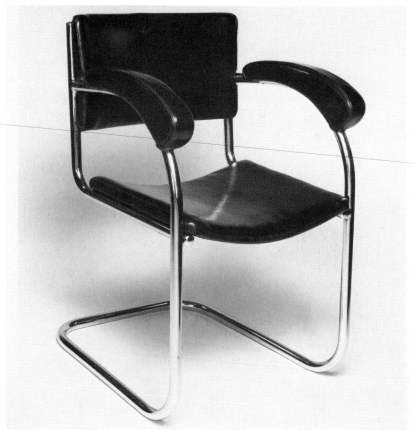

The fashionable avant-garde were the first patrons of this kind of furniture. Oliver Bernard, for example, had used two Thonet tubular steel chairs in the foyer of the Strand Palace Hotel, and a reviewer in 1932 described how a scene in Noël Coward's *Private Lives* 'showed the balcony of a hotel in France which was most charmingly furnished with tubular steel furniture'. The more conservative, however, found it 'as interesting as modern sanitary fittings', and it was not until new patrons like the BBC (prestigious) and Margate's 'Dreamland' (popular and lucrative) used the furniture to demonstrate efficiency as well as modernity that the market expanded. (Tubular steel furniture, designed by McGrath, Coates and Chermayeff, and manufactured by Cox and Pel was used throughout Broadcasting House.) This was essentially a 'contract' market, however, and tubular steel furniture was rarely used in the home, where the best-selling status symbol throughout the thirties was the three-piece suite – a sofa and two armchairs – their dimensions 'suited' (sic) to the suburban house and fireside.

The development of the use of plastics for consumer goods also expanded

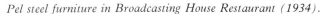

Pel steel furniture in Broadcasting House Restaurant (1934).

in the twenties and thirties, especially after the introduction of bakelite on to the British market in the early twenties. The temptation, of course, with these new materials was to disguise them, and to try to make them look like wood or ceramics. Pevsner, in his *Enquiry*, for example, condemns 'a bakelite hairbrush made to look like enamel'. Moreover, because of production techniques as well as costs, it was essential to manufacture plastics goods in quantity, in order to recover the initial costs of making moulds; it did not make sense, therefore, to attempt to make plastics goods look 'crafted', although, of course, a great many firms did so. A writer in the contemporary periodical *Decoration* summed up the situation:

> Plastics are brand new materials with certain very special characteristics, and in order to utilise them to full and lasting advantage they must be moulded into shapes which will prove convenient, practical, and yet be good looking, and so adapted that the material itself is exploited to full advantage. A new tradition must be created from plastics, and it is doing these materials an ill service by adopting makeshift styles . . . What is most urgently needed is professional designers with a working knowledge of plastics who can be trusted to evolve a distinctly new and satisfying Plastic Style.
>
> (Paul L. Smith, 'Plastics in the home' in *Decoration*, August 1936)

One firm which succeeded in pioneering the 'Plastic Style' was E. K. Cole Ltd (Ekco). Ekco's managing directors, W. Verrello and Eric Cole, had established a moulding plant for plastics at Southend in 1930, and shortly after this they launched a competition for the design of a radio cabinet. Several leading designers, including Chermayeff and McGrath, submitted entries; the winning design, however, was by Wells Coates, who introduced the revolutionary concept of a circular radio set. The shape, as well as

Wells Coates: Ekco wireless set (1934).

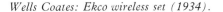

relating to the circular loud speaker, also exploited the potential of the
moulding process, and the Wells Coates set became a best seller after it was
introduced in 1934. A larger version, also designed by Coates, was introduced
the following year, and in 1937 he designed the 'Thermovent' range of
electric heaters for them, which remained in production for sixteen years.
Chermayeff also designed a radio set for Ekco, which was a best seller, and
Pevsner described the success of these radical designs in new materials as 'an
immense credit to the British public', proving that there was a market for
new and radical design in this country.

The radio industry, of course, produced a whole range of receivers, some
being far too kitsch for the Pevsner seal of approval. Pevsner was impressed,
however, by the fact that the industry offered two equally successful solutions
to the problem: Wells Coates, he maintained, had designed 'a piece of
modern machinery', while with Gordon Russell's work for Murphy 'the
governing idea [was] to create a modern piece of furniture'. Both approaches
were equally valid as far as Pevsner was concerned, and he deemed this the
'only trade where the best English models are . . . better in design than any
to be found abroad'.

The artist as designer: the work of Paul Nash

The designer–client–consumer relationship, however, was not always so
harmonious. The painter Paul Nash, for example, was totally convinced that
the artist had a valid and practical role to play in industry, a role, as he put
it, that was 'outside the mystical circle of arts and crafts'. Nash had
experimented with textile design in the twenties, working for an experimental
firm called Footprints. The liaison was unsuccessful, mainly because the
colour, as well as the printing, did not come up to Nash's standards. Then in
1929 Nash was approached by Tom Heron of Cresta Silks (Wells Coates's
patron) to produce a range of dress fabrics for the Cresta Shops. In theory,
this was an ideal commission, since both the client and the designer were in
agreement about the standards they required. Once again, however, Nash's
perfectionism inhibited production. The printers (G. & P. Baker, well known
for the quality of their work) could not, with the best will in the world,
reproduce the water-colour based tones that he required, and in this case
Nash agreed, with some reluctance, to compromise.

Nash's career as a designer is interesting in so far as it demonstrates the
ambiguity of an 'art' or 'artist' led industry. Like William Morris before him,
Nash was not prepared to lower his standards; unlike Morris, however, Nash,
who saw himself as a designer rather than a craftsman, believed that the path
to social as well as aesthetic reform lay in industry's willingness to accept the
dictates of the artist. Needless to say, most attempts to demonstrate so one-
sided a relationship failed, on grounds either of cost or impracticality.
E. Brain & Co, for example, manufacturers of 'Foley' china, attempted such
an experiment in 1932 when they invited a group of artists (including Nash,
Vanessa Bell and Duncan Grant) to design patterns for a new range of china.
These were adapted by Clarice Cliffe for hand-painting onto earthenware,

and the results were exhibited by Harrods in 1934 (colour pl. 9). From the point of view of public interest and sales, however, the experiment was a total failure. Cliffe wrote later:

I remember what head-aches we had over the reproduction . . . but sad to relate, from a commercial point of view, i.e. sales to the public, it was so disappointing that it was the closest thing to a flop that, I am glad to say, I have ever been associated with.

These experiments in areas for which he had ideals rather than expertise were, it seemed, doomed to failure – no doubt because working with industry requires specialisation, or at least a willingness to understand and participate in production processes – priorities which Nash's Swedish contemporaries were prepared to acknowledge. Nash's well-intentioned excursions into design, however, were successful when he was able to relate the commissions more or less directly to his preoccupations as a painter. He did not need to compromise, for example, in the poster designs he did for London Transport or for Shell, and his most successful (and prestigious) commission, ironically, was the bathroom he designed for the dancer Tilly Losch in 1932 (a project in the artist/decorator tradition). The client in this case was the eccentric millionaire Edward James (one of the few British patrons of Surrealist painters in the thirties), and the bathroom, which was reconstructed for the Arts Council's 'Thirties' exhibition in 1980, was a remarkable demonstration of Nash's preoccupation with light, reflection and space. Nash used mirror and textured glass, stainless steel, black fitments and neon lighting to emphasise space and spatial ambiguity, creating a three-dimensional abstract painting in an exercise that was theatrical as well as avant-garde.

Paul Nash, Rye Marshes *(1932), for an advertisement for the Shell Petroleum Company.*

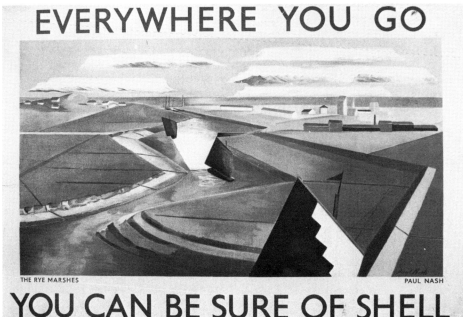

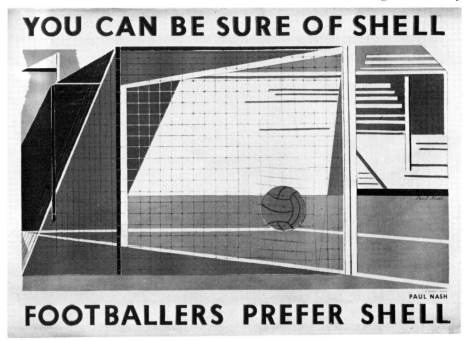

YOU CAN BE SURE OF SHELL

PAUL NASH

FOOTBALLERS PREFER SHELL

Paul Nash, Footballers Prefer Shell *(1935).*

The professionalisation of design

Such eccentric and élitist commissions were to become more rare in the
thirties; nevertheless it was during this period that the design profession,
backed by government support, consolidated its identity, concentrating on the
need for collaboration with trade and industry to achieve results that were
socially and economically as well as aesthetically viable. Professionalisation
was, of course, an urgent necessity, and the Society of Industrial Artists was
founded in 1930 to meet this need, early members including Paul Nash,
McKnight Kauffer and Serge Chermayeff. Its aim was 'to secure a recognised
status for artists working for industry and commerce, and to provide a
controlling authority to advance and protect their interests'. And although
the SIA (now SIAD – Society of Industrial Artists and Designers) has never
achieved an authority equivalent to that of the RIBA, it did, in those early
years, provide a focus for debate on common issues and causes, and it also
challenged the hegemony of London, active SIA branches being established
in industrial centres such as Stoke, Manchester and Liverpool. The stress on
'status' and 'protection' in the original statutes also indicates that the society
was concerned with professional practice – a recommended scale of fees was
established, and membership of the SIA was intended to indicate a reliable
standard of professionalism. Again the authority of the design profession was
reinforced in 1936, when the Royal Society of Arts established the award of
the title Royal Designer for Industry RDI, which was, and still is, of
considerable prestige.

It was in the early thirties, therefore, that post-1945 policies for the promotion of British design were established. In 1931, for example, The Board of Trade set up a committee under the chairmanship of Lord Gorell to investigate 'the desirability of forming in London a standing exhibition of articles of everyday use and good design of current manufacture and of forming temporary exhibitions of the same kind'.

The brief, as stated, seems neither adventurous nor innovative. But in formulating the parameters for such an exhibition, the committee had obviously to put forward some definition of what was meant by 'good design of current manufacture', and at the same time it had to suggest ways in which 'good' design might be achieved. The committee members included Roger Fry, Clough Williams-Ellis, the architect, Sir Eric Maclagen, the director of the Victoria and Albert Museum, and E. W. Tristram, professor of painting at the Royal College of Art. Manufacturing interests were represented by A. E. Gray, a pottery manufacturer from Stoke-on-Trent, and by Sir Hubert Llewellyn Smith of the British Institute of Industrial Art. This was, of course, essentially an 'establishment' committee, and just as there was no spokesman for 'Continental' modernism among them, manufacturing interests, as well as expertise, were also under-represented. The committee, however (its report was published in 1932) did attempt to lay some ghosts from the past in putting forward its recommendations for the future. Craft ideals, for example, were rejected 'because they are not adequate to meet the conditions of large-scale production required to supply the needs of a modern community'.

There has been a growing realisation of two facts: first, that a reversion to handicraft cannot, for economic reasons, solve the problems of beautifying the articles of common use within the purchasing powers of such consumers; secondly, that the fundamental differences between the techniques of industrial manufacture and of handicraft make the problem of adapting design to industry a wholly different one from the production of unique specimens of artistic workmanship.

Inevitably perhaps, the solutions proposed were vague and somewhat ill-defined:

It has been stated in public that manufacturers are uncertain – mainly for want of proper artistic advice – what style and design to follow in their new products; whether to indulge in imitations of the past or in an ill-considered form of so-called modern work. Yet here, in our own country are the potential advisers; we must now secure scientific planning for the future and a continuous exhibition policy administered with care and vision, designed to make first rate material readily accessible to all interested. If we adopt such a policy, coupled with first-rate art teaching, first rate opportunities for designers, and a new determination on the part of manufacturers to seek the advice of the best artists of the day, the remediable evils of the present position will be gradually overcome, and the country's Industrial Art will be based upon a secure foundation.

References to 'scientific planning' indicate an awareness of the Continental, and especially the German approaches to industrial design, but neither 'science' nor 'planning' bear any cogent relationship to the recommendation to 'work in collaboration with first-rate artists at every stage of production'.

The committee, therefore, fell back on the then century-old advice that education was needed, at every level, to form public taste, and to produce, through relevant art school training, designers (or artists) capable of working for or with industry. Herbert Read, for one, was very dubious about these recommendations. He analysed and quoted extensively from the report in *Art and Industry*, stressing his thesis that 'art' cannot be applied to industry, but should arise from an understanding of the processes of production.

Following the publication of the Gorell Report, however, there were concerted efforts (government, DIA, SIA and industry sponsored) to establish practical means of carrying out the report's recommendations, and to demonstrate that quality could be related to quantity (and therefore low-cost) production. In 1933, for example, a major exhibition of 'Industrial Art in the Home' was held in Dorland Hall in London. The exhibition was sponsored by *Country Life* magazine, with DIA and SIA involvement, and the promoters had complete control of the selection and display of the exhibits. As well as designs that were in current production, experimental work was also shown, including a one-room flat by Wells Coates, and an all-glass exhibit by Oliver Hill for Pilkington Brothers. Oliver Hill was also the co-ordinating architect, and the exhibition, under the patronage of HRH Prince George, was described by Pevsner as 'the best of its kind ever held in England'.

The exhibition, however, was evidently a hard act to follow – a second Dorland Hall display in 1934 did not have the same impact – and a major exhibition of 'British Art in Industry' held at the royal academy in 1935 was generally considered a failure. A correspondent in the *Spectator* wrote that 'it compromised the vulgarity of Tottenham Court Rd, the sham modernity of Wigmore St. and the expensiveness of Bond St.' The *Architectural Review* maintained that the 'pottery section shows a complete lack of life', and that the glass demonstrated 'timidity, lack of inspiration, refusal to let the material have its own way'. Pevsner, damning with faint praise, wrote:

An easy and good-natured conservatism seems to have set the standard, as well befitted an institution which six weeks before the opening of the exhibition gave to a Royal Prince an eighteenth century bracket clock as a wedding present, and as equally well befitted an executive committee of whose twelve members six were over sixty years old, four between fifty and sixty, and only two under forty.

In this case the 'taste' of the selectors – a team of Royal Academicians who acted as a sort of 'hanging committee' – prevailed, and their concentration on somewhat conservative conventions of beauty meant that most of the items were expensive as well as exclusive.

There was no lack of less pretentious exhibitions in the thirties, however, many of them (in the provinces as well as in London) organised by the DIA, who attempted to restrict the choice to affordable items of mass-production. This stress on cost became more evident in the years leading up to the War. The RIBA, for example, perhaps as a counter-blast to the Royal Academy, organised its 'Exhibition of Everyday Things' in 1936; shops such as Heals, Liberty, Dunns of Bromley, and Bowmans (which sold low cost furniture in Camden Town) encouraged the sale of 'modern' design at a reasonable price,

and trade exhibitions (in newly built halls at Olympia and Earls Court) also sponsored an achievable ideal of design.

The pattern of post-war reforms, however, was established with the formation by the Board of Trade of the Council for Art and Industry in 1934, under the chairmanship of Frank Pick. The Council (to be reconstituted as the Council of Industrial Design in 1946) established a Scottish branch, instituted a National Register of Industrial Designers and was campaigning for a permanent exhibition site at the outbreak of war.

In the late thirties, therefore, a viable design profession seemed to have been established in this country, with government as well as manufacturers' support and promotion. Designers were working in many areas of the consumer goods industries, several of them making the transition from 'designer/decorator' to designer for quantity production. Marion Dorn, for example, who had established her reputation with private patrons in the twenties, went on to work as a consultant designer to the Wilton Royal Carpet Factory in the thirties. She also worked with the textile industry (Alex Hunter, production manager at Warner & Sons Ltd, collaborated with her to produce both woven and printed textiles), and she designed for Donald Brothers Ltd. Duncan Grant designed a range of screen-prints for Allan Walton Textiles in the mid-thirties (some of these are being re-issued by Laura Ashley). Enid Marx (b. 1902) then one of a younger generation of art college trained designers (the Central School and the Royal College of Art) set up her own textile printing workshop in the twenties; she was a remarkably versatile designer, working in graphic design (illustration, book jackets, posters and postage stamps). She also worked (under the patronage of Frank Pick) for London Transport, designing seating fabrics in the thirties. This experience of working to a very specific brief to produce low-cost and hard-wearing fabrics made her an ideal choice as fabric designer to the wartime Utility Scheme.

Several firms in the ceramics industry were also employing consultant designers. Keith Murray (1829–1981) for example, a New Zealander who had come to England in his teens, and who had trained as an architect, worked as a designer for Wedgwoods in the thirties, producing commercially successful ranges that were displayed in most major exhibitions. (He also designed the new Wedgwood factory which was opened at Barlaston in 1940.) Susie Cooper (b. 1902) who had trained at the Burslem School of Art, worked for A. E. Gray, becoming the firm's chief designer in the twenties. She left in 1929 to set up her own pottery in Burslem, and had established a reputation for marketable as well as modern design before the outbreak of war. Clarice Cliffe (1899–1972) also studied at the Burslem Art School and joined A. J. Wilkinson in 1916; in the twenties she began experimenting with decoration, painting on some of the firm's outdated ranges, and in 1925 when Wilkinsons amalgamated with another local firm, she introduced her Bizarre ware, ranges with unique shapes, colours and patterns. Because of their eccentricity, and because they evoked French Art Deco rather than the sobriety of modernism, Clarice Cliffe's work failed to meet the approval of the design establishment in the twenties and thirties. Nevertheless her designs were commercialy successful, and today her ceramics have become much sought-after collectors' items.

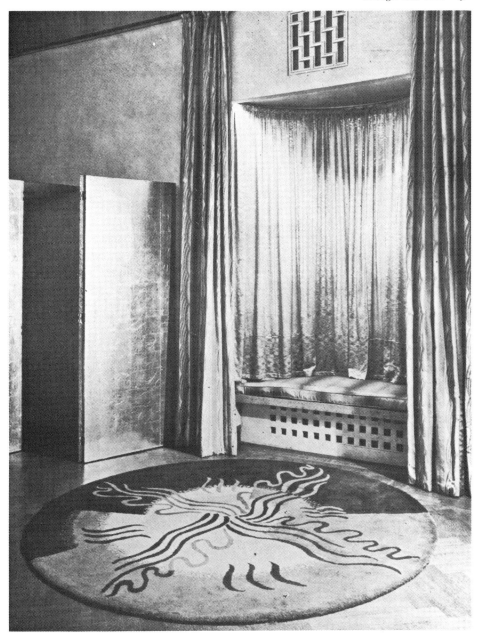

Marion Dorn: rug, for the Wilton Royal Carpet Factory.

In 1936, therefore, when the RDI award was established, here was a body of professional designers to choose from. Keith Murray was appointed an RDI in that year (together with Harold Stabler and C. F. A. Voysey from an earlier generation). It is significant, however, that most of these early RDIs were graphic designers or typographers, indicating, perhaps, the influence of patrons such as Frank Pick, and the willingness of the advertising profession

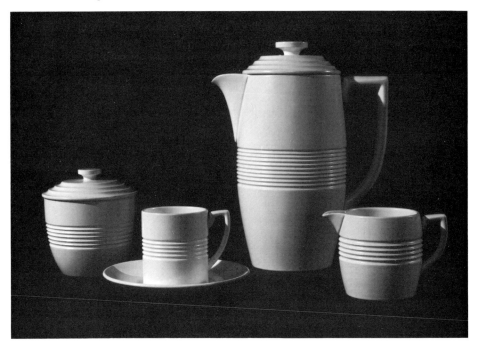

Keith Murray: 'Moonstone'-glaze coffee set, for J. Wedgwood and Sons Ltd (1934).

to promote modern design. And it was from the 'fringes' of this profession that the first industrial design teams were to emerge. Milner Gray, for example, who was appointed an RDI in 1937, had been working as a graphic designer (posters, packaging and print) in the 1920s; he formed a consultancy, and became Senior Partner of the Industrial Design Partnership in 1934. The firm was reorganised after the war, and the Design Research Unit (DRU), as it was renamed, became of the most prestigious and successful of several design consultancies that were set up in the post-war years.

Designers in England, therefore, faced problems that were entirely different from those of their counterparts in Europe and America. The traditions of craftsmanship that had been established in the nineteenth century had established design as a social rather than an economic problem; at the same time large sections of British industry, with their experience of success in Commonwealth and Colonial markets, saw no reason to employ designers. The establishment of the profession was painfully slow, and the rapprochement of designer and industry only worked when industry was convinced of the viability of such co-operation, or when new patrons demonstrated the potential of these new professionals. Design ideologies in the twenties and thirties were never as radical as those in Weimar Germany; patterns of wealth and patronage did not produce an avant-garde élite, as in France; Britain's consumer goods industries were not structured to promote a continuation of the craft ideal, as in Scandinavia, nor was the economy geared to create mass markets, as in the United States. In his *Enquiry* of 1937

Pevsner wrote: 'Things are extremely bad. When I say that 90% of British industrial art is devoid of any aesthetic merit, I am not exaggerating.' He did acknowledge, however, that he did not 'know of any modern country where the majority of industrial products is not deplorably bad in design'. Pevsnerian judgement, and the Pevsnerian aesthetic, however, were as stern and uncompromising as they were critical. Britain did succeed in establishing a design profession in the inter-war years, and firms employing designers did enjoy some measure of commercial success. The Ruskinian conviction, however, that it was the duty of the manufacturer to form the market as much as to supply it only gradually lost its validity, and post-war developments have demonstrated the futility of attempts to impose standards of 'taste', giving people what they ought to want. The design profession, as established in the thirties, was sufficiently flexible to demonstrate that there is no 'one true way', and that the British market can absorb a variety of approaches. Whether these inter-war developments equipped designers to cope with the multi-markets of the 1980s is another story.

Sunnyfields Estate, Mill Hill, London (1936).

9 John Laing's Sunnyfields Estate, Mill Hill

SIMON PEPPER

John Laing's 'Sunnyfields Estate' in Mill Hill merges easily into north-west London's suburban 'Metroland'. Like any other 1930s estate, half-a-century's accretion of car ports, coach lamps, storm porches, roof rooms and self-build sun lounges has given it the 'lived-in' feeling that 'community architects' of the 1980s now strive hard to achieve. However, such intrusions would greatly have distressed the builders, promoters and 'eminent architects' of a scheme which was intended to set new standards of 'dignity and refinement' in speculative housing design – nothing less than the reversal of the deterioration in domestic architecture that was seen to have accompanied the inter-war building boom.

Today the inter-war housing revolution is recognised as one of the more important socio-economic developments of modern times. In 1914 some ninety per cent of Britain's housing was rented from private landlords and about ten per cent owner-occupied, leaving a small fraction – about 20 to 30,000 dwellings – publicly owned. By 1939 the addition of just over a million council houses had produced what was, in effect, a new class of tenant, constituting some ten per cent of British households (and in many Northern cities a much higher proportion). But the most striking change was in owner-occupation. More than three million new houses were built for sale during the twenties and thirties, and by the Second World War over thirty per cent of Britain's families owned their own homes. Cheap money, speculators, and the building societies had together achieved a giant step toward what politicians of all colours now describe as 'property owning democracy'. Moreover, the council and private enterprise builders had changed the face of Britain's cities. What before the Great War of 1914–18 had been small islands of garden suburb development, by the end of the thirties had become vast swathes of low density two-storey housing surrounding practically every town.

Not all of this was seen as improvement. Williams-Ellis wrote *England and the Octopus* (1928) as a polemic against the ribbon development that threatened to engulf the remaining countryside. 'Municipal neo-Georgian' encapsulated the standardised sterility of many new council estates, while

'Stockbroker's Tudor' and 'Bypass' – even 'Suburban' – were thirties terms that at once described and denigrated a petit bourgeois lifestyle and its design preferences. For most architects the new semi-detached suburbs represented not only an artistic affront, but a missed opportunity to involve themselves professionally in the most productive sector of the building industry. Here there were two obstacles; a fee structure that prevented members of the Royal Institute of British Architects offering discounts on repeat commissions, and the widespread (and perhaps not unfounded) belief on the part of builders that architects were unwilling or unable to produce cheap houses which would appeal to the man in the street. The fee scale problem was resolved in 1932. But the architect's effective exclusion from speculative housing design continued to be debated hotly in the professional press. So it was something of a coup when in 1933 John Laing, later Sir John Laing (1879–1978), was persuaded to participate in an open design competition for housetypes to be built on his firm's ten-acre site off Lawrence Street, Mill Hill.

Laings was one of the giants of London housebuilding. In 1920 John Laing had moved his firm south from Carlisle, where three generations of the family had worked as builders. The firm had expanded rapidly on strategic contracts during the Great War, taking a major part in the construction of the enormous explosives factory and munitions workers' township at Gretna, where John Laing came under the influence of Raymond Unwin (see Chapter 2, 'The Garden City', p. 104) who was then serving as chief housing architect for the Ministry of Munitions. It was council housing and other public sector projects that brought Laing south after the war but, as this kind of work declined in the late 1920s, the firm diversified into speculative housebuilding.

Motorised suburbia: the Watford by-pass, near Mill Hill, in the 1930s.

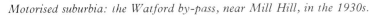

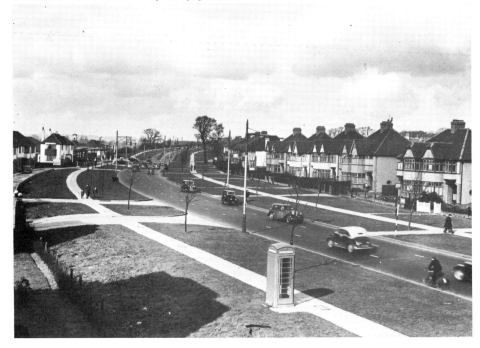

'Laing's Little Palaces' quickly won a reputation for quality. The roughcast cement rendering and fake half-timbering that so often concealed shoddy construction were eschewed by the Carlisle master builder, who demanded fair-faced cavity brickwork in all his schemes. The estates were developed on garden suburb lines by the firm's staff architect, David Adam (1882–1953), another Gretna veteran who probably designed more houses in London's suburbs than any other architect of his generation.

Well built and well laid out, John Laing's estates were always either located close to existing centres or planned in conjunction with shopping and industrial developments financed by Laing subsidiaries. And in its sales techniques the firm again broke new ground. In 1934 a fully furnished show house was built in the forecourt of King's Cross station, and opened to visitors from 9.30 a.m. to 10 p.m. Films of the various developments were screened in the garage, and the firm provided free car rides to estates for the more serious prospective customers. February 1937 saw the opening by Sir Kingsley Wood (Minister of Health) of the 'New Home Exhibition' inside a department store at 520 Oxford Street, near Marble Arch. Here three full-sized Laing show houses were built and furnished. Visitors entered the demonstration area along a 'remarkable avenue of cut-out pictures of house types in full colours' before entering the detached 'Coronation House' (priced £1,100), the 'Jubilee House' (£1,000) or the 'Elsdale', a semi-detached dwelling at the bottom of Laing's price range which sold for about £600. At a time when New Ideal Homesteads and Hilberry Chaplin offered three-bedroom houses for as low as £325, and when solid firms like Taylor Woodrow and Wimpeys sold in the £350 to £550 bracket, Laing's Little Palaces were all in the upper suburban price range.

John Laing originally commissioned two stalwarts of the Garden City movement to design 'Sunnyfields'. For much of the 1920s Arthur Kenyon

Laing's Show House outside King's Cross station, featuring the popular 3-bedroom 'Rona' type, opened in March 1934.

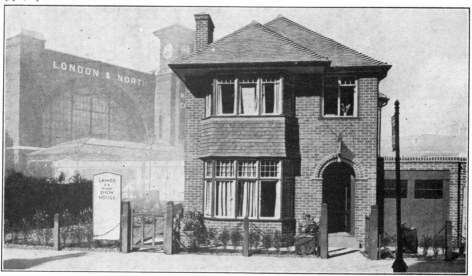

The advertisement for Laing's New Home Exhibition, opened in February 1937.

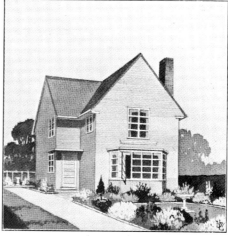

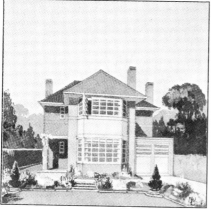

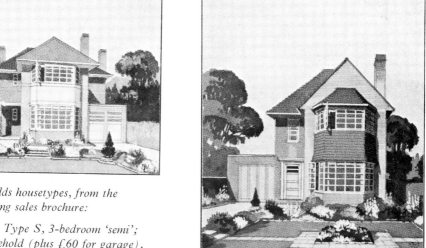

Sunnyfields housetypes, from the
John Laing sales brochure:

Top left: Type S, 3-bedroom 'semi';
£725 freehold (plus £60 for garage),
by Arthur Kenyon. Later sold as the
'Spey' with flat-roofed porch.
Top right: Type Z, 3-bedroom detached; £910, by Arthur Kenyon.
Later sold as the 'Yeovil'.
Bottom left: Type 9, 4-bedroom detached; £1,150, by Geddes Hyslop.
Later sold as the 'Newnham'.
Bottom right: Type 2C, 2-bedroom detached; £965, by T. Alwyn Lloyd.

(1885–1969) had served with Louis de Soissons as joint architect and town planner of Welwyn Garden City, before going into practice on his own account with a workload that included flats, factories, cinemas and a much praised design for St Alban's church, North Harrow. Thomas Alwyn Lloyd (1881–1960) had worked with Unwin on Hampstead Garden Suburb and the wartime munitions housing projects, becoming probably the leading housing architect in his native Wales, with a large number of garden suburbs, municipal estates and colliery villages to his credit. In 1933 he was elected President of the Town Planning Institute and chairman of the National

Housing and Town Planning Council. Kenyon and Lloyd laid out the
scheme in the form of a squared-off U-shaped crescent, with turning circles
at the corners. They also built most of the cheaper dwellings on the estate. It
was they who first suggested and later organised the competition for the
design of new housetypes.

The 'Competition for the Design of Small Villa Property' was held under
the auspices of the Architectural Association and was open to members of the
association and the Royal Institute of British Architects. Prizes of £25 were
offered to the winning designs in each of three classes of property: Group I
comprising four-bedroomed houses with plot frontages of 33 ft. 10 ins;
Groups II and III comprising three-bedroomed semi-detached houses with
individual plot frontages of 32 ft. 7 ins. and 31 ft. respectively. The real prize,
however, was the newly agreed RIBA scale fee payable on any scheme judged
practical enough to be built on Laing estates. Competitors were assisted by
the publication in the *Architect and Building News* of the Laing house plans
that would normally be built on a site of this kind. A series of articles in the
same journal gave hints on different aspects of design gleaned from the sales
experience of John Laing and the supposed preferences of the firm's
customers. Laing himself excluded flat roofs, rough cast and half-timbering,
as well as the visual confusion and expense of too many chimney stacks;
while the buying public were believed to dislike small window panes, stair
winders (because of the difficulty of laying carpet), and front doors on the
side of the house. Spacious entrance halls with draught lobbies, double doors
between sitting and dining rooms, bay windows and french doors, coal fires
in sitting rooms, and built-in bedroom cupboards were all believed to be
strong selling points.

The competition results were announced in October 1933. Eighty-two
competitors had submitted 192 designs, with clear winners in Classes I and
III, and a number of commendations in all three classes. When 'Sunnyfields'
was completed and published in the *Architectural Association Journal* of
December 1935, it became clear that the work of only three competitors had
been chosen for construction. Kenyon's 44 houses and Lloyd's 27 had taken
the lion's share of the plots, leaving room for only 10 of Frances Barker's, 6
of Geddes Hyslop's and 2 of Philip Herbert's units. The resulting mixture
provides an interesting commentary on the different strands of domestic
design in the mid-Thirties.

There were of course none of the flat roofed, white boxes then favoured by
the continental avant-garde. Laing's demand for tiles, however, left room for
a variety of roof forms: gables, mansards and generally steep pitches from the
older traditionalists; shallower pitches, pantiles and more disciplined hipped
shapes from the younger designers. Frances Barker produced the most
explicitly *modern* design in her Type 40 semi-detached pair, with its
simplified low-pitched roof, wide overhanging eaves, exposed concrete canopy
extending across the full frontage, and two bands of windows which ran
almost continuously across the elevation. She also employed the favourite
modernist trick (made famous by Gropius and Meyer in their pre-1914 Fagus
factory) of turning the steel windows round the corners. Steel window frames
were used in all of the houses, and divided more or less evenly between those

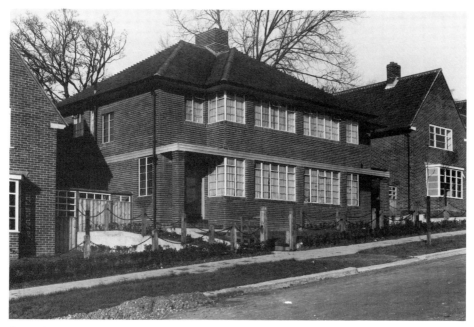

Sunnyfields Type 40, 4-bedroom semi, £1,050; by Frances Barker. Later sold as the 'Oxford'.

Type 40, detail of porch.

with a 'modern' horizontal emphasis in the panes, and those with the square or upright panes shared by the Georgian and Vernacular traditions. But 'modernistic' details cropped up in otherwise quite traditional designs. Even Kenyon was tempted to use a rounded concrete canopy cantilevering over some of his entrances.

A number of the architect-designed housetypes used an L-shaped plan, with the front door in the inside corner and consequently very short corridor and landing runs from a central hall and staircase. Geddes Hyslop's winning scheme in the 4-bedroom class used a T-shaped variant on this plan. Both L and T plans allowed the designer to plan the main rooms with windows facing in three possible directions and, besides giving interestingly shaped houses, allowed them to be placed facing in almost any direction – an important consideration in speculative developments. But the large area of external wall made them inherently more expensive than the simple box-like shapes favoured by most builders.

Of the competitive designs, Frances Barker's conformed most closely to the

*Type 40, floor plans of final version (*The Builder, 28 May, 1937*).*

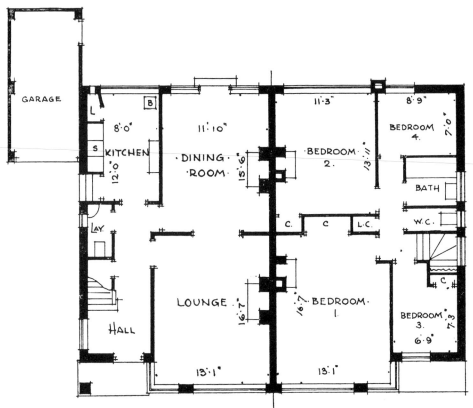

· GROUND · FLOOR · · FIRST · FLOOR ·

standard plan previously employed by Laings (and most other speculative builders). Not surprisingly, her improved version was the most widely used. Almost a square block, the central part of the semi-detached pair was pushed slightly forward to form half-bays to the living rooms and master bedrooms, with the wrap-around windows giving both rooms practically a complete strip of glazing. Large french windows opened onto the back garden. Sitting and dining rooms were connected by a wide opening, providing that 'sense of spaciousness' demanded by potential house-buyers. The only published interior photograph shows what might be described as sub-Arts-and-Crafts decor; with plain walls, simple farmhouse furniture, and a woven rug; the only 'modern' touches being the wide areas of steel framed clear glass and the electric fire standing in front of the traditional quarry-tiled fireplace. The interior steers a careful path between the unpopular and no doubt uncomfortable machine aesthetic of the contemporary avant-garde, and the heavily upholstered clutter of popular thirties furnishings, with their outsize three piece suites, light oak sideboards and dressers, dados, leaded lights, mirrors and tiled fireplaces that rivalled the newest Odeon cinemas in their 'Egyptian' or 'Jazz Moderne' styling. Here was an architect-designed Laing house of 'dignity and refinement' for £1,050.

The standard plan allowed the bathroom and WC to be placed directly above the kitchen and a second downstairs WC, thus simplifying the plumbing and drainage arrangements of what until about 1950 would have been regarded as an exceptionally well serviced home. An extra £45 would purchase 'special' bathroom and toilet fittings, lights, and door handles as well as the fully fitted 'De Luxe' kitchen which featured so prominently in Laing's sales literature: 'designed to dispel forever the idea that there is no pleasure in the kitchen'. Frances Barker's original design had incorporated space for a maid's toilet just outside the back door. The final design brought it indoors and enlarged the kitchen for the servantless housewife now equipped with a 'pull-out table with folding double seats . . . instantly available for meals . . . a "put-away" ironing board . . . and many other wonderful "notions"'. Only a fridge was missing from the complete modern kitchen. The idea of taking snack meals as well as working in this room represents a gigantic stride (forward or backward, according to one's politics) in the life style of Britain's middle class.

Competitors had been asked to make provision for garages, which could be provided for an extra £60. Frances Barker's improved version of the spec builder's plan placed detached garages in the back garden between each pair of semis, leaving the twin houses as a self contained standard unit occupying two very economical 30 ft. frontages. The styling also appealed, combining 'modern' features with the general economy of the simplified neo-Georgian, and it is no surprise that Miss Barker's design – together with some of the others – was built in a number of later John Laing estates.

The *Architectural Association Journal* waxed enthusiastic about the 'restraint, dignity and charm' achieved at Sunnyfields, cavilling only about the quality of the estate sign-board and the unofficial colour schemes already appearing on some houses. In future estates, it hoped, the developer would resist the 'temptation to add houses of a less architectural character, which

Type 40, Dining room interior.

might appeal to a certain type of purchaser . . .' John Laing himself wrote generously of the collaboration which 'has had a refining effect upon our staff, helping them to admire the beautiful, for which we all feel grateful'. But he expressed disappointment in the British public. Since the competition the firm had already begun to include the new housetypes on its larger estates where, although priced practically the same as similarly sized Laing houses, it was found that fully '75 per cent of the public chose the usual type', leaving only 'an educated minority who prefer the more individual architect's house'. This was a surprise and a setback, rather than the defeat which ended many of the avant-garde's attempts to build International Style houses in this country. With the benefit of hindsight, however, it speaks volumes for the difficulties facing those who sought to deliver 'architecture' to the mass clients of the 20th century, whether the new tenantry of the council estate or that 'certain type of purchaser . . .'.

Part III
Appendix: Further Reading and Reference

FRANK WHITEHEAD

Contents

Abbreviations

ARA	Associate of the Royal Academy
BBC	British Broadcasting Corporation
BFI	British Film Institute
CH	Companion of Honour
DBE	Dame Commander of the Order of the British Empire
DIA	Design and Industries Association
GPO	General Post Office
KCVO	Knight Commander of the Victorian Order
LCC	London County Council
MC	Military Cross
OM	Order of Merit
RA	Royal Academy *or* Royal Academician
RAM	Royal Academy of Music
RAMC	Royal Army Medical Corps
RCA	Royal College of Art
RCM	Royal College of Music
RIBA	Royal Institute of British Architects
YMCA	Young Men's Christian Association

Introduction

The first aim of this Appendix is to assist readers with little specialist knowledge of a particular art-form who wish to find their way towards experiencing (whether by listening, looking or reading) the most important works of the major creative talents of the period. To this end the greater part of the limited space available has been allotted to entries about individual artists (architects, authors, composers, craftsmen, designers, film-directors, painters and sculptors) designed primarily to support the discussion of them in the main body of the text. Where they exist, collected editions, catalogues or bibliographies are named, followed by a select list (in alphabetical order of author's names) of the most illuminating books of commentary or criticism, often with a gloss which indicates whether the book is introductory or more advanced, and any particularly noteworthy feature or line of approach. Since knowledge about an artist's life can sometimes enrich our understanding and appreciation of his or her work, a single biography is usually listed (very occasionally more than one) to supplement the necessarily sparse information in the entry itself.

Under each main section heading, the artist-entries are accompanied by lists of studies of the art-form in question. Any general studies appear first, followed by other works, arranged under appropriate, alphabetically-ordered sub-headings, so that the reader may pursue a particular line of interest and proceed towards more specialist study.

The opening pages provide an extensive though highly selective list of general books about the social and cultural setting within which the period's arts were produced. Some of these are indicated as suitable introductory reading, but in general the role of this section of the Appendix is to suggest further background reading for those who have already formed some acquaintance with the arts of the period.

Wherever possible, complete books have been chosen, in preference to articles in periodicals; place of publication is not given, but in the vast majority of cases is London.

I Cultural and Social Setting

1 General: bibliographies, histories

Given the vast amount of writing which has accumulated by now about British life in this period, any selection from it is bound to seem arbitrary and, indeed, biased. While many of the books recommended below are the outcome of more recent interpretation and research, the list also includes some which were written during the period and which may therefore convey some insight into how the world looked, to some people, at the time. For similar reasons the section includes a short but varied list of autobiographies, memoirs and diaries chosen to demonstrate the extent to which such writing can put flesh on the bare bones of social and historical analysis.

BIBLIOGRAPHIES
Readers wishing to pursue some particular topic may find further suggestions by consulting the following:

Elton, G.R., *Modern Historians on British History, 1485–1945: a Critical Bibliography 1945–1969* (1970) [annotated handlist, includes articles]

Fraser, A.G.S., *A Subject Bibliography of the First World War: Books in English 1914–1978* (1979)

Mowat, C.L., *British History since 1926* (1960) [a select bibliography]

Roach, J. (ed.), *A Bibliography of Modern History* (1968)

It should also be mentioned that the Historical Association's *Annual Bulletin of Historical Literature* contains a brief section on history since 1914.

HISTORIES

Bealey, F. and Pelling, H., *Labour and Politics 1900–1926* (1958)

Butler, D. and Sloman., A., *British Political Facts 1900–1979* (1980) [ministers, elections, parties, some statistics]

Cole, G.D.H., *History of the Labour Party from 1914* (1948)

Cole, G.D.H. and Cole, M.I., *The Condition of Britain* (1937)

Fulford, R., *Votes for Women* (1957)

Havinghurst, A.F., *Twentieth Century Britain* (1962)

Medlicott, W.N., *Contemporary England 1914–1964* (1967)

Roberts, J.M., *Europe 1880–1945* (1970)

Taylor, A.J.P., *English History, 1914–1945* (1965) [lively, entertaining, idiosyncratic; good bibliography]

Thomson, D., *England in the Twentieth Century 1914–1963* (1965)

2 Autobiographies, diaries, memoirs, reminiscences

Church, R., *Over the Bridge* (1955) [growing up in middle-class South London]

Daiches, D., *Two Worlds: An Edinburgh Jewish Childhood* (1957) [from 1919]

Davies, C. S., *North Country Bred: A Working-Class Family Chronicle* (1963) [south-east Lancashire]

Forrester, H., *Liverpool Miss* (1979)
Twopence to Cross the Mersey (1974) [Merseyside in the thirties]

Glasser, R., *Growing Up in the Gorbals* (1986) [Glasgow tenement life between the wars]

Hitchman, Janet, *King of the Barbareens* (1960, repr. 1966) [foster homes and institutions in East Anglia between the wars]

Holloway, J., *A London Childhood* (1966) [South London in the twenties]

Jameson, S., *Journey from the North* (Vol. 1, 1969, repr. 1984) [from Edwardian Whitby to literary London]

Jasper, A.S., *A Hoxton Childhood* (1969, repr. 1975) [working-class life in East London from before the First World War to the mid-twenties]

Kitchen, F., *Brother to the Ox* (1940, repr. 1961) [farm labouring in Yorkshire]

Lawrence, T.E., *Seven Pillars of Wisdom* (1935)

Lee, L., *Cider with Rosie* (1959) [growing up in a Cotswold village]

Norman, F., *Banana Boy* (1969) [Barnardo Homes childhood in the thirties]

O'Connor, F., *An Only Child* (1958) [southern Ireland from 1903 to the twenties]

Powys, J.C., *Autobiography* (1934, repr. 1949)

Roberts, R., *The Classic Slum: Salford Life in the First Quarter of the Century* (1971)
A Ragged Schooling (1978)

Rodaway, Angela, *A London Childhood* (1960) [poverty during the twenties and thirties]

Rowse, A.L., *A Cornish Childhood* (1942, repr. 1956)

Russell, B., *Autobiography* (2 vols., 1967 and 1978)

Sitwell, Osbert, *Laughter in the Next Room* (1949) [the fourth – particularly recommendable – volume of a five-part autobiography *Left Hand, Right Hand* (1945–50)]

Waugh, Evelyn, *A Little Learning: The First Volume of an Autobiography* (1964)

Webb, Beatrice, *My Apprenticeship* (1926)
Our Partnership (1948)
The Diaries 1912–24 (ed. M. Cole) (1952)
The Diaries 1924–32 (1956)

Wells, H.G., *Experiment in Autobiography* (1934)

Williams, E., *George; An Early Autobiography* (1961) [from South Wales to Oxford]

3 · Cultural institutions

GENERAL

Cockburn, C., *Bestseller: The Books that Everyone Read 1900–1939* (1972)

Eliot, T.S., *Notes Towards a Definition of Culture* (1948)

Hoggart, R., *The Uses of Literacy* (1957)

Leavis, F.R., and Thompson, D., *Culture and Environment* (1933) [seminal work, still highly recommendable]

Leavis, Q.D., *Fiction and the Reading Public* (1932, repr. 1968)

Munford, W.A., *Penny Rate: Aspects of British Public Library History 1850–1950* (1951)

Murison, W.S., *The Public Library* (1955)

Williams, R., *Culture and Society 1780–1950* (1958)
The Long Revolution (1961)
Communications (1962, rev. 1976)

EDUCATION

Armytage, W.H.G., *Civic Universities* (1955)

Cook, Caldwell, *The Play Way* (1917)
Curtis, S.J., *Education in Britain since 1900* (1952)
Isaacs, S., *The Intellectual Growth of Young Children* (1930)
 The Social Development of Young Children (1933)
Lowndes, D.A.N., *Silent Social Revolution: an Account of the Expansion of Public Education in England and Wales, 1895–1935* (1937)
Russell, B., *Education and the Social Order* (1932)
 On Education (1926)
Sampson, G., *English for the English* (1921, repr. 1952)
Stocks, M., *The W.E.A.: the First Fifty Years* (1953)
Whitehead, A.N., *The Aims of Education* (1929)

THE MEDIA

Angell, N., *The Press and the Organisation of Society* (1922, rev. 1933)
Briggs, A., *A History of Broadcasting in the United Kingdom* (4 vols., 1961–79)
 Mass Entertainment: The Origins of a Modern Industry (1960)
Coase, R.H., *British Broadcasting: A Study in Monopoly* (1950)
H.M.S.O. *Report of Royal Commission on the Press (CMD 7700)* (1949)
P.E.P. (Political and Economic Planning), *Report on the British Press* (1938)
Reith, J.C.W., *Into the Wind* (1949) [autobiography]
Thompson, D., *Between the Lines: or How to Read a Newspaper* (1939)
 Voice of Civilisation: An Enquiry into Advertising (1943) [penetrating analysis, well-documented]
Turner, E.S., *The Shocking History of Advertising* (1952, rev. 1965) [superficial, but informative]

4 *Economic and social background*

Abrams, M., *Condition of the British People 1911–1945* (1945)
Allen, C.J., *Locomotive Practice and Performance in the Twentieth Century* (1969) [Britain's railways in their heyday]
Brunner, E., *Holiday Making and the Holiday Trades* (1945)
Carr-Saunders, A.M. and Jones, D.C., *A Survey of the Social Structure of England and Wales* (1927, rev. 1937)
Clephane, J., *Ourselves, 1900–1930* (1933)
Cunnington, C., *English Women's Clothing in the Present Century* (1952)

Dibelius, W., *England* (1930)
Halsey, A.H. (ed.), *Trends in British Society since 1900* (1972)
Marsh, D.C., *The Changing Social Structure of England and Wales, 1871–1951* (1958)
Marwick, A., *Britain in Our Own Century: Images and Controversies* (1984)
 The Explosion of British Society 1914–1970 (1971) [previously *The Explosion of British Society 1914–1962* (1963)]
Orr, John Boyd, *Food, Health and Income: A Survey of Adequacy of Diet in Relation to Income* (1936)
Pankhurst, C., *Unshackled: The Story of How We Won the Vote* (1959)
P.E.P., (Political and Economic Planning), *Report on the British Health Service* (1937)
Pilgrim Trust, *Men Without Work* (1938)
Pollard, S., *The Development of the British Economy 1914–50* (1962) [pedestrian but encyclopaedic]
Robertson Scott, J.W., *England's Green and Pleasant Land* (1925, repr. 1947)
Rowntree, B. Seebohm, *Poverty and Progress* (1941)
Sinclair, R., *Metropolitan Man* (1937) [gruesome, carefully documented anatomy of London and its population's living conditions]
Stevenson, J., *British Society, 1914–45* (1984) [good readable social history]
Tawney, R.H., *Equality* (1931) (rev. 1952, 1964)
Titmuss, R.M., *Birth, Poverty and Wealth* (1943)
 Poverty and Population (1938)
Zweig, F., *Labour, Life and Poverty* (1948)
 Women's Life and Labour (1952)
 The British Worker (1952)

5 *Historical perspectives*

THE PRE-WAR YEARS (1900–14)

Dangerfield, G., *The Strange Death of Liberal England* (1936) [racy classic account of the Edwardian crisis from a thirties perspective]
Ensor, R.C.K., *England, 1870–1914* (1936)
Hearnshawe, E. (ed.), *Edwardian England* (1933)
Keating, P. (ed.), *Into Unknown England, 1866–1913* (1976)
Nowell-Smith, S. (ed.), *Edwardian England 1901–1914* (1964)
O'Day, Alan (ed.), *The Edwardian Age* (1979)
Priestley, J.B., *The Edwardians* (1970)

Read, Donald (ed.), *Edwardian England* (1982)

Sassoon, Siegfried, *The Old Century and Seven More Years*

Stratford, E.W., *The Victorian Aftermath* (1933)

Sturt, G. ('George Bourne'), *Change in the Village* (1912, repr. 1935)

Thompson, Paul, *The Edwardians* (1975) [oral history: the Edwardian age remembered]

FIRST WORLD WAR (1914–18)

Blunden, E., *Undertones of War* (1928, rev. 1930, repr. 1962)

Brittain, V., *Testament of Youth* (1933) [woman's-eye view]

Churchill, W.S., *The World Crisis, 1911–1918* (6 vols. 1923–31, abridged one-vol. edn 1960, repr. 1964)

Ferguson, J., *The Arts in Britain in World War 1* (1980) [includes popular arts]

Fussell, P., *The Great War and Modern Memory* (1975) [draws upon poetry, novels, memoirs, letters, etc., to reconstruct the war experience, and to probe its aftermath in the national consciousness]

Hart, B.H. Liddell, *The Real War 1914–1918* (1930); rev. and enl. as *A History of the World War 1914–1918* (1934, repr. 1972) [standard military history]

Graves, R., *Goodbye to All That* (1929, rev. 1957, repr. 1960)

James, R.R., *Gallipoli* (1965)

Jones, B. and Howell, B., *Popular Arts of the First World War* (1972)

Liddle, P., *Aspects of Conflict 1916* (1986) [ninety-five per cent visual: photos, letters, diaries, cartoons, etc., all annotated]

Macdonald, L., *The Roses of No Man's Land* (1980) [oral and personal accounts]

McKenna, S., *While I remember* (1922) [life in England during the War]

Manning, F., *The Middle Parts of Fortune: Somme and Ancre 1916* (1929, repr. 1977) [an expurgated version appeared in 1930 under the title *Her Privates We*]

Marwick, A., *The Deluge: British Society and the First World War* (1965, repr. 1967) [standard work on First World War and British social history]
Women at War 1914–1918 (1977)

Pankhurst, S., *The Home Front* (1932, repr. 1987)

Peel, C.S., *How We Lived Then* (1929) [the home front during the First World War]

Ponsonby, A., *Falsehood in Wartime* (1928, repr. 1940)

Read, Herbert, *In Retreat: Experiences in the British Fifth Army in March 1918* (1925, repr. 1930) [also repr. in *Annals of Innocence and Experience* (1946)]

Richards, Frank, *Old Soldiers Never Die* (1933, repr. 1964)

Sassoon, Siegfried, *Complete Memoirs of George Sherston* (1937, repr. 1972) [single-volume reprint of *Memoirs of a Fox-Hunting Man* (1928), *Memoirs of an Infantry Officer* (1930), and *Sherston's Progress* (1936)]
Siegfried's Journey 1916–1920 (1945, repr. 1973)

Taylor, A.J.P., *The First World War: an Illustrated History* (1963)

Terraine, J., *The Road to Passchendale: The Flanders Offensive of 1917: a Study in Inevitability* (1977)
The Smoke and the Fire (1980) [about the myths and pseudo-history]
To Win a War: 1918, The Year of Victory (1981)
White Heat: The New Warfare 1914–1918 (1982)

Winter, D., *Death's Men* (1978) [the experience of trench warfare]

Wolff, Leon, *In Flanders Field* (1959) [good account of the 1917 campaign]

BETWEEN THE WARS (1919–39)

Barnett, C., *The Collapse of British Power* (1972) [provocative account of national decline]

Beauman, N., *A Very Great Profession* (1983) [women's fiction between the wars]

Blythe, Ronald, *The Age of Illusion: Glimpses of Britain between the Wars 1919–1940* (1963, repr. 1983)

Bowley, M., *Housing and the State, 1919–1944* (1945)

Branson, N., and Heinemann, M., *Britain in the 1930s* (1971)

Donaldson, F. (*et al.*), *Those Were the Days: a Photographic Album of Daily Life in Britain, 1919–39* (1983)

Graves, R. and Hodge, A., (eds.), *The Long Week-end: A Social History of Great Britain, 1918–1939* (1940, repr. 1986) [very readable, avowedly superficial, frequently entertaining, not always reliable]

Green, M., *Children of the Sun: a Narrative of 'Decadence' in England after 1918* (1977) [mainly about Harold Acton and Brian Howard; an intriguing byway]

Hannington, W., *Unemployed Struggles 1919–1936* (1936)

Harrison, T. and Madge, C., *Britain by Mass Observation* (1939, repr. 1986)

Hutt, G.A., *Post-War History of the British Working Class* (1937)

Lewis, W.A., *Economic Survey, 1919–1939* (1940)

Mowat, C.L., *Britain Between the Wars, 1918–1940* (1955) [useful survey, helpful bibliography]

Muggeridge, M., *The Thirties* (1940) [highly entertaining]

Orwell, G., *The Road to Wigan Pier* (1937)

Pearsall, R., *Popular Music of the Twenties* (1976)

Pimlott, B., *Labour and the Left in the 1930s* (1977)

Priestley, J.B., *English Journey* (1934)

Sinclair, Andrew, *The Red and the Blue* (1986)

Stevenson, John and Cook, C., *The Slump* (1977, repr. 1979)

Symons, Julian, *The General Strike* (1957)
The Thirties: A Dream Revolved (1960) [partly autobiographical]

Waterson, M., (ed.), *The Country House Remembered: Recollections of Life Between the Wars* (1985)

6 The intellectual background

PHILOSOPHY

Ayer, A.J., *Language, Truth and Logic* (1936, repr. 1969)
Philosophy in the Twentieth Century (1982) [discusses Russell, Moore, Wittgenstein, Ryle, Collingwood]

Collingwood, R.G., *An Autobiography* (1939)
Essay on Philosophical Method (1933)
The Philosophy of History (1934)
Religion and Philosophy (1916)

Coppleston, F.C., *Contemporary British Philosophy* (1956) [dominant trends reviewed from a dissentient viewpoint]

Fann, K.T., (ed.), *Ludwig Wittgenstein: The Man and his Philosophy* (1967) [useful introduction; bibliography]

Magee, B., *Modern British Philosophy* (1971) [Based on radio interviews with thirteen philosophers; helpful reading-list]

Moore, G.E., *Ethics* (1912)
Philosophical Studies (1922)
Principia Ethica (1903)

Muirhead, J.H., *Contemporary British Philosophy: Personal Statements* (1st series 1924; 2nd series 1929; both repr. 1965)

Pears, D., *Bertrand Russell and the British Tradition in Philosophy* (1967)

Russell, B., *An Inquiry into Meaning and Truth* (1940)
Problems of Philosophy (1912)

Urmston, J.O., *Philosophical Analysis: Its Development between the Two World Wars* (1956)

Warnock, G.J., *English Philosophy since 1900* (1958)

Warnock, M., *Ethics since 1900* (1960)

Whitehead, A.N., *Essays in Science and Philosophy* (1948)
Modes of Thought (1938)

Williams, B. and Montefiore, A. (eds.), *British Analytical Philosophy* (1966)

Wittgenstein, L., *The Blue and Brown Books* (1958) [lectures 1933–5]
Philosophical Investigations, 1936–1949, ed. G. Anscombe (1953)
Tractatus Logico-Philosophicus (1920)

RELIGION

Eliot, T.S., *The Idea of a Christian Society* (1938)

Frazer, J.G., *The Golden Bough* (12 vols. 1890–1915)

Gilbert, Alan D., *The Making of Post-Christian Britain: a History of the Secularisation of Modern Society* (1980)

Harvey, G.C.H. (ed.) *The Church in the Twentieth Century* (1936)

Hastings, A., *A History of English Christianity, 1920–1985* (1986)

Lloyd, R.B., *The Church of England in the Twentieth Century*, Vol. 1, 1900–19 (1946), Vol. 2, 1919–39 (1950)

Spinks, G.S. (ed.), *Religion in Britain since 1900* (1952)

Watkin, E.L., *Roman Catholicism in England from the Reformation to 1950* (1957)

Wearmouth, R.F., *The Social and Political Influence of Methodism in the Twentieth Century* (1957)

SCIENCE

Bernal, J.D., *The Social Foundation of Science* (1939)
The Natural Sciences in Our Time (1969)

Crowther, J.G., *British Scientists of the Twentieth Century* (1952)

Dingle, H. (ed.), *A Century of Science, 1851–1951* (1951)

Heath, A.E. (ed.), *Scientific Thought in the Twentieth Century* (1951)

Taton, R., *Science in the Twentieth Century* (1966)

Waddington, C.H., *The Scientific Attitude* (1941)

Whitehead, A.N., *Science and the Modern World* (1925)

II Architecture and Design

Throughout the period many architects were actively concerned with the contents of the buildings they designed as well as the setting in which these buildings were placed. It is more convenient therefore to combine together (with appropriate sub-headings) the reference sections for Chapter 6 'Architecture'; Chapter 8 'Design and Industry'; Chapter 2 'The Garden City'; and Chapter 9; 'John Laing's Sunnyfields Estate, Mill Hill'.

1 General principles of design

Banham, R., *Theory and Design in the First Machine Age* (1960)

Benton, T. and C. (eds), *Form and Function: A Sourcebook for the History of Architecture and Design 1890–1939* (1975)

Bertram, A., *Design in Daily Life* (1937)
Design (1938, rev. 1942) [includes bibliography]

Carrington, N., *Design and a Changing Civilisation* (1935)
The Shape of Things: An Introduction to Design in Everyday Life (1939)

Le Corbusier, *Towards a New Architecture* (1927, first published in 1923 as *Vers une Architecture*)

Garner, P., Bayley, S., and Sudjic, D., *Twentieth Century Style and Design* (1987) [wide-ranging; international coverage; generously illustrated]

Gloag, J. (ed.), *Design in Modern Life* (1934)

Gropius, W., *The New Architecture and the Bauhaus* (1935)

Martin, J.L., Nicholson, B., and Gabo, N. (eds.), *Circle: International Survey of Constructivist Art* (1937)

Muthesius, H., *Das Englische Haus* (1904–5) (English translation ed. Sharp, D., 1979)

Pevsner, N., *An Enquiry into Industrial Art in England* (1937)
Pioneers of Modern Design (1936, repr. 1960) [seminal work, admirably chosen illustrations]
The Sources of Modern Architecture and Design (1968)
Studies in Art, Architecture and Design (2 vols., 1968, 1982)

Pevsner, N. and Richards, J.M. (eds.), *The Anti-Rationalists* (1973)

Read, H., *Art and Industry* (1934, rev. 1944, 1953, 1956, 1966)

Sharp, D. (ed.), *The Rationalists: Theory and Design in the Modern Movement* (1978)

2 Architects, artists, designers, etc.

Adam, David Alexander (1882–1953)
Architect; 1916–17 joined John Laing's team building the munition workers' township at Gretna; 1927–48 Laing's staff architect, designing the firm's first housing development at Esher, and supervising Laing's estate development through the 1930s.

Ashbee, Charles R. (1863–1942)
Architect, author and designer; 1886 articled, as architect, to Bodley; 1886–1901 designed silverware and cutlery while working in London's East End; 1888 founded Guild of Handicraft, establishing it in 1890 in Essex House, Mile End; 1898 founded Essex House Press, designing his own type-face in 1900; 1902 moved Guild to Chipping Camden; 1908 Guild dissolved after financial crisis. Buildings include houses at 38–9 Cheyne Walk (1901).
Writings:
Chapters in Workshop Reconstruction and Citizenship (1894)
An Endeavour Towards the Teaching of J. Ruskin and W. Morris (1901)
Socialism and Politics (1906)
Craftsmanship in Competitive Industry (1908)
Modern English Silverwork (1909)
The Guild of Handicraft (1909)
Should We Stop Teaching Art? (1911)
See:
Crawford, A., *C.R. Ashbee: Architect, Designer, and Romantic Socialist* (1986)
MacCarthy, F., *The Simple Life: C.R. Ashbee in the Cotswolds* (1981)

Belcher, John (1841–1913)
Architect; 1884 one of the original members (with Pite) of the Art Workers' Guild; 1885 took Pite into partnership, leading to success (1888) in competition for design of Institute of Chartered Accountants, Moorgate (completed 1893); 1897 Pite replaced by Joass, who remained as partner till 1913.
Buildings include:
Colchester Town Hall (1897–1902); (with Joass) Ashton Memorial, Lancaster

(1904–9), Whiteley's Department
Store, Queensway, Bayswater
(1910–12), and offices of the Zoological
Society, Regent's Park (1913).
Writings:
(with Macartney, M.,) *Later Renaissance
Architecture in England* (2 vols.,
1898–1901)
Essentials in Architecture (1907)
See:
Service, A., 'Belcher and Joass', in Service
(1975)

Bernard, Oliver P. (1881–1939)
Designer; designed stage sets in England
(Covent Garden) and US (Boston
Opera House); 1924 decorations for
Wembley Empire Exhibition; 1925
technical director for British exhibit at
Paris Exhibition; 1929–30 interiors for
Strand Palace Hotel; also designed
interiors for Cumberland Hotel, Regent
Palace Hotel and Lyons Cornerhouses;
from 1931 designed tubular steel
furniture for Accles and Pollock, and
other firms.
See:
Cock Sparrow (1936) [autobiography]

Burnet, John James (1857–1938)
Architect; 1875–8 studied architecture at
Ecole des Beaux Arts in Paris and
attended atelier of J.L. Pascal; joined
father's practice in Glasgow; after 1905
moved to London; 1914 knighted.
Buildings include:
Glasgow Savings Bank (1895); King
Edward VII Galleries, British Museum
northern extension, Montagu Place
(1904–14); (with T.S. Tait) Kodak
Buildings, Kingsway (1910–11); Vigo
and Westmoreland House, Regent
Street (1920–5); (with T.S. Tait)
Adelaide House, London Bridge
(1921–4).
See:
Walker, D., 'Sir John Burnet' in Service
(1975)

Chermayeff, Serge (b. 1900)
Designer; 1918–22 journalist in London;
1924–7 chief designer for decorating
firm; 1928 director of the Modern Art
Studio set up by furniture
manufacturers Waring and Gillow;
1931–3 designed modern interiors for
BBC; 1934–6 designed Unit furniture
for Plan Ltd., borrowing ideas from
Franz Schuster of Vienna; 1939
emigrated to America.

Coates, Wells (1895–1958)
Architect, designer, engineer; educated
McGill University; 1924 London
doctorate for research on the diesel
engine, followed by work as engineer
and journalist, then as
engineer–architect; from 1929 designed
shops and shop-fittings for Cresta
Silks; 1930–2 commissioned by R.
McGrath to design three sound studios
for BBC's Broadcasting House; 1931
won competition to design stand for
Venesta plywood company at
Manchester Trade Exhibition; also,
with J. Pritchard of Venesta, formed
Isokon Company; 1932 won Ekco
competition for wireless cabinet design
(produced 1934); 1933 founder member
and first chairman of MARS group,
and joined Paul Nash's Unit One;
1933–4 designed permanent stage set
for Old Vic Theatre; 1937 designed
Thermovent Ekco electric heater; 1944
appointed RDI (Royal Designer for
Industry). Buildings include Isokon
flats, Lawn Road, Hampstead (1934);
and flats at Brighton (1936).
Catalogue:
Wells Coates (1979)
See:
Cantacuzino, S., *Wells Coates* (1978)
Read, H., *Unit 1: The Modern Movement in
English Architecture, Painting and
Sculpture* (1934)

Day, Lewis Foreman (1845–1910)
Author, designer; designed stained glass,
textiles, pottery, carpets, wallpaper,
tiles, clocks and furniture; 1884
founder member of the Art Workers
Guild.
Writings include:
Windows (1897, repr. 1909)
Alphabets Old and New (1898, repr. 1910)
Lettering in Ornament (1902)
Painting Design (1903)
Stained Glass (1903)
Ornament and its Application (1904)
Enamelling (1907)
Nature and Ornament (2 vols., 1908–9)
(with Buckle, M.), *Art in Needlework* (1900,
rev. 1927; rev. 1974 as *Art Nouveau
Embroidery*)

Fry, Edwin Maxwell (1899–1987)
Architect; trained at Liverpool University
under Sir C. Reilly; as one of the
leaders of the modern movement in the
1930s, helped to bring Gropius to
Britain to escape Nazi persecution;
1932 edited DIA's journal *Design in*

Industry (first issue); 1934–6 partnership with Gropius. Buildings include: Sassoon House, Peckham (1932); Sun House, Frognal Way, Hampstead (1935); Kensal House (1937); with Gropius, Impington Village College, Cambridgeshire (1938).

Writings:
Autobiographical Sketches (1975)
Architecture and the Environment (1976)

Gimson, Ernest (1864–1920)

Architect, craftsman, designer; from 1901 designed furniture and, later, plasterwork and metalwork; designs were executed by craftsmen at Cirencester, and later in the Cotswolds at his own Daneway House Workshops, Sapperton, set up with Ernest and Sidney Barnsley and Peter Waals; 1907 large exhibition of his furniture at Debenham and Freebody's store in London; 1916 refused Lethaby's invitation to join DIA.

See:
W.R. Lethaby, *Ernest Gimson: His Life and Work* (1924)
Catalogue: *Ernest Gimson*, Leicester Museums, 1969.

Heal, Ambrose (1872–1959)

Designer; 1890–3 apprenticed as cabinet-maker; 1893 joined family firm (designer/retailer shop in Tottenham Court Road dedicated to sale of 'reasonable furniture'); from 1896 designed furniture in Arts and Craft style; 1907 managing director; 1913 chairman; 1925 silver medal for bedroom suite at Paris Exhibition; from 1930 success with more modern styles of design; 1933 knighted.

See:
Goodden, S., *A History of Heals* (1984)

Hill, Oliver (1887–1968)

Architect and designer; 1907–10 trained as architect; from 1910 built numerous houses in a range of styles for fashionable clientele, also making reputation as interior decorator; 1924 designed pottery section of Wembley British Empire Exhibition; 1931–2 Midland Hotel, Morecambe, with interiors incorporating work by Marion Dorn, Eric Gill, Duncan Grant and Eric Ravilious; 1933 supervising architect for Dorland Hall Exhibition of British Industrial Art; 1934 designed Exhibition of Contemporary Industrial

Art in the Home; 1937 British Pavilion at Paris International Exhibition.

Holden, Charles (1875–1960)

Architect; 1898–9 worked with C.R. Ashbee; 1899 joined firm of H. Percy Adams; 1924 commissioned by Frank Pick to design facade for Bond Street tube station, followed by fifteen years' collaboration over all aspects of London Transport design, including details such as street signs, cable posts and lamp standards, as well as underground stations (1926–8 southern extension to Northern Line, 1930–2 northern extension to Piccadilly Line), and 1927–9 London Transport headquarters, 55 Broadway, Westminster. Buildings include: Belgrave Hospital, Kennington (with H. Percy Adams 1900–3); Norwich House, 127 High Holborn (1904); Midhurst Sanatorium (1903–6); Central Reference Library, Bristol (1905–7); British Medical Association Building, 429 Strand (now Zimbabwe House 1907–8); Evelyn House, 62 Oxford Street (1908–10); University of London Senate House, near Russell Square (1932–53).

See:
Pevsner, N., 'Charles Holden's early works' in Service (1975)

Howard, Ebenezer (1850–1928)

Author and social reformer; originator of the garden city movement and founder of Letchworth and Welwyn Garden Cities; 1899 formed Garden City Association; 1927 knighted.

Writings:
Tomorrow: a Peaceful Path to Real Reform (1898), revised 1902 as *Garden Cities of Tomorrow* (repr. 1946, and 1965)

See:
Macfadyen, D., *Sir Ebenezer Howard and the Town Planning Movement* (1933)
Newton, E., 'The Garden City' and Macartney, M., 'Letchworth' in Service (1975)

Joass, John James (1868–1952)

Architect; started career in Glasgow; 1897–1913 junior partner with Belcher; from 1913, independent practice.

Buildings include: (with Belcher) Mappin House, 158–162 Oxford Street (1906–8); Royal Insurance office, 161 Piccadilly (1907–8); (on his own) various buildings at London Zoo, Regent's Park, including aquarium

under Mappin Terraces (1924–9);
Commonwealth Bank of Australia, 8
Old Jewry, in the City (1931);
Clarendon House, 17 New Bond Street
(1932).
See:
Service, A., 'Belcher and Joass' in Service
(1975)

Johnston, Edward (1872–1944)
Calligrapher, designer of lettering; 1899
to 1912 taught writing and lettering
at London County Council's Central
School of Arts and Crafts; from 1901
also taught at RCA; 1916–31
commissioned by Frank Pick to design
lettering and type-face for London
Transport underground and buses;
1945–6 commemorative exhibition at
Victoria and Albert Museum.
Writings:
Writing and Illuminating, and Lettering
(1906)
Manuscript and Inscription Letters (1909)
See:
Johnston, P., *Edward Johnston* (1969)

Kauffer, Edward McKnight (1890–1954)
American artist and designer working in
England from 1914–40; 1915 given first
commission for a poster by Frank Pick;
from 1920 gave up painting to
concentrate on designing posters (c. 250
in all) and book-jackets (c. 150); also
designed rugs and interiors; 1940
returned to US.
See:
Haworth-Booth, M., *E. McKnight Kauffer:
A Designer and his Public* (1979).

Kenyon, Arthur W. (1885–1969)
Architect, town planner; 1912 won
competition for King Edward VII
Memorial Hospital, Sheffield; for much
of the 1920s joint architect and town
planner (with Louis de Soissons) for
Welwyn Garden City. Other buildings
include the Majestic Cinema, Rochester
(1935), the Palace Cinema, Chatham
(1937) and St Alban's Church, North
Harrow (1937).
Writings:
(with Louis de Soissons) *Site Planning in
Practice at Welwyn Garden City* (1927)

Laing, John William (1879–1978)
Master builder; head of John Laing
Construction, where his evangelical
Christian philosophy influenced both
his approach to building design and his
dealings with his workforce; 1959
knighted.

See:
Coad, R., *Laing: The Biography of Sir John
W. Laing, CBE* (1979)

Lethaby, William Richard (1857–1931)
Architect, author, designer; from 1891
independent architectural practice,
chief works being large country houses,
including High Coxlease, near
Lyndhurst, Hampshire (1900–1), and
Melsetter House, Hoy Island, Orkneys
(1898–1902); also Church of All Saints,
Brockhampton near Ross-on-Wye,
Herefordshire (1901–2); first Professor
of Design at RCA (1900–18); 1915
active in the creation of DIA; as
surveyor, Westminster Abbey
(1906–28), became influential authority
on care of old buildings.
Writings include:
Architecture, Mysticism and Myth (1892,
repr. 1975); also rewritten in parts in
The Builder in 1928 and republished as
Architecture, Nature and Magic (1956)
*Medieval Art from the Peace of the Church
to the Eve of the Renaissance, 312–1350*
(1904, rev. 1912)
Architecture (1911)
Form in Civilisation (1922, repr. 1957)
Londinium, Architecture and Crafts (1923,
repr. 1976)
Home and Country Arts (1923, rev. and enl.
1930)
Westminster Abbey Re-examined (1925)
Philip Webb and his Work (1925, repr. 1935)
See:
Roberts, A.R.N., (ed.), *William Richard
Lethaby* (1957)

Lloyd, Thomas Alwyn (1881–1960)
Architect; studied at University of
Liverpool School of Architecture,
before entering the office of Raymond
Unwin at Hampstead Garden Suburb;
1912 moved to South Wales, first as
architect to the Welsh Town Planning
and Housing Trust Ltd (a leading
garden village developer), later as
architect and planner on his own
account.

Lubetkin, Berthold (b. 1901)
Architect; b. Russia; 1922 emigrated to
Paris; 1930 moved to London; 1932
formed Tecton group; 1948 architect-
planner to Peterlee New Town, Co.
Durham. Buildings include: Gorilla
House (1934) and Penguin Pool (1935),
London Zoo; High Point I, Highgate
(1935); High Point II (1938); Finsbury
Health Centre (1938)

Lutyens, Edwin Landseer (1869–1944)
Architect; 1897–1914 gained reputation
with numerous country houses; 1908–9
consulting architect to Hampstead
Garden Suburb; 1912 consulting
architect to New Delhi planning
commission; 1913 designer of Viceroy's
House (completed 1929); 1918
knighted; 1919 designed Whitehall
Cenotaph (followed by commissions for
numerous war memorials); 1920
designed Britannic (renamed Lutyens)
House, Moorgate; 1933 work
commenced on Liverpool R.C.
Cathedral (only part of the crypt was
built; a new design was obtained in
competition and built after 1955); 1942
OM

Life:
Hussey, C., *The Life of Sir Edwin Lutyens*
(1950, repr. 1953)
See:
Brown, J., *Gardens of a Golden Afternoon*
(1982)
Butler, A.S.G., *The Architecture of Sir
Edwin Lutyens* (3 vols., 1950)
Irving, R.G., *Indian Summer: Lutyens,
Baker and Imperial Delhi* (1981)
Lutyens, R., *Sir Edwin Lutyens, an
Appreciation in Perspective* (1942)
Pevsner, N., 'Building with wit: The
architecture of Sir Edwin Lutyens' in
Service (1975)
Reilly, C.H., *Representative British
Architects of the Present Day* (1931)
Weaver, L., *Houses and Gardens of Edwin
Landseer Lutyens* (1913)

McGrath, Raymond (1903–77)
Architect and designer; 1921 Sydney School
of Architecture; 1926 travelled to
England to take up research
studentship in architecture at
Cambridge; 1929–30 remodelled for
Mansfield Forbes the famous house
Finella in Cambridge; from 1929 in
charge of BBC Studio Design
Committee, himself designing in the
new Broadcasting House the studios for
dance music and chamber music, and
commissioning Chermayeff and Coates
to design other studios; also designed
wallpapers (for Sanderson), radio
cabinets (for Ekco), unit furniture and
aircraft interiors.
Writings:
Twentieth Century Houses (1943)
Glass in Architecture and Decoration (1937)

Mackintosh, Charles Rennie
(1868–1928)
Architect, designer, painter; 1885
Glasgow School of Art; 1890 visited
France and Italy with travelling
scholarship; winner in 1894 of
competition for new building of
Glasgow School of Art, 167 Renfrew
Street, Garnethill (completed 1900);
from 1897, with George Walton,
decorated and furnished four Miss
Cranston's tea-rooms in Glasgow; 1900
invited to exhibit at Secessionist
Exhibition in Vienna; 1902 Scottish
pavilion at Turin Exhibition, followed
by further acclaimed exhibitions in
Venice, Munich, Dresden, Budapest
and Moscow; 1913 gave up
architectural partnership in Glasgow
and moved to London, where he
worked on designs for textiles, together
with landscape painting (in Suffolk
1914–18) and flower-sketches;
subsequently devoted himself to
watercolours, mainly around Port
Vendres in Eastern Pyrenees; died in
London, almost forgotten.
Other buildings include: Queen's Cross
Church, Woodside, Glasgow (1897–9);
Ruchill Church Hall, Maryhill,
Glasgow (1899); (houses) 'Windyhill',
Kilmacolm, Renfrewshire (1899–1901)
and Hill House, Helensburgh,
Dumbartonshire (1902–4); Scotland
Street School, Glasgow (1904–6);
Library Wing, Glasgow School of Art
(1907–9).

Bibliography:
Dixon, E., *Charles Rennie Mackintosh: a
Selective Bibliography* (1981)
Catalogue:
Charles Rennie Mackintosh: Some Designs
(Architectural Association Exhibition,
1981)
See:
Billcliffe, R., *Architectural Sketches and
Flower Drawings by Charles Rennie
Mackintosh* (1977)
Charles Rennie Mackintosh (1979, rev.1980)
Charles Rennie Mackintosh Furniture (1985)
Charles Rennie Mackintosh Textile Designs
(1982)
Charles Rennie Mackintosh Watercolours
(1978, repr. 1979)
Bliss, D.P., *Charles Rennie Mackintosh and
the Glasgow School of Art* (1961)
Cooper, J. (ed.), *Charles Rennie Mackintosh:
The Complete Buildings and Selected
Projects* (1978, rev. 1980)
Howarth, T., *Charles Rennie Mackintosh
and the Modern Movement* (1952, rev.
1977)

Macleod, R., *Charles Rennie Mackintosh* (1968, rev. 1983)

Pevsner, N., *Charles Rennie Mackintosh* (1950, in Italian, translated in Vol. II of *Studies in Art, Architecture and Design*, 1968)

Mountford, Edward William (1855–1908)

Architect. Buildings include: 1890–7 Sheffield Town Hall; 1900–7 Central Criminal Courts, Old Bailey, London.

Pick, Frank (1878–1941)

Administrator, sponsor of good design; worked for London Underground from 1906; commissioned Edward Johnston to design type-face, tiles from Harold Stabler, fabrics from Marion Dorn, posters from artists such as Paul Nash and E. McKnight Kauffer; raised standard of book design; commissioned Charles Holden to design underground stations on southern extension to Northern Line (from 1926) and on northern extension to Piccadilly Line (1930–2), also London Transport headquarters (1927–9); 1928 managing director, London Underground; 1933 vice-chairman, London Passenger Transport Board; 1934 first chairman of Council for Art and Industry.

See:
Barman, C., *The Man Who Built London Transport: A biography of Frank Pick* (1979).

Pite, Arthur Beresford (1861–1934)

Architect; 1885–97 junior partner to Belcher; independent practice from 1897; 1900–23 Professor of Architecture at RCA; 1905–28 Architectural Director of LCC's School of Building at Brixton.

Buildings include: No. 82 Mortimer Street, Marylebone (1896); Christ Church, Brixton Road, Oval (1897–1903); Carnegie Public Library, Thornhill Square, Islington (1906–8); London, Edinburgh and Glasgow Assurance Company Buildings, Euston Square (1906–12); new Piccadilly entrance to Burlington Arcade, London (1911–30).

See:
Service, A., 'Arthur Beresford Pite' in Service (1975)

Rickards, Edwin Alfred (1872–1920)

Architect; in partnership with H.V. Lanchester, planner and engineer, won a series of major competitions between 1897 and 1906; long friendship with

Arnold Bennett, who based on him the protagonist of the novel *The Roll Call* (1918)

Buildings include:
Cardiff City Hall and Cardiff Law Courts (1898–1906); Deptford Town Hall (1902–4); Central Methodist Hall, Storey's Gate, Westminster (1905–11)

See:
Bennett, A., Lanchester, H. and Fenn, A., *The Art of E.A. Rickards* (1920)

Warre, J., 'Edwin Alfred Rickards' in Service (1975)

Russell, Gordon (1892–1980)

Designer and craftsman; educated in Chipping Camden, coming under influence of C.R. Ashbee; set up workshop in Broadway, Worcestershire, to conserve and rennovate antique furniture; after war service (1914–18) designed and made furniture in Arts and Crafts style with local craftsmen; from 1925 introduced machinery in the workshops; from 1930 turned to Modern Style furniture, also designing radio cabinets for Murphy; from 1942 a member of Board of Trade committee which initiated 'Utility' furniture; 1947 first Director of Council of Industrial Design; 1955 knighted.

Writings:
Designer's Trade (1968) [autobiographical]
See:
Baynes, K. and K., *Gordon Russell* (1981)

Scott, Gilbert Giles (1880–1960)

Architect; son of Gothic revivalist George Gilbert Scott; 1903 winner of competition for Liverpool Anglican Cathedral; 1924 knighted; 1932 appointed architect for new Waterloo Bridge (opened 1945); 1944 OM; 1948–50 restoration of House of Commons.

Other buildings include: (churches) St Alban's, Golders Green, London; St Michael's, Ashford, Middlesex; St Andrew's, Luton (1932); St Maughold's, Ramsey, Isle of Man; chapels for Charterhouse School (1926) and for Ampleforth Abbey, Yorkshire; (university buildings) University Library, Cambridge (1934); extension to Clare College, Cambridge (1924) and to Bodleian Library, Oxford (1942)

See:
Cole, D., *The Work of Sir Gilbert Scott* (1980)

Dixon, R. (ed.), *Sir Gilbert Scott and the Scott Dynasty*, (1980)

Scott, Mackay Hugh Baillie (1865–1945)
Architect and designer; 1898 designed
furniture made by the Guild of
Handicraft for the Palace of
Darmstadt; 1900–14 designed
furniture, tapestry and interiors for
manufacturers in Germany; buildings
include 1908–9 Waterlow Court in
Heath Close, off Hampstead Way,
Hampstead Garden Suburb.
Writings:
Houses and Gardens (1906, rev. and enl.
1933 with Beresford, E.A.)
See:
Kornwolf, J.D., *M.H. Baillie Scott and the
Arts and Crafts Movement* (1972)

Unwin, Raymond (1863–1940)
Architect, town-planner; friend of William
Morris, and of E. Howard whose ideas
he and Barry Parker put into practical
form, first experimentally in the village
of Earswick near York (1902), then at
Letchworth (1903) and at Hampstead
Garden Suburb (1907); from 1914 into
the early 1920s a civil servant; in the
1920s and 1930s a private planning
consultant, influential on committees
concerned with planning policies; 1932
knighted.
Writings:
Town Planning in Practice (1909)
Nothing Gained By Overcrowding! (1912)
See:
Creese, W.L. (ed.), *The Legacy of Raymond
Unwin: a Human Pattern for Planning*
(1967) [mainly a collection of Unwin's
writings]
Jackson, F., *Sir Raymond Unwin: Architect,
Planner and Visionary* (1985)

Voysey, Charles Francis Annesley
(1857–1941)
Architect and designer; from 1884 engaged
in design for stained glass, fabrics,
wallpaper, furniture, carpets and tiles;
houses include 17 St Dunstan's Road,
Hammersmith (1891–2); 'The
Orchard', Chorley Wood, Herts
(1900–1); 'The Homestead', Second
Avenue, Frinton-on-Sea, Essex (1905)
Writings:
Individuality (1915)
See:
Brandon-Jones, J., *A Life of C.F.A. Voysey*
(1957)
Gebhard, D., *Charles F.A. Voysey,
Architect* (1975)
Simpson, D., *C.F.A. Voysey: an Architect
of Individuality* (1979)

Webb, Aston (1849–1930)
Architect; 1904 knighted; president of
Royal Academy from 1919.
Buildings include: Victoria and Albert
Museum, Cromwell Road (1891–1909);
Christ's Hospital School, near
Horsham, Sussex (1893–1902); Royal
Naval College, Dartmouth
(1899–1905); University of Birmingham
(1900–9); Imperial College of Science
and Technology, South Kensington
(1900–6); Admiralty Arch, The Mall,
Westminster (1911); new East Front,
for Buckingham Palace (1912–13).
See:
H. Bulkeley Creswell, 'Sir Aston Webb and
his Office' in Service (1975)

Williams-Ellis, Clough (1883–1978)
Architect and author; from 1926 developed
Portmeirion, a model village in North
Wales.
Writings include:
(with A. Williams-Ellis), *The Pleasure of
Architecture* (1924)
England and the Octopus (1928)
(ed.) *Britain and the Beast* (1937)
Portmeirion: the Place and its Meaning
(1962, rev. 1973)
Architect Errant (1971)

3 Architecture
Two useful general works of reference are:
Briggs, M.S., *Everyman's Concise
Encyclopaedia of Architecture* (1959)
Richards, J.M. (ed.), *Who's Who in
Architecture from 1400 to the Present
Day* (1977)
The most important sources for the period
are the professional periodicals: *The
Architect* to 1926, thereafter *The Architect
and Building News*; *The Architects Journal*;
The Builder. These were published weekly
and all buildings of consequence were
described and illustrated, with plans, in one
or other of them; sometimes in all of them.
A further useful source is provided by the
publications of the Architectural
Association, namely *Architectural
Association Notes* (monthly, 1887–1904),
and *Architectural Association Journal*
(monthly, with some double-numbers,
1906–65). *The Architectural Review*
(monthly), which started publication in
1896 and continued throughout the period,
is important for critical articles.
 Readers wishing to view (at least from
the outside) the important or interesting
buildings of the period in whatever locality
will do well to consult the relevant volume

in the series, Pevsner, N. and others, *The Buildings of England* (1951, continuing). The volumes (forty-seven to date) are organised on a topographical basis, in most cases one to a county, and in each volume the Index of Artists is an invaluable source of reference to the work of the architects mentioned above.

GENERAL STUDIES

Archer, L., *Raymond Erith, Architect* (1985)
Baker, H., *Architecture and Personalities* (1944)
Betjeman, J., *Ghastly Good Taste* (1933)
Blomfield, R., *Memoirs of an Architect* (1932)
 The Mistress Art (1908) [Royal Academy Lectures of 1907]
Curtis, W.J.R., *Modern Architecture since 1900* (1982)
Dannatt, T., *Modern Architecture in Britain* (1959)
Dean, D., *The Thirties: Recalling the English Architectural Scene* (1983)
Edwards, T., *Good and Bad Manners in Architecture* (1924)
Frampton, K., *Modern Architecture: A Critical History* (1980)
Gomme, A., and Walker, D.M., *The Architecture of Glasgow* (1968)
Goodhart-Rendel, H.S., *English Architecture Since the Regency: an Interpretation* (1953)
Gould, J., *Modern Houses in Britain, 1919–1939* (1977)
Gray, A.S., *Edwardian Architecture: a Biographical Dictionary* (1985) [comprehensive and well-illustrated]
Hitchcock, H.R., *Architecture: Nineteenth and Twentieth Centuries* (1958) [authoritative account of the international background]
Jencks, C., *Modern Movements in Architecture* (1973)
Lancaster, O., *Pillar to Post* (1938, repr. 1963) [witty pictorial guide to architectural history]
Macartney, M., *Recent English Domestic Architecture* (1908)
Macleod, R., *Style and Society – Architectural Ideology in Britain 1835–1914* (1971)
Marriott, C., *Modern English Architecture* (1924)
MARS Group *Catalogue of the MARS Group Exhibition* (1938)
Martin, L., *Buildings and Ideas 1933–83* (1982)
Pritchard, J., *View from a Long Chair* (1984)

Reilly, C.H., *Representative British Architects of the Present Day* (1931)
 Scaffolding in the Sky (1938) [memoirs]
Service, A., *Edwardian Architecture: A Handbook to Building Design in Britain 1890–1914* (1977) [well-illustrated, good select bibliography; useful select list of buildings by leading architects]
Service, A. (ed.), *Edwardian Architecture and its Origins* (1975) [extensive, splendidly illustrated, distinguished contributors; a mine of fascinating material. Referred to above as Service (1975)]
Sharp, D., *The Picture Palace* (1969)
Summerson, J., *The Turn of the Century: Architecture in Britain Around 1900* (1975) [an illuminating summary]
Swenarton, M., *Homes fit for Heroes: the Politics and Architecture of early State Housing in Britain* (1981)
Weaver, L. (ed.), *Small Country Houses of Today* (1910)

4 Design and industry (Includes applied and decorative arts)
The authoritative scholarly reference-work for the period is: Coulson A.J., *A Bibliography of Design in Britain 1851–1970*; for the general reader the most helpful bibliographies are those included in MacCarthy (1982) and Naylor (1971) (see below). Well-researched articles on designers and patrons can also be found in *The Journal of the Decorative Arts Society* (1975, continuing).
 The most important and comprehensive collection of the period's artefacts is that in the Victoria and Albert Museum, South Kensington; apart from this, the products of greatest interest are rather widely dispersed and often difficult to track down. Some guidance may be obtained by consulting the 'Index of Special Collections' in Chapel, J. and Gere, C., *The Fine and Decorative Art Collections of Britain and Ireland* (1985); but the most useful source of information is the countrywide description of numerous collections at the end of MacCarthy (1982).

INSTITUTIONS AND PERIODICAL PUBLICATIONS

The most important of these were:
(i) *Design and Industries Association*, founded in 1915; published six Yearbooks (1922, 1924, 1925, 1927, 1928 and 1930), as well as the periodicals *DIA Quarterly* (1928–32), *Design in Industry* (one issue

only, 1932), *Design for Today* (monthly, 1933–6), and *Trend in Design of Everyday Things* (two issues only, 1936).
(ii) *British Institute of Industrial Art*, founded in 1920 with a small Treasury grant, which was withdrawn the following year; mounted seven exhibitions before its demise in 1933.
(iii) *Society of Industrial Artists*, founded 1930; published *SIA Bulletin*, to issue 13–14 September–November 1947; reconstituted in 1945 as *Society of Industrial Artists and Designers*.
(iv) *Council for Art and Industry*, established by the Board of Trade 1934; ten reports published by HMSO between 1935 and 1939.
(v) *The Studio Year Books of Decorative Art*, 1906–32, also constitute an extremely valuable (privately produced) source of information about the period.

GENERAL STUDIES

Adburgham, A., *Liberty's: A Biography of a Shop* (1975)
Anscombe, I., *A Woman's Touch: Women in Design from 1860 to the Present Day* (1984) [wide-ranging; international coverage]
Anscombe, I. and Gere, C., *Arts and Crafts in Britain and America* (1978)
Battersby, M., *The World of Art Nouveau* (1966)
 The Decorative Twenties (1969) [covers France, Great Britain and America]
 The Decorative Thirties (1971) [wide-ranging, informative]
Bell, Q., *The Schools of Design* (1963)
Campbell-Cole, B., and Benton, T. (eds.), *Tubular Steel Furniture* (1979)
Carrington, N. (ed.), *Design in the Home* (1933)
Cooper, N., *The Opulent Eye. Late Victorian and Edwardian Taste in Interior Design* (1976) [200 superb photographs]
Dowling, H.G., *A Survey of British Industrial Arts* (1935) [interesting illustrations]
Garner, P. (ed.), *Phaidon Encyclopaedia of Decorative Arts 1890–1940* (1978) [42-page section on United Kingdom]
Gloag, J., *Industrial Art Explained* (1934, rev. 1946)
Hillier, B., *The World of Art Deco* (1971)
Jullian, P., *The Triumph of Art Nouveau: Paris Exhibition 1900* (1974) [well-illustrated record]
Kirkham, P., *Harry Peach: Dryad and the D.I.A.* (1986)

Klein, D., McClelland, N. and Haslam, M., *In The Deco Style* (1987) [international coverage]
Lancaster, O., *Homes, Sweet Homes* (1939, repr. 1963) [witty pictorial guide to the interior of homes]
MacCarthy, F., *British Design Since 1880: A Visual History* (1982) [invaluable; splendidly illustrated, with clearly-written text, helpful bibliography, list of catalogues, and a description of collections country-wide]
 A History of British Design 1830–1970 (1979) [a revised version of *All Things Bright and Beautiful: Design in Britain, 1830 to Today* (1972)]
Madsen, S.T., (trans. Christopher, R.I.) *Art Nouveau* (1970) [a classic study, originally published 1967]
Masse, H.J.L.J., *The Art-Workers' Guild, 1884–1934* (1934) [an important record]
Naylor, G., *The Arts and Crafts Movement* (1971) [traces the history from Pugin to the 1920s; numerous well-chosen illustrations]
Open University, *History of Architecture and Design, 1890–1936*, Units 19 and 20 (1975)
Schmutzler, R., *Art Nouvaeu* (1964)
Sturt, G., *The Wheelwright's Shop* (1923, repr. 1943)
Tilbrook, A.J., *The Designs of Archibald Knox for Liberty and Co* (1976)
Todd, D., and Mortimer, R., *The New Interior Decoration* (1929)
Ward, N. and Ward, M., *Home in the Twenties and Thirties* (1978)
Warren, G., *Art Nouveau* (1972)

CATALOGUES

British Art and Design 1900–60, Victoria and Albert Museum, 1983, repr. 1984 [important collection]
Catalogue of an Exhibition of Victorian and Decorative Arts, Victoria and Albert Museum, 1952
Liberty's 1875–1975, Victoria and Albert Museum, 1975
Thirties: British Art and Design Before the War, Arts Council and Victoria and Albert Museum, 1979 [comprehensive, wide-ranging]

5 Housing and its social history

Abercrombie, P., *Town and Country Planning* (1933)
Adams, T., *Recent Advances in Town-Planning* (1932)

Burnett, J., *A Social History of Housing 1815–1970* (1978) [good overview]

Darley, G., *Villages of Vision* (1975) ['model villages' in Britain, 1770–1970]

Daunton, M.J., *House and Home in the Victorian City: Working Class Housing 1850–1914* (1983)

de Soissons, L. and Kenyon, A.W., *Site Planning in Practice at Welwyn Garden City* (1927)

Edwards, A.M., *The Design of Suburbia* (1981)

Englander, D., *Landlord and Tenant in Urban Britain 1838–1918* (1983)

Geddes, P., *Cities in Evolution* (1919)

Jackson, A., *The Politics of Architecture, a History of Modern Architecture in Britain* (1970)

Jackson, A.A., *Semi-Detached London: Suburban Development, Life and Transport, 1900–39* (1973) [the best overview for the period, and very readable]

Mumford, L., *The Culture of Cities* (1938)

Oliver, P., Davis, I., Bentley, I., *Dunroamin': The Suburban Semi and its Enemies* (1981) [good on suburban 'style']

Pepper, S., (ed.), 'The garden city idea', special number of *Architectural Review*, **162** (June 1978)

Purdom, C.B., *The Building of Satellite Towns: a Contribution to the Study of Town Development and Regional Planning* (1925, rev. 1949) [Letchworth and Welwyn Garden cities]

―*The Letchworth Achievement* (1963)

Sharp, T., *Town and Countryside* (1932)

―*Town Planning* (1940)

Tubbs, R., *Living in Cities* (1942)

Unwin, R., *Town Planning in Practice* (1909)

III Bloomsbury

1 General studies

Bell, Clive, *Civilisation, an Essay* (1928)

―*Old Friends: Personal Recollections* (1956)

Bell, Quentin, *Bloomsbury* (1968, repr. 1974)

Edel, L., *Bloomsbury: A House of Lions* (1979) [covers the period up to 1920 readably and informatively]

Gadd, D., *The Loving Friends* (1974) [wide-ranging, rather superficial]

Garnett, A., *Deceived with Kindness: A Bloomsbury Childhood* (1984, repr. 1985) [personal account by Vanessa Bell's daughter]

Johnstone, J.K., *The Bloomsbury Group: A Study of E.M. Forster, Lytton Strachey, Virginia Woolf and their Circle* (1954)

Kennedy, R., *A Boy at the Hogarth Press* (1972, repr. 1978) [the Woolfs as seen by a junior employee]

MacColl, D.S., *Confessions of a Keeper and Other Papers* (1931) [a selection from this volume was reprinted in 1940 under the title *What is Art?*]

Rantavaara, J., 'Virginia Woolf and Bloomsbury' in *Annales Academiae Scientiarum Fennicae* (Helsinki, 1953)

Rosenbaum, S.P., 'Keynes, Lawrence and Cambridge revisited' in *Cambridge Quarterly* **11** (1982) 252–64

Rosenbaum, S.P. (ed.), *The Bloomsbury Group* (1975)

Russell, Bertrand, *Autobiography* (3 vols., 1967–9, repr. in 1 vol. 1978)

Shone, R., *Bloomsbury Portraits: Vanessa Bell, Duncan Grant and their Circle* (1976) [comprehensive and enlightening; generous illustrations, mainly black-and-white]

Spater, S. and Parsons, I., *A Marriage of True Minds* (1977) [about Leonard and Virginia Woolf, and written from inside knowledge]

Woolf, L., *An Autobiography* (5 vols., 1961–9) [of great interest from many points of view, and very readable]

2 Authors

Keynes, John Maynard (1883–1946)
Economist; b. Cambridge; educated at Eton and King's College, Cambridge; 1912–14 edited *Economic Journal*; 1915–19 worked in the Treasury; 1919 *The Economic Consequences of the Peace*; 1925 married the Russian dancer Lydia Lopokova; 1930 *A Treatise on Money*; 1933 *Essays in Biography*; 1935 founded and funded the Arts Theatre, Cambridge; 1936 *The General Theory of Employment, Interest and Money*; 1940 Director of the Bank of England; 1942 created first Baron Keynes; 1949 *Two Memoirs* (ed. Garnett, D.).
Works:
Collected Writings (29 vols., 1971–9).
Life:
Harrod, R., *The Life of John Maynard Keynes* (1951)
See:
Robinson, E.A.G., *John Maynard Keynes* (1947)
Skidelsky, R., *John Maynard Keynes* (1984)

Strachey, (Giles) Lytton (1880–1932)
Biographer, essayist and critic; 1907–9

dramatic critic for *The Spectator*; 1912 *Landmarks in French Literature*; conscientious objector during First World War; 1918 *Eminent Victorians* (repr. 1969); 1921 *Queen Victoria* (repr. 1966); 1920 *Elizabeth and Essex: A Tragic History* (repr. 1981); 1931 *Portraits in Miniature* (repr. 1985).

See:

Holroyd, M., *Lytton Strachey: A Critical Biography* (2 vols., 1967–8)

Sanders, C.R., *Lytton Strachey: His Mind and Art* (1957)

See also:

Forster, E.M.; Woolf, Virginia (in section V.2 below); and Bell, Vanessa; Fry, Roger; Grant; Duncan (in section VII, 2 below).

IV Documentary Film

The British Film Institute, 127 Charing Cross Road, London WC2H 0EA, is the central resource for any study of film, and its *Film and Television Yearbook* provides a wealth of information and reference. Its *Monthly Film Bulletin* (from 1934) describes and reviews, with full production credits, every feature film released in Britain, as well as selected short films; while *Sight and Sound* (quarterly from 1932) provides valuable articles and selective reviews. The BFI also maintains the National Film Archive, set up in 1935 and now holding a collection of over 80,000 titles. *The National Film Archive Catalogue Volume 1: Non-Fiction Films* (1980) includes a vast number of British films from the 1920s and 1930s. Information about the Viewing Service for Archive films can be obtained from the Viewing Supervisor, 81 Dean Street, London W1.

In 1985, thirty-two films made by the GPO Film Unit between 1934 and 1941 were re-issued on VHS video-cassette (seven cassettes, each one hour approximately); details from Television, Entertainment and Learning, Ltd, 19 Knightsbridge, London SW7 1RB.

1 General Studies

Barsam, R.M., *Non-Fiction Film: a Critical History* (1973) [places British documentary in its international context; good bibliography]

Calder-Marshall, A., *The Innocent Eye: The Life of Robert Flaherty* (1963)

Jennings, M.L. (ed.), *Humphrey Jennings: film-maker, painter, poet* (1982) [includes filmography, bibliography]

Lovell, A. and Hiller, J., *Studies in documentary* (1972) [essays on Grierson and Jennings, with partial filmographies, plus short sketches of their associates]

Low, R., *The History of the British Film 1929–1939: Films of Comment and Persuasion of the 1930s* (1979)

The History of the British Film 1929–1939; Documentary and Educational Films of the 1930s (1979) [two invaluable volumes, carefully researched]

Rehrauer, G. (ed.), *The Macmillan Film Bibliography* (2 vols., 1980) [comprehensive listing of books about film world-wide, with helpful and reliable annotations]

Rotha, P., *Documentary Film* (1936, rev. 1939; rev. 1952 with Road, S. and Griffith, R.)

Paul Rotha: Documentary Diary (1973) [a personalised history of British Documentary, 1928–39]

Sussex, E., *The Rise and Fall of British Documentary* (1975) [based on interviews with film-makers; highly readable]

Wright, B., *The Long View* (1974, rev. 1976)

2 Directors/Producers

Cavalcanti, Alberto (1897–1982)

Born Brazil; avant-garde film-making in France; 1934 joined GPO Film Unit, in charge of technical operations and experiments with sound; 1935 directed *Coal Face*; 1937 succeeded Grierson as head of Unit, producing films directed by (among others) Pat Jackson, Humphrey Jennings, Stuart Legg, Len Lye, Harry Watt; 1940 joined Michael Balcon at Ealing Studios to make feature films.

Grierson, John (1898–1972)

1924–7 in USA studying mass communications; 1927–33 films officer to Empire Marketing Board; 1929 directed *Drifters*; 1934–7 head of GPO Film Unit, producing films directed by Alberto Cavalcanti, William Coldstream, Arthur Elton, Len Lye, Harry Watt, Basil Wright; 1939–45 commissioner to National Film Board of Canada; 1948 controller of film operations at (British) Central Office of Information; 1961 CBE.

Life:

Hardy, F., *John Grierson: a Documentary Biography* (1979)

Writings:

Hardy, F. (ed.), *Grierson on Documentary* (1966)

V Literature and Drama

1 General studies

Bell, M., *The Context of English Literature, 1900–1930* (1980) [takes in influence of philosophy, politics, psycho-analysis, and visual arts]

Bergonzi, B., *Heroes' Twilight: A Study of the Literature of the Great War* (1965)

Cary, H., *Mansfield Forbes and his Cambridge* (1984) [the university teacher to whom more than anyone else the Cambridge English School owed its distinctive character]

Costello, P., *The Heart Grown Brutal: The Irish Revolution in Literature from Parnell to the Death of Yeats 1891–1939* (1977)

Donoghue, D., *The Ordinary Universe: Soundings in Modern Literature* (1968)

Ellmann, R., *Eminent Domain: Yeats Among Wilde, Joyce, Pound, Eliot and Auden* (1967, repr. 1970)
 Golden Codgers: Biographical Speculations (1973)

Gillie, C., *Movements in English Literature 1900–1940* (1975) [helpful introduction to the major writers]

Glen, D., *The Individual and the Twentieth Century Scottish Literary Tradition* (1971)

Hampshire, S., *Modern Writers and Other Essays* (1969) [miscellany with a philosophical theme]

Hynes, S., *The Auden Generation: Literature and Politics in England in the 1930s* (1976) [detailed, informative]
 Edwardian Occasions (1972)
 The Edwardian Turn of Mind (1968)

Jarrell, R., *Kipling, Auden & Co: Essays and Reviews 1935–64* (1981) [good also on Housman and Yeats]

Kermode, F., *The Romantic Image* (1958)

Materer, T., *Vortex: Pound, Eliot and Lewis* (1979)

Muir, E., *The Present Age from 1914* (1939) [useful introductory guide]

Pritchard, W.H., *Seeing Through Everything: English Writers 1918–1940* (1977)

Robinson, A., *Symbol to Vortex: Poetry, Painting and Ideas 1885–1914* (1985)

Robson, W.W., *Modern English Literature* (1970) [useful selective survey]

Spender, S., *The Struggle of the Modern* (1963, repr. 1965)

Stewart, J.I.M., *Eight Modern Writers* (1963) [Hardy, James, Shaw, Conrad, Kipling, Yeats, Joyce, Lawrence]

Watson, G.J., *Irish Identity and the Literary Revival: Synge, Yeats, Joyce and O'Casey* (1979)

2 Authors

Auden, Wystan Hugh (1907–73)
Poet, dramatist and critic; educated at Gresham's School, Holt, and Christ Church, Oxford; 1930 first volume of poetry, *Poems*, followed by *Look Stranger* (1936), and *Another Time* (1940); collaborated with Christopher Isherwood on three verse plays, *The Dog Beneath the Skin* (1935), *The Ascent of F6* (1936), and *On the Frontier* (1938); 1939 emigrated to America, later becoming an American citizen; 1956 returned to England as Professor of Poetry at Oxford.
Works:
Collected Poetry (1945)
Collected Shorter Poems 1930–45 (1950)
Collected Shorter Poems 1927–57 (1960)
Collected Longer Poems (1968).
Life:
Carpenter, H., *Auden, a Biography* (1981)
Bibliography:
Beach, J.W., *The Making of the Auden Canon* (1957) [records omissions and alterations to texts of poems in *Collected Poetry* and *Collected Shorter Poems*]
Bloomfield, B.C. and Mendelson, E., *W.H. Auden: A Bibliography: 1924–1969* (1973)
See:
Callan, E., *Auden; A Carnival of Intellect* (1983)
Fuller, J.A., *A Reader's Guide to W.H. Auden* (1970) [helpful, well-informed commentary]
Haffenden, J. (ed.), *W.H. Auden: The Critical Heritage* (1983)
Mendelson, E., *Early Auden* (1981) [covers 1930–31]
Rodway, A., *A Preface to Auden* (1984)

Bennett, (Enoch) Arnold (1867–1931)
Novelist and playwright; b. Henley in the 'Black Country' and educated locally; early career in journalism; 1898 first novel, *A Man from the North*; 1902 *Anna of the Five Towns*; 1902–12 lived mainly in France; 1908 *The Old Wives' Tale*; 1910 *Clayhanger*; 1911 *Hilda Lessways*; 1912 (with co-author Edward Knoblock) *Milestones*, the first of many successful plays.
Writings include:
Flower, N. (ed.), *Journals* (3 vols., 1932–3)

Hepburn, J. (ed.), *Letters* (3 vols., 1966–70)
Wilson, H. (ed.), *Letters of Arnold Bennett and H.G. Wells* (1960).
Life:
Drabble, M., *Arnold Bennett: A Biography* (1974)
See:
Broomfield, O.R.R., *Arnold Bennett* (1984) [comprehensive survey]
Hepburn, J., *The Art of Arnold Bennett* (1965)
Hepburn, J. (ed.), *Arnold Bennett: The Critical Heritage* (1981)

Conrad, Joseph (1857–1924)
(Josef Teodor Konrad Nalecz Korzeniowski) Novelist and short story writer; b. Poland; 1874 travelled to Marseille to become a sailor; 1878 first visit to England; served in various British ships, travelling widely and rising to the rank of Captain; 1886 naturalised British; 1895 *Almayer's Folly* published; 1896 married and settled near London; 1900 *Lord Jim*; 1902 *Heart of Darkness*. Other major works include *Typhoon* (1902); *Nostromo* (1904); *The Secret Agent* (1907); *Under Western Eyes* (1911); *Chance* (1913), his first novel to gain wide popularity; *Victory* (1915); *The Shadow Line* (1917).
Works:
Collected Works (24 vols., 1946–58)
Collected Letters ed. Karl, F.R. and Davies, L., Vol. I, 1861–97 (1983); Vol. II, 1898–1902 (1986)
Life:
Baines, J., *Joseph Conrad: A Critical Biography* (1960)
Nadjer, Z., *Joseph Conrad: a chronicle* (1983)
See:
Berthoud, J., *Joseph Conrad: The Major Phase* (1978)
Guerard, A.J., *Conrad the Novelist* (1958, repr. 1969)
Sherry, N., *Conrad's Eastern World* (1966)
Conrad's Western World (1971)
Sherry, N. (ed.), *Conrad: the Critical Heritage* (1973)
Watt, I., *Conrad in the Nineteenth Century* (1980)
Watt, I. (ed.), *'The Secret Agent': a Casebook* (1973)

de la Mare, Walter (1873–1956)
Poet and story-writer; 1890–1908 clerk in a London office; 1902 *Songs of Childhood*; 1908 granted a Civil List pension to devote his time to writing; prose volumes included *The Return* (1910) and *Memoirs of a Midget* (1922, repr. 1982); 1948 made CH; 1953 awarded OM
Writings:
Best Stories of Walter de la Mare (1983)
Complete Poems (1969)
See:
Duffing,, H.C., *Walter de la Mare: A Study of His Poetry* (1949)
Hopkins, K., *Walter de la Mare* (1953)

Eliot, Thomas Stearns (1888–1965)
Poet, critic and dramatist; b. St Louis, Missouri; studied at Harvard and Merton College, Oxford; 1915 came to London, where he worked in a bank; 1917 first volume of poems, *Prufrock and other Observations*; 1922 *The Waste Land* published; 1923 established the quarterly, *Criterion*, which he edited till 1939; 1927 entered Church of England; 1930 *Ash Wednesday*; 1935 first complete play, *Murder in the Cathedral* performed at Canterbury Festival; 1935–42 *Four Quartets*; later plays include *Family Reunion* (1939) and *The Cocktail Party* (1950); critical writings include *The Sacred Wood* (1920); *Selected Essays* (1932, enl. edn. 1951); *The Use of Poetry and the Use of Criticism* (1933); 1948 awarded OM and Nobel Prize for Literature.
Works:
Collected Plays (1962)
Collected Poems 1909–62 (1963 repr. 1974)
Complete Poems and Plays (1969)
Facsimile of the Early Drafts of 'The Waste land', ed. Eliot, V., (1971)
Life:
Ackroyd, P., *T.S. Eliot* (1984).
Bibliography:
Gallop, D., *T.S. Eliot: a Bibliography* (1952, rev. 1969).
See:
Browne, E. Martin, *The Making of T.S. Eliot's Plays* (1960)
Calder, A., *T.S. Eliot* (1987)
Gardner, H., *The Art of T.S. Eliot* (1949, repr. 1968
The Composition of 'Four Quartets' (1978, repr. 1980)
Grant, M. (ed.), *T.S. Eliot: The Critical Heritage* (2 vols., 1982)
Harding, D.W., in *Experience into Words* (1963) [seminal reviews of the later poems]
Leavis, F.R., in *New Bearings in English Poetry* (1932, rev. 1950) [a pioneering appreciation]
in *Education and the University* (1943) [on 'Four Quartets']

in *Lectures in America* (1969) [an
overview]
in *The Living Principle* (1975) [his final
verdict on *Four Quartets*]
Moody, A.D., *Thomas Stearns Eliot: Poet*
(1979, repr. 1980)
Pinion, F.B., *A T.S. Eliot Companion: Life
and Work* (1986)
Smith, Grover, *T.S. Eliot's Poetry and
Plays, a Study of Sources and Meaning*
(1956)
Traversi, D., *T.S. Eliot: the Longer Poems*
(1976)

Ford, Ford Madox (1873–1939)
(b. Hueffer, changed name by deed-poll in
1919), Novelist and critic; 1891 received
into Roman Catholic Church; collaborated
with Joseph Conrad on *The Inheritors*
(1901) and *Romance* (1903); 1908–11
founded and edited *English Review*; 1915
The Good Soldier, his first successful novel;
1915–19 served in Welsh Regiment, and
was severely gassed while on active service
in France; 1922 moved to Paris where his
friends Joyce and Pound were living;
1923–4 edited *Transatlantic Review*; 1924
Some Do Not, first novel in the Tietjens
tetralogy (1924–8); from 1926 lived partly
in USA, partly in France.
Works include:
Parade's End (1950) [collected edition of the
four Tietjens novels]
MacShane, F. (ed.), *The Critical Writings of
Ford Madox Ford* (1964)
Life:
Mizener, A., *The Saddest Story* (1972) [full
and thorough].
Bibliography:
Harvey, D.D., *Ford Madox Ford,
1873–1939: A Bibliography* (1962).
See:
Cassell, R.A., *Ford Madox Ford: A Study
of his Novels* (1962)
Cassell, R.A. (ed.), *Ford Madox Ford:
Modern Judgments* (1972)
MacShane, F., *The Life and Works of Ford
Madox Ford* (1965)
MacShane, F. (ed.), *Ford Madox Ford: The
Critical Heritage* (1972)
Meixner, J.A., *Ford Madox Ford's Novels:
A Critical Study* (1963)

Forster, Edward Morgan (1879–1970)
Novelist and critic; educated at King's
College, Cambridge, of which he was later
made Honorary Fellow; early novels: 1905
Where Angels Fear to Tread; 1907 *The
Longest Journey*; 1908 *A Room with a View*;
1910 *Howards End*; 1912–13 visited India,
and again in 1921; 1924 *A Passage to India*;

1927 *Aspects of the Novel* (repr. 1976), his
Clark Lectures at Cambridge. Other works
include *Abinger Harvest* (1936, repr. 1953)
and *Two Cheers for Democracy* (1951),
collections of essays; *The Hill of Devi*
(1953) [letters from his visits to India with
later commentary; fascinating background
to *A Passage to India*]; *Maurice* (1971),
posthumous novel; *New Collected Short
Stories 1904–72* (1987); 1953 made CH;
1968 awarded OM.
Works:
The Abinger Edition, ed. Stallybrass, O.,
1972–8, ed. Heine, E. since 1980.
Life:
Furbank, P.N., *E.M. Forster: A Life* (2
vols. 1977–8, repr. in 1 vol. 1979)
See:
Advani, R., *E.M. Forster as Critic* (1984)
Beer, J., *The Achievement of E.M. Forster*
(1962)
Cavaliero, G., *A Reading of E.M. Forster*
(1979)
Colmer, J., *E.M. Forster: The Personal
Voice* (1975)
Das, G.K. and Beer, J., (eds.), *E.M.
Forster: A Human Exploration:
Centenary Essays* (1979)
Gardner, P. (ed.), *E.M. Forster: The
Critical Heritage* (1973)
Stone, W., *The Cave and the Mountain: a
Study of E.M. Forster* (1966)
Trilling, L., *E.M. Forster* (1944)

Graves, Robert (1895–1986)
Poet, novelist, critic, translator; from school
joined the Royal Welsh Fusiliers to serve in
the First World War; 1926 Professor of
English Literature at Cairo; 1929 *Goodbye
to All That* (autobiography); 1934 popular
success with novels *I, Claudius* and
Claudius the God; lived for some time in
Majorca and settled there permanently after
the Second World War; 1961 Professor of
Poetry at Oxford.
Works:
Collected Poems (1975)
Collected Short Stories (1966)
*Between Moon and Moon: Selected Letters of
Robert Graves 1946–72* ed. O'Prey, P.
(1984)
Critical works include:
A Survey of Modernist Poetry (with Laura
Riding, 1927); *The Common Asphodel*
(1949); *The Crowning Privilege* (1955)
[the Clark Lectures].
Life:
Graves, R.P., *Robert Graves: The Assault
Heroic 1895–1926* (1986)
Seymour-Smith, M., *Robert Graves: his life
and work* (1982).

Bibliography:

Higginson, F.H., *A Bibliography of the Works of Robert Graves* (1966).

See:

Canary, R.H., *Robert Graves* (1980) [inc. bibl.]

Keane, P.J., *A Wild Civility: Interactions in the Poetry and Thought of Robert Graves* (1980).

Hardy, Thomas (1840–1928)

Poet and novelist; b. Dorset, trained as an architect; 1871 first novel *Desperate Remedies*; 1874 popular success with *Far from the Madding Crowd*; 1896 hostile reception of *Jude the Obscure*, after which he gave up writing novels; seven volumes of poems published between 1898 and 1928; 1903–8 *The Dynasts*, epic drama in three volumes; 1910 awarded OM; 1912 death of his first wife, followed by a sequence of his very finest poems, 'Poems of 1912–13', included in *Satires of Circumstance* (1914).

Works:

Collected Works (37 vols. 1919–20)

Gibson, J. (ed.), *Complete Poems* (1976, Variorum edn 1979)

Taylor, R.H. (ed.), *The Personal Notebooks of Thomas Hardy* (1978)

The Dynasts (1 vol. 1978)

Hynes, S. (ed.), *The Complete Poetical Works* (3 vols. 1982–5)

 The Works of Thomas Hardy in Prose (18 vols., 1984)

Life:

Hardy, F.E., *The Life of Thomas Hardy, 1840–1928* (2 vols. 1930, repr. in 1 vol., 1982)

Millgate, M., *Thomas Hardy: a Biography* (1982)

Bibliography:

Purdy, R.L., *Thomas Hardy: a Bibliographical Study* (1954)

See:

Davie, D., *Thomas Hardy and British Poetry* (1973)

Gibson, J. and Johnson, T. (eds.), *Thomas Hardy, Poems: A Casebook* (1979)

Hynes, S., *The Pattern of Hardy's Poetry* (1961)

Paulin, T., *Thomas Hardy: the Poetry of Perception* (1975)

Pinion, F.B., *A Commentary on the Poems of Thomas Hardy* (1976)

 A Hardy Companion (1968, rev. 1976)

Taylor, D., *Hardy's Poetry, 1860–1928* (1981)

Wright, W.F., *The Shaping of 'The Dynasts'* (1967)

James, Henry (1843–1916)

Novelist, playwright and critic; b. New York City, son of wealthy Swedenborgian philosopher; first fiction published 1864; 1876 settled in England; 1898 moved to Rye in Sussex; 1904–5 returned to America for a visit which provided material for *The American Scene* (1907); from 1905 busy revising and writing Prefaces for the New York Edition (1907–9) of his works; 1915 became naturalised British subject; 1916 awarded OM. Works published after 1900 included the three major novels of his final phase, *The Wings of the Dove* (1902), *The Ambassadors* (1903) and *The Golden Bowl* (1904); his last volume of short stories, *The Finer Grain* (1910); and two autobiographical works, *A Small Boy and Others* (1913), and *Notes of a Son and Brother* (1914). Two unfinished novels, *The Sense of the Past* and *The Ivory Tower* published posthumously in 1917.

Works:

The Novels and Stories of Henry James, new and complete edition, ed. Lubbock, P. (35 vols., 1921–3)

The Complete Tales ed. Edel, L. (12 vols., 1962–4)

Tales, ed. Aziz, M. (Vol. I, 1973; Vol. II, 1978; Vol. III, 1984; proceeding)

The Complete Notebooks, ed. Edel, L. and Powers, L.H. (1987)

The Complete Plays, ed. Edel, L. (1949)

Letters, ed. Edel, L. (4 vols., 1974–84)

Selected Literary Criticism, ed. Shapira, M. (1963, repr. 1968)

Life:

Edel, L., *The Life of Henry James* (5 vols., 1953–72; 2 vol. edition, 1977; 1 vol. abridgement 1987)

Bibliography:

Edelson, L. and Laurence, Dan H., *A Bibliography of Henry James* (1957, rev. 1983)

See:

Berland, A., *Culture and Conduct in the Novels of Henry James* (1981)

Bewley, M., in *The Complex Fate* (1952) and *The Eccentric Design* (1959)

Gard, R. (ed.), *Henry James: the Critical Heritage* (1968)

Jefferson, D.W., *Henry James and the Modern Reader* (1964)

Krook, D., *The Ordeal of Consciousness in Henry James* (1962)

Mathieson, F.O., *Henry James: The Major Phase* (1964)

Joyce, James Augustine Aloysius
(1882–1941)
Novelist, poet and dramatist; b. Dublin;
educated at Jesuit schools, 1888–98, and at
University College, Dublin, 1899–1902;
1902–3 student life in Paris; August 1903
death of his mother; 1904 travelled to
Europe with Nora Barnacle (whom he
married in 1931), living subsequently
mainly in Trieste, Zurich and Paris; 1907
Chamber Music (poems); 1914 *Dubliners*
(short stories); 1914–15 *Portrait of the
Artist as a Young Man*; 1918 *Exiles* (play);
from 1918 *Ulysses* published in serial form
in *The Little Review*, New York; 1922
Ulysses published in Paris but banned in
Great Britain; from 1924 fragments of
Finnegan's Wake published in Paris; 1927
Pomes Penyeach; 1934 *Ulysses* published in
US; 1936 *Collected Poems*; 1939 *Finnegan's
Wake*.
Works:
The Critical Writings of James Joyce, ed.
 Mason, E., and Ellmann, R., (1959)
Letters of James Joyce (vol. I, ed. Gilbert,
 S., 1957; vols. II and III ed. Ellmann,
 R., 1962)
Selected Letters of James Joyce, ed. Ellmann,
 R., (1975)
Ulysses: a Critical and Synoptic Edition,
 revised text ed. Gabler, H.W., (3 vols.
 1984)
Ulysses: the Corrected Text, ed. Gabler,
 H.W., (1 vol., 1986) [the revised text
 only, without editorial apparatus]
Life:
Ellmann, R., *James Joyce* (1959, rev. 1982)
Joyce, Stanislaus, *My Brother's Keeper*
 (1958)
See:
Beja, M. (ed.), *James Joyce: 'Dubliners' and
 'A Portrait of the Artist as a Young
 Man': Casebook* (1973)
Bolt, S., *A Preface to James Joyce* (1981)
 [good introduction]
Budgen, F., *James Joyce and the Making of
 'Ulysses'* (1934, repr. 1937)
Campbell, J. and Robinson, H.M., *A
 Skeleton Key to 'Finnegan's Wake'*
 (1947, repr. 1954)
Denning, R.H., *James Joyce: The Critical
 Heritage* (2 vols., 1970)
Ellmann, R., *Ulysses on the Liffey* (1972)
Gilbert, S., *James Joyce's 'Ulysses': A Study*
 (1930, rev. 1953, repr. 1963)
Goldberg, S.L., *The Classical Temper: A
 Study of James Joyce's 'Ulysses'* (1961)
Parrinder, P., *James Joyce* (1984)
Peake, C.H., *James Joyce, the Citizen and
 the Artist* (1977)

Kipling, Rudyard (1865–1936)
Poet, novelist and story-writer; b. Bombay;
works after 1900 include *Kim* (1901); *Just
So Stories* (1902); *Puck of Pook's Hill*
(1906); 1907 Nobel Prize for Literature.
Works:
Complete Works in Prose and Verse (25
 vols., 1937–9)
Carrington, C. (ed.), *The Complete Barrack-
 Room Ballads* (1974)
Life:
Something of Myself (1937, repr. 1987) [a
 reticent autobiography]
Carrington, C., *Rudyard Kipling: His Life
 and Works* (1955, repr. 1986)
Bibliography:
Stewart, J.M., *Rudyard Kipling: A
 Bibliographical Catalogue* (1959)
See:
Elliott, L.G. (ed.), *Kipling and the Critics*
 (1965)
Ford, B., 'A Case for Kipling?' in *Scrutiny*
 XI (1942)
Green, R.L. (ed.), *Kipling: the Critical
 Heritage* (1971)
Rutherford, A., (ed.), *Kipling's Mind and
 Art* (1964)
Stewart, J.I.M., *Rudyard Kipling* (1966,
 repr. 1976)

Lawrence, David Herbert (1885–1930)
Novelist, poet and critic; b. Eastwood,
Notts, son of a coal-miner; 1906–8
University College, Nottingham; 1908–11
taught at an elementary school in Croydon;
1910 mother died; 1911 first novel *The
White Peacock*; 1912 eloped to Italy with
Frieda, wife of Professor Ernest Weekley;
1913 *Sons and Lovers*; 1914 returned to
England and married Frieda after her
divorce; 1915 *The Rainbow*, suppressed as
obscene; 1919 settled in Italy; 1920 *Women
in Love*; 1922 visited Australia; 1923
Kangaroo; 1922–3 and 1924–5 visits to New
and Old Mexico; 1925 *St Mawr*, and 1926
The Plumed Serpent; 1928 *Lady Chatterley's
Lover*, banned in England until 1960; died
of tuberculosis in Vence, in the south of
France.
Works:
Uniform edn. (33 vols., 1936–9)
Phoenix, ed. McDonald, E.D. (1936) [a
 rewarding posthumous miscellany]
Phoenix II, ed. Roberts, F.W. and Moore,
 H.T. (1968)
A Selection from Phoenix, ed. Inglis, A.A.H.
 (1971, repr. 1979)
Selected Literary Criticism, ed. Beal, A.
 (1961)

Complete Poems, ed. Pinto, V. de S. and
Roberts, W., 2 vols., (1964)
Complete Plays (1985)
*The Cambridge Edition of the Letters of D.H.
Lawrence*, Vol. I: 1901–13, ed. Boulton,
J.T. (1979); Vol. II: 1913–16, eds.
Zytaruk, G.J. and Boulton, J.T. (1982);
Vol. III: 1916–21, eds. Boulton, J.T.
and Robertson, A. (1984); Vol. IV:
1921–4, eds. Roberts, W., Boulton,
J.T. and Mansfield, E. (1987) [first
complete, unexpurgated and
authoritative edition of the letters in
progress]
*The Cambridge Edition of the Works of D.H.
Lawrence* [texts extensively corrected to
accord with the author's intention,
though the differences are mostly fairly
minor]:
Apocalypse and the Writings on Revelation,
ed. Kalnins, M. (1980)
The Lost Girl, ed. Worthen, J. (1981)
The Trespasser, ed. Mansfield, E. (1982)
St Mawr and Other Stories, ed. Finney, B.
(1983)
The Prussian Officer and Other Stories, ed.
Worthen, J. (1983)
The White Peacock, ed. Robertson, A.
(1983)
Mr Noon, ed. Vasey, L. (1984)
Study of Thomas Hardy and Other Essays,
ed. Steele, B. (1985)
*The Penguin Edition of the Works of D.H.
Lawrence* [very comprehensive, if not
complete]
Life:
Moore, H.T., *The Priest of Love* (1974)
Moore, H.T. and Roberts, W., *D.H.
Lawrence and his World* (1966) [useful
brief introduction with excellent
photographs of people and places]
Nehls, E.H. (ed.), *D.H. Lawrence, a
Composite Biography*, (3 vols., 1957–9)
[invaluable though lengthy compilation
of first-hand memoirs]
See also:
Chambers, J., *D.H. Lawrence: A Personal
Record* (1935–1980)
Lawrence, Frieda, *Not I, But The Wind*
(1934)
Bibliography:
Roberts, W., *A Bibliography of D.H.
Lawrence* (1963, rev. 1982)
See:
Coombes, H. (ed.), *D.H. Lawrence: a
Critical Anthology* (1973)
Daleski, H.M., *The Forked Flame: A Study
of D.H. Lawrence* (1965)
Draper, R.P. (ed.), *D.H. Lawrence: The
Critical Heritage* (1979)

Gomme, A.H. (ed.), *D.H. Lawrence: A
Critical Study of the Major Novels*
(1978)
Hobsbaum, P. (ed.), *A Reader's Guide to
D.H. Lawrence* (1981)
Leavis, F.R., *D.H. Lawrence, Novelist*
(1955) [still the one indispensable book
about Lawrence's fiction]
*Thought, Words and Creativity: Art and
Thought in Lawrence* (1976) [second
thoughts, always challenging,
sometimes disputable]

Leavis, Frank Raymond (1895–1978)
Critic and editor; b. Cambridge where he
lived throughout his life; 1914–18 service
on Western Front as stretcher-bearer with
Friends' Ambulance Unit; 1927–31
probationary lecturer in Cambridge English
Faculty; 1929 married Queenie Dorothy
Roth; 1932 director of English studies,
Downing College; 1932 contributed leading
articles to the quarterly *Scrutiny* (started by
L.C. Knights and Donald Culver) and
joined its editorial board with its third
issue, thereafter editing it, in effect, until its
demise in 1953; 1936 Fellow of Downing
and half-time lecturer in English Faculty;
1959 appointed Reader; after retirement
from Cambridge, Visiting Professorship at
University of York 1965–8; 1978 made CH.
Works up to 1945:
Mass Civilisation and Minority Culture
(1930)
*How to Teach Reading: A Primer for Ezra
Pound* (1932)
New Bearings in English Poetry (1932, rev.
1950 [mainy on Eliot, Hopkins, Pound,
with briefer comments on de la Mare,
Hardy, Thomas and Yeats]
For Continuity (1933)
Revaluation (1936).
Later volumes with chapters relevant to the
period include: *The Great Tradition*
(1948, rev. 1960) [Conrad, James]; *The
Common Pursuit* (1952) [Eliot, Forster,
James, Lawrence]; *Anna Karenina and
Other Essays* (1967) [Conrad, James,
Lawrence, Pound]; *The Critic as Anti-
Philosopher* (1982) [Hardy, James,
Joyce]; (with Q.D. Leavis) *Lectures in
America* (1969) [Eliot and Yeats].
(See also entries on Eliot and Lawrence,
above)
Life:
Hayman, R., *Leavies* (1976)
Thompson, D. (ed.), *The Leavises:
Recollections and Impressions* (1984).
See:
Bilan, R.P., *The Literary Criticism of F.R.
Leavis* (1979)

Boyers, R., *F.R. Leavis: Judgment and the Discipline of Thought* (1978)

Robertson, P.J.M., *The Leavises on Fiction: a Historic Partnership* (1981)

Walsh, W., *F.R. Leavis* (1980)

Watson, G., *The Leavises, the 'Social', and the Left* (1977)

O'Casey, Sean (1880–1964)
Dramatist; b. Dublin; little formal education; 1923 *The Shadow of a Gunman*, produced at Abbey Theatre, Dublin; 1924 *Juno and the Paycock*, established his reputation; 1927 moved to London; autobiography in six volumes, commencing with *I Knock at the Door* (1939).

Works:
Complete Plays (5 vols., 1984)
Krause, D. (ed.), *Letters* (Vol. I, 1975, Vol. II, 1980)
Bibliography:
Ayling, R. and Darken, M.J., *Sean O'Casey: a Bibliography* (1978)
See:
Ayling, R. (ed.), *O'Casey: The Dublin Trilogy: A Casebook* (1985)
Benstock, B., *Paycocks and Others: Sean O'Casey's World* (1976)
Simmons, J., *Sean O'Casey* (1983)

Owen, Wilfred (1893–1918)
Poet; b. Oswestry, Shropshire; educated London University; commission in infantry regiment, 1916; served in France December 1916 to June 1917, and again from August 1918; awarded MC, October 1918, and killed a week before the Armistice; only four poems published in his lifetime, in periodicals.

Works:
Poems ed. Sassoon, S. (1920)
Collected Poems, ed. Blunden, E. (1931)
Collected Poems, ed. Day Lewis, C. (1963) [as well as some previously unpublished poems and fragments includes the illuminating *Memoir* by Edmund Blunden]
Complete Poems, ed. Stallworthy, J. (2 vols., 1984) [Vol. I consists of the poems; Vol. II of fragments together with the poems' MSS]
Collected Letters, ed. Owen, H. and Bell, J. (1967)
Life:
Stallworthy, J., *Wilfred Owen* (1974, rev. 1977)
Owen, H., *Journey from Obscurity* (3 vols., 1963–5) [memoirs of the Owen family by the poet's younger brother]
See:
Hibberd, D., *Owen the Poet* (1986)

Welland, D.S.R., *Wilfred Owen: a Critical Study* (1960, rev. 1978)

Pound, Ezra Loomis (1885–1972)
Poet, essayist and translator; b. Hailey, Idaho; 1908–20 lived in London, becoming friendly with T.S. Eliot, James Joyce and Wyndham Lewis; 1909 first volume of poems, *Personae*; 1917–19 edited *Little Review*; 1920 *Hugh Selwyn Mauberley*; 1920–4 lived in Paris, then in Rapallo, Italy, until 1945; *Cantos* appeared at intervals from 1919 till 1969; 1946 returned to America and was tried for treason because of his Fascist broadcasts during the Second World War; acquitted as being of unsound mind, but confined to a mental hospital till 1958 when he returned to Italy.

Works:
Collected Shorter Poems (1953, repr. 1963)
Selected Poems 1908–1958 (1975)
The Cantos of Ezra Pound: Revised Collected Edition (1975), previously *New Collected Edition*
Literary Essays of Ezra Pound, ed. Eliot, T.S. (1854)
Ezra Pound and Music; the Complete Criticism, ed. Schafer, R.M. (1978)
The Translations (1953, repr. 1963).
Life:
Ackroyd, P., *Ezra Pound and His World* (1981) [brief, well-illustrated introduction]
Stock, N., *The Life of Ezra Pound* (1970)
Bibliography:
Gallup, D., *A Bibliography of Ezra Pound* (1963), revised as *Ezra Pound: a Bibliography* (1983)
See:
Berryman, Jo B., *Circe's Craft: Ezra Pound's 'Hugh Selwyn Mauberley'* (1983)
Brooker, P., *A Student's Guide to the 'Selected Poems' of Ezra Pound* (1979)
Davie, D., *Ezra Pound* (1975)
Espey, J.J., *Ezra Pound's Mauberley: A Study in Composition* (1955)
Homberger, E. (ed.), *Ezra Pound: The Critical Heritage* (1972)
Makin, P., *Pound's Cantos* (1985)

Rosenberg, Isaac (1890–1918)
Poet; b. Bristol; educated at elementary school in London; apprenticed to an engraver; 1911, entered the Slade School; enlisted in the army 1915, killed in action, April 1918.

Works:
Poems, ed. Bottomley, G. (1922)
Collected Works, ed. Bottomley, G. and Harding, D. (1937)

Collected Poems, ed. Bottomley, G. and
Harding, D. (1949)
Collected Works, ed. Parsons, I. (1979)
[fuller and more reliable text, together
with thirty-two plates reproducing
Rosenberg's paintings and drawings].
Life:
Cohen, J. *Journey to the Trenches* (1975)
Liddiard, J., *Isaac Rosenberg: The Half
Used Life* (1975)
Wilson, J., *Isaac Rosenberg, Poet and
Painter* (1975).
See:
Harding, D.W., in *Experience into Words*
(1963)
Silkin, J., *Out of Battle* (1972)

Shaw, George Bernard (1856–1950)
Dramatist; b. Dublin; 1876 moved to
London; 1884 joined the Fabian Society;
1892 first play *Widowers' Houses*; 1925
awarded Nobel Prize for Literature;
declined Order of Merit and peerage from
the first Labour Government. Plays after
1900 include *Man and Superman* (1903);
The Doctor's Dilemma (1906); *Misalliance*
(1910); *Pygmalion* (1913); *St Joan* (1924)
and *The Apple Cart* (1929).
Works:
Collected Plays with Prefaces, ed. Laurence,
Dan H., 7 vols. (1970–4)
Collected Letters, ed. Laurence, Dan H., 3
vols., (1965–85)
An Autobiography (selected from his
writings by Weintraub, S., 1969).
Life:
Ervine, St J., *Bernard Shaw: His Life,
Work and Friends* (1956)
Bibliography:
Laurence, Dan H., *Bernard Shaw: A
Bibliography* (2 vols., 1983)
See:
Evans, T.F. (ed.), *Shaw: The Critical
Heritage* (1976)
Ganz, G., *George Bernard Shaw* (1983)
Gibbs, A.M., *The Art and Mind of Shaw:
Essays in Criticism* (1983)
Holroyd, M. (ed.), *The Genius of Shaw*
(1979)
Whitman, R.F., *Shaw and the Play of Ideas*
(1977)

Synge, John Millington (1871–1909)
Dramatist; b. Dublin; educated at Trinity
College, Dublin; travelled in Germany,
Italy and France; 1903 first play *In the
Shadow of the Glen* produced; 1904 *Riders
to the Sea*; from 1906 a director of the
Abbey Theatre; 1907 *The Playboy of the
Western World*; *Deirdre of the Sorrows*
(1910) unfinished at his death.

Works:
Collected Works, Vol. I, *Poems*, ed. Skelton,
R. (1962); Vol. II, *Prose*, ed. Price, A.
(1966); Vols. III and IV, *Plays*, ed.
Saddlemeyer, A. (1968); all repr. 1982;
Collected Letters, ed. Saddlemeyer, A. (2
vols., 1983–4).
Life:
Greene, D.H. and Stephens, E.M., *J.M.
Synge 1871–1909* (1959)
See:
Benson, E., *John Millington Synge* (1982)
Grene, N., *Synge: A Critical Study of the
Plays* (1973)
Skelton, R., *John Millington Synge and His
World* (1971)
The Writings of John Millington Synge
(1971)

Thomas, Edward (1878–1917)
Poet, critic, essayist; 1897–1900 history
degree at Oxford; 1899 married Helen
Noble; struggled to make a living by
writing, on the one hand books about the
countryside, and on the other literary-
critical studies; 1913 formed friendship with
the American Robert Frost; July 1915
enlisted in the Artists' Rifles; 1916
commissioned in the Royal Artillery; killed
in action at Arras.
Works:
Collected Poems (1920, rev. 1928)
Edward Thomas: Poems and Last poems, ed.
Longley, E. (1973)
The Collected Poems of Edward Thomas, ed.
Thomas, R.G. (1981)
*The Childhood of Edward Thomas; A
Fragment of Autobiography* (1938, enl.
1983).
Life:
Eckert, R.P., *Edward Thomas: A Biography
and a Bibliography* (1937)
Moore, J., *The Life and Letters of Edward
Thomas* (1939, repr. 1984) [the best
biography]
See also:
Farjeon, E., *Edward Thomas: The Last Four
Years* (1958, repr. 1985)
Thomas, Helen, *As It Was* (1926) and
World Without End (1931) (collected in
one volume 1935, repr. 1978) [highly
personal memories, not to be missed]
See:
Coombes, H., *Edward Thomas* (1956)
Harding, D.W., 'A note on nostalgia' in
Determinations, ed. Leavis, F.R. (1934)
Motion, A., *The Poetry of Edward Thomas*
(1980)

Wells, Herbert George (1866–1946)
Novelist, short-story writer, essayist;

worked as a draper's assistant, and as apprentice to a pharmaceutical chemist; won scholarship to Royal College of Science, where he was taught and influenced by T.H. Huxley; 1890 London University B.Sc. through correspondence college; 1895 *The Time Machine*, first of the highly original 'scientific romances' culminating in *The War in the Air* (1908); joined Fabian Society, but after disagreements with Shaw and the Webbs resigned 1908; turned to social comedies with *Kipps* (1905), *Tono-Bungay* and *Ann Veronica* (1909), *The History of Mr Polly* (1910). Later works included *Outline of History* (1919–20); *The Shape of Things to Come* (1933); and, in 1945, the despairing *Mind at the End of its Tether*.
Works include:
Complete Short Stories (1927, repr. 1970)
Edel, L. and Ray, G.N. (eds.), *Letters of Henry James and H.G. Wells* (1958)
Gettman, R. (ed.), *Letters of George Gissing and H.G. Wells* (1961)
Wilson, H. (ed.), *Letters of Arnold Bennett and H.G. Wells* (1960)
Life:
Experiment in Autobiography (2 vols., 1934, repr. 1966)
Mackenzie, N., *The Time Traveller: Life of H.G. Wells* (1973) [definitive biography]
See:
Batchelor, J., *H.G. Wells* (1985) [useful introduction]
Bergonzi, B., *The Early H.G. Wells* (1961)
Bergonzi, B. (ed.), *H.G. Wells: A Collection of Critical Essays* (1976) [well-chosen, wide-ranging]
Costa, R.H., *H.G. Wells: Revised Edition* (1985) [comprehensive survey]
Hammond, J.R., *An H.G. Wells Companion* (1979)
Parrinder, P. (ed.), *H.G. Wells: The Critical Heritage* (1972)
Reed, J.R., *The Natural History of H.G. Wells* (1982)

Woolf, Virginia (1882–1941)
Novelist and critic; b. Kensington, daughter of Sir Leslie Stephen, critic and philosopher; nervous breakdown after her father's death in 1904; set up house with her brothers and sisters in Bloomsbury, becoming a leading spirit in the intellectual and artistic circle established there; 1912 married Leonard Woolf; 1914 another serious breakdown; 1915 first novel, *The Voyage Out*; 1917 founded the Hogarth Press with her husband; critical essays include *The Common Reader* (1st series 1925, 2nd series 1932); committed suicide while suffering from another mental breakdown.
Works:
Uniform Edition, (17 vols., 1929–55);
Collected Essays, ed. Woolf, L. (4 vols., 1966–7)
Letters, ed. Nicolson, N. (6 vols., 1975–80)
Moments of Being, Unpublished Autobiographical Writings, ed. Schulkind, J. (1976)
Diaries: Vols. I-V, 1915–41, ed. Bell, A.O. (1977–84)
Essays: Vol. I, 1904–12, ed. McNellie, A. (1986)
The Complete Shorter Fiction, ed. Dick, S. (1987).
Life:
Bell, Q., *Virginia Woolf, a biography* (2 vols., 1972, 1-vol. edn, 1982).
Bibliography:
Kirkpatrick, B.J., *A Bibliography of Virginia Woolf* (1957, rev. 1980).
See:
Apter, T.E., *Virginia Woolf: A Study of Her Novels* (1979)
Beja, M. (ed.), *Virginia Woolf: To the Lighthouse – A Casebook* (1970)
Fleishman, A., *Virginia Woolf: A Critical Reading* (1975)
Forster, E.M., *Virginia Woolf* (1954)
Lee, H., *The Novels of Virginia Woolf* (1977)
Majudmar, R. and McLaurin, A. (eds.), *Virginia Woolf: The Critical Heritage* (1975)
McLaurin, A., *Virginia Woolf: The Echoes Enslaved* (1973)
Poole, R., *The Unknown Virginia Woolf* (1978).
Zwerdling, A., *Virginia Woolf and The Real World* (1986)

Yeats, William Butler (1865–1939)
Poet and dramatist; b. Dublin; 1889 first volume of poems *The Wanderings of Oisin*; 1902 founding of Irish National Theatre Society with Yeats as President; 1904 opening of the Abbey Theatre, Dublin, of which he became director in 1906, with Lady Gregory and Synge; 1910 awarded Civil List pension (£150 p.a.); 1917 married Georgie Hyde Lees; 1922–8 member of the Irish Senate; 1923 Nobel Prize for Literature.
Works:
Collected Poems (1950)
Complete Poems, Variorum Edition ed. Allt, P. and Alspach, R.K. (1957)

Collected Plays (1952)
Complete Plays, Variorum Edition ed.
 Alspach, R.K. (1965, repr. 1966)
Autobiographies (1955, repr. 1973)
A Vision (1925)
Letters of W.B. Yeats, ed. Wade, A. (1956)
Collected Letters of W.B. Yeats, ed. Kelly,
 J., Vol. I (1986)
Life:
Ellmann, R., *Yeats, the Man and the Masks*
 (1948, repr. 1961)
Hone, J., *W.B.Yeats, 1865–1939* (1942, rev.
 1965)
MacLiammoir, M. and Boland, E., *W.B.
 Yeats and his World* (1971) [good
 photographs].
Bibliography:
Wade, A., *A Bibliography of the Writings of
 W.B. Yeats* (1951, rev. Alspach, R.K.,
 1968).
See:
Cullingford, E., *Yeats: 'Poems 1919–1935':
 A Casebook* (1984)
Donoghue, D., *Yeats* (1971)
Ellmann, R., *The Identity of Yeats* (1954,
 repr. 1964) [perceptive and convincing
 about a key aspect of the poetry]
Freyer, G., *W.B. Yeats and the Anti-
 Democratic Tradition* (1981)
Hough, G., *The Mystery Religion of W.B.
 Yeats* (1984) [a sensible brief
 examination of the relevance to the
 poetry of Yeats' occult philosophy]
Jeffares, A.N. and Knowland, A.S., *A
 Commentary on the Collected Plays of
 W.B. Yeats* (1975)
Jeffares, A.N. (ed.), *W.B. Yeats: The
 Critical Heritage* (1977)
Stallworthy, J. (ed.), *Yeats' 'Last Poems': A
 Casebook* (1968, repr. 1986)
Ure, P., *Yeats the Playwright* (1963)

3 Bibliographies

Davies, A., *An Annotated Critical
 Bibliography of Modernism* (1982)
English Association, *The Year's Work in
 English Studies* (annually from 1921.
 Separate chapter for 'The twentieth
 century' from Vol. **35**, 1956 onwards).
Modern Humanities Research Association,
 *Annual Bibliography of English
 Language and Literature* (from 1920)
*New Cambridge Bibliography of English
 Literature*, Vol. IV, 1900–50, ed.
 Willison, I.R.

4 Drama

Bablet, D., *The Theatre of Edward Gordon
 Craig* (originally pub. in French 1962,
 English trs. 1966, repr. 1981)

Kennedy, D., *Granville-Barker and the
 Dream of Theatre* (1985)
Maxwell, D.E.S., *A Critical History of
 Modern Irish Drama 1891–1980* (1984)
Trewin, J.C., *The Theatre Since 1900*
 (1951)
Williams, R., *Drama from Ibsen to Eliot*
 (1952) [enl. as *Drama from Ibsen to
 Brecht* (1968)]
Worth, K., *The Irish Drama of Europe from
 Yeats to Beckett* (1978)

5 Fiction

Batchelor, R., *The Edwardian Novelists*
 (1983)
Cavaliero, G., *The Rural Tradition in the
 English Novel, 1800–1939* (1977)
Friedman, A., *The Turn of the Novel: the
 Transition to Modern Fiction* (1966)
 [Hardy, Conrad, Forster, Lawrence]
Kettle, A., *An Introduction to the English
 Novel, Vol. 2: Henry James to the
 Present Day* (1953)
O'Faolain, S., *The Vanishing Hero: Studies
 in the Novelists of the Twenties* (1956)

6 Literary criticism

Bentley, E. (ed.), *The Importance of
 Scrutiny* (1948)
Empson, W., *Seven Types of Ambiguity*
 (1930)
 Some Versions of Pastoral (1935)
Forster, E.M., *Aspects of the Novel* (1927)
Hulme, T.E., *Speculations: Essays on
 Humanism and the Philosophy of Art*
 (1924, repr. 1960)
Knights, L.C., *Drama and Society in the
 Age of Jonson* (1937)
Leavis, F.R. (ed.), *A Selection from
 Scrutiny* (2 vols., 1968)
Muir, E., *The Structure of the Novel* (1928)
Murry, J. Middleton, *Aspects of Literature*
 (1920, repr. 1934)
 The Problem of Style (1922)
Richards, I.A., *Practical Criticism: A Study
 of Literary Judgement* (1929)
 Principles of Literary Criticism (1924)
 Science and Poetry (1926, repr. 1935)
Rickword, E., (ed.), *Scrutinies* (2 vols.,
 1928–31)
(See also section V.2 above under Eliot,
 Lawrence, and Leavis)

7 Periodicals

Blast: A Review of the Great Vortex, ed.
 Lewis, P. Wyndham (1914–15, repr.
 1967)
The Calendar of Modern Letters, ed.
 Rickword, E. and Garman, D. (1925–7,
 repr. 2 vols. 1966)

The Criterion, ed. Eliot, T.S. (1923–39, repr. 1967)
The English Review, ed. Hueffer, F.M. (1908–9), and others (1909–37)
New Verse, ed. Grigson, G. (1933–9, repr. 1966)
Scrutiny (1932–53, repr. 1963)

8 Poetry

CRITICAL WORKS

Alvarez, A., *The Shaping Spirit: Studies in Modern English and American Poets* (1958)
Fuller, R., *Owls and Artificers* (1971) [Oxford lectures on poetry, lively and astringent]
Graham, D., *The Trade of War: Owen, Blunden, Rosenberg* (1984)
Grubb, F., *A Vision of Reality: Liberalism in Twentieth Century Verse* (1965) [thoughtful discussion of issues central to the poetry of the period]
Johnston, J.H., *English Poetry of the First World War* (1964)
Pinto, V. de S., *Crisis in English Poetry, 1880–1940* (1951) [useful well-informed survey]
Silkin, J., *Out of Battle: the Poetry of the Great War* (1972) [comprehensive; useful bibliography]
Stead, C.K., *The New Poetic: Yeats to Eliot* (1964)
Tolley, A.T., *The Poetry of the Thirties* (1975) [detailed, informative]

POETRY ANTHOLOGIES

Bolt, S. (ed.), *Poetry of the 1920s* (1967) [good choice and notes]
Gardner, B. (ed.), *Up the Line to Death* (1964) [a historian's choice of poems from the First World War]
Hibberd, D. and Onions, J. (eds.), *Poetry of the Great War: An Anthology* (1987) [wide-ranging selection, with useful commentary and notes]
Jones, P., (ed.), *Imagist Poetry* (1972)
Larkin, P. (ed.), *The Oxford Book of Twentieth Century English Verse* (1973) [idiosyncratic choice; wide-ranging]
Parsons, I.M. (ed.), *Men Who March Away* (1965) [well-chosen selective anthology of First World War poets]
The Progress of Poetry (1936) [still the best selective anthology for the period as a whole]
Press, J. (ed.), *A Map of Modern English Verse* (1969)
Roberts, M. (ed.), *The Faber Book of Modern Verse* (1936, repr. 1965)

Silkin, J., (ed.), *The Penguin Book of First World War Poetry* (1979, rev. and enl. 1981)
Skelton, R. (ed.), *Poetry of the Thirties* (1964)
Yeats, W.B. (ed.), *The Oxford Book of Modern Verse* (1936) [idiosyncratic choice]

VI Music

British composers of the period are well covered in Sadie, S. (ed.), *The New Grove Dictionary of Music* (20 vols., 1980), and they are also well represented in the catalogues, normally published quarterly by *Gramophone*, of the recorded music currently available. There is guidance as to recordings in some of the Discographies listed below under composer-entries, and use can also be made of Greenfield, E., Layton, R., and March, I., *The Complete Penguin Stereo Record and Cassette Guide* (1984), supplemented by the same editors, *The Penguin Guide to Compact Discs, Cassettes and LPs* (1986). Recommendations can be up-dated by reference to reviews of new or re-issued recordings in *Gramophone* (monthly).

1 General studies

Bacharach, A.L., (ed.), *British Music of Our Time* (1946, rev. 1951) [articles on fifteen composers from Delius to Britten]
Cooper, M., (ed.), *New Oxford History of Music Vol. X: The Modern Age 1890–1960* (1974) [includes chapter on 'Music in Britain' by Hutchings, A.]
Ewen, D., (ed.), *Composers since 1900: A Biographical and Critical Guide* (1969)
Foreman, L., *British Musical Renaissance: a Guide to Research* (3 vols., 1972) [Vol. I gives sources for seventeen composers from Parry to Cyril Scott; Vol. II adds bibliographical data]
Frank, A., *Modern British Composers* (1953)
Howes, F., *The English Musical Renaissance* (1966) [valuable historical account, from 1890s to 1951]
Keller, H., *Criticism* (1987)
Lambert, C., *Music Ho! A Study of Music in Decline* (1934, repr. 1966)
Mackerness, E.D., *A Social History of English Music* (1964)
Mellers, W.H., *Studies in Contemporary Music* (1947) [chapters on Holst and Rubbra]
Pirie, P.J., *The English Musical Renaissance:*

*Twentieth Century British Composers
and their Works* (1979) [useful
chronologically-ordered survey,
1890–1978]

Schafer, M., *British Composers in Interview*
(1963) [sixteen composers including
Berkeley, Bush, Ireland, Rubbra and
Walton]

Scholes, P.A., *The Mirror of Music
1844–1944: A Century of Musical Life
in Britain as reflected in the pages of
'The Musical Times'* (2 vols., 1947)

Searle, H. and Layton, R., *Twentieth
Century Composers: Vol. III, Britain,
Scandinvia & the Netherlands* (1972)
[British composers from Elgar to
Britten]

Trend, M., *The Music Makers: Heirs and
Rebels of the English Musical
Renaissance from Elgar to Britten* (1985)
[readable, gossipy, wide-ranging
introduction]

2 Composers

Bax, Arnold (1883–1953)
From 1902 'Celtic' period (influenced by
W.B. Yeats), with publication of three
volumes of tales under the pen-name
'Dermot O'Byrne'; first success 1916 with
The Garden of Fand (symphonic poem);
1917 two further symphonic poems *Tintagel*
and *November Woods*; 1937 knighted; 1942
Master of the King's Music; 1953 KCVO.
Other compositions include:
(orchestral) Symphonic Variations for Piano
 and orchestra (1917); seven
 Symphonies between 1922 and 1939;
 Cello Concerto (1932); Violin Concerto
 (1937–8)
(chamber) Sonata for Viola and Piano
 (1922); Oboe Quintet (1922); Nonet
 (1930).
Life:
Farewell my Youth: An Autobiography
 (1943)
Catalogue:
Parlett, G., *Arnold Bax: A Catalogue of his
 Music* (1972).
See:
Foreman, L., *Bax: a Composer and his
 Times* (1983) [includes catalogue and
 discography]
Hull, R.H., *A Handbook on Arnold Bax's
 Symphonies* (1932)
Scott-Sutherland, C., *Arnold Bax* (1973)

Bliss, Arthur (1891–1975)
1913 BA and MusB, Cambridge University;
army service throughout First World War;
1922 *Colour Symphony* commissioned by
and performed at the Gloucester Festival;
1930 *Morning Heroes* (symphony for orator,
chorus and orchestra) performed at
Norwich Festival; 1950 Knighted; 1953
Master of the Queen's Music.
Other compositions include:
Oboe Quartet (1927); Clarinet Quintet
 (1931); Viola Sonata (1933); *Things to
 Come* [film score] (1934–5); Music for
 Strings (1935); *Checkmate* [ballet]
 (1937); *Miracle in the Gorbals* [ballet]
 (1944).
See:
As I Remember (1970) [autobiography]
Foreman, L. (ed.), *Arthur Bliss: a
 Catalogue and Critical Survey* (1979)
 [includes discography]

Bridge, Frank (1879–1941)
Studied violin at RCM and, from
1899–1903, composition under Stanford;
played violin in three string quartets, and
conducted opera; 1910 Phantasie Piano
Quartet; 1911 *The Sea* (orchestral suite);
1914 *Summer* (symphonic poem); 1921–4
Piano Sonata; 1926 Quartet No. 3; 1927
Enter Spring [tone poem for large
orchestra] for Norwich Festival]; 1929
Piano Trio No. 2; 1937 String Quartet
No. 4.
See:
Hindmarsh, P., *Frank Bridge* (1983)
 [includes discography]
Payne, A., *Frank Bridge – Radical and
 Conservative* (1984)
Payne, A. and Foreman, L., *The Music of
 Frank Bridge* (1976)
Pirie, P.J., *Frank Bridge* (1971)

Britten, Benjamin (1913–76)
From 1924 a pupil of Frank Bridge; from
1930 studied piano and composition at
RCM; 1935–7 worked for GPO Film Unit;
1948 founded the Aldeburgh Festival; 1953
CH; 1965 OM; 1976 life peerage.

Compositions include:
A Simple Symphony (1934); *Our Hunting
 Fathers* (1936); Variations on a Theme
 of Frank Bridge (1937); *Les
 Illuminations* (1939); Violin Concerto
 (1939); *Seven Sonnets of Michelangelo*
 (1940); *Sinfonia da Requiem* (1940);
 First String Quartet (1941); Serenade
 for tenor, horn and string orchestra
 (1943); *Peter Grimes* (opera) (1945).
 (For compositions after 1945 see
 volume 9.)
Life:
Mitchell, D., *Britten and Auden in the
 Thirties: the Year 1936* (1981)

Mitchell, D. and Evans, J. (eds), *Benjamin Britten 1913–1976: Pictures from a Life* (1978) [superbly illustrated]

White, E.W, *Benjamin Britten: his Life and Operas* (1948, rev. 1954, 1970 and 1983)

Catalogue:

Mitchell, D., (comp.) *Benjamin Britten: a Complete Catalogue of his Published Works* (1973)

See:

Keller, H. and Mitchell, D. (eds.), *Benjamin Britten: a Commentary on his Works* (1952, repr. 1972) [includes catalogue]

Kennedy, M., *Britten* (1981) [includes discography]

Palmer, C. (ed.), *The Britten Companion* (1984)

Butterworth, George (1885–1916)

Enthusiasm for folksong fired by association with Cecil Sharp and Vaughan Williams; enlisted in 1914; killed in action and awarded MC posthumously.

Compositions include:

(orchestral) *2 English Idylls* (1911); *A Shropshire Lad – Rhapsody* (1912); *The Banks of Green Willow – Idyll* (1913)

(vocal) two series of settings of poems by A.E. Housman, *A Shropshire Lad* (1911) and *Bredon Hill* (1912).

See:

Copley, I., *George Butterworth and his Music; a Centennial tribute* (1985)

Delius, Frederick (1862–1934)

b. Bradford, son of a wool-merchant, and intended for a business career; 1884 orange-planting in Florida; 1886 student at Leipzig Conservatorium; encouraged and influenced by Grieg; from 1888 lived mainly in Paris; 1897 settled near Fontainebleau, henceforth his home; recognition first in Germany, with 1905 *Appalachia*, 1906 *Sea Drift*, and 1907 *A Village Romeo and Juliet* (opera); from 1909 championed in England by Beecham; 1925 became blind and paralysed from syphilis; 1928 Eric Fenby became his amanuensis, their collaboration resulting in 1930 *A Song of Summer*, and Third Violin Sonata, 1930–2 *Songs of Farewell*; 1929 six-day Delius Festival at Queen's Hall, London; 1929 CH.

Other compositions include:

(orchestral) *Paris: The Song of a Great City* (1901); Piano Concerto (1904); *Brigg Fair* (1907); *In a Summer Garden* (1908); *On Hearing the First Cuckoo in Spring* (1912); *North Country Sketches* (1913–14); *Summer Night on the River* (1914); Violin Concerto (1916); *Eventyr* (1917)

(chamber) First Violin Sonata (1914); Cello Sonata (1916); Second Violin Sonata (1923);

(vocal and choral) *A Mass of Life* (1909) [texts from Nietzsche]

(operas) *Koanga* (1904); *Fennimore and Gerda* (1919).

Life:

Beecham, T., *Frederick Delius* (1959, repr. 1975) [characteristically idiosyncratic with interesting memoirs]

Carley, L. (ed.), *Delius: A Life in Letters, 1862–1908* (1983) [includes fascinating reminiscences by Delius and by his wife Jelka]

Carley, L., *Delius: the Paris Years* (1975)

Delius, Clare, *Frederick Delius: Memories of my Brother* (1935)

Fenby, E., *Delius as I Knew Him* (1935)

Catalogues:

Lowe, R., *Frederick Delius, 1862–1934: a Catalogue of the Archives of the Delius Trust* (1974)

Threlfall, R., *A Catalogue of the Compositions of Frederick Delius* (1977)

Walker, M. and Upton, S., *Delius Discography* (1973)

See:

Carley, L. and Threlfall, R., *Delius* (1984)

Fenby, E., *Delius* (1971)

Heseltine, P., *Frederick Delius* (1923)

Hutchings, A., *Delius* (1948)

Jefferson, A., *Delius* (1972)

Palmer, C. (ed.), *Delius: Portrait of a Cosmopolitan* (1980)

Redwood, C. (ed.), *A Delius Companion* (1976)

See also:

Delius Society Journal, published quarterly from 1962.

Elgar, Edward (1859–1934)

b. Broadheath, near Worcester where his father owned a music-shop; no formal training in music; 1885–9 succeeded his father as organist at St George's Roman Catholic Church, Worcester; 1890 *Froissart Overture* performed at Worcester Festival; 1897 first London success, with *Imperial March* composed for the Jubilee; 1900 Hon. Doctorate conferred by Cambridge University in recognition of *Enigma Variations* (1899); 1904 knighted; 1904–8 held chair of music specially created and endowed for him at Birmingham University; 1911 OM; no important compositions after his wife's death in 1920;

1924 Master of the King's Music; 1931 created baronet.
Other compositions include:
(orchestral) *Cockaigne Overture* (1901); first four *Pomp and Circumstance Marches* (1901–7); *Introduction and Allegro for Strings* (1905); Symphony No. 1 (1908); Violin Concerto (1910); Symphony No. 2 (1911); *Symphonic Study: Falstaff* (1913); Cello Concerto (1919)
(chamber) String Quartet (1918); Piano Quintet (1919)
(vocal and choral) *Sea Pictures* (1899); *Dream of Gerontius* (1900); *The Apostles* (1903); *The Kingdom* (1906); *The Spirit of England* (1915–17).
Writings:
Letters and Other Writings (1956, ed. Young, P.M.
Letters to Nimrod: Edward Elgar to August Jaeger 1897–1908 (1965)
A Future for British Music and other Lectures by Edward Elgar (1968).
Catalogues:
For list of compositions see entry in *New Grove*, Vol. V
Knowles, J., *Elgar's Interpreters on Record: an Elgar Discography* (1977, rev. 1986)
See also:
Moore, J.N., *Elgar on Record: The Composer and the Gramophone* (1974) [composer–conductor recordings from 1913 to 1933].
Life:
De-la-Noy, M., *Elgar the Man* (1983)
Moore, J.N., *Elgar: A Life in Photographs* (1972).
See:
Kennedy, M., *Portrait of Elgar* (1968, rev. 1982, 1987) [a good introduction]
Elgar Orchestral Music (1970)
McVeagh, D.M., *Edward Elgar: His Life and Music* (1955)
Maine, B., *Elgar: his Life and Work* (2 vols., 1933, repr. 1973)
Moore, J.N., *Edward Elgar: A Creative Life* (1984) [comprehensive, thoroughly researched, lengthy, invaluable for the Elgar enthusiast]
Parrott, I., *Elgar* (1971)
Redwood, C. (ed.), *An Elgar Companion* (1982)
Young, P.M., *Elgar O.M.: A Study of a Musician* (1955, rev. 1973)
See also:
Elgar Society Newsletter 1973– (renamed *Elgar Society Journal* 1979)

Finzi, Gerald (1901–56)
1930–3 taught composition at RAM; 1937

settled in the Hampshire Hills; returned to London during Second World War to work in a government department; 1951 learnt he was dying slowly of leukaemia.
Compositions include:
(vocal) five cycles of settings of Hardy's poems, composed between 1921 and 1956; 1926, *Dies Natalis* (words by Traherne); (choral) 1950 *Intimations of Immortality* (Wordsworth)
(orchestral) 1949, Clarinet Concerto; 1955, Cello Concerto.

Gurney, Ivor (1890–1937)
Studied composition under Stanford at RCM; enlisted in 1915; wounded, gassed and shell-shocked in 1917; published two volumes of poems, *Severn and Summer* (1917) and *War's Embers* (1919); 1918 resumed studies at RCM, now under Vaughan Williams; eighty-two published songs, mainly written between 1919 and 1922; 1922–37 spent in various mental hospitals.
See:
Hurd, M., *The Ordeal of Ivor Gurney* (1978)

Holst, Gustav (1874–1934)
b. Cheltenham, to family of Swedish origin; 1895 studied composition under Stanford at RCM, making life-long friend of fellow-student R. Vaughan Williams; played trombone on seaside piers and (from 1898) in Scottish Orchestra; 1899 out of interest in mysticism learnt enough Sanskrit to translate the Vedic hymns; director of Music at St Paul's Girls' School from 1905 until his death, and also at Morley College from 1907; 1918–19 organised music for troops in Salonika, invited there by YMCA; 1919 first public performance of *The Planets* brought brief spell of public acclaim; 1919–24 Professor of Composition at RCM; 1923 *The Perfect Fool* (opera) baffled Covent Garden audiences; 1925 'Keats' choral symphony performed at Leeds Festival; 1927 Holst Festival at Cheltenham.
Other compositions include:
A Somerset Rhapsody (1907) [dedicated to Cecil Sharp], *Savitri* (1908, first performance 1916) [opera da camera]; *The Hymn of Jesus* (1917, first performance 1920); *At the Boar's Head* (1925) [opera based on Shakespeare's Falstaff]; *Egdon Heath* (1928); *The Wandering Scholar* (1929–30) [opera, first performance 1934].

Life:
Holst, I., *Gustav Holst: a Biography* (1938, rev. 1969)
Short, M. (ed.), *Gustav Holst: Letters to W.G. Whittaker* (1974)
Vaughan Williams, U. and Holst, I. (eds.), *Heirs and Rebels* (1959, rev. 1974)
See:
Holst, I., *The Music of Gustav Holst* (1951, rev. 1975)
Short, M. (ed.), *Gustav Holst (1874–1934): A Centenary Documentation* (1974) [includes discography]

Ireland, John (1879–1962)
Studied piano at RCM 1893–7, and composition under Stanford 1897–1901; 1904–26 organist and choirmaster in London; 1923–39 taught composition at RCM.
Compositions include:
(song-cycles) *Land of Lost Content* (1921) [poems by A.E. Housman] and *Five Poems by Thomas Hardy* (1926)
(piano) Sonata (1920) and Sonatina (1927)
(orchestral) Concertino Pastorale for Strings (1939).
See:
Chapman, E., *John Ireland: A Catalogue of Published Works and Records* (1968)
Longmire, J., *John Ireland: Portrait of a Friend* (1969)
Searle, M.V., *John Ireland: The Man and his Music* (1979).

Parry, Hubert (1848–1918)
1883 joined teaching staff of RCM becoming its Director in 1894; 1900–8 Professor of Music at Oxford University; 1898 knighted; 1903 baronetcy.
Compositions include: 'I was glad' (1902) [anthem for coronation of Edward VII]; *A Vision of Life* (1907); Symphony No. 5, *The Soul's Ransom* ('symphonia sacra') and *An Ode on the Nativity* (1912); choral song 'Jerusalem' and *Songs of Farewell* (six motets) (1916); seventy-four songs collected in *English Lyrics*, 12 vols. (1885–1920).
Writings:
Style in Musical Art (1911).
See:
Graves, C.L., *Hubert Parry* (1928)
Maitland, J.A. Fuller, *The Music of Parry and Stanford* (1934).

Rubbra, Edmund (1901–1986)
1921–5 studied piano and composition at RCM; 1925–39 musical journalism; 1937 First Symphony; 1947–68 Lecturer in Music, Oxford University; 1963 Fellow of Worcester College, Oxford.

See:
A Complete Catalogue of Compositions by Edmund Rubbra to June 1971 (1971)
Foreman, L. (ed.), *Edmund Rubbra: Composer* (1977) [includes discography]

Stanford, Charles Villiers (1852–1924)
1873 organist, Trinity College, Cambridge; 1883 Professor of Composition and Orchestral Playing, RCM; 1887 Professor of Music, Cambridge University; 1902 knighted.
Compositions include:
Songs of the Sea (1904), and *Songs of the Fleet* (1910) [words by Newbolt]; *Stabat Mater* (1907).
See:
Greene, H. Plunket, *Charles Villiers Stanford* (1935)
Porte, J.F., *Sir Charles V. Stanford* (1921, repr. 1976)

Vaughan Williams, Ralph (1872–1958)
1890–2 studied composition with Parry and Stanford at RCM; 1892–5 history B.A. degree at Cambridge University; 1895–6 further year at RCM; 1897 studied with Bruch; 1901 Cambridge Doctorate; 1901 earliest successful composition, the song 'Linden Lea'; from 1903 fieldwork collecting folk-songs (over 800 in all); 1906 edited *The English Hymnal*; more song-settings included 1904 *Songs of Travel* (R.L. Stevenson), 1903 'Silent Noon' (D.G. Rossetti), and 1909 *On Wenlock Edge* (A.E. Housman); 1907 Leeds Festival success with *Toward the Unknown Region* (text from Whitman); 1908 studied with Ravel; 1910 *Fantasia on a Theme by Thomas Tallis*; 1914 *A London Symphony* (rev. 1920); 1914–19 army service, first as private in RAMC, later with commission in the artillery; seven more symphonies between 1922 and 1958; also five operas, 1924 *Hugh the Drover*, 1929 *Sir John in Love*, 1936 *The Poisoned Kiss*, 1937 *Riders to the Sea*, 1951 *The Pilgrim's Progress*; and 1930 the ballet *Job*; 1935 OM; 1946 President, English Folk Dance and Song Society.
Writings:
Vaughan Williams, R. and Holst, G., *Heirs and Rebels: Letters Written to Each Other and Occasional Writings on Music*, ed. Vaughan Williams, U. and Holst, I. (1959)
Catalogue:
Kennedy, M., *Catalogue of the Works of Ralph Vaughan Williams* (1980)
Life:
Vaughan Williams, U., *RVW: a Biography of Ralph Vaughan Williams* (1964)

Vaughan Williams, U. and Lunn, J.E.,
*Ralph Vaughan Williams: a Pictorial
Biography* (1971)
See:
Day, J., *Vaughan Williams* (1961)
Howes, F., *The Music of Ralph Vaughan
Williams* (1954)
Kennedy, M., *The Works of Ralph Vaughan
Williams* (1964, rev. 1980)
Ottaway, H., *The Vaughan Williams
Symphonies* (1972).

Walton, William (1902–83)
Oxford University 1918–20, without a
degree; from 1920 lived in Chelsea or
abroad as adopted brother of Osbert and
Sacheverell Sitwell (met at Oxford); first
success with *Façade* (1922, revised 1926)
[settings for poems by Edith Sitwell]; 1931
Belshazzar's Feast (oratorio) at Leeds
Festival; from 1934 music for British films,
including Olivier's versions of Shakespeare;
married 1948, and made his home in Italy;
1951 knighted; 1961 OM.
Compositions include: (orchestral) *Portsmouth
Point* (overture) (1925); Viola Concerto
(1928–29); First Symphony (1935);
Violin Concerto (1939); Cello Concerto
(1956); Second Symphony (1960);
(chamber) String Quartet (1947)
(opera) *Troilus and Cressida* (1954).
Catalogue:
Craggs, S.R., *William Walton: a Thematic
Catalogue of his Musical Works* (1977)
See:
Howes, F., *The Music of William Walton*
(1965, rev. 1974) [gives detailed
analysis of works]
Ottaway, H., *William Walton* (1972)
Tierney, N., *William Walton: His Life and
Music* (1985)

Warlock, Peter (1894–1930)
Born Philip Heseltine; conscientious
objector, 1914–18, but classed as unfit;
influenced first by Delius (about whose
music he published a book in 1923) and
then by Bernard van Dieren; 1916–17
Saudades (song-cycle); developed a dual
personality, reflected in two aspects of his
music – introspective, melancholy Heseltine
vs roystering, extrovert Warlock; by mid-
twenties an acknowledged authority on
Elizabethan music; wrote a vast number of
songs (for list see entry in *New Grove*,
Vol. XX); most notable compositions are:
1922 *The Curlew* (setting for voice and
chamber ensemble of poems by W.B.
Yeats); 1926 (orchestral) *Capriol Suite*.

See:
Copley, I.A., *The Music of Peter Warlock: a
Critical Survey* [the most
comprehensive study] (1979)
Gray, C., *Peter Warlock: a Memoir of
Philip Heseltine* (1934)
Tomlinson, F., *Warlock and Delius* (1976)
Warlock and van Dieren (1978)

3 Conductors

Barbirolli, John (1899–1970)
Conducted operas at Covent Garden and
Sadler's Wells between 1929 and 1937;
1931–4 conductor of Scottish Orchestra;
1943 permanent conductor, Hallé
Orchestra; 1949 knighted; 1958 conductor-
in-chief, Hallé; 1968 conductor-laureate,
Hallé; 1969 CH.
See:
Kennedy, M., *Barbirolli* (1971) [includes
discography]
The Hallé Tradition (1960)

Beecham, Thomas (1879–1961)
Son of a wealthy manufacturing chemist;
self-taught as a conductor; 1909 founded
the Beecham Symphony Orchestra; 1915
formed the Beecham Opera Company ;1916
knighted and succeeded to his father's
baronetcy; 1932 founded the London
Philharmonic Orchestra; 1932 became
artistic director at Convent Garden; 1946
founded the Royal Philharmonic Orchestra;
1957 CH.
Life:
A Mingled Chime (1944, repr. 1979)
[autobiography]
Procter-Gregg, H. (ed.), *Beecham
Remembered* (1977)

Boult, Adrian (1889–1983)
1914 B.Mus. Oxford University; 1924–30
musical director of City of Birmingham
Symphony Orchestra; 1930 trained and
conducted newly formed BBC Symphony
Orchestra; 1937 knighted; 1950–7 musical
director of London Philharmonic Orchestra;
from 1957 on, continued remarkably active
as a freelance conductor, with much
recording; 1969 CH.
Life:
My Own Trumpet (1973) [autobiography]
Kennedy, M., *Adrian Boult* (1987).

Harty, Hamilton (1879–1941)
From c. 1911 conducted London
Symphony Orchestra, and during the War,
Hallé Orchestra; 1920–33 permanent
conductor with Hallé; 1925 knighted.

See:
Greer, D., *Hamilton Harty: his Life and his Music* (1979)
Kennedy, M., *The Hallé Tradition* (1960).

Wood, Henry (1869–1944)
Early experience as theatre and opera conductor; 1895 formed permanent orchestra for the first season of Promenade Concerts at Queen's Hall, Langham Place; continued as musical director, in sole charge until 1940; in addition numerous influential conducting engagements all round the country; 1911 knighted; 1941 Queen's Hall destroyed by air raid, and Proms removed to Royal Albert Hall; 1944 CH.
Life:
My Life of Music (1938, repr. 1971) [autobiography]
See:
Cox, D., *The Henry Wood Proms* (1980)
Pound, R., *Sir Henry Wood* (1969).

4 Folk music

Dean Smith, M., *A Guide to English Folk Song Collections 1822–1952* (1954)
Finkelstein, S., *Composer and Nation: The Folk Heritage of Music* (1960)
Howes, F., *Folk Music in Britain – and Beyond* (1969)
Karpeles, M., *Cecil Sharp: his Life and Work* (1967)
Kidson, F. and Neal, M., *English Folk-Song and Dance* (1915, repr. 1972)
Lloyd, A.L., *Folk Song in England* (1967)
Sharp, Cecil, *English Folk Song: Some Conclusions* (1907, rev. Karpeles, M., 1965)
Strangways, A.H. Fox, *Cecil Sharp* (1933)
Vaughan Williams, R. and Lloyd, A.L., *The Penguin Book of English Folk Songs* (1959)

VII The Visual Arts

A useful general reference work, with good coverage of the first half of the twentieth century, is Bindman, D. (ed.), *Encyclopedia of British Art* (1985). Among periodicals the most important is *Studio International* (quarterly, from 1893, originally *The Studio*).

Many of the volumes listed in this section contain excellent reproductions or photographs, but it will be realised that these can be no substitute for the experience of viewing the paintings or sculptures themselves. The Tate Gallery,

Millbank, London is the major public gallery for modern art, and all the artists below are represented in its collection, often quite extensively. In addition, the Imperial War Museum, Lambeth Road, SE1 contains important paintings and sculpture by the large number who were Official War Artists during the First and/or Second World Wars, while most of the painters are included in the collection of twentieth-century water-colours at the Victoria and Albert Museum, South Kensington.

Outside London the art of the period is well-represented in the civic art galleries at Birmingham, Huddersfield, Leeds, Liverpool, Manchester and Southampton; while there are good, though smaller collections at Aberdeen, Bradford, Bristol, Cambridge (Fitzwilliam Museum and Kettle's Yard), Cardiff (National Museum of Wales), Hull (University), Leicester, Sheffield and Swindon. In Edinburgh, the Scottish National Gallery of Modern Art (established 1960) is steadily building up its holdings and is notable for the display of sculpture in its grounds.

Two invaluable volumes, full of helpful detail, are Abse, J., *The Art Galleries of Britain and Ireland: A Guide to their Collections* (1975), and Chapel, J. and Gere, C. (eds.) *The Art Galleries of Britain and Ireland* (1985); these can be supplemented by Strachan, W.J., *Open Air Sculpture in Britain: A Comprehensive Guide* (1984). In the 'Artist-entries' below, provincial (or smaller London) galleries are mentioned only if they contain several or particularly significant works by the artist in question.

1 General studies

Anscombe, I., *Omega and After: Bloomsbury and the Decorative Arts* (1981) [interesting on the later years, including Charleston]
Baron, W., *The Camden Town Group* (1979) [full and valuable account; generous, mainly black-and-white, illustrations]
Chamot, M., *Modern Painting in England* (1937)
Collins, J., *The Omega Workshops* (1983) [detailed, well-illustrated]
Cork, R., *Art Beyond the Gallery in Early Twentieth Century England* (1985) [fascinating and superbly-illustrated account of Epstein's Strand statues, Cave of the Golden Calf, Omega Workshops interiors, Wyndham Lewis's painted rooms, Restaurant de la Tour Eiffel, and the overhead

sculpture on Holden's London Transport Headquarters building]

Vorticism and Abstract Art in the First Machine Age (2 vols., (1975–6) [full and authoritative]

Farr, D., *English Art 1870–1940* (1978, repr. 1984) [useful introductory survey, covering applied as well as 'pure' arts]

Hammacher, A.M., *Modern English Sculpture* (1967) [splendidly illustrated: includes Epstein, Gaudier, Hepworth, Moore]

Harries, M. and S., *The War Artists: British Official War Art of the 20th Century* (1983) [wide-ranging survey, more anecdotal than critical]

Harrison, C., *English Art and Modernism 1900–1939* (1981) [soundly researched historical survey]

Laughton, B., *The Euston Road School: A Study in Objective Painting* (1986)

Morphet, R., *British Painting 1910–1945* (1967)

Nairne, S. and Serota, N. (eds.), *British Sculpture in the Twentieth Century* (1981)

Read, H., *Contemporary British Art* (1951, rev. 1964)

Read, H. (ed.), *Unit 1. The Modern Movement in English Architecture, Painting and Sculpture* (1934) [fascinating contemporary document: coverage includes Burra, Hepworth, Moore, Nash, Nicholson, Wadsworth]

Rothenstein, J., *British Art since 1900* (1962) [eclectic anthology of excellent reproductions]

Modern English Painters, Vol. I: *From Sickert to Smith* (1950); Vol. II: *From Lewis to Moore* (1956) (rev. 1984 as Vol. I: *Sickert to Grant*; Vol. II: *Nash to Bawden*) [on their own level, useful compilations]

British Artists and the War (1936)

Shone, R., *A Century of Change: British Painting Since 1900* (1977)

Spalding, F., *British Art Since 1900* (1986)

Sutton, D., *British Art 1890–1923* (1971)

Watney, S., *English Post-Impressionism* (1980)

Wees, William C., *Vorticism and the English Avant-Garde* (1972)

2 Artists

Bell, Vanessa (1879–1961)
Painter; daughter of Sir Leslie Stephen and older sister of Virginia Woolf; 1901–4 studied at Royal Academy Schools; 1907 married Clive Bell; 1910–12 influenced by the two Post-Impressionist exhibitions organised by Roger Fry and Clive Bell; from 1913, alongside figurative and abstract paintings, worked on decorative commissions for Omega Workshops; from 1916 with Duncan Grant decorated Charleston, the house near Lewes, Sussex, now restored as a memorial to Bloomsbury; 1919 joined London Group; 1922 first solo exhibition. Paintings at Courtauld Institute, London; Bradford.
Catalogue:
Vanessa Bell: A Memorial Exhibition of Paintings, Arts Council (1964)
See:
Shone, R., *Bloomsbury Portraits: Vanessa Bell, Duncan Grant, and Their Circle* (1976)
Spalding, F., *Vanessa Bell* (1983) [authorised biography]

Bomberg, David (1890–1957)
Painter; b. Birmingham, into a family of Polish-Jewish immigrants who moved in 1895 to London's East End; 1908–10 attended evening classes at Central School of Arts and Crafts, and Sickert's evening classes at the Westminster School; 1911–13 Slade School; 1914 first solo exhibition, also joined London Group; 1915 enlisted in Royal Engineers; 1917 commissioned to paint a picture for a Canadian war memorial, but first version was rejected; 1919 one-man exhibition unfavourably received; disillusioned, 1920–2 retired to Hampshire, and 1923–7 to Palestine; visits to Spain from 1929 on, inaugurated preoccupation with a new approach to landscape; 1942 worked briefly as Official War Artist; 1945–53 taught at Borough Polytechnic, London; 1954 moved to Spain. Paintings at Manchester; Sheffield; Southampton; York.
Catalogues:
David Bomberg: 1890–1957, Arts Council (1958)
David Bomberg 1890–1957, Arts Council (1967)
David Bomberg: The Later Years, Whitechapel Art Gallery (1979)
David Bomberg in Palestine 1923–27, Israel Museum, Jerusalem (1983)
See:
Cork, R., *David Bomberg* (1987)
Lipke, W., *David Bomberg: A Critical Study of his Life and Work* (1967)
Oxlade, R., *David Bomberg, 1890–1957* (1977)

Burra, Edward (1905–76)
Painter; 1923–5 RCA; 1929 first solo exhibition; from 1931 engaged in theatre

design; 1933 joined Unit One; 1936 exhibited at International Surrealist Exhibition, London; 1973 retrospective exhibition at Tate Gallery. Works at British Museum; Edinburgh.
Catalogue:
Causey, A., *Edward Burra: Complete Catalogue* (1985) [valuable lengthy introduction]
See:
Chappell, W. (ed.), *Edward Burra: A Painter Remembered by his Friends* (1982)
 Well Dearie! The Letters of Edward Burra (1985)
Rothenstein, J., *Edward Burra* (1973)

Dobson, Frank (1888–1963)
Sculptor; 1906–10 Hospitalfield Art Institute, Arbroath; 1914 first solo exhibition of paintings and drawings; 1914–18 active service in France in Artists' Rifles; 1920 exhibited in Group X exhibition; 1921 first solo sculpture exhibition; 1924–8 president of London Group; 1946–53 Professor of Sculpture at RCA. Sculptures at Courtauld Institute, London; Bradford.
Catalogues:
Frank Dobson, CBE, RA, 1886–1963, Memorial Exhibition Arts Council (1966)
Frank Dobson 1886–1963. True and Pure Sculpture Kettles Yard, Cambridge (1981)
See:
Earp, T.W., *Frank Dobson, Sculptor* (1945)

Epstein, Jacob (1880–1959)
Sculptor and painter; b. New York City; 1902 migrated to Paris; 1905 settled in London; 1911 naturalised; 1907 invited by architect Charles Holden to decorate new British Medical Association building in the Strand; 1908 public outcry excited by the eighteen over-life-size nude figures; further puritan attacks on carving for Oscar Wilde's tomb in Paris 1912, and memorial to W.H. Hudson (*Rima*), 1925; from 1916 onward portrait bronzes gradually gained public acceptance, but no further public commission till 1929 (Holden's London Transport Headquarters building); 1933 successful exhibitions of paintings of Epping Forest, and flower paintings, 1936 and 1940, but continuing hostility to large stone carvings, notably *Genesis*, 1931, *Son of God*, 1933, *Ecce Homo*, 1935, *Adam*, 1939; 1948 first breakthrough with *Lazarus*, included in Battersea Park exhibition for Festival of Britain in 1951; thereafter numerous large-scale commissions; 1954 knighted.
 Large sculptures on view include: in London, *Rima* and *Bowater House Group* in Hyde Park, *The Visitation* in Tate Gallery, *Day* and *Night* at 55 Broadway, SW1, *Madonna and Child* in Cavendish Square, W1, and TUC war memorial in Great Russell St., WC1; in Birmingham Art Gallery *Lucifer*; in Coventry Cathedral *St Michael and the Devil*; in Llandaff Cathedral *Christ in Majesty*; in Liverpool *Liverpool Giant* at Lewis's Store; in New College, Oxford *Lazarus*. For portrait busts visit Tate Gallery, Imperial War Museum, National Portrait Gallery, Westminster Abbey (William Blake in Poet's Corner); Bolton; Manchester.
Writings:
Jacob Epstein to Arnold Haskell, *The Sculptor Speaks* (1931)
Epstein, J., *Autobiography* (1935)
 Let there be Sculpture (1940, rev. and enl. as *Epstein: An Autobiography*, 1955)
Exhibition catalogue:
Jacob Epstein: Sculpture and Drawings, Leeds City Art Galleries and Whitechapel Art Gallery (1987) [excellent illustrations, and a number of interesting essays].
See:
Buckle, R., *Epstein Drawings* (1962)
 Jacob Epstein: Sculptor (1963) [excellent and copious photographs].
Cork, R., *Jacob Epstein. The Rock Drill Period* (1973)
Friedman, T., and Silber, E. (eds.), *Jacob Epstein Sculpture and Drawings* (1987)
Silber, E., *The Sculpture of Epstein with a Complete Catalogue* (1986)

Fry, Roger (1866–1934)
Painter and writer; 1905–10 Director of Metropolitan Museum of Art, New York; 1910 organised first exhibition of French Post-Impressionists at Grafton Gallery, London; 1912 second Post-Impressionist Exhibition; 1913–19 founded and directed Omega Workshops. Paintings in Courtauld Institute, London.
Writings include:
Vision and Design (1920)
Last Lectures (1939, repr. 1962)
Sutton, D. (ed.), *Letters of Roger Fry* (2 vols., 1972).
Bibliography:
Laing, D.A., *Roger Fry: An Annotated Bibliography of the Published Writings* (1979).

Catalogue:

Vision and Design: The Life, Work and Influence of Roger Fry, Arts Council (1966)

See:

Spalding, F., *Roger Fry: Art and Life* (1980)

Falkenheim, J.V., *Roger Fry and the Beginnings of Formalist Art Criticism* (1985)

Woolf, V., *Roger Fry: a Biography* (1940)

Gaudier-Brzeska, Henri (1891–1915)
Sculptor; born Henri Gaudier, he added to his surname that of Sophie Brzeska, the Polish woman with whom he lived in Paris and London from 1910; no formal art education; 1913 exhibited with the Allied Artists' Association, and worked briefly with Omega Workshops; 1914 joined the Rebel Art Centre, and contributed to *Blast*; September 1914 joined French infantry, and was killed in action June 1915; 1918 memorial exhibition at Leicester Galleries, London. Sculptures at Bristol; Cambridge (Kettles Yard); Eastbourne.

Catalogue:

Henri Gaudier-Brzeska, Sculptor 1891–1915, Kettle's Yard, Cambridge (1983)

See:

Cole, R., *Burning to Speak, the Life and Heart of Henri Gaudier-Brzeska*, (1978) [informative brief life; numerous good photographs]

Ede, H.S., *Savage Messiah* (1931) [largely letters and diaries]

Pound, Ezra, *Gaudier-Brzeska: A Memoir* (1916)

Gertler, Mark (1891–1939)
Painter; born and grew up in East London; 1908–12 Slade School; exhibited with London Group; from 1920 suffered from tuberculosis and spent short periods in sanatoria; June 1939 committed suicide. Paintings at Belfast; Bradford; Manchester; Southampton.

See:

Carrington, N. (ed.), *Mark Gertler: Selected Letters* (1965)

Woodeson, J., *Mark Gertler: Biography of a Painter, 1891–1939* (1972) [thorough and authoritative, with catalogue]

Gill, Eric (1882–1940)
Sculptor, engraver and typographer; 1903 decided to become a professional stone-cutter; 1907 moved to Ditchling, Sussex, where shortly before the War the Roman Catholic 'Ditchling Community' formed itself; 1928 sculpture commissioned for London Transport Headquarters building; 1929 commissioned to carve sculptures for the facade of Broadcasting House; 1938 completed panels for the League of Nations building in Geneva.

Writings:

Art and a Changing Civilisation (1934, repr. 1949)

Autobiography (1940, repr. 1947)

Last Essays (1942)

Letters of Eric Gill, ed. Shewring, W. (1947)

Bibliography:

Gill, Evan R., *Bibliography of Eric Gill* (1953, repr. 1973)

Catalogues: Gill, Evan R., *The Inscriptional Work of Eric Gill: An Inventory* (1966)

Physick, J.F., *The Engraved Work of Eric Gill*, (Victoria and Albert Museum, 1963)

See:

Attwater, D., *A Cell of Good Living: the Life, Works and Opinions of Eric Gill* (1969).

Skelton, C., *The Engravings of Eric Gill* (1983)

Speaight, R., *The Life of Eric Gill* (1966)

Yorke, M., *Eric Gill: Man of Flesh and Spirit* (1981) [comprehensive and persuasive reappraisal]

Gilman, Harold (1876–1919)
Painter; 1897–1901 Slade School; 1907 meeting and subsequent friendship with Sickert; 1908 founded, and exhibited at, Allied Artists' Association; 1911 founder member of Camden Town Group; 1913 first president of London Group; 1918 commission from Canadian Government for a war memorial painting; February 1919 died in the influenza epidemic. Paintings at Cardiff; Leeds; Manchester; Oxford; Southampton; York.

Catalogues:

Harold Gilman 1876–1919, Arts Council, 1954

Harold Gilman 1876–1919, Arts Council, 1981

See:

Baron, W., *The Camden Town Group* (1979)

Lewis, W. and Fergusson, L.F., *Harold Gilman: an Appreciation* (1919)

Ginner, Charles (1878–1952)
Painter; 1899–1904 worked in an architect's office in Paris; studied painting at Ecole des Beaux Arts; 1908 exhibited with Allied Artists' Association; 1909 settled in London; 1911 founder member of Camden Town Group; 1913 founder member of

London Group; 1916 drafted into the army, later becoming Official War Artist; 1920 joined New English Art Club; in Second World War again an Official Artist; 1950 CBE. Paintings at Bradford; Huddersfield; Leeds.
Catalogue:
Charles Ginner: Paintings and Drawings, Arts Council (1953)
See:
Baron, W., *The Camden Town Group* (1979)

Gore, Spencer Frederick (1878–1914)
Painter; 1896–99 Slade School; 1904 formed friendship with Sickert; 1908 with Gilman founded Allied Artists' Association; 1911 first president of Camden Town Group; 1913 joined London Group; March 1914 died of pneumonia. Paintings at Bradford; Leeds; Southampton.
Catalogues:
Spencer Frederick Gore, Arts Council (1955)
Spencer Frederick Gore 1878–1914, Anthony d'Offay Gallery (1974 and 1983)
See:
Baron, W., *The Camden Town Group* (1979)

Grant, Duncan (1885–1978)
Painter and designer; 1906–7 studied in Paris; from 1910 influenced by the two Post-Impressionist Exhibitions; 1913 helped found Omega Workshops, and after they closed in 1919 continued to work on decorative commissions; 1935 commissioned, with Vanessa Bell, to decorate the new Cunard liner *Queen Mary*, but his large murals were rejected; 1959 retrospective exhibition at Tate Gallery. Paintings at Eastbourne; Leicester.
Catalogues:
Duncan Grant: A Retrospective Exhibition, Tate Gallery, 1959
Duncan Grant: A Nintieth Birthday Exhibition of Paintings, Scottish National Gallery of Modern Art, 1975
See:
Mortimer, R., *Duncan Grant* (1948)
Roche, P., *With Duncan Grant in Southern Turkey* (1982)
Shone, R., *Bloomsbury Portraits: Vanessa Bell, Duncan Grant and their Circle* (1976)

Hepworth, Barbara (1903–75)
Sculptor; born Wakefield; 1919 Leeds School of Art; 1921 RCA; 1928 first solo exhibition; 1939 left London for St Ives, Cornwall; retrospective exhibitions at Venice Bienniale (1950), at Whitechapel Gallery (1956) and at Tate Gallery (1968); 1962–3

Dag Hammarskjold Memorial, New York; 1965 DBE.
 Works at Trewyn Studio, St Ives (now an outstation of Tate Gallery); Yorkshire Sculpture Park, West Bretton; Wakefield. Also on John Lewis store, Oxford Circus, London.
Catalogue:
Barbara Hepworth, Tate Gallery (1968)
Life:
A Pictorial Autobiography (1970, rev. 1978)
See:
Bowness, A., *The Complete Sculpture of Barbara Hepworth, 1960–69* (1971) [superb photographic record of a productive decade]
Gardiner, M., *Barbara Hepworth* (1982)
Hammacher, A.M., *Barbara Hepworth* (1968) [good introduction]
Hodin, J.P., *Barbara Hepworth* (1961)
Read, H., *Barbara Hepworth: Carvings and Drawings* (1952)

John, Augustus (1878–1961)
Painter and draughtsman; 1894–8 Slade School; 1899 first solo exhibition; 1928 RA; 1942 OM; 1954 retrospective exhibition at Royal Academy.
Writings:
Chiarosco, Fragments of Autobiography (1952)
Finishing Touches (1964).
See:
Easton, M. and Holroyd, M., *The Art of Augustus John* (1974)
Holroyd, M., *Augustus John: The Years of Innocence* (1974)
Augustus John: The Years of Experience (1975)
Rothenstein, J., *Augustus John* (1944)

John, Gwen (1876–1939)
Painter; sister of Augustus John; 1895–8 Slade School; 1904 settled in Paris, and formed relationship with Rodin; 1913 received into Roman Catholic Church; 1926 her only solo exhibition (New Chenil Galleries, London); later years spent as a recluse.
Catalogues:
Gwen John: A Retrospective Exhibition, Arts Council (1968)
Gwen John: An Interior Life, Barbican Art Gallery (1985)
See:
Chitty, S., *Gwen John, 1876–1939* (1981) [biography]
Taubman, M., *Gwen John* (1985)

Lewis, Percy Wyndham (1882–1957)
Painter and writer; 1899–1901 Slade

School; 1911 exhibited drawings with
Camden Town Group; 1913 briefly joined
Omega Workshops; 1914 organised the
Rebel Art Centre, and edited the first of the
only two issues of *Blast*, a Vorticist review;
1915 organised the first and only Vorticist
Exhibition; 1916 enlisted in the Garrison
Artillery; from 1917 served in France, first
as a gunner, later as War Artist; 1919 first
solo exhibition; 1920 organised an
exhibition by X Group, an abortive attempt
to revive Vorticism; during the inter-war
years, despite poverty and persistent illness,
held several exhibitions, published c.
twenty books, and edited two short-lived
periodicals, *Tyro* (1921–2) and *The Enemy*
(1927–9); welcomed Hitler in *Hitler* (1931)
but recanted in *The Hitler Cult* (1939); 1938
portrait of T.S. Eliot rejected by Royal
Academy; 1939–45 spent in US and
Canada; 1949 retrospective exhibition; 1951
Civil List pension; by 1954 totally blind;
1956 Tate Gallery retrospective exhibition,
Wyndham Lewis and Vorticism.

Paintings in National Portrait Gallery;
and at Aberdeen; Cambridge (Magdalene
College); Edinburgh; Leeds; Southampton.

Writings include:
Tarr (1918, rev. 1928, repr. 1982) [his first
novel]
Blasting and bombardiering (1937)
[autobiographical]
Rude Assignment (1950) [autobiographical]
Self-condemned (1954, repr. 1983) [partly
autobiographical]
Michel, W. and Fox, CJ., *Wyndham Lewis
on Art: Collected Writings, 1913–1956*
(1969)
Munton, A. (ed.), *Wyndham Lewis:
Collected Poems and Plays* (1979)
Rose, W.K. (ed.), *The Letters of Wyndham
Lewis* (1963)
Bibliographies:
Morrow, B. and Lafourcade, B., *A
Bibliography of the Writings of
Wyndham Lewis* (1978)
Pound, O.S. and Grover, P., *Wyndham
Lewis: a Descriptive Bibliography* (1978)
Life:
Meyers, J., *The Enemy: A Biography of
Wyndham Lewis* (1980)
See:
Cork, R., *Vorticism and Abstract Art in the
First Machine Age* (2 vols., 1975–6)
Durham, M. and Munton, A., 'Wyndham
Lewis and the Nature of Vorticism', in
Cianci, G. (ed.), *Wyndham Lewis:
letteratura/pittura* (Palermo, 1982)
Farrington, J., *Wyndham Lewis* (1980)
Jameson, F., *Fables of Aggression:*

*Wyndham Lewis, the Modernist as
Fascist* (1979)
Materer, T., *Wyndham Lewis the Novelist*
(1976)
Meyers, J. (ed.), *Wyndham Lewis: a
Revaluation* (1980)
Michel, W., *Wyndham Lewis: Paintings and
Drawings* (1971)
Wagner, G., *Wyndham Lewis: Portrait of
the Artist as the Enemy* (1957)

Moore, Henry (1898–1986)
Sculptor; b. Castleford, Yorkshire; 1917
enlisted in Civil Service Rifles, gassed at
Cambrai; 1919 Leeds School of Art; 1921
scholarship to RCA; 1925 travelling
scholarship to Italy; 1928 first solo
exhibition; commissioned to carve relief on
London Transport Headquarters building;
1933 helped form Unit One; 1936
participated in International Surrealist
Exhibition in London; 1938 exhibited in
Exhibition of Abstract Art in Amsterdam;
1940 Official War Artist, gaining acclaim
for his 'Shelter' drawings of London
Underground Stations; 1948 International
Prize for Sculpture at Venice Bienniale;
1951 'Reclining Figure' for Festival of
Britain; 1953 CH; 1957 'Reclining Figure'
for UNESCO Headquarters in Paris; 1963
OM.

Sculptures at Hull; Leeds; Manchester;
Wakefield; and a variety of open-air sites,
including Battersea Park; Harlow New
Town; Much Hadham, Herts.; Shawhead,
Dumfries.

Writings:
My Ideas, Inspiration and Life as an Artist
(1986)
Catalogues:
Henry Moore, Arts Council (1968)
The Drawings of Henry Moore, Tate
Gallery (1977)
Henry Moore: 80th Birthday Exhibition,
Bradford Art Galleries (1978)
See:
Henry Moore, Sculpture and Drawings,
Vol. I, 1921–48 (ed. Sylvester, D.,
1944, rev. 1957); subsequent volumes
ed. Bowness, A., Vol. II (1955, repr.
1965); Vol. III (1965); Vol. IV (1977);
Vol. V (1983).
Grigson, G., *Henry Moore* (1943)
Grohmann, W., *The Art of Henry Moore*
(1966)
Hall, D., *The Life and Work of a Great
Sculptor: Henry Moore* (1966)
Melville, R., *Henry Moore: Sculpture and
Drawings* (1970)
Mitchison, D., *Henry Moore: Unpublished
Drawings* (1971)

Packer, W., *Henry Moore: An Illustrated Biography* (1985)
Read, H., *Henry Moore* (1965)
Russell, J., *Henry Moore* (1968, rev. 1973, rev. 1980).

Nash, Paul (1889–1946)
Painter; 1910–11 (Slade School; 1912 first solo exhibition (watercolours); 1913 joined Omega Workshops; 1914 enlisted in Artists' Rifles; 1917 invalided home from France; exhibition of war drawings; returned to the Front as Official War Artist; 1920–1 designed theatre sets, and later designed textiles and posters; 1930 early member of Society of Industrial Artists; 1933 organised the formation of Unit One, including Moore, Burra, Hepworth, Ben Nicholson and Wadsworth; 1940 again appointed Official War Artist; July 1946 died of pneumonia.

Works at Aberdeen; Leeds; Manchester; Sheffield; Southampton.
Writings:
Outline: An Autobiography and Other Writings (1949)
Abbott, C.C. and Bertram, A. (eds.), *Poet and Painter: Correspondence between Gordon Bottomley and Paul Nash, 1910–1946* (1955).
Catalogues:
Paul Nash: A Memorial Exhibition, Tate Gallery (1948)
Paul Nash 1889–1946, Scottish National Gallery of Modern Art, Edinburgh, 1974
Paul Nash: Paintings and Watercolours, Tate Gallery (1975)
See:
Bertram, A., *Paul Nash: The Portrait of an Artist* (1955)
Causey, A., *Paul Nash* (1980) [comprehensive and authoritative]
Eates, M. (ed.), *Paul Nash: Paintings, Drawings and Illustrations* (1948) [includes bibliography and list of works in public galleries]
Postan, A., *The Complete Graphic Works of Paul Nash* (1973) [lithographs and woodcuts]

Nevinson, Christopher Richard Wynne, (1889–1946)
Painter; 1909 Slade School; 1913 founder member of the London Group; 1914 active in the Rebel Art Centre, and published, with Marinetti, a manifesto associating Vorticism with Futurism; 1914–16 served in France with Friends' Ambulance Unit; 1916 first solo exhibition; 1917 returned to France as Official War Artist; 1939–45 more war paintings.

Paintings at Cambridge (Fitzwilliam Museum); Swindon.
Writings:
Paint and Prejudice (1937) [includes monochrome reproductions]
See:
Flitch, J.E.C., *The Great War: Fourth Year. Paintings by C.R.W. Nevinson* (1918)
Konody, P.G., *Modern War Paintings by C.R.W. Nevinson* (1917)
Salaman, M.C., *C.R.W. Nevinson* (1932)
Sitwell, O., *C.R.W. Nevinson* (1925)

Nicholson, Ben (1894–1982)
Painter; 1910–11 briefly at Slade School; 1912–18 spent travelling abroad; 1924 joined the Seven and Five Society; 1934 joined Unit One; 1940 moved with Barbara Hepworth, his second wife, to Cornwall; 1951 mural for Festival of Britain; 1955 retrospective exhibition at Tate Gallery; 1968 OM, also second retrospective exhibition at Tate Gallery.

Works at Cambridge (Kettle's Yard); Edinburgh; Huddersfield; Leeds; Manchester; Swindon.
Catalogues:
Ben Nicholson, Tate Gallery (1969)
Ben Nicholson: the Years of Experiment 1919–39, Kettle's Yard, Cambridge (1983)
See:
Baxendall, D., *Ben Nicholson* (1962)
Hodin, J.P., *Ben Nicholson: The Meaning of His Art* (1957) [brief introduction]
Read, H., *Ben Nicholson: Paintings, Reliefs, Drawings. Vol. I: 1911–1948* (1948, rev. 1955); *Vol. II: Work since 1947* (1956)
Russell, J., *Ben Nicholson: Drawings, Paintings and Reliefs 1911–1968* (1969) [c. 300 plates]
Sausmarez, M. de, *Ben Nicholson: A Studio International Special* (1969)
Summerson, J., *Ben Nicholson* (1948)

Sickert, Walter (1860–1942)
Painter; 1881 briefly at Slade School, then became pupil of Whistler, and influenced by friendship with Degas; 1898 moved to Dieppe; 1905 returned to London; 1908 founder member of Allied Artists' Association; 1911 founder member of Camden Town Group; 1913 founder member of London Group; 1927–29 President of Royal Society of British Artists.

Works in many provincial galleries.

Writings:
Sitwell, O. (ed.), *A Free House* (1947).
Life:
Sutton, D., *Walter Sickert* (1976) [includes
 bibliography]
Catalogues:
Sickert, National Gallery (1941)
Late Sickert, Paintings 1927–42, Arts
 Council (1981)
See:
Baron, W., *Sickert* (1973) [mainly stylistic
 development]
Bertram, A., *Sickert* (1955)
Browse, L., *Sickert* (1960) [numerous
 plates]
Lilly, M., *Sickert, The Painter and his
 Circle* (1971)
Pickvance, R., *Sickert* (1967)
Rothenstein, J, *Sickert* (1961)
Woolf, V., *Walter Sickert: a Conversation*
 (1934)

Smith, Matthew (1874–1959)
Painter; b. Halifax; 1900–4 studied applied
design at Manchester School of Art; 1905–7
Slade School; 1908–14 lived in France,
exhibiting, 1911 and 1912, at the Salon des
Independants, and attending briefly at
Matisse's school in Paris before it was
disbanded; 1916–18 army service; 1920
lived in Cornwall (series of landscapes);
from 1921 lived mainly in France, including
Paris (two series of nudes, 1923–4 and
1930–2), and from 1933 in the south of
France (landscapes); 1940 evacuated from
France by RAF; 1953 retrospective
exhibition at Tate Gallery; 1954 knighted.
 Paintings at National Portrait Gallery
(self-portrait); and at Birmingham; Bristol;
Leeds; Manchester; Southampton.
Catalogues:
Matthew Smith, Tate Gallery (1953)
Matthew Smith, Barbican Art Gallery
 (1983)
See:
Hendy, P., *Matthew Smith* (1944)
Hendy, P., Halliday, F. and Russell, J.,
 Matthew Smith (1962)

Spencer, Stanley (1891–1959)
Painter; b. Cookham-on-Thames; 1908–12
Slade School; 1915–18 service in RAMC
and, from 1917, the Royal Berkshires,
including two years in Macedonia; from
1919 worked mainly in Cookham; 1927–32
moved to Burghclere to decorate the
Sandham Memorial Chapel with murals
based on his own war experiences; 1932
elected ARA; 1935 resigned from Royal
Academy after rejection of two of his

paintings; 1940 commissioned by War
Artists' Advisory Committee to paint
pictures of shipyards; 1947 retrospective
exhibition at Temple Newsam Gallery,
Leeds; 1950 rejoined Royal Academy and
elected RA; 1953 retrospective exhibition at
Tate Gallery; 1958 knighted.
 Paintings at Stanley Spencer Gallery,
Cookham; Sandham Memorial Chapel,
Burghclere, Berks; and many provincial
galleries including Birmingham, Bradford,
Cambridge, Leeds, Manchester, Newcastle,
Southampton.
Life:
Collis, L., *A Private View of Stanley
 Spencer* (1972) [the memoirs of his
 second wife Patricia Preese 'ghosted'
 by his biographer's daughter]
Collis, M., *Stanley Spencer: A Biography*
 (1962)
Rothenstein, J. (ed.), *Stanley Spencer the
 Man: Correspondence and Reminiscences*
 (1979)
Spencer, G., *Stanley Spencer* (1961) [by his
 brother].
Catalogues:
Stanley Spencer 1891–1959, Arts Council
 (1976)
Stanley Spencer R.A., Royal Academy
 (1980) [plentiful illustrations]
Spencer in the Shipyard, Arts Council
 (1981) [valuable record of his eight
 Shipbuilding on the Clyde paintings]
See:
Behrend, G., *Stanley Spencer at Burghclere*
 (1965) [numerous black-and-white
 plates]
Carline, R., *Stanley Spencer at War* (1978)
Newton, E., *Stanley Spencer* (1947)
Robinson, D., *Stanley Spencer: Visions from
 a Berkshire Village* (1979) [useful
 introduction]
Rothenstein, E., *Stanley Spencer* (1945)
 [good and well-chosen reproductions]
Wilenski, R.H., *Stanley Spencer:
 Resurrection Pictures 1945–50* (1951)
 [detailed account of the *Resurrection;
 Port Glasgow* series of paintings]

Wadsworth, Edward (1889–1949)
Painter; 1908–11 Slade School; 1913 briefly
joined Omega Workshops; 1914 member of
Rebel Art Centres; 1915 exhibited in
Vorticist Exhibition; served with Royal
Navy until 1917, and later became Official
War Artist; 1933 founder-member of Unit
One.
 Paintings at Leeds.
Catalogues:
Edward Wadsworth Memorial Exhibition,
 Tate Gallery (1951)

Edward Wadsworth 1889–1949, Colnaghi's Gallery (1974)

3 Books dealing individually with other artists

Alley, R., *Graham Sutherland* (1982)
 William Roberts ARA (1965)
Bowness, A. and Lambertini, C., *Victor Pasmore, with a 'Catalogue Raisonne' of the Paintings, Constructions and Graphics 1926–79* (1980)
Clark, K., *Paintings of Graham Bell* (1947)
Clements, K., *Henry Lamb: The Artist and his Friends* (1985)
Fraser Jenkins, D. *et al.*, *John Piper* (1983)
Pyle, H., *Jack B. Yeats* (1970)
Roberts, William, *Paintings 1917–1958* (1960)
Rothenstein, J., *Sir William Coldstream* (1980)

4 Exhibition catalogues

Art in Britain 1930–40 centred round Axis, Circle, Unit One, Arts Council (1965)
Artists at War 1914–18, Kettle's Yard Gallery, Cambridge (1974)
British Art in the 20th Century, Royal Academy of Arts (1987)
British Art: the Modern Movement, 1930–1940, Welsh Arts Council (1962)
Circle: Constructive Art in Britain 1934–40, Kettle's Yard Gallery, Cambridge (1982)
Concise Catalogue of Paintings, Drawings and Sculpture of the First World War 1914–18, Imperial War Museum (1924, rev. 1963)
Concise Catalogue of Paintings, Drawings and Sculpture of the Second World War 1939–45 (1956, rev. 1964) [Note: Mindata Ltd have produced also a micropublication, *British War Art of the 20th Century* (1982), reproducing on mono and colour microfiche the principal works commissioned as 'Official War Artists' records of two world wars']
Decade 1910–1920, Arts Council (1965)
Decade 1920–1930, Arts Council (1970)
Drawings at the Camden Town Group, Arts Council (1961)
The Euston Road School, Arts Council (1948)
Landscape in Britain 1850–1950, Arts Council (1983)
London Group 1914–64, Jubilee Exhibition: Fifty Years of British Art, Tate Gallery (1964)
The Modern British Paintings, Drawings and Sculpture, Tate Gallery, 2 vols., divided alphabetically by surname of artist (1964) [invaluable]
Thirties: British Art and Design before the War, Arts Council (1980)
Vorticism and its Allies, Arts Council (1974)

Sources of Illustrations

The publishers gratefully acknowledge the help of the many individuals and organisations who cannot be named in collecting the illustrations for this volume. In particular, they would like to thank Carol Varley for her help with picture research. Every effort has been made to obtain permission to use copyright materials; the publishers apologise for any errors and omissions and would welcome these being brought to their attention.

2 From John Ellis; *Eye Deep in Hell*, by permission of Croom Helm Ltd
46 Illustration © 1914 Wyndham Lewis. Copyright © 1981 by the Estate of Mrs G.A. Wyndham Lewis with the permission of the Wyndham Lewis Memorial Trust. Reprinted with the permission of Black Sparrow Press/By permission of the Syndics of Cambridge University Library
64 By permission of the Estate of Harry T. Moore, the Estate of Mrs Frieda Lawrence Ravagli, Laurence Pollinger Ltd
76 Mrs Peggy Strausfeld/By permission of the Syndics of Cambridge University Library
96 The Edward Gordon Craig Estate
102, 103 From Ebenezer Howard; *Garden Cities of Tomorrow* (1898)
105a Simon Pepper
105b The Architectural Press Ltd/Photo: Simon Pepper
106 From Raymond Unwin; *Town Planning in Practice* (1909)
108 From Raymond Unwin; *Nothing Gained by Overcrowding* (1912)/The Architectural Press Ltd
109 Simon Pepper

111, 112a Port Sunlight Information Services, Unilever UK Central Resources Ltd
112b Port Sunlight Information Services, Unilever UK Central Resources Ltd/Photo: Don Valentine
113 From *The Builder*, 5 July, 1912
116, 121 BBC Hulton Picture Library
156 City of Manchester Art Galleries
158 Private Collection/Courtauld Institute of Art
159 Crown Copyright National Railway Museum, York
163 Kettle's Yard, University of Cambridge
164 © Estate of Edward Wadsworth, 1988, All rights reserved, DACS/The Museum of Fine Arts, Houston, Museum Purchase with funds provided by the Brown Foundation
165 Kathleen Nevinson/National Gallery of Canada, Ottawa, Gift of the Massey Foundation, 1946
167 The Tate Gallery, London
171 The Property of The Lefevre Gallery, London
173 Aberdeen Art Gallery & Museums
175a Angela Verren-Taunt/City of Manchester Art Galleries
175b By permission Ivor Braka Ltd, London
176 The Tate Gallery, London
177 Private Collection/Michael Parkin Fine Art Ltd, London
179 Reproduced by kind permission of the Henry Moore Foundation
180, 183 The Tate Gallery, London
185 Granada Television Ltd
186 Leeds City Art Galleries

Colour Plates

Index